ABNORMAL PSYCHOLOGY

3rd Edition

Sarah K. Sifers, Ph.D.

Minnesota State University Mankato
Mankato, MN

Timothy W. Costello, Ph.D. Joseph T. Costello, Ph.D.

Contributing Editor

Brad Mossbarger, Ph.D. Austin Peay State University Clarksville, TN

An Imprint of HarperCollinsPublishers
Property of Library
Cape Fear Community College
Wilmington, NC

ABNORMAL PSYCHOLOGY. Copyright © 1992, 2006 by HarperCollins Publishers. All rights reserved. Printed in the United States. No part of this book may be used or reproduced in any manner whatsoever without written permission except in the case of brief quotations embodied in critical articles and reviews. For information address HarperCollins Publishers, 10 East 53rd Street, New York, NY 10022.

An American BookWorks Corporation Production

HarperCollins books may be purchased for educations, business, or sales promotional use. For information please write: Special Markets Department, HarperCollins Publishers, 10 East 53rd Street, New York, NY 10022.

Library of Congress Catalog-in-Publication has been applied for.

ISBN: 978-0-06-088145-0 ISBN-10: 0-06-088145-3

06 07 08 09 10 CW 10 9 8 7 6 5 4 3 2 1

Contenta

Prefac	e	.V
1 Th	e Field of Abnormal Psychology	.1
2 Th	e History of the Problem of Abnormal Behavior	.13
	search in Abnormal Psychology	
	ychodynamic, Humanistic, and Existential Perspectives	
5 Be	chavioral, Cognitive, Biogenic, and Sociocultural Perspectives	.58
6 As	sessment and Classification	.70
7 Ps	ychodynamic Forms of Psychotherapy	.84
8 Be	chavioral, Cognitive, and Biogenic Therapies	.97
9 Ar	nxiety Disorders1	12
10 So	omatoform and Dissociative Disorders	26
11 Ps	ychological Factors Affecting Physical Conditions	36
12 Pe	rsonality Disorders1	51
13 M	ood Disorders	67
14 Sc	hizophrenia and Other Psychotic Disorders	84
15 Su	abstance-Use Disorders	202
16 Se	exual and Gender Disorders	219
17 Oı	rganic Disorders	236
18 M	ental Retardation	252
	bnormal Behavior of Children and Adolescents	
20 Ea	ating and Sleeping Disorders	280
21 Le	egal Issues and Social Policy	288
Gloss	ary	305

is an althoritain and the training

for in ample

Preface

The goal of this outline is to provide you with information about abnormal psychology. Specifically, you will find the symptoms, onset, causes, course, and common treatment methods of the most frequently noted disorders contained in the *Diagnostic and Statistical Manual*, 4th Edition, Text Revision. The outline provides information about and examples of research in abnormal psychology. Furthermore, it aims to educate you about historical and modern issues in abnormal psychology, including legal and social concerns. The comprehensive and yet concise nature of this outline make it an ideal resource not only for students of abnormal psychology but also for professionals and educators in psychology and related fields.

This outline's format provides an easy reference and helps you organize the material, thus facilitating learning. This concise, easy-to-access layout makes it ideal for a quick review or for gaining a basic understanding. The information provided includes a balance of historical context and modern research from multiple perspectives within the field. Each chapter contains review questions to assess for comprehension of the material and suggested readings if you would like a more in-depth or first-hand account of the topics covered. The outline also includes a glossary and index to facilitate rapid reference to key terms.

The outline begins with an overview of the field of abnormal psychology followed by the history of the discipline. Next is an outline of basic research strategies and issues within abnormal psychology, plus a description of the common theoretical orientations and their strengths and weaknesses. Following this introduction is a chapter on the assessment and classification of psychological disorders, and then a discussion of common approaches to the treatment of mental illnesses. Subsequent chapters focus on the major categories of disorders commonly identified in abnormal psychology. Closing the outline is a chapter on legal and social issues pertaining to abnormal psychology.

The current edition of this outline began with the work of Timothy W. Costello and Joseph Costello. Revisions to the text sought to maintain the quality of work and be consistent with the original authors' vision, with updates for changes in the field from revisions to the *Diagnostic and Statistical Manual* to the quickly expanding literature on abnormal biopsychology. I am largely indebted to the foundation that Timothy W. and Joseph Costello began in this outline.

Sarah K. Sifers

yan bas. In

Steen foliated to the second s

The Field of Abnormal Psychology

onsidering that approximately 44.3 million people living in the United States report meeting the diagnostic criteria for at least one psychological disorder in the past year, the issue is of top concern. Psychological disorders take many forms. They range from relatively unnoticed symptoms that largely affect only the individual with the disorder to behavior that can seriously impinge upon the rights of others. Psychological disorders also range from mild symptoms to more extreme symptoms or symptoms that seem bizarre.

In the modern world, high-tech communications reveal abnormalities around the corner as well as around the globe. Celebrities gain infamy for abuse of all kinds of substances and situations, while others are spotlighted for their suffering of such mental disorders as depression, eating disorders, and psychoses. On the societal level, whole groups of people marked by their cruelty, suicidal behavior, or common idiosyncratic behaviors have gained the attention of the world. The average person, however, still remains only vaguely aware of psychological disorders around him or her. Perhaps one knows a person with a psychological condition but, for the most part, holds opinions about abnormal behavior are based on bits of information or erroneous reports. Common misconceptions about abnormal behavior are that it is incurable or inherited; that those with psychological disorders are dangerous; that abnormal behavior is always bizarre; that psychological disorders come from weakness of will or immoral behavior. These statements are either totally false or apply in only limited ways. Apart from misconceptions, even the question, "How does one distinguish between normal and abnormal behavior?" is a perplexing one.

Abnormal psychology is the branch of psychology that concerns itself with establishing criteria to distinguish abnormal from normal behavior, describing the various types of abnormal behavior, searching out the causes of that abnormal behavior, seeking appropriate means of treating it, and ultimately finding ways to prevent it. More formally, we can define abnormal psychology as the scientific study of behavior that is not considered normal.

The field of abnormal psychology is such a developing one that professionals have created and repeatedly modified the most frequently used classification system of psychological disorders. Originally issued in 1952 by the American Psychiatric Association, the *Diagnostic and Statistical Manual* (DSM) lists the symptoms and other related information about widely accepted psychological disorders. The most recently published manual, the *Diagnostic and Statistical Manual*, 4th Edition, Text Revision (DSM-IV-TR), was published in 2000. It provides a means of classifying all recognized psychological disorders and evaluating their severity. The manual uses five axes to enable clinicians to be precise about diagnosis and evaluation. The axes are:

Axis I: The clinician reports any recognized clinical syndromes except personality disorders and mental retardation.

Axis II: The clinician indicates any personality disorders or mental retardation.

Axis III: The clinician identifies any physical conditions that might affect psychological functioning.

Axis IV: The clinician specifies any psychosocial or environmental stressors that might influence the individual's functioning, diagnosis, treatment, or prognosis.

Axis V: The clinician rates the highest level of the individual's overall functioning.

Controversy over inclusion of such novel manifestations as "road rage" continue to divide those involved in the revisions of the DSM. So far, such additions have been thwarted by those who do not want this system to provide the criteria for every behavior that is not totally conformist or conventional. For now, however, the following definition of mental disorders is purported by the DSM.

[A mental disorder] is conceptualized as a clinically significant behavioral or psychological syndrome or pattern that occurs in an individual and that is associated with present distress (e.g., a painful symptom) or disability (i.e., impairment in one or more important areas of functioning) or with a significantly increased risk of suffering death, pain, disability, or an important loss of freedom. In addition, this syndrome or pattern must not be merely an expectable and culturally sanctioned response to a particular event, for example, the death of a loved one. Whatever its original cause, it must currently be considered a manifestation of a behavioral, psychological, or biological dysfunction in the individual. Neither deviant behavior (e.g., political, religious, or sexual) nor conflicts that are primarily between the individual and society are mental disorders unless the deviance or conflict is a symptom of a dysfunction in the individual, as described above (American Psychiatric Association 2000, pp. xxi).

The DSM does not refer to the causes of mental disorders in order to avoid implying adherence to any specific theoretical orientation. It also refers to mental disorders as the product of dysfunctions that reside in individuals, not groups. Hence, according to this definition, there are no disordered groups. Although the DSM's definition of mental disorders is generally accepted, it has been challenged for its redundancy. Using this definition requires that problematic behavior be a symptom of dysfunction in the individual if it is to qualify as an instance of mental disorder. So, the problem behavior could not itself be the dysfunction.

In the 1990s, Jerome Wakefield offered the idea of mental disorder as "harmful dysfunction." Harm, in this definition, is explained in terms of social values (for example, suffering, the inability to work, and so on), with dysfunction referring to an underlying mechanism that does not perform according to its evolutionary design. Wakefield's definition follows:

A mental disorder is a mental condition that (a) causes significant distress or disability, (b) is not merely an expectable response to a particular event, and (c) is a manifestation of a mental dysfunction. (1992a, p. 235).

Although this definition is viewed as an improvement by some, there are still problems with it. Specifically, no defective operating mechanisms have been identified for most disorders. It would be quite an incredible undertaking to be able to identify a distinct underlying dysfunction that is biological in nature for the many DSM diagnoses currently in existence.

Thus, this chapter further examines the basic aspects of abnormal psychology—answering, in a basic way, questions that novices to its study often have in mind. How does one distinguish between normal and abnormal behavior? How prevalent is mental illness? What causes mental illness? Why does professional help become necessary? Where can such help be found? Who is professionally qualified to offer help?

WHAT IS NORMAL? WHAT IS ABNORMAL?

"Normal" and "abnormal," as applied to human behavior, are relative terms. Many people use these classifications subjectively and carelessly, often in a judgmental manner, to suggest good or bad behavior. As defined in the dictionary, their accurate use would seem easy enough: normal means conforming to a typical pattern; abnormal means deviating from a norm. The trouble lies in the word norm. Whose norm? For what age person? At what period of history? In which of the world's many cultures?

Goodness As a Criterion of Normal

Equating normal with good behavior and abnormal with bad behavior has its problems. Some questions that must be asked are these: Good or bad by whose values or standards? Under what circumstances? Is assertive behavior bad because it is disconcerting, and compliant behavior good because it is easy to accept? Is aggressive behavior always bad? Is behavior that violates parental rules bad, and behavior that conforms to parental expectations good? Is behavior that conforms to minority cultural standards but not to mainstream cultural standards bad? Psychologists who work in the field of abnormal behavior (usually referred to as clinical psychologists) have come to grips with those problems and offer more objective criteria.

Two Basic but Different Concepts of Normal and Abnormal

Social science offers two ways of distinguishing between the normal and abnormal. One way, emphasized by sociologists and anthropologists, considers the question meaningful only as it applies to a particular culture at a particular time: Abnormal is that which deviates from society's norms. The other, stressed more by psychologists, sets as the basic criterion the individual's well-being and the maladaptiveness of his or her behavior. The first we will call the criterion of deviance; the second, the criterion of maladaptive behavior.

Abnormal Defined As Deviation from Social Norms

The criterion of deviation from society's norms—that is, cultural relativism—provides an easy way of identifying abnormal behavior. According to this definition, if behavior differs significantly from the way in which others in the same society typically behave, it is abnormal. Cultural relativism bypasses the question of whether there are sick societies whose values are pathological, such as disregarding basic human rights. When such a sick society changes radically, for example as Germany did after World War II, does that make all the previously conforming individuals abnormal and all the resistive, nonconforming individuals now normal?

Another problem faced by the cultural relativists is the question of whether there are any types of abnormal behavior whose observable symptoms cut across all cultures. Emil Kraeplin's Textbook of Psychiatry, published in 1923, provided a basis for classifying mental illness that is still used today. Through his case studies, he felt that depression, sociopathy (fixed patterns of antisocial behavior), and schizophrenia were universal disorders, appearing in all cultures and societies. Kraeplin's astute observations were reinforced by a Swiss psychiatrist named Eugen Blueler (1857-1939), whose detailed

poverty.

of what we would now recognize as specific phobia and obsessive-compulsive disorder. disease. The founder of psychoanalysis, Sigmund Freud (1856-1939), described many interesting cases (1864-1915) presented an unusual clinical picture of his patients that came to be known as Alzheimer's toms (syndromes) of what we today call schizophrenia and bipolar disorder. Alois Alzheimer descriptions of patients were clearly indicative of those suffering from the symptoms or clusters of symp-

abnormal behavior from normal behavior. psychologists question the usefulness of social acceptability as a meaningful criterion for sorting out tion that some mental illnesses appear more frequently in some cultures than in others. However, most There is no question that cultural factors color the symptoms of any mental illness, nor is there ques-

Maladaptiveness As a Criterion of Abnormal Behavior

growth or significantly limits it is considered abnormal. growth and well-being is considered normal behavior, while behavior that maladaptively prevents that With that value in place, instead of acceptability by the society, behavior that promotes an individual's world has followed suit, although such an individualistic orientation is not consistent across all cultures. tant and that assuring the well-being of the individual assures the well-being of society. The Western United States, society has made such an initial judgment, that the well-being of the individual is impornot necessarily scientifically justifiable—that some values are intrinsically good in themselves. In the To reject cultural relativism requires that the individual or the society make a value judgment—one

eliminate those social problems that can erode a society's well-being, such as racism, discrimination, and irreparably self-damaging. It includes a concern for the well-being of families and a mission to work to deviant behavior, which may stimulate the society to re-examine itself and its goals, so long as it is not being perspective allows room for the conforming behavior necessary for group cohesiveness and for nition: not merely survival, but growth and fulfillment, which are paths to self-actualization. The wellbehavior is adaptive and normal or maladaptive and abnormal. "Well-being" here is given a broad defiior, but it does put that decision in the hands of those who will use science to evaluate whether any given Such a criterion does not do away with all subjectivity in evaluating the normality of anyone's behav-

SPECIFIC CRITERIA FOR JUDGING MALADAPTIVENESS

which he or she may have lived. Those factors may cause a transitory spell of maladaptive behavior. take account of severely stressful life situations that the individual may face or catastrophic events through impairs necessary functioning, especially in interpersonal relations and in occupational pursuits. They also adaptiveness of behavior, psychologists consider the frequency of the behavior and the extent to which it takes one alcoholic drink more than is sensible, never feels depressed or anxious. In evaluating the malwhose behavior is never maladaptive—who never becomes angry in a self-damaging way, who never Using maladaptive behavior as a criterion of abnormality has its own problems. It is the rare person

adaptive in that they threaten the well-being of the individual. A description of them follows. ders that may benefit from psychological treatment. All those disorders, in one way or another, are mal-There are certain kinds of conditions or behaviors that suggest the presence of psychological disor-

Long Periods of Subjective Discomfort

feelings as anxiety and depression or frenetic behavior persist and appear to be unrelated to events surcriticism. But those feelings are transitory, and they are related to real or threatened events. When such loved one's illness, fearful anticipation of a challenging assignment, or aggrieved feelings after an unfair Everyone goes through periods of psychological discomfort such as worry about the severity of a

rounding the person, they would be considered abnormal. Thoughts, feelings, or behaviors that are distressing to an individual and do not pass in a reasonable period of time suggest the possible presence of a psychological disorder.

Impaired Functioning

A distinction must be drawn between periods of transitory inefficiency and prolonged inefficiency; between inefficiency whose cause can be identified and lasting inefficiency which seems to be inexplicable. Important examples that would be considered signs of an abnormal psychological condition are as follows: frequent loss of jobs or frequent job changes without apparent justification; prolonged performance notably below the individual's potential, the most common examples of which are the very bright student who gets only low or failing grades, or the brilliantly talented person who fails in one effort after another.

Bizarre Behavior

The term "bizarre" does not refer to unconventional behavior that is carried out for some specific reason that can be understood by others—for example, behavior carried out to gain attention or to achieve notoriety. Just a mere decade and a half ago, body piercings were considered highly deviant. Today, such embellishments are considered a fashion statement and are more typically known as body art. Rather, bizarre behavior indicative of abnormality has no rational basis, is unconnected to reality, and seems to suggest that the individual is disoriented. Such behavior indicates a serious psychological disorder. These psychoses (to be described in Chapter 14) frequently bring on hallucinations (baseless sensations), such as hearing voices when no one is present, or delusions (beliefs that are patently false, yet steadfastly held). An example is delusions of grandeur, in which an individual believes he or she is a great historical character who is long dead.

Disruptive Behavior

The implication here is impulsive, seemingly uncontrollable behavior that regularly disrupts the lives of others or deprives them of their rights. Such behavior is characteristic of several psychological disorders. The antisocial personality disorder (to be described in Chapter 12), for example, has as one of its principal characteristics conscienceless and apparently purposeless aggressive or exploitative behavior.

All of the described abnormal behaviors are maladaptive because they directly affect well-being by blocking growth and fulfillment of the individual's potential or do so indirectly and, in the long run, by seriously interfering with the well-being of others.

■ HOW COMMON ARE PSYCHOLOGICAL DISORDERS?

The study of the distribution of mental disorders is called mental health epidemiology. In considering the extent of psychological disorders, a distinction is drawn between prevalence, which is the number of individuals suffering a mental disease at a given time in a given population, and incidence, which is the number of new cases of a condition in a given period of time and population. Associated risk factors is another term used in reporting incidence, an example of which would be the lifetime expected occurrence of disorders for individuals with relatives having a mental illness.

The prevalence of abnormal behavior (mental illness or psychological disorder, as we will call it in this book) in the United States is 20.9 percent for children ages 9 to 17, 28 percent to 30 percent for adults ages 18 to 55, and 19.8 percent (exclusive of Alzheimer's and substance abuse) for adults 55 and older. The direct costs of health services for mental disorders (including Alzheimer's disease and substance

abuse) was \$92 billion in 1998, and the indirect cost includes \$105 billion a year in lost productivity and \$8 billion a year in welfare and crime.

Prevalence of Specific Disorders

Later chapters in this outline describe in detail the variety of psychological disorders. Some classes of disorders, such as substance abuse and anxiety, are quite common, while others, such as psychoses, are less common.

Age and Gender Differences

There are both gender differences and age differences in the types of mental disorders suffered. Although men and women experience mental disorders in equal numbers, they differ in the kinds of mental illnesses affecting them. Alcoholism, for example, affects 24 percent of the male population, but only 4 percent of females. Women are more prone than men to suffer depression and anxiety, except in the Jewish culture. Drug dependence occurs most frequently in the age group of those eighteen to twenty-four; depression and alcoholism most frequently develop during the age span of twenty-five to forty-four years of age. Disorders of thinking such as dementia are most prevalent among older adults.

■ WHAT ARE THE PRINCIPAL FACTORS THAT CAUSE ABNORMAL BEHAVIOR?

In this introductory chapter, we can take only a broad-brush approach to describing causative factors in mental illness. There are three concepts that are important for you to grasp in considering the development of psychological disorders: stress, coping mechanisms, and vulnerability. It is the interaction among those elements that determines the development of mental illness. Detailed descriptions of causative elements can be found in chapters describing specific disorders.

Stress

Stress is a set of emotional tensions accompanied by biological changes (principally of the autonomic system; that is, sweating, heart pounding, blood pressure changes) caused by a threatened external event. In milder forms, it causes worry and fretfulness. The experience of some level of stress is a frequent event in everyone's life. When the stressing external event is extreme, such as a serious automobile accident or an earthquake, or when it imposes prolonged frustration of an important human need or a bewildering conflict in which a decision is required, such as divorce, a major adjustive effort is required of the individual. That demand may push the individual into a breakdown of adaptive responses and cause the appearance of abnormal behavior. Whether that breakdown occurs at all and whether it is mild or extreme depends on the existence of previously learned adaptive behavior or, in its absence, on the presence of a tendency to depend upon specific coping mechanisms. Existing vulnerabilities predispose the individual to the possibility of mental disorder in extremely stressful situations.

Coping Mechanisms

When faced with a stressful event or set of circumstances, a person may rise to the challenge by directing behavior primarily at dealing with the stressful event; that is, by problem-focused coping. Alternatively, the person may focus on managing his or her emotional reaction to the stressor by avoiding, distancing, or reinterpreting the stressor, which is called emotion-focused coping. Sometimes, coping behaviors are effective in managing stress, but other times, they do not successfully counter the effects of stress or else can result in additional negative consequences. Much maladaptive or abnormal behavior is the result of ineffective coping behaviors.

Vulnerability

Whether individuals respond adequately to stress depends upon their vulnerability, or susceptibility, to the development of psychological disorders. There are, of course, "soft spots" or vulnerabilities in the personalities of all people, but when they are significant or multiple they can predispose the individual to break down and exhibit maladaptive behavior. Vulnerability can be due to biological (for example, genes), psychological (for example, inappropriate belief that situations are out of one's control), social (for example, inadequate parenting), or environmental factors (for example, living in a dangerous area).

WHY PROFESSIONAL HELP BECOMES NECESSARY

Despite expert opinion that psychological disorders (along with physical disorders) are most effectively treated at the earliest sign of significant disturbance, many people, for one reason or another, delay treatment, deluding themselves that palliatives or self-help approaches will cure the illness. In most cases, it requires some relatively powerful influence to bring an individual to the therapist's office. Troubled individuals finally enter therapy as a result of one of three kinds of influence: personal discomfort, the pressure of relatives and friends, and/or the demands of community or legal authorities.

Personal Discomfort

Most people who seek professional psychological help are suffering from physical or emotional discomfort. Many discomforting, even frightening, physical symptoms stem from or are made worse by emotional disorders. Among them are cancer and hypertension. Among the physical symptoms are chronic fatigue, heart palpitations, stomach complaints, and pain. Often, the effective stimulus motivating the individual is the family physician, who has ruled out physical causes for a disorder and suggests that the person seek psychological or psychiatric assistance.

Emotional symptoms, particularly intense anxiety or spells of depression, may become so painful or alarming that they overcome whatever reasons the person may have had for delaying treatment. Many clinicians feel that a client must be experiencing notable psychological pain to persist with therapy and to respond to it.

The Influence of Family and Friends

The behavior associated with abnormal behavior may be more painful to family members or friends than to the disordered individual. Examples are abuse of alcohol, assaultive behavior, emotionally draining dependence, or exploitative behavior. Sometimes, desperate to change things, family or close friends will bring pressure on the individual to seek help. That pressure may benignly be brought to bear in a heart-to-heart talk, but strong methods are also used. Common examples include a spouse who threatens to leave; a parent who states that the house will be locked against the individual unless treatment is sought; or previously supportive friends who simply desert the individual. The kind of pressure used to induce the individual to enter therapy will, of course, have an effect on the individual's responsiveness to treatment, sometimes causing an indifferent attendance at therapy sessions with little emotional involvement or, in other situations, causing a panic-stricken demand that the therapist do something to help.

The Influence of Legal or Community Authorities

Psychological disorders can produce behavior that is so antisocial or disruptive as to call the individual to the attention of community authorities such as a social worker to whom the family has become known, a clergy person who has tried to help, or, in extreme cases, the police or other legal authorities. With that kind of intercession, the pressure to seek therapy is made more powerful. How that power is brought to bear will also have an effect on the individual's attitude toward therapy. Individuals who have been court-ordered to receive mental health services often do so grudgingly and with little internal motivation to change.

■WHY IS PROFESSIONAL HELP NEEDED AND WHO PROVIDES IT?

Throughout later chapters, we consider the variety of help, called therapies, available to those with psychological disorders. The first step in that process is an assessment of the individual's condition. That process leads to a diagnosis, which enables the clinician to fit the psychological troubles of the individual into a specific category of mental illness. That diagnosis gives the clinician an initial understanding of some of the elements in the individual's illness and enables the clinician to plan a course of treatment.

There are three professions that provide those helping services, either as a team or individually. They are psychologists, psychiatrists, and social workers. The academic and experiential training they receive, although different for each of the professions, prepares them in ways relevant to their discipline to offer psychological help in a skilled and responsible fashion. Beyond that primary group of mental health professionals, there are other professionals and paraprofessionals who offer specialized ancillary services, but not psychotherapy. They ordinarily work in association with psychiatrists, psychologists, or social workers.

Psychologists

These professionals, who are trained to make psychological assessments and to provide psychotherapy, will carry one of three titles: clinical psychologists, counseling psychologists, or school psychologists. Only these three categories of psychologist are trained to offer professional help for psychological disorders. Ordinarily, in five or six years of post-baccalaureate schooling, they acquire a Ph.D. (doctor of philosophy), which is a scientific degree preparing the individual for research as well as for clinical practice, or a Psy.D., (doctor of psychology), which is an applied degree providing training principally for psychological practice. During the last year of their degrees, both groups complete a supervised one-year applied internship.

Clinical psychologists specialize in working with those who suffer psychological disorders. Counseling psychologists, in addition to assessment and therapy, typically offer consultation on vocational and career problems. School psychologists work mostly with children who are having school problems, the source of which may be emotional problems. All states require those three types of psychologists to pass a licensing or certification test.

Psychiatrists

These professionals are medical doctors who, after completing their medical education, spend three or four years in residence, under supervision, in a mental health facility. After that training, they may choose to become board certified by passing an examination. In most states, only physicians can write prescriptions for drugs, admit an individual to a hospital, or undertake biological forms of therapy.

Clinical Social Workers

These are professionals who have completed a two-year master's program in a school of social work, including applied internships. Some may continue on for a doctoral degree. Their training emphasizes skilled assessment, interviewing, and treatment of individuals and groups in the mental health setting. Many social workers consider individual strengths and social influences in their psychotherapeutic work.

Psychiatric Nurses

Psychiatric nurses, beyond their R.N. (registered nurse) degree, have had special training to work with individuals with psychological disorders in psychiatric hospitals. Psychiatric nurses work with individuals to develop and implement plans of care including medication, education, and other interventions. Advance practice registered nurses (APRNs) with psychiatric training also are able to conduct psychotherapy and, in some states, prescribe medication.

Occupational Therapists

Occupational therapists typically complete a master's degree in occupational therapy, plus an internship with the physically and psychiatrically challenged, focusing on helping these individuals to make the most of their resources. Occupational therapy utilizes a holistic approach to individualized interventions to develop daily living skills.

Pastoral Counselor

These professionals are usually a member of the clergy but could be lay people trained in psychology with an internship in a mental facility. This individual typically has a ministerial background and may serve as a chaplain.

Other Professionals

Psychiatric attendants or mental health technicians are a paraprofessional group who work in the psychiatric wards of hospitals. Skill therapists put into effect the suggestions of the principal therapists to provide recreational, artistic, dance, music, or occupational activities (largely crafts). They hold such titles as dance or music therapists. Case managers often have bachelor's degrees in social work or psychology and help to seek out and coordinate services for their clients.

Settings in Which Mental Health Therapists Work

A large number of mental health clinicians—that is, psychologists, psychiatrists, and social workers, work in private practice, either singly or in groups. Clients or patients are referred to them by family doctors, clergy, social agencies, insurance companies, or by former clients. Additionally, many individuals use the phone book or Internet to locate service providers, but doing so has its risks, because there are no guarantees regarding the clinician's competence.

Other mental health professionals practice in outpatient settings, which usually are sponsored by community mental health centers or other social agencies, or are affiliated with a hospital. General hospitals and psychiatric hospitals may sponsor outpatient psychological service, but most frequently, they provide service only for hospitalized patients. Some clinicians work for schools or social service agencies.

SUMMARY

Abnormal psychology is the branch of psychology that establishes criteria distinguishing normal from abnormal behavior, describes the various types of abnormal behavior, searches out its causes, and seeks to find means of treating or preventing it.

The Diagnostic and Statistical Manual is a list of commonly accepted psychological disorders and related information. It has been revised several times and is used in classifying abnormal behavior.

Psychologists consider maladaptive behavior—that is, behavior that interferes with the individual's well-being and psychological growth—to be the overriding criterion for diagnosing abnormality. They do not consider behavior that deviates from society's norms as necessarily a sign of abnormality.

There are four principal criteria for considering behavior maladaptive: long periods of personal discomfort; impaired social, educational or occupational functioning; bizarre behavior; or disruptive behavior.

In assessing the problem of mental disorders, social scientists speak of prevalence (the total number of individuals in a specific category suffering a mental disorder) and incidence (the rate at which new cases of mental disorders, usually of a particular type, will occur in a specified population during a stated period of time).

The principal factors causing mental disorders are stress, failure to learn adequate coping mechanisms, and vulnerability (such as genes or social risk factors).

People seek professional help because of personal discomfort, the urging of family or friends, and the influence of legal or community authorities.

There are three professional groups that offer help to victims of mental disorders. They are psychologists, psychiatrists, and clinical social workers. They are assisted by other professional groups such as psychiatric nurses, occupational therapists, and pastoral counselors, as well as such paraprofessional groups as mental health technicians, skills therapists, and case workers. These professionals tend to work in private practice, outpatient clinics, or hospitals.

SELECTED READINGS

Amador, X., & Johanson, A. (2000). I am not sick, I don't need help! Peconic, NY: Vida Press.

Beutler, L. E., & Malik, M. L. (2002). Rethinking the DSM: A psychological perspective. Washington, DC: American Psychological Association.

Corey, G., Corey, M. S., & Callahan P. (2002). Issues and ethics in the helping professions (6th ed.). Belmont, CA: Brooks/Cole.

Chesler, P. (2005). Women and madness: Revised and updated. Hampshire, U.K.: Palgrave Macmillian.

Kaplan, B. (Ed.). (1964). The inner world of mental illness. New York: Harper Row.

Kottler, J. A. (2003). Introduction to therapeutic counseling: Voices from the field. Belmont, Ca: Brooks/Cole.

Lee, W. M. L. (1999). Introduction to multicultural counseling. London: Taylor & Francis Group.

Test Yourself

- 1) Abnormal behavior is always incurable. True or false?
- 2) Abnormal psychology is defined as that branch of psychology that concerns itself with those who are gifted (those with cognitive abilities above a measured IQ of 130) and with those with mental retardation (those with a measured IQ below 69). True or false?
- 3) The Diagnostic and Statistical Manual (DSM) is a list of
 - a) all possible abnormal behavior
 - b) psychological disorders and related information
 - c) treatments for all existing psychological disorders
 - d) the prevalence of odd behaviors
- 4) Distinguishing normal from abnormal human behavior is difficult because it is a relative term based on a norm. The meaning of "relative" in this definition means that behavior is considered abnormal depending upon
 - a) who establishes the norm
 - b) the age of the person concerned
 - c) the culture and time period of the person concerned
 - d) all of the above
- 5) Goodness is an appropriate criterion to be used when comparing normal to abnormal behavior. True or false?
- 6) In his *Textbook of Psychiatry* (1923), Kraeplin found certain abnormal behaviors as universal; that is, cutting across cultures. True or false?
- 7) Jerome Wakefield's idea of "harmful dysfunction" is the panacea to the definition of mental disorder. True or false?
- 8) Which of the following is an appropriate criterion for maladjustment?
 - a) significant personal discomfort
 - b) immorality
 - c) violation of social norms
- 9) Prevalence, incidence, and associated risk factors are statistics used in reporting mental illness. True or false?
- 10) Which of the following professionals provide psychotherapy?
 - a) psychologists
 - b) mental health technicians
 - c) clinical social workers
 - d) all of the above
 - e) both a and c

Test Yourself Answers

- 1) The answer is **false.** Many common misconceptions exist regarding abnormal behavior including its inability to be cured. Other misconceptions are that the mentally ill are dangerous and bizarre and that mental illness derives from weakness of will or immoral behavior, or is always inherited. Most of the preceding apply only in limited situations, if at all.
- 2) The answer is false. Abnormal psychology is that branch of psychology that concerns itself with establishing criteria to distinguish abnormal from normal behavior and providing necessary diagnostic criteria in an effort to seek the means to appropriately treat and, if possible, prevent it.
- 3) The answer is **b**, a list of psychological disorders and related information. The DSM does not include all possible abnormal behavior (that book would be infinitely large) or treatments for psychological disorders. Although it does include the prevalence of psychological disorders, it does not include all odd behaviors. It does include a list of commonly recognized psychological disorders and information related to those disorders.
- 4) The correct answer is **d**, all of the above. The perspective of the person establishing norms, the age of the person concerned, and the culture and time in history in which the person lives are all significant factors when distinguishing normal behavior from abnormal behavior.
- 5) The answer is **false**. Goodness is subjective, depending upon personal and societal values and perspectives. A much more appropriate criterion would be the degree of deviation from societal norms or, perhaps even better, maladjustment.
- 6) The answer is **true**. Providing a basis for the method of classification of mental illness still in use today, Emil Kraeplin reported symptoms that seemed to cut across all cultures in the manifestation of depression, sociopathy (antisocial behavior), and schizophrenia.
- 7) The answer is **false**. Although Wakefield's proposal has offered a helpful step forward, it still does not provide a totally adequate definition of mental disorders. Nevertheless, his conceptualization provides the basis for a good working definition.
- 8) The answer is a, significant personal discomfort. In lieu of another cause, significant personal discomfort clearly suggests maladjustment associated with abnormal behavior. Violation of moral standards and social norms may occur in the case of a psychological disorder, but such violations do not automatically indicate a psychological disorder. For example, having an extramarital affair may violate certain moral and societal standards, but is not a necessarily a symptom of a psychological disorder. However, an extramarital affair that occurs along with other extreme pursuits of pleasurable activities despite serious risk of personally painful consequences may be a symptom of a manic episode (discussed in Chapter 13).
- 9) The answer is **true.** Prevalence is the number of individuals suffering a mental disease at any given time. *Incidence* reports the rate at which new cases of a specified disorder appear in the population during a stated period of time. Associated risk factors is an additional term used in reporting incidence that indicates the rate of a disorder in a specific population thought to be at higher risk for that disorder.
- 10) The answer is **e**, both a and c. Psychologists and clinical social workers both provide psychotherapy; that is, talk therapy geared toward treating psychological disorders. Mental health technicians may help implement therapeutic plans such as use of behavior modification or skills building, but do not conduct psychotherapy.

The History of the Problem of Abnormal Behavior

The problem of mental disorders is as old as humankind. Recorded history reports a broad range of interpretations of abnormal behavior and methods for correcting it, which have generally reflected the degree of enlightenment and the trends of religious, philosophical, and social beliefs and practices of the times. It is not surprising that earlier efforts to deal with the problem were fraught with difficulties and that the evolution of the science of abnormal psychology has been painfully slow. This has been the case for two reasons.

First, the very nature of the problems caused by abnormal behavior has made it a "thing apart," arousing fear, shame, and guilt in the families and communities of those afflicted in many cultures. Hence, the management of the mentally disordered has been turned over to the state and the church, which have been the traditional guardians of both group and individual behavior. Second, the evolution of all the sciences has been slow and sporadic. Many of the most important advances have been achieved only against great resistance. Although this has been more typical of abnormal psychology than of other disciplines, the difference is only relative. In reviewing the historical account that follows, one should not be too critical. Although it is true that in earlier times the abnormal person was misunderstood and often mistreated, the lot of the "normal" individual was not a much happier one.

PRIMITIVE PERIOD

Archaeological findings suggest that some types of mental illness must have been recognized as far back as the Stone Age. Skeletal remains from that period reveal that attempts were made to relieve brain pressure by chipping away an area of the skull. Although the procedure was similar to the operative technique now known as trephining, there is serious question as to whether it was based on any knowledge of brain pathology. It seems more likely that the operation was performed in the belief that, in this way, an avenue of escape was provided for "evil spirits." Our knowledge of primitive psychiatry does not go beyond speculations suggested by such skeletal remains.

PRECLASSICAL PERIOD

Although primitive superstitions persisted into and beyond the Classical period, history shows that attempts were being made before the classical ages of Greece and Rome to find a more rational approach to the understanding and treatment of the mentally disordered.

In Asia

About 2600 B.C.E., in China, forms of faith healing, diversion of interest, and change of environment emerged as the chief methods for treating mental disorders. By 1140 B.C.E., institutions for the "insane" had been established there, and patients were being cared for until "recovery." In the writings of physicians in India around 600 B.C.E. are found detailed descriptions of some forms of mental disease and epilepsy, with recommendations for kindness in treatment.

In the Middle East

Egyptian and Babylonian manuscripts dating back to 5000 B.C.E. describe the behavior of the mentally disordered as being due to the influence of evil spirits. Aside from the practice of trephining (opening the skull), treatment was restricted almost exclusively to the work of priests and magicians. Biblical sources indicate that the Hebrews looked upon mental illness as a punishment from God and that treatment was principally along lines of atonement to him.

CLASSICAL PERIOD

As in all areas of scientific and social thought, important strides were made toward a more reasonable and humane treatment of the mentally ill in the era of classical Greece and Rome. It was at this time that the first glimmer appeared of a medical approach to the problem.

In Greece

Some of the more significant assumptions of Greek thought have been confirmed by modern research, and much of the terminology of modern psychiatry (as of medicine and science in general) is a legacy from this period. The humane, rational approach to mental illness that emerged during this era was due largely to the findings of the following people.

Pythagoras (circa 500 B.C.E.)

Before 500 B.C.E., priest-physicians combined the use of suggestion, diet, massage, and recreation with their more regular prescriptions of incantations and sacrifices; however, in all treatment, the guiding motive was appeasement of good or evil spirits. Pythagoras was the first to teach a natural explanation for mental illness. He identified the brain as the center of intelligence and attributed mental disease to a disorder of the brain.

Hippocrates (460–377 B.C.E.)

Hippocrates, the father of medicine, held that brain disturbance is the cause of mental disorder. He emphasized that treatment should be physical in nature, urging the use of baths, special diets, bleeding, and drugs. Hippocrates taught the importance of heredity and of predisposition to mental illness. He related sensory and motor disturbances to head injuries. Anticipating modern psychiatry, he also believed that the analysis of dreams can be useful in understanding the patient's personality.

Plato (428-347 B.C.E.)

The Greek philosopher Plato displayed keen insight into the human personality. He recognized the existence of individual differences in intelligence and in other psychological characteristics, and he asserted that man is motivated by "natural appetites." To Plato, mental disorders were partly moral, partly physical, and partly divine in origin. He described the patient-doctor relationship in the treatment pattern, believed that fantasy and dreams are substitute satisfactions for inhibited "passions," and introduced the concept of the criminal as a mentally disturbed person.

Aristotle (384-322 B.C.E.)

Aristotle accepted a physiological basis for mental illness, as taught by Hippocrates. Although he did consider the possibility of a psychological cause, he rejected it, and so strong was his influence on philosophical thought that for nearly 2,000 years, his point of view discouraged further exploration along these lines.

Alexander the Great (356-323 B.C.E.)

Alexander established sanatoriums for the mentally ill where occupation, entertainment, and exercise were provided. These practices were continued during the later Greek and Roman periods.

In Rome

The Romans, for the most part, continued to follow the teachings of the Greek physicians and philosophers in their treatment of mental illness. Greek physicians settled in Rome, where they continued their studies and teaching.

Aesclepiades (124-40 B.C.E.)

This Greek-born physician and philosopher was the first to differentiate between acute and chronic mental illness. He developed mechanical devices for the comfort and relaxation of mental patients. Additionally, he opposed bleeding, restraints, and isolation in dungeons. Whereas his predecessors had considered both delusions and hallucinations under one heading (phantasia), Aesclepiades differentiated between the two.

Aretaeus (C.E. First-Second Centuries)

Aretaeus was the first to suggest that mental illness is an extension of normal personality traits. He believed that there existed a predisposition to certain forms of mental disorders. One of his original thoughts was placing the location of mental disease in the brain and the abdomen, which foreshadowed the psychosomatic approach to medicine.

Galen (C.E. 129-199)

Galen's contribution to medical science, although of great value in one respect, served to impede development in another. Like Hippocrates, who lived seven centuries earlier, he gathered and organized an enormous amount of data concerning mental and physical illness and conducted studies in the anatomy of the nervous system and its relation to human behavior. He recognized the duality of physical and psychic causation in mental illness, identifying such varied factors as head injuries, alcoholism, fear, adolescence, menopausal changes, economic difficulties, and love affairs. Because his prestige was great, progress was encumbered by controversies over the metaphysical aspects of his contributions and, thus, independent thinking in the medical sciences was delayed until well into the eighteenth century.

In Arabia

The last faint echo of the efforts of the classicists to conquer the problem of mental disorder was heard not in the West, but in Arabia, where Avicenna (C.E. 980-1037) and later, his follower, Averrhoes (C.E. 1126-1198), maintained a scientific approach to the mentally ill and urged humane treatment. Elsewhere, as we shall see, a return to primitive notions prevailed.

MEDIEVAL PERIOD

With the dissolution of the Greco-Roman civilization, learning and scientific progress in Europe experienced a grave setback. Ancient superstitions and demonology were revived and contemporary theological thinking did little to discourage the "spiritistic" approach to the problem of mental illness. Exorcism (expelling an evil spirit) was considered imperative, and incantations were regarded as a legitimate adjunct of medicine. Even the application of rationally based techniques had to be accompanied by the pronouncement of mystical phrases. The physicians of the time tended to use amulets. For example, Alexander of Tralles (c.e. 525–605), who stressed the importance of physical factors and related them to specific types of mental disorders, treated colic by the application of a stone on which an image of Hercules overcoming the lion was carved.

The Dancing Mania

At intervals from the tenth to the fifteenth centuries, the dancing mania, also referred to as "mass madness," in which large groups of people danced wildly until they dropped from exhaustion, was seen in Europe. In Italy, the condition was called tarantism, because the mania was thought to be due to the bite of the tarantula. Elsewhere in Western Europe, the mania was called Saint Vitus's dance. It is difficult to say whether these seemingly epidemic manifestations have been greatly exaggerated in the telling. It has been suggested that a large number of people were suffering from various forms of chorea (a disease associated with involuntary jerky movements). Fear of this unexplained disorder may have resulted in mass suggestibility and hysteria, which mounted unchecked and subsequently was recorded as a single clinical entity.

Witchcraft: Belief in Demonology

The period from the fifteenth to the eighteenth centuries comprises a sorry chapter of history with respect to the fate of the mentally ill. Their afflictions were generally ascribed to possession by the devil. Treatment, consisting chiefly of attempts to "cast out the demon," was hardly distinguishable from punishment. The Black Death (bubonic plague) had ravaged Europe in the fourteenth century and the resulting depression and fear rendered people highly susceptible to accusations of witchcraft. The humane, scientific approach to the mentally ill (for that matter, to all illness) was indeed at a low ebb.

Late in the fifteenth century, the plight of people with abnormal behavior was intensified by the publication of Malleus Maleficarum (The Hammer of Witches) by Henry Kraemer and James Sprenger. Their book, appearing in 1486, was to be the handbook of inquisitors for two hundred years. Courts of the Roman Catholic Church searched out persons thought to be "possessed of the Devil," and the unfortunates were then turned over to civil authorities to be tortured or executed. Sprenger and Kraemer met some early resistance from cooler heads in the church and community but soon won support from people already full of a fear of witchcraft. Their crusade caught fire and thereafter spread throughout both Roman Catholic and Reformed centers in Europe. So widely held was the belief in witches that the persecution of witches continued off and on for the next three centuries.

Institutional Care of the Mentally III

The kind of institutional care afforded the mentally ill during the late medieval and early Renaissance periods was that seen at "Bedlam" (the name is a contraction of Bethlehem). As early as 1400, the monastery of Saint Mary of Bethlehem in London began caring for "lunatics" and in 1547, the monastery was officially converted into a mental hospital. Because of the inhumanity of the treatment there, "bedlam" has come to stand for anything that is cruel in the management of the mentally ill. But this era was not entirely without examples of tolerance and mercy. The shrine of Saint Dymphna at Geel in Belgium (established in the fifteenth century) not only lent solace to thousands of afflicted persons who visited there but also grew gradually into a colony that was dedicated to the care of the mentally ill. Its work still goes on, and Geel is regarded as the model for similar cottage-structure psychiatric institutions and community-living organizations elsewhere.

RENAISSANCE PERIOD

Although those with mental disturbances became engulfed in a morass of superstition and inhumanity, voices of reason were raised in certain countries of Europe by enlightened people of religion, medicine, and philosophy. Their efforts during this period can well be described as lights in the darkness.

In Switzerland

Paracelsus (Theophrastus von Hohenheim), 1493–1541, rejected demonology, recognized psychological causes of mental illness, and proposed a theory of "bodily magnetism," a forerunner of hypnosis. Like Hippocrates, he suggested the sexual nature of hysteria. However, like so many otherwise reasonable men of his time, he laid great store on astral influences, assigning to various planets control over specific organs of the body.

In Germany

Heinrich Cornelius Agrippa (1486–1535) fought against the hypocrisy and bloodthirsty application of law of the Inquisition. A scholar, Agrippa was persecuted and reviled for his views and died in poverty. Johann Weyer (1515–1588) was a physician who studied under Agrippa. In 1563, he published a scientific analysis of witchcraft, rejecting the notion of demon causation in mental illness. His clinical descriptions of mental disorders were remarkably concise and uncluttered with opinions and theological illusions. Weyer is regarded by some as the father of modern psychiatry.

In England

Reginald Scot (1538–1599) published a scholarly, painstaking study titled *The Discovery of Witchcraft: Proving That the Compacts and Contracts of Witches and Devils ... Are but Erroneous Novelties and Imaginary Conceptions.* But King James I ordered the book seized and burned, and the king published a refutation of Scot's views.

In France

Saint Vincent de Paul (1576–1660) urged a more humane approach to the mentally ill. He emphasized the fact that mental diseases differ in no way from bodily diseases. In the hospital he founded at Saint Lazare, he put into practice what he held to be a basic Christian principle; namely, that we are as much obligated to care humanely for the mentally ill as for the physically ill.

B EIGHTEENTH TO TWENTIETH CENTURIES

The transition from the demonological to the scientific approach to mental illness was not accomplished overnight. In France, for example, capital punishment for convicted "sorcerers" was not abolished until 1862. The first general trend toward specialized treatment of the mentally ill probably came in the wake of the social, political, economic, and scientific reforms that characterized the latter half of the eighteenth century.

In France

Soon after the Revolution, Philippe Pinel (1745–1826) removed the chains from the inmates at Bicetre and provided pleasant, sanitary housing, along with walkways and workshops. Later, at Salpetriere, he introduced the practice of training of the attendants. Jean Esquirol (1772–1840) continued Pinel's work and through his efforts, ten new mental hospitals were established in France.

In England

William Tuke (1732-1822), a layman and a Quaker, interested the Society of Friends in establishing the York Retreat in 1796. Through his urging, special training was instituted for nurses working in this field. John Conolly (1794–1866), founder of a small medical association which later became the British Medical Association, was mainly responsible for the wide acceptance of nonviolent measures in the treatment of the mentally ill.

In Germany

Anton Muller (1755–1827), working in a hospital for mental diseases, preached humane treatment of the insane and protested against brutal restraint of patients.

In Italy

Vincenzo Chiarugi (1759-1820) published his Hundred Observations of those with mental illness and demanded humanization of treatment of individuals with psychological disorders.

In Latin America

The first asylum for the "insane" in the Americas was San Hopolito, organized in roughly 1570 by Bernadino Alvarez in Mexico City, but it is difficult to say whether it was really more than a place of confinement. Elsewhere in Latin America, the earliest mental hospitals began to appear in the 1820s. As late as 1847, visitors to Mexico and Peru reported that "lunatics" were displayed for the amusement of the public, who paid for the exhibition (as had been done at Bedlam three centuries earlier).

In the United States

In Philadelphia, the Blockley Insane Asylum was opened in 1752. The only other institution for the mentally disturbed in the United States before the nineteenth century was the Eastern State Lunatic Asylum in Virginia, opened in 1773.

Humanitarian treatment of the mentally ill was encouraged by Benjamin Rush (1745–1813), who is generally accepted as the father of American psychiatry. Rush organized the first course in psychiatry and published the first systematic treatise on the subject in the United States. In the latter half of the nineteenth century, Dorothea Lynde Dix (1802–1887) carried on a militant campaign for reform in the care of people with psychological disorders. She was responsible for a more enlightened attitude and improved programs in twenty states. In New York, her efforts resulted in the State Care Act of 1889, which did away with confinement of individuals with mental illnesses in jails and almshouses. Her influence was felt also in Canada, Scotland, and England.

At Utica State Lunatic Asylum (now Utica State Hospital), an Association of Superintendents of American Institutions for the Insane was formed in 1846. The name was changed to American Medico-Psychological Association in the 1880s. It finally became the American Psychiatric Association of today. Its professional scientific publication, originally called the American Journal of Insanity (now called the American Journal of Psychiatry), has been published continuously for over 150 years.

In the early years of the twentieth century, Clifford Beers (1876–1943) described his experiences as a mental patient in the book A Mind That Found Itself. The wide distribution of this volume stimulated public interest in a movement to improve conditions in mental hospitals and gave rise to the formation of the National Committee for Mental Hygiene, in which Beers played an active role. That organization was later incorporated, along with other smaller groups, into the National Mental Health Association.

In the Western World: National and International Efforts

The mental hygiene movement spread throughout the Western world. During the first half of the twentieth century, a variety of national and international organizations were established to aid in the development of improved facilities for the mentally ill. In recent decades, there has been a trend toward public acceptance of both humanitarian and scientific approaches to the problem of mental abnormality. This new attitude has been reflected in the activities of world organizations such as the World Health Organization, UNESCO (United Nations Educational, Scientific, and Cultural Organization), and the World Federation of Mental Health, as well as in those of innumerable national and local public and private agencies. (For a discussion of modern treatment approaches, see Chapters 7 and 8.)

Deinstitutionalization

In the 1970s, conditions in institutions for individuals with psychological disorders in the United States were exposed to still be inhumane and overly restrictive. This brought about pressure from consumers of psychological services, families of individuals in the institutions, and the general public to move toward less restrictive care. The pressure resulted in a trend known as deinstitutionalization; that is, the placement of individuals with psychological disorders in the community rather than institutions and the provision of psychological services in community settings.

Legislation was passed requiring the formation of community mental health systems to serve such individuals. The community mental health system, while often struggling to meet demand for services with limited resources, has increased the number of services available for those with mental disorders in communities. Additionally, public and private agencies have created group homes and other communityliving arrangements for individuals with severe psychological and developmental difficulties.

As individuals moved out of institutions, many state and private psychiatric institutions closed. The unfortunate difficulty in deinstitutionalization is that often there are not sufficient services to support individuals with mental illnesses in their communities. This has resulted in a large number of individuals not receiving appropriate care and sometimes ending up homeless or in jails or prisons.

■ THE MODERN ERA: DEVELOPMENTS IN PSYCHIATRIC THOUGHT

The development of psychiatric thought and the subsequent contributions to the understanding of mental abnormality during the eighteenth to twentieth centuries may be summarized under two headings: organic interpretations and psychological interpretations.

Organic Interpretations

The importance of brain pathology in the causation of mental illness was recognized by Albrecht von Haller (1708-1777), who sought corroboration of his beliefs through postmortem studies. In 1845, William Griesinger (1817-1868) published his Pathology and Therapy of Psychic Disorders, in which he held that all theories of mental disturbances must be based on brain pathology. The psychiatrist Henry Morel (1809-1873) attributed mental illness to hereditary neural weakness. Valentin Magnan (1835-1916) investigated mental illness occurring in relation to alcoholism, paralysis, and childbirth.

Perhaps the most influential figure in psychiatry in the latter nineteenth and early twentieth centuries was Emil Kraepelin (1856-1926). In 1883, he published a textbook outlining mental illness in terms of organic pathology. He focused on the disordered functioning of the nervous system in particular, a point of view that oriented his approach to the general problem of mental disturbances. He described and classified many types of disorders and provided a basis for descriptive psychiatry by drawing attention to clusters of symptoms. Kraepelin evolved a theoretical system that divided mental illness into two large categories: those due to endogenous factors (originating within the body) and those due to exogenous factors (originating outside the body). His classification remained substantially unchanged until a few years after World War I. Kraepelin made notable contributions to psychiatry, but his approach to mental illness was that of an experimentalist and, consequently, he studied disease processes as entities in themselves rather than as the dynamic reactions of living individuals.

In 1897, Richard von Krafft-Ebing (1840–1902), a Viennese psychiatrist, disclosed experimental proof of the relationship of general paresis (a psychosis) to syphilis (see Chapter 17). In 1907, Alois Alzheimer established the presence of brain pathology in senile psychoses (later known as Alzheimer's disease). In 1917, Julius Wagner-Jauregg (1857–1940) inoculated nine paretic patients with malaria, with consequent alleviation of their condition. These and other discoveries during the early twentieth century lent strong support to the believers in the organic approach to mental illness.

Early biological treatments for mental illness often were discovered by accident and had significant negative effects or risks. In the 1920s, both insulin and electricity were used to induce convulsions to treat schizophrenia and depression. Although this was sometimes effective in improving symptoms, it also resulted in unintended side effects and even, in some cases, death. Electroconvulsive therapy (ECT) is still used in a greatly modified way to treat depression that does not respond to less extreme treatments.

In the 1930s, lobotomies (a form of psychosurgery where part of the brain is destroyed or removed) began to be used to treat psychoses and aggressive behavior. The lobotomy fell out of favor in the 1950s when research continued to indicate that lobotomies were no better than chance in improving the symptoms they were designed to treat and that they resulted in significant harm and, occasionally, death.

In the 1950s, neuroleptics and tranquilizers were developed and used to treat psychoses, anxiety, and other psychological concerns. Unfortunately, both classes of medications were found to be only partially effective and to carry significant side effects and risks. Since then, medications have continued to improve, showing fewer side effects and greater effectiveness as development continues.

Psychological Interpretations

Despite the achievements of the organically oriented investigators in certain limited areas, very little progress was being made in treating patients with mental disorders. As early as the first decades of the eighteenth century, vague and uncertain theories (for example, mesmerism) had postulated psychological causation.

Mesmerism

The development of a psychological interpretation of mental illness can be traced from the early works of Franz Anton Mesmer (1734-1815). Mesmer developed and applied a technique he called animal magnetism. He attributed his cures to the control and alteration of magnetic forces, which he believed to be the cause of mental diseases. One English physician, John Elliotson (1792–1868), used mesmerism in surgery. Another, James Braid (1795-1862), studied the process and concluded that it was a purely psychological phenomenon whose chief characteristic was suggestion and, in 1841, he termed the process hypnosis. Ambroise-Auguste Liebeault (1823–1904) and Hippolyte-Marie Bernheim (1840–1919), two French physicians, investigated the influence of suggestion in inducing a hypnotic state. They concluded that both hypnosis and hysteria are due to suggestion. Jean-Martin Charcot (1825–1893), a French neuropsychiatrist, disagreed with them, believing that hypnosis was dependent upon physiological processes as well as upon suggestion. He insisted that persons capable of being hypnotized were hysterical.

The Development of Psychoanalysis

The foregoing observations laid the groundwork for the accomplishments of the psychologically oriented scientists: Janet, Breuer, Freud, and others. Pierre Janet (1859-1947) developed the first psychological theory explaining neurosis. Using hypnosis as his investigating technique, he did extensive research on hysteria, and his work did much to attract attention to the psychological point of view in mental illness.

In Vienna, Josef Breuer (1842-1925) in 1880 successfully treated hysteria with hypnosis and observed that the release of pent-up emotion resulted in the removal of symptoms. This discovery served as a point of departure for the development of psychoanalysis. However, also in Vienna, a colleague of his, Sigmund Freud (1856-1939), who was a physician and neurologist, was less successful with hypnosis and thus worked out the cathartic method in which free association and dream interpretation are used to uncover dynamic and unconscious material. Freud's technique and his theory are the cornerstones of the psychoanalytic school (see Chapter 4).

Behaviorism

Around the same time that Sigmund Freud was developing his techniques of dream interpretation, a Russian physiologist named Ivan Pavlov (1849–1936) discovered that pairing two stimuli could result in the natural response to one stimulus generalizing to the other. This phenomenon has become known as classical conditioning and consists of unconditioned and conditioned stimuli being paired repeatedly until the conditioned stimulus eventually results in the unconditioned (now conditioned) response.

Pavlov's work influenced an American psychologist in the 1920s, John B. Watson (1871–1958), to focus his research on observable behavior rather than unobservable thought processes. This orientation became known as behaviorism (see Chapter 5). Watson and his students applied classical conditioning and observation of behavior to people. In the 1930s, B. F. Skinner (1904-1990) began researching and writing about operant conditioning. Operant conditioning is the process by which behavior is learned through the consequences of that behavior (such as reinforcers and punishers).

In the late 1940s and early 1950s, Joseph Wolpe (1915-1997) used behaviorism and principles of conditioning to treat individuals with phobias. In doing so, he became one of the originators of behavior therapy, the practice of using principles of behaviorism and learning to change maladaptive behaviors. Although not the panacea that Watson and Skinner imagined, behavior therapy and related orientations (such as cognitive-behavioral therapy) are still used today (see Chapter 8).

The differences in the organic and psychological points of view that were present in the early history of abnormal psychology continue to form the backdrop of this field of scientific endeavor. The question of the relative importance of organic and psychological factors in the causation of mental illness remains unanswered.

SUMMARY

Psychological disorders, expressing themselves in a variety of maladaptive behavior patterns that differ, to some extent, from one time period to another and from one culture to another, have beset people for as long as we have any record of humankind's existence. Interpretations of those disorders and ways of caring for those with psychological disorders have, over the centuries, rested on superstition, religious beliefs, the speculations of philosophers and, to some extent, on common sense and compassion.

The earliest record of any physical mode of treatment is found in the skeletal remains of primitive humans, which reveal holes chopped into skulls from the prehistoric period, presumably to release the evil spirits within.

In the earliest periods for which we have historical records (about 2600 B.C.E.), faith healing, diversion of interest, and change of environment emerged as the chief methods of treating mental disorders. In Egypt and Babylon, manuscripts dating back to 5000 B.C.E. attribute mental disorders to evil spirits. In India, around 600 B.C.E., medical records describe some forms of mental disorder, including epilepsy.

During the Grecian classical period, Hippocrates held that brain disturbance was the cause of mental disorders. Although Plato considered mental disorders partly moral, partly physical, and partly divine in origin, Aristotle followed Hippocrates and shaped medical thinking for centuries to come by attributing mental disorder to physiological influences.

During the medieval period, ancient superstitions and demonology were revived to explain the abnormal behavior of those with disorders. Remnants of that way of thinking about mental disorders continued to be influential until the late seventeenth century.

The foreshadowing of the modern approach to mental disorders appears during the Renaissance Period in the work of exceptional individuals in Europe.

The social, political, economic, and scientific reforms accelerated by the Industrial Revolution in the late nineteenth century introduced radically new ways of understanding and treating people with psychological disorders. Pinel in France, for example, removed their chains; William Tuke, an English Quaker, introduced psychological training for nurses working in the field; in North and South America, psychiatric hospitals were established; and in the United States, Benjamin Rush published the first psychiatric textbooks. Despite attempts to improve conditions of institutions for those with psychological disorders, such facilities continued to provide care that was far less than ideal and, eventually, a trend toward deinstitutionalization grew from concern about the welfare of such individuals. This movement resulted in increasing numbers of individuals being treated in the community rather than hospitals beginning in the 1970s.

Among other advances during this period were Krafft-Ebing's experimental demonstration that general paresis was caused by the syphilis spirochete and Alzheimer's establishment of brain pathology as a cause of senility. In the early twentieth century, Wagner-Jauregg inoculated nine paretic patients with malaria and thereby provided a treatment for the disease. Those findings lent strength to an organic interpretation of mental disorders. Kraepelin generalized that point of view by providing a systematic classification of mental disorders that he attributed to a malfunctioning of the brain. Such organic theories were supported by accidental discoveries of biological treatments such as insulin shock therapy, electroconvulsive therapy, lobotomy, and medications such as neuroleptics and tranquilizers. Unfortunately, early biological treatments tended to be only moderately successful at best and carried significant negative side effects and risks.

Recognition of the influence of psychological elements in causing mental disorders can be traced to Mesmer, who suggested that magnetic forces caused mental disorders. James Braid, in examining Mesmer's work, concluded that the influences he described were psychological in nature, largely the result of suggestion provided in a hypnotic-like trance. That finding was elaborated upon by Liebeault, Bernheim and Charcot, who concluded that both hypnosis and the mental disorder then called "hysteria" were caused by suggestion.

Building on those insights, Pierre Janet developed the first psychological theory explaining neurosis. In 1880, Breuer successfully treated hysteria with hypnosis. That early work blazed a path for the profound insights of Sigmund Freud. At the same time as Freud's work, behavioral models of learning were beginning to be studied. This work was further developed, resulting in behavioral and cognitivebehavioral theories.

SELECTED READINGS

Alexander, F. G. & Selesnick. S. T. (1995). The history of psychiatry: An evaluation of psychiatric thought and practice from prehistoric times to the present. Lanham, MD: Jason Aronson.

Beers, C. (1970). A mind that found itself. (Rev. ed.) New York: Doubleday.

Hunt, M. (1994). The story of psychology. New York: Anchor.

Robinson, D. N. (1995). An intellectual history of psychology. (3rd ed.). University of Wisconsin Press.

Van Amber, J. (2002). Regina's record. Philadelphia: Xlibris.

Test Yourself

- 1) Psychological disorders were not acknowledged until the 1700s. True or false?
- 2) Biological interpretations of psychological disorders did not exist until the nineteenth century. True or false?
- 3) In the past, abnormal behavior associated with psychological disorders was thought to be due to
 - a) witchcraft
 - b) evil spirits
 - c) biological causes
 - d) all of the above
- 4) Care of those with mental illnesses often was substandard from the medieval period through the twentieth century. True or false?
- 5) Scientific proof of a connection between psychological disorders and brain dysfunction was discovered in the late 1800s and early 1900s. True or false?
- 6) Which of the following have been used as biological treatments for psychological disorders?
 - a) insulin and electricity induced convulsions
 - b) sedation with tranquilizers
 - c) destruction of part of the brain
 - d) all of the above
- 7) Which of the following theories focuses on unconscious urges?
 - a) Mesmerism
 - b) psychoanalysis
 - c) behaviorism
 - d) all of the above
- 8) Behavior therapy is no longer used today. True or false?

Test Yourself Answers

- 1) The answer is false. Archeological evidence suggests that psychological disorders were likely acknowledged (and attempts were made at treatment) in the Stone Age.
- 2) The answer is false. Biological theories of psychological disorders have been around since Pythagoras, in around 500 B.C.E.
- 3) The answer is **d**, all of the above. At various points in history, psychological disorders have been thought to be signs of witchcraft, evil spirits, and biological dysfunctions. The only theory that has scientific support is the biological theory.
- 4) The answer is true. Despite exceptions such as in Geel, Belgium, much of the care of individuals with psychological disorders was inhumane and unnecessarily restrictive until the deinstitutionalization movement in the 1970s.
- 5) The answer is true. Krafft-Ebing revealed the relationship between syphilis and general paresis in 1897 and Alzheimer discovered the presence of brain pathology in senile psychoses (now called Alzheimer's disease) in 1907.
- 6) The answer is d, all of the above. Insulin and electric shock treatment, sedation, and lobotomization were all used to treat psychological disorders in the twentieth century. These techniques were associated with modest, if any, improvements and significant negative effects. They are used in greatly modified form only in extreme cases today.
- 7) The answer is **b**, psychoanalysis. Psychoanalysis focuses on unconscious urges and uses hypnosis, free association, and other techniques to produce catharsis, or release of such pent up emotions. Mesmerism focuses on the manipulation of magnetic fields and behaviorism focuses on modifying observable behavior through pairing stimuli or managing consequences.
- 8) The answer is false. Despite some concerns about restrictiveness of interventions and opinions that psychological disorders run deeper than observable behavior, many psychologists today use behavior therapy in treating psychological disorders.

Research in Abnormal Psychology

uman behavior, even behavior that varies from the norm, is something everyone can claim some knowledge of based on his and her own experiences and casual observations. People have their own notions about the causes of human behavior and, perhaps, especially about the causes of abnormal behavior. As Chapter 1 indicated, those notions are often off the mark. Casual observation is an unreliable way of arriving at an accurate knowledge of normal or abnormal behavior. What distinguishes scientific research from speculation is that scientists attempt to test their theories. They design research studies that help them get closer to an understanding of how and why things occur.

Over the years, the study of abnormal behavior has adopted the rigor and controls of scientific methodology. This chapter first examines the characteristics, requirements, and vocabulary of scientific research. It then describes the research designs most frequently used in the study of abnormal behavior. Along the way, it describes basic concepts of statistical analysis.

As in all fields, research is at the core of learning all we can about mental disorders to help us better understand their etiology (causes) and to provide the best care possible for those afflicted. Research allows us to study the nature of disorders, whether the symptoms are acute (occurring for a short time) or chronic (lasting for a long time), what kinds of deficits are associated with certain disorders, and so on. Research allows for a greater understanding of the etiology of disorders. Finally, information from research assists in providing the best care possible for those in need. Various research methods are utilized to continue learning, communication amongst professionals, growth toward greater understanding, and developing better methods of treatments.

Research on abnormal behavior is subject to limitations imposed by ethical considerations and practicality. An intervention introduced into an experiment in physics is a matter only of its usefulness in completing the experiment. An intervention in studying abnormal behavior must take into account any negative effects on the participant and any unrelated and confounding reactions it might arouse in those whose behavior is being studied.

THE GOALS OF SCIENTIFIC STUDY

There are three goals of scientific study: description, prediction, and understanding. Each of these goals involves forming a hypothesis (a guess or theory based on existing knowledge) and then carefully testing it.

Description

In pursuit of describing a psychological phenomenon, the basic activity of the scientist is observation. Scientific observation requires special training. To give scientific significance to their activities, scientists usually limit their observations to the areas of their training and competence. Astronomers observing people's behavior would miss much of significance in the behavior of those they were observing, and psychologists would be equally handicapped in observing the celestial bodies.

On the basis of trained observation, scientists are able to describe the phenomena under study in great detail. They group similar phenomena (symptoms) into named categories (diagnoses) and seek to discover relationships among the categories. They use various means to clarify their observations and make them more precise. Researchers make their observations many times (when they can), sometimes of the same person or, at other times, by observing many people, frequently people in different settings. This helps them test whether results are likely due to the phenomena being studied rather than a fluke event. They use instruments such as psychological tests, questionnaires, rating scales, checklists, and magnetic resonance imaging (MRI, a type of brain scan). The use of such supplements to observation increases the reliability (dependability) and comparability of repeated observations.

To make their observations as precise as possible, scientists define variables under study in operational terms by quantifying them using detailed, concrete descriptions. They describe the results of their research and make comparisons in statistical values, such as measures of central tendency (for example, means, or averages) and measures of scatter or distribution (for example, standard deviation). To identify relationships between variables, they use correlation coefficients. They compare or contrast the quantitatively expressed results of their observations using statistical procedures (for example, analysis of variance). The goals of quantifying and analyzing observations is to tell them whether the differences found were a matter of chance or the result of true differences between the two phenomena that were measured.

Prediction

The result of scientific observation and statistical treatment of measured observations is a statement that may lead to the prediction of future behavior or events; for example, a prediction of the likelihood of later development of criminal behavior.

Dorene M. Rentz and her colleagues (2004) wondered how well tests of memory predicted likelihood of developing Alzheimer's disease in older adults. Three and a half years after initially testing 42 older adults, Rentz and colleagues found that nine of the eleven people who had lower scores on the memory test showed signs of cognitive difficulties associated with dementia (such as Alzheimer's disease). Two years later, five of the nine people with cognitive difficulties had been diagnosed with dementia. Rentz and her colleagues successfully identified a way to use a memory test to predict the likelihood that older adults will develop Alzheimer's disease (nine of eleven predicted to be at-risk had symptoms after three-and-a-half years, and five of eleven were diagnosed after five-and-a-half years).

Understanding

This goal of scientific research is to be able to identify a cause-and-effect relationship between two phenomena or events. Establishing a causal relationship requires that three conditions be met: (1) If one event is said to cause another, the two events must vary together—that is, for example, when one is absent, the other is absent, or when one changes, the other changes; (2) the stated cause must exist or occur before the stated effect; and (3) there must be no other reasonable alternative cause for the relationship between the two events.

The third condition is usually the most difficult to establish. An example of failure to meet the condition occurred in early studies of schizophrenia. Researchers hypothesized that there might be measurable differences in the blood or urine chemistry of people with schizophrenia and people without schizophrenia. To test their hypothesis, they compared blood and urine in two sample populations, a group of hospitalized schizophrenics and a nonhospitalized normal population. They did find notable differences, but those differences resulted from a confounding effect: the difference between a hospital diet and an uncontrolled diet. The differences had nothing to do with schizophrenia.

MAKING SENSE OF RESEARCH

There are a few concepts that are crucial in understanding and evaluating the scientific study of abnormal psychology.

Confounding Effects and Internal Validity

To draw a conclusion about causality, the two populations compared must differ significantly only in respect to the variable under study. There cannot be more than one variable that could have caused the reported effect. When that condition has been established (and it is not always easy to accomplish), the study is said to have internal validity. Thus, the study of schizophrenia and blood/urine described in the preceding section does not have good internal validity because the effect was likely due to diet, not schizophrenia.

External Validity

The external validity of judgments about causation may be established by the conclusion's generalizability; that is, does the same relationship between variables occur when different groups are studied, in different situations, or with different researchers? Establishing generalizability is possible only when the populations under study are representative of the people they are chosen to represent. If, for example, causal factors in the development of a conversion disorder (hysteria) are hypothesized only on the basis of patients seen in psychoanalytic therapy drawn from the upper classes of a highly specific culture (Freud's practice), the sample on which the conclusion is based could hardly be considered representative of people generally. The external validity of Freud's studies, therefore, is not well established.

Representativeness

The representativeness of a sample is best assured by randomly selecting members of the group to be represented; that is, selecting them in such a way that each member of the population has an equal chance of being selected. The sample must also be large enough to be statistically reliable. Another technique used to enhance representativeness is to match individuals selected to the population being studied. For example, one could recruit participants so that their gender, age, socioeconomic status, ethnicity, and so on, match those of the population from which they were drawn. It is only when a sample is representative of the population under study that the results can be said to generalize, or also apply to, that population.

Statistical versus Clinical Significance

If the results of a study are larger than would be expected based on chance, they are said to be statistically significant. Results that are statistically significant mean that the reader can be confident that the differences reported are actual, rather than a fluke. However, this does not necessarily mean that the results are significant to the casual observer or individuals in a study. When a study finds differences that are significant to the study participants or those around them (such as participants feeling less depressed), the results are said to be clinically significant.

Replication

It is important to note that one study does not prove a point. There must be replications (subsequent studies using the same procedures) to support the original study before the results can be assumed to apply across situations. Sometimes researchers will conduct a meta-analysis, where results from many similar studies are compared, in order to reach conclusions about phenomena.

M RESEARCH DESIGNS

There are six basic ways in which psychologists attempt to study abnormal behavior in a scientific way: (1) descriptive studies, (2) developmental designs, (3) correlational designs, (4) experimental designs, (5) analogue designs, and (6) experiments of nature.

Descriptive Studies

The most basic design is one in which the researcher gathers data in such a way as to describe the phenomena under study. The researcher may want to describe the history of a phenomenon; that is, the events leading up to the present state of affairs. In this case the psychologist, and perhaps the psychiatrist, social worker, medical doctor, relatives, and friends, gather or provide the information that goes into a case history. Alternatively, the researcher may wish to describe the current state of affairs, principally the prevalence and distribution of one variable; for example, psychiatric illness, in a large, described population, in which case the survey method is used.

Case History

The earliest studies of psychiatric disorders were based on the life story and current symptomatology of patients in therapy—these are called case histories (discussed in more detail in Chapter 6). Such a history begins with the present and goes back to the earliest years that can be recalled by the patient or other knowledgeable persons. The patient's own account of those years is frequently supplemented by reports from friends, relatives, school and medical records, and whatever sources of information are available about the individual's life. Today, the case history usually also includes a battery of psychological tests.

In a case history, the clinician or researcher may seek an understanding of a particular individual's illness, or the clinician may hope to understand the etiology of the disease itself and possible treatment approaches from a number of case histories of the same illness.

Freud's work provides abundant examples of both values of the case history. In the course of his treatment of a number of patients with what was then termed hysteria, he was able to demonstrate the value of his newly developed psychoanalytic method. Additionally, on the basis of the case histories of his patients, he came to an understanding of the illness itself. Freud concluded from his studies that repressed wishes were the cause of hysteria. Once his preliminary hypothesis was developed, he could test its validity by examining the case histories of a subsequent group of patients with the same disorder.

Kraeplin, principally on the basis of case studies, was able to provide the framework for a classification of psychiatric disorders that is still used today. Bleuler, in taking the case histories of a number of psychiatric patients, drew the conclusion that schizophrenia was not one but at least two quite different disorders. As a scientific method, the case history has both advantages and serious limitations.

ADVANTAGES OF THE CASE STUDY

The case history offers three advantages: (1) The case history provides a description in its natural setting as the individual experienced it. In this way, it is superior to the experiment, which introduces much artificiality not characteristic of real life. (2) The case history explores types of human behavior that,

because of their bizarreness or rarity, cannot often be studied by other methodologies such as the survey or experiment. (3) The case history, thoughtfully considered, is a source of worthwhile hypotheses to study and verify or dispute.

DISADVANTAGES OF THE CASE STUDY

There are three disadvantages of the case study: (1) The patient's recall of life experiences is not complete. Memory, attitudes, and the patient's expectations about what the therapist wants to hear all cause the patient to be highly selective in what he or she includes in the case history. The described experiences are retrospective and colored by all that followed in the individual's life. The description of a childhood experience twenty years after it happened may not closely resemble the reality of the experience. (2) A life history is a one-time event. The experience of gathering it cannot be repeated in exactly the same way. A clinician's practice is ordinarily a varied one, embracing patients with a variety of illnesses. Repeatability (or replication) is ordinarily a requirement of the scientific method, yet it is a practical impossibility in using the case history. A clinician's practice cannot be drawn from a representative sample, not even a representative sample of all people suffering from the same psychiatric disorder. As has been described previously, Freud's patients, for example, were drawn from a very narrow cultural base: middle- and upper-socioeconomic status members of Viennese society during the Victorian period. Even when clinicians gather the case histories of many individuals, those histories would not be selected randomly. They are what might be called an opportunity sample whose characteristics were influenced more by the nature of the clinician's practice than by random selection. (3) It is never possible, when constructing a case study, to exclude the possibility of other influential causes that have not been revealed by the patient. To find compelling evidence of causation, we would have to know that one event, the cause, was always followed by a described effect, and that when an effect was present, it had always been preceded by the hypothesized cause. But even many case histories may not provide that information.

The Survey

A survey is essentially a counting of experiences; for example, the number of people in midtown Manhattan who have psychological problems, or the psychiatric disorder that accounts for the largest number of hospital admissions. The information is gathered from public records or from brief door-todoor, telephone, or online questioning of a sample population. Information that can be gathered in that way is valuable in planning mental health resources, but it tells us very little about etiology or effective treatment because of difficulty establishing cause and effect. However, it often leads to the development of hypotheses about etiology, associated factors, and treatment.

CHARACTERISTICS OF THE SURVEY

The American Psychological Association and The Infinite Mind in 2002 conducted a survey of responses to the terrorist attacks on September 11, 2001. They interviewed 1,900 individuals and found that 24 percent of Americans reported feeling more anxious or depressed at that time than they had anytime previously, and 16 percent said that these feelings were due to the terrorist attacks. This research not only tells us the frequency of individuals struggling with the direct or indirect effects of the terrorist attacks but also suggests hypotheses for future investigation. For example, although the terrorist attacks clearly had a significant negative impact on many individuals, the majority of Americans appear to be coping well with the stress—perhaps the majority of Americans are resilient (that is, can cope effectively with stress).

Survey research is of two types: (1) reactive surveys, in which participants are required to answer questions in an interview or on a printed questionnaire, and (2) nonreactive surveys, in which a survey uses available records, without seeking any reaction from members of the population being surveyed. The

terrorism example exemplifies a reactive survey. Nonreactive surveys use hospital, school, or other public records.

In survey research, a representative sample of the population to be described is critical. Without a representative sample, survey results are meaningless. Scientific surveys carefully describe procedures used to obtain a random sample. In addition, they set the size of the sample required for reliable descriptions in accordance with statistical formulae for such purposes. In reporting results, they usually indicate the margin of error in their results. The larger the sample, the smaller the probable error. For example, in the nationwide portion of the sample in the terrorism study, the margin of error was $\pm 1/2.5$ percent. However, the margin of error for the portion of the population polled only from New York (which was smaller than the total sample) was $\pm 1/-5.9$ percent.

ADVANTAGES OF THE SURVEY METHOD

The principal advantages to using surveys are as follows: (1) They provide useful information on the incidence of a disorder (number of new cases by time period, for example, annually) and its prevalence (number of cases in a described population). (2) Because a survey usually relates the psychiatric disorder to other information about the individual, the information provided helps identify individuals at risk and increases our understanding of point of onset and future course of the illness. (3) Statistical relationships uncovered in a survey often suggest hypotheses as to possible etiology. (4) Surveys are able to target a large number of individuals, increasing the generalizability to the general population.

DISADVANTAGES OF THE SURVEY METHOD

There are two possible hazards in survey research. They are as follows:

(1) As mentioned previously, the value of a survey is dependent totally upon the representativeness of the sample. To assure that participants have been selected randomly, researchers have to state in advance how they will be selected, so that each member of the population under study will have an equal chance of being selected. (2) Surveys also may be biased by respondents or researchers. In reactive surveys, the social desirability of an answer sometimes causes the respondent to give that answer rather than one that more accurately states the facts. Many adult individuals, for example, might not be willing to state that they frequently have nightmares or often feel depressed. The researcher can often phrase questions in too forceful a way. The problem with doing so is that it might produce too many inaccurate answers.

Correlational Studies

In studying abnormal behavior, psychologists often go beyond simple descriptive studies, such as those provided by the case history or the survey, to consider how two aspects of the individual's behavior are related. They ask the question, for example, how do divorce and the presence of a psychological disorder correlate with each other? Or the psychologist may seek to test the hypothesis that poverty influences juvenile delinquency by recording delinquency rates and the prevalence of poverty in different sections of an urban community. He or she might then correlate those two prevalence levels. If the two correlated (varied together), one could say that poverty and delinquency were associated. It is important to note, though, that correlation does not indicate a cause-and-effect relationship. It just means that two factors tend to occur together.

The Coefficient of Correlation

The coefficient of correlation is the statistical ratio used to assess the degree to which two events or conditions vary together (or co-occur). A coefficient of correlation may be positive (expressed in a positive number) and thus indicate that as one variable (a factor under study) increases, the second variable also increases. A negative correlation coefficient indicates that as one variable increases, the other decreases.

A perfect relationship, in which each variable increased to the same degree as the other, would be expressed by a coefficient of 1.00. Such a finding rarely, if ever, occurs when measuring human characteristics. For example, research reports that there is a negative correlation between time spent studying and failure rate. Some hard-working students may be disappointed to discover that the negative relationship is not minus 1.00, indicating a perfect negative relationship. Some students, despite hard work, still sometimes get a failing grade. The converse also is true—some students who barely crack open a book do well in the class.

Correlation and Causality

There is a temptation with correlation to believe a causal relation exists between the two variables. An important caveat is in order here: Correlation does not demonstrate causality. Determining a causal relation demands more careful study than simply identifying a correlation between the two variables. For one thing, the time order between the two variables has to be considered. For example, individuals in the survey indicated whether their feelings of anxiety or depression occurred before or after September 11, 2001. Clearly, symptoms occurring before the attacks were not due to the attacks.

Beyond that, the researcher must consider the possible presence of an independent third variable influencing or confounding both other variables. For example, a number of the individuals in the survey indicated that their feelings of anxiety and depression were due to things that just happened to occur around September 11 (such as a divorce) or things that were only indirectly related to September 11 (such as financial hardships due to the economic state of the nation shortly after September 11). In the first case, there was a correlation between the terrorist attacks and feelings of anxiety and depression, but the feelings were not caused by the attacks. In the second case, again, there was a correlation, but the feelings were only indirectly related to the attacks. In studies of abnormal behavior, spurious correlations may be found and conclusions drawn that ignore the presence of a third common influence on the two variables being studied.

Researchers attempt to eliminate the presence of a contaminating or confounding variable by matching the participants under study in as many characteristics as possible. There is a problem with doing so: Such matching sometimes results in the groups becoming so highly selected as to be unrepresentative. An example illustrating the danger, cited by Bootzin (1988) follows: Matching senior citizens and college students on general health would lead to a most unrepresentative group of senior citizens, because so many of them have health problems as they age.

Advantages of the Correlational Method

A principal advantage of the method is that it allows the study of naturally existing groups when ethical or practical considerations would rule out the more rigidly structured experimental approach (to be discussed later in this chapter). For example, it is helpful to understand the relationship between stressful events, such as terrorist attacks, and anxiety and depression. Understanding this relationship could help individuals experiencing stressful events to not develop anxiety and depression. However, it is not ethical to create or simulate a terrorist attack just to study its effects on an individual's emotions. Researchers label such studies of the relationship between naturally occurring variables a correlational research design.

The correlational method provides a precise measurement of the covariation of any two measurable variables. There are many occasions in abnormal psychology when obtaining such a measurement would be helpful. Correlational studies are free of the artificiality of laboratory research.

Disadvantages of the Correlational Method

The correlational study does not allow the research to draw any definitive conclusions about causal relations. To counterbalance that disadvantage, it does encourage (or discourage) further research efforts to test a speculative hypothesis.

Developmental Studies

Developmental studies focus on the development of characteristics and disorders. There are two major categories of developmental studies: retrospective (backward-looking) and prospective (forwardlooking). When the developmental study involves a retrospective recall of early development on the part of the patient, it resembles the case study method. Such retrospective recall, as has previously been suggested, is highly unreliable.

Prospective research involves following the course of an individual's development over many years. This offers many advantages, the principal one of which is establishment of a time-order relationship between lifetime crises and psychiatric disorders; for example, the role of traumatic events in phobic reaction or losses in depression. This methodology is essentially a variation of the correlational design and is subject to its limitations. Specifically, the sequence of events, one event following upon another, by itself does not establish a causal relationship. There are three types of prospective developmental designs; longitudinal, cross-sectional, and sequential.

The Longitudinal Study

The longitudinal method has certain problems. Attrition of the population under study is one of them. A beginning population of one hundred participants over a period of five to ten years might become so small as to become unreliable for statistical analysis because of the difficulty of maintaining contact with participants. Also, there is the issue of a possible cross-generational effect. The cross-generational effect occurs when individuals of one age differ from people who are the same age at a different time because of their experiences of different cultures and events. Sometimes in abnormal psychology, a longitudinal study begins when the individual first comes to the attention of a clinic because of early signs of psychological difficulty. Such studies are called high-risk research strategy.

A study by Huessman and colleagues (2003) is a good example of the developmental research design. They followed 329 youths over 15 years and found that early exposure to violent media and identifying with aggressive characters in childhood is associated with aggression in adulthood. This suggests that violent media might result in aggressive behavior in adulthood, but one study does not prove a theory. This study must be replicated in order to confirm that violent media does result in aggression.

The Cross-Sectional Study

A variation of the longitudinal research design is the cross-sectional study. A typical longitudinal study follows the same group of individuals over several years. In a cross-sectional study, at a single point in the study, groups of individuals representing a cross section of different ages are compared to trace the development of certain behavioral patterns. For example, Segal, Coolidge, Mincic, and O'Riley (2005) investigated why older adults are less likely to access mental health services. They compared a group of young people (average age, 20.6) and a group of older people (average age, 75.1) on their beliefs about psychological disorders and willingness to seek help. The results suggest the developmental difference in willingness to seek psychological services is due to more negative attitudes of older adults toward people with psychological disorders.

This method is more economical of time and effort than the longitudinal study. It has, however, more value in tracing developmental sequences than in identifying etiological factors in psychiatric disorders. But as with correlational studies, it tends to build (or weaken) hypotheses under consideration but does not crucially test them. Its weakness is that it ignores the effect of varying (and unmeasured) life experiences among the individuals studied. Its rationale for doing so is the assumption that a large enough sample will wash out individual differences. Additionally, the cross-sectional design is vulnerable to the cohort effect. The cohort effect describes the phenomenon of people of different age groups at the same time differing on variables other than age because of their experiences.

The Sequential Study

The sequential design is a cross between the longitudinal and cross-sectional designs. It follows several cohorts (groups of people approximately the same age) over a period of time (typically shorter than a longitudinal study). This design minimizes the likelihood of attrition because it is shorter than the longitudinal design. It minimizes the likelihood of cross-generational effects because several groups are used, and it minimizes the likelihood of cohort effects because it follows the same individuals over time. However, even though it is less vulnerable to these weaknesses, they are not entirely removed, so the sequential design has all of the weakness of the longitudinal and cross-sectional designs, they are just less likely to significantly skew the results.

Trzesniewski (2004) followed three groups of individuals for eight years, assessing their self-esteem. By following the same individuals, it was discovered that self-esteem is relatively stable over time. By following people over the age range of 25 to 96, it was discovered that the stability of self-esteem decreases as individuals enter late adulthood. Furthermore, the results indicated that having more positive relationships lead to higher levels of self-esteem and higher levels of self-esteem lead to more satisfactory relationships across the lifespan.

The Experimental Research Design

A well-conducted experiment is an ideal model of the scientific method. As with all experiments, experimental research in abnormal behavior begins with a hypothesis. The experimenter's hypothesis usually relates to speculation about possible causes of a psychiatric disorder or possible therapies. It may have been formed on the basis of other research that is tentative, or it may stem from a theory that, as yet, has not been tested thoroughly. Such hypotheses grow out of findings in case studies or in correlational studies, sometimes even from surveys. Because the two most important goals of research in abnormal psychology are the identification of causes and the testing of hypotheses for effectiveness of treatment, hypotheses usually relate to those questions.

In all experimental research, there are two variables whose relationship is the prime concern of the researchers: an independent variable and a dependent variable. The independent variable is the hypothesized cause of a particular phenomenon. A dependent variable is one whose occurrence is dependent on whether the independent variable preceded it. The most rudimentary experimental design may be illustrated as follows: pretest, experimental treatment, posttest. Here, the experimental treatment is the independent variable. The dependent variable is any change between pretest and posttest scores. A requirement of a good experiment is that all variables be operationally defined; that is, there should be a quantified or measured statement of the independent and dependent variables and how they will be assessed.

In most experiments, two groups are set up, one known as the experimental group, the other the control group. Such a two-group experiment may be diagrammed as follows:

Experimental Group:

Pre-test → Experimental Treatment → Post-test

Control Group:

Pretest → No Experimental Treatment → Post-test

If participants in such an experimental design have been assigned randomly to each group so that each group is representative of the population being studied, and if the number of participants is large enough to produce statistically reliable results, the researchers may conclude that any difference between the experimental group and the control group in the posttest would have been caused by the experimental treatment.

We can best illustrate the various steps in experimental research by describing a well-controlled experiment reported by Feinfeld and Baker in the Journal of Clinical Child and Adolescent Psychology (2004). Here are the steps the researchers took:

- Step 1: Developing a hypothesis. The authors developed a treatment they felt would be effective in treating young children with externalizing disorders (for example, noncompliance, aggression). This hypothesis was based on reviewing past research on treatments for externalizing behavior in young children. They then proceeded to test the hypothesis in an experiment.
- Step 2: Operationally defining the independent variable. The independent variable was participation in a treatment consisting of parent and child combined groups, parent-only groups, child-only groups, and individual meetings following a detailed curriculum specified in the manual previously developed by the researchers.
- Step 3: Measuring the dependent variable. The dependent variables in this experiment were the children's externalizing behavior, parenting practices, and parent stress. These were measured through questionnaires completed by the children's parents and teachers.
- Step 4: Setting up a control group. Approximately half of the children were randomly assigned to receive the intervention right away and the other half were assigned to receive the intervention later, after the first group had completed the treatment and could be compared to the group who had not yet participated in the treatment.
- Step 5: Drawing a conclusion. In an experiment, the critical finding is a statistically significant difference between the control and the experimental groups on their post-experimental treatment results. In comparison to the children who had not yet participated in the treatment, parents of families who did receive the treatment reported significantly fewer behavior problems, improved parenting practices, and decreased parenting stress. Five months after the treatment, teachers and parents both reported significant improvements in child behavior. Because the results were significant, the authors concluded that the study supports the efficacy of the treatment; that is, the treatment caused the improved behavior.

Special Experimental Controls

There are two special precautions researchers can take to rule out confounding factors when running an experiment. First, they can use what has become known as an ABAB, or reverse research design. This design seeks to measure the effectiveness of an experimental treatment by showing that the individual's behavior changes in opposite directions with alternating conditions of experimental treatment and no experimental treatment. A second precaution is to eliminate both participant and experimenter bias by keeping both participants and experimenter blind as to which are the experimental participants and which are the controls.

THE ABAB (REVERSE DESIGN)

This design utilizes only one group of participants. Instead of using an experimental and a control group, the experimenter sets up two experimental conditions, one with the experimental treatment and the other without. An ABAB research design can be diagrammed as follows:

Determination of Baseline without Treatment (A) → Experimental Treatment (B) → No Treatment $(A) \rightarrow Experimental Treatment (B)$

If there is a change (alleviation of symptoms) during or after treatment, but no such change without treatment, the experimenter can conclude that the experimental treatment produced the change. Such a

result when the experiment is a test of a specified therapy would cause experimenters to consider the treatment effective for the condition studied. The ABAB design is frequently also called a reverse design experiment because any improvement in behavior after Condition I (with treatment) is likely to be reversed after Condition II (without treatment).

Here is an example of an ABAB design testing the effectiveness of a specific drug. For a three-week period, a number of depressed patients' symptoms of depression are measured (baseline without treatment: A). Then, during Condition I, the patients are given daily doses of the drug to be tested (Treatment: B). At the end of the three-week period, the presence of depressive symptoms is rated by neutral and uninformed (blind) observers. A period of three weeks (Condition II) is allowed to elapse, during which time the patients receive a placebo (a useless drug with the same external features as the actual drug), and the patients' symptoms return to their previous level (no treatment: A). For a second period of three weeks (Condition III), each day the participants are given the medication (Treatment: B). Again, at the end of the period, the researchers assess the depressive symptoms. If there has been improvement in the depression after Condition I and III but not after Condition II, the experimenter can judge the drug to be an effective agent for relieving depressive symptoms.

THE DOUBLE-BLIND EXPERIMENT

Frequently described as an elegant design, the double-blind experiment is typically used in all major drug therapy research. In the double-blind experiment, some participants (the experimental group) are given dosages of the drug under study; others (the control group) are given a placebo. In the experiment, both participants and experimenters are kept blind as to which group individuals belong to until the experiment has been completed. Only after the results are completed are the control and experimental groups officially identified. The double-blind design eliminates any interfering effects from suggestibility in participants, a phenomenon known as the placebo effect, and possible bias by experimenters.

Evaluation of the Experimental Design

Two strong advantages of the experimental design have been identified by Rosenhan and Seligman (1989). To quote those authors, the experiment "is the foremost method for isolating causal elements." The careful control built into the experiment, which largely limits the operation of extraneous variables, is the principal factor giving the experiment that capability. The second advantage is its repeatability; almost all significant experiments are replicated, sometimes on different populations, to test the generalizability of the experiment's conclusions.

A crucial limiting disadvantage of the experiment is its artificiality. The circumstances of the experiment signal to the participants that they are a special group under study for scientific purposes. Attitudes created by that knowledge can cause them to behave in unnatural ways.

Experiments of Nature

Catastrophic events such as floods, earthquakes, disastrous storms, rape, airplane accidents, and military combat provide occasions for studying certain types of abnormal behavior. Such unfortunate events have, for example, provided the basis for describing onset of post-traumatic stress disorder, its symptomatology, possible therapies, and even possible preventive measures. After such studies, the fully developed diagnostic criteria for that disorder were first presented in DSM-III (1980).

With such traumatic events, the striking, extreme, and all-encompassing nature of the event allows the researcher to conclude that any significant departure from previous levels of functioning can legitimately be considered an effect of the trauma. That conclusion is a broad, global one that does not specify what it is about the occurrence that causes the breakdown. There are many possibilities, such as suddenness, immediate threat of death, or guilt about personal survival while relatives and friends did not survive. These are all psychologically disruptive experiences that could possibly cause a psychological disorder. Psychological opinion suggests that the specific causal agent varies with the nature of the trauma.

In a sense, such catastrophic events can be labeled experiments of nature. From that point of view, the catastrophe is the independent variable and, for example, post-traumatic stress disorder would be the dependent variable. The psychological literature provides many examples of how studying the effect of natural catastrophes or other trauma increases our understanding of abnormal behavior. Catastrophes such as the following have been studied in follow-up: terrorist attacks in New York and Washington, D.C., in 2001; the Columbine High School Shooting in Colorado in 1999; and Hurricane Andrew in Florida in 1992.

Behavior Genetics

The study of the hereditary bases of behavior is called behavior genetics. Many personality traits and psychological characteristics tend to run in families. This has led researchers to study the heritability (the variation of a trait in a population due to genes) of psychological traits. However, just because one inherits a genetic tendency does not mean that tendency will be evidenced. The set of genes that a person inherits is his or her genotype. A person's genotype will interact with the environment to determine his or her phenotype, or observed traits. Understanding the genetic basis of psychological disorders might provide insight that will help treat or prevent psychological disorders.

There are three ways that behavior geneticists typically study the roles of genes and environment in the development of psychological disorders: family studies, twin studies, and adoption studies.

Family Studies

Science can now approximate the percentage of common genes in family members of varying degrees of closeness. It is, for example, estimated that siblings have in common 50 percent of their genes, aunts and uncles 25 percent, and cousins 12.5 percent. That knowledge provides one method of testing the influence of heredity on the development of mental disorders. Starting with a patient with a diagnosed mental disorder, a researcher can seek out relatives who vary in their closeness to that individual and count the number of family members of each degree of relationship showing signs of the same illness. A correlation between the degree of relationship and the illness, other factors being equal, suggests a hereditary influence. That is, when a disorder is more common in the close relatives of an individual with that disorder than more distant relations, it is likely that there is a genetic component to that disorder.

Just that kind of research was undertaken with a group of people with schizophrenia. The results indicated that the closer the relationship to the individual with schizophrenia, the higher the incidence of the same disease. Such a study does not prove the certain influence of hereditary factors as a cause of schizophrenia, because common environmental conditions among the relatives could not be ruled out as a causative factor. It is nevertheless strongly suggestive of a relationship.

Twin Studies

The scientific reasoning in twin studies can be tighter than in family studies, because monozygotic twins (identical twins developed from a single fertilized egg) have exactly the same genes. Their physical characteristics, and presumably their mental characteristics, are almost identical. They are to be contrasted with dizygotic, or fraternal, twins, developed from two separate eggs, fertilized at the same time. Their genes are not more alike than any two siblings. The concordance rate (the percentage of times both twins have the same illness) is studied. When the concordance rate is higher for monozygotic twins than dizygotic twins, a genetic component is suggested.

Such studies of people with schizophrenia reveal, for example, that the identical twins show a concordance rate three to five times as high as nonidentical twins. The finding provides a very strong argument for a hereditary effect on the development of schizophrenia.

Adoption Studies

Adoption studies compare adopted children to their biological families, with whom they share genes but not environment, and their adoptive families, with whom they share environment, but not genes. If a child who was adopted as an infant is more similar to a biological family member than an adoptive family member on a given trait, then that trait likely has a genetic component. If the child is more similar to his or her adoptive family on that trait, then it likely is determined more by environment than genes.

When one identical twin with schizophrenia has been adopted and raised apart from his or her cotwin, because the hereditary factor is identical but environmental influences can be assumed to be different, the situation provides a critical test of the possible hereditary influence on development of the disease. Because concordance rates, despite environmental differences, are high, such studies provide strong evidence for the hereditary transmission of a tendency toward schizophrenia; not as absolute as the inheritance of eye color, for example, but quite strong.

Evaluation of Psychological Research

As society's interest in protecting the individual's rights increases, limits have been placed on what can be done experimentally on human and animal participants. For example, the early experiment performed by Watson and Raynor in 1920, in which they created a phobia in an eleven-month-old child, would now be forbidden by law and by ethical considerations.

Because of an experiment's artificiality and the social and ethical limitations placed on certain types of experimentation, the study of abnormal behavior will continue to be dependent upon correlational studies and experiments of nature, and we will continue to look toward the case study as a source of promising hypotheses.

SUMMARY

Abnormal psychology shares the goals of all science. Those goals are description, prediction, and understanding. The basic activity of the scientist is observation refined by special training and aided by the use of instruments. Abnormal psychology examples of instrumentation include psychological tests, rating scales, and electroencephalography.

Research in abnormal psychology is principally interested in describing the individual's symptoms, understanding the causes of mental disorders, and learning what therapies are helpful.

The basic requirements for scientific research in abnormal psychology are the absence of confounding effects, which are extraneous factors that may influence the results (internal validity); generalizability to other populations by other researches (external validity); and the representativeness of the sample (the extent to which the sample is truly similar to the population being described). Abnormal psychology research looks at statistical and clinical significance and attempts to replicate results to reach firm conclusions.

There are six basic research designs in abnormal psychology. They are descriptive studies, developmental or longitudinal studies, correlational studies, experiments, analogue experiments, and experiments of nature.

- Descriptive studies: There are two types, the case history and the survey.
- Developmental studies: Such studies may be retrospective or may be prospective, observing changing patterns of behavior in individuals (longitudinal), in a cross section of different age groups (crosssectional), or both (sequential).
- Correlational studies: Here, the researcher attempts to discover whether two types of behavior tend to be associated; that is, do they tend to vary together? The measure of that variation is the coefficient of correlation. Correlation cannot be used to imply causation.

- The experiment: Here, the observation takes place in a laboratory setting in which the experimenter is able to control all significant variables. The experiment is set up so that the researcher can evaluate the effect of the independent variable (the variable under his or her control) on the dependent variable able (the factor that is hypothesized to be dependent on the influence of the independent variable). There are five critical steps in experimental research: developing a hypothesis; quantifying the independent variable (providing an operational definition of it); setting up a control group (free of any influence from the independent variable) and the treatment group who receive the independent variable; measuring the dependent variable for the experimental and control groups; and drawing a conclusion.
- **Experiments of nature:** Here, the researcher studies the impact of some catastrophic natural occurrence (considered the independent variable) on the behavior of the surviving victims of the disaster (the dependent variable).
- Behavior genetics: Behavior geneticists research the relative contributions of genes and environment to behaviors, traits, and psychological disorders. They use family studies, adoption studies, and twin studies.

Each of the six research designs has specific advantages and disadvantages. Ethical and practical considerations frequently determine which design will be chosen.

SELECTED READINGS

Hock, R. R. (1998). Forty studies that changed psychology: Explorations into the history of psychological research (3rd ed.). Prentice Hall.

Lilienfeld, S. O., Lynn, S. J., & Lohr, J. M. (Eds.) (2004). Science and pseudoscience in clinical psychology. New York: Guilford Press.

Mook, D. G. (2001). Psychological research: The ideas behind the methods. New York: W. W. Norton & Company.

Roberts, M. C., & Ilardi, S. S. (eds.) (2005). Handbook of research methods in clinical psychology. Oxford: Blackwell Publishers.

Test Yourself

1)	Which of the following is a goal of	research in abnormal psychology?	
	a) description	c) understanding	
	b) prediction	d) all of the above	
2)	The degree to which the results of a founding variable is called	study are due to the factor under investigation rather than a con-	
	a) external validity	c) internal validity	
	b) generalizability	d) representativeness	
3)	Research involving observation is the false?	ne preferred method of research in abnormal psychology. True or	
4)	A survey where a large number of individuals fill out a questionnaire about symptoms of anxiety disorders to determine the prevalence of anxiety disorders is an example of what type of research design?		
	a) descriptive	c) experimental	
	b) developmental	d) natural	
5)	i) If two variables are correlated, that means one causes the other. True or false?		
6)	The blind research design is used to counteract what effect?		
	a) cohort effect	c) cross-generational effect	
	b) placebo effect	d) visual effect	
7)	Which of the following describes re- of time?	search that follows a group of individuals over an extended period	
	a) case history	c) longitudinal	
	b) cross-sectional	d) sequential	
8)	Researchers in abnormal psychology are exempt from ethical obligations in research. True or false?		

Test Yourself Answers

- 1) The answer is d, all of the above. The scientific study of abnormal psychology includes research geared toward describing, predicting, and understanding psychological phenomena associated with disorders.
- 2) The answer is c, internal validity. Internal validity is the degree to which the results of a study are due to the factor under investigation. External validity is the degree to which results of a study can be generalized to other populations or settings. Generalizability is the degree to which results of a study apply to people who differ from those in the original study. Representativeness is the degree to which the sample of a study are similar to the overall population from which the sample was drawn.
- 3) The answer is false. Although observations and anecdotal records of case studies are extremely important, use of the scientific method helps turn hypotheses into proof. Tested data using an experimental and a control group provide factual evidence for future reference.
- 4) The answer is a, descriptive. The survey, along with the case history, is an example of a descriptive research design.
- 5) The answer is false. When two variables correlate, that means that they co-occur. One could cause the other, but both also could be caused by a third, or confounding, variable.
- 6) The answer is b, placebo effect. The placebo effect is when an individual's symptoms improve because of suggestibility when the person thinks he or she is getting the treatment, but instead receives an inert substance/intervention. The blind research design hides from participants whether they are receiving the active intervention or an inert placebo substitute to avoid results being skewed by the placebo effect. The cohort effect, a weakness of cross-sectional research, is the phenomenon of people of different age groups differing on variables other than age because of their experiences. The cross-generational effect, a weakness of longitudinal research, is when individuals of one age differ from those of people who are the same age at a different time because of their experiences of different cultures and events.
- 7) The answer is c, longitudinal. The longitudinal design follows the same individuals over time to study the development of traits or disorders. The case history follows one individual to study rare conditions. The cross-sectional design compares several groups of people at different ages to study development. The sequential design compares several groups that are different ages over an intermediate range of time to study development.
- 8) The answer is false. Researchers in abnormal psychology must follow all relevant ethical regulations when conducting research, including protecting the rights of human and animal research participants.

Psychodynamic, Humanistic, and Existential Perspectives

bnormal psychology has moved a great distance from the sometimes primitive interpretations of abnormal behavior offered in past centuries. Its advances have been considerable, even when compared with those of the early years of the twentieth century. Although much scientific work was done earlier, particularly in identifying biological causes of abnormal behavior, dramatic new understandings of abnormal behavior began with the work of Sigmund Freud. Soon after Freud's work, from a different direction, came the behaviorism of John B. Watson and the influential body of research by B. F. Skinner, which established the behavioral perspective on a rigid empirical basis. More recent to arrive as explanations of human behavior are the cognitive, humanistic, and existential points of view.

Today, the student of abnormal psychology will find broad areas of agreement among psychologists about causation and treatment of abnormal behavior, but the student will also find various schools of psychology that bring different perspectives to their interpretations of abnormal behavior. Perhaps in future decades, as these schools of thought become a part of the history of psychology, there will evolve a unified understanding of most complexities that still exist in the field.

It is not now possible to find a complete explanation of either the causes of all abnormal behavior or the best means of treatment by viewing human behavior through any one of the perspectives. For that reason, many clinicians in the field take an eclectic point of view, selecting from each of the schools the insights that increase understanding and promote effective treatment. In this book, we follow their example and have chosen an eclectic perspective.

The existence of differing models for studying and understanding human behavior parallels developments in all sciences. Differing interpretations of phenomena exist, for example, in physics or astronomy, until a brilliant scientific breakthrough develops, out of years of research effort, to provide new insights and to unify thinking. Examples include Einstein's contribution to physics and Freud's contribution, in earlier years, to psychology. But even such quantum leaps forward can be subject to revision by later research, as is some of Freud's and Einstein's thinking today.

This chapter examines the psychodynamic perspective, traceable to Freud's work in psychoanalysis, but will also consider deviations from it by the neo-Freudians and the humanistic and existential schools. Chapter 5 considers the behavioral, cognitive, and biological perspectives.

THE PSYCHODYNAMIC PERSPECTIVE

Although, as Chapter 2 suggests, early indications of a psychodynamic approach to abnormal behavior began to appear in the late nineteenth and early twentieth centuries, the full sweep of the perspective comes out of the clinical practice and writings of Sigmund Freud, whose work began in the latter half of the nineteenth century and ended in 1939. His profound contributions have been extended and modified by early disciples and thereafter by neo-Freudians and by ego psychologists.

Basic Concepts of the Psychodynamic Perspective

Key to an understanding of the perspective is an understanding of the word psychodynamic. From the dictionary comes this definition: "the interaction of various conscious and unconscious mental or emotional processes, especially as they influence personality, behavior, and attitudes" (American Heritage Dictionary, 2004).

Psychoanalysts and other psychodynamic theorists typically specify that definition to include the importance of early life experiences in determining adult characteristics.

Almost universally, members of the psychodynamic school identify three basic concepts underlying the psychodynamic perspective: psychic determinism, unconscious motivation, and the role of childhood experiences.

Psychic Determinism

Psychodynamic theorists believe that although we have a sense of freely choosing what we will think about, desire, and do, much of our behavior actually is determined for us or at least strongly influenced by earlier life experiences.

Unconscious Motivations

Motivational forces operate, to a considerable degree, at an unconscious or, at most, preconscious level. The psychodynamic theorists hold that the full basis for significant behavior, especially for motivation, is largely unknown to the affected individual. This belief significantly influences psychotherapeutic techniques, which are discussed in Chapter 7.

Childhood Experiences

The individual is most vulnerable to influences from the environment during the early years of life. For these reasons, most, but not all, psychodynamic thinkers believe that critical dynamic forces influential throughout the lifespan of the individual are developed during the early years of childhood. This principle of the psychodynamic perspective also has an important influence on treatment approaches, especially on psychoanalytically oriented treatment.

Sigmund Freud: Psychoanalytic Theory

Because of the originality of Freud's ideas and his continuing influence on modern psychological thinking and practice, this chapter gives special attention to the details of his psychoanalytic theories. There are four principal aspects of psychoanalytic theory: the three levels of consciousness; the structural components of the human mind; psychosexual development; and the defense mechanisms.

The Three Levels of Consciousness

Freud described three levels of consciousness: perceptual consciousness; the preconscious; and the unconscious.

PERCEPTUAL CONSCIOUSNESS

At any moment, the individual attends to—that is, is consciously aware of—only a small number of items or events. This awareness Freud called the perceptual consciousness. An example of the perceptual consciousness follows: An individual may be aware of the content of a book he or she is reading, yet hears the phone ring, and perhaps with less sharpness, is aware of the person sitting across the table.

THE PRECONSCIOUS

This level of consciousness comprises those events or facts not in the center of attention, yet readily retrieved from memory: an experience in class yesterday; a forthcoming appointment; or a meal eaten two hours ago.

THE UNCONSCIOUS

The largest amount of memory of past experiences, impulses, and data lies at the unconscious level. There are two types of unconscious material. The first are those that have been forgotten, for whatever reason. The second are those that, because of conflict and the anxiety they produce, are repressed and actively excluded from consciousness. Ordinary forgotten events, such as the exact price paid for last year's textbook or a difficult-to-understand theory in chemistry, gradually fade out of memory and have little subsequent influence on personality. But repressed items live on and show up in a variety of covert ways: dreams; fairly well-disguised fantasies; slips of speech; motivated recall under hypnosis or drugs; and, for some people, in a variety of psychological disorders. They are among the most influential forces in mental disorders, according to psychoanalytic theory.

The Structural Process of the Human Personality

The human personality in psychoanalytic theory is structured by three kinds of dynamic and interactive processes. Freud makes clear that they are neither objects nor places, but ways in which personality expresses itself. The three are the id, the ego, and the superego.

THE ID

The word id itself comes to us from the original German word es, meaning "it," by way of Latin, which translates "it" as id. Formally defined, it is that division or process of the psyche or personality associated with instinctive impulses and demands for immediate satisfaction of primitive and essentially biological needs.

According to Freud, this energy comes from one of two basic instincts within the id, one of which he named eros. The energy derived from the eros is libido, or the life instinct. The other major instinctive force within the id is thanatos, or the death instinct, to which Freud and his disciples have attributed only a small role in affecting human behavior.

In the first few weeks of life, all of the organism's activities motivated by the id process, the instinctive and biological, seek immediate and uninhibited gratification. As maturing takes place, the libido, the id's source of energy, provides life-furthering power and driving force for later activities that are part of psychological growth and biological survival. The id process operates raw and unrestrained under the demand of the pleasure principle, which seeks immediate gratification of impulses and immediate reduction of tension. A comparison frequently used is that the id behaves like an extremely spoiled child. This primitive irrational process is labeled primary process thinking.

THE EGO

Under the influence of the id process, individuals know no limits to what they will do, and thus would eat whatever they please, express aggressions indiscriminately, and find sexual satisfaction without social or moral limitations.

Ego, from the German word ich, by way of the Latin word ego, means "I." The ego is that part of the self that operates to some extent at a conscious level, most immediately controls behavior, and is most in touch with the real world. The ego allows expression of the id but only in ways that meet the requirements of reality, and thus it operates in accordance with the reality principle.

Freud uses the example of horse and rider to describe the possible interactions between the ego and the id. He puts it in these words: "The horse supplies the locomotive energy, while the rider has the privilege of deciding on the goal and of guiding the powerful animal's movements. But only too often, there arises between the ego and the id the not-precisely-ideal situation of the rider being obliged to guide the horse along the path by which it (the id) itself wants to go."

The ego process can begin to function in this way only when children's maturing reaches the point at which they can use reason to allow thought, memory, evaluation, and planning to control behavior. The individual under the influence of the ego process behaves in a way to minimize negative results from the influence of the id. The increasing control of behavior required by the ego process is a maturing form of behavior and is called secondary process.

THE SUPEREGO

The superego loosely resembles the conscience. It comprises values, ethical standards, and concepts of what is right and what is wrong, almost all of which have been acquired from parents. The superego is formed out of the child's resolution of the Oedipal or Electra complexes (to be described later in this chapter). The superego, like the id, develops with only limited relation to reality. Typically, instead of allowing reality to provide boundaries for its development, it aims for an ego ideal that sets unrealistically high standards for the suppression of id impulses.

With the development of the superego, some time around the age of six or seven, the child's personality expresses itself under the influence of three forces: the id, made up of pleasure-seeking impulses, all unconscious; the ego, the only one of the forces in direct contact with reality; and the superego, the strong voice of conscience.

The ego then works as a kind of gatekeeper in seeking outlets for id impulses that the superego will not object to as being taboo.

Psychosexual Development

Freud divided the child's personality development into five stages: oral; anal; phallic; latency; and genital. In each of the first three stages, the pleasure-seeking behavior of the id is associated with an area of the body—the mouth, the anus, and the genital region, respectively, which have been called erogenous zones. As children go through each of these three phases, they face conflicts between personal demands for gratification and the restrictions of reality. For example, the child is asked to give up the nipple or bottle, but still desires its satisfactions; toilet training places limitations on anal satisfactions; during the phallic phase (notice the masculine emphasis Freud gave to this naming process), the child is taught that any attention paid to the genital area is "naughty." The latency period is a period of respite, giving the child a time of quiet and freedom from sexual tensions of the earlier periods. How the child resolves the conflicts and frustrations of the early three phases shapes the adult personality, particularly in the psychosexual areas of life.

Freud's use of the words sex and sexual can lead to misunderstanding of what he meant by the pleasures to which he attaches those words. The words have broad application to any pleasurable psychic feelings, as well as to sexual activities and fantasies about sex.

THE ORAL STAGE

At birth, the child is equipped to suck the nipple or the bottle reflexively and thus is, from the beginning, naturally equipped to obtain food and find oral pleasure. As the neural system matures, the child is able to do much more with his mouth: mouthing objects; biting; chewing; rolling food around in it. The child soon develops special feelings for a number of objects: a pacifier; a security blanket to suck on or chew; his or her thumb; and many more. The psychologically significant conclusion Freud drew was that experiences with these early oral satisfactions shape later personality traits. For example, a child whose oral needs are not adequately satisfied may turn, later in life, to overeating, heavy smoking, or even alcoholism. Such traits as tenacity, disruptiveness, or acquisitiveness, in psychoanalytic thinking, may be shaped by early oral experiences. The end of the first year of life marks the end of the oral stage.

THE ANAL STAGE

During the second year of life, the child's id strivings for pleasure focus on the anus. All of a sudden, toilet training becomes an important influence on later personality traits. Early in life, the child finds pleasure in retaining and expelling the feces and finds pleasure in the reduction of the tensions that accompany bowel movements.

Those representatives of reality, parents, insist on surrounding anal activities with rules. The confrontation is a sharp one, and the frustration imposed, as well as the resulting testing of will with parents, can be more disturbing even than weaning. The discipline of voluntary control of pleasurable impulses is a first-time experience for the two-year-old. How parents approach this training activity will, Freud states, have significant effect on later personality traits. Too strict a regimen, for example, can lead to what has been called the anal retentive personality, characterized by stinginess, obsessiveness, and excessive concern with cleanliness. Too little control can lead to tolerance of mess and sloppiness characteristic of the anal expulsive personality. When such over-concern with the experiences of particular psychosexual phases develops, Freud speaks of the freezing of development, which has been called fixation.

THE PHALLIC STAGE

During this third phase of the child's psychosexual development, between the third and fifth or sixth year, the child seeks pleasure from stimulation of the genitalia, expressed in much relatively innocent masturbatory behavior. The child is soon again confronted with another first-time demand, that he or she give up pleasures that are not reflexively produced but brought on by voluntary stimulation of the child's own body. This confrontation does much to direct children's attention to their own body. With that focus, self-identity, a sense of independence, and willfulness lead to a kind of narcissistic preoccupation.

The phallic stage is of special importance because during it, the Oedipus complex develops. How children resolve that complex will affect, in significant ways, their sexual adjustment in later life. The story of King Oedipus, originally a Greek legend, has become a part of the mythology of most countries of the Western world. King Oedipus, after a great struggle, finds that he has killed his father in that struggle and has married his mother. Crushed by grief and guilt, Oedipus gouges out his own eyes. Freud uses that metaphor to describe the young boy's psychosexual experiences toward the end of the phallic stage. The metaphor for girls is the Electra complex, from the story of a daughter who avenges her father's death by killing her mother and her mother's lover.

Under the influence of the Oedipus complex, the boy in the late years of the phallic stage falls incestuously in love with his mother. The guilt and fear arising out of those impulses generates castration anxiety, a fear that his father will punish him for his forbidden impulses. That anxiety, under normal circumstances, is resolved as the incestuous impulses are repressed and kept unconscious. In accomplishing this, the boy, instead of continuing to fear a war with his father, joins the "enemy" in a process of identification through which the boy internalizes (makes part of himself) the values, sentiments, and even the external mannerisms of his father and incorporates them into his own behavior.

Under the influence of the Electra complex, the girl experiences a similar set of consequences. As she comes to realize that she has been born without a penis, penis envy develops. That envy seems to impel her toward incestuous desires for her father. Freudian psychoanalysts would say her reasoning is that if she cannot have her own penis, she can make up for that loss through possession of her father. Her response to the guilt and fear aroused in her by these forbidden wishes cause her to declare peace with her mother and to identify with her.

THE PERIOD OF LATENCY

Once the Oedipus and Electra complexes are resolved at age six or seven, the child's sexual impulses become latent. The libido seems at rest, and the narcissistic preoccupation with self disappears as the child turns to the outside world. During this period, there is time for learning and the acquiring of social and technical skills that serve as steps toward maturity.

THE GENITAL STAGE

With the arrival of puberty, the adolescent experiences a new stirring of sexual impulses, but not now directed narcissistically toward his or her own body. The child's interests are now aroused by other people. The child has arrived at the foothills of maturity. Altruistic love and tenderness gradually prepare the individual for mature sexual behavior. Dependence moves toward independent resourcefulness and the ability to master work skills.

Anxiety and the Defense Mechanisms

Freud distinguished three kinds of anxiety. Realistic anxiety, which modern psychology calls fear, arises out of the presence of danger in the real world. That danger may result from a physical hazard, such as military combat or being trapped in a burning building. But it may also be psychological in nature, for example, tensions resulting from real-life frustration or irresolvable conflict. Neurotic anxiety, in Freud's thinking, arises out of concern that unconscious impulses, particularly sexual and aggressive ones, will gain the upper hand in a conflict between the id and the ego. Moral anxiety arises out of concern that behavior will violate one's personal standards or conscience (a conflict between the ego and the superego). The experience of anxiety (any one of the three types described by Freud) is a disquieting trial from which the individual attempts to escape, often through the use of defense mechanisms.

Defense mechanisms are the unconscious attempts of individuals to protect themselves from threats to the integrity of the ego or self and also to relieve the tension and anxiety resulting from unresolved frustrations and conflicts. All people employ these self-deceptive measures to some extent, attempting in this way to maintain their self-esteem and soften the impact of failure, deprivation, or a sense of guilt. It must not be assumed that defense mechanisms invariably signify abnormal personality structure. Such mechanisms frequently result in gains for the individual using them. Their reactions may be a constructive form of adjusting. Excessive dependence on defense mechanisms to block out significant aspects of the individual's personality indicates abnormal modes of adjustment. The principal defense mechanisms are described below.

COMPENSATION

Using this mechanism, individuals devote themselves to a given pursuit with increased vigor in an attempt to make up for some feelings of real or imagined inadequacy. The compensation may be direct or indirect. Direct compensation refers to the generation of an intense desire to succeed in an area in which one has experienced failure or inadequacy. A classic example is the effort of Demosthenes to become an outstanding orator because of his early childhood speech disabilities; the very existence of this frustrating handicap provided the motivation to work more intensely to overcome it. Indirect compensation consists of the effort to find success in one field when there has been failure in another. This is seen in the vigorous efforts frequently made toward social achievements by students who fail to make their mark in academic circles or on the athletic field. Overcompensation is compensatory effort that is made at the expense of a well-rounded and complete adjustment to a variety of life's demands.

DENIAL

In this mechanism, an individual avoids painful or anxiety-producing reality by unconsciously denying that it exists. The denied reality may be a thought, a wish, or a need, or some external object or condition. Denial may take on verbal form in an occasional statement that something is not so or in a compulsively repeated formula which is resorted to as a means of keeping the thought, wish, and so on out of consciousness. In an extreme form, such a denial may result in complete loss of contact with surrounding reality.

DISPLACEMENT

This mechanism employs a process in which pent-up emotions are redirected toward ideas, objects, or persons other than the primary source of the emotion. Displacement may occur with both positive and negative emotions. For example, feelings of love that cannot be expressed openly toward a married person may be displaced toward a child of that person. Another way in which displacement may be shown is by changing the channel of expression for the emotion; for example, physical aggression may be inhibited but expressed verbally.

DISSOCIATION

Here is a defense mechanism in which a group of mental associations are separated or isolated from consciousness and operate independently or automatically. The end result may be a splitting of certain mental content from the main personality or a loss of normal thought-affect relationships. Examples are amnesia, development of multiple personalities (see dissociative identity disorder in Chapter 9), and somnambulism (sleep-walking).

FANTASY

In this mechanism, daydreaming or some form of imaginative activity provides escape from reality, with satisfaction obtained through imagined achievements or, occasionally, even martyrdom of some sort. A certain amount of daydreaming, especially in the earlier years of life, must be regarded as normal. As a preparation for creativity, fantasy is not only desirable but even essential. But fantasy becomes a dangerous and sometimes disabling mechanism if it is consistently preferred to reality and is indulged in as a method of problem-solving.

DENTIFICATION

In using this mechanism, the individual enhances his or her self-esteem (or believes he or she is doing so) by patterning behavior after another person. This may be done in fantasy or in real life. Employed in moderation, identification may be both helpful and stimulating, and it frequently leads to superior achievement. Used to excess, it may deny the individual gratification of his or her own personality needs.

PROJECTION

Individuals using this mechanism protect themselves from awareness of their own undesirable traits or feelings by attributing them to others. In its function of self-deception, this mechanism is particularly harmful to healthy personality development, because it blocks self-insight.

RATIONALIZATION

This is a common mechanism in which individuals justify inconsistent or undesirable behavior, beliefs, or motivations by providing acceptable explanations for them. A sour grapes reaction, in which one denies wanting what one has failed to obtain, is a common example.

REACTION FORMATION

This is a mechanism in which impulses that are not acceptable to consciousness are repressed (kept unconscious) and, in their place, opposite attitudes or modes of behavior are expressed with considerable intensity. For example, over-protestations of sincerity or of willingness to help may often mean the very opposite. Scrupulosity (over concern about the morality of one's behavior) may stem from unacceptable desires.

REGRESSION

Confronted by anxiety, threat, or frustration, an individual retreats to an earlier and psychologically more comforting level of adjustment. Mild regression is seen in the return of an older child to babyish mannerisms upon the birth of a sibling. The infantile behavior of some people with psychoses (see Chapter 13) is an expression of extreme regression.

REPRESSION

Here the individual prevents dangerous or intolerably painful or guilt-producing thoughts or impulses from entering consciousness. Repression is essential for the existence and operation of all the other defense mechanisms. It should be distinguished from suppression, which is the conscious control of unacceptable impulses, feelings, and experiences.

SUBLIMATION

Here, unconscious and unacceptable desires are channeled into activities that have strong social approval. The unacceptable desires, in Freudian theory, are sometimes sexual in nature, and their expression may be sublimated as creative effort in music, art, and literature. Other areas of life that provide avenues for sublimation are social welfare, teaching, and the religious life.

UNDOING

In this defense mechanism, individuals symbolically act out in reverse (usually repetitiously) something they have done or thought that is unacceptable to them. Through this behavior, they strive to erase the offending act or thought and with it the accompanying sense of guilt or anxiety. An example of undoing would be being overly nice to someone to whom one had previously been rude.

Breakdown in Defenses

The function of a defense mechanism is to maintain the integrity of the ego and thus to keep the individual in a state of psychological equilibrium. When the stress is too great for the personality to resist, defenses are weakened, and the personality begins to disintegrate. This process is called decompensation. In decompensation individuals may at first attempt to use other measures. They may, for example, pass from superficial rationalization to severe projection. The decompensation may produce a panicked state of anxiety as the individual is confronted with the breakthrough of unconscious material. From a psychological point of view, the final stages of decompensation for some individuals may be florid psychotic reactions (loss of contact with reality).

OVERVIEW OF FREUDIAN CONCEPTS

Because Freud's work created a major scientific breakthrough in our understanding of both normal and abnormal behavior, and because it continues to provide the framework for psychodynamic thinking, this chapter has presented Freud's thinking in detail. After a brief critique of Freudian concepts, the chapter continues with his description of normal and abnormal adjustment.

Limitations of Freud's Work

Freud's development of psychoanalytic theory suffers from two critical limitations. In the first place, the structure he outlined, the developmental states described, and the conflicts experienced are largely unverifiable-violating a criterion for all scientific work. Beyond that, modern study disputes many of Freud's statements about infancy and childhood.

Second, Freud's professional experience was severely limited in the kinds of contacts he had with human behavior. Except for his own family experiences, he spent no time studying the behavior of infants or children. Even his clinical practice was limited to the kind of clients he had opportunity to study. They were principally upper socioeconomic status men and women in early and middle age and were all drawn from the highly stylized Viennese culture. Both limitations narrowed his views as to the nature of all the influences operating on the human being's psychological development. As a result, later psychoanalysts and others with a psychodynamic point of view have modified significantly Freud's theories about human development.

The Freudian Concept of Normal Development

Freud taught that both normal and abnormal individuals were subject to irrational forces. The personalities of both normal and abnormal individuals are formed, according to Freud, out of childhood experiences occurring before the age of six. They differ only in the nature of those experiences and in the effect they have had on the formation of personality.

The essential distinction between normal and abnormal for Freud was in the balance achieved by normal individuals in the influence of id, ego, and superego. There is, in the normal individual, greater strength and flexibility in the gatekeeping function of the ego.

The Freudian Concept of Abnormal Development

For Freud, the neurotic individual (a classification that includes what today are termed anxiety disorders and somatoform disorders) is one in whom spells of overwhelming anxiety have created the need to become overly dependent on personality-warping defense mechanisms. Damaging early childhood experiences are the source of the anxiety. The result is severe impairment in functioning and the development of severely uncomfortable symptoms.

Psychosis (described fully in later Chapter 14) develops from a severe weakening of the ego, either from extreme underdevelopment in early life or from later life experiences. The result is a breakdown of the personality's defense system, with resultant overpowering anxiety as id forces become dominant. Associated with this development is loss of orientation, incoherence of speech, and delusions and hallucinations in which voices are heard issuing destructive demands.

EARLY DISSONANT VOICES

Although Freud's original concepts evoked doubt or strong opposition from many contemporaries, his work also attracted a number of brilliant and influential students, two of the foremost of whom were Carl Jung and Alfred Adler. Additionally, his daughter, Anna Freud, expanded upon the work of her father. In later years, other clinicians with an initial Freudian perspective made their own powerful contributions to ways of thinking about human development, all of them markedly different from Freud's. This section examines briefly the contributions of the two most influential of Freud's students, Jung and Adler, plus Anna Freud, and then the contributions of Harry Stack Sullivan, Karen Horney, Erik Erikson, and Margaret Mahler.

Carl Gustav Jung (1875–1961)

Among the voices dissonant from Freud's, Carl Jung stands alone because, although accepting the Freudian unconscious, he added to it the existence of a collective unconscious. It comprises a variety of archetypes, or universal ideas, with which we are born. The child does not have to learn fears of darkness, fire, or death, for example; he is born with those predispositions. Jung moved away from the concept of libido with its emphasis on sexual energy and hypothesized the existence of a spiritual instinct. He gave much more emphasis than did Freud to the importance of religion, mythology, mysticism, and the occult.

Alfred Adler (1870-1939)

Adler departed from orthodox Freudian teaching in three important directions. He disagreed with what he felt was Freud's undue emphasis on the libido or sexual drive and substituted for it an aggressive drive for dominance. He also placed much less emphasis on early childhood experiences, believing instead that psychological difficulties had their roots in the immediate social context surrounding the individual. And finally, Adler assigned a social responsibility to the individual. Adler taught that to attain maturity, the individual must give up his self-absorbed power struggle and focus on service to others. In moving away from the biological emphasis of Freud, Adler accented the importance of self and gave it a creative function that enabled the individual to work out his lifestyle.

In popular thinking, Adler is perhaps best known for his concept of the inferiority complex, a feeling of inadequacy which stirs up compensatory strivings for power and dominance.

Anna Freud (1895-1982)

Anna Freud expanded upon her father's work on defense mechanisms, particularly as they are evidenced in adolescents. Additionally, she applied the elder Freud's theories of psychoanalysis to children. As one of the founders of clinical child psychology, Anna Freud understood that children's symptomatology differed from that of adults. She remained faithful to Sigmund Freud's original theories, but explored ways to apply them to the treatment of children who are not dealing with issues from childhood past, but in the present.

LATER MODIFICATIONS OF FREUDIAN VIEWS

Four clinicians independent of Freud, but psychoanalytically trained, suggested further modifications in orthodox Freudian thinking. They are Karen Horney, Harry Stack Sullivan, Erik Erikson, and Margaret Mahler.

Karen Horney (1885-1952)

In her influential book, The Neurotic Personality of Our Time, Horney presented what was perhaps her most significant modification of Freudian theory. In her work, she presented the case that neurosis was a response to the values of industrial society, which pressed for competition and materialism, leaving the individual with anxieties about aggression and an overweening interest in seeking affection, but an incompatible inability to express affection.

Behind this proposition was her understanding of the nature of neurosis, which was a disturbance in human relationships, expressing itself in basic anxiety, the result of having to face a hostile world. Its cause lay in bad parenting, whether too strict or too indulgent, negligent or too concerned, and led to neurotic strategies of adjustment, such as helplessness, hostility, or isolation.

Horney also criticized the androcentric nature of Freud's theories. She argued that not all women experience penis envy, and that penis envy actually reflects a desire for power that tended, in society at that time, to be granted to men but withheld from women.

Harry Stack Sullivan (1892-1949)

Sullivan's contributions to the newly developing psychodynamic/psychoanalytic perspective were twofold: the importance he assigned to the self concept, and his willingness to use psychoanalytic therapy in the treatment of psychotics, an approach that Freud considered of little value. Sullivan believed that personality could not develop apart from the social context in which it operated and is perceived. He defined psychological disorders as those that occurred in social relationships. The self concept, he stated, evolves principally out of the appraisal of the self by others. When those appraisals are hostile, the individual blocks them out of consciousness by denial. When this warping of reality in the self-concept becomes extreme, Sullivan believed, psychological disturbance results.

Sullivan was the first to use psychoanalysis successfully with psychotic individuals. Much of that success came less from the theory behind it than from the nonconfrontational, warm, and supportive approach Sullivan took to those he treated. Sullivan's style in therapy has become a part of the modern psychodynamic perspective.

Erik Erikson (1902-1990)

Erikson brought to psychoanalysis a strong anthropological orientation, which gave his concepts a heavily social emphasis and also a more hopeful point of view than Freud's. He saw personality development as taking place over eight stages. At each stage, there was a challenge to be faced, largely psychological in nature. As individuals face each challenge successfully, they work out what Erikson called their ego identity, an integrated, unique, and autonomous sense of selfhood. Each stage offers the individual a chance to eradicate earlier damaging experiences. Personality formation does not end with childhood, but continues on through the adult years. In influencing personality, Erikson added the influence of teachers, advisers, friends, and others to that of parents.

Margaret Mahler (1897-1985)

Mahler offered major changes in Freud's theories that have significantly affected the psychodynamic way of thinking about human behavior. A major contribution was her development of the theory of object relations. Objects here means persons to whom the individual becomes emotionally attached, principally the child's caretaker, usually the mother. Mahler describes the movement toward psychological maturity and the formation of the awareness of self as a process of separation (from the mother) and individuation (that is, the child's independent development). That process comprises a series of stages of the child's experience in mother/child relationships. Gradually, after children first experience separateness from mother, the changing ups and downs in that relationship conclude as they internalize (make part of themselves) the image of the mother. This step, object constancy (as she calls it), finally stabilizes the relationship. Any tendency on the mother's part to rush or delay the natural process of separation causes problems in personality development.

AN OVERVIEW OF THE PSYCHODYNAMIC PERSPECTIVE

As the individual theorists whose contributions we have just described, beginning with the concepts of Jung, moved further and further away from the emphasis of Freud, the importance of interpersonal relationships has become a central feature of the psychodynamic perspective. For the student desirous of understanding the modern psychodynamic interpretation of abnormal behavior, a good summary statement is the following:

Abnormal behavior can best be understood by studying the individual's past and present relationships with other people. Begin by assigning principal weight to the child's interpersonal relations with parents, and then continue on through the life of the person's interpersonal relations with siblings, grandparents, teachers, and early and current friends. It is that set of relationships that offers the best understanding of his or her personality and any pathology that may be present.

HUMANISTIC AND EXISTENTIAL PERSPECTIVES

Two separate groups of theorists, working individually, have developed ways of looking at the human personality, normal and abnormal, that can conveniently be discussed under the headings, The Humanistic Approach and The Existential Approach. These orientations have only slight connections to psychoanalytic ways of thinking about human behavior. The humanistic group traces its theoretical roots back to William James (1842–1910), Gordon Allport (1897–1967), and Gardiner Murphy (1895–1979).

The existential school harkens back to nineteenth century philosophers Soren Kierkegaard (1813–1855) and Martin Heidegger (1889–1976).

The humanistic approach is best represented by Abraham Maslow (1908–1970) and Carl Rogers (1902–1987). The existential perspective can be described in the formulation of Rollo May (1905–1994). Both schools, humanism in America and existentialism in Europe, grew out of major social changes that seemed to dehumanize humankind (the technological society) and to devalue human life (the millionperson slaughter of World War I). Both trends seemed to these theorists only to be growing in strength with Hitler, Stalin, World War II, and nuclear bombs. The emphasis of the humanistic perspective is to reestablish a belief in the basic strength of the human psyche, its goodness and great potential for growth; the concepts emphasized by existentialists are choice, the search for meaning, authenticity, and social obligation. Existentialists identify, as a central anxiety-producing problem for humanity, the nothingness and nonbeing that death brings to everyone.

The Humanistic Perspective

The two outstanding proponents of a humanistic way of thinking about human adjustment efforts, Abraham Maslow and Carl Rogers, made the main focus of their perspective a principal concern not about pathology but about helping the average individual to move from being merely normal and mediocre toward full self-actualization.

Abraham Maslow

Maslow, working independently of Rogers, described in his hierarchy of human needs the aspirations humanistic psychology holds out for the developing individual. That hierarchy served, so to speak, as a map, providing guidance on the path to maturity.

The individual's life in Maslow's hierarchy is a progression from the lowest, yet fundamental, needs—physiological and safety—through the psychological needs of self-esteem and love/belongingness to the highest achievement of self-actualization. Each level of need must be met before the individual moves to the next highest. Environmental influences, especially within the family, that block this progress—for example, neglect, rejection, oversolicitousness, or authoritarianism—are the negative forces that individuals must be helped to understand and to overcome in order for them to move toward self-actualization. That form of becoming is a continuing process through the life of the individual. Its strands are fulfillment of mission, a deeper understanding of capacities and personality, and a more fully integrated unity of personality.

Carl Rogers

Rogers developed an almost revolutionary new form of psychotherapy, which he described in his book, Client Centered Therapy, published in 1951. The theory of personality development, which he later theorized, was fully described in his 1966 publication, On Becoming a Person. Rogers places the self concept at the center of personality. Through this concept, the individual organizes the world, decides what is good or bad for growth, and moves toward self-actualization in terms dictated by the self. Whether the individual accepts this valuing process is a result of the interaction of the organism (the sum total of the individual's perceptions of the world) and the self-awareness of one's own identity. When the two begin to come together, the individual moves toward self-actualization.

To have this happen requires that the individual, in the developing years, experience positive regard. Life sets conditions on what forms of behavior will be well regarded. In a happy environment, the child incorporates these into the self as conditions of worth. When those conditions are extreme or overdemanding, individuals redefine themselves to exclude any behavior or desire forbidden by the conditions set. The individual is thus prevented from being a fully rounded, whole person. Taught by parents to be docile and sweet at all costs, for example, a person may never be able to feel the anger that can be a normal human outlet. Anxiety is aroused by the unconscious tensions created by that abnormal inhibition. The individual resorts to defensive behavior, the process of self-actualization is stopped, and symptoms of abnormal behavior develop.

It is the nature of client-centered therapy to remove this blockage through the individual's own efforts by surrounding the client in therapy with warmth and unconditional expressions of regard, in the course of which the therapist reflects back acceptingly the feelings expressed by the client. In this way, the need for thwarting defensive behavior is reduced, and the person can move toward integrating his or her perceptions and those of the self, and thus be freed to move toward self-actualization.

Erich Fromm (1900-1980)

Erich Fromm rejected the determinism of Freud's theories and explored people's responses to freedom and existential angst. He viewed love not as an intense emotion but an interpersonal relationship based on care, respect, knowledge, and responsibility. Fromm also contributed to social psychology, focusing on the impact of societies on individuals.

The Existential Perspective

Although the vocabulary used by Rogers and that found among existentialists is notably different, the processes they describe leading to healthy growth instead of pathology and unhappiness have certain striking similarities. Rogers identified the organism and the self. The existentialists speak of "existence" (which is the given), the world in which the individual finds himself or herself, and the "essence" (what the individual makes of that world by the choices he or she makes). The latter point is succinctly made by Sartre: "I am my choices." Both schools place responsibility for fulfillment and happiness on the individual, but also credit him or her with the strength to assume that responsibility. In making choices, the individual is driven by the need to find meaning and value in life. Rollo May describes it as the person's effort to provide a stable foundation on which the center of existence can be preserved. Not inconsistent with Rogers' understanding of maladjustment is May's contention that in the face of internal or external threats, individuals shrink the world that they admit into existence. May states, "That shrinking is a way

of accepting nonbeing in order that some little being may be preserved." The goal in existential therapy is to help individuals find a way of accepting a fuller world that is uniquely theirs, with the responsibility and loneliness that go with it.

There is a pessimistic tone in the philosophy of existentialism: feelings of alienation or spiritual death, brought on by a vast amoral and technological society that seems to have no place for the individual. The point of living on, existentialists say, is to combat the anxiety of existence in such a world, with the feelings of nothingness it creates, by directing our choices to give significance to our lives. One way of doing so is to recognize our social obligations in an indifferent world.

SUMMARY

Although they express their positions in differing words, adherents of the three perspectives described in this chapter—psychodynamic, humanistic, and existential—agree on three basic propositions: Human motivations have unconscious roots; a significant difference between unconscious motivations and what the individual believes motivates behavior will cause maladaptive behavior; the struggle between unconscious motives and controls that the individual imposes on behavior causes anxiety that the individual protests against through defensive behavior, which often constitutes the substance of the abnormal individual's disorder. Impulses and feelings that the individual cannot accept are repressed (in the psychodynamic perspective) or screened out (in the humanistic and existential perspectives). An overarching similarity among the three perspectives is recognition of the complexities produced in the individual's behavior by the dynamic interaction among opposing forces operating within the individual's psyche (the individual's functioning mind).

The psychodynamic perspective, stemming from the early work of Freud, but much modified by those who came after him, has, as its central theme, the significance of unconscious conflicts originating in childhood. It sees abnormal behavior as the development of maladaptive symptoms unconsciously used by the individual as defenses against the intolerable anxieties aroused by the childhood conflicts, the influence of which persists into later life. In orthodox Freudian theory, those conflicts grow out of a tension between biologically based psychosexual impulses, the pleasurable expression of which is inhibited by limitations set by reality.

Adherents of psychodynamic deviations from Freud substantial enough to be thought of as a different perspective moved away from his biological orientation and gave less weight to the id and more significance to the ego or self. They all but dismissed the significance of early psychosexual development and focused on the broader concepts of interpersonal relations. They considered important not only interpersonal tensions of early life, but characteristics of the individual's present life. The anxiety at the root of abnormal behavior was considered traceable not only to psychosexual conflict but also to conflicts about aggressive behavior, feelings of inadequacy, and the difficulty of establishing satisfying interpersonal relations. Room is made for the pressures on the individual from the society itself.

The humanistic and existential perspectives developed separately and outside of mainstream psychoanalytic thinking. Both give heavy emphasis to the individual's own responsibility for self-fulfillment and assign, as a principal cause of abnormal behavior, the failure to accept oneself. This failure interferes in the humanistic perspective with self-actualizing efforts, and in the existential perspective with failure to develop authenticity, which is a way of living one's full personality.

SELECTED READINGS

The American Heritage Dictionary of the English Language (4th ed.). (2000). Wilmington, MA: Houghton Mifflin.

Fromm, E. (1970). The Crisis of Psychoanalysis (1st ed.). New York: Holt, Reinhart, Winston.

Gay, P. (1986). The Bourgeois Experience: Victoria to Freud. Oxford University Press.

Martin, J. (1988). Who Am I This Time: Uncovering the Fictive Personality. New York: Norton.

Maslow, A. H. (1971). Farther Reaches of Human Nature. New York: Viking Press.

May, R., E. Angel, E. & Ellenberger. H. S. (Eds.). 1958. Existence: A New Dimension in Psychiatry and Psychology. New York: Basic Books.

Rogers, C. R. (1989). Carl Rogers: Dialogue, Conversations with Martin Buber, Paul Tillich, B.F. Skinner, Gregory Bateson, Michael Polanyi, Rollo May and Others. Boston, MA: Houghton-Mifflin.

Van Herck, J. (1982). Freudian Femininity and Faith. Berkeley, CA: University of California Press. Yalom, I. (1980). Existential Psychotherapy. New York: Basic Books.

1) Which of the following is a key component of psychoanalytic theory?

Test Yourself

	a) childhood experiences	c) unconscious motivations
	b) psychic determinism	d) all of the above
2) Events that are not in the center of one's attention but can easily be recalled are in the		er of one's attention but can easily be recalled are in the
	a) conscious	c) unconscious
	b) preconscious	d) metaconscious
3)	The part of the personality that mediates conflict between impulses and the internalized rules of parents is the	
	a) alter ego	
	b) ego	
	c) id	
	d) superego	
4) According to Freud, during what stage do the Oedipal and Electra complexes form?a) anal		hat stage do the Oedipal and Electra complexes form?
	b) genital	
	c) oral	
	d) phallic	
5)	Which defense mechanism is characterized by the belief that others possess the traits or feelings to one wishes he or she did not have?	
	a) identification	c) rationalization
	b) projection	d) reaction formation
6)	According to Freud, normal behavior occurs when the id, ego, and superego are in balance and the ego is strong. True or false?	
7)	Which individual developed a critique of Sigmund Freud's theory from a feminist perspective?	
	a) Anna Freud	c) Margaret Mahler
	b) Karen Horney	d) Harry Stack Sullivan
8)	Which orientation deals with helping individuals not just avoid pathology but reach self-actualization	
	a) existential	c) psychoanalytic
	b) humanistic	d) psychodynamic
9) Which of the following names is associated with client-cen		s is associated with client-centered psychotherapy?
	a) Abraham Maslow	c) Erich Fromm
	b) Erik Erikson	d) Carl Rogers

Test Yourself Answers

- 1) The answer is d, all of the above. Childhood experiences, psychic determinism, and unconscious motivations are the three key components of psychoanalytic theory.
- 2) The answer is **b**, preconscious. The preconscious includes events or facts that are not currently in the conscious awareness, but can be called into awareness when needed.
- 3) The answer is **b**, ego. The ego mediates conflicts between the urges of the id and admonitions of the superego.
- 4) The answer is **d**, phallic. The Oedipal and Electra complexes, characterized by desire to have the opposite-sex parent and feelings of competition with or fear of the same-sex parent, are theorized to develop in the phallic stage (during the preschool years).
- 5) The answer is **b**, projection. Projection is the defense mechanism whereby a person disowns his or her unacceptable thoughts or feelings by assuming that others possess those same traits.
- 6) The answer is true. According to Freud, a well-balanced psyche with a strong ego results in normal behavior. This is opposed to an unbalanced psyche, which necessitates the over-reliance upon defense mechanisms, resulting in abnormal behavior.
- 7) The answer is b, Karen Horney. Horney critiqued Freud's phallus-focused work, challenging his belief that all women experience penis envy. This is in addition to her theory that neuroses were in large part due to responses to the industrial society and resulting disturbances in human relations.
- 8) The answer is b, humanistic. A major focus of humanistic psychology is self-actualization, or the attainment of the highest needs of humankind, such as a fulfillment of a mission in life and development of a fully integrated personality.
- 9) The answer is d, Carl Rogers. Rogers was the founder of client-centered psychotherapy, which focuses on developing a therapeutic relationship that is warm, authentic, and provides unconditional positive regard that allows the client to become self-actualized through his or her own efforts.

Behavioral, Cognitive, Biogenic, and Sociocultural Perspectives

series of conditioning experiments by the Russian physiologist, Ivan Pavlov (1884–1936), provided John B. Watson (1887–1958) in the 1920s with the basis for the first major statement of behaviorism: Psychology is a purely objective, experimental science that needs introspection as little as do chemistry and physics. Watson was able to give scientific strength to his statement by demonstrating that a highly subjective human experience, fear, could be produced by the objective, measurable process of conditioning. Watson's campaign to establish behaviorism as the only scientific method of psychology was directed primarily against psychologists who were using introspection to identify mental states as a source of particular human reactions. Some of his criticisms brushed off on the methods of psychoanalysis.

Pavlov and Watson were interested in the causal effect of what preceded a response. Edward Lee Thorndike (1874–1949), in his animal studies, instead asked a reverse kind of question: What are the effects of what follows a response on the likelihood of its recurrence? He expressed his findings as the Law of Effect, which states simply that rewarded responses are strengthened, and unrewarded responses are weakened. B.F. Skinner (1904–1990), in years of carefully quantified research, refined Thorndike's Law of Effect and renamed it the Principle of Reinforcement.

In turn, the exclusively stimulus-response framework of behaviorism and reinforcement theory aroused the opposition of a group of psychologists, who contended that the effect a stimulus-response connection produced was dependent upon the mediation of mental events or cognitions between stimulus and response. They stated that, for example, thoughts or expectations, which themselves had been learned from past experiences, gave meaning to the stimulus and the response. For cognitive psychologists, it is the subjective meaning given to external events and their consequences that shape the influence of both the stimulus and the response.

This chapter first describes respondent or classical conditioning and then operant conditioning, two of the principal ways through which behavior is changed or learned. According to some theorists, both respondent and operant conditioning function through the mediating influence of cognitive activities. The details of that mediating effect make up the cognitive perspective on human behavior. The chapter then goes on to discuss the two remaining perspectives: the biogenic perspective, which uses a medical model to examine abnormal behavior; and finally, the sociocultural perspective, drawn largely from sociology and anthropology.

M THE BEHAVIORAL PERSPECTIVE

Behaviorists trace all human behavior to a limited number of biological drives (hunger is one) which are extended through subsequent conditioning experiences. Respondent conditioning is easiest understood through the experiments of Pavlov and operant conditioning is easiest understood through the experiments of Skinner.

Respondent (Classical) Conditioning

In the latter part of the nineteenth century, Pavlov published the first account of respondent conditioning. His work earned him the Nobel Prize. It was to have a dramatic effect on developments in the then young science of psychology. As with many great scientific discoveries, Pavlov's work began with his scientific curiosity about a casual observation. He had noticed that when he merely walked into the room to feed a laboratory dog, the animal began to salivate. For Pavlov, this signaled that the animal had come to attach a reflex action, salivation, previously triggered only by taking food into its mouth, to a neurologically unrelated stimulus, his presence.

Fascinated by this observation, Pavlov then conducted a series of experiments that provided the first scientific basis for the behavioristic perspective.

Pavlov's Experiment

What Pavlov called the conditioned stimulus (CS)—a tone—was sounded just prior to the animal's feeding. Food, the unconditioned stimulus (US), elicited a flow of saliva, the unconditioned response (UR). After several repetitions of that sequence, the animal had "learned" to connect the tone (the CS) not just to the unconditioned stimulus (food), but to the now conditioned response (CR), salivation. Respondent conditioning can be diagrammed simply, as follows:

Food (US) \rightarrow Saliva (UR)

Tone (CS) + Food (US) \rightarrow Saliva (UR) repeated several times, which soon led to:

Tone (CS) \rightarrow Saliva (CR)

Significance of Pavlov's Experiment

Such pairings as those illustrated by Pavlov's experiment are common human experiences. Responses, particularly autonomic responses, including those related to such emotional experiences as fear and anxiety (for example, rapid heartbeat and increased perspiration) can be readily conditioned. The behavioral perspective emphasizes the possibility that fears and anxiety may be initially brought about by such conditioning experiences. In the behavioral perspective, many disordered emotional responses, such as irrational fears (phobias), can be cured by reversing the process of respondent conditioning (see Chapter 9).

The importance of respondent conditioning, in the view of the behaviorists, is that all emotions, preferences, and even values in later life develop from conditioning of the Pavlovian type; that is, the associating of a neutral stimulus with an emotion being felt by the individual. In time, with a sufficient number of those couplings, or even with a single coupling when the emotion is an intense one, the conditioned stimulus develops the power to elicit the emotional response. For example, if a person were mugged and physically assaulted on Avenue X, the next time he or she walked through that street the emotion experienced in the attack would again be experienced, perhaps less intensely. In this way, respondent conditioning produces a broad range of both pleasant and distressing emotional experiences. The latter, if intense, can be the source of phobias or panic attacks. With this possibility in mind, behaviorists have developed a number of treatment techniques to promote the extinction of abnormal emotional reactions.

Basic Principles of Respondent Conditioning

Two of the simplest principles operating in respondent conditioning were identified by Pavlov in his experiments.

ACQUISITION

The first is acquisition of a response. Acquisition is the learning of a response based on the contingency (the timed togetherness) between a conditioned stimulus and an unconditioned stimulus. An example is the sequence of tone and food in Pavlov's experiment. Experience teaches that it usually takes at least three to four pairings to acquire a conditioned response.

EXTINCTION

A second principle is extinction, which is the loss of the conditioned stimulus's potential for eliciting the previously conditioned response. Extinction is produced by presenting the conditioned stimulus in Pavlov's experiment, the tone—but no longer following it with the food, the unconditioned stimulus. The length of time required for extinction varies with the strength of the original conditioning experience.

STIMULUS GENERALIZATION

There are two other principles operating in respondent conditioning, which were identified in work following Pavlov's original experiments. The first is stimulus generalization: Once an individual has been conditioned to one stimulus, the person may make the same response to other similar stimuli. For example, a child who, in a frightening experience, has learned to fear dogs may come to fear other animals. Or, in the behavioral perspective, a child who has been conditioned to respond with hostility to a parent may show less intense but nevertheless noticeable hostility to other people of the same gender.

STIMULUS DISCRIMINATION

The remaining principle, stimulus discrimination, is almost the reverse of generalization. Through a proper sequence of stimuli, a person can be taught to discriminate, for example, between two quite similar tones. This will take place when a person experiences an electric shock following a high-pitched sound, but no shock when hearing a sound lower in pitch.

Operant (Instrumental) Conditioning

Following the lead of educational psychologist Edward Thorndike, Skinner initiated a lifelong research effort to study the principles governing the effect of responses to particular behaviors on future behavior. Those principles he named operant conditioning.

Significance of Operant Conditioning

Behaviorists hold that it is through operant conditioning, as a result of reinforcement following specific responses, that children acquire skills such as walking, reading, and craft or athletic competencies and learn ways of behaving to satisfy their needs, both to gain what they consider desirable and to avoid what they consider undesirable. It is the combination of respondent and operant conditioning that fleshes out the individual's efforts to adjust to life circumstances. Respondent conditioning influences preferences and creates needs. Operant conditioning influences the way an individual goes about satisfying those needs.

Basic Principles of Operant Conditioning

The basic elements in the Skinnerian form of conditioning are operants (responses) that can be strengthened by positive reinforcement (something that is applied that increases the likelihood of that behavior occurring again) or negative reinforcement (something that is taken away to increase the likelihood of a behavior occurring again).

Negative reinforcement must be distinguished from punishment. A negative reinforcer is an aversive experience (in animal research, an electric shock is an example), the removal of which increases the likelihood of that behavior's reoccurrence. Punishment can be positive (something that is applied to decrease the likelihood of a behavior, such as a spanking) or negative (something is removed to decrease the likelihood of a behavior, such as grounding).

ACQUISITION AND EXTINCTION

Acquisition and extinction are produced differently in operant conditioning than they are in respondent conditioning. A response in operant conditioning is acquired when it is followed by a positive reinforcer a number of times. Extinction occurs when the response is unreinforced over a period of time. The time it takes to acquire or extinguish a response varies with the schedule of reinforcement.

SCHEDULES OF REINFORCEMENT

Skinner's research has revealed an extremely important (Skinner says it is the most important) aspect of operant conditioning, the scheduling of reinforcement. There are two types of reinforcement: continuous reinforcement, in which every response is reinforced, and partial reinforcement. Continuous reinforcement promotes rapid learning, but it allows rapid extinction once the response is no longer reinforced. In partial reinforcement, the aftereffect may be provided randomly or, for example, every fifth, time.

Partial reinforcement causes two significant differences in the way learning occurs: It takes longer for a response to be learned, but once learned, it is more difficult to extinguish. Some troublesome symptoms of abnormal behavior—for example, addictive gambling—persist long after a partial pattern of reinforcement has ended for this reason. An option that combines the best of continuous reinforcement and the best of partial reinforcement is a process called fading. In the case of fading, continuous reinforcement is used to teach the new behavior, and then reinforcement is faded, or switched to a gradually decreasing schedule or partial reinforcement until the behavior is occurring without reinforcement.

SHAPING

A significant process in operant conditioning, one that is especially valuable in treatment, is shaping. The shaping process can be compared with the children's game of "you're getting warmer," a comment that serves to guide the child to the hidden object. In operant conditioning, when the goal is to teach a complex response, any response the individual makes in the direction of the complex response, even though a meager one, is reinforced. An example is one of Skinner's early studies. His goal was to teach a pigeon to peck at the center of a target hung on an interior side of its cage. The sequence of reinforcement was as follows: any movement toward the correct side of the cage (in the children's game, equivalent to the comment, "You're getting warmer"), then any movement toward the target, then any pecking behavior in the direction of the target, then any pecking behavior directly on target. To encourage the pigeon to continue to move toward the goal, any approaching-response was reinforced only until a response more directly at the target occurred. That response was then reinforced. This process of shaping, which has been used to teach animals extremely complex skills, also is useful in teaching new skills to human beings.

Modeling (Observational Learning)

A widely influential form of learning, modeling, is subsumed under the rubric of behavioristically viewed learning. Children soon learn to imitate the behavior of parents and, later in life, of other admired persons. As a parent expresses approval of a child's modeling efforts, those efforts are reinforced, and the probability of their recurrence is increased. In time, only a child's awareness that it has successfully modeled a parent's behavior or that of another admired person is reinforcement enough to cause the behavior to persist.

Observational learning is powerful enough that individuals can learn from observing the reinforcement or punishment of others. For example, students who observe their classmates receiving praise from an instructor for answering questions in class are much more likely to participate in class discussions than those who observe their peers being criticized by the instructor. In fact, this type of observational learning has been hypothesized to be a possible cause for simple phobias. Observing or even hearing about a traumatic experience with a dog, for example, could lead to a phobic reaction to dogs.

■ THE COGNITIVE PERSPECTIVE

Discontented with what they considered the simplistic stimulus-response explanation of human behavior, cognitive psychologists have created a number of theories. Their research has indicated that memories, beliefs, and expectations serve as a mediating influence between stimulus and response, and influence the kind of connection the individual will make to the stimulus. Cognitive psychologists write the old formula as follows: stimulus-organism-response (SOR).

In the cognitive perspective, there are four overlapping interpretations of how cognitive elements influence an individual's behavior. Categorized by the principal author of the concept, they are discussed in the following sections.

Bandura: Expectations

For Albert Bandura (1925–), the important cognitive influence on behavior is the individual's expectations, which may be thought of as beliefs or hopes of what a particular response will bring. Bandura divides expectations into two types: outcome expectations, expectancies that a given response will lead to a certain outcome; and efficacy expectations, expectancies that one will be able to carry out the response effectively. Such expectations are, of course, the product of earlier experiences.

Atkinson: Decision Theory

John W. Atkinson (1923-2003), a decision theorist, presents his point of view by asking how an individual will make a decision to do anything, to make any response. Atkinson states that when faced with a situation requiring a decision, before taking action, the individual will consider two elements. One he calls utility, or the subjective value to be gained by taking the action. The second is the probability of the individual's capacity to be successful in carrying out the action. Those are essentially the elements of Bandura's thesis, but Atkinson uses the language of decision theory. The cognitive elements identified are no doubt shaped or at least influenced by the basic processes of respondent and operant conditioning, which have occurred during previous experiences, especially those of an interpersonal nature.

Mischel: Five Cognitive Variables

According to Walter Mischel (1930-current), a cognitive psychologist, there are five variables that influence an individual's response to a stimulus: competencies; encodings; expectancies; values; and plans.

Competencies

The individual acquires a number of skills through past learning, including technical skills and social skills. The level of those skills will help determine the individual's response in a particular situation. Suppose a classmate responds to someone's statement in class by saying, "No, you're absolutely wrong." If the first person has developed the trait of assertiveness, that individual will respond in one way; if not, the person will respond in a quite different way.

Encodings

All human beings perceive and categorize experiences in a particular way, perhaps even uniquely. The categories they create cause them to sort new experiences into one or another of those categories. An individual's response reflects the category into which he or she has sorted the situation. Political categories, for example, are an important source of encoding. How an individual responds to a Republican president's budget proposal will be significantly affected by that individual's party membership-Republican or Democratic—and also by the significance of political values in his or her thinking.

Expectancies

Here, Mischel joins Bandura. Previous experience teaches us all to expect (or hope, or fear) certain outcomes from particular types of behavior. Those expectations influence significantly how an individual will respond.

Values

Very early in life, individuals learn to prize or value certain social, religious, and artistic points of view. Modernists in art would respond one way to a friend's invitation to visit a Rembrandt exhibition and quite a different way to an invitation to the Museum of Modern Art. On the other hand, the value they assign to friendship might cause them to accept either invitation.

Plans

Most individuals start each day with some plan as to how they will spend it. The plan decided upon will influence their decision to enter into situation A or situation B. The decision will hinge, no doubt, on how much either will disrupt their plans. Plans can also be made as to how we intend to spend the next few years of our life; for example, to complete a law degree. Unless a proposed alternative is very attractive indeed, long-term plans will likely determine our response.

Attribution of Causality

The individual's thoughts about what causes the things that happen—that is, to what he or she attributes causality—also will influence behavior. Julian B. Rotter's theory of internal or external control (1973) provides a good example. People's beliefs can be placed on a continuum that extends from the idea that nothing they do counts (external control) to a conviction that they are master of their own fate and that what they do counts a great deal (internal control). Given an opportunity to work hard for a promotion, it is easy to guess how those two different beliefs will influence behavior. Another major type of attribution is either the conviction that the world and its people are hostile, or that, in general, they are neutral or even kind. Behavior in a wide array of situations will vary according to attributions. Life experiences do much to shape the nature of one's beliefs about why things happen.

THE BIOGENIC PERSPECTIVE

The most extreme form of the biogenic perspective expresses the belief that all, or at least most, abnormal behavior can be traced to organic (biophysical) factors, usually affecting the brain in one way or another. Some professionals in the medical field, physicians and medical researchers, accept this position. Most, however, accept a modified view of that position, believing that biological, psychological, and social factors interact to cause abnormal behavior (termed the biopsychosocial model). An unanswered question is this: In which direction does the causality flow? Is abnormal behavior initiated by the prior occurrence of a biophysiological imbalance? Or do the emotions and tensions associated with abnormal behavior stir up the biochemical imbalance?

Aside from the broad implications of the biogenic perspective, it is certainly true that brain damage or malfunction can produce psychic changes, and that a limited number of mental disorders and developmental aberrations directly result from biogenic causes, most of them very specific. Support is given for some version of the biogenic perspective by the increasingly successful use of a variety of pharmaceutical drugs in the treatment of certain mental disorders and by the results of brain imaging studies.

An aspect of the biogenic perspective is the emphasis given to the medical model for studying mental illness. Possible causes of mental illness considered by those of the biogenic view are infection, genetics, chemical imbalance, and neuroanatomy. Medical researchers, physicians, and other scientists with a biogenic orientation approach the understanding of illness in a relatively standard fashion.

According to the medical model, there is the creation of a syndrome, a collection of diverse symptoms that seem to occur in the patient at the same time. Once the syndrome has been identified and its symptoms described in detail, the search for causes (the etiological phase) is begun. Here, as has been previously indicated, four sources of hypotheses for the cause of the illness are considered: infection, genetics, chemical imbalance, and neuroanatomy. Once etiology has been established, the next step is either to attempt to find ways of preventing the illness, which in modern medicine is a first priority (especially in illnesses deemed to be untreatable), or to search out methods of treatment for those who already suffer from the illness. That approach, with appropriate adaptations for mental illnesses, is taken by those with the biogenic perspective. The medical model also sets a pattern for nonmedical professionals, principally psychologists, in their studies of mental illness, even though they may bring a different perspective to the problem.

Infection As a Cause of Mental Illness

The first mental illness to be associated with infection was paresis, now recognized as the result of long-term infection by the syphilis spirochete. The syndrome-establishing phase was initiated in the latter part of the seventeenth century by Thomas Willis. He grouped together "dullness of intellect" and "forgetfulness" with the later development of "stupidity" and "foolishness." Jean Esquirol added mental deterioration and paralysis, with death soon to follow. A.L.J. Boyle later brought the process to its conclusions by describing its symptoms in detail and identifying them as a separate disease, which he labeled "general paresis." It was decades later before the specific cause of the illness was discovered, and still later before a reliable method of testing for syphilis was developed and a method of treating it was found.

Inherited Genes As a Factor in Mental Illness

"Bad seed" as a nineteenth-century derogatory term for defective genes has long been connected in the lay mind with certain kinds of abnormal or unacceptable behavior: alcoholism, criminal behavior, and other forms of "immoral" behavior. In the twentieth century, science has vigorously pursued the nature of genetic influence, if any, on abnormal behavior.

Biochemical Imbalance As a Cause of Mental Illness

An excess or deficiency in one or another chemical element in the body has also been studied as a possible cause of mental illness. It is one of the psychoses that provides evidence to support the hypothesis. Research suggests, for example, that individuals with schizophrenia have excess dopamine (a chemical, known as a neurotransmitter) in the brain. Supporting evidence for its effect comes from one form of treatment used for schizophrenia. Drugs used in that treatment relieve some, but not all, of the symptoms of schizophrenia, and also reduce the amount of dopamine usable by the brain.

Neuroanatomy As a Causative Factor in Mental Illness

It has long been known that mental symptoms associated with aging—particularly memory loss and difficulty in coping with new situations—result from changes in the cortical or higher levels of the brain, which tend to weaken before other parts of the brain. Basic biological functions are maintained long after memory is impaired.

Integration of Biological Theories

It is likely that these biological causes of abnormal behavior interact. Intensive studies of one family with a high incidence of manic-depressive psychosis provided a possible example of how genetic factors and chemical factors interact to effect mental illness. In the instance of the family studied, a genetic weakness seemed to produce biochemical changes in the brain, thus suggesting that it is the combination of defective genes producing a biochemical imbalance that tends to cause the development of manicdepressive psychosis.

MITHE SOCIOCULTURAL PERSPECTIVE

Study of the influence of the surrounding social and cultural environment on personality and abnormal behavior is a relatively recent development within psychology. Such a study has been largely influenced by the disciplines of sociology, anthropology, and social work, which have used sociocultural perspectives much longer than psychology. The sociocultural perspective in psychology has two quite different aspects. One might be called intercultural, largely having to do with differences in mores, family life, social pressures, and religions that are prevalent in different regions of the world. The other has to do with the effect of differences in social, educational, and economic levels existing among sectors of the same cultural area, such as an urban area in the United States. These are called intracultural factors. This section will consider both aspects separately.

Cultural Influences

The field of study of social anthropologists represents the ways in which people living in separated sections of the world carry on their daily routines, set up interpersonal structures (including sex and marriage), and develop ethical codes. Anthropologists compare one culture with another and attempt to draw conclusions about reasons for the different style of life and the effects of those different styles on the individuals affected. Anthropological studies are handicapped by weakness of scientific controls and difficulties in quantifying results of their efforts. Nevertheless, significant and widely influential conclusions have been drawn from their studies, which are usually conducted during a period of residence in the community under study.

Three principal conclusions about abnormal behavior can be drawn from their research, each of which is a facet of the sociocultural perspective.

Criteria of Mental Disorder

People who cannot control their own behavior, cannot assume basic roles in society, and cannot even care for themselves in a prudent fashion are considered mentally disordered in all cultures. Interpretations of causality may vary, but acceptance of the fact of mental illness is universal.

Culture-Bound Patterns of Mental Illness

Apart from universally recognized mental illnesses, some types of abnormal behavior seem to be tied to a particular culture; for example, anorexia nervosa, a disorder in which there is such a preoccupation with staying thin that the individual loses all appetite for food, seems to occur only in Western societies, and most frequently in the United States. Likewise, brain fag, a condition where excessive mental work results in difficulties with vision, concentration, and memory, is typically only found in Western Africa or individuals who ascribe to Western African cultural beliefs.

Patterns of Child-Rearing Practices

Americans tend to believe that their child-rearing practices are universal: how and when infants are nursed and toilet trained; who primarily takes care of the children; when children are considered adults. Anthropological studies suggest that quite the opposite conclusion is closer to the truth. Even among Western cultures, child-rearing practices vary. And as child-rearing practices differ in significant ways, one can expect different patterns of normal behavior in the adult population and different symptom patterns in abnormal behavior.

Intracultural Factors

There are wide differences within cultures, often depending on socioeconomic status, urban versus rural dwelling, and experiences of deprivation.

Socioeconomic Status Differences

It should be noted that child-rearing practices can differ among socioeconomic status levels in the same culture. British upper-socioeconomic status parents, for example, send children to private boarding schools at relatively young ages; lower-socioeconomic status members have neither the tradition nor the money to do so.

Urban versus Rural Differences

There are correlational studies showing a covariance (two factors tending to vary together) between the presence or absence of psychosis and urban versus rural residence within the same large culture. In the United States, three times as many psychoses are reported in urban society as in rural society, a result that may be due either to better medical facilities in urban areas (and therefore better reporting procedures) or greater willingness in rural areas to care for the mentally ill at home. A pinpointed study in support of the influence of sociocultural influences on abnormal behavior reports a greater number of mental illnesses among residents of cities undergoing rapid change than among those living in stable urban settings. The finding is only correlational and not necessarily demonstrative of a causal relationship.

Influence of Deprivation

Epidemiological studies indicate higher incidences of mental illness in those areas where there is also a high incidence of impoverishment, discrimination, and illiteracy. It is not difficult to understand that the misery of living under those conditions places a heavy burden on the individual's resources for healthy adjustment, and such conditions can be seen as a cause, but only a contributory cause, of mental illness. That is, most individuals experiencing such challenging circumstances do not develop mental illnesses, despite the adversity they undergo.

Mental Illness As the Product of Sociocultural Influences

A more strongly stated aspect of the sociocultural perspective describes mental illness as the product of social ills. Those who hold this belief might, for example, support their position with the finding that during the recession of the late seventies and early eighties, admissions to mental hospitals, suicides, and stress-related deaths increased. That fact presents a strong argument for the position that widespread economic setback pushed some of them, perhaps only those with a preexisting predisposition or the presence of genetic weakness, into severe mental illness.

Mental Illness As a Social Institution

The most forthrightly stated position in the sociocultural perspective describes mental illness as a myth. One of its most ideologically convinced advocates (Thomas Szasz, 1961) holds that mental illness is a socially convenient myth used to explain away people who do not live according to society's norms. Such deviations from norms, it is said, are expressions of "problems in living" in society as it is now constituted. Adherents of this view ask the question, how does society decide which deviants from its norms are mentally ill? And why do individuals so labeled accept the label?

Adherents of this strong position along the sociocultural continuum might answer that "abnormal" behavior is not, in fact, unusual but that in certain cases it is labeled as a mental illness by society. Once a person has been labeled as "mentally ill," he or she experiences extreme pressure and even rewards for conforming to this role.

ECLECTICISM

One helpful way to make use of the various perspectives is to take an eclectic point of view, which recognizes that no one perspective can explain all mental illness or provide effective therapy. Most mental illness results from or takes on characteristics influenced by causative elements featured by several of the perspectives. For example, biogenic factors may create a predisposition, which is made worse by interpersonal problems, conditioning experiences, or poorly learned coping mechanisms. The individual's self-concept will be an important variable in the prognosis of the illness, as will one's capacity to deal with problems presented by modern society.

SUMMARY

Several perspectives or models that different psychologists use in defining human behavior as normal or abnormal were presented in this chapter. These include the behavioral perspective, which stresses the role of learning. There are three theories of learning. Respondent conditioning was first demonstrated by Pavlov and seized upon by Watson to establish the school of behaviorism. Operant conditioning was the basis of reinforcement theory created by the research of Skinner. Modeling, or observational learning, describes how individuals learn from observing others.

The cognitive perspective gives a central place to cognitions (expectations, beliefs, values, and plans) in determining what response an individual will make in confronting life situations.

Increasingly more important in abnormal psychology is the biogenic perspective, which attributes much abnormal behavior to biological anomalies—for example, heredity, chemical imbalances, and neuroanatomical abnormalities.

The sociocultural viewpoint emphasizes inter- and intracultural variables such as where a person lives and socioeconomic status.

The eclectic perspective takes aspects from multiple theories and integrates them in understanding and treating psychological disorders.

SELECTED READINGS

Bateson, P. (2000). Design for a life: How biology and psychology shape human behavior. New York: Simon and Schuster.

Bandura, A. (1976). Social learning theory. Englewood Cliffs, NJ: Prentice Hall.

Evans, G. W. (2004). The environment of childhood poverty. American Psychologist, 59, 77–92.

Mischel, W. (1979). On the interface of cognition and personality: Beyond the person-situation debate. American Psychologist, 34, 740-754.

Rescorla, R. A. (1988). Pavlovian conditioning: It's not what you think it is. American Psychologist, 43, 151-160.

Skinner, B. F. (2005). Walden two. New York: Hackett Publishing Company.

Test Yourself

- 1) Which of the following best diagrams classical conditioning?
 - a) (CS) + (US) \rightarrow (UR) repeated several times, which soon leads to (CS) \rightarrow (CR)
 - b) (CS) + (CR) \rightarrow (UR) repeated several times, which soon leads to (US) \rightarrow (UR)
 - c) (CR) + (UR) \rightarrow (US) repeated several times, which soon leads to (CR) \rightarrow (CS)
 - d) (US) + (CS) \rightarrow (CR) repeated several times, which soon leads to (US) \rightarrow (UR)
- 2) According to operant conditioning, learning occurs through
 - a) reinforcement
 - b) punishment
 - c) pairing stimuli and responses
 - d) both a and b
- 3) Which of the following schedules of reinforcement is best for quickly learning new behavior?
 - a) partial
 - b) continuous
 - c) random
 - d) interval
- 4) Observational learning can result in the development of phobias. True or false?
- 5) Cognitive theory focuses on which of the following influences on human behavior?
 - a) defense mechanism
 - b) neuroanatomy
 - c) expectations
 - d) impact of poverty
- 6) According to the biogenic perspective, which of the following influence human behavior?
 - a) neurochemistry
 - b) infections
 - c) genes
 - d) all of the above
- 7) The sociocultural perspective focuses on intercultural differences (between cultures), but not intracultural differences (within cultures). True or false?
- 8) A psychologist with an eclectic orientation might use theories from psychodynamic, biogenic, and behavioral perspectives at the same time. True or false?

Test Yourself Answers

- 1) The answer is $a_1(CS) + (US) \rightarrow (UR)$ repeated several times, which soon leads to $(CS) \rightarrow (CR)$. In classical conditioning, repeated pairing of an unconditioned stimulus and a conditioned stimulus eventually results in the conditioned stimulus eliciting what is now called the conditioned response.
- 2) The answer is **d**, both a and b. Operant conditioning focuses on the role of consequences of behavior, both punishment and reinforcement, on the behavior itself. Classical conditioning focuses on learning occurring through the pairing of stimuli and responses.
- 3) The answer is b, continuous. Continuous reinforcement results in the quickest acquisition of new behavior; however, this behavior is then quite vulnerable to extinction. Partial reinforcement results in longer acquisition periods, but less risk of extinction.
- 4) The answer is true. Observational learning can result in the development of phobias when an individual witnesses or learns about the traumatic experience of another with the object/situation that becomes feared.
- 5) The answer is c, expectations. Expectations are a central component of cognitive theories. Defense mechanisms are associated with psychodynamic theory. Neuroanatomy is associated with biogenic theories. The impact of poverty is associated with the sociocultural perspective.
- 6) The answer is **d**, all of the above. According to biogenic theory, neurochemistry, infections, and genes all influence human behavior. Biogenic theory also states that neuroanatomy, exposure to neurotoxins, and brain injuries can influence human behavior. Most psychologists agree that these biological factors interact with each other and the experiences of the individual and the environment in determining human behavior.
- 7) The answer is **false.** The sociocultural perspective focuses on intercultural differences, such as country or time in history, as well as intracultural factors, such as socioeconomic status and region.
- 8) The answer is **true.** The eclectic perspective integrates aspects of different theories for use in understanding and treating abnormal behavior. Hence, an eclectic psychologist could use psychodynamic, biogenic, and behavioral perspectives together to help one person. This could include treating depression by addressing the defense mechanism of devaluation, referring for antidepressant medication, and increasing the number of pleasurable (reinforcing) activities engaged in by the client.

Assessment and Classification

In their initial contacts, clinicians set out to appraise the severity of the client's illness, the strengths and weaknesses the individual brings to therapy, earlier life history, and the characteristics of the client's interpersonal life. That appraisal is formally called the assessment process. It may be a relatively informal procedure undertaken by the therapist in the early sessions of therapy. Alternatively, it may be an extensive process conducted by a team that includes a psychiatrist, psychologist, social worker, and often a general-practice physician. A variety of techniques are used, each related to the special competence of each team member.

The principal goal of the assessment process in abnormal psychology is the development of what some psychologists refer to as the dynamic formulation of the client's problem. This may be formalized in a comprehensive case history that contains informative summaries of all material gathered in the assessment process. The case history describes the current situation and its history, proposes hypotheses about the causes of the maladaptive behavior, and presents a diagnosis drawn from an officially approved classification system.

Assessment, then, is a scientific process that observes and describes significant aspects of a client's behavior. That description is used as a basis for predictions about future behavior of the client, which, in turn, provides the information and hypotheses for making decisions about a program of treatment. In that regard, questions considered might include the type of therapy indicated, likely outcome, expected length of treatment, and most fitting therapist for the particular client.

After considering the characteristics of a good assessment, the chapter considers four components of a comprehensive assessment: the physical examination; the interview; observation of the client's behavior; and the psychological test. The chapter concludes with a description of the use of the *Diagnostic and Statistical Manual of Mental Disorders* (DSM-IV-TR) in assessing and diagnosing psychological disorders.

■THE CHARACTERISTICS OF A GOOD ASSESSMENT

There are two major characteristics of a good assessment tool: its reliability and its validity. Of lesser but notable importance are such practical considerations as the cumbersomeness of the procedure and the time it takes to complete. In the reality of the practice of modern psychology, all four characteristics are taken into account in selecting assessment tools. Ease of administration and time required must be considered in the busy schedule of clinicians. However, if a test is not reliable and valid, it is not useful, even if it is convenient.

Reliability

The degree to which an assessment consistently gives the same results is the measure of its reliability. The higher the reliability, the more likely it is that repeated assessments will arrive at the same conclusion, measure, or diagnosis. Reliability says nothing about the accuracy of the measurement—it speaks only to the dependability of the measure. The reliability of an assessment procedure or of a psychological test can be determined in three ways: internal consistency; test-retest consistency; and interrater consistency.

Internal Consistency

The method of internal consistency answers the question: Do different sections of the test appear to measure the same thing? For a psychological test, the method correlates one part of the test against scores earned on a different part of the test. If the correlation is high, the test is considered reliable. High internal consistency suggests that all of the items on a test measure the same construct (a goal of most psychological tests). When a clinician finds low internal consistency among a client's responses on a psychological test that usually has high internal consistency, he or she may question the accuracy of the client's responses.

Test-Retest Reliability

Will a second administration of the assessment device, conducted independently of the first, lead to the same conclusion? If concordance is high, the assessment device would seem to be reliable. This method is used to test reliability of psychological tests. Most tests aim to assess stable characteristics, so they aim for high test-retest reliability. When a test with high test-retest reliability shows a significant change in scores, the clinician may suspect that the client's level of functioning has changed, such as an improvement or decline over the course of therapy.

Inter-Rater Reliability

How likely is it that a test or assessment procedure, when scored or interpreted by different clinicians, will yield the same results? This mode of testing reliability has been used extensively in the work done to establish the DSM-IV-TR, which is the official classification system used in abnormal psychology. In that effort, the question asked was, when different clinicians use the diagnostic criteria set up in the manual, to what extent do their conclusions correspond? It is ideal that psychological assessment techniques have high inter-rater reliability, because idiosyncratic assessment results have limited use for other professionals working with the same individual.

Validity

The validity of a test or procedure is an indication of the degree to which it measures what it claims to measure. Does an intelligence test measure what is generally considered to be intelligence? Does a personality test truly measure, for example, the trait of extraversion? A test or procedure may be highly reliable without being valid. For example, the daily temperature can be measured with a high degree of reliability; it is not, however, a valid indicator of whether the sun is out. A test cannot be valid if it is not reliable. If a test measures something inconsistently, it will inevitably be inaccurate at times.

Validity may be evaluated in two ways: descriptive validity and predictive validity.

Descriptive Validity

Descriptive validity is a measure of how accurately a score, diagnosis, or interpretation describes the current behavior of those who have been assessed. For example, a valid intelligence test should have a high degree of accuracy in indicating a person's ability to learn new tasks or information. With respect to psychiatric diagnoses, when it comes to descriptive validity, there is a problem. Individuals with different diagnoses may show identical current symptoms. For example, a person with bipolar I disorder and those with certain types of anxiety-based disorders may exhibit both low self-esteem and depression. Additionally, those with an identical diagnosis may currently show quite different behavior. Of two individuals with a diagnosis of bipolar I disorder, one may have manic symptoms and the other may have depressive symptoms.

A psychiatric diagnosis is not a statement of the individual's characteristics but a statement of the individual's typical pattern of behavior. There will always be an overlapping of individual symptoms among different diagnoses. If a diagnosis accurately describes the overall pattern of an individual's behavior, as it usually does, it meets the criterion of descriptive validity.

Predictive Validity

When a test, assessment procedure, or diagnosis accurately predicts future behavior, it meets the criterion of predictive validity. In abnormal psychology, the clinician is interested in predicting the course of the individual's illness; that is, its prognosis—the likelihood of recovery, in response to what form of treatment, and in how long a period of time.

Failure to meet the criterion of predictive validity may result from low reliability of the test, assessment procedure, or diagnosis. If three different clinicians arrive at three different diagnoses, their diagnostic procedures have low reliability and, therefore, low validity. Recent modifications of the Diagnostic and Statistical Manual have increased reliability of its diagnoses. For example, one study indicates a 74 percent agreement on diagnosis among different diagnosticians. That percentage of agreement is considered a relatively high degree of reliability and has been shown to be even higher in studies using standardized diagnostic procedures. Improving the reliability increases the likelihood of higher predictive validity.

PROBLEMS IN ASSESSMENT

There are three major types of influence that tend to bias the assessment process and negatively influence the end result, or diagnosis. They are the characteristics of the clinician, especially the theoretical perspective he or she holds; the setting in which the diagnosis is made; and the purpose for which a diagnosis is made.

Characteristics of the Clinician

Such basic characteristics as the age, ethnicity, and gender of the clinician may influence the rapport (warmth and sincerity of the relationship) between clinician and client, especially when there is a notable difference between the two. The result can be difficulty communicating on the part of the client, or even selectivity in what the client will be willing to discuss. A formal and austere approach by the clinician may have the same effect.

A principal barrier to accuracy of diagnosis is the personal bias of the clinician and the clinician's theoretical perspective. Both will influence the weight clinicians assign to the components of the assessment process. For example, a particular clinician may be expert in one of the psychological tests and give more weight to it than to the total picture drawn by other components of the assessment. One clinician may have a tendency to see psychological weaknesses more quickly than psychological strengths. A clinician with a strongly biogenic perspective may tend to favor diagnoses with a physiological or neurological basis.

Influence of the Setting

A clinician in a mental health setting may be quicker to pick up a mild anxiety-based disorder than a clinician working in a psychiatric hospital who is accustomed to primarily seeing seriously disturbed patients. The theoretical orientation of the chief of service may influence the interpretations and diagnoses made by staff members.

Purpose for Which a Diagnosis Is Made

Psychiatric assessments are undertaken for a variety of purposes. The principal one is to plan a course of treatment. Such a purpose is least likely to bias decisions made. However, assessments may be sought for other purposes, such as in criminal cases, for insurance purposes, or to establish a disability. The clinician may be subtly influenced by what will most benefit the immediate circumstances of the client.

■ THE COMPONENTS OF THE ASSESSMENT PROCESS

This section examines the four principal components of the assessment process: the physical examination; the interview; observation of behavior; and psychological tests. Not all of these procedures are used in each assessment, but often some or all of them are integrated into an evaluation.

The Physical Examination

The physical examination has as its purpose an evaluation of the individual's general health and the discovery of any physical, medical, or neurological factors that may be influencing the individual's behavior. It is not always required as part of a psychological assessment, but is called for when there is the suspicion of a physical component to the client's concerns.

The Medical Check-Up

Basic to the physical examination is a medical check-up, in which a physician takes a medical history from the patient and checks the major systems of the body. That examination will ordinarily include measurement of blood pressure, a blood chemistry test, and palpation of various parts of the body. It may also include an electrocardiogram to test the heart and a lung X-ray. The examination may have been done before the patient seeks psychotherapeutic help, especially by those suffering from somatoform disorders or hypochondriasis. It is especially important when addictive or organic disorders are suspected.

Specialized Procedures

More advanced and highly technical procedures may be ordered for special purposes. Some of these are as follows.

EEG: With the electroencephalogram (EEG), electrical activity in the brain cells is picked up by electrodes attached to the skull and recorded in oscillating patterns that are called brain waves. The EEG is used to help detect tumors or brain injuries that may be affecting the individual's behavior.

CAT scan: The computerized axial tomography (CAT) scan uses a computer analysis of X-ray beams directed across areas of the patient's brain or other bodily parts. The CAT scan quickly provides information about brain injuries.

PET scan: The positron emission tomography (PET) scan adds to the data provided by a CAT scan. The PET is a measurement of the body's metabolic processes (brain activity) after a compound (such as glucose) is metabolized by the brain or other organs of the body. In this way, it can be used to pinpoint sites in the brain that produce epileptic seizures, brain damage, or cancerous tissues.

MRI: Magnetic resonance imaging (MRI) is the most recent development in brain imaging. The MRI uses magnetic fields, radio waves, and a computer to create a detailed image of soft tissue (including the brain). These detailed images allow for the detection of brain tumors, signs of stroke or bleeding in the brain, and brain abnormalities such as those associated with schizophrenia. MRI scans provide clearer, more detailed images than CAT scans do.

fMRI: Functional magnetic resonance imaging (fMRI) uses a computer to combine multiple pictures taken of the brain to understand how activity in the brain (as measured by blood flow) changes during particular behaviors or experiences. The fMRI provides more detailed images than does PET without the use of radioactive substances required for PET scans. fMRI is currently being used in researching the neurophysiology behind psychological disorders as well as in developing and assessing the efficacy of psychopharmacological medications.

Such medical procedures may be supplemented by the Halsted-Reitan Battery, which is an elaborate, six-hour neuropsychological test that measures cognitive and psychomotor deficit resulting from any cerebral damage or disease. The test provides an index of cognitive impairment and information about functioning in various skill areas and is typically administered by a psychologist. Other tests assessing visuospatial processing, sensorimotor, auditory, or other neuropsychological functions may also be prescribed by the medical team.

The Assessment and Interview

A face-to-face conversation in which the clinician seeks information about the client's concerns, typical behavior, life circumstances, and early history is the most commonly used assessment procedure. The interview with the client may be supplemented by interviews with family members, teachers, or others knowledgeable about the client. Use of multiple reporters can be very helpful, because information from any one source is vulnerable to the biases of that person. In many situations, the interview is the only assessment made as the clinician uses the first few sessions to assess the client. For relatively minor adjustments or emotional or interpersonal problems, such an approach is efficient and accurate enough to meet the client's needs. Nevertheless, such a relatively unstructured use of the interview has been criticized as too unreliable for arriving at a precise diagnosis. Research suggests that there is basis for this criticism. There have been several attempts to improve the unstructured interview. Four are briefly reported here: the structured interview; the computer-assisted interview; the self report; and the other report.

The Structured Interview

Structured interviews consist of a series of previously prepared questions, asked in a fixed order, and phrased so as to have the client describe what he or she did in a variety of life situations. This method assures full coverage, in the client's own language, of critical behavior patterns. Follow-up research using the inter-rater method of testing reliability indicates a notable improvement in agreement on a diagnosis when this approach is used rather than unstructured interviews.

Interviewing with the Help of a Computer

Computer-assisted interviewing is a relatively new approach to assessment that is growing in popularity. There are now numerous programs that conduct psychiatric interviews for adults and children by presenting questions on a computer screen and recording answers on standard forms. The advantage claimed is that pertinent information is gathered more fully than would be the case in a less formally conducted interview. Some reports indicate a reduction in costs for conducting the assessment with the help of a computer. One criticism of the use of the computer is that it mechanizes a process that is and should be highly interpersonal. The absence of rapport between computer and client could limit the candor and completeness of the interview process.

The Self Report

The self report, in which the client writes answers about his or her own behavior to standardized questions or responds to a problem checklist, is less mechanized than the use of a computer, but it still minimizes the interpersonal aspect of the process. When the self report is followed by a personal interview, as it usually is, the danger of mechanizing the process is reduced.

The Other Report

Just as sometimes other people in the life of the client are interviewed, sometimes people who know the client well will respond to standardized questions or a symptom checklist. This is a helpful adjunct to the self report, allowing the clinician a broader view of the client.

Clinical Observation of Behavior

Observation of the client's behavior in natural and typical family and interpersonal situations is a rich and accurate source of information. One disadvantage, of course, is that it is expensive and timeconsuming. Furthermore, there is concern that the individual will change his or her behavior if he or she is aware of the observation. It is usually more practical to observe children in the classroom—especially valuable when the problem is school related—and to observe psychiatric patients in a hospital setting.

To extend the process to other situations, the assessor can design role-playing situations among family members or with the partners in a marriage. The clinician sets the stage, usually around a communication problem or around a topic on which there is disagreement. Although not as absolute as field observation, the role-playing approach does reveal nuances of the problem about which the client may not be conscious and, therefore, is unlikely to report in an interview. A rating scale can be used to standardize recordings of the observation. The rating scale usually allows the clinician to indicate not only the existence of the behavior, but also its frequency or duration. Added to those observations can be observations of behavior in the assessment process itself, especially during the psychological tests.

Psychological Tests

A principal means of assessing behavior, which is almost always administered and interpreted by a psychologist, is the psychological test. Tests are of two types: ability or performance tests, of which the principal type is the intelligence test; and personality tests.

Ability Tests

Among the ability tests are those that assess academic functioning. An example of such a test is the Woodcock-Johnson-III, which assesses a broad range of academic skills, allowing the clinician to compare an individual's performance to others of a similar age or academic level. This is helpful in assessing academic difficulties or learning disabilities.

Another example of ability tests are intelligence tests. The concept of the intelligence test and the first intelligence test was developed in 1905 by Alfred Binet, a French psychologist, who introduced it into the French schools to screen children for educational purposes. Intelligence tests may be entirely verbal, but most individually administered tests (the type used most frequently in clinical settings) combine verbal and performance items. Although there are many intelligence tests, those used in the clinical setting in the United States are likely to be the Wechsler Scales, which have an adult version and two children's versions.

THE WECHSLER SCALES

The Wechsler Adult Intelligence Scale (WAIS-III), used here to illustrate types of item content, consists of seven verbal scales and seven performance scales, which yield a verbal and a performance IQ

(intelligence quotient) as well as verbal comprehension, perceptual organization, working memory, and processing speed index scores. The subscale totals can be combined to provide a total IQ score.

Typical verbal items are: word definitions; identifying similarities in paired words, for example, cat and dog; and fund of general information. Performance items include assembling pieces of a jigsaw-like object, putting colored blocks together to match an exposed picture, and transcribing a code. Performance items are timed. Each type of item presents a scale of items from very easy to very difficult. The score is the number of credits earned for each item, plus credit for speedy performance.

The other two Wechsler scales are the WISC-IV—the Wechsler Intelligence Scale for Children, 4th Edition—with a range from six years to sixteen years and eleven months of age, and the Wechsler Preschool and Primary Scale of Intelligence (WPPSI-III) for children ages two years and six months to seven years and three months. These measures are similar in structure and item type to the WAIS-III except, of course, that the content is appropriate for younger people.

Weaknesses or Limitations of Intelligence Testing

There are three principal weaknesses or limitations of intelligence testing. First, intelligence tests are time-consuming to administer. In many clinical situations, the problem presented may not require a precise measure of intelligence and/or indications from the client's job or educational level may provide an adequate indication of intellectual level without taking inordinate amounts of time. Second, as Wechsler himself has pointed out, intelligence is not something than can be directly measured as is, for example, one's heart rate. It has to be inferred from the officially correct answers that the testee is able to report on an intelligence test. With this limitation in mind, some psychologists define intelligence as whatever intelligence tests measure. Third, the charge has been made that intelligence tests assume a common middle socioeconomic status cultural background and measure the individual's response to that background. Impoverished children and many ethnic minority children, for the most part, come out of a very different cultural background. Yet what happens to them, how they are classified for future educational opportunities, and what careers are recommended to them all depend on a measuring device that may not be fair to them.

Strengths of Intelligence Testing

There are three significant strengths of intelligence testing. First, during the administration of an intelligence test, the psychologist has rich opportunities to observe the client's behavior as he or she responds to an unfamiliar and challenging situation. Such anxiety-producing situations are normally faced in everyday life, and observing the client in such a situation provides the clinician with much information. Does the client respond with apprehension and anxiety? Does the client invest adequate effort and try hard enough? Are there notable mannerisms? Does the client try too hard; is success all-consuming? Are there speech defects or idiosyncrasies, or visual or hearing impairment?

Second, apart from the overall score, the intelligence test analysis details the client's cognitive functioning and lists strengths and weaknesses. In addition, the test may reveal the earliest indication of possible brain damage.

Finally, intelligence tests measure, fairly accurately, the likelihood of the individual's potential for success in the American educational system. Even though that may not be a full measure or definition of intelligence, it is a forecast of likely success in an arena in which a child or adolescent will spend a great deal of time, and success in which is a principal gate opener.

Personality Tests

Personality tests are of two types: projective tests, which offer the testee an unstructured way of responding; and objective tests, which limit the client's answers to yes or no or multiple-choice items.

Because these tests are principally in the province of the psychologist, this section provides detailed descriptions of them. This section examines in detail the Rorschach Inkblot Test, which ranks among the most frequently used projective tests. The most widely used personality test in clinical practice, the Minnesota Multiphasic Personality Inventory-II (MMPI-2), an objective test, is also described in detail.

The Rorschach Inkblot Test

Herman Rorschach, a Swiss psychiatrist, created the test named for him in 1912. The test consists of ten cards, each having on it an ink blot such as might be made by folding in half a sheet of paper on which a blot of ink has been left. The ink blots, as a result, are all symmetrically balanced. They range in color from blacks and grays to bright, varicolored designs. There are three phases to the test:

- 1. A card is held up by the psychologist, who asks clients what they see there.
- 2. After the ten cards have been exposed, the psychologist holds up each card again, asking clients what it was about the card that caused them to see what they reported.
- 3. The test is then scored in accordance with a manual of detailed instructions.

It is that pattern of scoring that the psychologist uses to arrive at a description of the underlying personality characteristics, motivations, conflicts, level of intelligence, and possible psychoses or brain damage. For example, certain patterns of responses on the Rorschach can suggest personality traits such as self-centeredness or obsessive-compulsiveness.

A major criticism of the test is the low inter-rater reliability reported for interpretations of the test and the paucity of information about its validity. Despite those criticisms, the test continues to be widely used, although psychologists have come to use it less often during the past thirty years. Still, many psychologists and psychiatrists continue to consider it a valuable tool for suggesting leads as to psychodynamic influences of unconscious materials. Many clinicians using the Rorschach today use Exner's computergenerated interpretations. In using that approach, clinicians can count on inter-rater reliability of interpretations, if there is initial agreement in scoring, about which there is only moderate criticism.

The Minnesota Multiphasic Personality Inventory-2

Although, as has been indicated previously, there are hundreds of personality tests, the one upon which clinicians most commonly rely is the MMPI-2. That test is the most widely used personality test in clinical practice and for research in abnormal psychology. The test is essentially a self report in which clients answer true or false (agree or disagree) to 567 statements.

Typical of the statements are the five listed below, taken from the test form published by Hathaway and McKinley in 1951:

- I go to a party every week.
- I forgive people easily.
- I often feel as if things were not real.
- Someone has it in for me.
- I sometimes enjoy breaking the law.

The MMPI-2 has been subject to more research scrutiny than any other personality test. That research foundation can be categorized as follows.

Original Validation Studies

The original questions were administered first to a large sample of individuals and several groups of psychiatric patients. All statements were then subjected to an item analysis (with items clustered into identifiable groups). This enabled the authors to discover which items differentiate among the several groups; that is, which differentiated psychiatric patients from the nonpsychiatric population, and which differentiated one disorder from another in the psychiatric population.

The study enabled the authors to develop ten scales, each of which assesses tendencies to respond in unusual ways, similar to the ways in which patients with known psychological disorders responded. In presenting its graphic summary to the clinician, the psychologist (or a computer) plots, on a graph, scores earned by the client on the ten scales, to be compared with a mean score on each scale for the nondisordered population.

Thus, at a glance, the clinician can see, from the profile, in which areas the individual deviates significantly from average. That evaluation does not necessarily establish a diagnosis, but it does suggest the nature of characteristically abnormal behavior of the individual under study.

Subsequent Validation

In the past, the original MMPI was criticized for its dated language, circa 1950. Fourteen percent of the items have now been changed to bring them up to date. Additional scales have been validated and are now part of the test. Two forms of the test have been developed, one for adults (MMPI-2) and the other for adolescents (MMPI-A).

Critique of the MMPI-2

Despite the endorsement suggested by its widespread use, criticisms of the test appear in the psychological literature. The most basic is that the test is a more valid indicator, not of an appropriate diagnosis, but of the degree of overall disturbance experienced by the individual, or whether the client is mildly disturbed or deeply disturbed. The more the individual's scores deviate in a negative direction from the average profile, the more severe is the disturbance. It should be noted that even that finding, apart from any indication of diagnosis, is a significant contribution to the assessment process.

A second criticism is that response sets that a person brings to a personality testing situation may warp the accuracy of the answers. Clients, it is said, tend to give socially desirable answers, but they also have an acquiescence set, causing them to agree with statements proposed. These two sets would have opposite effects—for example, to the statement, "I sometimes tell lies"—a socially desirable set would motivate a "no" answer; an acquiescence set would stimulate a "yes" answer.

In answer to that criticism, it should be pointed out that three scales in the test tend to control for response set. They are as follows:

- The L scale, which assesses the tendency to claim excessive virtue, or a tendency to answer too often in a socially desirable way
- The F scale, which assesses a tendency to acquiesce too often and to report psychological problems inaccurately
- The K scale, in a reversal of the F scale, measures a tendency to see oneself in an unrealistically positive way, excessively denying symptoms of distress

DIAGNOSIS AND THE OFFICIAL CLASSIFICATION SYSTEM

One significant outcome of the assessment process is to provide a diagnosis that fits the individual into a category of psychological disorder that is recognized by an official classification system. In addition, the diagnosis also includes a rating on the severity of the disorder, the level of the individual's current functioning, an indication of acuteness or chronicity of the disorder, and a description of any current stressors the individual faces (described more fully in Chapter 1). All of these options are expressed in a way consistent with categories established by the official classification system. The official American classification of psychiatric disorders is the Diagnostic and Statistical Manual of Mental Disorders (DSM-IV-TR).

Emil Kraeplin, a psychiatrist, developed the first useful classification system for mental disorders in the latter part of the nineteenth century. Although features of his classification system continue to influence recent developments, his approach to mental illness was based on a narrowly organic view of the field. Following the medical model, he tended to believe that similar groups of symptoms (a syndrome), labeled with the same diagnosis, would result from similar causes, respond to similar treatment, and would follow a similar course during treatment. In the earliest version of the Diagnostic and Statistical Manual, set out in 1952 by the American Psychiatric Association, many of the same assumptions were used.

There have been revisions of that manual, the most recent in 2000. That revision, the DSM-IV-TR, has attempted to increase the reliability, validity, and usefulness of its classification system. All syndromes (clusters of symptoms, which are the diagnostic categories) are presented descriptively. Detailed and specific, and in some cases quantitative, criteria are listed to promote inter-rater reliability. Most theoretical perspectives in abnormal psychology now find the manual acceptable and useful.

Typically, psychologists will take all of the information gathered during the assessment process—the results of the physical examination, interviews, observations, and/or psychological tests—and integrate the information. The clinician then compares what has been learned about the client to what is known about specific psychological disorders (this information is detailed in the DSM-IV-TR). The clinician identifies any disorders that may be indicated by a match between the assessment results and knowledge of psychological disorders.

Value of a Diagnosis

There is value in attaching a diagnosis to a client, but there are also costs. There are four advantages of diagnosing: it provides information about prognosis and possible treatments; it suggests likely causes; it fosters communication; and it is sometimes needed to secure services.

A diagnosis places a client into a group of other individuals with a known disorder. The diagnosis says that the symptoms and patterns of behavior of this client are similar (not identical) to other individuals who have been diagnosed as having the named disorder. The most immediate value of that decision is that, at this stage of development in abnormal psychology, we have learned much about the prognosis of the various disorders (their predicted future course) and about which therapies are likely to help an individual.

A second value is that, for a limited number of mental disorders, there is knowledge of specific causes of the disorder, in which case a diagnosis can be helpful in planning treatment. For other illnesses for which specific causes may not have been identified, certain other factors, sometimes (unfortunately) general, have been related to the illness. That knowledge can also be helpful.

Diagnoses help research psychologists group people in accordance with some scientifically acceptable criteria, which adds scientific value to their studies through facilitating communication. Beyond the clinical focus, psychologists regularly conduct research that provides additional information about specific disorders. Being able to communicate clearly allows researchers to provide information to aid clinicians in better serving their clients and allows clinicians to aid researchers in devising more helpful research.

Finally, often a diagnosis is needed for a client to receive services. For example, schools often do not provide special education services for students until a diagnosis has been established. Insurance and other managed care companies typically do not pay for psychological treatments without a diagnosis. Social service agencies often provide support for individuals only after an official diagnosis has been made. Therefore, a diagnosis is frequently a first step toward securing necessary services.

Criticism of the Diagnostic Process

There are four principal criticisms of the diagnostic process: the problems caused by labeling; the suggestion in a diagnosis that the abnormal is qualitatively different from the normal; the illusory effect of believing that a diagnosis is an explanation; and the fact that a diagnosis accords with the medical school model of illness, an interpretation that some psychologists resist.

A diagnostic label stereotypes people and tends to bias the way in which clinicians, and society in general, tend to regard them. It may, for example, blind the clinician to the individual's abilities and resources for growth and self-fulfillment, which could be of significance in a program of treatment. There is also danger that, to some extent, a diagnosis may become a self-fulfilling prophecy: Once classified, the individual is expected (one fears that he or she is even encouraged) to behave in ways consistent with the diagnosis.

Calling individuals phobic, obsessive-compulsive, histrionic, or dependent personalities holds at least the suggestion that they are in a class by themselves; that is, that they are a different kind of human being. Despite efforts to the contrary, there is still a stigma regarding psychological disorders in American society. Labeling individuals with psychological disorders can support this stigma and fails to recognize the similarities of individuals with and without psychological disorders. It is for this very reason that psychologists refer to an individual with a diagnosis as opposed to using the diagnosis to refer to the person (that is, "individuals with schizophrenia," not "schizophrenics").

A diagnosis by itself, although helpful, does little to help explain what caused the illness or what treatment will cure it. Without the support of a well-developed case history and an understanding of the individual, a clinician is unable to create an optimal treatment plan. Merely using a diagnosis to plan treatments oversimplifies the client's life experiences and treats the client as a label rather than a human being. As helpful as the diagnosis may be in the clinical process, its presence is open to the possibility that clinicians will tend to think about it in stereotyped ways, thus ignoring the fact that the person is a unique human being and is entitled to be treated as such.

Many psychologists do not see mental health as a dichotomy—someone is mentally ill or mentally healthy, a disorder is cured or not. Rather, these psychologists see mental health as a continuum with varying degrees of health and disturbance. Who, for example, has never experienced an irrational fear? Irrational fears clearly are not phobias, but seem to fall somewhere on the spectrum of problematic anxiety. Additionally, some psychologists take issue with the medical model's implication that psychological conditions can be cured. They view psychological treatment as healing a disordered condition, not in completely removing it. That is, there is no way to remove the experience of having had depression, although an individual may recover from a depressive episode.

SUMMARY

The assessment process seeks to evaluate and include in a case history the client's illness, strengths and limitations, life circumstances, early history, and current interpersonal relations.

A quality assessment is both reliable (including internal consistency, test-retest reliability, and interrater reliability) and valid (including descriptive and predictive validity). There are a number of challenges that threaten the quality of an assessment, including characteristics of the clinician, the influence of the setting, and the purpose for which a diagnosis is made, all of which can bias an assessment.

The principal means of conducting the assessment process may include each of the following. A physical examination may be called for to rule out physical concerns. This examination may include such advanced medical procedures as the electroencephalogram (EEG), the computerized axial tomography (CAT scan), the positron emission tomography (PET scan), magnetic resonance imaging (MRI), or functional magnetic resonance imaging (fMRI).

The diagnostic interview may be largely informal and unstructured. Adaptations of the simple interview are a structured interview with a comprehensive list of questions for use by the interviewer or even that can be administered by a computer. Alternatively, self report (completed by the client) and other report (completed by someone who knows the client well) measures can be a useful and convenient way to collect information.

Psychological tests include ability tests such as achievement and intelligence tests. The most commonly used are the Wechsler Scales with separate forms for use with adults, older children, and younger children. Personality tests may be projective (ambiguous stimuli onto which the individual projects his or her own interpretations) or objective (a list of statements with which the individual may agree or disagree). The most commonly used projective test is the Rorschach ink blot test. The most widely used objective personality test is the Minnesota Multiphasic Personality Inventory-2, which, by means of 567 questions, provides a ten-scale personality profile and other clinically helpful information.

The assessment process develops a dynamic formulation of the client's disorder and may provide support for a diagnosis drawn from the Diagnostic and Statistical Manual of Mental Disorders (DSM-IV-TR), which is the official American classification system for psychological disorders.

SELECTED READINGS

Brenberm, J. D. (2005). Brain imaging handbook. New York: W. W. Norton & Company.

Gould, S. J. (1996). The mismeasure of man. New York: W. W. Norton & Company.

Kaplan, R. M. & Saccuzzo, D. P. (2004). Psychological testing: Principles, applications, and issues (6th ed.). Belmont, CA: Wadsworth Publishing.

Kaufman, A. S. & Lichtenberger, E. O. (1999). Essentials of WAIS-III assessment. Hoboken, NJ: Wiley.

Nichols, D. S. (2001). Essentials of MMPI-2 assessment. Hoboken, NJ: Wiley.

Pope, K. S., Butcher, J. N., & Seelen, J. (2000). MMPI, MMPI-2, & MMPI-A in court: A practical guide for expert witnesses and attorneys (2nd ed.). Washington, DC: American Psychological Association.

Rose, T., Maloney, M. P., & Kaser-Boyd, N. (2000). Essentials of Rorschach ® assessment. Hoboken, NJ: Wiley.

Wood, J. M., Nezworski, M. T., Lilienfeld, S. O., & Garb, H. N. (2003). The Rorschach inkblot test, fortune tellers, and cold reading. The Skeptical Inquirer, 27 (4), 29–33.

Test Yourself

1)	Which type of reliability focuses on	cor	nsistency between two assessors?
	a) internal consistency	c)	test-retest reliability
	b) inter-rater reliability	d)	testing consistency
2)	Which type of validity focuses on thor diagnosis?	e de	egree to which a test accurately identifies a person's abilities
	a) descriptive validity	c)	face validity
	b) divergent validity	d)	predictive validity
3)	Which of the following can bias assessment?		
	a) characteristics of the clinician		
	b) the purpose for which the diagnosis is made		
	c) the setting		
	d) all of the above		
4)	Which of the following creates clear, detailed images of brain structures?		
	a) computerized axial tomography (CAT)		
	b) magnetic resonance imaging (MI	RI)	
	c) electroencephalogram (EEG)		
	d) all of the above		
5)	Which of the following is a means of gathering information about a client from people who know him or her well?		
	a) computerized interview	c)	self report
	b) other report	d)	structured interview
6)	Which of the following is a drawback of clinical observation of behavior?		
	a) can change people's behavior	c)	time consuming
	b) expensive	d)	all of the above
7)	The fact that traditional intelligence tests are culturally biased is a significant weakness of intelligence testing. True or false?		
8)	In the <i>Rorschach Inkblot Test</i> , the clinician interprets the client's responses to what he or she sees in the cards and what in the cards suggested the client's response. True or false?		
9)	One of the major criticisms of the MMPI-2 is that it is difficult to score and interpret. True or false?		
10)	Which of the following is an advantage of diagnosing?		
	a) It eliminates self-fulfilling prophecies		
	b) It facilitates communication amongst clinicians and researchers		
	c) It results in a reduction of stigma		
	d) all of the above		

Test Yourself Answers

- 1) The answer is **b**, inter-rater reliability. Inter-rater reliability is the degree of agreement between two independent assessors. Internal consistency is the degree to which items within a test agree. Testretest reliability is the degree to which scores on the same test given at different times agree. Testing consistency is a made-up term.
- 2) The answer is a, descriptive validity. Descriptive validity is the degree to which the results of a test accurately describe an individual's abilities, diagnosis, or other traits. Divergent validity is the degree to which a measure that assesses something unrelated to the test in question differs from that test. Face validity is the degree to which a test appears to measure what it is supposed to measure. Predictive validity is the degree to which a test predicts future behavior or a diagnosis.
- 3) The answer is **d**, all of the above. Characteristics of the clinician, the setting, and the purpose of the assessment all can bias the results of the assessment.
- 4) The answer is **b**, magnetic resonance imaging (MRI). MRI produces a clearer, more detailed image than the CAT, which is imprecise. The EEG measures brain waves and does not produce an image of the brain.
- 5) The answer is **b**, other report. Computerized and structured interviews and self reports all gather information directly from the client. Other reports specifically query people who know the client well about the client's behavior or traits.
- 6) The answer is d, all of the above. Clinical observations of behavior can be time-consuming and expensive. Furthermore, observation can cause people to change their behavior.
- 7) The answer is **true.** Traditional intelligence tests tend to be biased toward middle socioeconomic status experiences, which is a significant weakness in their ability to objectively measure cognitive abilities.
- 8) The answer is **true.** When administering the *Rorschach Inkblot Test*, the clinician shows the client each card one at a time, asking what the client sees. Then the psychologist goes through the cards a second time, asking the client what caused him or her to see the specific things mentioned. Finally, the clinician interprets the client's patterns of responding.
- 9) The answer is false. The MMPI-2 is pretty easy and straightforward to score and interpret. In fact, there are computer programs that quickly provide scores and interpretive reports. However, the MMPI-2 has been criticized for measuring general distress rather than specific psychopathology and for being susceptible to socially desirable responding.
- 10) The answer is b, it facilitates communication among clinicians and researchers. Diagnosing facilitates communication among clinicians and researchers by creating a concise way of communicating a complete syndrome of symptoms. However, diagnosing can result in stigma and self-fulfilling prophecies.

Psychodynamic Forms of Psychotherapy

In the United States, in any one year, one of every twenty Americans will visit a mental health clinic, a psychiatric hospital clinic, or a clinician in private practice to seek help with an emotional or adjustment problem. Many will follow up and undertake a program of psychotherapy. Most will need only relatively short-term treatment, two or three months, occasionally only three or four visits. Others will continue longer and some forms of psychotherapy continue for years.

What will they experience? There are so many different therapies that the question is difficult to answer. Over 250 different types of therapy have been identified, although many of these are not frequently used. Unfortunately, research testing the comparative effectiveness of the various therapies has not kept pace with their growth. All of those therapies can be grouped into one or another of the perspectives discussed in Chapters 4 and 5. Many of the therapies differ in only slight ways, and although research suggests that most forms of therapy are at least somewhat helpful, there are none that consistently outperform all others.

Most clinicians will select a mode of treatment consistent with their perspective on human behavior. They will set therapeutic goals, follow procedures, and schedule and terminate treatment in ways consistent with that perspective. However, clinicians increasingly are adopting an eclectic point of view and adopting psychotherapeutic approaches from one or another of the ideologies in a way that best suits the needs of the client. Furthermore, clinicians are facing pressures from insurance and other managed care companies to keep therapy brief, and it is becoming more common for clients to make requests for specific types of therapy.

Psychotherapies may be classified in multiple ways, for example, therapies that set insight as a goal versus those that set a change in behavior as a goal, or therapies considered by the therapist as a precise science versus those in which the therapist considers therapy a skilled but flexible art. Another way of thinking about the differences in therapies is in terms of the behavior that the therapist believes needs changing. Targets for change can be affective (emotional) reactions, such as irrational fears or depression; cognitive processes, such as irrational or unrealistic thoughts, beliefs, or expectations; or maladaptive behavior, ways in which the client is responding to environmental pressures. Furthermore, the seriousness of the abnormal behavior, measured by its disruptive effect on the client's life, is always a prime concern of the therapist.

The diversity of therapies also can be illustrated in the different ways therapists respond to the client. The behavior of therapists may vary from seemingly passive listening, with an occasional interpretation

or a question interjected, to active confrontation with the client about the irrationality of his or her beliefs; from active participation in activities with the client (for example, walking through the busy thoroughfares of New York City to desensitize the client to fears of open spaces) to intently listening to the client in order to really hear the client as he or she, perhaps, has never been heard or understood before.

No wonder choosing a therapist may be, for many people, a troubling question. Clinicians have developed guidelines to help a perplexed person make the right choice. After dealing with those introductory but important questions, the chapter describes the characteristic features of the principal psychodynamic therapeutic approaches, and the chapter concludes with an evaluation of the effectiveness of psychotherapy in general.

THE DIVERSITY OF THERAPIES

Therapies differ in their goals, the attitude therapists hold toward the therapeutic process, their methodology, and the demands made upon patient and therapist.

Goals of Therapy

There are two principal and very different goals set by therapists with differing perspectives on human behavior: the development of insight into the causes of the client's abnormal behavior or the direct modification of undesired or undesirable specific actions of the client.

Insight As a Goal

The choice of insight as a goal, which is the preference of clinicians with a psychodynamic perspective, is based on the belief that certain critical previous experiences (some of them from early childhood) are currently producing anxiety and its symptoms, as well as disturbed interpersonal relations, irrational thinking, and damaging affective behavior. The humanistic and existential clinicians also seek to develop insight, but they are more likely to focus on the present or the recent past than on early childhood.

The therapist will choose methods that make possible insight into repressed, unconscious material. He or she will encourage reexamination of current emotional patterns and existing interpersonal relations in the light of the insights developed. In developing insight, especially in psychoanalytically oriented therapy, care must be taken that the so-called insight is not a detached, cold intellectualization, which will not have any real impact on the client's behavior. Once an emotionally felt and accepted insight is achieved and its relationship to current behavior is understood and accepted, the job of the therapist is to lead the client to behavioral change, a goal that brings the therapist close to action-oriented therapy.

Action Therapy: Behavioral Change

Behaviorists and their cognitive associates believe that faulty learning is a principal cause of abnormal behavior. Their approach to therapy is to help the client unlearn abnormal patterns of behavior and to learn new, more adaptive patterns. That approach to therapy may involve the therapist and client together in real-life situations that the client finds problematic. Their procedures heavily involve respondent and operant conditioning (see Chapter 5). Little time is given to emotional experiences of the past, except when doing so helps to identify the faulty learning patterns that are producing the abnormal behavior. Whereas insight therapy might seem occasionally to have a meandering aspect to it, behavioral, action-focused therapy is likely to be precise; it sometimes has technical aspects to it, such as the use of measurement. Behavioral and cognitive therapies are described more fully in Chapter 8.

The contrast between insight therapy and action-focused therapy is frequently one between a global approach to achieve a major change in personality and a specific approach to effect a reduction in symptoms or other problematic behaviors.

Attitude of Therapists Toward the Treatment Process

The most important attitude of therapists stems from their theoretical perspective. Related to perspective is the answer the therapist will make to the question: Is therapy a science or an art? Those therapists with a behavioral perspective are likely to consider it a science. The psychodynamic therapists, and those with a humanistic or existential point of view, will tend to consider it an art form that uses intuition and empathy, but nevertheless is based on scientific foundations.

Therapy As Applied Science

The clinician who considers himself or herself a scientist-practitioner will enter into the therapeutic setting with the expectation that a predictable result will follow a carefully researched, step-by-step treatment process. Gordon Paul, in an overall review of behavioral therapy, puts it this way: The behaviorally oriented scientist-practitioner, before beginning a treatment program, asks: "What treatment, and by whom, is most effective for this individual, with that specific problem, under which set of circumstances?" The questions are very close to those a brain surgeon might ask, except that the psychotherapist understands that the answers to such questions will not have the same precision as those to a brain surgeon's questions. The answers they identify as variables affecting therapy are nevertheless based on the solid evidence of careful research.

Psychotherapy As an Applied Art Form

Therapists within the psychodynamic, humanistic, and existential perspectives, for example, criticize the applied scientific approach as resembling too closely what might be done to an experimental animal. They would contend further that what must be done in psychotherapy can be learned only as it gradually reveals itself in early sessions. They probably will not say how many sessions are necessary until therapy is well underway.

One must be careful not to conclude that, because intuition and empathy seem such subjective terms, the art form of therapy is a completely subjective process. The intuitive judgments and the empathic responses of the art-form therapists are the result of much prior training and experience under the supervision of experienced therapists. Carl Rogers, in his humanistic approach, summarizes the point of view of the art form of therapy. He states that a soft, warm, empathic approach is necessary to gain the feedback from the client that will, as the sessions go on, enable the therapist to be helpful.

Choosing the Right Therapist

Given the diversity of therapies, prospective clients face a puzzling decision. Fortunately, experienced clinicians with various perspectives agree on a set of suggestions that, when followed, are likely to increase the effectiveness of any of the various forms of therapy, even biologically based therapy, discussed in Chapter 8.

Motivations and Expectations

Prospective clients should begin by examining their motivations for therapy and what they expect to get out of it. Unless they consider therapy a serious business at which they will be expected to work even more persistently than does the therapist, psychotherapy can offer little help. To accept such a heavy burden requires that one's anxiety level or the painfulness of one's symptoms or the severity of life's problems provide strong motivation to learn more about the psychodynamics of one's behavior or to learn how to change undesired behavior.

Of almost equal importance are one's expectations—what one expects from therapy. Possibilities are elimination of a phobia, more satisfying interpersonal relations, a reduction in the level of anxiety, or recovery from depressing moods. As early as 1905, Freud recognized the importance of expectations in these words: "Expectations ... colored by hope and faith ... [are] an effective force with which we have to reckon ... in all our attempts at treatment and cure." Years of clinical experience since then have taught therapists how right he was. The most important psychological assets a client can bring to therapy are strong motivations to use therapy effectively and to have realistic expectations.

Gathering Information about the Therapeutic Process

Few, if any, clinicians would want prospective clients to delay therapy until they had become technically knowledgeable about the treatment process. However, knowledge gained by reading nontechnical but accurate books, pamphlets, or Web sites written just for prospective clients, supplemented by information gathered from psychology-friendly and knowledgeable physicians or religious counselors, will be helpful. The knowledge gained will help shape realistic expectations about what will be required of the client and what behavior or procedures might reasonably be expected from the therapist.

Some Cautionary Rules for Prospective Clients

The client, once in therapy, might wisely keep in mind the following rules suggested by experienced clinicians:

- 1. Do not continue working with a therapist whose personality traits are unacceptable to you.
- 2. Be wary of therapists who urge you to behave in ways that go against your religious, moral, or ethical standards. For example, a therapist who makes sexual advances of any sort is behaving unprofessionally and destroying any possible effectiveness of the treatment.
- 3. Try not to hold back information from your therapist.
- 4. Do not hesitate to ask questions or to raise objections to what a therapist is doing or proposing.

MITHERAPIES OF THE PSYCHODYNAMIC PERSPECTIVE

Because the underlying philosophy of the psychodynamic perspective and the earliest techniques used were set by Freud, orthodox Freudian psychoanalysis is described first. Then changes introduced following Freud, with an emphasis on modern psychoanalytic practice, are set forth.

Basic Characteristics of the Psychodynamic Therapies

In general, all the psychodynamic therapies are insight therapies and are global in their expected outcome. Psychodynamic therapists are more inclined than others to see therapy as an art in which the therapist's intuitions and theories are important ingredients. The principal activity of the client is talking with the therapist. The therapist, through such techniques as free association and dream analysis, leads the client into verbalizations and emotional reactions that will reveal his or her early life history and uncover unconscious or less conscious feelings and attitudes toward principal family members and toward the client himself or herself. The therapist will be less active than the patient, suggesting broader or more significant meaning to what the client has reported and occasionally commenting on the client's behavior in therapy. Modern psychodynamic therapists are likely to be more active than orthodox Freudian analysts and are also likely to go beyond interpretations of what the client has reported in order to give direction and advice, particularly on current interpersonal difficulties. They also are more likely to accept supplementary assistance from the use of some biogenic methods, particularly the use of pharmaceutical drugs to lighten depression or anxiety.

Freudian Psychoanalysis

Orthodox Freudian analysis is now less frequently used than in the years following Freud's introduction of it to American psychologists, but it still remains a powerful influence on the practice of modern clinicians of the psychodynamic persuasion. The following sections discuss the setting and principal techniques of orthodox Freudian psychoanalysis.

Setting

In order to minimize any distractions to the client's efforts to explore unconscious material, the individual reclines on a couch facing away from the therapist, who sits, for the most part, quietly in the background, occasionally providing an analytically oriented interpretation of what the client is saying. Aside from the infrequent interpretations, the client is expected to talk for most of the session, fifty minutes, on three or four days each week, a procedure that, in some cases, may continue for years.

Techniques Used

Because the goal is to explore the unconscious, the analyst depends principally on five techniques that efficiently help in that process: free association; dream analysis; analysis of resistance; hypnosis; and analysis of transference.

FREE ASSOCIATION

With free association, the therapist directs the client to say whatever comes into his or her consciousness, no matter how personal, embarrassing, painful, hostile to the therapist, or innocuous. These associations, to an untrained ear, or even (perhaps especially) to the client, may seem random or unconnected. Analysts do not consider them so, but believe that they have connections which exist only in the individual's unconscious. With the analyst's background of training and experience (a condition of becoming a psychoanalyst is that the trainee undergoes a personal analysis), he or she is, in time, able to see the connections. Bit by bit, the analyst interprets them to the client, gradually allowing him or her to form a meaningful explanation of long-repressed feelings, beliefs, or attitudes. From these interpretations initially comes insight into significant unconscious motivations and, with the help of the analyst, later understanding of defense mechanisms the client is using. With that step taken, the client can begin to see that the maladaptive responses he or she is making in life are outgrowths or expressions of long-repressed material.

DREAM ANALYSIS

Long before Freud undertook dream analysis with his clients, Plato had described dreams (and fantasies) as substitute satisfaction for inhibited "passions." Freud, with his extensive knowledge of mythology and symbolism, was more fully able than Plato or others after him to understand the rich contributions of dreams to an understanding of the unconscious, and made dream analysis a regular part of his treatment as a means of accessing the unconscious.

Freud recognized that in sleep, the individual's defenses were weakened and thus allowed unconscious material to surface. But because defenses are never completely given up, he also recognized that unconscious material would be expressed in dreams only in a symbolic or masked fashion. Freud called the client's description of the dream the manifest content, but he understood that there was also latent content, unconscious material that could be understood only by interpreting the symbolic message in the manifest content. A simple example might be the dreamed presence of a monster hovering over a small and frightened boy, which could symbolize the client's fears of an overbearing and punishing father. Free association of the dream's manifest content aids the therapist in unlocking the symbolic meaning of sometimes seemingly meaningless dreams.

ANALYSIS OF RESISTANCE

Sometimes, therapy bogs down. The flow of associations is sparse, there are no reported dreams, and appointments are cancelled. Often, that defensiveness occurs after a period of good progress. This suggests to the analyst the client's unwillingness to explore more profoundly certain unconscious material. This very unwillingness further suggests the probable importance of the content being protected. The job of the analyst is to point out what the client is doing and why, and perhaps even speculate on what the client is unconsciously trying to hide.

HYPNOSIS

Hypnosis is used by some psychodynamic clinicians as a way to move beyond defenses to access unconscious conflicts. Once accessed, these conflicts then can be addressed, leading to a resolution of the psychological difficulties.

ANALYSIS OF TRANSFERENCE

As the analysis proceeds, the relationship between therapist and client increases in complexity and emotionality. Soon, the relationship may take on the characteristics of childhood reactions to parents or other significant people—over-submissiveness, dependence, hostility, and childlike love's attempt at gift giving. Analysts consider this an important step in therapy and use the behavior as examples of unconscious material affecting the client's present interpersonal relations; that is, long-forgotten (repressed) mechanisms for relating to parents or others now are being utilized in relating to the therapist. This process of transferring to the therapist feelings characteristic of early life is described by some psychoanalytic therapists as a transference neurosis, which then has to be worked through before the client can face up to the shadowy presence of childhood conflicts and longings in his or her real-life disorder.

In contrast to transference, countertransference is the therapist's emotional reaction to the client. By exploring their countertransference, therapists can gain clinically helpful information about their clients.

Post-Freudian Psychodynamic Therapies

Relatively few clinicians now closely follow the therapeutic practices of Freud, yet notable traces of his thinking still color the theoretical orientation and technical practices of present-day psychodynamic therapists. They depart, however, from some of his basic concepts about human development and personality formation. For example, they tend to ignore Freud's strongly biological emphasis, downgrade his stress on id and libido in favor of ego development, and pay little attention to the early psychosexual stages so prominent in Freudian theory. As they have moved away from his theories, they have also modified and, in some cases, eliminated, the techniques he used to explore the unconscious.

Freudian Influences on Current Psychodynamic Theory

Nevertheless, in a broader sense, psychodynamic therapy still shows the influence of Freudian thinking and practice. A central theme is the influence of unconscious motivations on the development of symptom formation. There still remains the Freudian goal of providing clients with insight into the sources of their unhappiness and maladaptive behavior. And, although methods of conducting psychotherapy have changed radically, techniques developed by Freud-for example, dream analysis and examination of resistance and transference—are still found useful, although they are not as heavily depended upon.

Post-Freudian Changes

Departures from Freudian thinking and practices fall into two major categories: changes in the theoretical framework within which therapy is conducted; and the techniques used by therapists.

CHANGES IN THEORETICAL PERSPECTIVES

Today, modifications of Freudian theory introduced by post-Freudian analysts dominate the content of therapy sessions. Analysts now talk of a Jungian analysis, bringing into the sessions Jung's archetypes and unconscious material and psychodynamics quite different from those of Freud; an Adlerian analysis, with much emphasis on the drive for power; a Sullivanian analysis, in which the focus is on current interpersonal relationships; an analysis stressing the object relations of Mahler; or an analysis of the societal pressures pointed up by Horney (see Chapter 4). All of these changes are in sharp contrast to the Freudian accent on sexual and aggressive impulses. Such expansions on Freud's original ideas allow for a much broader application of basic psychodynamic principles.

Perhaps the most striking theoretical change in modern psychodynamic theory is a shift from id dominance to recognition of the importance of the ego, which, in its conscious and rational functioning, can serve constructive purposes in leading the client back to normal adjustment. With that shift has come an increasing interest in the client's interpersonal relations, especially those within the family.

CHANGES IN THERAPEUTIC PRACTICE

There are three principal ways in which modern psychodynamic therapy differs from traditional analytical practices. They are as follows:

- 1. Today's therapist is more active—more direct in providing interpretation, giving advice, and elaborating options available to the client.
- 2. Therapy is briefer and, in a sense, more to the point. The couch is rarely used. Sessions are held once or, at most, twice a week. Therapy is of shorter duration. For example, one approach is to set time limits on the duration of therapy. An approach that focuses on symptom relief limits the number of sessions to twelve. Even where the therapy is more global with a goal of changing the client's personality, another time-related approach offers only up to thirty sessions.
- 3. The therapy is more likely to explore the client's current life and interpersonal relations, only going back to earlier life experiences to give perspective and understanding to the present.

CRITIQUE OF PSYCHODYNAMIC THERAPY

Surveys indicate that short-term psychodynamic therapy is one of the most widely practiced of any of the psychotherapies, yet there is controversy about its theoretical foundations and its effectiveness. There are three principal criticisms leveled against the psychodynamic approach.

First, the theoretical propositions of psychodynamic therapy, it is said, are difficult (if not impossible) to prove scientifically. Those outside the psychodynamic perspective charge that most writings of psychodynamic therapists, including reports on successful treatment, are influenced more by intuition and subjective judgment than by scientific investigation.

Second, the number of psychodynamic theories and the differences among them are also seen as weaknesses. The question is asked: How can such different perspectives about the causes of abnormal behavior provide, in any consistent fashion, useful insights to the client? Do the insights vary with the therapist rather than the dynamics in the client's life? Is it, for example, more a matter of the therapist persuading the client to his or her point of view, and is the success of therapy more dependent on the therapist's persuasive powers than on the accuracy of the insight? Can it be that the helpful nature of the relationship between therapist and client is the source of the healing, rather than the content discussed? That question cannot be answered yet. Research does indicate, though, that clients do get better, and they often attribute their improvement to new ways of looking at themselves.

A third criticism is that psychodynamic therapy is for a relatively narrow slice of the population needing psychological help. Costs are high and, although some health insurance programs help in meeting those costs, not everyone who might benefit from psychological help has access to such insurance. Without it, only the comparatively affluent can afford therapy. In addition to the financial barrier, there is a psychological barrier. Psychodynamic therapy is a highly verbal procedure that requires the client to be intelligent and articulate. The statement is made in criticism that only YAVIS clients can benefit; that is, only the young, attractive, verbal, intelligent, and successful client can be helped. It can be defended by noting that at least it does benefit some part, if not a large one, of the population with mental disturbances. Furthermore, not all medical cures work for everyone, either.

Despite criticisms of psychodynamic therapy, there are positive statements to be made about it. Large numbers of clients who have experienced psychodynamic therapy report deeper understanding of themselves, a reduction in anxiety and maladaptive behavior, and better interpersonal relations. Those word-of-mouth testimonials have, no doubt, something to do with the large number of troubled people who undertake psychodynamic therapy. Beyond that, there are carefully conducted studies that report positive results with a substantial majority of those who have completed therapy.

CLIENT-CENTERED, EXISTENTIAL, AND GESTALT THERAPIES

There are three therapeutic approaches that stand apart from mainstream psychotherapeutic efforts, whether psychodynamic or behavioral. They draw neither on the Freudian-toned concepts of the first or the learning concepts of the second. Although, even when combined, the number of clients they treat a very small minority of all clients in therapy, they are discussed here because of the contrast de with major forms of therapy and the range of therapeutic approaches they suggest. They are ered therapy (based on the humanistic perspective), existential therapy, and Gestalt therapy. ree therapies have as their primary goal increasing the clients' insights into the causes of their y bringing into awareness repressed and unconscious material. Additionally, they all are global ed-for outcomes. Beyond those commonalities with psychodynamic therapy, their conceptual ngs and the therapeutic techniques they employ are notably different. (For a discussion of the and existential perspectives, see Chapter 4.) The client-centered and existential therapies pare in common the goal of maximizing the client's sense of freedom to choose, reducing any being bound or determined by circumstances, and encouraging clients to choose their own

itered Therapy: The Humanistic Approach

entered therapy has evolved from an original treatment described by Carl Rogers n 1950. He initially called it nondirective therapy. In subsequent publications, he developed property to his therapeutic approach (the humanistic perspective) and a conceptual framegers ultimately preferred to call his approach person-centered therapy, thereby suggesting ling of the two individuals involved in the therapeutic endeavor. A principal emphasis in o create a profound and intensely personal relationship between therapist and client. To there are two principal thrusts made in the therapeutic effort; helping the client to expebist's unconditional regard; and the therapist's efforts to achieve empathy with the client ne world as he or she does.

Positive Regard

ndamental conviction giving direction to client-centered therapy is the belief that peogood even when they are doing "bad" things. It is, Rogers would say, because they have nditional positive regard from significant people in their lives that they do "bad" things or may overestimate the degree to which their actions are "bad." Unless the therapist first attempts to meet the client's need for positive regard, the client remains defensive and will not let down his or her psychological guard to relate honestly to the therapist. Unconditional acceptance of the client is the most important message a Rogerian therapist initially attempts to deliver.

KC 454 14.42 2001

Empathy with the Client

Once the therapist feels that the message of unconditional positive regard has been felt by the client, the therapist uses his or her trained skills to relate to the client so empathically as to share the client's world as the client, in the security of the therapist's positive regard, reveals it. To move the client toward insight, client-centered therapists listen intently to what the clients are saying, and then reflect back their understanding of feelings expressed, conflicts, and frustrations experienced, and goals envisioned. In that way, the therapist helps the client to clarify and know life experiences for what they are, and eventually to accept and deal with them.

Existential Psychotherapy

The treatment practices of this school can best be described by stating the two major conceptual propositions of the existential perspective (discussed more fully in Chapter 4). The first is that human beings are free to make their own choices, but they must assume responsibility for the consequences of those choices. Their problems are of their own making, and only they can undo them. The second proposition has been labeled "the ontological context," the "here and now," the individual's "lived world." The therapist's goal in promoting insight is to focus on that world, to clarify it, and to confront the client with the problems of dealing with it. Existential therapeutic practices are whatever will bring into focus and clarify for the client those two determinants of the individual's problems.

The approaches of existential therapists and the techniques used vary from therapist to therapist. Two techniques used by Viktor Frankl (1905–1997), a founder of the existential mode of therapy, illustrate the wide range of existential therapeutic practices that characterize existential therapy.

Paradoxical Intervention

Here, clients are encouraged to act out, even to exaggerate their symptoms—for example, to eat a gluttonous meal when overeating is the problem. The point is to drive home the individual's freedom of choice, even to choosing that very behavior he or she considers the most undesirable. This strategy also provides the client with the perspective that symptoms could be worse and a sense of power in that he or she is an active agent rather than being acted upon by a therapist.

Dereflection

That odd term refers to the second of Frankl's therapeutic techniques, in which the client's attention is directed away from his or her symptoms, and then the therapist helps the client to visualize how much richer life could be, how much more enjoyment there could be, if the client were not so preoccupied with his or her symptoms. To the extent that those exercises lead clients to take responsibility for what they do, they become conscious of what they are doing with their lives, more aware of their choices and values, with the possibility that their lives will then become more open, honest and meaningful; or, in existential terminology, more authentic.

Gestalt Therapy

Drawn from a major German school of psychology, Gestalt therapy emphasizes the wholeness of the human being. It combines insight and behavioral change components. It requires, to begin with, that the client identifies significant emotional conflicts of the past, and then that the client acts those out in a roleplaying way. Clients are encouraged to be as vivid, even violent, as possible, stopping only at physical attack, except, for example, such minor assaults as kicking over a chair or banging on a table.

Frederick (Fritz) Perls (1893–1970), the founder of Gestalt therapy, maintained that in identifying an early emotional crisis and acting it out with strong feeling, clients will confront their feelings, assume responsibility for them, and gradually control them. The ultimate goal of Gestalt therapy is to integrate

past disruptive feelings into a wholeness of personality—healthier, more spontaneous, open, and honest and, in that way, less maladaptive.

Critique of Client-Centered, Existential, and Gestalt Therapies

Four principal criticisms have been leveled against these therapies: their failure to base therapeutic approaches on a fully developed and integrated view of the human personality; a vagueness about what their goals in therapy are; lack of empirical support; and difficulty in operationally defining the key concepts. They also have been criticized for the great variability in the approaches they take to therapy; but because clients range so widely in the nature of their problems, their motivations, and the circumstances of their lives, that diversity in treatment techniques might be considered more of a strength than a weakness.

The humanistic approach is less subject to those criticisms, because Rogers has systematically developed a theory of personality that is widely respected. In order to submit his approach to outside evaluation, he has been one of the first to tape his therapy sessions for discussion and evaluation by peer groups.

Despite critical comment, there is no doubt that these relatively newer therapies have influenced the thinking and practices of psychodynamic therapists. Their hopeful view of the client's basic psychological strengths and uniqueness and their emphasis on personal responsibility and self-determined choice have constructively influenced those therapies and introduced a broad eclecticism in their methods of treatment, so much so that it accurately may be said that an eclectic form of psychotherapy is today the most widely practiced.

SUMMARY

One of every twenty Americans seeks psychological treatment in any one year, visiting a mental health clinic, a psychiatric hospital, or a clinician in private practice. Therapies offered are remarkably diverse. Estimates indicate that there may be more than 250 different specific therapies available today. Although most clinicians will select an appropriate mode of therapy consistent with their psychological perspective, more and more therapists take an eclectic approach (one that draws on a number of points of view) and use a flexible set of techniques.

Therapists differ in the goals they set, the attitudes they hold, and the demands they make of their clients. There are two different types of goals set in therapy. One is providing the individual with increased insight into motivational elements, as in psychodynamic therapy; the other is producing a change in behavior, a goal set principally in behavioral and cognitive therapies. Therapists consider therapy either a precise science (behavioral therapists) or an applied art form (Rogerian therapists, for example). Their methodologies will follow their perspective on those two matters. All therapists count on the individual's strong motivation to get well.

Choosing a therapist is an important decision and should be carefully considered after consultation with knowledgeable others. Once in therapy, the individual should consider such issues as the congeniality of the relationship, behavior or suggestions that disregard his or her ethical standards, candor in revealing problems, and freedom to ask questions and to challenge the therapist.

The principal psychodynamically oriented therapies are psychoanalysis, person-centered therapy, existential therapy, and Gestalt therapy. Psychodynamically oriented therapy principally involves the client talking to the therapist, particularly about early life experiences. The therapist will employ such therapeutic approaches as free association, dream analysis, analysis of the client's resistance to therapy, and an analysis of transference. It is often a long-term, intense commitment. More recently developed psychoanalytic therapies, sometimes called neo-Freudian, have shortened the process, moved away from the biological emphasis of orthodox Freudian therapy, given more attention to current problems than to early childhood relationships, and are more willing to give advice and direction.

Client-centered, existential, and Gestalt therapy stand apart from both orthodox psychoanalytic and behavioral theory. In client-centered therapy, also referred to as the humanistic approach, the therapy is totally influenced by the goal of providing a sense of unconditional self-regard by empathizing with the patient; that is, demonstrating an understanding and acceptance of the client's feelings.

The existential therapist emphasizes the client's freedom for making his or her own choices and the need to accept responsibility for them. The essence of Gestalt therapy is a process of reenacting, in a vivid, emotional fashion, early emotional conflicts and, in this way, reintegrating them more fully into one's personality.

SELECTED READINGS

Leichsenring, F. (2005). Are psychodynamic and psychoanalytic therapies effective?: A review of empirical data. International Journal of Psychoanalysis, 86, 841–868.

May, R. (1994). The discovery of being: Writings in existential psychology. New York: W. W. Norton and Company.

Mearns, D. & Thorne, B. (1999). Person-centered counseling in action. Thousand Oaks, CA: Sage Publications.

Perls, F. S. (1973). The Gestalt approach and eye witness to therapy. Palo Alto, CA: Science and Behavior Books.

Yalom, I. (2003). The gift of therapy: An open letter to a new generation of therapists and their patients. New York: Harper Perennial.

Test Yourself

- 1) Psychodynamic therapy tends to have behavioral change as its goal and psychodynamic therapists tend to view therapy as a science. True or false?
- 2) Clients are encouraged to raise questions or objections if they have concerns about what their therapist is suggesting or doing. True or false?
- 3) In psychodynamic therapy
 - a) The therapist is more active than the client.
 - b) The client is more active than the therapist.
 - c) The therapist and client are equally active.
 - d) The client and therapist are equally passive.
- 4) Which psychotherapeutic technique uses free association and dream analysis?
 - a) client-centered therapy
- c) Freudian psychoanalysis
- b) existential psychotherapy
- d) Gestalt therapy
- 5) Which psychotherapeutic technique uses acting out early emotional crises?
 - a) client-centered therapy
- c) Freudian psychoanalysis
- b) existential psychotherapy
- d) Gestalt therapy
- 6) Which psychotherapeutic technique uses dereflection and paradoxical intervention?
 - a) client-centered therapy
- c) Freudian psychoanalysis
- b) existential psychotherapy
- d) Gestalt therapy
- 7) Which psychotherapeutic technique uses empathizing with the client and unconditional positive regard?
 - a) client-centered therapy
- c) Freudian psychoanalysis
- b) existential psychotherapy
- d) Gestalt therapy
- 8) Compared to Freudian psychoanalysis, contemporary psychodynamic therapy
 - a) is briefer
 - b) involves a more active therapist
 - c) is more likely to focus on the current life of the client
 - d) all of the above
- 9) Psychodynamic therapy has been criticized because its theoretical foundation is quite difficult to prove scientifically. True or false?

Test Yourself Answers

- 1) The answer is false. Psychodynamic therapy tends to have insight as its goal, and psychodynamic therapists tend to view therapy as an art.
- 2) The answer is true. It is important to raise concerns with a therapist. Other suggestions include not working with a therapist one finds unacceptable, being cautious of therapists who ask one to violate his or her values, and avoiding holding back information from a therapist.
- 3) The answer is **b**, the client is more active than the therapist. In psychodynamic therapy, the client is expected to do most of the talking, while the therapist will occasionally ask questions or interject insights.
- 4) The answer is c, Freudian psychoanalysis. Freudian psychoanalysis uses free association and dream analysis in addition to hypnosis, analysis of resistance and analysis of transference. Client-centered therapy focuses on unconditional positive regard and empathizing with the client. Existential psychotherapy utilizes paradoxical interventions and dereflection. Gestalt therapy encourages vividly acting out early emotional crises.
- 5) The answer is **d**, Gestalt therapy. Gestalt therapy encourages vividly acting out early emotional crises. Freudian psychoanalysis uses free association, dream analysis, hypnosis, analysis of resistance, and analysis of transference. Client-centered therapy focuses on unconditional positive regard and empathizing with the client. Existential psychotherapy utilizes paradoxical interventions and dereflection.
- 6) The answer is b, existential psychotherapy. Existential psychotherapy utilizes paradoxical interventions and dereflection. Freudian psychoanalysis uses free association, dream analysis, hypnosis, analysis of resistance, and analysis of transference. Client-centered therapy focuses on unconditional positive regard and empathizing with the client. Gestalt therapy encourages vividly acting out early emotional crises.
- 7) The answer is a, client-centered therapy. Client-centered therapy focuses on unconditional positive regard and empathizing with the client. Freudian psychoanalysis uses free association, dream analysis, hypnosis, analysis of resistance, and analysis of transference. Existential psychotherapy utilizes paradoxical interventions and dereflection. Gestalt therapy encourages vividly acting out early emotional crises.
- 8) The answer is **d**, all of the above. In comparison to traditional Freudian psychoanalysis, contemporary psychodynamic therapy is briefer (more likely to meet once a week than several times a week and for a shorter course of treatment), the therapy is more likely to focus on the client's current life situation (as opposed to focusing predominately on early conflicts), and the therapist is more active (rather than mostly passive).
- 9) The answer is true. The difficulty of scientifically proving the theory underlying psychodynamic therapy is one of the major criticisms against this orientation to psychotherapy. Other criticisms include concerns regarding the diversity among the multiple psychodynamic theorists and the likelihood that psychodynamic therapy is best suited for a somewhat narrow portion of the population. Arguments against these critiques have been made, and many clients report benefits from psychodynamic therapy.

Behavioral, Cognitive, and Biogenic Therapies

istorically, and into modern times, one or another variant of the psychodynamic approach to therapy has dominated psychotherapeutic practice. This chapter examines three forms of therapy, radically different in their methodology from the psychodynamic approach, developed largely in the post-Freudian era, with little, if any, traces of psychoanalytical influence. These three therapies have grown in popularity to the point where they are more prevalent than psychodynamic therapies in many parts of the United States.

These therapies are as follows:

- Behavioral therapy, with its foundations in learning theory, principally classical and operant conditioning
- Cognitive therapy, which is based on developments in cognitive psychology and traces its beginning to John Dollard (1900–1967) and Neal Miller (1909–2002)
- · Biogenic therapy, which treats mental illness through medical/physical intervention

The chapter examines them in that order and concludes with a brief discussion of several forms of multiple person therapy.

Of all the perspectives described in this book, the cognitive-behavioral model (an integration of cognitive and behavioral therapies) is the one that has, in the past 40 years, most increased its influence on therapeutic practice in the United States. It has, to a notable extent, drawn clinicians away from an exclusively psychodynamic practice, especially for certain types of emotional disorders. For example, behavioral techniques are now recognized as the treatment of choice for phobias; it has also been called the backbone of modern psychotherapeutic practice for sexual disorders. Similarly, cognitive techniques have been found to be effective in treating depression.

BEHAVIORAL THERAPIES

Behavioral therapy is an action-oriented therapy that is specific, not global, in its focus and is conducted as an applied science using precise technical approaches. As described in Chapter 5, behaviorists believe that maladaptive behavior is the result of faulty learning that prevents the individual from developing effective coping mechanisms for adjusting to life's stresses. The behavioral perspective further

states that much, if not all, learning results from either respondent or operant conditioning. Although behavioral therapy takes a variety of forms, all, in one way or another, make use of the basic principles of conditioning. Because the behavioral therapies are embraced by the conditioning framework, which has already been discussed in detail in Chapter 5, it will be possible here to consider the most frequently used of them only briefly.

Basic Principles of Behavioral Therapy

The basic principles of conditioning used most frequently in behavioral therapy are the following:

- 1. A stimulus regularly paired with a second stimulus that elicits a response will come to elicit that same response.
- 2. Reinforced behavior is strengthened and likely to reoccur.
- 3. Behavior that is not reinforced will tend to disappear from the individual's behavioral repertoire.
- 4. Any response that removes an unpleasant or hurtful condition will be strengthened.
- 5. Reinforcement of the components of a desired response in a way to move the individual toward that response will eventually make that response a part of the individual's way of behaving.
- 6. Although infrequently and warily used, punishment following a response will cause an undesired response to disappear, but may produce other undesired consequences.

The therapeutic application of those principles essentially involves an unlearning of the faulty and maladaptive learning. That initial step is best followed by other learning sessions in which effective coping behavior can be learned.

Specific Types of Behavioral Therapy

The following sections give brief descriptions of widely used behavioral therapeutic techniques, with examples of behavior they seek to modify. The descriptions are grouped by the type of conditioning upon which they rely. Behavior therapy strategies based on classical conditioning include systematic desensitization, aversion therapy, and covert sensitization. Behavior therapy strategies based on operant conditioning include removal of reinforcers, overcorrection, and positive reinforcement.

Extinction by Systematic Desensitization

Joseph Wolpe created a three-step procedure for reducing anxiety produced by specific tensioncausing situations; for example, being around dogs for someone with a phobia of canines. Wolpe first trains the client in relaxation. He uses any of several methods, including the occasional use of hypnosis and drugs. Once the client has learned to relax, the therapist encourages the client to describe a number of anxiety-producing situations, ranging from those that cause mild anxiety to those producing extreme anxiety. With the client fully relaxed, the third step is to have the client imagine the previously identified anxiety-producing situations, beginning with the least disturbing and gradually working up to the most disturbing. Because of the incompatibility of feeling safely relaxed and anxious at the same time, the client gradually desensitizes to the unpleasant anxiety, and the maladaptive response is extinguished, alleviating the fear.

Aversion Therapy

Instead of using removal of reinforcement as a means of modifying behavior, aversion therapy pairs undesirable behavior with an aversive aftereffect. It has been found useful in problems of impulse control; for example, alcohol abuse or cigarette smoking. Here, the undesired activity is paired with a nausea-inducing drug, or one that produces a severely unpleasant taste. For example, when a person takes the medication Antabuse and drinks alcohol, the combination results in the person becoming extremely ill. It is thought that this pairing will condition the person to avoid drinking alcohol. It can be easily understood that full cooperation from the client is required for the ethical use of aversive therapy.

Covert Sensitization

An occasional substitute for aversion therapy is to have the client imagine, rather than experience, the unpleasant consequences of maladaptive impulsive behavior. The client is directed to pair the image of the undesired behavior with vivid images of unpleasant consequences; for example, imagining the revolting and possibly dangerous consequences of getting drunk.

Extinction by Removal of Reinforcers

Undesirable behavior is sometimes taught by situations in the environment that, in an unplanned way, reinforce the behavior. A common example in many homes is that of the child throwing a temper tantrum, which is unwittingly reinforced by the child becoming the center of everyone's attention, especially that of the parents. Once the parents leave the room or totally ignore the tantrum, thereby no longer reinforcing it, the temper tantrum subsides. If that practice is followed regularly, temper tantrums disappear or, at least, become less frequent.

Similarly, dependency or helplessness in adults can be reinforced by giving in to it; and conversely, can be reduced if the person appealed to—a spouse, an older child or, a friend—can be taught to refuse to comply with the plea for help in a compassionate way.

A familiar application of the technique of extinction has been labeled "time out." Predominantly used with children, the behavioral technique is to place the child in a completely neutral setting, where there are no reinforcements to be found, when the undesired behavior occurs. Compassion for the child demands that the isolation be relatively brief and that the place of removal is not frightening or dangerous to the child. Research suggests that, when used appropriately, time out can be very effective in decreasing children's misbehavior.

Overcorrection

In overcorrection, the individual is required to restore a situation damaged by his or her behavior to better than the original condition. This technique contains elements of punishment (it typically is not pleasant to have to make these extreme restitutions) but the emphasis is on learning the desired behavior. An example would be, after a child has wet the bed at night, he or she must get up, go to the toilet and try to urinate. Then the child will remove his or her pajamas and sheets, placing the pajamas and sheets in the wash and bathe. The child will then put on clean pajamas and sheets before going back to bed. This method of overcorrection has been helpful in treating bed wetting in children as well as correcting other inappropriate behavior of adults with developmental disabilities and children.

Positive Reinforcement

The most satisfactory method of modifying behavior is reinforcement of desired behavior. But because therapy is principally sought to eliminate undesired behavior, the primary challenge to using that method is eliciting the desired behavior. There are five well-tested techniques for successfully meeting that challenge: shaping, modeling, assertiveness training, differential reinforcement, and biofeedback.

SHAPING

When an individual seems unable to make a desired response instead of a maladaptive one, or when the desired response is a complex one, the client can be gradually led in the right direction by shaping his or her behavior; that is, reinforcing any response, no matter how slight, that moves the client toward the targeted goal, which is any behavior that approximates the desired response. For example, where a child

with autism (see Chapter 19) avoids any interaction with other children, behavior as simple as turning in the direction of another child sitting in the room would be reinforced every time the child does so. A step toward the other child, as it occurs, would be rewarded next, until finally, the child has reached the point of standing in front of the other child and making eye contact with him or her. The procedure would be repeated at subsequent sessions, taking care not to reinforce a previous response once the child has made a promising one, which is, of course, reinforced. The procedure does work to produce rudimentary social behavior, which, once engaged in, can produce its own reinforcing effects.

MODELING

Observing the successful efforts of others and then modeling one's behavior on theirs is a very common human learning experience. It begins early—for example, the success of the one-year-old imitating behavior of an older sibling or a parent—and continues on throughout life; for example, the golf novice imitating the stance of the golf professional. We all model our behavior on that of parents, teachers, friends, and, particularly in adolescence, celebrities.

It is just as easy to imitate good behavior as bad behavior, adaptive behavior as maladaptive behavior. That fact has turned the attention of psychologists to modeling as a form of treatment. The positive reinforcement that motivates modeling is two-fold: anticipated success in enjoying what another person seems to be enjoying, and the self-satisfaction of modeling the behavior of an admired person.

Its use in therapy is ordinarily easy to arrange: the admired therapist demonstrating his or her lack of fear of snakes; allowing the client to watch a group of children enjoying the antics of a dog; in a controlled setting, surrounding a child with children who are modeling desired behavior. Assertiveness training (discussed in the following section) offers positive modeling experiences for adults.

ASSERTIVENESS TRAINING

Assertiveness training, a well-known and widely used technique for encouraging shy or submissive people to assert themselves, can be viewed as a desensitizing technique and a shaping procedure with elements of modeling. The trainer, or group leader, might begin by stating the goal of the training, describing nonassertiveness as a common but handicapping trait, and assuring the group that active participation is voluntary. A next step is to get someone to volunteer to act out a very mild expression of assertiveness. The trainer might suggest a possible situation. After the performance, the encouraging comments of the trainer serve as reinforcement. Other volunteers are drawn into role-playing assertiveness in a variety of situations. The participants are then directed to attempt a real-life demonstration of an assertive position.

Three positive influences are operative in assertiveness training: positive reinforcement; the desensitizing effect of engaging in behavior that is gradually made more assertive; and the modeling effect of peer behavior. Assertiveness training is a useful therapy when maladaptive anxiety is due to a lack of self-assertiveness; however, the treatment has little relevance for conditions involving nonpersonal situations.

DIFFERENTIAL REINFORCEMENT

Differential reinforcement is the practice of reinforcing either desired behaviors or behaviors that are at least not undesired. A modification of this approach is differential reinforcement of behaviors that are incompatible with the undesired behavior. Differential reinforcement of other behaviors may be illustrated by a therapist praising a client for expressing distress through talking about feelings rather than acting them out in a self-destructive manner. An example of differential reinforcement of incompatible behavior would be a client receiving a reward for working on crafts when distressed rather than knocking around furniture and slamming doors (it is impossible to knock around furniture while, for example, painting).

BIOFEEDBACK

The essential element in biofeedback is immediately reporting back to a person any changes in autonomic activity, such as heart rate, blood pressure, changes in skin temperature, or galvanic skin response (a measure of perspiration). Those are all associated with emotional responses and are involved in anxiety attacks and phobic reactions.

Until the early sixties, voluntary control of autonomic responses was not thought to be possible. With the development of sensitive electronic devices that could accurately measure such physiological responses, it was soon discovered that they could be modified by such learning procedures as respondent and operant conditioning. With that discovery came the possibility that the unpleasant subjective experiences associated with heightened autonomic response could be controlled by the process of what has been called biofeedback. The procedure is itself a rather simple one, although it requires the use of equipment that can be elaborate and expensive. Autonomic responses are carefully measured, and the measurements are converted into visual or auditory signals that are quickly fed back to the client, who is then encouraged to use the signals in an effort to reduce the undesired autonomic response. The goal of treatment is to teach the client to control internal responses that may intensify the emotional responses associated with anxiety or panic reactions.

In the short term, it is now known that that goal can be achieved to some extent, but the effect is not a lasting one outside the therapy setting. With that finding, many clinicians have drawn the conclusion that a more efficient and longer-lasting treatment is relaxation training, which allows the client to induce relaxation independent of feedback from any equipment.

Critique of Behavioral Therapy

Behavioral therapy is here to stay, at least for the treatment of specific symptoms; for example, phobias, certain types of anxiety attacks, and impulse control. It has two strong advantages: sound, widely accepted theoretical underpinnings (the behavioral principles of learning on which it is based); and the precision and relative ease with which it can be used.

Its disadvantages are that as an action-oriented therapy, it leaves the client with little insight as to underlying causes of the symptom or its associated psychological disorder. A possible, although not frequent, unfortunate result can be that the treated symptom is replaced by a different one, which may be even more disruptive than the original symptom. For example, if the compulsive hair pulling symptomatic of trichotillomania is treated but the underlying cause of the disorder (for example, unconscious conflicts according to the psychodynamic perspective) is not treated, then hair pulling might be replaced with, for example, cutting oneself. One other possible limitation (at least for scientific purposes) is that subtle and unreported behavior of the therapist—for example, powerful suggestion—may be as influential as the behavioral procedures themselves.

COGNITIVE THERAPIES

As early as 1950, Dollard and Miller, themselves both possessing strong behavioral leanings, had proposed that cognitions (previously excluded from psychological research by behaviorists) were as much events subject to psychological study and modification as were actions. They, in effect, proposed changing the stimulus response formula to one including the organism with all its idiosyncratic cognitions in the formula, making it an S-O-R (stimulus-organism-response) arrangement.

Not until 1965 was this concept followed up in any systematic way. At that time, other behaviorists argued that stimulus-response connections were not automatic, that what thoughts and beliefs the individual brought to the situation influenced interpretations given to a stimulus and placed particular values on one response as compared with another response. Chapter 5 discussed those developments in detail. Examples of important cognitions that might influence what response an individual makes to a given stimulus are expectations, plans, and competencies.

The new approach drew from both behaviorism and cognitive psychology to establish new therapies and is frequently labeled cognitive-behavioral therapy. Within this perspective, there is no one accepted mode of the therapy. Here, we exemplify it in the practices of three clinicians: Albert Ellis; Aaron Beck; and Donald Meichenbaum and associates. Each is described briefly.

Albert Ellis: Rational-Emotive Therapy

Albert Ellis (1913-) bases his therapeutic approach on what he calls the irrational beliefs individuals bring to situations that cause them to respond maladaptively. An example is the belief that one should be competent, intelligent, and achieving in all situations. The client with such a belief sees depressioncausing failure in many situations in which success should never have been expected; expectations of constant successful performance were irrational.

Ellis's treatment is assertively, or even aggressively, confrontational. After discovery of the client's principal irrational beliefs, Ellis bluntly spells out the irrationality of the belief and directs the client to monitor behavior dictated by such beliefs and correct it. Between therapy sessions, the therapist encourages the client to behave in ways contrary to one or another of his or her irrational beliefs.

Ellis's proposed theory was so radical a departure from the well-established psychodynamic therapies that it was first looked upon scornfully by many clinicians. However, despite the discouraging start, rational-emotive therapy is still in use today and has empirical support (see for example, Gilbert, Cicolini & Mander, 2005).

Aaron Beck: Cognitive Therapy

Close in theory to rational-emotive therapy, Aaron Beck's (1921–) therapeutic methods are notably different. Beck's methods are based initially on his theory of depression, which he thought to be the result of irrational self-devaluation, an irrationally pessimistic view of one's life expectancies, and an irrationally gloomy view of the future.

The job of the therapist in Beck's approach is to draw out the client's unidentified irrational beliefs by Socratic questioning, thereby helping the client perceive his or her irrationality; for example, asking a client who is having interpersonal difficulties in keeping the peace because of suppressing emotions, "How well does keeping things in to avoid conflict work for you?" Beck's softer approach gradually allows clients to reach their own conclusions about the irrational nature of their beliefs. Beck and others using his techniques have reported success in using his method for treatment of depression, anxiety, and phobias.

Donald Meichenbaum: Self-Instructional Therapy

The unique feature of Donald Meichenbaum's therapy is self-talk. Behavior, he believes, is influenced by what people say to themselves before, during, and after their actions. For example, a nail biter, unhappy with the habit and unable to break it, might habitually self-talk in these words: "There I go again. I'll never be able to stop." Once the therapist is able to discover self-talk patterns such as that one, he or she attempts to change it from a self-defeating to a coping way of talking. Meichenbaum gives this example: "There I go again. Just this one nail. Then I'll stop . . . I knew the treatment wouldn't help me. I just can't control myself. Cut it out! You always make excuses for yourself. Take a slow, deep breath. Relax. Just think of sucking my finger in front of everybody. What a picture!" Clients are trained to practice encouraging self-talk on their own. The technique is useful not only in therapy but also in everyday use to build confidence. Today, star athletes can be seen on television engaging in self-talk at critical moments in their games.

Critiques of Cognitive Therapy

Within the limits set by its goal, a change in specific behavior, research reports indicate positive outcomes for all three therapies described in the preceding sections. Control of depression has been particularly promising. Critics of this style point out that the techniques offer the client little insight into broader personality characteristics and the theoretical framework for these techniques is not particularly well developed. Nevertheless, the positive outcomes have encouraged its growth in both therapeutic practice and theory development. Currently, cognitive therapy is frequently combined with behavioral techniques, which are drawn from classical and operant conditioning, into what is called cognitive-behavioral therapy.

BIOGENIC THERAPIES

Treatment of mental illness by direct alteration of bodily states has a long history. Even prehistoric people drilled holes into the skulls of those judged abnormal to allow evil spirits to escape. Long after that, primitive practices continued: purging the body of substances thought to cause mental disorders by laxatives; and bleeding, which continued through the eighteenth century as a common medical practice for physical and mental illnesses.

Successful treatment of mental disorders has trailed far behind effective treatment of physical illness. But as bodily functions have become better understood and as science has learned the effect of surgery, drugs, and even electricity on those functions, progress in treating physical conditions has led to increased physical treatment of mental disorders.

Some of those early efforts now seem as primitive and, in fact, were at least as dangerous as the archaic efforts of earlier centuries. Two of them, electro-convulsive therapy and psychosurgery, have all but disappeared. Today's biogenic therapies for mental illness are relatively safe and easily administered. But as with all treatment, in the hands of hasty and careless therapists or as used by careless, severely disturbed patients, they can have uncertain consequences.

The most progress in biogenic forms of treatment has come from developments in the field of pharmacology (the study of drugs and their effects on the body). Pharmaceutical drugs in current use aim at producing physiological changes that affect specific symptoms of mental illness. They have proven strikingly effective in the treatment of anxiety-based disorders, mood disorders, schizophrenia, and attention-deficit/hyperactivity disorder.

This section describes briefly electroconvulsive therapy, psychosurgery, and five types of drug treatment: antianxiety drugs; drugs for psychotic symptoms; antidepressant drugs; mood stabilizing drugs; and stimulants. All the described treatments are administered by a medical professional.

Electro-Convulsive Therapy

The administration of increasing dosages of insulin, a procedure that brings on shock and coma from an acute shortage of glucose (sugar) in the blood, was introduced in 1932. It was a drastic form of biogenic treatment with significant physiological complications, some fatal, but was nevertheless used widely in the treatment of schizophrenia until the end of the 1930s, when it gradually faded out as a treatment because of a high rate of relapse and a relatively high fatality rate.

Beginning in 1938, electrically induced convulsions gradually became the preferred form of convulsive type therapy. Following a short period when electroshock was used to induce convulsions in people with schizophrenia, its use was shifted to the severely depressed. The effective use of drugs for depression and other forms of mental disorders has narrowed its use to that of a fairly effective treatment of last resort for severe depression. Additionally, modern electro-convulsive therapy (ECT) is much more controlled and has much fewer side effects than the original methods used. A typical course of ECT may involve six to twelve sessions over the course of several weeks, during which the patient's medical and psychological conditions are monitored closely.

Psychosurgery

For a twenty-year period (1935–1955), prefrontal lobotomy, which involved the destruction of precisely defined and minute parts of the brain, was a frequently used treatment for severe psychoses. Although the operation did eliminate or reduce the most disturbing symptoms of the patients and thus made them more manageable, it also brought many of them to a mere vegetative existence. Since the development of effective antipsychotic drug therapies with only relatively mild side effects, psychosurgery is used only in extreme situations; for example, to reduce severe, life-disrupting seizures in individuals with epilepsy. In such cases, the surgical procedures are much more carefully planned and precisely focused to the affected brain structure than were the comparatively haphazard lobotomies.

Drug Therapies

Among biogenic therapies, drug treatment is far and away the most commonly used treatment for mental disturbances. It is easily administered and relatively effective for a variety of mental disturbances. Drug therapies have been found effective in the treatment of anxiety disorders, mood disorders, and schizophrenia, among others. We describe four types of drug treatment: antianxiety; antipsychotic; antidepressant; mood stabilizing drugs, and stimulants.

Antianxiety Drugs

Some of the antianxiety drugs are a class of medications called benzodiazepines, including brand names such as Ativan, Klonopin, Valium, and Xanax. Their widespread use suggests that they are an effective means of reducing tension. When followed up with psychotherapy, they can help the patient to deal with problem-causing anxiety. However, too often, both doctor and patient settle for regularly renewed prescriptions with no attempt at insight therapy. When that happens, both doctor and patient are inviting troublesome secondary problems: overdependence on the drug and the likely need to increase the dosage or to experiment with other, perhaps dangerous, drugs; failure to confront important psychological problems; and, in extreme cases, the temptation to take overdoses or to mix one drug with another, a step that has resulted in serious illness or death. Perhaps the best that can be said for benzodiazepines is that they are useful in the short term to help an individual gather psychological strength to undertake a proper course of psychotherapy or to deal with an immediate crisis.

Other medications have been found to be effective in treating anxiety with less potential for addiction or abuse. The other class of medications for treating anxiety disorders is known as selective serotonin reuptake inhibitors (SSRIs). These medications also are effective in treating depression (see the "Antidepressent Drugs" section). Brand names include Lexapro, Paxil, Prozac, and Zoloft. SSRIs are more frequently used for long-term treatment of anxiety disorders than benzodiazepines.

Antipsychotic Drugs

Schizophrenia was one of the first psychological disorders to be (relatively) effectively treated with medication. At that time, psychopharmacology was at best a crude science. Significant advances have been made in antipsychotic medications since then. The original antipsychotic medications are now referred to as traditional or typical antipsychotics, and the newer medications are referred to as atypical antipsychotics.

TRADITIONAL ANTIPSYCHOTICS

Traditional antipsychotics (also called neuroleptics) were major tranquilizers and they often reduced major symptoms of schizophrenia. The most commonly prescribed of the traditional antipsychotic drugs is the group of phenothiazines, which are available under the names Haldol, Mellaril, Stelazine, and Thorazine. Unfortunately, they have significant side effects. Common problematic side effects include tardive dyskinesia (involuntary movements, especially affecting the tongue and mouth), dry mouth, and muscle stiffness. The principal result of the drug treatment is to calm the person with schizophrenia, sometimes into a state of harmless drowsiness; however, not all symptoms of schizophrenia are alleviated. Specifically, negative symptoms of schizophrenia (see Chapter 14) tend not to respond to traditional antipsychotic medications.

ATYPICAL ANTIPSYCHOTICS

Atypical antipsychotics were developed to address negative symptoms of schizophrenia and to have fewer side effects. Abilify, Clozaril, Risperdal, Seroquil, and Zyprexa are all brand names of atypical antipsychotics. However, these medications still have significant side effects. Clozaril, for example, requires regular blood monitoring to avoid a dangerous white blood cell condition. As newer antipsychotic medications are developed, they tend to have less severe side effects and tend to better manage both positive and negative symptoms.

Many individuals, while on antipsychotic medication, are able to live in the community, where they seem to function adequately. Others may require periodic visits to hospitals to be re-stabilized on medication or may live in supportive environments in the community or long-term care facilities. These drugs are not a cure for schizophrenia, only a means of controlling the most disturbing symptoms of the illness. A major social problem created by the therapeutic use of the drugs is the early release into the community of people who are still struggling with symptoms of schizophrenia, with no family support and no community program of aftercare. Many such individuals have become part of America's population of the homeless.

Antidepressant Drugs

Commonly used antidepressant drugs are Celexa, Lexapro, Paxil, Prozac, and Zoloft, part of a group named the selective serotonin reuptake inhibitors (SSRIs). This class of medication prevents the reabsorption of the neurotransmitter serotonin, increasing the amounts of serotonin in the synapse (gap between two neurons). Although these drugs are slow to take effect, they have become a major source of relief for individuals with depression. Unfortunately, abruptly discontinuing the medication can result in unpleasant symptoms including dizziness, gastrointestinal distress, anxiety, irritability, sleep disturbance, and flu-like symptoms. As is true for most drug therapies, full treatment is best affected when it is combined with a program of psychotherapy.

There are other classes of antidepressant medications. For example, the tricyclic antidepressants include Elavil, Pamelor, and Tofranil. Ticyclic antidepressants prevent the reabsorption of serotonin and norepinephrine, increasing their concentrations in the synapses. The monoamine oxidase inhibitors (MAOIs) include Nardil. MAOIs prevent the breakdown of the neurotransmitters serotonin, dopamine, and norepinephrine, increasing their levels in the synapses. Unfortunately, both tricyclic antidepressants and MAOIs have significant side effects and, therefore, are less frequently used than SSRIs. There is one dopamine reuptake inhibitor, with the brand name Wellbutrin, that has been found to be effective in the treatment of depression and an aid in smoking cessation. Often, the process of finding the antidepressant that is most effective for an individual with the least disruptive side effects is a process of trial and error.

Mood Stabilizing Drugs

The principal mood stabilizing drug is lithium, a natural mineral salt that has proved effective in ending 70 percent of all manic episodes. The principal problem in its use is establishing the proper dosage. The difficulty is that raising the dosage too close to the margin of toxicity in an attempt to increase its effectiveness can produce serious illness. Fortunately, the patient on a self-maintenance regimen is

usually troubled by minor physical symptoms that should signal the need to reduce the medication prior to any serious concerns. In any case, lithium levels have to be monitored regularly.

Another class of medications that are frequently used in the treatment of bipolar disorder is anticonvulsant medications, such as Depakote, Lamictal, Tegretol, and Topomax. Each of these medications has its own profile of side effects and benefits in the treatment of bipolar disorder. Although not as effective in treating mania, they do not present the same concerns with toxicity as does lithium, so their popularity is increasing.

Stimulant Medication

Stimulant medication has been found to be effective in the treatment of attention-deficit hyperactivity disorder (abbreviated ADHD; see Chapter 19). Adderall, Concerta, and Ritalin are examples of brand names of stimulant medications regularly used to treat ADHD. Research suggests that stimulant medication can be very effective in the treatment of ADHD, especially when combined with psychotherapy to address associated concerns. As with any medication, there are some side effects of stimulant medication. There have also been recent concerns regarding overprescription of stimulants to children, but when an appropriate diagnosis has been made, stimulants can dramatically improve the functioning of individuals with ADHD.

There is a nonstimulant medication that does not fit into any of the categories listed above, but that has become a popular treatment for ADHD. Strattera is a brand name of a norepinephrine reuptake inhibitor, which prevents the reabsorption of norepinephrine. It has become popular because it does not have the side effects of stimulant medication (increased risk of tics, potential for abuse, and so on); however, it is not without side effects. These include stomach upset, mood swings, dizziness, and tiredness.

MULTIPLE-PERSON THERAPIES

One of the most distinctive developments in psychological treatment is multiple-person therapy. It takes a variety of forms. The most common of them are group therapy, peer group therapy, and family and marriage therapy.

Group Therapy

Simply defined, group therapy is the assembling of a group of people with psychological problems for the purpose of discussing their problems under the guidance of a professionally trained leader, frequently a psychologist. Within that framework, group therapy can take a variety of specific forms determined principally by the theoretical perspective of the leader and the kinds of problems the participants bring.

The most precise way of describing possible therapeutic values to be found in group therapy is to describe, from Irwin Yalom's book, The Theory and Practice of Group Psychotherapy (1975), nine benefits that group therapy offers. They are as follows:

- 1. Information about a problem, its possible causes, and remedies that might be helpful.
- 2. Hope; that is, knowing something about a problem generates a feeling that something can be done.
- 3. Commonality; that is, knowing that other people have similar problems and that the patient is not alone.
- 4. Altruism, because as group members try to help each other, they come to feel better about themselves.
- 5. Family membership; a group can soon establish family-like relationships. This new family can teach new ways of relating to parents, spouses, children, and friends.
- 6. Development of social skills, including listening, talking, and interacting with others are all likely to improve social skills. Particularly helpful is the feedback one gets to one's own behavior from other members of the group.

- 7. **Modeling;** that is, an individual may find it helpful to emulate the behavior of other participants or of the group leader.
- 8. Catharsis, or the open exchange of feelings among members may encourage the venting of hostile or embarrassing feelings that, when previously bottled up, caused tensions.
- 9. **Belongingness**; a well-run group quickly establishes a sense of cohesiveness that, one hopes, creates a sense of belonging in the participants.

Peer Group Therapy

Some of the benefits of professionally led groups can be found in peer groups, a group of individuals with similar problems—substance abusers, for example—who come together to give each other social support and possible guidance in solving problems. One widely known and well-thought-of peer group is Alcoholics Anonymous (A.A.). The group is distinctive, because its operation is based on a number of strongly held beliefs: Once an alcoholic, always an alcoholic; no one can stop drinking without help; in offering that help to others, one helps oneself. The program is widely supported by former alcoholics who have benefited from it and by many clergy of all faiths. There is much debate about the effectiveness of mutual support groups such as Alcoholics Anonymous among psychologists. Research suggests that A.A. is effective in preventing relapse for alcoholics who actively participate in the program; however, A.A. is spiritual in nature, which may be objectionable to some clients or their therapists. Many psychologists view A.A. or other such groups as helpful adjuncts to professional treatment.

Family and Marital Therapy

A family with children or a couple can be thought of as a group with a structure; roles that are enacted; and communication among members, whether good or bad. Where any of those elements are warped—for example, a family structure with a domineering head, a scapegoat role for one of the children, or contradictory messages from parents or sometimes from the same parent—problems will develop. Both family and marital therapy, with the help of a neutral outside person, attempt to bring maladaptive practices out into the open and effect changes in them.

A psychologist's approach to family or marital therapy is influenced by his or her orientation (psychodynamic, cognitive-behavioral, and so on). Furthermore, some orientations have developed that focus specifically on the family. The family systems orientation views the family as a dynamic, reciprocally influenced system—when one member of the family changes, it results in other members changing to maintain balance. The family is treated as a unit, not a collection of individuals. Individual behavior is seen as having multiple determinants, including genetic, biological, psychological, and social factors. Interventions tend to focus on interactions within the family.

A variety of techniques have been found useful in family and marital counseling. Two examples are the communication approach, in which an effort is made to identify and discuss covertly contradictory messages used by one or more members of the family or marital group, and paradoxical intention, in which a family member will be encouraged to role-play offensive behavior that has been identified and to learn how it affects other members, who are encouraged to react to it. An emphasis in marital therapy is dialogue between the two members, with an attempt to motivate both to express their feelings about what is wrong with their ways of talking to each other.

SUMMARY

Behavioral therapy is an action-oriented therapy with the goal of effecting specific behavioral change. It is therefore considered specific in its focus, and is looked upon as an applied science in its methodology. Several therapeutic techniques are outlined—eight strictly behavioral therapies, and three that are considered cognitive or cognitive-behavioral.

- Extinction of undesirable behavior: This is a form of behavioral therapy in which any reinforcement of the undesired response, no matter how subtle or indirect—for example, merely paying attention to it—is eliminated. A common form is a "time out," in which, for example, a misbehaving child is placed in a neutral situation and isolated from all social reinforcements of the undesired behavior.
- Extinction by systematic desensitization: Used principally to reduce anxiety or phobias, the goal is to gradually allow the individual to experience graded levels of tension producing stimuli under highly relaxed and protected circumstances until the individual becomes desensitized to the stimuli.
- Overcorrection: In overcorrection, the individual is required to reverse the impact of his or her undesirable situation by returning the situation to better than the original condition. An example would be requiring a child who has wet the bed to clean him or herself, pajamas, and bedding.
- **Shaping:** To encourage an individual to move toward more complex but desirable social skills, for example, the therapist reinforces any behavior that moves the individual in the desired direction.
- Modeling: This is a simple therapy in which a situation is created to allow the client to observe examples of the desired behavior and to imitate them.
- Assertiveness training: This is a group form of therapy in which an overly inhibited individual is taught to be more assertive by verbal instruction, protected trials, and then relatively safe real-life trials, which are later reported to the group.
- Differential reinforcement: Differential reinforcement includes the reinforcement of more desirable behaviors or behaviors that are incompatible with the undesirable behavior.
- Biofeedback: To learn to control various physiological responses that support undesired symptoms—for example, anxiety—the therapist arranges equipment so that the client can immediately get feedback on such physiological responses as pulse rate and blood pressure and then, while watching the feedback data, the client is directed to lower the physiological response.

In cognitive-oriented therapy, faulty ways of thinking, such as "everyone must like me," that would lead to maladaptive submissive behavior, are first identified and then corrected. Such thinking includes unrealistic expectations, impossible plans, and feelings of inferiority about one's competence. There are three principal cognitive therapies.

- Rational-emotive therapy: Developed by Albert Ellis, the therapy first identifies irrational beliefs. The therapist, in a confrontational fashion, then points out in multiple ways how irrational the belief
- Cognitive therapy: Aaron Beck, instead, uses a gentler form of changing irrational beliefs. He employs a Socratic questioning method to reduce the grip of the irrational belief on the individual's behavior.
- Self-instructional therapy: Donald Meichenbaum encourages clients to take a self-instructional approach. He directs them to talk to themselves in ways that attack the false beliefs or encourage the desired behavior.

Finally, there are two principal forms of biogenic therapy.

- Drug therapy: The most widely used is drug therapy. Drugs are now available to reduce anxiety, psychotic symptoms, depression, manic behavior, and hyperactivity/inattention. All have at least a short-term effect on the undesired symptoms, but are most effectively used when accompanied or followed by psychotherapy.
- Other biogenic therapies: Other forms of biogenic therapy, such as psychosurgery and electroconvulsive therapy, are occasionally used as treatments of last resort.

Much therapy takes place in a one-to-one relationship between client and therapist. However, a variety of multiple-person therapies have been developed. The two principal types are peer group therapy, which may be led by a professionally trained leader or carried on by the clients themselves as in Alcoholics Anonymous, and family/marital therapy, in which all members of a family group are seen in therapy, both as a group and individually.

SELECTED READINGS

Alcoholics Anonymous (2002). *Alcoholics Anonymous* (4th ed.). New York: Alcoholics Anonymous World Services.

Beck, J. S. (1995). Cognitive therapy: Basics and beyond. New York: Guilford Press.

Bentley, K. J. & Walsh, J. (2000). The social worker and psychotropic medication: Toward effective collaboration with mental health clients, families, and providers (2nd ed.). Belmont, CA: Wadsworth Publishing.

Brabender, V. (2002). Introduction to group therapy. Hoboken, NJ: Wiley.

Ellis, A. (2001). Overcoming destructive beliefs, feelings, and behaviors: New directions for rational emotive behavior therapy. Amherst, NY: Prometheus Books.

Ellis, A. & Wilde, J. (2001). Case studies in rational emotive behavior therapy with children and adolescents. Upper Saddle River, NJ: Prentice Hall.

Gilbert, M., Cicolini, T., & Mander, A. (2005). Cost-effective use of rational emotive behavior therapy in a public mental health service. *Journal of Rational-Emotive & Cognitive Behavior Therapy*, 23, 71–77.

Goldenberg, H. & Goldenberg, I. (2003). *Family therapy: An overview* (6th ed.). Belmont, CA: Wadsworth Publishing.

Spiegler, M. D. & Guevremont, D. C. (2002). *Contemporary behavior therapy* (4th ed.). Belmont, CA: Wadsworth Publishing.

Test Yourself

1)	The technique of teaching relaxation to alleviate phobias is called	strategies that the client uses while imagining feared situations			
	a) assertiveness training	c) positive reinforcement			
	b) aversion therapy	d) systematic desensitization			
2)	Rewarding successive approximations of a desired behavior is called				
	a) covert sensitization	c) overcorrection			
	b) modeling	d) shaping			
3)	Aggressively challenging irrational beliefs is characteristic of which psychologist's approach?				
	a) Aaron Beck	c) Donald Meichenbaum			
	b) Albert Ellis	d) Joseph Wolpe			
4)	What strategy teaches clients to cont	rol autonomic responses?			
	a) biofeedback	c) differential reinforcement			
	b) covert sensitization	d) extinction			
5)	Which psychologist is known for usi	ing the Socratic method to draw out client's irrational beliefs?			
	a) Aaron Beck	c) Donald Meichenbaum			
	b) Albert Ellis	d) Joseph Wolpe			
6)	Which type of therapy relies on people with similar difficulties helping each other?				
	a) peer group therapy				
	b) rational-emotive therapy				
	c) self-instructional therapy				
7)	One of the criticisms of behavioral the	herapy is			
	a) The theoretical basis is difficult to prove.				
	b) It offers clients minimal insight.				
	c) The theoretical foundation is not	well developed.			
	d) It has significant side effects.				
8)	One of the criticisms of cognitive therapy is				
	a) It places too much emphasis on unconscious conflicts.				
	b) As symptoms are removed, they				
	c) The theoretical foundation is not	well developed.			
	d) It has significant side effects.				
9)	Electro-convulsive therapy and psychosurgery are no longer used. True or false?				
10)	Selective serotonin reuptake inhibito	ors (SSRIs) are used to			
	a) treat attention problems	c) treat schizophrenia			
	b) treat depression	d) stabilize mood			

Test Yourself Answers

- 1) The answer is **d**, systematic desensitization. Systematic desensitization is used to treat phobias by providing the client with relaxation techniques. These relaxation techniques are used while imagining progressively more anxiety-provoking situations so that the client learns to associate relaxed feelings, rather than anxious feelings, with the feared situation.
- 2) The answer is **d**, shaping. Shaping is the process whereby new behavior is taught by rewarding only behavior that is increasingly closer to the desired behavior. It can be used to teach many skills, from writing to social behavior.
- 3) The answer is b, Albert Ellis. Ellis actively confronted his clients to help them move beyond their irrational beliefs. Some people find these techniques too strong, but others believe that it takes a strong approach to break through years of habits of irrational beliefs.
- 4) The answer is a, biofeedback. Biofeedback uses equipment to provide clients with feedback regarding their autonomic responses, such as heart rate and galvanic skin response. Clients then use this feedback to learn to control their autonomic responses, allowing the client to decrease physiological symptoms of emotional states such as anxiety and anger.
- 5) The answer is a, Aaron Beck. Beck's method of challenging irrational thoughts is much less confrontational than Ellis's model. Beck utilizes the Socratic method of asking insightful questions to allow the client to come to the realization of the irrationality of his or her own thoughts.
- 6) The answer is a, peer group therapy. Peer group therapy encourages people with similar problems to help each other. Perhaps the best known example of this is Alcoholics Anonymous, a fellowship of people with alcoholism who share their own experiences of living life sober with others who have drinking problems, and helping each other stay sober.
- 7) The answer is **b**, it offers clients minimal insight. Critics of behavior therapy claim that it offers clients little insight because therapists actively combat symptoms rather than trying to help the client understand those symptoms.
- 8) The answer is c, the theoretical foundation is not well developed. Critics of cognitive therapy take issue with the fact that cognitive theory does not have a well-developed foundation. In particular, it is pointed out that there is not a comprehensive cognitive theory of personality.
- 9) The answer is false. Electro-convulsive therapy and psychosurgery are not used as frequently as they have been in the past and have certainly changed dramatically since the techniques were first developed. However, they are both still used as treatments of last resort for individuals who have not responded satisfactorily to other treatment methods. Specifically, electro-convulsive therapy still is used to treat depression and psychosurgery is used to treat epilepsy.
- 10) The answer is **b**, treat depression. SSRIs are used to treat depression, in addition to anxiety disorders. In fact, SSRIs are the most frequently used antidepressant medications and among the most frequently used psychotropic medications (medications that affect the mind, emotions, or behavior).

Anxiety Disorders

ome of the most prevalent of all the clinical syndromes studied in abnormal psychology are the anxiety disorders. The National Institute of Mental Health estimates that nineteen million people in this country suffer from one or another of the disorders.

Because of their prevalence and the suffering caused by them, much effort has been expended in attempting to understand the nature of these psychiatric illnesses. That understanding is not only necessary for the work of psychologists and psychiatrists but also of practical value in such other professional fields as medicine, social work, teaching, the ministry, and police work. Those professions are often asked to help people who have the disorders. It also is useful in giving the healthy person insight into his or her own fears and occasional attacks of anxiety.

Beginning with a discussion of fear and anxiety that are complexly involved in certain of the anxiety disorders, the chapter continues with a statement on the DSM-IV-TR classification of the anxiety disorders. It then describes six types of anxiety disorders (specific phobia, panic disorder, social phobia, post-traumatic stress disorder, generalized anxiety disorder, and obsessive-compulsive disorder), their symptoms, and how widespread they are. Stress and reactions to stress such as adjustment disorders also are discussed. Causal factors and therapeutic approaches also are examined.

FEAR AND ANXIETY

Fear and anxiety are disturbing emotional states that affect all individuals at some time or another, but appear more prominently and with more disruptive effect in the lives of those with anxiety disorders. Although they are intertwined in the symptomatology of the anxiety disorders and tend to reinforce each other in harmful ways, they are distinguishable, and their differences are a concern of the student of abnormal psychology.

Fear

Fear occurs more frequently than anxiety. It is an emotional and apprehensive response to a specific thing or situation. People fear heights, dogs, snakes, crowds, or disease. Anxiety, on the other hand, is a diffuse response focused on no specific object.

The Elements of Fear

Psychologists have identified four elements in the fearful response: the cognitive element, in which there is a preoccupying dread of possible danger or harm; the somatic reaction, which ranges from pupillary and respiratory changes through immune system responses and bladder tension or release; the emo-

tional element, which includes feelings of apprehension; and finally, the behavioral element, the response to the fear-inducing situation such as fleeing, attacking, or otherwise attempting to cope.

Normal Fears

The experience of fear in the face of real or threatened danger is a normal and healthy experience. Walking through a dangerous neighborhood late at night will arouse some fearfulness in almost everyone. A construction worker atop a skyscraper may experience fright in the face of a strong wind. Few people in combat have escaped fear.

Abnormal Fears

Fear is an abnormal response when there is no real or possible danger and when most people would not be frightened; that is, when the fear is irrational. Examples of such fears are fright at the approach of a leashed dog or the presence of a cat rummaging in the garbage. The abnormality of the fear is more certain when the fearful response takes extreme form and severely limits the individual's life activities.

Anxiety

Although anxiety has the same four elements as fear, it is to be distinguished from it. In anxiety, the cognitive element is vague and intellectually unfocused. Instead of awareness of a clear and known danger, the individual feels a generalized apprehensiveness. The predominating thought is that "something terrible is going to happen to me." The sufferer cannot attack or destroy the cause of anxiety because it has no specific existence, nor can he or she flee from it. The emotional and somatic elements of anxiety are similar to those of fear but usually more intense. Short periods of anxiety can occur to the normal person and, when mild, does not cause significant impairment. When anxiety is severe, persistent, and disruptive of normal life activities, it signals an anxiety disorder.

SPECIFIC PHOBIA

A phobia is a persistent fear reaction to some specific object or situation. The fear is disproportionate to the likelihood of danger. Frequently, it is a fear many normal people also feel, such as fear of darkness, heights, spiders, snakes, or disease. The response of an individual with a phobia, however, is extreme. In the case of dog or cat phobias, for example, the fear response can make a normal life difficult or impossible. Some phobias, even though maladaptive, may have minimal influence on a person's activities; for example, a snake phobia will not much trouble a city dweller and hardly needs treatment. Other phobias may completely disrupt a person's life.

Types of Phobias

Simple phobias fall into five types: animal (for example, dogs, snakes); blood-injection-injury (for example, seeing blood or receiving an injection); natural environment (for example, heights and storms); situational (for example, planes or enclosed places); and other types (for example, clowns or contracting an illness). Often, individuals with a specific phobia have more than one phobia. In all the simple phobias, the individual goes to extreme lengths to avoid the source of fear. For example, a person with a fear of heights may avoid bridges and balconies. As a result, he or she may be limited in travel, work choices, and social activities.

Prevalence and Course

Estimates suggest that 11 percent of the population will at some time experience specific phobia. Women are twice as likely as men to have a specific phobia. Specific phobias often begin in childhood and persist into adulthood.

PANIC DISORDER

Panic disorder is defined as a series of recurrent, unexpected panic attacks followed by concerns about having more panic attacks, worry about the meaning of the attacks, or a corresponding change in behavior. The symptoms of a panic attack are multiple and terrifying and, although they usually peak in ten minutes, the symptoms can linger afterward. Typical symptoms during the attack are shortness of breath, heart palpitations, profuse sweating, dizziness, and intense fear of dying or going crazy. Often, such an attack seems to follow a disturbing life experience such as an enforced job change.

Presence or Absence of Agoraphobia

Panic disorders are broken into two categories: panic disorder with agoraphobia and panic disorder without agoraphobia. The principal symptom of agoraphobia is a fear that a panic attack will occur when the individual would feel unsafe, such as in a crowd, in an open space, when traveling, or even on the street. Agoraphobia results in additional impairment beyond the panic attacks; in many cases, the individual is unwilling to leave home.

Prevalence and Course

Panic disorder is twice as common in women as in men and affects approximately 3.5 percent of the population. It often first occurs in late adolescence or early adulthood. Panic disorder may be a lifelong illness, may occur intermittently, or may remit spontaneously. About one third of individuals with panic disorder also have agoraphobia.

SOCIAL PHOBIA

The exclusive concern of the individual with social phobia is being seen, watched, or evaluated. Thus, they would avoid or worry about eating in restaurants, performing a job task while being watched, or speaking or performing in public for fear of doing something humiliating. They avoid crowds because they may be watched critically. All of these experiences produce an acute sense of embarrassment and the urge to escape.

Social phobia may be limited to certain situations or may occur across a broad range of contexts. Individuals with social phobia often experience physical symptoms such as blushing or shaking.

Social phobias most frequently develop in childhood or adolescence, with gradual onset. Later on, the disorder may produce serious disruption in the life of the individual, causing the person, for example, to give up job after job for fear of being watched. Social phobia occurs equally frequently across genders and affects approximately 13.3 percent of people in the United States.

REACTIONS TO STRESS: ADJUSTMENT DISORDERS AND POST-TRAUMATIC STRESS DISORDER

Adjustment disorders and post-traumatic stress disorder are reactions to an actual undesirable and usually recent or ongoing event. Adjustment disorders and post-traumatic disorders grow out of stress, the consequence of a trying situation to which the individual is attempting to adjust.

Stressors and Adjustive Demands Imposed by Stress

Stressors are adjustive demands made on the individual by such events as missing an important engagement or having an argument with a spouse. But life also requires adjustive demands to very serious events: divorce; death of a loved one; and even such catastrophic events as military combat or natural disasters. Stressors impose one or another of three types of unpleasant psychological states to which the individual must adjust: frustration; conflict; and/or pressure.

Frustration

When an obstacle, either external or internal, stands in the way of an individual's goal, or when the individual can find no suitable goal to focus on, frustration results. External obstacles are unavailability of satisfying employment or rejection in a romantic pursuit; internal obstacles (characteristics of the individual) may be incompetence, physical handicap, or handicapping personality traits. Frustration causes anger, feelings of inadequacy, and self-deprecation. When prolonged, it can elicit the fight-or-flight reaction.

Conflict

Everyone's life is occasionally beset by conflict, minor or major. There are three patterns of conflict:

- Approach-avoidance conflict, a situation in which the individual has reason both to approach a goal and to avoid it. A desirable goal, such as an early marriage, has an undesirable consequence, such as necessitating postponing a college education.
- Double approach conflict, in which an individual seems doubly blessed having to choose between two equally desirable goals—two attractive job offers, for example. Although a happy type of problem, the stress in making a decision can be trying.
- Double avoidance conflict, a problem of choosing between two undesirable options—a poignant example is that of the elderly individual who must choose between a painful and risky operation and continuing to live with a painful and debilitating medical condition.

The stress of conflict causes troubling thoughts, fits and starts of activity, and, if prolonged, emotional exhaustion.

Pressure

Life can be full of pressure to do well at school, to get a job, or to "shape up." Sometimes, the pressure is from external sources (referred to as pressure to conform); at other times it may be self-imposed (referred to as pressure to perform). Perhaps surprisingly, the latter may be the more stressful. Later on, life may bring other pressure from a spouse, from the demands of a job, or pressure to care for elderly parents.

Factors Affecting the Severity of the Stress

Severity of the stress is judged by its disruptive effects on the individual's behavior. Disruptive effects are determined by an interaction among the characteristics of the stressor (for example, degree of change, controllability, duration), the biological and psychological characteristics of the individual (for example, temperament, appraisal, intelligence), and the social supports available to him or her (for example, family environment, global social support).

Characteristics of the Stressor

Duration, cumulative effect, and multiple stressors all increase the extent of the disruption. A second day of a nagging headache is disruptive indeed. Mounting stress can lead to a breakdown. One stressor after another is bound to weaken the individual's capacity to adjust. Some values in life are especially meaningful; an attack on them can be extremely stressful. Stressors that introduce a large amount of change can be particularly difficult.

The Individual's Characteristics

Vulnerability and the presence of positive coping mechanisms are essential to understanding the likely disruptive effects of stress. The coping techniques life has taught an individual are critical. A problem-focused approach reduces the negative impact of stress; the very effort of doing something may help. Emotion-focused behavior, which is essentially a protective effort to reduce the painfulness of the symptoms, may help in the short term or when problem-focused coping is not an option. Meaning-focused coping includes strategies oriented toward making sense of and coping with stress. Meaning-focused coping can be an effective strategy for long- or short-term stressors and for controllable or uncontrollable stressors. Evidence also suggests a genetic component to vulnerability or hardiness in response to stress. Characteristics with inherited components such as intelligence and temperament affect responses to stress. For example, individuals with easy temperament or average levels of intelligence adapt to stress more effectively than individuals with difficult temperaments or below (or above) average intelligence.

Social Supports

Never are helpful relatives or friends more appreciated than in times of stress—to talk with, to suggest options, and to provide tension-relieving social activities or material assistance. Of course, sometimes loved ones are the sources of stress rather than support. Group support, although less personal, also can provide helpful resources. Support can be found in religious or community groups and professional help from social or governmental agencies.

Reactions to Stress

There are four principal reactions to stress: problem-focused coping; emotion-focused coping; meaning-focused coping; and decompensation.

Problem-Focused Coping

In some instances, individuals faced with stress will direct efforts toward a goal in a task-oriented way, meeting the adjustive demands of the stressor. Typical problem-focused responses include objectively appraising the situation, developing possible options, selecting one, and observing its impact on the stress. The more secure or flexible the individual, the more willingness there will be to change behavior in response to feedback obtained from its effect. If attempting to change the situation won't work, a person may shift to making personal changes. Examples are working harder, acquiring new skills, or asking for assistance.

Emotion-Focused Coping

Emotion-focused coping frequently has short-term positive effects, but may have long-term maladaptive effects. Emotion-focused coping includes efforts to manage an emotional response. Examples include expression of emotion (which can be beneficial or harmful depending on how the emotion is expressed) and avoidance of stressful situations. It has the short-term effect of releasing tension, and also, perhaps, gaining sympathy. But as time goes on and no effort is made to address the problem, problems mount as the stressor becomes chronic.

Meaning-Focused Coping

Meaning-focused coping includes strategies that do not attempt to change the stress directly or cope just with the emotions, but put the stressor in a different light that facilitates coping. Examples include finding joy even in times of stress, finding good in difficult circumstances, and changing goals. Meaning-focused coping has been found to be associated with positive outcomes in people facing a range of stressors.

Decompensation

The most seriously disruptive reaction to stress is decompensation. When the stressor situation is extremely demanding or prolonged—a siege of combat duty or being held captive as a hostage or in a concentration camp, for example—any adaptive capacities of the individual may be overwhelmed. Efficiency is lost, vulnerability to other stressors is increased, disorders develop, and complete exhaustion makes any self-sustaining effort impossible. Decompensation usually is both biological and psychological.

BIOLOGICAL DECOMPENSATION

The general adaptation syndrome of Hans Selye is a widely used model to picture the course of biological decompensation under extreme stress. He pictures three phases of that reaction: the alarm phase, during which the body's resources are called into action and all the body's physiological defenses against assault are alerted; the stage of resistance, a prolonged period during which the biological resources of the individual work at maximal level to reduce the stress; and the exhaustion phase, when collapse results due to the depletion of the body's resources. The consequence is disintegration—physical health declines and, if outside help is not provided, death may be imminent.

PSYCHOLOGICAL DECOMPENSATION

The psychological analogue follows exactly the stages of biological decompensation except that psychological, not biological, resources are utilized. In the alarm stage, the individual is alert and mobilizes mental energies. Emotional arousal, tension, and sharpened sensory power lead to the initiation of coping responses. The stage of resistance intensifies coping behavior. If stress continues unabated, the individual's mental resources are expended. Individuals vary in the length of time that process will take. When decompensation does take place, psychological collapse matches biological collapse and may lead to an adjustment disorder or post-traumatic stress disorder.

MADJUSTMENT DISORDERS AND POST-TRAUMATIC STRESS DISORDER

The DSM-IV-TR gives formal recognition to two types of stress-related disorder: adjustment disorder, a response within three months of the occurrence of a stressor within the range of common experience (for example, death of a loved one, divorce), and post-traumatic stress disorder, the development of severe symptoms following a traumatic event outside the range of typical human experience (an earthquake, military combat, being held hostage).

Adjustment Disorders

The essential feature of the adjustment disorder is a maladaptive response to an identifiable psychosocial stressor. Critical diagnostic signs are notable impairment in social, occupational, or academic functioning, or symptoms that exceed normal or expected response to the stressor. The impairment may result in depressive symptoms, anxious symptoms, disturbed conduct, or any combination thereof.

Symptomatology

The severity of the symptoms often varies with the duration of the stressor, the presence of secondary stressors, timing in the individual's life cycle, and the importance of the value threatened by the stressor. The same stressor does not affect all people in the same way. In a vulnerable individual, a mild or moderate stressor can produce severe symptoms; a major or continuing stressor may produce only minor symptoms in a less vulnerable person. Aside from disruption in work or ordinary routines, adjustment disorders may cause depression, with feelings of hopelessness, crying, apprehensiveness, jitteriness, and restless behavior. Erratic behavior may also be present, during which the individual ignores the rights of others, or is combative, reckless, or irresponsible in meeting legal or financial obligations.

Prevalence and Course

There are no reliable figures on the prevalence of adjustment disorders. The disorder may occur at any age. Onset must be within three months of the occurrence of the stressor. The disorder is expected to remit within six months after the stress eases, with or without therapy. However, sometimes therapy can ease the transition, especially when the stressor is chronic.

Post-Traumatic Stress Disorder

Diagnosing PTSD rests on two essential elements: the occurrence of a catastrophic stressor in the past history of the individual and a characteristic pattern of symptoms.

Stressors Associated with PTSD

These are always experiences that do not occur to the average individual, such as military combat, rape, being held hostage, captivity in a concentration camp, or natural disasters such as flooding or earthquakes. Almost everyone would show significant signs of distress following any of those experiences. The condition is PTSD if three highly specific symptoms occur.

Characteristic Symptoms

The three symptom patterns are as follows: reliving the event (for example, recurrent nightmares, sharp periodic recollections of the event or feeling as though the event were recurring, called flashbacks); avoidance of things associated with the trauma and numbness to outside events (for example, inability to recall aspects of the trauma, feelings of detachment); and symptoms of arousal (for example, exaggerated startle response, difficulty concentrating).

Prevalence

The lifetime prevalence rate of PTSD is estimated to be 7.8 percent. It is more common in women than in men. It is important to note that not all individuals exposed to traumatic events develop PTSD.

MOBSESSIVE-COMPULSIVE DISORDER

The primary symptoms characterizing obsessive-compulsive disorder (OCD) are preoccupying yet unwanted thoughts (obsessions) that induce anxiety and repetitive, irresistible, and undesired behavior (compulsions) that are intended to reduce anxiety. Both types of behavior in mild form commonly appear in the general population. Although maladaptive, they do little harm. In severe form, they are disruptive to ordinary life activities and are often associated with depression.

Normal Obsessions and Compulsions

Examples of normal obsessions are persistent thoughts, sometimes unpleasant, about an upcoming event, a longed-for experience, a song that cannot be cleared from consciousness, or a persistent thought that harm will come to a loved one. They are irritating and maladaptive but not pathological.

Examples of normal compulsions are repeatedly checking to see that a door has been locked, a stove is turned off, or that the baby is safely asleep. The superstitious and repetitive behavior of some athletes

is a good example of a compulsion that results from the past reinforcement of the repetitive behavior. Normal compulsions, for the most part, occur only sporadically. Although they are bothersome, they cause no major disruption in the individual's life.

Pathological Obsessions and Compulsions

Pathological obsessions do not easily pass away, they are not easily controlled, and they significantly disrupt the individual's life. Their content is often unacceptably sexual or hostile and violent.

Pathological compulsions are most often of one or two types: a checking or ordering ritual or a cleansing ritual. They are not the occasional rituals of many people but use up hours of the day in compulsive behavior. In the checking ritual, the individual may go from checking all the doors to checking all the windows, repeating the process again and again in fear that he or she may have missed one. In the cleansing compulsion, the individual seems driven to engage in some cleansing activity to get rid of contamination or to prevent it. It most often takes the form of hand washing, which may, in extreme cases, take place a hundred or more times a day, every time an object has been touched.

Other Symptoms of Obsessive-Compulsive Disorder

With both obsessions and compulsions, the individual finds no satisfaction in either the thoughts or the actions. In the former case, the person's helplessness in driving the thoughts out of his or her mind is depressing; with compulsions, the individual is continuously fearful about the result of not carrying them out. In the most extreme cases of obsessive thinking, the individual does not listen to what other people are saying; their words are lost in the obsession. With compulsions, the individual can do little else during the day except to carry out the compulsion and is thus prevented from living a normal life in the family or on the job.

The compulsions of this disorder should be distinguished from compulsive eating or compulsive gambling. In those activities, the individual finds satisfaction (even though of an abnormal sort) from the activity itself. In OCD, the compulsion is forced on the individual to avoid the tension of not carrying it out.

Prevalence

Obsessive-compulsive disorder has a lifetime prevalence of 2.6 percent of the general population. It occurs at equal rates in both women and men. Onset is usually in childhood, adolescence, or early adulthood.

GENERALIZED ANXIETY DISORDER

In generalized anxiety disorder (GAD), the central symptom is the anxiety itself, persistent (for at least a month) and unfocused. It is sometimes called free-floating anxiety. It may be centered in one or two aspects of the individual's life—for example, school grades or career prospects—but it usually cuts across the individual's entire life.

Symptomatology

The excessive worry of GAD is coupled with other symptoms, including muscle tension, restlessness or feeling on edge, difficulty concentrating, sleep problems, being easily fatigued, and/or irritability. A secondary problem that frequently develops is overuse of alcohol or anxiety-reducing drugs to cope with the symptoms of GAD. These are activities that, in the long run, can be more damaging than the anxiety.

Prevalence

Approximately 4 percent of Americans have GAD in any given year. GAD is twice as common in women as in men. The onset is typically in childhood or adolescence and is usually gradual.

CAUSAL FACTORS IN ANXIETY DISORDERS

There are four principal sets of life experiences that may lead to anxiety disorders: those emphasized in the psychodynamic point of view, which are negative interpersonal experiences (especially within the family) and the consequent development of maladaptive defense mechanisms; faulty learning experiences, which are the emphasis of the behavioral perspective; blocked personal growth, which is central to the humanistic-existential perspective; and biogenic factors, such as genetics. Most psychologists believe that anxiety disorders are caused by a combination of several of these factors. Sociocultural factors tend not to influence the existence of anxiety disorders as much as their type and focus.

The Psychodynamic Perspective: Damaged Interpersonal Relations

Stemming from the early work of Freud but going beyond it, the psychodynamic perspective gives great weight to the causal effect of such early life experiences as deprivation, parental oversolicitude, and paternal authoritarianism. Without an appropriate parent-child relationship, the individual does not develop the psychic resources to manage the anxieties inherent in life, resulting in an anxiety disorder.

Early Deprivation

Emotional or physical neglect by parents can cause a child to feel unwanted and unworthy. Those feelings generate anxiety in the face of normal demands of life. Sometimes such deprivation takes the form of coldness and intellectualization in parental attitudes that lack any nurturing warmth, even though perfunctory care is provided. Without the secure relationship that comes from a warm parent-child relationship, the child is unable to muster the resources to cope with the normal anxieties inherent in growing up, and pathology results.

Oversolicitude

When a parent blocks the development of independence and self-confidence through overbearing supervision and control or worries fretfully about the child, the child falters in developing adequate coping behavior required for adjusting to life's ups and downs, with resultant anxiety when those trials appear. That is, the child is not allowed the independence to develop the ego strength to cope with anxiety-inducing experiences that naturally occur and reaches adulthood without the skills. Once the person reaches adulthood, he or she is expected to be independent, but lacks the necessary skills and can be overwhelmed by anxiety.

Authoritarianism and Dictatorial Parental Behavior

Parenting strategies that set absolute and detailed rules or rigid standards and demands for submissiveness and total compliance can cause one of two reactions: rebellion, which brings its own problems; or anxiety caused by the hostile thoughts and aggressiveness, covertly felt, in an overly submissive child. Unable to contain the fear of an inability to live up to a parent's demands, the child's reaction may take the form of inhibitory tensions that forbid involvement in ordinary life activities. For example, a child cannot play because of overwhelming fear of the parent's response if the child were to get dirty. With those satisfactions lost, the next step might very well be the development of an anxiety disorder.

The Behavioral/Learning Perspective: Faulty Learning

This perspective considers three possible paths to the development of anxious behavior: failure to learn adaptive coping mechanisms; learning anxiety through conditioning experiences; or learning anxious patterns by observation and modeling.

Failure to Learn Adaptive Coping Mechanisms

Children typically learn methods of coping with difficult situations as they mature. However, some children, perhaps due to in adequate parenting or an unsupportive environment, do not learn these skills. These children simply are not taught how to cope with the anxieties that are inherent in life and, without these skills, easily become overwhelmed by anxiety-producing situations.

Learning Anxiety Through Conditioning

A two-stage set of conditioning experiences illustrates another way in which anxiety may be learned. An example best illustrates the two stages. The first is respondent conditioning. A father makes an impossible demand on his daughter. The daughter grows anxious at her inability to comply. The next time the father makes a demand, the daughter remembers the previous anxiety-provoking situation and again experiences the anxiety that was paired with the previous demand.

In stage two, the daughter comes to avoid her father, and her previous anxiety is not felt. In this fashion, the avoidant response, in accordance with operant conditioning, is reinforced. Later on, through generalization, the daughter tends to avoid all people (or demands) and become inhibited, shy, and withdrawn.

Observation and Modeling

Observation of a horrifying experience involving someone else or the model of a worrying, fretful parent can be carried over into a child's life and serve as the basis for anxiety. People learn about danger from watching others' experiences. This can be a beneficial mode of learning, but when taken to the extreme can result in the development of anxiety disorders. The process of modeling has been explained in Chapter 8. Just as adaptive behaviors can be learned through modeling, so can maladaptive behaviors such as those found in anxiety disorders.

The Humanistic-Existential Perspective: Blocked Personal Growth

The humanistic perspective shares with the psychodynamic view a concern about the individual's early interpersonal experiences, which it states may limit the individual's capacity for self-actualization and growth. It is, according to this school, that discrepancy between the individual's damaged self image and the ideal self envisioned by the person that causes anxiety. The emphasis in the existential perspective is on the concept of authenticity. Individuals suffering an anxiety disorder, it is stated, are uncomfortable living with the gap that exists between the true self and the self which the adjustment to society demands. It is this conflict, no doubt stemming from vulnerability produced by early life experiences, that produces the anxiety and ultimately the psychological disorder. Others accept the personality mask imposed by society, forgetting their real selves. In so doing, they avoid the troubling anxiety.

The Biogenic Perspective

There are studies suggesting that genetic influences may cause vulnerability to GAD, OCD, PTSD, social phobia, specific phobia, and panic disorder (including agoraphobia). Although the exact mechanism of this transmission is not clear (no specific gene or genes have been identified), it is evident that there is a genetic component to anxiety disorders. There is consistent support from family studies that anxiety disorders run in families.

The Sociocultural Perspective

The culture in which a person lives is more likely to influence the type of anxiety disorder the individual develops than the occurrence of the disorder. Several examples illustrate a seeming relation between cultural influences and type or focus of psychological ailment. For example, cultures that have a strong emphasis on cleanliness, such as Muslim and Hindu cultures, have higher rates of obsessivecompulsive disorder with obsessions of contamination and cleaning compulsions than are found in other cultures.

THERAPEUTIC APPROACHES TO THE ANXIETY DISORDERS

Chapters 7 and 8 provide a detailed description of the various treatment approaches to psychiatric illness. Here, only brief reference is made to those thought to be helpful in treating anxiety disorders.

Therapeutic Effectiveness in Treating Anxiety Disorders

Based on numerous studies of the treatment of anxiety disorders, there is strong evidence that psychotherapy can improve symptoms of anxiety disorders for children and adults consistently and over time. This seems to be true across a range of psychotherapeutic orientations. The choice of a particular therapy is dictated by the specific diagnosis established, the level of functioning and preferences of the individual, and the hypothesis developed by the therapist as to possible causes of the disorder (which is largely influenced by the therapist's orientation).

Increasingly, an eclectic approach to therapy is being used, in which methods from any of the major perspectives are adopted by the therapist to suit the individual's needs; for example, an interpersonal, psychodynamic approach may be supplemented by one of the behavioral/learning techniques. In the eclectic approach, the goals of therapy, which are insight, elimination of symptoms, and improved functioning, are more influential in selecting a treatment approach than theoretical perspectives. Specifically and briefly, each of the four theoretical perspectives offers particular treatment techniques.

The Psychodynamic Perspective

The psychodynamic perspective offers insight development, which may take the form of orthodox psychoanalysis or one or another of the modified procedures developed since Freud. It is believed that once the client has insight into his or her disorder, the symptoms will be alleviated.

Behavioral/Learning Perspective

From the behavioral/learning perspective comes relearning strategies, the principal ones of which are desensitization or exposure to the anxiety-causing object or situation. Desensitization is explained in Chapter 8. In exposure, the person is gradually exposed to the feared situation/object and learns that the fear of that situation/object is unfounded when nothing negative happens after the exposure. Cognitive strategies such as recognizing and challenging irrational thoughts also can be effective in the treatment of anxiety disorders.

Humanistic-Existential Perspectives

Carl Rogers, the chief exponent of the humanistic school, has developed person-centered therapy, the goal of which is to expand and strengthen the individual's self-concept. In it, the therapist's role is to listen empathetically and reflect back the meanings and feelings the client is expressing. The therapist's role is to give the client the conviction of really being heard, perhaps for the first time in his or her life. It is believed that once the client feels heard, he or she will be able to work through the anxiety utilizing his or her own resources, bolstered by the therapist's empathic support. The existential therapist is even more extreme in holding back any of his or her own thoughts and, in this way, participates empathetically in the client's own world. Clients are provided an environment in which they can flourish and utilize their own resources to work through the anxiety.

Biogenic Perspective

Research provides evidence for the effectiveness of benzodiazepines in the short-term alleviation of anxiety symptoms. Sometimes, these medications are combined with psychotherapy to enhance the effectiveness of interventions such as desensitization or exposure therapies. SSRIs have been found to have effectiveness in the longer-term treatment of anxiety disorders. See Chapter 8 for more details.

SUMMARY

Estimates indicate that the anxiety-based disorders together constitute one of the most prevalent forms of psychiatric illness. Fear, which is related to a specific situation, is differentiated from anxiety, which is a vague sense of unease. Normal anxiety is differentiated from pathological anxiety by the degree of impairment that pathological anxiety causes.

This chapter has described the disorders categorized in the diagnostic manual under the heading anxiety disorders: simple phobia, in which there is an intense, irrational fear of a specific object or situation; panic disorder (with or without agoraphobia), in which there is an intense fear of having a panic attack in a situation where getting help or escaping would be difficult; social phobia, where there is an irrational fear of being humiliated while being observed or evaluated; post-traumatic stress disorder, in which a variety of debilitating symptoms develop as the direct result of a catastrophic event; obsessive-compulsive disorder, in which the core anxiety is masked by tensions associated with the individual's obsessions and compulsions; and generalized anxiety disorder, in which a disruptive, unfocused apprehensiveness is the predominating symptom. For each disorder, information about prevalence and course is provided.

Stressors are situations that require adjustment and affect individuals psychologically and physically. Severe or prolonged stress can result in anxiety disorders (including adjustment disorders) and physical illnesses. However, individuals also can cope with stress using problem-focused, emotion-focused, or meaning-focused coping.

There are numerous theorized causes of anxiety disorders, including faulty learning, observation or experience of a traumatic event, early childhood experiences, and genetic vulnerabilities. Anxiety disorders can be effectively treated through cognitive-behavioral or insight-oriented therapies and/or medication.

SELECTED READINGS

Barlow, D. H. (2004). Anxiety and its disorders, second edition: The nature and treatment of anxiety and panic. New York: Guilford Press.

Campbell, E. & Ruane, J. (1999). The Earl Campbell story: A football great's battle with panic disorder. ECW Press.

Marks, I. M. (2002). The maturing of therapy: Some brief psychotherapies help anxiety/depressive disorders but mechanisms of action are unclear. *British Journal of Psychiatry*, 180, 200–204.

Wilensky, A. S. (1999). Passing for normal: A memoir of compulsion. New York: Broadway Books.

Test Yourself

1)	Anxiety	is appre	hension	about	a specific	situation.	True o	or false?
----	---------	----------	---------	-------	------------	------------	--------	-----------

- 2) Which disorder is characterized by an intense, irrational fear of a certain situation or object that results in the individual going to great lengths to avoid that situation/object?
 - a) panic disorder

c) specific phobia

b) post-traumatic stress disorder

- d) social phobia
- 3) What disorder is characterized by a free-floating sense of worry and physical complaints?
 - a) adjustment disorder

c) panic disorder

b) generalized anxiety disorder

- d) post-traumatic stress disorder
- 4) What disorder is characterized by an atypical response to a commonly occurring situation that may result in anxiety, depression, or disturbance of conduct?
 - a) adjustment disorder

c) post-traumatic stress disorder

b) obsessive-compulsive disorder

- d) specific phobia
- 5) Panic disorder affects what percentage of the population?

a) 1.2 percent

c) 11.7 percent

b) 3.5 percent

- d) 24.9 percent
- 6) How many people will experience PTSD in their lifetime?

a) 0.9 percent

c) 7.8 percent

b) 2.4 percent

- d) 15.3 percent
- 7) Social phobia is more common in women than in men. True or false?
- 8) Many people without OCD have minor obsessions or compulsions that do not cause them significant distress. True or false?
- 9) Anxiety disorders are likely due to an interaction of a variety of factors. True or false?
- 10) Anxiety disorders can be successfully treated with either psychotherapy or medication. True or false?

Test Yourself Answers

- 1) The answer is false. Anxiety is much more vague than fear, which is tied to a specific situation or object. Both can be adaptive in motivating an increase in effort (anxiety) or avoidance of dangerous situations (fear). However, both also can be maladaptive when taken to the extreme, such as in generalized anxiety disorder (anxiety) or specific phobia (fear).
- 2) The answer is c, specific phobia. Specific phobia's defining characteristic is an intense, irrational fear of a specific object or situation, such as heights or spiders. It can be differentiated from other anxiety disorders by noticing the subject of the fear (for example, an animal), as opposed to being humiliated or having a panic attack.
- 3) The answer is b, generalized anxiety disorder. GAD results in anxiety or worry about multiple situations and physical complaints such as muscle tension, sleep problems, feeling keyed up, and so on.
- 4) The answer is a, adjustment disorder. Adjustment disorders are maladaptive reactions to situations that, while unpleasant, are not traumatic or outside typical human experience (for example, the loss of a loved one or the ending of a relationship). Adjustment disorders are more intense than the typical reaction to such a stressor and can result in any combination of anxiety, depression, or conduct disturbance. The onset is within three months of the stressor and they resolve, with or without treatment, within six months of the cessation of the stressor.
- 5) The answer is b, 3.5 percent. Panic disorder is more common in women than in men and affects about 3.5 percent of the population.
- 6) The answer is c, 7.8 percent. Although not all people who experience trauma develop PTSD, it has a lifetime prevalence of 7.8 percent.
- 7) The answer is false. Social phobia affects 13.3 percent of the population, including equal numbers of men and women.
- 8) The answer is true. Many people who do not have OCD still have unwanted repeated thoughts (for example, "Did I turn off the iron?") and irrational behaviors (for example, superstitions such as lucky objects or avoiding the number 13). The obsessions and compulsions do not cause significant distress or impairment the way the obsessions and compulsions of OCD do.
- 9) The answer is true. The most likely explanation for anxiety disorders is a combination of causal factors such as a genetic vulnerability and a traumatic experience or faulty learning.
- 10) The answer is true. There is a large amount of evidence supporting the effectiveness of a variety of types of psychotherapy and medication in the treatment of anxiety disorders. Some of the most commonly used treatments are cognitive-behavioral therapy and SSRIs.

Somatoform and Dissociative Disorders

The disorders described in this chapter show few, if any, signs of the anxiety characteristic of the anxiety disorders (see Chapter 9); however, the psychodynamic school considers the symptomatology a defense against an underlying and unconscious core of anxiety. In the DSM-IV-TR, somatoform and dissociative disorders are grouped more on the basis of symptomatology than on distinctiveness of etiology (causation). Somatoform disorders are characterized by physical complaints without an organic (biological) cause. Dissociative disorders are characterized by detachment from conscious experiences.

SOMATOFORM DISORDERS

A sharpened focus on some bodily function, with the development of physical symptoms or complaints without an organic basis, is the common characteristic of the somatoform disorders. Dysfunction produced by the symptoms ranges from specialized sensory or motor disability to preoccupation with symptoms; from symptom formation in any bodily function to hypersensitivity to pain. There are five principal somatoform disorders: conversion disorder; hypochondriasis; somatization disorder; pain disorder; and body dysmorphic disorder.

Conversion Disorder

Conversion disorder almost always develops in a setting of extreme stress; for example, military combat or the death of a loved one. Its course is usually dramatic and short-lived. Although symptoms are present, the individual may be severely handicapped and, in unusual circumstances, the primary symptom may persist for a prolonged period, causing atrophy or contracture of the muscle groups involved.

Symptomatology

The primary symptom is a loss or alteration in physical functioning without a detectable organic basis. Despite the seriousness of the physical disability, the individual commonly (but not always) reacts with a relative lack of concern, an attitude that has been named *la belle indifference*.

Common forms of the primary symptoms are paralysis, seizures, aphonia (loss of speech), or blindness. Of significance in the conversion disorder is the secondary gain (side benefits) that results from the

disability: The primary symptom enables the individual to escape from or avoid a psychologically stressful situation without the need to admit to responsibility for doing so. The primary symptom is beyond the individual's control and is not seen by the person as related to the stressful situation that is being avoided. There may be a gray area in which awareness of the secondary gain (including insurance payments or court settlements) tends to worsen or prolong the symptoms.

For convenience, the primary symptoms are grouped into three categories: sensory symptoms; motor symptoms; and visceral symptoms.

- Sensory symptoms: These include anesthesia (numbness), excessive sensitivity to strong stimulation (hyperesthesia), loss of sense of pain (analgesia), and unusual symptoms such as tingling or crawling sensations.
- · Motor symptoms: In motor symptoms, any of the body's muscle groups may be involved, including arms, legs, and vocal chords. Included are tremors, tics (involuntary twitches), and disorganized mobility or paralysis.
- Visceral symptoms: Examples are trouble swallowing, frequent belching, spells of coughing, or vomiting, all carried to an uncommon extreme.

In both sensory and motor symptoms, the areas affected may not correspond at all to the nerve distribution in the area. For example, in glove anesthesia, the individual cannot feel anything on the hand (that is, the area that would be covered by a glove) but has feeling in the forearm; this is not neurologically possible (anesthesia in the hand also would involve such symptoms in the forearm, based on the way the nervous system operates). Conversion disorder may be characterized by more than one of the preceding types of symptoms at a time.

Caution in Diagnosis

Because conversion disorder can simulate almost every known physical ailment, care must be taken to exclude any organic basis for the disorder. Support for the psychological basis of the disorder can be found in such criteria as these: an attitude of indifference to the symptom; a lack of correspondence between the known symptoms of a particular disease and the individual's complaints; the disappearance of the symptom under hypnosis or narcosis (drug-produced sleep); or suggestibility of the individual in responding to the therapist's efforts to control or change the symptom. Also, conversion disorder should be distinguished from conscious faking of a disorder for secondary gains (malingering).

Prevalence

Although conversion disorder, along with hypochondriasis and the dissociative disorders of amnesia and dissociative identity disorder, are given much notoriety in news stories, on television, and in movies, they are, as a group, much less prevalent than other disorders and seem to have been more prevalent in past years than they are today. The prevalence of conversion disorder is unclear, but estimates vary between 11 and 300 cases per 100,000 people. Conversion disorder is more common in women than in men. Onset is usually early in life, and it is usually triggered by a severely stressful event.

Etiology

There is evidence of a genetic predisposition toward conversion disorder. The symptoms appear in response to a stressor. Often, symptoms mirror those of an individual in the environment of the person with conversion disorder, suggesting social influences on the development of the disorder. The reduction in stress or conflict that results from the symptoms likely maintains the disorder.

Treatment

Treatment of conversion disorder typically focuses on resolving the precipitating stressors or modifying help-seeking behavior.

Hypochondriasis

In conversion disorder, the individual develops a functional disorder (psychologically caused); contrariwise, in hypochondriasis, the individual has no real physical disability or illness but is nevertheless preoccupied with and worried about ordinary bodily functions (for example, heartbeat, bowel movements, minor sores, blemishes, coughs). The individual reads into the sensations of normal bodily functions the presence of a feared disease.

Symptomatology

The individual magnifies small irregularities in bodily functions and expresses concern about the general state of his or her health. He or she may shift from one bodily system to another or focus on one major system, for example, persistent concern about a heart condition. There is much doctoring, as the individual goes from one doctor to another after being told that there is nothing wrong. People with hypochondriasis find pleasure in criticizing doctors and explaining to family and friends why the doctors are wrong.

Those with hypochondriasis experience some impairment in interpersonal relationships and in job performance. But often, except for frequent job changes, the illness is limited to years of doctoring and endless descriptions of symptoms with no other impact on functioning. In extreme cases, however, the individual may become a lifetime invalid and take to bed with a complete collapse in independent activity.

Prevalence

The ailment is frequently seen by family doctors, but because of the individual's resistance to accepting a psychological interpretation of the illness, people with hypochondriasis frequently reject any referral to a mental health facility. Estimates of prevalence are approximately 0.8 percent of the general population or 3 percent of individuals seeking medical services at primary care facilities. Onset can occur at any time of life, with peaks in adolescence, middle age, and late adulthood. Hypochondriasis affects men and women equally.

Etiology

Individuals with hypochondriasis likely have minor physical symptoms that they misinterpret as being signs of serious illnesses. This produces anxiety and an intensified focus on the symptoms, which results in the misidentification of more symptoms.

Treatment

Treatment for hypochondriasis typically involves a combination of challenging illness perceptions and reassurance. This is likely provided by both physicians and mental health professionals,

Somatization Disorder

Somatization disorder very much resembles hypochondriasis, but there are significant differences between the two. Both are characterized by concerns about physical symptoms, but in the case of somatization disorder, the concern is about the symptoms themselves rather than the possibility of the symptoms implying a serious illness.

Symptomatology

The primary symptom in somatization disorder is multiple complaints of physical ailments over a long period of time, beginning before the age of 30. One strong difference between hypochondriasis and this disorder is in the attitude the individual has to the physical disorder. The individual with hypochondriasis fears there might be a physical disorder, yet seems to hope that the doctor will find it upon examination. In somatization disorder, the symptoms of physical disorder are believed to be real, and the individual is convinced of its existence and worried about it. There may also be dramatic reactions to this strongly held belief, such as submission to unnecessary surgery, threats of suicide, or seeking release in substance abuse. Perhaps understandably, given his or her belief in the presence of serious illness, the individual is frequently depressed and finds difficulty in living an orderly existence.

Prevalence

The prevalence of somatization disorder has been estimated to be 2 percent in women. Somatization disorder occurs at one-tenth of this rate in men. Onset is often in adolescence, but can occur at any point in the life span.

Etiology

Although a direct cause of somatization disorder has not been discovered, there is evidence of genetic and environmental components; that is, there tends to be an inherited vulnerability and a tendency to model the sick role from family members. It is likely that the attention and sympathy received in response to illness maintains the symptoms.

Treatment

Somatization disorder is difficult to treat. Interventions typically consist of two prongs: counseling focusing on developing healthy ways of relating to others; and cognitive-behavioral therapy to manage stress, provide reassurance, and modify help-seeking behavior.

Pain Disorder

The primary—indeed, the only—symptom in somatoform pain disorder is severe and prolonged pain in the absence of a physical basis for it. Diagnosis may be difficult, because extensive medical testing may be necessary to rule out an organic basis.

Certain psychological cues may be helpful in clarifying the functional (psychological) nature of the illness: a conflictual or stressful event preceding the experience of pain; the existence of secondary gain, if pain is present; or the individual's persistent need for attention. A history of past physical injury or illness, which no longer accounts for the pain, may nevertheless provide the patient with justification for complaining.

Research suggests that the prevalence of pain disorders is 5.4 percent. It is more common among women than men.

Body Dysmorphic Disorder

Body dysmorphic disorder (BDD) is characterized by fixation on an imagined fault in appearance. Individuals with body dismorphic disorder experience overwhelming concern and distress about their appearance, which they view as grotesque or deformed despite objective opinions to the contrary. The condition focuses on a specific feature (for example a nose that is perceived to be crooked or a finger perceived as being unusually long) rather than a generalized distortion of overall body image as in the case in anorexia nervosa, for example. However, it is not unheard of for an individual with BDD to be fixated on more than one specific body part (for example, hair loss and skin discoloration).

Prevalence

Prevalence estimates are difficult because of the secrecy many individuals with BDD keep due to discomfort about their appearance. However, estimates range from 0.3 percent to 2.2 percent. The age of onset is typically early adolescence through the twenties, and the course is typically lifelong.

Etiology

BDD appears to be the result of a cycle of obsessions about appearance that leads to self-scrutiny, resulting in increased anxiety. Attempts to change one's appearance only serve to increase concerns and focus on the feature of concern.

Treatment

The similarity in symptoms between OCD and BDD has led to trying similar treatment approaches. In fact, research supports the use of cognitive-behavioral therapy, such as exposure therapy, and medication, such as SSRIs, in treating BDD and OCD. Exposure therapy entails the client facing the distressing stimulus, in this case the physical feature believed to be problematic, without allowing the individual to engage in strategies such as hiding or attempting to fix the distressing feature.

M DISSOCIATIVE DISORDERS

The DSM-IV-TR lists four varieties of dissociative disorder: dissociative amnesia; dissociative fugue; dissociative identity disorder; and depersonalization disorder. Although much notoriety is given to them by the media, they are relatively uncommon disorders. They have in common an attempt by the individual to escape from a significant personal problem or responsibility by severing, forgetting, or distancing himself or herself.

Dissociative Amnesia

Amnesia is the inability to recall or identify one's past experience or identity. It may result from a variety of pathological brain conditions such as illnesses or injuries. When it develops as a response to extreme psychosocial stress, it is labeled dissociative amnesia. Common examples of such stressful situations are living through a catastrophic event such as an earthquake, a personally experienced threat of death or major injury, or the need to escape an unbearable life situation; for example, facing a bankruptcy or other financial calamity.

Symptomatology

Symptom formation in dissociative amnesia may follow any one of four different patterns: localized amnesia; selective amnesia; generalized amnesia; or continuous amnesia.

LOCALIZED AMNESIA

In this pattern of psychogenic amnesia, the individual fails to recall all details of a particular event, usually one that is traumatic. An example would be failing to recall all the circumstances of a rape. Localized amnesia is the most common form of psychogenic amnesia.

SELECTIVE AMNESIA

Following closely behind localized amnesia in prevalence is selective amnesia. Here the individual blanks out certain details of a traumatizing experience. An example would be an uninjured survivor of a car accident that killed all of his or her immediate family, who can remember making the funeral arrangements but not discussions held with other family members.

GENERALIZED AND CONTINUOUS AMNESIA

The least common forms of psychogenic amnesia are generalized amnesia, in which the individual may be unable to recall the details of an entire lifetime, and continuous amnesia, in which the person forgets everything subsequent to a specific time or event, including the present. Retrograde amnesia is when an individual forgets events that occurred prior to the onset of amnesia, and anterograde amnesia is when an individual forgets events from the onset of the amnesia to the present.

Prevalence and Course

Dissociative amnesia of the first or second type is more common than generalized or continuous. All four types have a combined prevalence of 1.8 percent. Dissociative amnesia typically resolves on its own.

Dissociative Fugue

A fugue is simply a type of generalized amnesia in which the added feature is a flight from family, problems, and location, and sometimes the creation of a new identity that may be maintained for days, weeks, months, or even for years. The fugue is typically brought on by a significant stressor. The individual's behavior during fugue states of limited duration may be very casual, such as going from one movie theater to another without being able to recall where he or she has been. An uncommon pattern is for the person to create a whole new life. It is estimated to have a prevalence of 0.2 percent. It typically occurs in adulthood. Dissociative fugue symptoms usually resolve on their own after the stressor has passed.

Dissociative Identity Disorder

The most dramatic of all the dissociative disorders is dissociative identity disorder (DID), in which there is the occurrence in the same individual of two or more personalities, each of which is able, for an interval in the person's life, to live a stable life and to take control of the person's life, although not necessarily in a mentally healthy way.

Symptomatology

In dissociative identity disorder, the individual acts out one or another of coexisting personalities. In a famous case of Dr. Prince, there were seventeen different personalities, each quite different from the other. One personality may be the governing or good personality; another full of unacceptable and immoral impulses. There may be complete or partial amnesia during the existence of other personalities or a pattern in which whatever becomes known to the principal personality (but to that person only) is known to all other personalities (asymmetrical amnesia). There have been a number of notorious cases of feigned dissociative identity disorder, with the purpose in mind to evade criminal culpability. One means of detecting the feigned disorder is the likelihood in such cases that the amnesia is symmetrical (that is, what is known by any of the individuals is known by all). Impaired functioning or illegal behavior may occur in a form that depends on the number and characteristics of the personalities assumed.

Prevalence

Much has yet to be learned about dissociative identity disorder. There is no certainty about even its prevalence. There is, in fact, disagreement among psychologists regarding the existence of the disorder. Prevalence has been estimated at 0.5 percent to 1 percent. DID occurs nine times more frequently in women than in men. Onset is frequently reported in childhood, although it usually is several years after the onset of symptoms before the disorder is diagnosed.

Etiology

The cause of DID is not entirely clear. It is likely that there is a biological vulnerability and a susceptibility to suggestion that, when combined with trauma such as severe childhood abuse, results in attempts to escape the trauma that become pathological. In other words, the combination of significant early trauma with a biologically based vulnerability results in the fragmentation of identity.

Treatment

Treatment typically focuses on coping with the trauma and symptoms of DID. Research on treatment to reintegrate personalities suggests that it might be helpful for some, but not all, individuals with DID.

Depersonalization Disorder

Mild feelings of depersonalization, feelings of being someone other than oneself or of not being able to control one's movements are common human experiences, occurring to more than 30 percent of young adults. When the symptom is recurrent and impairs social or occupational adjustment, the person is said to be suffering from depersonalization disorder.

Symptomatology

The disorder is characterized by a change in the person's perception of self and in the way self-identity is experienced. Strange feelings about the size of arms and legs abound, and the individual has a sense of looking at his or her body from a distance, sometimes described as floating above the body and looking down at it. Despite the extreme distortion of self-awareness, the individual's reality-testing function remains intact, and there are no delusions or hallucinations. The sufferer may experience difficulty of recall and a loss of awareness of time going by.

Prevalence

Onset is sudden, frequently occurring in adolescence, but symptoms linger, disappearing only gradually. The disorder is rare, with a prevalence of only 0.8 percent. No sex differences are reported.

Treatment

Treatment of depersonalization disorder typically involves developing strategies to deal with the symptoms and resolving the stressors that precipitate feelings of depersonalization.

SUMMARY

The DSM-IV-TR describes five somatoform disorders. The primary symptom of conversion disorder is a loss or alteration in physical functioning—for example, blindness or paralysis—without a detectable organic basis. In hypochondriasis, the individual has no real physical disability, but nevertheless is preoccupied with and worried about ordinary bodily processes. The primary symptom of somatization disorder (which may be easily confused with hypochondriasis) is multiple complaints of physical ailments over a long period of time, a set of symptoms that cause the individual to go from doctor to doctor, seeking confirmation of his or her complaints. Pain disorder causes severe and prolonged pain in the absence of any physical basis for it. Body dysmorphic disorder is characterized by intense preoccupation and distress regarding a perceived physical anomaly, which is not apparent to the objective observer.

The dissociative disorders include dissociative amnesia, dissociative fugue, dissociative identity disorder, and depersonalization disorder. All those disorders have in common an attempt by the individual to escape from an unpleasant life situation by forgetting or distancing himself or herself. In dissociative amnesia, the individual loses memory for some aspect of a previous existence. The amnesia may be selective or general. In fugue, the individual not only forgets but also escapes from the old life through travel, occasionally creating a new life. In dissociative identity disorder, there is the occurrence in the same individual of two ore more personalities, each of which controls the individual's behavior for some period of time. Depersonalization disorder causes a loss of self-identity and strange feelings about one's body and his or her relation to other people.

SELECTED READINGS

Brady, J. P. & Lind, D. L. (1968). Experimental analysis of hysterical blindness. In L.P. Ullman & L. Krasuer (eds.). Case studies in behavior modification. New York: Holt, Rinehart, and Winston.

Cantor, C. & Fallon, B. (1996). Phantom illness: Shattering the myth of hypochondria. Boston, MA: Houghton Mifflin Company.

Keyer, D. (1981). The minds of Billy Milligan. New York: Random House.

Papanicolaou, A. C. (2005). The amnesias: A clinical textbook of memory disorders. Oxford, UK: Oxford University Press.

Parkin, A. J. (1997). Memory and amnesia: An introduction. Hove, UK: Psychology Press.

Phillips, K. A. (ed.) (2001). Somatoform and factitious disorders. Arlington, VA: American Psychiatric Publishing.

W., A. T. (2004). Got parts? An insider's guide to managing life successfully with dissociative identity disorder. Ann Arbor, MI: Loving Healing Press.

Test Yourself

1)	What disorder is likely to be caused by ways of relating and coping with stress	difficulties in relating to others and is treated by teaching new?			
	a) conversion disorder	c) dissociative fugue			
	b) dissociative identity disorder	d) somatization disorder			
2)	What disorder is characterized by feelings of detachment and of being an observer of one's life?				
	a) body dysmorphic disorder	c) depersonalization disorder			
	b) conversion disorder	d) dissociative identity disorder			
3)	What disorder results in a severe physical impairment without a biological cause?				
	a) body dysmorphic disorder	c) hypochondriasis			
	b) conversion disorder	d) somatization disorder			
4)	What disorder is probably due to severe trauma combined with a biological vulnerability and susceptibility to suggestion?				
	a) conversion disorder	c) depersonalization disorder			
	b) dissociative identity disorder	d) hypochondriasis			
5)	What disorder is caused by misinterpretation of physical sensations and results in anxiety about their meaning?				
	a) hypochondriasis	c) dissociative fugue			
	b) body dysmorphic disorder	d) depersonalization disorder			
6)	Memory loss and travel are symptoms of what disorder?				
	a) depersonalization disorder	c) dissociative fugue			
	b) dissociative amnesia	d) dissociative identity disorder			
7)	Which of the following disorders is often treated with a combination of cognitive behavioral treatment and medication?				
	a) body dysmorphic disorder	c) dissociative amnesia			
	b) conversion disorder	d) dissociative fugue			
8)	What disorder results in memory loss th	hat is localized, selective, generalized, or continuous?			
	a) depersonalization disorder	c) conversion disorder			
	b) dissociative amnesia	d) somatization disorder			
9)	What condition is characterized simply	by physical pain without a psychical cause?			
	a) conversion disorder	c) pain disorder			
	b) hypochondriasis	d) somatization disorder			

Test Yourself Answers

- 1) The answer is **d**, somatization disorder. Individuals with somatization disorder tend to relate to people only in the sick role. They seem to be lacking in interpersonal and coping skills, resulting in reliance upon multiple physical symptoms as a means of avoiding stress and getting attention from others.
- 2) The answer is **c**, depersonalization disorder. The symptoms of depersonalization disorder include feelings of detachment and the sensation that one is observing his or her actions or thoughts from outside of oneself. These sensations tend to be related to stress and are quite disturbing to the individual experiencing them.
- 3) The answer is **b**, conversion disorder. Conversion disorder is characterized by a physical impairment (motor, sensory, and so on) that does not have a biological cause. In fact, the physical impairment frequently is something that is physically impossible based on human anatomy, but it seems logical to the person with the disorder.
- 4) The answer is **b**, dissociative identity disorder. DID typically results from a combination of trauma, such as severe childhood abuse, a biological vulnerability, and a susceptibility to suggestion. These factors combine, resulting in an attempt at coping with the abuse that becomes a pathological disintegration of identity.
- 5) The answer is **a**, hypochondriasis. In hypochondriasis, the individual misinterprets physical sensations as signs of a serious illness. This results in anxiety and over-focusing on physical sensations, leading to fear about having a grave disease.
- 6) The answer is **c**, dissociative fugue. Dissociative fugue is characterized by memory loss and traveling. Occasionally, the individual will develop a partial, or even an entirely new identity; however, this is relatively rare among those with dissociative fugue.
- 7) The answer is **a**, body dysmorphic disorder. The obsession with a perceived but nonexistent physical flaw that characterizes BDD resembles the obsessions of OCD. In fact, treatments used for OCD, such as exposure and response prevention and medication with SSRIs, have been found to be effective in the treatment of BDD.
- 8) The answer is **b**, dissociative amnesia. Dissociative amnesia is characterized by memory loss that is localized (only covers a specific period of time), specific (only covers certain topics), generalized (covers a person's lifetime), or continuous (begins at the time of a trauma). Dissociative amnesia must be distinguished from amnesia due to biological causes such as brain damage.
- 9) The answer is **c**, pain disorder. The sole symptom of pain disorder is physical pain at one or more sites that does not have a biological basis.

Psychological Factors Affecting Physical Conditions

he effect of the psychological on the physical, prior to the arrival on the philosophical front of scientific rationalism, would have been labeled a mind/body problem. Prescientific humanity, led by their philosophers and religious leaders, considered mind and body to be independent entities.

The dichotomy of the two was an easy concept for primitive humans. It provided an explanation of death. There was the body, but it was lifeless. Its spirit, or soul, had left it. It was dead. That way of thinking about body and mind became a part of the Judeo-Christian religious beliefs. The concept dominated religious thinking throughout the Middle Ages and was formally elaborated in the thirteenth century in the scholastic philosophy of Thomas Aquinas, who was an influential interpreter of Christian thought in medieval Europe.

In philosophical thought, Plato created a complete dichotomy between body and mind. The "rabble of the senses," which he equated to bodily processes, was a different order of being and knowing from the world of ideas, created out of the thought processes, and unchanging. Other philosophers were even more extreme in their thinking. For example, Berkeley, the eighteenth-century Irish philosopher and idealist, maintained that everything was mind. Whatever existed, existed in the mind only.

Rene Descartes removed the mind/body problem from religious thinking and constructed a dual way of thinking about the two. Early scientists Galileo and Newton provided the kind of early scientific thinking that brought medicine and psychology to their modern interpretation of mind/body relationships. The two put philosophical and religious thinking aside as not within their province. Their thinking blazed the way for modern theory, which considers that body and mind function as a unit.

■ INTERACTIONS BETWEEN PSYCHOLOGICAL AND PHYSICAL FUNCTIONING

We have seen in the history of abnormal psychology that at least by 1883, with the publication of Emil Kraeplin's textbook on psychiatry, recognition of the influence of somatic (bodily) changes on mental activities was commonplace. The important effect of organic conditions on particular mental disorders had been recognized well before Kraeplin; but his broadened interpretation of those influences gave additional emphasis to their presence.

The acceptance of influence in the opposite direction—that is, the mind influencing physical disease—was a much later concept. However, there were exceptions. For years, observant physicians had

noted the cause-and-effect relationship, for example, between physical ailments, such as high blood pressure, and worrying and chronic emotional tension. Conditions known as psychosomatic disorders had been introduced gradually into classifications of medical diagnoses.

But it was not until the 1960s that a much-broadened way of thinking developed about the influence of psychic factors on bodily processes. During that period, physiological psychologists, aided by the development of sensitive electronic instruments that could precisely measure physiological responses such as blood pressure, pulse rate, and bodily temperature, demonstrated that those responses, once thought to be involuntary, could be brought under voluntary control. Their work was a very persuasive demonstration that psychological forces—for example, the decision to lower one's heart rate—could affect autonomic system responses.

That research generated speculation that perhaps psychological influences also operated even in such conditions as cancer and infectious disease. There are reports in the psychological and medical literature that make it unwise to dismiss those speculations out of hand. In 1991, for example, carefully controlled, parallel studies conducted in Pittsburgh and in Salisbury, England, led to the conclusion that high levels of psychological stress could almost double a person's chances of catching a cold. Stress lowers bodily resistance to viral infection. Although much more work needs to be done with particular physical disorders, in recent years a dozen or more illnesses—for example, coronary disorders and cancer—have been related to psychological factors. Currently, the DSM-IV-TR, on Axis I, provides the heading, "Psychological Factors Affecting Physical Condition." The manual asks the diagnostician to list on Axis III the specific physical condition related to the psychological factors specified in Axis I.

MODELS OF PSYCHOLOGICAL-PHYSICAL INTERACTION

Science today knows that the brain is the bodily organ that controls both bodily activities and subjective events, such as cognitions and feelings; but what biological processes does the brain command to produce the interaction between mind and body? We examine three models that suggest how that interaction takes place: the diathesis-stress model; the general adaptation syndrome; and psychoneuroimmunology (PNI).

Diathesis-Stress Model

The diathesis-stress model states that human disorders, both physical and mental, result from the presence of a diathesis, or predisposition for developing a particular disease; for example, tuberculosis or schizophrenia. The diathesis, or vulnerability, may result from genetics (for example, schizophrenia) or from earlier physical disease (for example, whooping cough in infancy). That predisposition is provoked by a stressor; that is, a disturbing bodily invader, in the case of a physical disorder, or a disturbing early life emotional experience, in the case of a psychological disorder. Here we will be applying the model to psychophysiological disorders, which may be defined as disorders in which psychological events, such as cognitions and feelings, contribute to the development of physical disorders or diseases. The stressors on which we focus in this discussion are distressing emotional experiences.

The damage caused by a stressor acting on a vulnerability is dependent upon the coping mechanisms available to the individual. Those mechanisms are outcomes of positive earlier experiences; for example, favorable parent-child relationships or positive learning experiences when facing earlier stressful situations. To put it more succinctly, psychologically healthy individuals ordinarily deal with stress in ways that do not trigger physical vulnerabilities to produce a psychophysiological disorder.

The General Adaptation Syndrome

Selve's adaptation model does not deal with causal factors, but rather describes the sequential way in which the individual psychologically and physically responds to stressful events. He identifies three

stages of the organism's response to a stressor event. The first stage is the alarm phase, which arouses the individual's defenses—either psychological defenses or the defensive reactions of the autonomic system, which in general prepare the body for action. The second stage is the stage of resistance, in which all the resources of the individual are employed defensively. If they succeed, there is no third stage; but if they are inadequate, a third stage of collapse, called decompensation, is reached in which the tensions produced by the stressor cannot be reduced, and there is the likelihood that those tensions will now combine with a vulnerability in the body, and a psychophysiological disorder will develop. Once developed, the disorder may remain as a lifetime weakness of the individual that flares up whenever stressful events threaten. The complex interaction between psychological and physical factors in the general adaptation syndrome model can perhaps most poignantly be illustrated by looking at some of the coping mechanisms employed as the resistance phase turns into decompensation. There are, in fact, numerous common attempts at coping that people employ that are detrimental to their health. Although they seem to be offering resistance, behaviors such as excessive eating or smoking really are hastening physical and psychological decompensation.

Psychoneuroimmunology

Psychoneuroimmunology (PNI) is the study of how psychological factors affect the nervous system's role in the immune response. It is now quite clear that there are direct pathways from the brain to the tissues and organs that make up the basis of the immune system. Research unmistakably indicates that psychological factors directly affect health through changes in the immune system. Specifically, negative mood, hostility, and interpersonal conflict are associated with declines in immune system functioning while positive mood, optimism, and social support are associated with increases in immune system functioning (Kiecolt-Glaser, McGuire, Robles & Glaser, 2002).

By integrating these models, we can, at least hypothetically, outline the complex development of psychophysiological disorders. Examining the specific ways in which stressors affect the individual will further clarify the etiology of those disorders.

■ THE ROLE OF STRESS IN PSYCHOPHYSIOLOGICAL DISORDERS

In Chapter 9, we examine the influence of stressors on human behavior. Stressors can range from natural disasters to highly personal events—divorce, for example—that arouse the body's autonomic system and, in turn, its immune system.

Autonomic Reactions and Stress

Walter Cannon, very early in the history of what was then called psychosomatic illness (1936), postulated that in order to survive, our primitive ancestors had need of bodily reactions that would respond to the life-and-death struggle of their daily lives. Cannon called that process the fight-or-flight pattern, and he identified the autonomic nervous system as the mechanism that prepared the individual to make either of those responses.

The autonomic system responds to external events that threaten the individual by initiating a whole series of physiological changes, Selye's alarm reaction. Those changes increase the individual's capacity to respond to external danger, either to fight or to flee. The autonomic nervous system increases breathing and heart pumping in order to increase the body's oxygen supply, causes flushing (which brings a supply of blood to the musculature), increases the blood sugar for increased energy, causes pupillary dilation for increased acuity in seeing, and increases the flow of neurotransmitter secretions to increase the speed of reactions.

All of those physiological changes aided primitive humans in their fight to survive. The effects of those changes were consumed in the battle or race that ensued; but for civilized humans, most of whose

threats are not physical but the emotional tensions of intangible psychological situations, those autonomic changes are not helpful or even relevant, and only intensify apprehensiveness and anxiety. Many modern stressors are chronic and do not resolve with fighting or fleeing. When the disturbing conditions are repetitive or long-lasting, they negatively affect one or several organs of the body through the brain-immune system connection. They affect most often those that are vulnerable, possibly for genetic reasons.

The Immune System

The body's alarm reaction, in itself, does not cause infection or disease, but over time it reduces the body's defenses by impairing the functioning of the immune system. The components of the immune system are the blood, thymus, bone marrow, spleen, and lymph glands. The system is a complex one, and there is much yet that medical science has to learn about its functioning. We focus here on a critical element, the white blood cells.

The white blood cells of the immune system recognize and destroy pathogens that have invaded the body, such as bacteria, viruses, fungi, and tumors. Their massive presence in the lymph system and the bloodstream is an indication of the importance and complexity of the work done by the white cells. In the healthy individual, there are 7,000 to 25,000 white blood cells in each drop of blood.

We do know that there are two types of white blood cells: lymphocytes and phagocytes. Their composition and function are somewhat different, but their combined functions are to detect and destroy antigens (invasive agents in the body) or foreign cells. Any impairment on the functioning of the immune system will reduce its ability to protect the body against disease-causing elements or damaging tissue growth. For example, the cancerous disease leukemia reduces the white cell count and therefore weakens the body's resistance to other diseases. The frightening effect of AIDS is basically its attack on the body's immune system, which leaves the body defenseless against a multitude of antigens, which eventually proves fatal.

Physical Effects of Psychological Stressors

One explanation of the way in which psychological tensions cause or contribute to the development of physical disease is that some physiological changes of the psychologically intense alarm reaction may impair the effective working of the immune system. It is known, for example, that in the alarm reaction, there is a release into the bloodstream of such neurohormones as catecholamine and cortical steroids, both of which, in different ways, lower the efficiency of the white blood cells in their defensive work. The effect is a vulnerability to what are now called psychophysiological disorders.

There is abundant evidence that stressors, some of them present sooner or later in the lives of all of us, will reduce the effectiveness of the immune system and create a vulnerability to physical illness. The research literature cites the following examples: The intense grief at the death of a spouse or partner can produce a measurable lowering in the activity of the immune system, and the development of a wide variety of illnesses seems to be more likely when the individual is an unhappy person.

The influence of psychological factors on physical health is also demonstrated in positive ways. People who are happy in their interpersonal relationships and content with the work they do seem to develop a heightened immunity to certain physical disease, for example, colds. If they are not totally immune, they at least recover more quickly.

Mediating Influences on the Effects of Stressors

Distressing events are part and parcel of the human condition. They occur more frequently to some than to others, their severity varies, and some stages of the life cycle seem more vulnerable than others. But regardless of those variables, there is abundant evidence from research on the problem that stressful events need not lead to physical disorders. What are the critical factors that control that effect?

To illustrate that range of possibilities, we examine three influencing factors of many that have been suggested in the research. They include one's lifestyle, what has been called explanatory style, and certain personality traits.

Lifestyle

Aspects of how one chooses to live one's life have been related to the development of psychophysiological illness. People differ in what they eat, how much they eat, and in their manner of eating. Powerfully persuasive evidence points to the damaging effect of smoking; lung cancer is only one of the fatal diseases it causes. On the other hand, physical exercise is suggested as a healthful aspect of lifestyle by all health experts.

More subtle factors are also part of lifestyle: one's impatience to get things done; temper flareups; strongly conflicting attitudes or needs. Those traits have been identified with the Type A personality, which is also associated with coronary illness.

J. H. Knowles, in an editorial in Science (1977), describes a healthy lifestyle: If no one smoked cigarettes or consumed alcohol, and if everyone exercised regularly; maintained optimal weight on a lowfat, low-refined carbohydrate, high-fiber diet; reduced stress by simplifying their lives; obtained adequate rest and recreation; drank fluoridated water; followed the doctor's orders for medication and self-care if disease was detected; and used available health resources, we would all live healthier and happier lives. Sadly, it will take more than reading that paragraph to produce any converts.

Explanatory Style

People differ in the way in which they explain life's events; consequently, they also differ in what they expect from life. Explanatory styles have been sorted into two principal types: the pessimistic and the optimistic. Individuals who have developed a pessimistic outlook see negative events as a part of the way things are, or as the result of what they seemingly are always doing. We are, they conclude, surrounded by bad happenings and this can't be changed.

Individuals with a pessimistic explanatory style, unfortunately, are creating their own fate in that attitude. For example, they are, as a group, at greater risk of illness, infectious disorders as well as those that are more apparently related to emotional tensions. The physiological team of Peterson and Seligman (1988), who have been pursuing the effects of varying explanatory styles, identified explanatory style as a mediating influence on the effect of stressors.

In what has been called the Harvard study, 5 percent of the Harvard classes of 1939–1944 have been followed since leaving college. At the age of 25, their explanatory style, one axis of which is important here, pessimism-optimism, was assessed. Peterson and Seligman report that pessimists at age 25 were in poorer health at age 45 than were those at the optimistic end of the scale.

In another study (1987), they report that similar results were obtained in a group of undergraduates whose health was monitored for a year after explanatory style was measured. Pessimists reported twice as many infectious disorders and visits to the doctor as did optimists.

One other study, reported by researchers at the National Cancer Institute, suggests that even the effects of breast cancer reflect the level of pessimism of the patient. In a group of 34 patients with a recurrence of breast cancer, pessimists died sooner than optimists.

Personality Traits

One group of psychologists, focusing on a trait they called hardiness, studied a group of executives in high-stress jobs. They found that three aspects of the trait identified stress-resistance individuals, those in whom stress produced minimal health changes: openness to change (the most powerful variable); a sense of involvement or commitment to their jobs; and feelings of being in control of their lives.

Hopelessness, a trait very different from hardiness, has been studied extensively as a factor in vulnerability to illness. The persistence and severity of diseases as different as cancer and influenza have been related to depression or feelings of hopelessness. Studies of residents of nursing homes suggest that survival rate after placement in a nursing home is related to the amount of control the individuals felt they had over what happened to them. That feeling of control enhances the attitude of hopefulness that the individual develops about future events.

■ PSYCHOLOGICAL FACTORS IN SPECIFIC PHYSICAL DISORDERS

Mounting evidence such as that which we have reported indicates that mind and body act as a unit. In this section, we examine the effect of psychological facts in triggering or in contributing to specific disorders. Although there are many specific psychophysiological disorders, this section reports on those that have been researched most extensively.

Coronary Disease

An exciting event on the psychosomatic front was the arrival of the concept of the Type A personality. In 1974, in a book of that title, Friedman and Rosenman described the concept, and they were able to relate that personality type to heart disorders. The concept caught on with many health-conscious people and also elicited research activities among medical and psychological professionals.

Friedman and Rosenman described Type A personalities as aggressive, competitive, hostile (at least unconsciously), feeling pressured by time, and always striving to succeed. They also described Type B individuals as relaxed and opposite in many ways to Type A personalities. Diagnoses of the personality types are made either on the basis of a stress-type interview or by a self-administered questionnaire.

On either type of assessment, Type A personalities are likely to admit such things as eating too fast, being too active, needing to slow down, setting work deadlines or quotas, and being irritated at interruptions in their work. Type B answers are at the opposite pole to those responses.

Two levels of research have been directed at the Type A concept: prospective studies that predict risk of heart attack from a personality assessment and research that attempts to pinpoint what it is in a Type A personality that increases risk of cardiac disease.

Predicting Coronary Heart Disease from Personality Assessments

This section describes the three best known and carefully researched studies of the relationship between a heart attack and personality type.

THE WESTERN COLLABORATIVE STUDY

In the Western Collaborative study (Rosenman, 1975), researchers tested first for personality type, and then followed 3,200 males and monitored their medical status for the next eight years. They found that men with Type A personalities had more than twice as many heart attacks as did those men who had been judged to be Type B.

THE FRAMINGHAM-MASSACHUSETTS STUDY

In the Framingham-Massachusetts study (Haynes, 1980), researchers studied a population of 1,600 men and women white-collar workers, who had been classified as Types A or B. The researchers found three times as many cases of coronary heart disease among Type A men and two times as many among Type A women than among Type B men and women.

THE BELGIAN HEART DISEASE PREVENTIVE PROGRAM

In the Belgian Heart Disease Preventive Program (Shekelle, 1985), 2,000 men in good health, as determined by a physical stress test, were rated on a Type A/Type B scale and followed for five years. The results were similar to the earlier studies. The men on the Type A side of the scale had almost twice as many cardiac symptoms as did those on the Type B end of the scale.

Characteristics of the Type A Personality That Cause Coronary Heart Disease

Findings such as those just summarized have challenged research psychologists to find precisely what it is about Type A personalities that makes them high risks for heart disease. They have pursued most vigorously two characteristics: hostility and chronic negative emotion.

HOSTILITY

Several researchers have followed a lead provided in the writings of the psychoanalytically oriented Franz Alexander, who related high blood pressure to the way in which individuals dealt with their aggressions. They found that when hostility was felt but not expressed overtly, the frequent result was high blood pressure, inhibited hostility and a Type A personality. Subsequent research also has supported the theory that long-term high levels of anger may be a key component linking the Type A personality and coronary heart disease.

CHRONIC NEGATIVE EMOTION

Other research has indicated that negative emotions such as anxiety and depression, not just anger, are the link between Type A personality and heart disease. In fact, it is easy to see a connection between the pressure and driven nature of the Type A personality and chronic negative emotions. Research evidence then suggests that chronic negative emotion is tied to increased risk for coronary heart disease rather than the personality traits themselves.

Essential Hypertension

Medical findings indicate that in 90 to 95 percent of hypertensive patients, there is no preexisting physical cause. Thus, almost all patients with high blood pressure are diagnosed with essential hypertension. In medical terms, "essential" means the absence of known physical causes. This is not to say, however, that there is an absence of physical correlates of high blood pressure. The first advice of a doctor to an overweight patient with high blood pressure is, "Lose some weight" or "Let me suggest a diet."

Even granted the presence of potentially dangerous dietary practices, the consensus of psychomedical opinion emphasizes the large role played by psychological elements in high blood pressure. A variety of psychological causes have been suggested. Two important ones come with research support: a psychoanalytically oriented hypothesis that high blood pressure is associated with suppressed rage, as well as research indicating the importance of negative emotion and lack of social support in hypertension.

Suppressed Rage

Anger is a strong emotion. Its immediate effects on the body are, in time, usually reduced by its open expression, assuming there is no physical violence against others that may produce other negative results. When an individual faces, for example, a strongly authoritarian and punitive father, or a life role that requires obsequiousness and containment of emotional expression, the result may be that the tensions present can be internalized and inflicted upon the body's vascular system by raised blood pressure. A 1977 study by Esler and others reports that individuals with hypertension who also exhibit signs of repressed hostility frequently have personalities that are overly submissive, overly controlled, and guiltridden. It is this pattern that would seem to provide the background for high blood pressure.

What is needed beyond such findings, in order to substantiate the causative role of suppressed hostility, is a prospective study that predicts, from early childhood parenting practices, which children will develop hypertension. Unfortunately, practical problems and the time period required for such an effort make that research difficult, if not impossible. However, research does indicate higher levels of anger and hostility in persons with hypertension and lower levels of hypertension among people who express anger appropriately.

Social Support and Negative Emotion

Research has found strong links between a lack of social support, loneliness, depression, and other negative emotions and hypertension. It is theorized that negative emotions might be responsible for the relationship between social support and hypertension. That is, low levels of social support are associated with negative emotional states. Negative emotional states are then linked to elevations in blood pressure.

Cancer

Most people find it understandable that certain physical disorders can be caused by emotional strain. Among those disorders are those we have discussed. On the other hand, the possibility of such a relationship in cancer is most often greeted with skepticism. It is not the severity of the disorder that causes that skepticism. Both cancer and coronary arterial disease have a high death rate. In this country, 600,000 people die of cardiac failure each year; cancer causes death in 514,000 people each year.

Perhaps the skepticism results from the concrete nature of cancer's physical growth, increasing in size each day, or spreading in minute cells that travel throughout the body. Other diseases do not seem to be so vividly imaginable. Another factor in causing the skepticism may be the well-known emphasis medical science gives to biological treatment and its effectiveness in many cases. When we think of cancer, we think immediately of radiation, chemotherapy, or even surgery. We do not often consider the influence of psychotherapy, although it can indeed be helpful in dealing with the knowledge that one has cancer.

Emotional Inhibition

One researcher (Caroline Bedell Thomas) had her own thoughts about that skepticism. She and other researchers, in the early 1940s, had noticed the coincidence of cancer and particular personality characteristics. In 1946, she administered a series of personality tests to a group of medical students who were conveniently available to her. Each year thereafter, with admirable persistence, she contacted them to inquire about their health. By 1977, forty-eight of her subjects had developed cancer. Comparing their personality profiles with those of the participants who had not developed cancer, she noted strong tendencies to repress intense emotions in the cancer patients. These people, she felt, might be described as having emotionally inhibited personalities.

Other researchers have confirmed her original findings of relationships between cancer and psychological characteristics, but in a somewhat different way. Rogentine and others, for example, reported in 1979 that those cancer patients who freely expressed negative emotions about the illness were more likely to survive than those who were more emotionally restrained. Later research indicated that cancer patients who received group psychotherapy lived longer than those receiving similar care but without psychotherapy.

Hopelessness in Cancer

Subsequent research has focused on hopelessness as a factor in development of cancer. One illustration of this is what might be called a serendipitous opportunity for research: Fifty-one women who entered a clinic for a cancer test were interviewed after medical examinations had revealed suspicious cells in the cervix that had to be investigated further before a definite diagnosis of cancer could be made.

The interview revealed that eighteen of the fifty-one had suffered significant losses in the preceding six months, to which, the interview further revealed, they had responded with feelings of hopelessness and a resultant sense of helplessness. Of the eighteen, eleven had a cancer diagnosis. Among the other thirtythree, with no such preceding life experiences reported, only eight had cancer. Although the difference seems small, statistical tests revealed those differences to be significant; that is, the likelihood was that they were more than chance happenings.

Other research with different types of cancer (lung cancer and breast cancer) has confirmed those earlier findings. One study reported that upon the news of a cancer diagnosis, a fighting spirit was associated with a better rate of survival five years later. Those studies by no means designate hopelessness as a primary cause of cancer; they suggest rather that personality variables play a part, at least, in affecting survival rates once cancer is diagnosed.

AIDS

AIDS affects the immune system, which is greatly effected by psychological factors. Therefore, do the two interact? That is, do psychological factors influence the course of AIDS? Research suggests yes. Psychosocial support groups for individuals who are HIV positive have been found to be associated with higher immune functioning, slower disease progression, and longer survival times. Subsequent research suggests that the decrease in negative emotions resulting from the support group might be responsible for the improved immune functioning. Other research suggests that positive emotions, rather than simply the absence of negative emotions, are associated with longer life expectancy in individuals who are HIV positive and experiencing the stress of caring for a loved one with a more advanced stage of the disease (see for example, Billings, Folkman, Acree & Moskowitz, 2000).

OVERVIEW ON CAUSATIVE FACTORS IN PSYCHOLOGICALLY AFFECTED PHYSICAL DISORDERS

A question that is now the target of a new and fast-growing branch of medicine, psychoneuroimmunology, is as follows: Are there other diseases not now considered psychosomatic that are triggered by emotional tension that consequently reduces the functioning of the immune system? With the number of psychosomatic ailments, and with so extensive a body of research on them, there is a place for each of the major perspectives on human behavior to provide interpretations of their etiology.

The Biogenic Perspective

There are two principal emphases in the biogenic perspective on psychosomatic disorders: genetic influences and involvement of the body's immune system. The current focus of the biogenic perspective is the diathesis-stress model as a way of thinking about the interaction between physical and psychological factors.

Genetics

Family studies, twin studies, and animal breeding research lend strong support to the presence of genetic factors, at least in certain of the psychosomatic disorders. Both family studies and twin studies indicate a genetic basis for hypertension, heart disease, and many types of cancer.

Genetic hypothesizing has suggested the somatic weakness theory. In that theory, it is speculated that genetic factors may create a vulnerability in some organ systems of the body, which makes them the weakest links in the body and thus especially sensitive to disease. There is research implicating a genetic vulnerability to breast cancer, for example. When this genetic vulnerability combines with other risk factors, the individual is at increased risk for developing breast cancer in comparison to others without the genetic vulnerability.

There is also evidence that each of us has a unique physiological reaction to all types of stressful situations. That this pattern is an inherited one is implied by research indicating that the infant's distinctive autonomic response is similar to his or her parents and persists throughout life. Given such a predisposition, it can be argued that any triggering emotional stress will produce a specific psychosomatic ailment.

Immune System

The body's immune system, as we describe in "The Immune System" section earlier in this chapter, defends the body against disease-causing foreign agents. Much evidence from animal laboratories demonstrates that in animals such psychological tensions as, for example, those created by a condition of helplessness, reduce the effectiveness of the immune system. In that way, the body's vulnerability to physical disease is increased. Recent research is beginning to suggest that positive emotions (beyond the mere absence of negative emotions) has a boosting effect on the immune system.

The Psychodynamic Perspective

Today, the psychodynamic theorist attributes psychosomatic illness to some aspect of a disturbed parent-child relationship, the same pattern that underlies other anxiety-based disorders. Psychodynamic therapies, although taking into account the physical aspects of the illness in treatment, approach the individual as they would any other individual with psychological problems, attempting to resolve inner conflicts.

One group of psychodynamicists, led by Flanders Dunbar and Franz Alexander, evolved a whole series of personality types, different for each of a variety of psychosomatic symptoms. For example, migraine patients were thought to be hard-working, conscientious, or perfectionistic personality types; hypertensive patients were considered to be covertly angry personality types who defended themselves against their anger by the symptoms of hypertension. Research directed by such hypotheses has failed to support them; individuals with those psychosomatic ailments could not be grouped into similar personality types according to the predictions required by the hypotheses. Their personalities were widely heterogeneous. Nevertheless, the relationship between the Type A personality and risk of heart attack, which fits the earlier psychodynamic conceptualization, suggests the possibility that there may yet be discovered a match between personality and certain psychosomatic disorders.

The Behavioral Perspective

Until recently, the rationale for considering psychosomatic symptoms to be the result of conditioning, either respondent or operant, was difficult to establish. For one thing, autonomic responses were considered to be beyond voluntary control. They, therefore, would not respond to operant conditioning. Second to hypothesize respondent conditioning as the cause of the illness would require frequent associations between a neutral stimulus to be conditioned and some unconditioned stimulus known to produce the response reflexively. In ordinary living, that eventuality would be a rare occurrence indeed.

In the 1960s, a principal block to a behavioral interpretation was removed when it was demonstrated that a variety of autonomic responses could be operantly conditioned in a very precise way; at least the theoretical possibility of a causal relationship between operant conditioning and a physical disorder was demonstrated. A powerful result of that research has been the development of a behavioral approach to the treatment of some forms of psychophysiological illness, which is known as biofeedback.

Following this research, behavioral scientists were able to condition a suppression of the immune system. While not under conscious control, it is now understood that learning can result in decreases in

immune functioning. For example, the condition of learned helplessness, where an individual learns through repeated experience that he or she is unable to control the outcome of situations, has been associated with suppressed immune system functioning.

The Cognitive Perspective

Attempts at understanding differences in survival rates of individuals who are HIV positive has resulted in investigating coping styles. Research indicates that using meaning-focused coping results in positive cognitions and increased survival rates. That is, individuals who are HIV positive, but choose to focus on obtainable goals, create meaning in light of difficult experiences, and acknowledge even small positive experiences live longer than those who do not engage in such types of cognitions.

TREATMENT APPROACHES TO PHYSICAL DISEASES AFFECTED BY PSYCHOLOGICAL FACTORS

Psychophysiological illness almost always brings the individual first to a medical doctor; and biological measures, directed mostly to symptom control, are the principal treatments used in such illnesses. In extreme cases—for example, of a heart attack—hospitalization, either on an emergency basis or for prolonged treatment, may be necessary. In mild to moderate psychophysiological illness with no lifethreatening features, ameliorative medical measures are taken. These include tranquilizers to reduce the exacerbating effect of emotional tensions on the symptoms or antihypertensive medications, usually for a lifetime.

Of the psychotherapeutic approaches, behavioral and cognitive therapies are more specifically prescribed than are psychodynamically oriented therapies. Three of the most widely used behavior therapies are biofeedback, behavior modification, and relaxation therapy. Cognitive therapies frequently involve psychosocial support groups.

Biofeedback

One study (Long et al., 1967) describing the use of biofeedback to control heart rate in a group of volunteers illustrates the main principle involved in that therapy. Participants watched a visual display of their heart rate and were directed to limit the rate to a prescribed range. The participants could not explain how they did it; but in time they had learned how to regulate their heart rate. The technique has been used with limited success in several other psychophysiological disorders. They include hypertension, headaches, and irregular heart beat. Immediately after treatment, patients control or moderate their symptoms. A positive effect is noticeable in mild to moderate illnesses; there are reports, however, that it is not a lasting one.

A variation of biofeedback uses biofeedback—for example, blood pressure as the response to be controlled—and combines it with psychotherapy. Connected into a biofeedback apparatus, the patients discuss, in interview fashion, various aspects of their lives. Whenever the machine beeps, signaling a jump in blood pressure, it also signals an area of life that is causing emotional tension. When followed with further discussion, the individuals can be helped to develop less stressful ways of responding to the troublesome aspects of their life situations.

Behavior Modification

This technique is essentially the application of operant conditioning principles to efforts to reduce or change psychosomatic symptoms. That is, for example, following the symptom either with an aversive stimulus or with the absence of a reward. Such conditioning would, in time, extinguish the undesired symptom. TIME Magazine, in a 1966 issue, reported the control of prolonged and energy-draining sneezing by following each sneeze with a painful, but not dangerous, electrical shock. A sixteen-month follow-up indicated that the sneezing had been controlled (Kusher, 1968). Behavior modification is most frequently used, however, to improve lifestyle factors associated with illnesses, such as smoking cessation, diet maintenance, and medical regimen compliance.

Relaxation Therapy

The therapy is a simple one. Under the guidance of the therapist, the individual is taught relaxation skills. These skills are then used outside of therapy on a regular basis to reduce tension and stress. Relaxation therapy has been shown to improve immune functioning, lower blood pressure, and help individuals cope with pain.

Psychosocial Support Groups

Psychosocial support groups exist to provide information and support for individuals with a common concern, such as cancer or AIDS. Research suggests that such groups have been effective in reducing negative emotions and improving life expectancies for individuals with AIDS and cancer.

SUMMARY

Research establishing the existence of a causal relationship between certain physical diseases and psychological stress clearly suggests that the body and mind work as a unit. The key finding in that research is the demonstration, made possible by modern technical developments, that various unconscious physiological reactions can be brought under voluntary control. With that finding, we may conclude that the body's functioning affects the way we feel and our psychological reactions affect the way in which the body functions.

A prime model for understanding the interaction between physical illness and psychological stress is the diathesis-stress formula, which states that human disorders (physical and mental) result from the presence of a diathesis (a predisposition or vulnerability), which may be genetic or the result of an early physical illness or injury. The vulnerability in this model is activated by some stressor in the environment; for example, a bereavement or loss of a job.

An external stressor activates the body's alarm reaction that, if maintained over a period of time, impairs the functioning of the body's immune system, comprising the blood, thymus, bone marrow, spleen, and lymph glands. With that impairment, there may be a reduction in the number of white blood cells in the bloodstream. These white blood cells function to destroy pathogens such as bacteria, viruses, fungi, and tumorous growths. As a result of that impairment, the body becomes especially susceptible to a number of physical ailments. Whether an illness will actually develop is influenced by the individual's lifestyle, "explanatory style" (the way the individual tends to explain what happens to him or her), and various other personality traits.

A hazardous lifestyle includes bad eating habits, smoking, consuming large amounts of alcohol, and such personality traits as impatience or hostility. A pessimistic "explanatory style" is one that attributes bad happenings to fate or "the way things are," explanations that dismiss any possibility of personal control of one's own destiny. One of the principal personality traits related to the development of psychologically caused physical disease is hopelessness.

The principal physical illnesses affected by those three aspects of the individual's personality are coronary disease, essential hypertension, cancer, and AIDS.

Among the psychological factors effecting coronary disease, the one most widely researched is Type A personality; that is, one that is aggressive, competitive, hostile, pressured, hypersensitive to being successful, and with a strong need to control others. Major large-scale studies have demonstrated a striking relationship between coronary disease and chronic negative emotions such as anger.

Essential hypertension is high blood pressure in the absence of an organic reason for it. Two possible psychological causes of it are suppressed rage and negative emotions.

Beyond those psychosomatic illnesses, the personality traits of emotional inhibition and hopelessness have, in a small number of research studies, been related to the occurrence of cancer and rate of

Reduction in negative emotions and presence of positive emotions have been associated with slower disease progression and longer survival in those infected with HIV.

Treatment of the mild and moderate psychosomatic illnesses is often ameliorative with the use of the minor tranquilizers (for example, Valium or Xanax). Among the psychotherapeutic treatment techniques are biofeedback, behavior modification, relaxation therapy, and psychosocial support groups.

SELECTED READINGS

Billings, D. W., Folkman, S. Acree, M. Moskowitz, J. T. (2000). Coping and physical health during caregiving: The roles of positive and negative affect. Journal of Personality and Social Psychology, 79, 131-142.

Daruna, J. H. (2004). *Introduction to psychoneuroimmunology*. Burlington, MA: Academic Press. Baum, A. & Andersen, B. L. (eds.) (2001). Psychosocial interventions for cancer. Washington, DC: American Psychological Association.

Kiecolt-Glaser, J. K., McGuire, L., Robles, T. F., & Glaser, R. (2002). Psychoneuroimmunology: Psychological influences on immune function and health. Journal of Consulting and Clinical Psychology, 70, 537-547.

Larkin, K. T. (2005). Stress and hypertension: Examining the relation between psychological stress and high blood pressure. New Haven, CT: Yale University Press.

Molinari, E., Compare, A., & Parati, G. (2006). Clinical psychology and heart disease. New York: Springer.

Monnette, P. (1998). Borrowed time: An AIDS memoir. San Diego, CA: Harvest Books.

Straub, R. O. (2001). Health psychology. New York: Worth Publishers.

Test Yourself

1)	What model of the interaction between stress and health focuses on the three stages of alarm, resistance, and decompensation?			
	a) diathesis-stress model	c) psychoneuroimmunology		
	b) general adaptation syndrome	d) psychosomatic model		
2)	What model of the interaction between stress and health focuses on the role of vulnerabilities and activating factors?			
	a) diathesis-stress model	c) psychoneuroimmunology		
	b) general adaptation syndrome	d) psychosomatic model		
3)	Which of the following is/are mediating factor(s) on the influence of stress?			
	a) explanatory style	c) personality		
	b) lifestyle	d) all of the above		
4)	The development and progression of cancer is thought to be related to			
	a) genes	c) repressed emotion		
	b) hopelessness	d) all of the above		
5)	Research suggests relaxation training and biofeedback can be helpful in treating			
	a) AIDS	c) essential hypertension		
	b) cancer	d) coronary heart disease		
6)	Coronary heart disease is linked to			
	a) autoimmune response	c) Type B personality		
	b) chronic negative emotion	d) repressed Oedipal conflict		
7)	Longer life expectancy of individuals with this disorder have been associated with both lower levels of negative emotions and higher levels of positive emotions			
	a) AIDS	c) coronary heart disease		
	b) cancer	d) essential hypertension		
8)	Psychosocial support groups have True or false?	been found to be helpful for individuals with physical illnesses.		
9)	Behavioral techniques have not bee ical illnesses. True or false?	en found effective in improving the health of individuals with phys-		

Test Yourself Answers

- 1) The answer is **b**, general adaptation syndrome. General adaptation syndrome describes a response to stress wherein the individual initially responds with alarm (arousing resources), then resistance (fighting the stress), and, if the stressor continues, eventually responds with decompensation as exhaustion occurs.
- 2) The answer is a, diathesis-stress model. The diathesis-stress model is a theory of illness based upon an interaction of a vulnerability (diathesis) and an activating factor (stress). For example, a genetic predisposition toward cancer could combine with environmental exposure to carcinogens resulting in the development of cancer. Both the diathesis and the stress can be biological or psychological.
- 3) The answer is **d**, all of the above. Explanatory style (attributions an individual makes about the causes of events), lifestyle (decisions such as diet, exercise, and smoking), and personality (such as harboring negative emotions) all impact the relationship between stress and health. When an individual has a negative explanatory style, makes unhealthy lifestyle choices, and is characterized by pent-up negative emotions, he or she is at greater risk for a number of health problems.
- 4) The answer is d, all of the above. Genes, hopelessness, and repressed emotions all have been associated with the development and progression of cancer. As of yet, medicine has not found a way to change genes, but psychosocial groups have been found to improve hope and facilitate expressions of emotion, and are associated with higher survival rates.
- 5) The answer is c, essential hypertension. Biofeedback and relaxation training both have been found to be effective in reducing high blood pressure, the defining symptom of hypertension. Relaxation training has the benefit of being easy to practice at home.
- 6) The answer is b, chronic negative emotion. Chronic negative emotions such as anger have been tied to coronary heart disease. In fact, it is theorized that this is the key component of Type A personality, which links personality type and heart disease.
- 7) The answer is a, AIDS. Individuals with AIDS who have low levels of negative emotion have been found to have better survival rates. Additionally, individuals with higher levels of positive emotions, despite experiencing stress, were found to live longer.
- 8) The answer is **true.** Psychosocial groups have been found to be an effective way to decrease negative emotional states and increase the life span and life quality of individuals with a variety of illnesses, including AIDS and cancer.
- 9) The answer is **false**. Behavioral techniques such as relaxation training and behavior modification have been found to be effective in improving the health of people with physical illnesses, such as hypertension.

Personality Disorders

he category of psychiatric illnesses labeled personality disorders includes an array of widely different types of maladaptive behaviors ranging from extreme passivity to violently antisocial behavior. In between those extremes, an individual with a personality disorder may characteristically show any one of the following types of abnormal behavior: narcissistic; histrionic; eccentric; hypersensitive; reclusive; overdependent; perfectionistic; or inflexible.

The common characteristic justifying the diagnosis of personality disorder among those widely differing groups of people is that they have developed, early in life, personality traits that are persistent and maladaptive. These traits cause either significant impairment in social and/or occupational adjustment or extreme personal distress. The behavior pattern constituting the disorder can usually be recognized during middle to late adolescence. It persists through adulthood, although sometimes tapering off during middle age. The behavior of the individual with a personality disorder is not episodic, nor is it notably related to stress. Instead, it is a characteristic way of behaving in all or most of the interpersonal relationships the individual enters.

Personality disorders differ in significant ways from other categories of psychiatric illness. Personality disorders are long-established traits of personality that characterize the individual's behavior from adolescence or even childhood. The personality disorders involve the whole personality, permeating all the individual's thoughts and behavior. Personality disorders usually cause less pain to those with the disorder than to those with whom they are associated (for example, fellow workers, friends, and family). Given his or her ways of thinking about human relationships, an individual with a personality disorder leads a highly patterned, inflexible, life. Although likely to see the world principally through the very narrow perspective of his or her selfish interests, an individual with a personality disorder usually maintains an adequate contact with reality.

This chapter describes the various types of personality disorders, including what is known about their etiology and treatment.

THE TYPES OF PERSONALITY DISORDERS

Although the earliest identification of one type of behavior now classified as antisocial personality disorder goes back to the middle of the 19th century, when "depraved," criminal, or immoral behavior was labeled "immoral insanity," the first systematic classification of the personality disorders appeared in the American Psychiatric Association DSM I, published in 1952. Since its first listing, various refinements have been made in it, and the process of refinement continues. The ten types of personality disorder are organized into three clusters, labeled simply as A, B, and C.

Cluster A Personality Disorders

Grouped into one cluster are three personality disorders—paranoid, schizoid, and schizotypal—in all of which the characteristic behavior of the individual appears odd or eccentric, although the behavior may take varying forms.

Paranoid Personality Disorder

Unreasonable, baseless, and persistent suspiciousness is the hallmark of paranoid personality disorder. The trait shows itself in almost every aspect of the individual's behavior.

SYMPTOMATOLOGY

Ordinarily, being suspicious in some life situations can be a prudent response; the normal person gives up his or her suspicions when credible evidence to do so is presented. The individual with paranoid personality disorder ignores such evidence and may develop elaborate reasons to dismiss it or may become suspicious of the person presenting the evidence. The paranoid individual is hypervigilant, always looking for trickery or slipperiness in the behavior of others. Such individuals trust no one's loyalty, often accusing others of having ulterior motives, for example.

Each new situation they enter must be examined carefully for any possible pitfalls or entrapment. They will seize upon the slightest out-of-the-way occurrence to justify their suspicions. They delight in finding hidden meanings in what someone says or in catching anyone in a misstatement.

Other traits associated with their illness are argumentativeness and litigiousness; absence of sentimental or tender feelings; overseriousness and humorlessness. They are overly concerned with rank and class distinctions, are covertly envious of those in high positions and disdainful of those who seem to be weak or soft people. Although they frequently come close to difficulties with authority figures, an element of their behavior that causes frequent job changes, their very suspiciousness causes them to back away from getting into real trouble. When it threatens, they are capable of covering up their symptoms.

PREVALENCE

Paranoid individuals rarely entrust themselves to the close interpersonal contact of therapy. However, it is estimated that 4.4 percent of the population meets criteria for paranoid personality disorder. The disorder is more frequently seen in females.

ETIOLOGY

The cause of paranoid personality disorder is unclear at this time. It appears that early teachings about distrust from parents or culture may be influential in the development of the disorder. From a psychodynamic perspective, it is possible that failure to develop basic trust in the early parent-child relationship could lead to a paranoid personality.

TREATMENT

Treatment of paranoid personality disorder is quite difficult due to the mistrust that is symptomatic of the disorder. However, the techniques that are most frequently used involve challenging paranoid cognitions.

Schizoid Personality Disorder

The outstanding feature of the schizoid personality is an inability to form social relationships, a trait that makes them loners in any society.

SYMPTOMATOLOGY

Persons with schizoid personality disorder show a lack of capacity to experience personal warmth or deep feelings; they are, as a result, unable to relate to others. They are insensitive to praise, criticism, or the feelings of others. Self-absorbed, they may appear to others to be absent-minded or off in another world; they are nevertheless free of the eccentricities of behavior, thought, or speech characteristic of the schizotypal personality disorder (described in the following section).

Associated with their illness are excessive daydreaming, vagueness about their goals, and indecision and hesitancy about their actions. They tend to be, as one might expect, humorless, dull, cold, and uninteresting. Nevertheless, given a job that allows them to function by themselves, they often make a good occupational adjustment.

PREVALENCE

Estimates suggest that approximately 3.1 percent of the population meet criteria for schizoid personality disorder.

ETIOLOGY

Little is known about the cause of schizoid personality disorder. There is some evidence of lower density of dopamine receptors in the brains of individuals with the disorder, suggesting a biological component. Additionally, it easily can be seen how a lack of social skills or limited range of emotions would lead to social isolation and being unaffected by praise or criticism, a vicious cycle that may perpetuate early symptom expression.

TREATMENT

Treatment for individuals with schizoid personality disorder typically focuses on teaching social skills and attempting to help the person see the value of interpersonal relationships. However, individuals with this disorder rarely request treatment on their own because of the lack of distress symptomatic of the disorder.

Schizotypal Personality Disorder

The two separate categories of personality disorder, schizoid personality disorder and schizotypal personality disorder, were developed to distinguish more clearly between the two types of behavior and to separate both of them from schizophrenia. In schizoid personality disorder, the primary symptom is social withdrawal with few if any symptoms of eccentricity. The schizotypal personality disorder is characterized by oddities of perception, speech, thought, and behavior which are not extreme enough to meet the diagnostic criteria for schizophrenia.

SYMPTOMATOLOGY

The oddities observed in the schizotypal person include rambling speech, although not the incoherence of schizophrenia; illusory experiences (reporting that he or she feels that something illusory was real); and magical thinking, such as claims to be able to read the thoughts of others or tell the future. Also present are ideas of reference, in which the individual reports (without foundation) that irrelevant events have some special, personal significance. Other symptoms may include extreme superstitiousness, social isolation, suspiciousness bordering on paranoia, and inappropriate or limited expressions of emotions.

PREVALENCE

The prevalence of schizotypal personality disorder is estimated to be about 3 percent.

ETIOLOGY

There is evidence of a familial pattern of schizophrenia among the relatives of the individuals with schizotypal personality disorder. Again, a lack of social skills and unusual beliefs or behaviors likely contribute to disrupted social interactions, but the details of psychosocial causes of schizotypal personality disorder are unclear.

TREATMENT

As might be guessed, treatment tends to include teaching social skills. Sometimes antipsychotic medication is used to attempt to decrease odd behaviors and ideas of reference. Unfortunately, treatment has a low success rate.

Cluster B Personality Disorders

The four disorders gathered here present symptoms that are more dramatic, attention-seeking, impulsive, and erratic than are the other personality disorders. The four personality disorders of Cluster B will be discussed here: histrionic personality disorder; narcissistic personality disorder; borderline personality disorder; and antisocial personality disorder.

Histrionic Personality Disorder

The central concern of the histrionic individual is to be on stage at all times.

SYMPTOMATOLOGY

Self-dramatization, heightened emotionality, and the need to capture everyone's attention typify the lifestyle of people with histrionic personality disorder. Their behavior is reactive and intensely expressed in dominating group discussions by dramatic recitals with elaborate exaggerations of events that others might mention in passing. Everything that happens to them is a major event that they seem to assume is of great interest to everyone else. On early acquaintance, they can be extremely charming, but that charm soon grows thin in the face of stormy explosions that often occur and the shallowness of emotion and selfishness of demands which are soon perceived by others.

The histrionic individual often is highly gullible in interpersonal relations, establishing unrealistic dependent relationships and expecting unreasonable favors from others. He or she may be seductive in the attention paid to others, but personal relations are superficial and sexual life is transitory. Dramatically developed possible catastrophes, including threats of suicide, are manipulatively used by the individual to gain his or her ends. Impaired and stormy relationships follow the individual through life.

PREVALENCE

The disorder has a prevalence of 1.8 percent and is equally common among women and men. Symptoms of histrionic and antisocial personality disorder frequently co-occur. In fact, it has been hypothesized that the two disorders are simply one disorder with different presentations depending on the gender of the individual (women more frequently appearing to be histrionic and men antisocial). This theory has not yet been supported or refuted.

ETIOLOGY

Little is known about the cause of histrionic personality disorder.

TREATMENT

There is not currently an effective treatment of this disorder. Attempts to use behavioral methods or improve interpersonal relationships are sometimes used.

Narcissistic Personality Disorder

The dominating feature of this disorder is an all-consuming self-absorption with grandiose notions of the individual's own unique importance, talent, and right to special consideration.

SYMPTOMATOLOGY

There is an absence of capacity to empathize with others or to consider others' needs. Their selffascination leads them to make exorbitant demands on others; to be exploitative with no pangs of conscience; and to respond with arrogance, disdain, or dismissal when their demands are unfulfilled. Yet with all of that felt self-importance, there is an underlying lowered sense of self-esteem, which reveals itself in a constant need for reassurance and admiration from others and a quick response of rage or disdain to any proffered criticism. The narcissist may dismiss failure with nonchalance, describing it as an unimportant experience. There is a sense of being special with focus on dreams of unlimited success.

PREVALENCE

The prevalence of narcissistic personality disorder is 0.5–1 percent.

ETIOLOGY

Some personality theorists consider narcissistic behavior a compensatory and defensive response to deep feelings of inadequacy, perhaps stemming from early childhood experiences of disapproval and rejection. There is also the possibility that parents, through catering to the child and building unrealistic expectations about what he or she should expect from others, or failing to model empathy, foster the narcissistic personality. Another theory is that a hedonistic, individualistic culture encourages the disorder.

TREATMENT

Treatment tends to focus on developing empathy, decreasing grandiosity, and coping with criticism. Little is known about the effectiveness of such treatment.

Borderline Personality Disorder

The distinguishing characteristic of the disorder is marked instability in interpersonal relations, mood, and even in image of self. Because the borderline personality from time to time shows symptoms of antisocial personality, schizotypal personality, narcissistic or histrionic personality, and occasionally the symptoms of the mood and anxiety disorders, the diagnosis of borderline personality disorder is a challenging problem.

SYMPTOMATOLOGY

To keep the category from becoming such a hodgepodge, the DSM-IV-TR requires that before the diagnosis is made, the individual show at least five of nine types of maladaptive and disordered behavior. The nine behaviors considered diagnostic are impulsive or unpredictable self-damaging emotional behavior, physically self-damaging behavior, instability and inappropriate or maladaptive intensity in interpersonal relationships, spells of intense and uncontrollable anger, self-identity disturbances, emotional instability involving marked and short-term shifts in mood, intense fear of abandonment, occasional symptoms of paranoia or dissociation in response to stress, and unrelieved feelings of emptiness or boredom.

Borderline personality disorder has a prevalence of about 5 percent and appears more frequently in women than men.

ETIOLOGY

There is evidence of an inherited vulnerability to impulsivity and mood disturbance in the families of individuals with borderline personality disorder. Individuals with borderline personality disorder often have a history of trauma, suggesting that traumatic experiences may play a causal role in the development of the disorder, although it is clear that trauma alone is insufficient to cause the disorder.

TREATMENT

Treatment of borderline personality disorder typically is two pronged: biogenic and cognitivebehavioral. The biogenic approach typically involves the use of antidepressant medication, such as SSRIs. The cognitive-behavioral approach typically focuses on coping skills training, such as dialectical behavior therapy (DBT). DBT is an intensive treatment that focuses on teaching problem solving, mood managing, and interpersonal skills. It has been found to have some success in reducing symptoms. The symptoms of borderline personality disorder tend to diminish in middle age.

Antisocial Personality Disorder

Behavior such as that now described as an antisocial personality was first identified and distinguished from other psychological disorders in 1837 by the British psychologist J. C. Prichard, who considered it to be "moral insanity." Clinicians of that day considered it a disorder of the will that made the person incapable of conforming to society's demands. In the late 19th century, the disorder came to be called psychopathic personality, and with the biogenic bias of the day, a hereditary basis for the disorder was assumed. This "bad seed" interpretation held sway until the early part of the twentieth century, when social influences were thought to be important causes of the illness and the disorder was named sociopathy. Today, the agreed-upon diagnosis is the neutral antisocial personality disorder, although both earlier terms frequently make their appearance. Modern thinking recognizes interpersonal, biogenic, and sociocultural factors as possible causative elements in the disorder.

Example of Antisocial Personality Disorder

Gary Gilmore, whose criminal behavior and life history are now a matter of public record, is an extreme example of the antisocial personality. His behavior and his reactions to that behavior well illustrate two of the most prominent characteristics of the antisocial personality: purposeless and irrational antisocial behavior with no remorse about the harm done. In his own words, Gilmore describes the murder that led to his death sentence and electrocution: "I pulled up near a gas station. I told the service station guy to give me all his money. I then took him to the bathroom and told him to kneel down and then I shot him in the head twice. The guy didn't give me any trouble, but I just felt like I had to do it." That vicious and purposeless crime was the finale of a long history of assorted antisocial activity beginning during early adolescence.

Symptomatology

Most individuals with antisocial personality disorder do not commit as egregious crimes as Gilmore did. Symptoms of the antisocial personality fall into two principal categories: overt antisocial behavior (behavior that violates the rights of others or rules necessary for the smooth functioning of society) from an early age and underlying personality traits that provide the basis for that behavior.

OBSERVABLE ANTISOCIAL BEHAVIOR

The diagnostic manual, which rests its diagnosis on observable behavior with no attribution of causality, indicates the following examples as characteristic of the personality disorder: failure to accept social norms; irritability and aggressiveness; irresponsibility in meeting financial, parenting, or other

obligations; impulsiveness and failure to plan ahead; deceitfulness; lack of remorse; and reckless behavior. No one of these tendencies or a single instance of one or two, especially without an early life history of antisocial behavior, justifies a diagnosis of personality disorder. The diagnostic manual specifies that at least four of the patterns be exhibited since the age of fifteen.

Personality Characteristics of Antisocial Personality Disorder

Psychologists who have studied the antisocial personality go beyond the objective criteria of the diagnostic manual to identify personality characteristics of the disorder that seem to engender the described antisocial behavior. Several personality traits deeply ingrained in many people with antisocial personality disorder have been identified by psychologists.

Emotional Poverty

The antisocial personality seems never to have developed the capacity to feel strong or deep emotional attachments. There is no real capacity for deep love or loyalty to anyone else. The ordinary emotions of anger, grief, and despair are absent. People with antisocial personality disorder show no pity or sympathy for the victims of their crimes, not even much sadness about the sorry plight in which they ultimately find themselves as a result of their behavior.

Absence of Conscience

Along with a flat affective lifestyle, a nonworking conscience is seen. Although intellectually able to know right from wrong and even ostentatiously mouthing the principles of ethical behavior, they exhibit no remorse about unprincipled behavior, no guilt about irresponsible, sometimes vicious behavior. Nothing seems to affect them about their crimes except perhaps mild unhappiness about having been caught.

Facile Charm and Glibness

A capacity to be charming and to use this charm to manipulate or exploit others is characteristic of a person with antisocial personality disorder. An especially troublesome trait is their glibness and skill in talking others into victimization. Many victims, even after having been exploited, maintain good feelings about the individual who victimized them. Individuals with antisocial personality disorder frequently are able to escape arrest or punishment by their persuasiveness and deliberately projected air of candor and sincerity. They make friends easily, and just as easily give them up or take advantage of them. They easily persuade others of their good faith, and at times almost delude themselves into believing that what they say is all right.

Inadequately Motivated Behavior

As much as we may deplore criminal behavior, we can still make sense of what the normal criminal has attempted—to make money, to collect on an insurance policy, to make important connections. The antisocial behavior of the individual with this disorder seems purposeless and spur of the moment: a crime, perhaps a heinous one, committed simply because the individual felt like doing it. The person with antisocial personality disorder is unable to say why he or she committed the crime. In the place of the usual motives for the crime there is impulsiveness and the need to seek thrills and excitement.

Inability to Learn or Benefit from Experience

Individuals with antisocial personality disorder go through life without ever seeming to learn from mistakes, to be more calculating in planning their behavior the next time, or to make efforts to avoid detection. The ordinary punishments that most people would fear seem meaningless to them. Their needs

are immediate, and memories of past punishments have little if any influence on what they will do today or tomorrow.

Shattered Interpersonal Relations

Initial friendships won by their glibness and exploitative charm are very quickly shattered by their soon-to-be-discovered cynical, ungrateful, and unfeeling behavior to the newly acquired friends. Lifetime interpersonal relationships are nothing but a series of short-term contacts, callously looked upon by the individual with antisocial personality disorder as new opportunities for manipulation and exploitation.

Warped Reactions to Punishment

Certain punishments that normal people try diligently to avoid seem meaningless to people with antisocial personality disorder. They seem not to be influenced by physical punishment and do not care about social disapproval except as it might interfere with an immediate exploitative venture. However, at least one experiment demonstrated that people with antisocial personality disorder respond to loss of money as a punishment. The proper conclusion to draw here is that punishment is influential for those with antisocial personality disorder only if it specifically interferes with an ongoing goal, and it is therefore especially aversive.

Prevalence

Epidemiological studies indicate the prevalence of antisocial personality to be around 3.6 percent. It is more common in men than women. Onset for males is typically in preadolescence; for females it is during early adolescence. Typically, the onset of antisocial personality disorder is preceded by conduct disorder (see Chapter 19) in childhood.

Etiology

There is substantial agreement among psychologists that antisocial personality disorder develops out of some mix of four principal elements: early family relationships; defects in learning; biogenic factors, both genetic and physiological; and sociocultural factors.

EARLY FAMILY RELATIONSHIPS

When parents fail to give their children the loving nurturing that healthy growth requires, the child's own emotional growth is stunted, and emotional poverty may soon result. That emotional deprivation can result from sheer neglect, rejection, or from coldness on the part of the parent. When the latter is the case, family life, viewed from the outside, can appear to be stable and happy but be unrewarding for the child. Such covert unhappiness at home may account for the occasional adolescent who seems to have come from a stable, happy home but develops antisocial personality disorder.

DEFECTIVE EARLY LEARNING EXPERIENCES

Ethical values and principled behavior are normally learned at home. When the models that parents and siblings offer are inappropriate, children fail to develop a sense of discipline or ethical control. When the reward/punishment practices at home are inconsistent, or when each parent takes a different approach—for example, a stern, disciplinarian father and a mother who compensates by leniency, secretive rewards, and giving in to any demands made by the child—the child grows up confused about values. He or she may pick up hostility to all authority as representing the hated father and learn manipulative and exploitative behavior from the unwitting cooperation of his or her mother.

BIOGENIC FACTORS

Possible biological factors causing antisocial behavior fall into two categories, genetic and physiological, the latter of which may, however, be caused by the genetic anomalies.

Genetic Factors

Much research has been devoted to the question of possible genetic causes of antisocial personality disorder. The safest conclusion to draw from those studies is that the disorder is the result of a combination of hereditary and environmental influences. The report of a Danish study will both illustrate the nature of the research conducted and the findings.

Using official Copenhagen registration data and police files, the researcher isolated a group of people with antisocial personality disorder who had been adopted in infancy. He found that the biological relatives of these people were four to five times more likely than the adoptive relatives to meet the criteria for a diagnosis of antisocial personality. He nevertheless reported that the small differences justified only the conclusion that although there is a genetic factor operating, environmental influences must also be considered as significant. Comparable studies conducted in the United States confirm that conclusion.

Considering the existing research, the evidence suggests a genetic factor, but one that interacts with environmental influences causes antisocial personality disorder. To put it loosely, it can be said that although a predisposition to antisocial behavior has a genetic base, the mode of antisocial behavior will be learned from the environment the individual experiences.

Physiological Factors

Given possible genetic causative influence, the question remains, what is it that is inherited to cause the development of antisocial behavior? One strongly supported interpretation suggests that people with antisocial personality are born with a physiological deficiency that creates a cortical immaturity. A delayed development of the higher functions of the brain results. Two well-known characteristics of the disorder give credence to this interpretation. Between 30 and 38 percent of all people with antisocial personality disorder show abnormal brain wave patterns (electroencephalographic recordings). The most common feature of the abnormality is a slow brain wave activity characteristic of infants and children, but not of adults. Given time, the immature brain will, later in life, finally mature. With the maturing of the brain, changes in behavior can be expected. Such change does take place in many individuals with antisocial personality disorder as they grow older, when much of their flagrant antisocial behavior diminishes.

Because much of the abnormal slow brain wave activity comes from the temporal lobes and the limbic system, areas of the brain that control both memory and emotional behavior, it is thought that genetic influences operate by impairing those parts of the brain. Their impairment would seem to create a physiological basis for the low level of arousal characteristic of the antisocial personalities and their difficulties with avoidance learning. In fact, several early studies of the antisocial personality indicate that those with the disorder are underaroused by emotional or noxious stimuli that would strongly arouse nonaffected individuals. For example, individuals with antisocial personality disorder are much less likely to learn from punishment or frightening experiences compared to those without the disorder. There is physiological evidence to suggest that their autonomic nervous systems respond at a low level of variability, lowering the level of fear and anxiety they experience. A series of skillfully constructed and carefully controlled experiments seemed to demonstrate that their low level of arousal not only causes impulsive and stimulus-seeking behavior but also results in deficient avoidance learning.

To test the hypothesis that low levels of arousal among individuals with antisocial personality disorder impairs their ability to learn from negative experiences or punishment (avoidance learning), a group of people with the disorder were compared with a group of people without the disorder in learning a mental maze. They were asked to learn which one of four levers turned on a green light. Two of the levers produced the wrong response of red. The fourth lever produced an electric shock. The task was one of considerable complexity. Both groups, as expected, made the same total number of errors; but while the nondisordered subjects quickly learned to avoid the punishing electric shock, people with antisocial personality disorder took much longer to do so. Their capacity to avoid punishment seemed to be impaired, possibly because the electric shock was not as punishing for them as it was for the nondisordered participants.

SOCIOCULTURAL FACTORS

The diagnostic manual reports that antisocial personality disorder is more common in lower socioeconomic groups. In interpreting that statement, care must be taken not to identify poverty with psychiatric illness and not to conclude that poverty by itself is a cause of antisocial behavior. At most, an impoverished home life can be a contributory cause only when other social and biogenic causes are operative. For example, facing the demands of poverty may result in difficulties in parenting that have been found to be associated with antisocial personality disorder. Conversely, it could be that the irresponsibility and impulsiveness of individuals with antisocial personality disorder results in their being of lower socioeconomic status. These people then pass on a genetic predisposition toward antisocial behavior to their children.

Treatment

In general, individuals with antisocial personality disorder very seldom self-refer to treatment given their tendency to deflect responsibility for their actions and to have little genuine emotional reaction to life events. There is universal agreement among psychologists that people with antisocial personality disorder make poor candidates for treatment. Personality characteristics of the antisocial personality, and often their life circumstances, operate against their responding to treatment. Nevertheless, clinicians continue to try new therapeutic approaches. At least one of those, the residential treatment center, seems mildly helpful.

NEGATIVE INFLUENCES ON RESPONSE TO THERAPY

Three elements work against successful therapy with the antisocial personality: the ingrained nature of their symptoms; their inability to relate to others; and the involuntary nature of the therapy that society frequently forces upon them.

Deeply Ingrained Personality Traits

The underlying causes of the antisocial behavior are personality traits that have developed in the individual from early childhood. Lifelong patterns of behavior are resistant to change. Those patterns of the antisocial personality resist even prolonged psychotherapy.

The Nature of Symptoms

The principal characteristics of the antisocial personality described previously make impossible any interpersonal relationship that is dependent upon mutual trust, and such trust is a requirement of all forms of psychotherapy.

Involuntary Treatment

People with antisocial personality disorder are more likely to wind up in the prison system than in mental health clinics or psychiatric hospitals. The rehabilitation programs provided are largely involuntary, and they have little impact. For them, the penal system seems to be a revolving door; in and out, unchanged.

PROMISING TREATMENT EFFORTS

Despite the discouraging results, psychologists continue to explore other avenues of treatment. A 1978 publication advises therapists attempting to treat antisocial personality disorder to take three precautions in establishing a therapeutic relationship. They are as follows: be on guard for any attempts at manipulation and exploitation in the therapy relationship; assume that much information provided by the patient will be distorted or even fabricated; and be patient—a therapeutic relationship with an individual with antisocial personality disorder will take a long time to develop.

Aside from that advice for anyone who would attempt one-on-one therapy, programs based entirely on learning principles are being attempted. These programs would first withdraw any reinforcement of antisocial behavior, including the use of attention-providing punishment; second, they would use change agents-that is, admired others, including the therapist and peers, upon whom to model the desired behavior, which can then be rewarded when the individual responds; third, material rewards are gradually eliminated as the individual finds self-established symbolic rewards effective in motivating behavior.

It is clear that only in a residential treatment center in which the person can be supervised continuously could such a program be implemented successfully. In one program based on learning theory for adolescents with antisocial behavior, program leaders reported a change in behavior while the individual continued to reside at the center. However, the change did not endure after the individual had been released. This finding is consistent with many other learning-based residential treatment programs for individuals with antisocial personality disorder.

Antisocial personality disorder has been found to be prevented through intensive early intervention programs for children and their families. However, once the disorder is fully established, the typical pattern is of incarceration to protect the public rather than any effective program of treatment. Symptoms of antisocial personality disorder do, however, appear to decrease in middle age.

Cluster C Personality Disorders

The third grouping of personality disorders brings together three disorders in which, unlike the other clusters, the individual may experience bouts of anxiety and apprehensiveness. The disorders are avoidant, dependent, and obsessive-compulsive personality disorders.

Avoidant Personality Disorder

Although lonely and desirous of affection and acceptance, the person with avoidant personality disorder avoids or withdraws from social contacts. Unlike the person with schizoid personality disorder, who withdraws from social situations because he or she sees no value in them, the person with avoidant personality disorder prizes social relationships, but self-esteem is so low and sensitivity so high that the person is afraid to reach out and make contact with others.

SYMPTOMATOLOGY

Symptoms of avoidant personality disorder include a hesitancy to take interpersonal risks, poor selfimage, social inhibition, overconcern with criticism or rejection, lack of willingness to get involved with others due to fear of being disliked, restraint even in close relationships, and avoidance of interpersonal interactions. The person with avoidant personality disorder will choose to have lunch in a company cafeteria alone rather than join a table of associates where there is a vacant place. He or she cannot summon the courage to make a phone call, although the person may badly want the phone to ring. He or she can

walk by even a small group of classmates and make no effort to join them. They often interpret even gentle kidding as a dreaded rebuff.

PREVALENCE

The prevalence of avoidant personality disorder is about 2.4 percent. It is more common in women than men.

ETIOLOGY

It is not entirely clear what causes the symptoms of avoidant personality disorder. However, the individual with avoidant personality disorder often finds himself or herself in a vicious cycle, demanding guarantees of acceptance and freedom from even hints of criticism, so that social life soon becomes extremely limited. The failure to make friends lowers self-esteem, which, of course, intensifies the anxiety at entering social situations. Left alone, the person worsens the problems by dwelling on shortcomings and magnifying social failings. The behavior of a person with avoidant personality disorder is self-defeating; unwillingness to reach out results in the absence of the very relationships that are desired. As time goes by, any social skills are lost, and the isolation becomes more complete. Career opportunities are limited to those few positions where any social contact is momentary and unimportant. Hence, once symptoms have developed, they easily can become ingrained.

TREATMENT

Treatment of avoidant personality disorder typically focuses on helping the client manage anxiety and improve social skills, frequently using behavioral and cognitive techniques.

Dependent Personality Disorder

Like avoidant personality disorder, dependent personality disorder stems from a seriously low level of self-esteem. In dependency, however, the individual flees into turning over his or her life to other people, meekly carrying out decisions others are pressed to make for him or her.

SYMPTOMATOLOGY

The individual with dependent personality disorder struggles with routine decisions, abdicates responsibility for his or her life, has difficulty expressing disagreement, has a hard time engaging in independent activities, goes to extremes to get support from others, has excessive fear of being incompetent, feels an intense need to be in a relationship in order to be taken care of, and/or is overly concerned with fears of being abandoned and required to care for him or herself.

Because of a lack of self-confidence, people with dependent personality disorder look to other people, such as parents, spouses, neighbors, and friends, to make all their decisions: what career to pursue; whom to marry; where to live; how to dress. They tend to think they are too stupid to make their own decisions. A frequent complication of extreme dependency in an unhappy situation is depression and loss of interest or pleasure in all usual activities.

PREVALENCE

Dependent personality has a prevalence of about 0.5 percent, occurring more frequently in women than in men.

ETIOLOGY

Dependent personality disorder might be linked to attachment difficulties in early childhood that result in normal dependency needs not being met. Like other disorders, dependent personality disorder is a vicious cycle. The more passive the person becomes in accepting the decisions of other people, the more

incompetent the individual feels, thus spiraling down into complete passivity, accepting whatever life, in the form of others, brings.

TREATMENT

Little is known about the effective treatment of avoidant personality disorder. Like many of the other personality disorders, the very symptoms of avoidant personality disorder make it difficult to treat. This is the client who appears to be ideal, but the client's submissiveness actually impairs his or her ability to increase in independence, which would be the goal of treatment.

Obsessive-Compulsive Personality Disorder

Perfectionism, a dominating concern with the rightness of the way things are done, and a crippling preoccupation with detail, much of it trivial, is characteristic of the person with obsessive-compulsive personality disorder (OCPD).

The disorder should be distinguished from the obsessive-compulsive disorder (described in Chapter 9). In obsessive-compulsive disorder (OCD), the individual is distressed by the symptoms, sees they are irrational, and would be rid of them if only it were possible. In the OCPD, the individual takes pride in perfectionism and expects that others will see things as he or she does; the concern of the individual is with getting things right, not the possibility that he or she is experiencing a disorder.

SYMPTOMATOLOGY

Symptoms of OCPD may include rigidity or stubbornness, miserliness, unwillingness to delegate, difficulty getting rid of items of no value, scrupulosity, extreme dedication to work, perfectionism, and fixation on details or organization. The person with OCPD is so tied to the need to get everything right that he or she has no time to relax and no capacity to find pleasure in life. Life is filled with constant concern for detailed planning of every event to the extent that there is no opportunity to enjoy it by the individual or by others who share the experience. Rigidity, over-conscientiousness, and overly controlled behavior, to the exclusion of warmth and spontaneity, characterize the behavior of the individual. Although job success and hard work are of great significance, time-consuming checking of trivia usually makes success difficult or impossible. Although driven to be exacting and demanding of others, the individual is rarely open to the suggestions of others.

PREVALENCE

OCPD has a prevalence of approximately 1 percent. It occurs equally frequently in men and women.

ETIOLOGY

There is likely a genetic component in the etiology of OCPD, but its exact nature is unclear. Parental reinforcement of conscientiousness may also play a causative role in OCPD.

TREATMENT

There is not currently a commonly accepted, effective treatment of OCPD. Treatment is likely to challenge irrational fears and teach skills to cope with anxiety caused by not following self-induced rigid guidelines.

SUMMARY

The common characteristics of all personality disorders are the development early in life of personality traits that are persistent, maladaptive, and that cause either significant impairment in social or occupational adjustment or extreme personal distress.

The DSM-IV-TR organizes the ten types of personality disorder into three clusters. This includes Cluster A, which consists of the paranoid, schizoid, and schizotypal disorders. In all of these, the characteristic symptom is odd or eccentric (but not bizarre) behavior.

Cluster B includes histrionic personality disorder, narcissistic personality disorder, antisocial personality disorder, and borderline personality disorder. They are expressed in self-centered and inordinately selfish behavior.

Cluster C includes avoidant, dependent, and obsessive-compulsive personality disorders. These have in common the high degree of personal distress experienced by those with the disorder.

Of the personality disorders, more is known about antisocial and borderline personality disorders than any of the other personality disorders. However, all personality disorders are complex in their origins and difficult to treat.

SELECTED READINGS

Bornstein, R. F. (1993). The dependent personality. New York: The Guilford Press.

Friedel, R. (2004). Borderline personality disorder demystified: An essential guide to understanding and living with bpd. New York: Marlowe & Company.

Kantor, M. (2003). Distancing: Avoidant personality disorder, revised and expanded. Westport, CT: Praeger Publishers.

Kantor, M. (2004). Understanding paranoia: A guide for professionals, families, and sufferers. Westport, CT: Praeger Publishers.

Kaysen, S. (1993). Girl interrupted. New York: Random House.

McGlashen, T. H. (1986). Schizotypal personality disorder. Chestnut Lodge follow-up study: VI long-term follow-up perspectives. Archives of General Psychiatry, 44, 143–148.

Millon, T., Millon, C. M., Meagher, S., Grossman, S., & Ramnath, R. (2004). Personality disorders in modern life (2nd ed.). Hoboken, NJ: Wiley.

Test Yourself

1)	Which personality disorder is difficult to tre	eat l	because of the client's suspiciousness and mistrust?		
	a) narcissistic personality disorder	c)	schizoid personality disorder		
	b) paranoid personality disorder	d)	schizotypal personality disorder		
2)	What personality disorder is thought to be due, at least in part, to unusually low levels of arousal?				
	a) antisocial personality disorder	c)	histrionic personality disorder		
	b) borderline personality disorder	d)	narcissistic personality disorder		
3)	What personality disorder is characterized by restraint in relationships, overconcern with criticism and rejection, and social inhibition?				
	a) avoidant personality disorder	c)	dependent personality disorder		
	b) borderline personality disorder	d)	obsessive-compulsive personality disorder		
4)	What personality disorder is sometimes treated with antipsychotic medication?				
	a) histrionic personality disorder	c)	schizoid personality disorder		
	b) paranoid personality disorder	d)	schizotypal personality disorder		
5)	Which personality disorder is differentiated by grandiosity, fantasies of success, and feelings of being special?				
	a) antisocial personality disorder	c)	histrionic personality disorder		
	b) borderline personality disorder	d)	narcissistic personality disorder		
6)	Which personality disorder is characterized tionism?	by	scrupulosity, preoccupation with details, and perfec-		
	a) avoidant personality disorder	c)	obsessive-compulsive personality disorder		
	b) dependent personality disorder	d)	schizoid personality disorder		
7)	Which personality disorder is likely to have childhood trauma as a partial causative factor?				
	a) antisocial personality disorder	c)	histrionic personality disorder		
	b) borderline personality disorder	d)	narcissistic personality disorder		
8)	What personality disorder is thought to be associated with a reduced density of dopamine receptors?				
	a) avoidant personality disorder		schizoid personality disorder		
	b) paranoid personality disorder	d)	schizotypal personality disorder		
9)	What personality disorder has symptoms of difficulty making routine decisions, expressing disagreement, and taking autonomous action?				
	a) avoidant personality disorder	c)	dependent personality disorder		
	b) borderline personality disorder	d)	obsessive-compulsive personality disorder		
10) Which personality disorder is differentiated by intense but shallow expression that is vague and hyperbolic, and suggestibility?					
	a) antisocial personality disorder	c)	histrionic personality disorder		
	b) borderline personality disorder	d)	narcissistic personality disorder		

Test Yourself Answers

- 1) The answer is **b**, paranoid personality disorder. The very symptoms of this disorder make it difficult to treat. However, treatment typically focuses on attempts to change the client's paranoid thinking.
- 2) The answer is a, antisocial personality disorder. Antisocial personality disorder is likely due to an interaction between biological components, such as low levels of arousal and genetic contributions, social factors such as modeling, and family factors such as parental neglect.
- 3) The answer is a, avoidant personality disorder. The symptoms of avoidant personality disorder include restraint in relationships, overconcern with criticism and rejection, and social inhibition in addition to avoiding interpersonal contact, unwillingness to interact with others unless ensured of being liked, poor self-image, and hesitancy in taking interpersonal risks.
- 4) The answer is **d**, schizotypal personality disorder. Antipsychotic medication and social skills training are typically used in treating schizotypal personality disorder.
- 5) The answer is **d**, narcissistic personality disorder. The symptoms of narcissistic personality disorder may include grandiosity, fantasies of success, and feelings of being special, as well as need for admiration, sense of entitlement, exploitation, lack of empathy, arrogance, and envy.
- 6) The answer is c, obsessive compulsive personality disorder. This disorder is characterized by scrupulosity, preoccupation with details, and perfectionism in addition to excessive emphasis on work, difficulty getting rid of items of no value, inability to delegate, miserliness, and rigidity.
- 7) The answer is **b**, borderline personality disorder. Borderline personality disorder is likely due to an interaction of causal factors, perhaps including a genetic component and early trauma.
- 8) The answer is c, schizoid personality disorder. This condition is likely caused by a variety of factors, perhaps including a reduced density of dopamine receptors, poor social skills, and limited emotions.
- 9) The answer is c, dependent personality disorder. Dependent personality disorder is characterized by difficulty making routine decisions, expressing disagreement, and taking autonomous action, as well as a need for others to take responsibility for one's life, going to excessive lengths to receive support, fears of inability to care for oneself, feeling uncomfortable alone, and frantically seeking relationships to avoid being alone.
- 10) The answer is c, histrionic personality disorder. Symptoms of this disorder include intense but shallow expression of emotions, speech that is vague and hyperbolic, suggestibility, a need to be the center of attention, sexually provocative behavior, use of physical appearance to get attention, and belief that relationships are more intimate than they actually are.

Mood Disorders

are, indeed, are those individuals who are never "in a mood"—downcast, discouraged, even depressed; or on the other hand, elated, optimistic, and energetic beyond one's usual feelings. It is normal, occasionally, to be down in the dumps, a mood that may be triggered by a disappointment, a promotion not granted, a romantic affair broken off, a disturbing family spat. It is just as normal to go through a period of feeling that everything is rosy, when problems melt away, energy and optimism are high, and much activity, sometimes bordering on the frenetic, goes on.

In the depressed mood, energy drains away, interest in old pleasures wanes, and little is accomplished. In a manic spell, much seems to get done, but not always precisely as planned; new projects are begun, resolutions are made, old projects are finished, high hopes are preoccupying, only to fade away too soon when reality is confronted once again.

Among the general population, these moods have their beginning in some real life situation, and they are terminated by a real life event. Depression disappears after a happy family day or upon receipt of an unexpected compliment. Elation disappears as the reality of life's problems captures our attention. They are both of relatively short duration, and they lead to no drastic or damaging actions. Such moods are to be distinguished from the extreme moods or mood swings described in this chapter. They are mentioned in order to reiterate a point that has been made before with other psychiatric disorders: Abnormal behavior finds its place on a continuum of behavior from the normal and well-adjusted to the extreme and severely maladaptive.

One other point needs mention here in this introductory statement. The array of diagnoses involving mood disturbances may seem like hair splitting. However, the distinctions made among mood disorders exist because, although on the surface they may seem similar, they represent different disorders that follow their own course, often respond to different therapies and, in extreme cases, lead to markedly different outcomes, including suicide or suicidal attempts.

The chapter first identifies the symptoms of depression and mania, then describes the classification of mood disturbances, and briefly indicates their prevalence. It continues with a discussion of possible causes of mood disorders, and then examines the principal therapies found helpful in their treatment. Finally, it examines the sad phenomenon of suicide, a possible outcome of a severe mood disorder.

■ DEPRESSION AND MANIA

The two principal affective (emotional) states of the mood disorders are depression and mania. Either can appear alone as the principal symptom of the disorder, or both can appear cyclically. Of the two states,

depression is the much more frequent, occurring in 90 percent of the mood disorders. A long-known form of the disorder is one that alternates between depression and mania. It was formerly labeled manicdepressive psychosis and is now called bipolar disorder. Occasionally in bipolar disorder, mania and depression occur at the same time.

Symptomatology: Depressive Episode

Sadness or irritability dominates the life of the individual during the depressed stage. Those feelings may be accompanied by feelings of worthlessness and a sense of the futility of life. There may be profuse weeping or periodic heavy sighing. There may be thoughts of death. The individual's posture, stooped over, head down, glum facial expression, flat voice, all signal the depression the individual is experiencing. Spontaneity and expressive movements disappear. Actions are slow and plodding in an overall psychomotor retardation. The person may remain all day in slippers and bathrobe; or clothing will be sloppy and stained, the hair uncombed. The behavior of the individual says very clearly, "I don't care anymore." There may be loss of appetite and weight; or, on the contrary, the individual will overeat, not a full planned meal, but small servings, all day long. Sleep patterns are disturbed; there may be difficulty in falling asleep or waking after an hour or two and being unable to sleep. Or, in contrast, there may be excessive sleeping or drowsing in bed all day long. Sexual interest wanes or disappears altogether. Nothing seems fun or pleasurable anymore. These feelings last for at least two weeks, often longer.

Symptomatology: Manic Episode

As one would expect, in mania the behavior is at the opposite extreme of that of the depressed individual. Characteristically, the individual with mania is highly charged, and expends energy uselessly and steadily. Elation, unrealistic optimism, expansiveness, and planning, seemingly backed by endless energy, are the beginning affective symptoms. Blocked or criticized, the individual experiencing mania will turn irritable, which can soon become belligerency, with abusive and profane language. The individual's strong and unleashed emotions lead to uninhibited behavior, argumentative reactions to others and, occasionally, uninvited and unacceptable sexual advances. People experiencing mania become incoherent in speech as they attempt to express racing thoughts. They are readily judged to be disordered.

The range of behavior symptoms in mania have been graded into two categories. Hypomania is a less extreme version of mania. The individual seems supercharged in mood and overreactive in behavior. The push in their affective life leads to bad judgment, but not delusions. They are grandiose and dominating in conversation, and are unprepared to listen to reason. Although this level of mania is indeed a mood disorder, it is often accepted by those who have grown used to it. They may, for example, simply describe the individual as boorish and unpleasant company, but basically harmless.

In classifying the mood disorders, three major criteria are considered. First is the cyclical or noncyclical nature of the illness-that is, whether or not there are alternating periods of depression and mania. Second is the degree of the depression or mania—mild or severe. The difference between the mildest category of the disorder, whether manic or depressive, and the most extreme category, is considerable. The former borders on the normal range of depressive or manic mood, and the latter often justifies the diagnosis, "with psychotic features," and can require a period of hospitalization. The third criterion, the duration of the illness, categorizes the disorders as acute, chronic, or intermittent.

TYPICAL DEPRESSED MOOD

Although there is no DSM-IV-TR classification for "typical depression," the condition is prevalent, and can be alleviated by help from a mental health specialist. Even though normal depression requires no outside help in most cases, when there is any doubt, it is better to err on the conservative side than to take chances.

Grief

Certain events in life bring on the emotion of grief and plunge the individual into the grieving process. The most common cause of grief is, of course, the death of a loved one. There are other griefcausing sorrows in life: the loss of a long-held job (even through promotion or transfer), thereby cutting the individual from a daily network of happy social experiences; the moving away of a lifelong friend; the sale of a home in which one has lived for years. Any of these experiences can bring on grieving. In psychological terms, they are called stressors; that is, an event or situation causing stress. As long as the grieving process does not go to extreme lengths or last longer than a month or two, it can be a quiet time of recovery from an emotionally affecting loss and is not at all abnormal. It is a frequent and probably useful device to break the grieving period by a treat of some sort, such as a short trip, a shopping spree, or a small family party.

Life Situations Causing Depressed Mood

In some life situations, a depressed mood can follow very normal life experiences. Students can experience a kind of post-graduation depression. Among doctoral candidates, depression might appear right after their final oral examinations; among undergraduates, a "normal" depression often hits the day after commencement. Throughout the college years, students can be overwhelmed by dependency needs, of feelings of being ineffective or inadequate, or demands of college life, with a resulting depressive spell, usually of short duration.

There is no sure antidote for depression caused by those unpleasant but normal and all-too-frequent life experiences. Reaching out to close and supportive friends or relatives, if the individual can mobilize the energy to do so, can be helpful. Also, the knowledge can be reassuring that in most cases the stimulation of the normal pleasures and demands of life soon terminate the depression.

MILD TO MODERATE MOOD DISORDERS

There are two mood disorders characterized as mild to moderate: one is cyclical, cyclothymia; the second, dysthymia, is characterized only by depression.

Cyclothymia

Cyclothymia was at one time considered a personality disorder because it seems to be a lifetime pattern of behavior in which the individual experiences moods alternating between hypomania (mild to moderate spells of heightened activity) and mild depressive periods. It is now listed as a mood disorder, not a personality disorder. There is research to suggest that it is a less severe form of bipolar mood disorder (discussed in the "Bipolar I Disorder and Bipolar II Disorder" section later in this chapter).

Symptomatology

The DSM-IV-TR lists as diagnostic criteria for cyclothymic disorder a two-year period of numerous spells of alternating mild depressive symptoms and hypomanic symptoms. The two phases may be separated by months-long periods of normal mood. Among the prominent symptoms are the following:

- During the depressed phase, low energy level and chronic fatigue, insomnia or too much sleeping or drowsing, feelings of inadequacy, social isolation, and reduced levels of functioning, complicated by difficulties with concentration, memory, and thinking.
- During the hypomanic phase, there is a pattern of behavior that is the very opposite of that which exists during the depressed phase, including more energy, less need for sleep; high self-esteem; talkativeness, with much laughter and boisterousness; over-optimism; exaggerated efforts at produc-

tivity, including working at unusual hours; heightened social activity, with the possibility of hypersexuality with little sense of responsibility; and foolish activities, such as buying sprees, reckless driving, and baseless boasting.

None of the behavior is extreme enough to justify a diagnosis of a major mood disorder. There are no hallucinations, delusions, or loosened associations.

Prevalence

Lifetime prevalence has been estimated to be 0.4 percent to 1 percent. Cyclothymia begins early in life and has a chronic course. It is equally common among men and women.

Dysthymia

The DSM-IV-TR's diagnostic criterion for the disorder is a two-year period during which the individual suffers most of the time from symptoms of depression that are milder than those of a full-blown depressive episode.

Symptomatology

Except for the absence of manic or hypomanic phases, the individual's symptoms are those of the depressed phase of cyclothymia. The depressed moods may be persistent, or interrupted by short periods of normal mood. There is an absence of psychotic features. Dysthymia may be a chronic condition in which a mild depressive mood is a characteristic way of responding to life.

Prevalence

Dysthymia has a lifetime prevalence rate of 5.4 percent. It is more frequently found among women. Onset is usually early in life. A number of individuals with dysthymia also meet criteria for major depressive disorder. This dual diagnosis is known as double depression.

MODERATE TO SEVERE DISORDERS

The more severe mood disorders follow similar patterns to the mild to moderate mood disorders. In fact, cyclothymia has been said to look like chronic, low-grade bipolar disorder and dysthymia is often characterized as a longer-lasting, milder major depressive disorder.

Bipolar I Disorder and Bipolar II Disorder

This disorder of alternating patterns of depression and mania was labeled manic depressive psychosis by Kraepelin in 1899. That diagnosis was used for many years. The DSM-IV-TR uses the diagnosis bipolar disorder, and divides it into categories determined by the presence of mania or hypomania. Bipolar I disorder is characterized by alternations between mania and depression and bipolar II disorder is characterized by alternation between hypomania and depression. Bipolar disorders also are labeled based on the most recent phase evidenced (that is, manic, hypomanic, depressed).

Bipolar I disorder has a lifetime prevalence of 0.4 percent to 1.6 percent. It is equally common in men and women. Bipolar II disorder has a lifetime prevalence of about 0.5 percent. It is more common in women than in men.

Major Depressive Disorder

In the absence of manic features, a moderate to severe mood disorder is labeled major depression. There are two subcategories of major depression: single episode—that is, without a prior history of depression; and recurrent, in which the individual has had one or more major depressions in the past.

Major depressive disorder has a lifetime prevalence of about 16.2 percent. It is more common in women than in men.

Specifiers of Mood Disorders

There are special features of these more serious mood disorders. These special features are characteristics that may or may not be present during the course of the disorder. They are included in the diagnosis as specifiers; that is, additional information to clarify the presenting symptoms.

Melancholia

In major depression with melancholic aspects, in addition to the specific symptoms of the typical major depression, the individual shows a loss of pleasure in all activities, even those that were formerly pleasurable. The patient reports not feeling any better, even for the moment, when something good happens. In addition, the DSM-IV-TR requires that at least three of the following symptoms be present: depression is regularly worse in the morning; early morning waking; notable psychomotor retardation or agitation; loss of appetite or weight loss; or marked feelings of guilt. The diagnosis, melancholic type, is considered of special significance for two reasons: the psychiatric literature suggests that there are biological correlates of it; and it seems to respond well to biologically based therapy.

Psychotic Features

When mood disorders are severe, they may include such symptoms of psychosis as marked impairment in reality testing, manifested in hallucinations or delusions (called psychotic features); or the presence of a depressive stupor, which is signaled when the individual becomes mute or is totally unresponsive (called catatonia). The delusions or hallucinations may be mood congruent; that is, consistent with such depressive themes as personal inadequacy, guilt, deserved punishment, disease, death, or nihilism. Or they may be mood incongruent; that is, the content of the impaired reality testing is unrelated to depressive themes. Included here are persecutory themes and thought insertion or thought broadcasting.

With Postpartum Features

When a mood disorder beings within four weeks of the individual giving birth, it is said to have postpartum features.

Atypical

Atypical depression is characterized by mood improving at least temporarily in response to positive events and at least two or more of the following: increase in appetite or weight gain; excessive sleeping; feeling leaden; and oversensitivity to interpersonal rejection.

Course Specifiers

Mood disorders also can be longitudinal (lasting for long periods of time), seasonal (with depression occurring during fall and winter months and remitting in the spring), or rapid cycling (with brief alternations between depression and mania/hypomania).

■ CAUSATIVE FACTORS IN MOOD DISORDERS

Full explanations for the occurrence of mood disorders continue to challenge medical and psychological science. Two broad categories of possible causes have been established: biogenic factors and psychosocial factors. In neither one does there exist an entirely adequate explanation for the etiology of mood disorders—the cause is likely an interaction between the two.

Biogenic Causative Factors

There are three major factors that medical and psychological research have focused on: genetic; biochemical; and neuroendocrine elements. There is research support of varying conclusiveness for the possible causative influence of each.

Genetic Predisposition

Three strands of evidence tend to establish faulty genes as influential, at least in predisposing the individual to a mood disorder. They are as follows.

- · Biological relatives of those with a mood disorder have a higher incidence of the disorder than is found in the general population. For example, a group of individuals with mood disorders was matched with a group of nondisordered individuals. The presence of mood disorders among the blood relatives of those with mood disorders was eight times higher than among relatives of the nondisordered population.
- · The concordance rate for mood disorders is much higher for identical twins than for fraternal twins (those having different genes).

Neither of the first two approaches clearly disentangles environmental from hereditary influences. That job has been accomplished by the third type of study.

• Studies of identical twins who have been reared apart assure that while genetic factors are identical, environmental influences are likely to be varied. High concordance rates for the presence of a mood disorder were found among the identical twins, even though the environments in which they grew up varied. The most certain conclusion to be drawn about causative factors in the mood disorders is that among a substantial number of those suffering a mood disorder, there exists a predisposing genetic factor that makes them vulnerable to the effect of stressors in their environment.

Biochemical Factors

Research evidence, accumulating since the 1960s, has brought under suspicion biochemical elements as a cause of mood disorders. Those elements seem to affect the neurotransmitters of the brain, which regulate the passage of nerve impulses across the synaptic gap between neurons in the brain. Attention was drawn to this possibility by the observation that several biological therapies used with mood disorders-for example, electroconvulsive treatment, antidepressant drugs, and lithium-affect the concentration of neurotransmitters at the synapses and determine whether particular pathways in the brain facilitate or slow down transmission of brain impulses. Current research suggests that the balance of neurotransmitters such as serotonin and norepinephrine plays a causal role in mood disorders. Additional research suggests a role of dopamine in disorders with mania or psychotic features.

Neuroendocrinal Factors

The body's endocrine glands secrete hormones, and the effect of those hormonal influences is a focus of much research. One hormonal substance, cortisol, is particularly suspect as having an effect on the development of mood disorders. While the cause of this relationship is unclear, there is some speculation the effect is due to cortisol's impairment of neuronal growth. Similarly, hypothyroidism (underactivity of the thyroid gland) results in imbalances of hormones and seems to be related to depres-

An important outcome of research in the biological sciences is the suggestion that there is a variety of biological causes of mood disorders that may be reactive to different forms of biogenic therapy. Such findings tend to increase the role of medicine in the treatment of depression, a development that in no way is antithetical to the positive influences of psychotherapy in the reduction of depression.

Psychosocial Factors

The possible effect of a large number of psychosocial factors has been the subject of psychological research, the principal of which are as follows: environmental stress; attitudes held by the individual toward life and the future; and learned helplessness.

Environmental Stressors

It is well known that environmental stressors produce strong emotional responses that, in turn, affect the body's functioning in a variety of ways. When the stressors are operative over a period of time, or when they are catastrophic, the bodily changes they cause bring about biochemical/hormonal changes, especially in genetically predisposed individuals.

Aaron Beck, a cognitive psychologist, who has developed his own approach to the treatment of depression, identifies six types of stressors that are especially likely to trigger depression:

- · Those that lower the individual's self-esteem—for example, failure in an important endeavor or neglect from loved ones
- Frustration in achieving major life goals or facing unresolvable conflict
- Physical disease or illness that brings on thoughts of death
- Stressors of catastrophic dimension
- A series of stressful encounters that suggest a never-ending sequence
- · Stressors, below the level of consciousness, that nevertheless sap the individual's energies and spirit

However, it is important to note that not everyone who experiences one, or even several, of these stressors develops a mood disorder. It appears that stressful life events must interact with something else (for example, biological or other psychosocial vulnerability) to result in a mood disorder.

Negative Attitudes

Beck also has reported the prior existence among individuals with depression of a set of negative attitudes toward the self, the world, and the future. These enduring negative beliefs typically are clouded by cognitive distortions (for example, the perception that everything is bad and always will continue to be so) and seem to lay a foundation for mood disorders. There is the suggestion in psychological research that such bleak attitudes are frequently found in adults who, as children, have experienced significant losses. Beck's treatment of depressed individuals (described in the section "Beck's Procedures in Therapy") is directed at reversing those negative attitudes.

Learned Helplessness

A concept that has received much research attention as a possible cause of depression is learned helplessness. The concept, much favored by those of behavioral/cognitive persuasion, assumes that helplessness is learned in early life experiences in which the child comes to feel that nothing he or she does counts in making life more pleasant or less unpleasant. Given that attitude of hopelessness, the individual falls into depressive inactivity. Martin Seligman, who proposed the concept, finds parallels between helplessness and depression. He also has proposed that treatment of depression should provide learning experiences that undo the sense of hopelessness about the effect of what one does.

Although helplessness is certainly congruent with depression, there are two counterpoints to Seligman's concept:

- · Learned helplessness (or hopelessness) may be an effect rather than a cause of depression. In a depressed state, inactive and discouraged, the individual will indeed feel helpless and therefore hopeless.
- Individuals with depression may not be continuously depressed. The question, then, is what has become of their learned helplessness which, during that period, no longer produces depression?

The least that can be said about learned helplessness is that a life that has taught an individual that he or she is powerless to change things is a depressing thought, but not necessarily one that leads to depression. The alternative might be to learn how to empower oneself (as difficult as that may be). The difference between the two responses may lie in the individual's predisposing vulnerability to depression.

MITREATMENT OF MOOD DISORDERS

Mood disorders respond to two major forms of treatment: biogenic and psychotherapeutic. There is abundant evidence to indicate that the best approach to the mood disorders is a well-planned combination of the two. For the severe disorders, in which there is likely to be some biological involvement, biogenic treatment, to begin with, is probably necessary. Psychotherapy should accompany it as soon as the patient seems open to it.

Biogenic Treatment

Three major types of drugs—the tricyclics, MAO inhibitors, and selective serotonin reuptake inhibitors (SSRIs)—are used in treatment of the moderate to severe mood disorders. In extremely severe cases in which those drugs have not been helpful, electroconvulsive therapy may be tried. Lithium carbonate and anticonvulsants are used to treat the bipolar mood disorders. See Chapter 8 for a listing of brand names of common medications in each of these categories.

Tricyclic Antidepressants

One well-supported belief is that unavailability of norepinephrine, a neurotransmitter substance, is a causative factor in depression. Support for the hypothesis is provided by the successful use of the tricyclics in the treatment of depression. The reasoning behind that statement is that an important effect of the tricyclics is an increase in the availability of norepinephrine at the synapses (the gap between one neuron and another), which seems to reduce the depressive reaction. The tricyclics block a process in which the sending neuron reabsorbs the norepinephrine present at the synapse (the process is called re-uptake). This results in the brain making pre- and post-synaptic changes that result in norepinephrine and other neurotransmitters returning to appropriate levels. The exact details of the effects of tricyclics on brain chemistry are complex and not entirely understood, but the medication has been shown to be effective for many people with depression. Although the tricyclics have side effects, none of them is life-threatening. They are drowsiness, insomnia, agitation, tremors and blurred vision. However, when taken in large doses or by children, tricyclics can be lethal.

Monoamine Oxidase Inhibitors (MAOIs)

MAO inhibitors are prescribed only for patients who have not responded to tricyclics. They are as effective (or perhaps slightly more effective) than tricyclics. They, too, increase the availability of norepinephrine and serotonin between neurons. There is a difference between the ways in which the tricyclics and the MAO inhibitors increase the availability of norepinephrine. The MAO inhibitors prevent the MAO enzyme from breaking down the norepinephrine at the synapse. Again, this process eventually results in the adjustment of the balance of neurotransmitters, alleviating the symptoms of depression.

Possible side effects of MAO inhibitors are quite serious and can be life-threatening. The MAO inhibitors prevent the MAO enzyme (monoamine oxidase) from carrying out its normal function, which is to break down tyramine, a substance found in cheese, beer, wine, and chocolate. Failure to do so triggers what is known as the tyramine-cheese reaction, which causes increased blood pressure, vomiting, and muscle twitching and can, if untreated, cause intracranial pressure and death. Patients on MAO inhibitors therefore must scrupulously restrict their intake of the dangerous substances. Sometimes with individuals with severe depression, voluntary restriction of diet is a high risk to take. It is prescribed only with strong precautions about proper diet.

Selective Serotonin Reuptake Inhibitors (SSRIs)

SSRIs, as their name suggests, prevent the reabsorption of serotonin from the synapse, which results in an increase in serotonin. SSRIs have been found to be effective in treating depression. However, they also have significant side effects, including physical agitation, sexual dysfunction, insomnia, and gastrointestinal upset. However, many people prefer the side effects of SSRIs over the side effects of tricyclic antidepressants or the dietary restrictions of MAOIs, with the exception of the sexual side effects.

Delayed Effect of the Antidepressant Drugs

Aside from the unpleasant and possibly dangerous side effects of the antidepressant drugs, another potentially serious limitation is their delayed reaction on the depression. Two to eight weeks must go by before the patient will notice any relief from depression. That delay can be critical with suicidal patients or with restless and impatient individuals whose disappointment in the effect of the drug can cause them to fail to take the medication or to withdraw from treatment. Also, antidepressant medication is not effective for all individuals with depression.

Electroconvulsive Therapy (ECT)

To some extent, because of the frightening nature of the treatment, but principally because of its history of misapplication and disturbing aftereffects, electroconvulsive treatment is used to treat depression only when it is extreme and only after antidepressant drugs have been used to no avail. The disturbing aftereffects include short-term memory loss and confusion, which typically (although not always) resolves in a few weeks. ECT is not always effective, but sometimes helps individuals who did not respond to medication. Relapse can occur after ECT, so ongoing treatment with medication and therapy is often used.

Lithium Treatment of Bipolar Mood Disorders

In an Australian research study in 1949, lithium was discovered to create lethargy in guinea pigs. With that finding, it was then tried on humans to reduce mania. For more than forty years now, lithium carbonate has been used in this country and around the world in treating bipolar disorder. Full or partial reduction of symptoms is reported for as many as 60 percent of individuals with bipolar disorder taking the medication. The chemical or physiological reasons for lithium's beneficial effect are unknown. Lithium typically is considered a lifetime maintenance medication for bipolar disorder.

There is one serious problem with its use. For many patients needing the medication, the effective dosage is close to a toxic dose. If too much lithium is taken, the toxicity that results can cause convulsions and delirium. Fortunately, the onset of toxicity is accompanied by the unpleasant symptoms of nausea and vomiting, which warn the patient to discontinue the medication for a time. As a precaution against such toxic attacks, patients on maintenance dosages of lithium are usually advised to monitor the level of lithium in their system by having their blood tested regularly.

Anticonvulsant Treatment of Bipolar Disorder

The exact action of anticonvulsant medication on bipolar disorder is unclear. Research suggests that the medications do decrease bipolar symptoms, although not always as effectively as lithium, and they are not as effective as lithium in preventing suicide in particular.

Psychotherapeutic Approaches

Although not the only psychotherapeutic approach used in treating depression, a technique developed by Aaron Beck has proven successful in treating depression, particularly depressions in the mild to moderate range. It is a good example of a psychotherapeutic approach to depression. Beck uses the technique of rational emotive therapy (see Chapter 8). Beck's therapy is based on his belief that a depressing triad of negative thoughts about the self, life experiences, and prospects for the future dominate the patient's thinking. He states that added to this are systematic logical errors (described in the following section) that further cloud thinking and cause depression.

Systematic Logical Errors Causing Depression

According to cognitive theory, there are a number of systematic logical errors that can play a causative role in depression.

- Arbitrary inference: Drawing a conclusion without supporting evidence. For example, the patient, without being able to point to any evidence, will nevertheless insist that coworkers don't respect him.
- Selective abstraction: The individual accents one relatively unimportant detail while ignoring significant aspects of a situation. For example, although a client may get regular positive feedback from a boss, she dwells on one comment about her being late once.
- Overgeneralization: Here, the patient draws broad conclusions, principally about self-worth, on the basis of a single, sometimes insignificant, failure; for example, brooding over failure to fix a leaky faucet. The average person would settle for calling a plumber and let it go at that.
- · Magnification and minimization: Here, small failures are magnified, and significant achievements are minimized. An example might be castigating oneself for the messiness of a computer room and ignoring the achievement of having created a new computer program.
- **Personalization:** Incorrectly assuming personal responsibility for bad events that happen around an individual; for example, assuming responsibility for a neighbor's accident because the client never got around to suggesting that the neighbor have the automobile tires checked.

Beck believes that because the individual's cognitive life is dominated by the triad of negative thoughts and systematic logical errors, he or she will express negative thoughts to him or herself over and over again, even though fleetingly. It is those thoughts, Beck maintains, that support the depression.

Beck's Procedures in Therapy

Beck's therapy begins by his leading the patient to identify negative thoughts and faulty reasoning. His approach in doing so is soft, supportive, and encouraging, yet persistent. Once the individual has verbalized a number of those negative thoughts and illogical cognitions, the therapist, in Socratic fashion, questions the individual to draw out the illogicality of the cognitions. When the client has recognized the faultiness of the cognitions, he or she is encouraged to reevaluate real life experiences from a more logical and less depressing perspective. As the therapy progresses and the client has developed a more optimistic way of thinking, the therapist directs the client's attention to problem-solving thoughts about difficult life circumstances.

An Experimental Test of Biogenic and Cognitive Therapies

In a study reported in 1989, an interesting comparison was made of the differing effect on depression of tricyclic therapy, cognitive therapy, and both together. Sixty-four individuals with major depression were assigned randomly to one of the three treatment approaches. The dependent variables (those contingent upon the treatment used) were relief from depression, a change in explanatory style—that is, to what does an individual attribute failure or trouble—and relapse rate after a two-year period.

On explanatory style, there was no relationship between treatment by tricyclics and an improved explanatory style. In the group receiving both treatments, improvement in style was strong. In the group receiving only cognitive therapy, improvement in explanatory style was very strong. On relapse after two years, the most significant variable, evidence indicates that those who did not change their explanatory style showed a higher relapse rate than those who did change. The findings suggest that drug therapy may only activate patients, but cognitive therapy changes the way in which they look at causes. One can thus speculate that it is that change that produces the lasting effect.

Clinicians typically feel it is desirable to use both antidepressant drugs and cognitive therapy. The results reported suggest clearly, however, that if drug therapy alone is to be used, the only reasons for doing so is resistance on the part of the patient to psychotherapy or other reasons that make it impossible.

SUICIDE

A consideration in all mood disorders is the possibility of a suicidal attempt, and nonoffensive, common sense protective measures should be taken to prevent it. All threats of suicide should be taken seriously, and suicidal talk should be considered as a warning. Yet it must be observed that a person determined to commit suicide is difficult, perhaps impossible, to stop.

The saddest fact about suicide is that, inexplicably to others, it often occurs during the recovery phase, at a point at which the patient seems to be coming out of the deepest gloom of the depression. One possible explanation is that it is only when enough energy has been recovered through an alleviation of the depression that the individual can plan and execute the suicide.

The danger of suicide is at a prevalence level of one percent during the year of depression; it increases to 15 percent during the lifetime of individuals with recurring depression.

The Scope of the Problem

Suicide and suicidal attempts are a significant problem. In 2000, it was the 11th leading cause of death in the United Sates. Suicide is the third most common cause of death in people ages 10 to 24. The most disturbing statistic of all is that for every completed suicide, there is estimated to be another 8 to 25 attempts.

Studies of Suicide

Because of its significant consequences to the individual and those left behind, the problem has received a great deal of study. Yet neither the social sciences nor the medical sciences have provided us with any certain answer to the question, why do some people commit or attempt to commit suicide? Various methods have been tried to find an understanding of the causes of suicide.

What is known about suicide is that several factors correlate with increased likelihood of attempting or completing suicide. The majority of individuals who commit suicide have depression. More women than men attempt suicide, but more men than women complete suicide because they choose more lethal means. Older adults (particularly men over 85) are more likely to commit suicide than younger people. Substance abuse increases the likelihood of suicide attempts and completion.

Possible Etiological Factors in Suicide

Factors that are considered to be at least contributory to a suicidal attempt include physical factors, social factors, and psychological factors. This section considers each briefly.

Biological Factors

Both genetic and biochemical factors have been implicated in suicide.

GENETIC FACTORS

Research suggests that there is an inherited vulnerability to suicide. The nature of this genetic component is, as of yet, unclear. It is likely that the genetic vulnerability interacts with psychological, social, and environmental factors to result in suicide.

BIOCHEMICAL FACTORS

With the strong evidence that links biochemical elements to depression, it is no surprise that biochemical elements have been found in the brains of patients considered more likely than others to commit suicide. It is reported that patients in whom suspected biochemical elements have been found are more likely to choose violent methods of killing themselves and often have a history of impulsiveness, aggressiveness, and violence. The finding has raised the possibility of a connection between suicide and aggression.

As with depression, the biochemical fault is attributed to abnormal enzyme activity in neurotransmitters. The chemical abnormality identified as a possible contributory cause of suicide is a low level of five hydrooxyindaleacelic acid (5HIAA), an element produced when serotonin, a neurotransmitter that affects mood and emotions, is broken down. The finding is a tentative one and, in any case, it is unlikely that that biochemical factor is anything more than a contributor to a vulnerability to psychological states that lead to suicide.

Social Factors

Both exposure to suicide and adverse life circumstances have been associated with slightly higher rates of suicide.

EXPOSURE TO SUICIDE

Research has found that suicide rates increase after hearing about a suicide, whether in the community or that of a celebrity. This explains an increase in suicides in the days following the announcement of the suicide of a celebrity and why suicides appear to occur in clusters.

ADVERSE LIFE CIRCUMSTANCES

In the Great Depression of the 1930s, the suicide rate increased from 10 to 17 per 100,000 people; in the recession of the early 1970s, suicides increased to more than 12 per 100,000 people. The suicide rates among the divorced, those threatened with downward mobility, and those living in rapidly changing urban areas, are all higher than in the general population. There is no question that adverse living circumstances, caused by financial problems, interpersonal unhappiness, or severe health problems, increase the likelihood of suicide, but by themselves, those adverse life circumstances do not provide an adequate explanation of suicide. Too many others face equal adversity without resorting to suicide as an escape; most of them, probably, without even considering it.

Psychological Factors

A number of psychological factors are associated with suicide. Depression and hopelessness, along with impulsivity and substance abuse, have been associated with suicide.

DEPRESSION AND HOPELESSNESS

The one condition most frequently found prior to suicide attempts is depression. Correlational studies conducted by various investigators among different populations uniformly report high correlation between preexisting depression and suicidal attempts. A sample of the findings: The suicide rate among a depressed population admitted to a psychiatric hospital was 36 times higher than for the general population; 80 percent of another hospitalized population admitted for suicidal attempts were found, upon admission, to be depressed. Even among children, depression is a frequent precursor to a suicide attempt.

Among a depressed population, hopelessness about the future (even beyond depression itself) seems to be the more determinative cause of a suicide attempt. A study by Beck provides persuasive evidence for that conclusion. His population was 207 hospitalized psychiatric patients who had expressed suicidal thoughts but who had no history of suicidal attempts. Within seventy-two hours of being admitted to the hospital, each of the patients was assessed on three psychological characteristics: degree of hopelessness; degree of depression; and extent of suicidal thinking. In a ten-year follow-up period, fourteen of the patients had committed suicide.

What differentiated that group of fourteen from the other patients in the study was their high scores on hopelessness. Scores on level of depression and extent of suicidal thinking did not significantly vary between the suicidal group and the larger nonsuicidal group. One study can never be definitive, but Beck's work, consistent with the thinking of other researchers in the field of depression, offers impressive evidence of the critical importance of feelings of hopelessness as a crucial factor causing suicidal attempts. Efforts to prevent suicide surely must take account of that precursor to a suicidal attempt.

SUBSTANCE ABUSE AND IMPULSIVITY

Both substance abuse and impulsivity decrease a person's ability to think clearly through the consequences of his or her actions. Research has indicated that substance abuse is a factor in many suicides. There also is empirical support for impulsive behavior prior to the attempt being characteristic of people who commit suicide.

Efforts at Prevention

The success of any prevention program depends upon our knowledge of early signs of a suicidal effort and the speed with which that information can be communicated to a trained professional who will assume some level of responsibility for intervention. There are known danger signals: a state of extreme depression; mild depression with expressions of suicidal intent; bouts of depression with alcohol or drug abuse; suicide in the family of a depressed individual; and previous suicide attempts. Any one of those conditions should trigger a strong effort to get professional help.

Crisis Intervention

It is believed that most persons who attempt suicide do not really want to die. That belief seems substantiated by the fact that most people who attempt suicide provide an early warning of their intentions, seemingly a plea for help. Responding to that plea as quickly as possible is the surest way to prevent suicide. Attempts to do that are called crisis interventions. Crisis intervention programs seek to provide immediate, intensive, short-term treatment aimed at resolving the provoking crisis. Crisis intervention usually involves a short period of hospitalization, where medical treatment and counseling can be offered immediately. Psychotherapy is intensive until the crisis seems resolved and the patient's panic has been reduced. More traditional psychotherapy, spaced over a period of time, should follow the patient's release from the hospital.

Crisis Prevention Centers

In an intensified effort to prevent suicides, hundreds of suicide prevention centers have been established, making it as easy as possible for potential suicide attempters to reach out for help. Suicide hotlines are made available twenty-four hours a day. At the receiving end of the call, the suicidal person will find a trained individual who is prepared to help. Such individuals are trained to work toward, first of all, maintaining contact and creating a relationship; as that develops, they seek to obtain identifying information—name, phone number, and the name and phone number of a relative or friend. Once those minimal goals have been accomplished, more substantive information about the suicidal risk is sought; an evaluation of the likelihood of an immediate suicide attempt; identifying the principal stressors producing the crisis; searching out possible strengths of the individual and social supports among friends or relatives. A final step is to initiate an action plan, which should describe an immediate action for the individual to take (which might be coming to the crisis center) and a follow-up program; for example, a referral to a social agency the next day for further discussion.

Statistics on the effectiveness of suicide prevention centers are difficult to interpret. For example, how does one interpret the fact that 95 percent of callers never call again? Do they no longer need help? Did they not find it helpful? Or perhaps the effort at prevention failed. Unfortunately, there is not yet consistent research indicating the success of such programs.

SUMMARY

Mood disorders are a significant psychiatric problem, affecting millions of people, and causing the hospitalization of the largest number of psychiatric patients. The most common form of mood disorder is depression; in much smaller numbers, the disorder causes alternating spells of depression and mania (bipolar disorder).

In the more serious depressions, antidepressant drugs and, in extreme cases, electroconvulsive therapy, have proven successful in reducing depression. Psychotherapy is a necessary follow-up. In milder cases, psychotherapy alone may be all that is necessary.

Mounting evidence strongly indicates that a genetic factor causes vulnerability to depression. Biochemical elements, perhaps the result of faulty genes, also seem to be operative. Among the possible psychosocial causes of depression are overwhelming stressors in the environment; negative attitudes toward the self and the future, frequently based on illogical reasoning; preexisting personality traits in the depressed individual—for example, unfortunate early learning patterns of helplessness that leave the individual with little hope of doing anything to reduce the adverse circumstances of his or her life.

Suicide is a major and growing problem in American society, especially among its youth. It is often associated with alcohol or drugs. Depression, with a deep-seated feeling of helplessness, seems the most common presuicidal state. Efforts at prevention include increased attempts to identify the early signs of suicidal risk and the establishment of crisis intervention centers that can work expeditiously with the client to prevent his or her suicide.

SELECTED READINGS

Akiskal, H. S., & Cassano, G. B. (eds.). (1997). Dysthymia and the spectrum of chronic depressions. New York: Guilford Press.

Ghaemi, S. N. (2003). Mood disorders: A practical guide. Philadelphia, PA: Lippincott Williams & Wilkins.

Jamison, K. R. (2000). Night falls fast: Understanding suicide. New York: Vintage.

Jamison, K. R. (1995). An unquiet mind. New York: Alfred A. Knopf.

Mondimore, F. M. (1999). Bipolar disorder a guide for patients and families. Baltimore, MD: Johns Hopkins University Press.

Power, M. (ed.). (2006). Mood disorders: A handbook of science and practice. Hoboken, NJ: Wiley. Price, P. (2005). The cyclothymia workbook: Learn how to manage your mood swings and lead a balanced life. Oakland, CA: New Harbinger Publications.

Solomon, A. (2001). The noonday demon: An atlas of depression. New York: Scribner.

Test Yourself

1) Which of the following is/are a symptom(s) of a depressive episod	1)	Which of	the	following	is/are a	symptom(s)	of a	depressive	e episode
--	----	----------	-----	-----------	----------	------------	------	------------	-----------

- a) feelings of worthlessness
- c) sleep disturbance

b) lack of appetite

- d) all of the above
- 2) The symptoms of dysthymia are similar to major depressive disorder, but milder and longer lasting. True or false?
- 3) Cyclothymia is characterized by alterations between depression and mania. True or false?
- 4) Bipolar I disorder has a lifetime prevalence of 0.4 percent to 1.6 percent. True or false?
- 5) What disorder is characterized by alternating episodes of depression and hypomania?
 - a) bipolar I disorder
- c) cyclothymia
- b) bipolar II disorder
- d) dysthymia
- 6) Which of the following is/are a risk factor(s) for suicide?
 - a) family history of suicide
- c) substance abuse

b) mood disorder

- d) all of the above
- 7) Which of the following is the likely cause of mood disorders?
 - a) biological factors such as genes and neurochemicals
 - b) experiences such as learned helplessness or stressors
 - c) psychological factors such as negative thoughts
 - d) an interaction of all of the above
- 8) Which of the following is true about the treatment of mood disorders?
 - a) Electroconvulsive therapy is not effective in treating depression.
 - b) Lithium has been found effective in treating major depressive disorder.
 - c) Psychotherapy and medication are frequently used together.
 - d) MAO inhibitors are the medication of choice for bipolar I disorder.

Test Yourself Answers

- 1) The answer is **d**, all of the above. A depressive episode is characterized by depressed mood, diminished pleasure, loss of appetite, psychomotor agitation or retardation, feelings of worthlessness, thoughts of death, sleep disturbance, fatigue, and diminished ability to concentrate. The five or more symptoms must last for a minimum of two weeks for a depressive episode to be diagnosed.
- 2) The answer is **true.** Dysthymia has been referred to as a chronic, mild depression because of the similarity between symptoms of the two disorders, with the exception of the symptoms of dysthymia being milder and lasting for at least two years. Dysthymia and major depressive disorder can co-occur—this is called double depression.
- 3) The answer is **false.** The primary symptom of cyclothymia is alternation between mild depressive symptoms (as seen in dysthymia) and hypomania (a milder form of mania). Because these symptoms are milder and longer lasting (two years) than bipolar I disorder, cyclothymia is occasionally described as a milder, longer-lasting version of bipolar I disorder.
- 4) The answer is **true.** Bipolar I disorder does have a lifetime prevalence of 0.4 percent to 1.6 percent. The onset is typically early in life, and the course is usually chronic.
- 5) The answer is **b**, bipolar II disorder. The defining symptom of bipolar II disorder is variation between depressive episodes and hypomanic episodes. It is distinguished from cyclothymia by the presence of full-blown depressive episodes and from bipolar I disorder by the presence of hypomania, but not full-blown manic episodes.
- 6) The answer is **d**, all of the above. Risk factors for suicide include a family history, presence of a mood disorder, substance abuse, neurochemical imbalances, impulsivity, helplessness, and exposure to other suicides.
- 7) The answer is **d**, an interaction of all of the above. No one factor sufficiently explains all cases of mood disorders. The most likely cause is actually an interaction of multiple causes including biological (for example, genes, neurotransmitter imbalances), psychological (for example, negative beliefs, hopelessness), and experiences (for example, events leading to learned helplessness, stressors).
- 8) The answer is **c**, psychotherapy and medication frequently are used together. Often psychotherapy and medication can be helpful and work together in treating mood disorders. That is, medication may help improve symptoms so that the individual may actively participate in and benefit from therapy. Meanwhile, therapy can help the client deal with side effects and maintain medication compliance. None of the other statements is true. ECT can treat depression. Lithium is used to treat bipolar disorder, not depression. MAOIs are used to treat depression, not bipolar I disorder.

Schizophrenia and Other Psychotic Disorders

he most disabling of the psychological disorders are the psychoses; they bring with them disorientation, hallucinations, delusions, and social disorganization. Among the most debilitating and complex of the psychoses is schizophrenia. That disorder is a complex illness, the nature of which is not yet fully understood, and the outcomes of its treatment are not as favorable as clinicians would like them to be. In addition to a detailed examination of schizophrenia, this chapter describes briefly a psychosis separately classified by DSM-IV-TR and labeled delusional disorder.

Although, as we shall see later, symptoms vary somewhat from culture to culture, schizophrenia exists worldwide. One percent of the world's population is afflicted with the illness.

Emil Kraepelin first identified the illness in 1896 when he distinguished it from the mood disorders. Kraepelin believed that all psychiatric disorders were caused by organic factors, and his experience suggested to him that the onset of the disease occurred early in the life of the individual. Hence, he called it dementia praecox, which means a premature deterioration of the brain.

In 1911, Eugene Bleuler, an eminent Swiss psychiatrist, disagreed with Kraepelin on both points. He had found that onset of the disease could occur in the later years, and he also reported that it was not characterized by a progressive deterioration over the life of the individual, which he felt was suggested by the term dementia. After an original severe deterioration, many with schizophrenia stabilized and remained at the same point in their illness for years.

To avoid any misunderstanding of the nature of the illness that might be caused by what he considered a misnomer, and to give emphasis to its true nature, Bleuler invented the word schizophrenia, putting together two Greek words meaning "split" and "mind." This does not mean, as is often suggested colloquially, that the individual has two personalities. Rather, Bleuler wished to emphasize the most basic feature of schizophrenia: a splitting of the mental functions; in particular, a splitting apart of the individual's affective and cognitive functioning.

PSYCHOSES

The lost contact with reality and the extreme deterioration makes the recognition of a psychotic disorder a relatively easy one. However, there are a variety of psychotic disorders and schizophrenia, in and of itself, has a variety of presentations. Because the disorders are now known to take several different

forms, each of which may vary in onset, symptomatology, etiology, and responsiveness to treatment, clinicians must then identify the disorder and classify it from several other points of view. There are several features used to do this.

Features Differentiating Psychoses

Psychoses can be differentiated along three dimensions: time; symptoms; and cause. Time differentiates between brief psychotic disorder, schizophreniform disorder, and schizophrenia. All three have strikingly similar symptoms; however, brief psychotic disorder lasts from one day to one month, schizophreniform disorder lasts from one to six months, and schizophrenia has a chronic course, lasting for a lifetime. Symptoms can be used to differentiate schizoaffective disorder and delusional disorder from schizophrenia. Schizoaffective disorder is characterized by mood disturbance in addition to psychosis. Delusional disorder is notable because of the presence of delusions without the other symptoms of schizophrenia. The source of the symptoms distinguishes shared psychotic disorder, psychotic disorder due to a general medical condition, and substance-induced psychotic disorder. Shared psychotic disorder develops in response to the delusions of a person close to the affected individual. Psychotic disorder due to a general medical condition, of course, has a medical cause. Substance-induced psychotic disorder, as its name indicates, is caused by the influence of a controlled substance.

Symptomatology

The specific symptom patterns defining schizophrenia have been debated since Kraepelin's early identification of the illness. The most recent authoritative statement was made in 2000 in DSM-IV-TR. With respect to duration, impact on functioning, and cause of symptoms for a diagnosis of schizophrenia, the manual requires the following:

- Symptoms must last for a minimum period of six months.
- · There must be an observable deterioration from the individual's previous level of functioning.
- · Symptoms cannot be explained by another disorder, substance, or medical condition.

Beyond those three criteria, there are five more that have to do with specific symptomatology, two of which must be present. There must be delusions, hallucinations, disorganized speech, disorganized or catatonic behavior, or negative symptoms (described in the following sections).

Delusions

Multiple delusions (bizarre yet strongly held obviously false beliefs) are the principal disturbance in the content of the schizophrenic's thought processes. There are two categories into which the delusions usually fall: persecutory delusions, in which the individual believes that others are spying on, spreading false rumors about, or planning harm to him or her; and delusions of reference, in which the person gives personal significance to totally unrelated events, objects, or people. Those thoughts are usually selfdeprecatory; for example, the person may accuse a newspaper or magazine of writing critical articles about him or her when there is no basis for the accusation. Common delusions are thought broadcasting, in which a person believes that his or her thoughts are being broadcast to the outside world; thought insertion, in which he or she may think that thoughts not his or her own are being inserted into his or her mind; and control by external forces. Other delusions (grandiose, religious, or somatic) may appear but are not as common as persecutory and referential delusions.

Certain delusions suggest a better prognosis than others. Buss (1966) reports that people with schizophrenia who are overtly paranoid "are more intact intellectually, perform better on a variety of tasks, and have a higher level of maturity." Research also indicates that patients suffering from schizophrenia with paranoid symptoms are hospitalized later than other people with schizophrenia, stay hospitalized for a shorter time, and have to be re-hospitalized less often. Thus, the presence of organized paranoid symptoms early in the disease seems to suggest a good prognosis.

Hallucinations

In schizophrenia, perceptions of the world are distorted by hallucinations (a perception in the absence of any appropriate external stimulus). Hallucinations may occur in any sense mode, but they most frequently are auditory. The voices "talking" to the patient may be of several people, of people familiar to the patient, or total strangers. The voices frequently say negative and threatening things or are described as a running commentary or discussion among two people. Messages may take the form of commands from, for example, God or the president, and they may be obeyed at high risk to others or to the patient. Hallucinations may be tactile, as in the form of electric shock, tingling, or burning sensations. Somatic hallucinations take the form of living things, such as snakes, crawling around inside the patient's body. Hallucinations in other sense modalities occur, but are rare.

Disorganized Speech

To be distinguished from the content of thought is the way in which schizophrenics express their thoughts, a symptom that is labeled disorganized speech. Here, associations are loose; that is, ideas shift from one subject to a completely unrelated one, statements meant to be connected are completely unrelated—the individual may shift frames of reference in conversation. Sometimes there is poverty of content, meaning that the communication is so vague, overly abstract or concrete, repetitive, or stereotyped as to be meaningless to the listener. Neologisms (the creation of new words), clanging (illogically stringing together words that rhyme or sound alike) and perseverative speech may appear in writing or speech.

Disorganized Behavior

Individuals with schizophrenia are so preoccupied with their own bizarre thoughts that they are "unavailable" to others. They literally live in a world of their own fantasies, egocentrisms, and illogicalities. They often are not fully aware of events around them or of major world events. This often results in odd behavior that can range from poor hygiene to inappropriate public sexual behavior. Behavior may appear to simply be silly or agitated and even menacing.

Positive versus Negative Symptoms

By the positive dimension is meant overt manifestation of psychotic symptoms such as bizarre behavior, hallucinations, and delusions. These are characteristics that are present in individuals with schizophrenia, but not typically in individuals without schizophrenia. Negative symptoms refer to the absence of adjustive behavior in the important areas of life, such as flatness of affect, limited speech, or absence of goal-directed behavior. These are things that typically are present in individuals without schizophrenia, but not in those with the disorder. The outcome of schizophrenia is typically better when there are more positive symptoms rather than negative symptoms. Two major negative symptoms, flat affect and avolition are described in the two following sections.

FLAT AFFECT

The principal and quite pronounced affective symptom is a blunting (flattening) or inappropriateness in the individual's emotional responses. The symptoms display themselves in a monotonic voice and immobile face. An oddity is the extreme lack of concordance between what the individual is saying and the emotion displayed. An example would be talking of being tortured by electrical shock while smiling or laughing.

AVOLITION

Significant ambivalence may paralyze the individual's will to take any action. The person with schizophrenia often has difficulty in pursuing any interest or carrying out a planned course of action. Even basic and routine daily responsibilities (for example, hygiene or cooking meals) can go unmet due to the individual's impaired goal-directed activity.

The Course of Schizophrenia

There are three phases of schizophrenia: the prodromal phase; the active phase; and the residual phase. The three stages of schizophrenia are not always clearly separated one from another. The individual sometimes seems to fade in and out of different phases of the disorder.

Prodromal Phase

The active or, as one might say, the florid phase, of the illness is usually preceded by a prodromal phase, in which there is a notable but not yet acutely psychotic deterioration from the individual's prior level of adjustment, a change that is often commented upon by relatives and friends.

In a 1973 article describing early experiences leading up to schizophrenia, Freedman and Chapman capture prodromal expressions and feelings of the individual with schizophrenia. Patients are quoted as saying the following: "I try to think and all of a sudden I can't say anything because it's like I turn off in my mind" "Maybe I'm not very sensitive . . . I keep thinking maybe I'm tired . . . the other night, in front of the television, I felt a sort of blurring like that." "My eyes seem to disappear when I look in the mirror." "Things sound more intense . . . sound louder. Interesting things sound louder than uninteresting things." "Say you're talking to another person, I don't understand a word they're saying . . . if there's more than one person talking, I don't follow them because it goes too quickly."

The length of the prodromal phase varies from a relatively short time to several years of slow deterioration. In the short-term prodromal phase, the onset of illness is preceded by a heightened awareness, foreboding, and urgency. Usually that reaction seems to be triggered by some relatively "normal" crisis, such as an ordinary change in life circumstances. Acute onset is typically associated with later onset and better prognosis. A longer prodromal phase, or insidious onset, is associated with an earlier onset (sometimes even in childhood) and a poorer prognosis.

As the individual comes closer to active schizophrenia, ideas of reference or of specialness begin to appear as the individual occasionally finds hidden meanings in ordinary events. Other, milder forms of later psychotic symptoms appear. Some of the more frequent are social withdrawal, impairment in role functioning, peculiar behavior, carelessness in personal hygiene, vagueness or circumstantial communication, and occasional bizarre thoughts.

The Active Phase

In the active phase, the person manifests the full array of symptoms associated with schizophrenia that distinguish it from other disorders. Those symptoms were described in the symptomatology section. In the active phase, the individual is frequently described as "floridly psychotic."

The Residual Phase

When the individual passes through the prodromal and active phases of the illness, a residual phase of the illness usually remains. Symptoms here revert to symptoms of the prodromal stage.

Specific Types of Schizophrenia

In diagnosing the schizophrenias, it is usual practice to diagnose the special type of the illness. DSM-IV-TR recognizes five specific types of full-fledged schizophrenic disorders. They are catatonic,

disorganized, paranoid, residual, and undifferentiated. The subtypes within schizophrenia can be differentiated by the symptoms present. Each is described in greater detail in the following sections.

Catatonic Type

Two overlapping patterns of behavior appear: excitement and withdrawal.

THE EXCITED PATTERN

In this form of the catatonic reaction, the disordered individual blusters about, talking and shouting, constantly on the move, pacing about or running back and forth until exhaustion takes over. Even in exhaustion, catatonic individuals sleep only for short periods of time. During their agitation, they can become violent, attacking others by throwing things or crashing a large object over their heads.

THE WITHDRAWN PATTERN

Individuals with catatonia are often mute, and may adopt strange positions and hold them for long. periods of time. At other times, they show a waxy flexibility, holding any position into which an outsider may "arrange" them. People with catatonia are, despite their withdrawal, highly suggestible. They will, for example, mimic sounds made by others (echolalia) or the actions of others (echopraxia). Despite exhibiting all the features of an individual totally withdrawn from the world, people with catatonia nevertheless show, in a variety of ways, that they are aware of what is going on around them.

People with catatonic schizophrenia, especially in the withdrawal phase, will not eat or control their bowel or bladder functions. Some patients alternate between periods of extreme stupor and extreme excitement. In one study, Morrison (1973) reported among 250 catatonic patients, almost 50 percent were withdrawn, about 21 percent were predominantly excited, and about 30 percent were mixed. Because of their uncontrolled excretory functions, their "wildness," and their occasional assaultive behavior, patients with catatonic type schizophrenia are exceedingly difficult to manage. They are almost always hospitalized; and even in the hospital, they must be closely supervised.

Disorganized Schizophrenia

Formerly called hebephrenic schizophrenia, and now one of the less common schizophrenias, this type of schizophrenia is the individual at his or her most immature and regressed. Much of the individual's behavior is literally infantile. Cognitive processes are severely disorganized, speech is incoherent, and there is much silly behavior and giggling. While systematized delusions (or, for that matter, any systematized cognitions) are absent, bizarre behavior, such as eating feces or finger painting with it, may be expected. The individual with disorganized schizophrenia may masturbate in public or fantasize publicly in weird fashion. There is much grimacing, jumbling words together ("word salad"), and disconnected associations.

Onset is earlier than in other types of schizophrenia. Ordinarily, the more florid manifestations of the disorder are preceded by a history of oddness, scrupulosity about trivial misdeeds, and preoccupation with religious and philosophical themes distorted from their usual context.

Paranoid Schizophrenia

The two most significant psychotic symptoms in the individual with paranoid schizophrenia are as follows:

 A systemized set of delusions, in which people weave bizarre, consistent plots. Belief in the hostile intentions and acts of relatives, friends, or even people who pass them on the street and concern that

- they are being poisoned, watched, followed, or influenced by outside forces are common delusions in individuals with paranoid schizophrenia.
- In addition, there frequently are delusions of grandiosity, in which the paranoid individual is, for example, a famed scholar, a millionaire, Christ, or Napoleon.

Delusions may be accompanied by hallucinations that fit their persecutory content. For example, God speaks to them, their enemies threaten them, or they hear confirmatory conversations. The paranoid delusions of persecution and grandiosity are sometimes interpreted as mechanisms through which the individual provides a sense of identity and importance that reality does not match. People with paranoid schizophrenia are notably different from others with schizophrenia in that their coping mechanisms and cognitive skills are at a higher level. Onset of paranoid schizophrenia, although it may be gradual and follow a long history of strained interpersonal relations, tends to be rapid and, occasionally, accomplished people, suddenly in the course of successful careers, break out in the classic paranoid fashion.

Undifferentiated Schizophrenia

Clinicians use this diagnosis when the person's symptoms clearly indicate schizophrenia but are so mixed or undifferentiated as to make classification into one of the other types of schizophrenia impossible. Sometimes such an undifferentiated set of symptoms is the prelude to a more fully developed schizophrenia, conforming to one of the specific types of schizophrenia.

Residual Schizophrenia

This diagnosis is used when individuals have been through at least one episode of schizophrenia (a six-month period of schizophrenic behavior), but now present no extreme symptoms of the disorder. Minor delusions or hallucinations may be present, but they do not dominate the patient's behavior. There may be emotional blunting, withdrawal, eccentric (but not bizarre) behavior, illogical thinking, and loosely connected associations.

Overall View of Schizophrenia

It will be reassuring to the student of abnormal psychology to know that the nature of schizophrenia sometimes seems to clinicians and research psychologists to be as complex as it must seem to one approaching the study of psychological disorders for the first time. In summarizing that complexity, we can nevertheless present six statements about schizophrenia with which psychologists generally agree.

- There is no one symptom or type of behavior that unequivocally points to the existence of schizophrenia.
- The symptoms of one person with schizophrenia may be different from those of another.
- Symptoms may change notably from one stage of the illness to another.
- People with schizophrenia slip in and out of periods of lucidity and contact with reality.
- Schizophrenia varies in its treatability and a complete recovery to earlier levels of functioning is rare.
- Most individuals with schizophrenia are left with a relatively stable residual form of the illness.

Causative Factors in Schizophrenia

Despite over 100 years of research on what is now called schizophrenia, the cause is still not entirely clear. However, certain statements about possible causality can be made. There is general agreement that the illness is the result of some interactive combination of biological and psychological factors.

Biogenic Factors

Four biogenic factors have been identified as causative in the development of schizophrenia. They are genetic factors, biochemical factors, neuroanatomical anomalies, and viral infection.

GENETICS

This section summarizes the research on the relationship between schizophrenia and genetic elements. It considers the variety of research designs used to test the hypothesis that genetics play a part in the development of schizophrenia and reports the findings of each type of research. There are three principal research designs: family studies; twin studies; and adoptee studies.

Family Studies

In a summary of published research on schizophrenia and genetics, Gottesman (2001) reports on the prevalence of schizophrenia. His analysis suggests that the closer the family relationship (and, therefore, the more genes in common), the higher the percentage of individuals with schizophrenia. Typical of his results are that 12 to 13 percent of the children of people with schizophrenia also have the disorder; in those cases in which both parents had schizophrenia, the percentage of children with it jumped to 36 to 37 percent. By comparison, schizophrenia appeared among nephews and cousins at the level of 2 to 3 percent. Prevalence in the general population is 1 percent. Similar findings have been found in repeated studies. The weakness in drawing a conclusion from this type of study is that it takes no account of the unfavorable environmental influences a child would experience living with one or both parents who have schizophrenia.

Comparison of Monozygotic and Dizygotic Twins

Keep in mind that monozygotic twins have identical sets of genes; dizygotic twins are no more genetically alike than ordinary siblings. An argument in favor of a genetic influence in schizophrenia would be a higher concordance rate (both twins having schizophrenia) in monozygotic twins and a significantly lower concordance rate among dizygotic twins. There has been research over the past 30 years that has continued to support a genetic component in schizophrenia based on twin studies. For example, a 2001 review of twin studies (Cardno & Gottesman) reported a 41-65 percent concordance rate in monozygotic twins and only a 0-28 percent concordance rate in dizygotic twins. The results suggest a heritability estimate (an estimate of the degree of variability of a trait in a population due to genes) of 80–85 percent. This study and others with similar results create the very strong suggestion that genetics plays a part in the development of schizophrenia. Even though the genetic factors do not directly transmit the illness, they may create a vulnerability that, when activated by other factors, results in the illness.

Adoption Studies

There have been 40 years of adoption studies suggesting the strong influence of genetic factors in creating a predisposition or vulnerability to schizophrenia. For example, the Finish Adoptive Family Study of Schizophrenia followed 190 adopted children with biological mothers who had a schizophrenia spectrum disorder (for example, schizophrenia, schizotypal disorder, schizoaffective disorder) and 192 adopted children whose biological mothers did not have a schizophrenia spectrum disorder. Tienari and colleagues (2003) found that the lifetime (up to age 44) risk for developing schizophrenia was 22.46 percent in children whose mothers had a schizophrenia spectrum disorder and only 4.36 percent in those whose mothers did not. This significant difference suggests a genetic component, but that the component is likely complex (that is, there is not one gene that causes schizophrenia).

More recent research (for example, Plomin, Owen & McGuffin, 1994) suggests that part of the inconclusiveness of genetic studies is the fact that a vulnerability to schizophrenia is caused by multiple genes. This theory is supported by the range of severity and type of schizophrenia and related disorders and by the increase in likelihood of a person having schizophrenia as the number of biological family members with that disorder increases. Molecular genetics research is currently being conducted to explore the possibility that several genes are implicated in schizophrenia.

Psychologists generally consider that such studies as we have cited, especially the adoptee studies, have provided conclusive proof of a genetic influence in the development of schizophrenia. Because in no study was the supporting evidence at the level of 100 percent, psychologists look to additional factors interacting with genetic elements for the actual development of schizophrenia.

BIOCHEMICAL FACTORS

The possibility that there might be biochemical factors involved in the development of schizophrenia has long been the subject of research. The advent of what has come to be called the antipsychotic medications—also called neuroleptics, or tranquilizing agents, the most frequently prescribed of which are the phenothiazines—has revolutionized the treatment of schizophrenia. In addition, it has led scientists to a new way of considering possible biochemical influences in the etiology of schizophrenia. Phenomena associated with phenothiazine treatment of schizophrenics turned attention to the possibility of abnormalities in neurophysiological functioning in that disorder, particularly in the effect of neurotransmitters. That possibility has been expressed in the dopamine hypothesis. Among those researchers with strong convictions about the influence of biogenic elements in the development of schizophrenia, interest has focused on this hypothesis.

The Dopamine Hypothesis

In treating schizophrenia with phenothiazines, it was soon observed that a course of treatment not only reduced schizophrenic symptoms but also caused side effects resembling Parkinson's disease. It is known that Parkinsonism results from too-low levels of the neurotransmitter dopamine, caused by a deterioration in a section of the limbic (or lower) area of the brain, which is involved in emotional behavior. Biochemists hypothesized that excessive dopamine might be associated with the development of schizophrenia. Their reasoning, simply expressed, is as follows: Phenothiazine reduces certain symptoms of schizophrenia, but it also induces Parkinsonian symptoms, which are the result of low levels of dopamine. The drug must therefore reduce levels of dopamine and, when it does, schizophrenic symptoms are reduced. High levels of dopamine, the hypothesis concludes, contribute to the development of schizophrenia.

That statement is a very simple description of a complex neurophysiological process. The dopamine hypothesis has stimulated much research. While a good portion of that research supports the dopamine hypothesis, the hypothesis has not yet been given unequivocal support by either biochemists or psychologists.

There is the initial evidence that when dopamine levels are reduced (indicated by the development of Parkinson-type symptoms), schizophrenic symptoms are reduced. The powerful effect of clozapine (developed in the late 1980s) in reducing the symptoms of schizophrenia adds strong support to the dopamine hypothesis, because its primary biochemical effect is to reduce levels of dopamine. Conversely, medications used to treat Parkinson's disease elevate levels of dopamine, and produce schizophrenia-like symptoms. Additionally, in large doses, the amphetamines are known to create a psychotic reaction indistinguishable from paranoid schizophrenia. That effect is known to be associated with the increased availability of dopamine caused by the amphetamines. Amphetamine psychosis is treated successfully with the same drug used to treat schizophrenia, the phenothiazines. But as has been stated, that drug blocks the receptors for the neurotransmitter, dopamine, making less of it available. It is thus argued that schizophrenia must result, in some unknown way, from excessive dopamine.

Two lines of evidence made possible by PET (positron emission tomography) scans give direct support to the dopamine hypothesis. In PET scans of the brain of individuals of the same age with and without schizophrenia, the brains of people with schizophrenia were shown to have a greater density of dopamine receptors, thus making excess dopamine available.

In 1986, Wong and colleagues compared PET brain scans of three groups of individuals: individuals without schizophrenia; drug-treated individuals; and totally unrelated people with schizophrenia. Confirming the dopamine hypothesis, he found that the density of dopamine receptors was significantly greater in the people with untreated schizophrenia than in either of the other two groups. The research also demonstrated that the effect of phenothiazine treatment was to reduce the density of dopamine receptors and thus to reduce the symptoms of schizophrenia.

More recently, postmortem analysis of the brains of people with schizophrenia confirm the findings of the PET scans. The postmortem analysis indicated clearly that the brains of individuals with schizophrenia have a larger number of dopamine receptors than the brains of nonaffected individuals.

Those who are still uncertain about the dopamine hypothesis point to several facts that do not agree with present statements of the dopamine hypothesis. Dopamine-blocking drugs, which are used so successfully with schizophrenia, are also effective in treating other psychiatric disorders, particularly, for example, some types of organic psychoses. The question asked is, how can excess dopamine be thought to cause schizophrenia when lowering levels of dopamine also has a positive effect on other psychiatric disorders unrelated to schizophrenia? Additionally, dopamine-blocking drugs are not helpful for a large number of people with schizophrenia.

Furthermore, the effect of phenothiazine in reducing dopamine levels takes places quickly (in hours), but any change in the behavior takes place gradually, over two or three weeks. If one causes the other, it might be assumed that the effect should be instantaneous.

Finally, dopamine-blocking antipsychotic medication typically is helpful with treating positive symptoms of schizophrenia, but not very effective with the negative symptoms. This suggests that there might be a factor other than excess dopamine that causes schizophrenia.

The answer to the dopamine question likely lies in advances in antipsychotic medication. Newer antipsychotics target specific types of dopamine receptors in the brain rather than the traditional antipsychotics that affected all dopamine receptors. This allows scientists to look at the different effects of different types of dopamine receptors independently. Specifically, there is evidence of excessive activity at one type of dopamine receptor (labeled D2) and deficient activity at another (labeled D1). These two types of receptors are commonly found in different parts of the brain and also help explain the variety of symptoms seen in schizophrenia.

Possible Role of Glutamate

Additional research that resulted from comparison of the symptoms of schizophrenia and intoxication with recreational drugs phencyclidine and ketamine implicate another neurotransmitter, glutamate. Research on the role of glutamate is just in its beginning.

Neuroanatomical Factors

A third connection between biological factors and the development of schizophrenia grows out of the discovery of structural anomalies in the brains of individuals with schizophrenia. So far, two types of structural differences between the brains of individuals with and without schizophrenia have been identified. First, the ventricles of the schizophrenic brain have been observed to be larger and asymmetrical when compared with nonaffected human brains. Ventricles are tissue-free, cavity-like chambers in the brain that are filled with fluid. Their anomalous enlargement is suggestive of deterioration or atrophy in the brain. The correlation of enlarged ventricles and schizophrenia is suggestive of, but not proof of, a causal relationship between the two. In fact, not all individuals with schizophrenia have enlarged ventricles.

Cranium size, cerebrum size, and perhaps most significantly, frontal lobe size, are all smaller in people with schizophrenia. The highest level of brain function takes place in the cortex. This part of the brain is implicated by the symptoms of schizophrenia as well as being greatly affected by the aforementioned deficits in dopamine activity at a specific type of dopamine receptor called D1 receptors. Additionally, reduced blood flow has been found in the frontal lobe of individuals with schizophrenia.

VIRAL INFECTION

Research on the occurrence of schizophrenia has implicated prenatal viral infection. Infants of mothers who were exposed to the influenza virus while pregnant are more likely to develop schizophrenia. Comparisons of identical twins exposed to influenza prenatally suggest signs of teratogenic effects of the virus on twins that later develop schizophrenia in comparison to their nonaffected co-twins. However, not all children of women who had the flu while pregnant develop schizophrenia. Clearly there are other factors involved.

Psychological Factors in the Development of Schizophrenia

The biogenic factors associated with the development of schizophrenia, as we have just described, provide a reasonably solid basis for believing that there is a biologically caused vulnerability such that an affected person can be thought of as schizophrenia-prone. That vulnerability does not always cause schizophrenia. To understand why it does in some individuals and not in others, we need to know what psychologically stressful circumstances that, when imposed on a vulnerability to schizophrenia, actually push the individual into developing the disorder.

An obvious candidate for consideration is a life crisis immediately preceding the schizophrenic breakdown. But Bowers (1974), in a careful study of developing schizophrenia, reports that the so-called life crises preceding the schizophrenic breakdown seem to be no worse than life crises faced by most young adults in our society; and, according to Bowers, such crises have not occurred immediately before the breakdown.

To psychologists considering the collapse of the individual in the face of only normal life stresses, it seemed that the answer must lie in earlier life experiences that were so psychologically crippling and disabling to the schizophrenia-prone individuals as to make it impossible for them to cope with any, even normal, later life crises. And it is a fact that most, if not all, individuals with schizophrenia grow up in disturbed family settings.

The search for early life experiences so psychologically damaging as to cause a schizophrenically vulnerable individual to break down and move into a full schizophrenic psychosis has centered on a variety of aspects of the schizophrenic's life experiences. Unfortunately, many of the theories, such as a cold, rejecting mother or a conflicting communication style, resulted in dead ends. However, one psychological factor is still under consideration: the way in which emotion is expressed in the family, labeled in the research as expressed emotion.

EXPRESSED EMOTION

One family communication pattern has been related to relapse in schizophrenia, although not necessarily to the onset—the way in which family members communicate their emotions, negative and positive. In a pattern called expressed emotions, family members express their feelings openly and intensely in ways that negatively affect individuals with schizophrenia. Two elements of those emotional expressions are particularly crucial in causing a pathogenic effect: emotional overinvolvement and excessive criticalness or hostility.

While it had been thought that high expressed emotion was a cause of schizophrenia, subsequent research has not supported that theory. Despite the fact that high expressed emotion in the families of individuals with schizophrenia is related relapse, it has not been found to be associated with onset of schizophrenia. For example, analysis of data and results from 25 studies of expressed emotion and schizophrenia (Bebbington & Kuipers, 1994) found a consistent and strong relationship between expressed emotion and relapse. That is, contact with family members with high levels of expressed emotion was associated with a higher risk of relapse and exposure to family members with low levels of expressed emotion was associated with lower risk of relapse.

OVERVIEW OF PSYCHOLOGICAL CAUSES OF SCHIZOPHRENIA

Despite a considerable body of research, it is not yet possible to describe one specific set of psychological dynamics that psychologists generally will agree precedes and is causative in the development of schizophrenia. What is widely accepted among clinicians and other authorities in the field is the view that with our present knowledge of the illness, a complex and dynamic biopsychosocial model is the most useful way of thinking about the disorder. In that model, a genetic vulnerability and other risk factors are constantly interacting across the early years of the individual's life. A heightened vulnerability and the periodic intervention of one or another stressor ultimately induces schizophrenia.

Cultural Factors in the Development of Schizophrenia

One might not assume that cultural environment would have an impact on the development of such a severe disorder as schizophrenia, yet there are statistical findings that relate the prevalence and type of schizophrenia to cultural factors. Cultural factors seem to be related to the prevalence of schizophrenia and to the form that it takes. However, it is important to take into account cultural differences in beliefs and behaviors when deciding whether an individual is psychotic. What is bizarre in one culture may not be as unusual in another. The most common subtype and prognosis of schizophrenia has been known to vary across countries. Additionally, there is some variability in prevalence rates, although they might be influenced by differences in diagnostic criteria.

Treatment of Schizophrenia

Reflecting the dual nature of causative factors in schizophrenia, clinicians take two interacting and complementary approaches to the treatment of schizophrenia: biological (largely pharmaceutical) and psychological. In this section, we first examine biological treatment of schizophrenia, and then look at modern approaches to psychological help for the disorder.

Primarily as a result of the development of tranquilizing drugs in the 1950s, which reduced the florid symptoms of people with schizophrenia and made them much more available for psychological types of therapy, today people with schizophrenia can enjoy a more hopeful prognosis. The modern treatment of schizophrenia takes a two-stage approach. In stage one, the goal is the reduction of the positive symptoms (hallucinations, delusions, and agitation), the initial stages of which take place immediately after hospitalization. Successful control of those symptoms usually requires that the patient continue the antipsychotic medication for long periods after discharge from the hospital. In stage two, the goal is to help the patient develop the ability to function socially. Pursuit of that goal begins before the patient's discharge and is continued out of hospital in carefully nurtured aftercare programs. It should be pointed out that in stage one, the treatment is almost entirely biological; in stage two, it is psychological with continued maintenance of drug therapy.

Antispychotic Medications

In using the newly synthesized antihistamines for the relief of asthma and other allergies, clinicians soon took note of their strong tranquilizing effect on patients. Experimentally, at first, psychiatrists began to use the drug with disturbed psychiatric patients. It was soon discovered that the drug they were using, chlorpromazine, had a dramatic tranquilizing effect on patients with schizophrenia. And so a revolution in the treatment of that disorder was begun.

EFFECTS OF DRUG THERAPY

The pharmaceuticals (chlorpromazine, phenothiazines, and butyphenones), also called neuroleptics or antipsychotic medications, were standard treatment until the late 1970s in the initial phase of treating schizophrenia. In the late 1980s, the new drug clozapine (the first atypical antipsychotic) was experimentally tested and found to be highly effective in the treatment of schizophrenia. At the introduction of the drug for the regular treatment of schizophrenics, a number of psychiatrists reported that "it worked wonders" in making it possible for people with schizophrenia to return to their families and even to find employment. Although without the usual negative side effects, the drug causes a fatal blood disorder in a small number of patients, requiring that they be followed up with an expensive monitoring program. Since that time, more antipsychotic medications have been developed. With each one, attempts are made to increase effectiveness and decrease side effects. While there is no medication that is always effective in treating all of the symptoms of schizophrenia and no medication is without side effects, there are a number of medications that are used today with great benefit.

The biochemical effect of antipsychotic drugs is to lower levels of dopamine in the brain. Clinically, that change reduces fear, agitation, thought disorders, delusions, and hallucinations, which are the most acutely disruptive of the patient's symptoms. Once those symptoms are alleviated, the patient is readied for the second phase of treatment and discharge from the hospital. Hospital statistics reveal the dramatic effect of drug therapy. In 1955, prior to widespread use of drug therapy, there were, in round numbers, 560,000 patients in psychiatric hospitals. By 1982, a report for the Department of Health and Human Services stated that that number had decreased to 160,000 (Witkin, 1981). That number has since dropped even more. The effective use of drug therapy was part of what made that reduction possible. But there are costs involved.

NEGATIVE CONSEQUENCES OF DRUG THERAPY

Negative factors associated with drug therapy are of two types: negative physical side effects and unhappy social consequences.

Negative Side Effects

One set of troublesome side effects is the development of Parkinson-type symptoms: muscle rigidity, immobile facial expression, and tremors. These symptoms are unquestionably the result of lowered dopamine levels produced by the medication. In some patients, there may also develop itching in the muscles, which leads to a constant need to move around. To relieve that discomfort, patients resort to pacing about restlessly. In time, use of the drugs leads to an exceedingly unpleasant disorder (tardive dyskinesia), in which patients continuously smack their lips and move their tongues. The symptoms, which are, as can be imagined, extremely discomforting to the patient, grow worse as the patient ages. The newer drugs have done much to reduce the negative side effects.

Negative Social Consequences

In past years, people with schizophrenia remained in the hospital for long periods, sometimes until their death. With the use of the antipsychotic medications, most patients can be discharged quickly. But as a consequence, readmission rates have soared, leading to a phenomenon nicknamed the revolving-door effect. In 1986, Hogarty and associates reported that the readmission rate within a two-year period was 79 percent. One explanation for that increased readmission rate is that in past years, many patients now discharged (for a variety of reasons) would never have been out of the hospital.

Trying to look on the bright side of things, we can say that at least 21 percent of those with schizophrenia who have been hospitalized now are able to stay out of the hospital for at least two years. For those who remain on medication and live in benign settings at home or elsewhere, that two-year period is even longer. For others, perhaps most of the discharged patients, the period out of hospital may not have been a pleasant one. Unknown numbers of discharged patients become part of the urban homeless population; others, while not homeless, may spend their time out of the hospital with a disruptive and fractious family that provided the setting for relapse.

POST-HOSPITAL CARE AND RELAPSE RATE

Studies of people with schizophrenia who have been discharged have identified four conditions that influence the length of time before a relapse and return to the hospital occurs:

- Whether the patient continued to take the antipsychotic medication
- The quality of family relations in the home to which the patient returns
- The availability of out-of-home activities for the patient
- The extent to which the patient has developed useful social skills and the availability of nonfamily interpersonal relations

MAINTENANCE DRUG THERAPY

Substantial research has related length of time before relapse and whether the patient has continued medication after hospital discharge. For example, a review of past research (Davis & Andriukaitis, 1986) indicated that without continued antipsychotic medication, about two thirds of individuals with schizophrenia experience significant symptoms. The review reported that maintenance medication (taken while the individual does not have symptoms to prevent a relapse) dramatically improves long-term outcomes including decreasing the likelihood of relapse. Another review of the literature (Viguera, Baldessarini, Hegarty, van Kammen & Tohen, 1997) reported that the relapse rate when antipsychotic medications are discontinued abruptly is 50 percent in 30 weeks. However, as important as continued medication is, it is not enough to lengthen the period before relapse for some patients. Other factors, principally psychological factors, play a part. Many patients, either to avoid negative side effects of the drugs or because of negligence, stop taking the drug. When they do, a shorter interval before relapse is the almost certain result.

FAMILY THERAPY

A number of studies indicate that a combination of continued medication and family therapy can be a powerful influence in lowering the relapse rate. In fact, a literature review by Huxley, Rendall, and Sederer (2000) found that family therapy is the most effective psychosocial treatment (when combined with pharmacotherapy) for schizophrenia. Specifically, in comparing 70 studies of treatment effectiveness for schizophrenia, family therapy had better results than group or individual therapy. This was true for symptom reduction and social and vocational functioning.

Successful family therapy stresses family relationships, how emotions are expressed, patterns of communication between the patient and other family members, and role relationships within the family. The therapist, working with the family as a unit, helps members recognize the damaging effect on the patient of intensely expressed emotion, whether the emotion surrounds the patient with emotional overprotection or offers criticism to "help" him or her. The therapist works to help family members cope with the stress of having the individual with schizophrenia in the home in ways that avoid the negative environment that could lead to relapse.

SOCIAL SKILLS TRAINING

Ordinary social skills used in relating appropriately to others or in seeking their help (for example, asking directions) are skills that most people use routinely with little difficulty. However, often these skills have been completely lost during the schizophrenic illness. Yet any successful attempt to resume a somewhat normal interpersonal life is dependent upon those skills. Once the individual's most disturbing symptoms have subsided, training can begin.

One well-conceived and carefully implemented program, described by Wallace and colleagues (1982), eased the patient's reentry into normal out-of-hospital social settings and enabled the patient to more comfortably meet life's ordinary social demands. The program divided social skills into three phases: 1) accurate perception of the social situation; 2) planning choices of response options; and 3) implementing the chosen response. Through therapy, the individual was trained in each separate step, and then integrated and practiced the steps in role-playing situations—in the beginning, with the therapist, and later in group situations, with other patients. For more lasting effect, the patient should have an opportunity to test new social skills in real life interpersonal situations, followed by a discussion with the therapist about any problems that may have developed.

MILIEU AND THERAPEUTIC COMMUNITIES

In the 1960s and 1970s, two full-time residential communities, providing a post-hospital experience that created a totally therapeutic environment for the patient, served as examples of what can be accomplished in such a setting with skilled and dedicated staff. Both The Lodge (developed by George Fairweather and associates in 1969) and Soteria House (established in the 1970s) used only psychosocial therapy without antipsychotic drugs. These programs had significant positive results, but were not replicated. As an explanation of that finding, Goldstein et al. (1984) point out that often the beneficial effects of alternative treatment programs disappear when the charismatic leadership of earlier programs is no longer present. Charisma is something that we have not yet learned to teach.

Today, such treatment programs that discourage antipsychotic medication do not exist. However, there are a number of group home and community-living organizations that provide support for individuals with schizophrenia while they are receiving psychological and pharmacological services in the community. These programs have had positive results in allowing individuals to function outside of hospitals and other long-term care facilities. Residing in such assisted-care living facilities as opposed to living independently has been found to be associated with increased participation in outpatient mental health care and pharmacotherapy and lower rates of medical and psychiatric hospitalization. Such facilities can provide comprehensive services at a much lower cost, while allowing the clients greater freedom in comparison to hospitalization.

Overview of Outcomes in Schizophrenia

There are various ways of describing outcomes following an initial schizophrenic episode; some of them pessimistic, others more optimistic. On the optimistic side, we can say that since the introduction of drug therapy, almost 90 percent of those individuals suffering a schizophrenic episode and entering a psychiatric hospital for the first time will improve and be discharged in a short time—for many, in a few weeks or less. To balance that optimism, it is necessary to report that many will have to be rehospitalized within the subsequent two years.

DSM-IV-TR provides what seems to be the most pessimistic report, stating that a complete recovery to preschizophrenic functioning is unlikely. Such a recovery is so rare that some clinicians would be uncertain of the diagnosis if such a recovery did take place. There is the possibility of full recovery, but the frequency of such recoveries is unknown.

DELUSIONAL DISORDER

There is another type of functional (nonorganic) psychosis, labeled in DSM-IV-TR as delusional disorder. Although often featured in motion pictures and occasionally headlined in newspaper accounts of unusual crimes, it is a rare psychiatric disorder. Scant published research about the illness is available, and we describe it here only briefly.

Types of Delusions

The central (and, for the most part, only) symptom is a well-established and often ably defended delusion. DSM-IV-TR lists seven specific types of delusion characteristic of the disease: persecutory type, in which the individual believes he or she is being threatened or mistreated by others; grandiose type, in which victims of the disorder believe that they are extraordinarily important people or are possessed of extraordinary power, knowledge, or ability; jealous type, in which the delusion centers on the suspected unfaithfulness of a spouse or sexual partner (this delusion is more common than the others); erotomanic type, in which individuals convince themselves that some person of eminence, often a movie star or well-known political figure (often one they have never met but to whom they have written frequently) is in love with them; somatic type, in which the false belief focuses on a delusional physical abnormality or disorder; mixed type, in which there is more than one type of delusion; and unspecified type, in which the delusions have not or cannot be categorized.

Diagnostic Criteria

For a diagnosis of the disorder, DSM-IV-TR requires that the delusions are not bizarre and be present for at least one month. The disorder is distinguished from paranoid schizophrenia, in which there would ordinarily be an array of other symptoms not found in delusional disorder, such as hallucinations, agitation, or social disorganization. It is also distinguished from paranoid personality disorder, in which paranoid thinking takes the form of suspicion of the motives of others but in which there is an absence of the elaborately developed and patently false delusions of the delusional disorder. The symptoms also cannot be due to a mood disorder, medical condition, or the effects of a controlled substance.

Associated Symptoms

All other symptoms are associated directly or indirectly with the central delusional belief. There may be resentments and anger, which occasionally cause violence. Especially in the persecutory type, there is likely to be social isolation, seclusiveness, and behavioral eccentricities. In defense of the delusions or consistent with them, the individual may initiate court actions, write long and involved letters to people he or she does not know, or become involved in long and complex conversations, even with strangers. These patients rarely seek treatment, and when they are forced to do so by relatives or social or legal organizations, they do not participate effectively in the treatment effort. The disorder is one of middle or later adult life. The course is quite variable with better prognosis for delusions of the jealous type and worse prognosis for the persecutory type.

Causative Factors

Although little systematic research has been done on the delusional disorder, clinicians generally believe that it has no genetic or other physical basis, but grows out of pathological early life experiences. Supporting that belief is a study of Kendler and Davis (1981) which reports that relatives of these patients are no more likely to develop schizophreniform symptoms than are individuals in the general population. The few researchers reporting on etiological factors in delusional disorder suggest a childhood characterized by aloofness, secretiveness, and resentment of criticism or punishment. Family experiences are reported to be authoritarian, domineering, and critical.

SUMMARY

Psychotic disorders, a group of disorders that distort the thought processes and cause anomalies (distortions) in the behavior and affective life of the individual, make up some of the most debilitating of psychiatric disorders. They affect 1 percent of the world's population. Rates in the United States are comparable.

The various psychotic disorders are distinguished by a set of three dimensions: duration; symptoms; and source of the disturbance.

Maladaptive changes in the individual with schizophrenia include bizarre thought content, anomalies in the form of the individual's thought processes, warped perceptions of the world, flattening or inappropriateness in emotional expression, paralysis of will, a loss of any sense of self-identity, and withdrawal from the outside world. There is no one symptom or type of behavior that unequivocally identifies schizophrenia.

In the development of schizophrenia, clinicians recognize three phases: the prodromal or early stage; the active stage, which brings on florid symptomatology; and the residual stage, which is characterized by milder symptoms after a schizophrenic episode.

DSM-IV-TR classifies five specific types of schizophrenia: catatonic; disorganized; paranoid; residual; and undifferentiated.

In considering the causes of schizophrenia, psychologists agree that the disorder results from some interactive combination of biological (including genetic) and psychological factors. There would seem to be a genetically caused predisposition to schizophrenia.

Most people with schizophrenia are hospitalized for treatment for at least a brief period of time. Typically, antipsychotic drugs are administered, followed by some form of supportive therapy. The rate of relapse and re-hospitalization is exceptionally high. Recovery to the preschizophrenic level of functioning is unlikely; but, some clinicians would add, not impossible.

SELECTED READINGS

Burke, R. D. (1995). When the music's over: My journey into schizophrenia. New York: Basic Books.

Goldstein, M. J. (Ed.). 1982. Preventive intervention in schizophrenia: Are we ready? Washington, D.C.: U.S. Government Printing Office.

Green, M. F. (2003). Schizophrenia revealed: From neurons to social interactions. New York: W. W. Norton & Company.

Ribar, A. V. (2004). First person Account: Schizoaffective Disorder and Suicide. Schizophrenia Bulletin, 30, 677-681.

Test Yourself

1)	What disorder is characterized by nonbizarre delusions?								
	a) delusional disorder	c) schizophreniform disorder							
	b) schizoaffective disorder	d) schizophrenia							
2)	What disorder is characterized by mood disturbance and psychosis?								
	a) delusional disorder	c) schizophreniform disorder							
	b) schizoaffective disorder	d) schizophrenia							
3)	What disorder is characterized by delusions, hallucinations, flat affect, and avolition?								
	a) delusional disorder	c) schizophreniform disorder							
	b) schizoaffective disorder	d) schizophrenia							
4)	Positive symptoms include flattening of affect and avolition. True or false?								
5)	Disorganized subtype of schizophrenia is characterized by either agitation or withdrawal, including stupor. True or false?								
6)	Prodromal phase refers to the period when impairment begins but before full-blown symptoms schizophrenia are present. True or false?								
7)	Schizophrenia is likely due to								
	a) genetic factors	c) neurochemical imbalances							
	b) environmental factors	d) all of the above							
8)	Schizophrenia is typically treated with								
	a) antipsychotic medication	c) skills training							
	b) family therapy	d) all of the above							

Test Yourself Answers

- 1) The answer is a, delusional disorder. In delusional disorder, nonbizarre delusions are present for a month or more in the absence of other symptoms of schizophrenia or mood disturbance.
- 2) The answer is **b**, schizoaffective disorder. This disorder is characterized by mood disturbance (depressive, manic, or mixed episode) and psychotic symptoms (delusions, hallucinations).
- 3) The answer is d, schizophrenia. The symptoms of schizophrenia are two or more of the following present for one month: delusions; hallucination; disorganized speech; and negative symptoms (such as flat affect and avolition).
- 4) The answer is **false.** Flat affect and avolition are negative symptoms. Positive symptoms include delusions and hallucinations.
- 5) The answer is false. Agitation or withdrawal are symptomatic of the catatonic subtype of schizophrenia. Disorganized type is characterized by disorganized speech, disorganized behavior, and flat or inappropriate affect.
- 6) The answer is **true**. The prodromal phase precedes full symptoms. The active phase is characterized by florid psychosis. The residual phase involves remission of symptoms, but without a return to preschizophrenia functioning.
- 7) The answer is **d**, all of the above. Multiple genes, environmental factors, and imbalances of neurotransmitters are all likely causes of schizophrenia.
- 8) The answer is **d**, all of the above. Schizophrenia frequently is treated with antipsychotic medication to manage symptoms, family therapy to support the individual, and skills training to provide the skills necessary to be effective in daily life.

Substance-Use Disorders

he problem of drug abuse is a central concern at all levels of American society. Along with poverty and racism, drug abuse has been targeted by national mental health authorities as one of the principal causes of mental health problems. Two of the three major institutes of the United States Public Health Service concern themselves exclusively with alcoholism and drug abuse.

Neighborhoods in major urban centers are beset by the thousands of drug peddlers on street corners; and even in so-called good neighborhoods, certain houses are known as drug drops, visited regularly by street peddlers. At the family level, there are few households that are not familiar with the problem, because of its presence either in their own home or in the families of relatives or neighbors.

The effects of substance abuse are devastating for the individual, his or her family, and society. We cite only a few examples of those effects here, leaving more details of their effects to later discussions of each of the addictive substances. Half of all suicides, more than half of all fatal automobile accidents, and almost half of all murders are alcohol-related. Almost all street crimes involve drug users.

Despite the negative effects of excessive use of alcohol and other psychoactive substances, they are, as the *Diagnostic and Statistical Manual of Mental Disorders* points out, frequently used to modify mood or behavior, in a recreational way, under circumstances that are considered normal and appropriate. There also exist subcultural groups who, in opposition to those practices, forbid, or at least strongly discourage, any use of alcohol, and by strong implication, all other psychoactive drugs.

Ill effects and all, the practice of using various substances to reduce pain and emotional tension, or to induce euphoria, is, as far as we can tell, an ancient practice. The virtues (if that is the right word) of wine were sung in the poetry of the Greeks and the Romans; the royalty of Persia and Egypt were subject to its influences. Persian history gives Cambysis, a sixth-century B.C.E. member of the royal family, the dubious distinction of being the first alcoholic in recorded history.

This chapter, although giving principal emphasis to alcohol, a substance negatively affecting many more individuals than all other drugs combined, describes the principal addictive substances, their effects, possible causes, and treatment programs.

M THE DSM AND SUBSTANCE ABUSE

Psychological disorders that are the result of substance use are divided into two types by the *Diagnostic and Statistical Manual*: substance dependence and substance abuse. As with other psychological disorders in the manual, the categories relate to behavior caused by the substance use and not to any etiological factors.

Substance Dependence

According to DSM-IV-TR, an individual is diagnosed as substance dependent when any three of the following seven types of symptoms or behavior patterns are characteristic of his or her behavior.

- The substance is taken in larger quantities or over a longer period of time than the individual planned.
- · Despite a strong desire to reduce or control substance use, the individual fails to do so in several attempts.
- The individual spends inordinate time trying to obtain the substance.
- Important social, occupational, or recreational interests are given up or neglected.
- · Substance use is continued despite the knowledge of having a persistent social, psychological, or physical problem that is caused or exacerbated by the use of the substance. Examples are as follows: exacerbation of an ulcer by continuing to drink alcohol; provoking a major family dispute because of drug abuse; or continuing use, even though it is followed by a severe depression.
- · A marked tolerance of the substance causes the individual to increase use of the substance or experience diminished effects.
- There are significant withdrawal symptoms, or the substance is taken to relieve or avoid withdrawal symptoms.

Substance Abuse

Substance abuse, a less severe reaction than substance dependence, is diagnosed by DSM-IV-TR when there is a pattern of pathological use, accompanied by impaired social or occupational functioning, for at least a month's time. Symptoms of substance abuse include a recurrent pattern of failure to fulfill obligations due to use, use in dangerous situations, legal problems related to use, and/or social or interpersonal problems related to use.

An extension of substance dependence is the diagnosis of organic mental disorder by psychoactive substance use when severe mental symptoms, such as delirium tremens, accompany withdrawal symptoms.

ETIOLOGICAL FACTORS IN SUBSTANCE-USE DISORDERS

More than any other psychological disorder, the development of substance-use disorders seems to be dependent upon the ready availability of the substance and its use by the individual's peers. Both biological and psychological factors also have been explored as possible causes of substance-abuse disorders. Alcohol use has been studied most extensively.

Not all individuals who have access to psychoactive substances or whose friends use one or more of them become dependent on the substance. To those two conditions, there is usually added either a set of life circumstances that are so unhappy for the individual as to cause him or her to seek escape from them, or life circumstances so boring and unexciting as to provoke the need for artificial stimulation. Once individuals are tempted to try the substance, its immediate psychological effects draw them into regular use of the substance and hence into addiction.

Characteristic Ways in Which Psychoactive Substances Work

To understand the etiology of substance-use disorders, we begin by describing the way in which most psychoactive substances work.

Richard Solomon (1977) describes three characteristics or phases of substance abuse that create a strong motive to continue using the substance. He has called his analysis the opponent-process model of addiction. It is so named because of the opposition between two phases of substance abuse. In all, there are three phases to Solomon's model: affective pleasure; affective tolerance; and affective withdrawal. Initially, the user seeks the pleasure of the substance's first phase. As the substance user moves into the third phase, going without the drug, and experiences withdrawal symptoms, he or she is drawn back into substance use to avoid the unpleasantness of withdrawal. The oppositional nature of the two processes is easy to see. They are, in a sense, opponents of each other.

Affective Pleasure

All psychoactive substances causing addiction, in their initial stages, provide positive emotional experiences. The nature of those experiences vary from one substance to another, but they are all, in one way or another, pleasing to the user. Alcohol releases inhibitions, overcomes shyness, and pushes current problems out of consciousness; heroin gives the user a "rush," bathing the individual in a warm ecstasy; cocaine provides a thirty-minute period of euphoria, well-being, and tirelessness. Those pleasant experiences invite the individual to come back again.

Tolerance

Users soon find that they develop a tolerance for the substance. The initial dosage no longer produces its initial "high." In the beginning, for example, two or three drinks would set the individual "on top of the world." Some time later, that amount no longer provides the desired effect; it then takes five or six to get the same effect. At that point, the individual moves toward addiction.

Withdrawal

Individuals, after a period of heavy substance abuse, may develop feelings of guilt about their habit; there may be pressure from a significant other, parents, or employers. They may then decide to give up their habit. If, by that time, their body's physiological processes have become dependent upon use of the substance, they will develop withdrawal symptoms. These are feelings of panic or heightened irritability. The reaction is a very unpleasant one, and now drives the individual, not so much to seek pleasure, but to reduce the unpleasantness of the withdrawal symptoms. The withdrawal symptoms cause users to frantically seek "a fix," sometimes at any cost. They have moved from drug abuse to drug dependence, with dire effects upon their lives, including possible criminal acts to obtain money for purchasing the drugs upon which they have now become dependent.

Biogenic Factors

Are there biogenic factors that make the individual vulnerable to substance abuse? Research suggests that there may be brain irregularities making some people quicker to become addicted than others, and making the addiction harder to cure. There is evidence of a genetic vulnerability to substance dependence as well.

TYPES OF PSYCHOACTIVE SUBSTANCES

This section describes five categories of psychoactive (that is, affecting cognitions, feelings, or behavior) substance: alcohol; narcotics (derived from opium); sedatives (principally the barbiturates); stimulants (principally cocaine and the amphetamines); and hallucinogens (including marijuana).

Alcohol

Consumption of alcohol is a major characteristic of the contemporary American social scene. We discuss here prevalence, effects, causative factors, and treatment approaches.

Prevalence

Many people drink alcohol. A survey in 2001 reported that 63.7 percent of Americans 12 and older reported using alcohol in the previous 12 months. Most of these people use alcohol without significant negative effects. However, estimates of alcohol dependence range from 3.81 percent to 10 percent. This wide range is likely due to reluctance to admit to symptoms of alcohol dependence. Alcoholism is more frequently diagnosed in men than in women.

The social and economic damage caused by drinking alcohol is extreme. The National Council on Alcoholism estimates that the overall cost of alcoholism, including work absences and health costs, comes to more than \$185 billion a year. It is difficult to quantify the cost of disrupted family life and neglected children and the personal suffering of the individual with alcoholism.

The Effects of Alcohol

There are both physiological and behavioral effects of drinking alcohol.

PHYSIOLOGICAL EFFECTS

Alcohol acts quickly. In a matter of minutes, alcohol is absorbed into the bloodstream through the walls of the stomach and the small intestine. It then goes to the liver, which has the capacity to metabolize (that is, to convert into energy) one ounce of 90-proof alcohol in one hour. In theory, if a person drank just one ounce of 90-proof alcohol every hour, there would be no alcohol available to the blood, and hence to the brain, to effect any behavioral changes. What alcohol that is not metabolized remains in the bloodstream and is carried to the brain.

Although often considered to be a stimulant, alcohol is a depressant. Its apparently stimulating effect results from its depressant effect on cortical control of emotion and behavior. It turns an overly inhibited individual into a relatively uninhibited one. With continued drinking, initial amiability may be converted into depression or aggression.

BEHAVIORAL EFFECTS

Even moderate doses of alcohol impair coordination and slow reaction time. It also interferes with speech, vision, and the higher mental processes, such as judgment and calculation.

SOCIAL EFFECTS

Two socially significant effects of alcohol are their impact on aggressive behavior and sexual behavior. The combination can be especially upsetting to those around the person consuming alcohol. Small doses of alcohol can cause aggression to be expressed in assertively arguing contrary political, ethnic, or religious views. With increased drinking, the individual may "look for a fight," or become assaultive. With respect to alcohol's effect on sexual behavior, psychologists enjoy quoting Shakespeare, from Macbeth: "Lechery, Sir, it provokes and it unprovokes; it provokes the desire, but it takes away the performance." Both of these effects are attributable to alcohol lowering individual's inhibitions.

THE INFLUENCE OF EXPECTATIONS

There is research support to indicate that much uninhibited behavior, resulting from a drink or two, comes more from what the individual believes will be the effect of alcohol than from the alcohol itself. For example, in two separate studies, groups of men and women were given what they thought were alcoholic drinks. Their behavioral reactions were then observed. With respect to aggressive behavior and to amorous behavior, both men and women behaved in notably uninhibited ways.

THE DRINKING CYCLE'S INFLUENCE ON EFFECTS

There is also research to indicate that the effect of alcohol varies with the timing of the drinking cycle. Using tests of abstract problem-solving and memory, Jones and Parsons (1971) were able to show that with identical levels of alcohol in the blood, those moving toward intoxication were much more intellectually impaired than those on their way to sobriety; that is, on the downward cycle of the drinking episode. In either phase, performance was lower than performance without alcohol.

LONG-TERM EFFECTS

The effects of alcohol discussed so far are those within a single drinking episode. With frequent drinking bouts over a prolonged period of time, there will be more damaging and long-term effects. Chronic alcoholism affects almost every tissue of the body. The most damaging long-term effects of chronic alcoholism are as follows: 1) Malnutrition; the calories of alcohol are empty of nutritive value and because alcohol is substituted for food, the body soon breaks down from the absence of nutrients essential for health, especially the absence of protein. 2) Severe psychiatric disorders develop. Korsakoff's syndrome (see Chapter 17) is a direct result of the absence of B-complex vitamins that results from the diet of the chronic alcoholic. 3) Cirrhosis of the liver is a likely possibility. This serious illness, in which fat replaces healthy liver tissue, impairs the liver's functioning and causes inflammation. Cirrhosis of the liver is often fatal, ranking twelfth among the principal causes of death.

One sad long-term effect of alcohol affects not only the woman alcoholic but, if she is pregnant, the fetus, as well. Alcohol consumption by pregnant women is a leading cause of birth defects. Most striking is fetal alcohol syndrome, which is associated with physical anomalies, cognitive deficits, learning difficulties, and behavior problems.

Special Factors in the Etiology of Alcoholism

Psychological research has focused on two possible causative factors in alcoholism: genetic or other biogenic causes and personality characteristics. Certain psychosocial factors, ethnicity and occupation, seem to be associated with alcoholism. They are not, however, considered to be primary causes of the alcohol addiction.

GENETIC CAUSES OF ALCOHOLISM

Although the genetic mechanism has not yet been described, there is clear evidence, from family and twin studies, that genetic factors play a part in causing alcoholism. Researchers are still trying to identify the particular genes that predispose a person to alcoholism. The individual's heredity causes a vulnerability to alcoholism; the effect is not that of a dominant gene, such as that which determines eye color. Something more, environmental factors working in conjunction with the genetically caused vulnerability, is needed to cause the disorder.

The evidence for the genetic influence stems from animal laboratories where studies find that animals can be bred to show a preference for alcohol over other beverages. That is strong evidence of a genetically caused weakness for drinking alcohol. With humans, there is less certainty. The weakest, but nevertheless suggestive, evidence of a genetic factor in alcoholism is the number of studies that report a higher incidence of alcoholism among the relatives and children of alcoholics than would be expected on a chance basis. Cloninger and associates (1986) report the following figures of the family histories of alcoholics: In a population of men with one alcoholic parent, the rate of alcoholism in family members was 29.5 percent, compared to 11.4 percent in the general population; with two alcoholic parents, that percentage jumps to 41.2 percent. Comparable rates in women were 9.5 to 5.0 percent with one alcoholic parent, and 25 percent with two alcoholic parents. The weakness of this evidence is the fact that common heredity is not the only variable operating. Relatives, including children of alcoholics, may have been surrounded by an alcohol-drinking environment.

Stronger evidence is provided in a study by Godwin and others (1973). That study reported that when children of alcoholic parents were raised apart from their parents by adoptive parents, the rate of alcoholism at the age of twenty among the adopted children was almost twice as high as among a matched control group. Comparing children of alcoholic parents raised by their own parents with those raised by adoptive parents in a second study found no statistically significant differences between the two groups; that is, 25 percent and 17 percent. Those figures suggest some small influence from the home environment. But what is most significant in causing alcoholism is the parents to whom one is born, and not the parents by whom one is raised.

PHYSIOLOGICAL FACTORS IN ALCOHOLISM

Volpicelli (1987) has suggested that alcohol dependence may result from the same physiological relationships that cause other narcotic addiction. Psychoactive drugs, he states, mimic the way in which the brain's naturally producing compounds prevent the feeling of pain. When certain types of psychoactive drugs are used, they cause a sense of pleasure. It is that pleasure, now artificially produced by the psychoactive substance taken into the body, that is sought by the individual. Subsequent research has identified several brain systems that alcohol affects. One such system is the GABA system, associated with inhibition and anxiety. This explains the disinhibition and antianxiety effects of alcohol consumption. Other systems are being studied, including the glutamate system involved in learning and memory, and the serotonin system involved in mood, sleep, and eating. These other systems could explain the effects of alcohol on cognitive abilities (for example, blackouts) and cravings, respectively.

Personality Characteristics in the Etiology of Alcohol Use

Two markedly different approaches have been taken to seeking an understanding of the alcoholismprone personality. One is the psychoanalytic approach. It offers a number of hypotheses based largely on the descriptions of alcohol-dependent patients seen by analysts. The second is a set of longitudinal studies that followed into adulthood a group of children whose behavior patterns had been observed. The consensus of psychological opinion is that no single alcohol-prone personality has been identified. That finding, as later discussion will reveal, is generally true for other substance abusers as well.

Although a prealcoholic personality has not been identified, common personality traits have been identified in those who are already alcoholics. These are negative self-image, feelings of inadequacy, low tolerance for stress, isolation, and depression. As the problem worsens, the individual with alcoholism shows low impulse control, a lack of responsibility, and extremely poor decision making. There are no published studies that report those traits as being present prior to alcohol abuse.

PSYCHOSOCIAL FACTORS

There are ethnic and occupational correlates of alcoholism. Such factors cannot be interpreted as causative in any real sense; they are likely to be environmental conditions that make it easy to drink alcohol, and social conditions in which peers drink alcohol. Ethnic differences are found within and between countries. These are likely due, at least in part, to culturally based attitudes and practices regarding alcohol. From an occupational perspective, prevalence of alcohol abuse is highest in such occupations as railroad workers, sailors, bartenders, waiters, and liquor salesmen. Here, availability and peer group practices provide the environmental impetus for drinking. Another possibility is that individuals who are prone to alcoholism may choose careers that allow drinking.

Treatment for Alcohol Abuse and Alcohol Dependence

The principal hurdle for all treatment programs is the prevention of a relapse. Professional treatment for alcoholism usually takes place in three stages. An important adjunct to professional treatment is the help of such groups as Alcoholics Anonymous.

STAGE ONE OF RELAPSE PREVENTION TREATMENT

Hospitalization for a minimum of a month begins the process. That period is sometimes called a drying-out time. In any case, the time in the hospital should be long enough to give the individual a significant period of time without using alcohol. The discovery that he or she has gone without alcohol, even though in a protected environment, can give the individual a sense of accomplishment. Additionally, this time provides a medically supervised detoxification period during which withdrawal symptoms can be monitored and treated, if necessary.

STAGE TWO OF RELAPSE PREVENTION TREATMENT

At the end of that initial period, the individual must be confronted with his or her alcohol problem, which may, up to this point, have been denied. The individuals with alcoholism are led to admit that they have been alcoholics and that they have a vulnerability to the problem. That possible vulnerability requires an on-guard defensive stance for the rest of their lives.

STAGE THREE OF RELAPSE PREVENTION TREATMENT

At this point, a period of psychotherapy is initiated, often in a group setting. A principal emphasis here is identification of the types of situation that usually lead to heavy drinking. In therapy, many approaches focus on the development of cognitive strategies to handle situations that put the alcoholic at risk. These strategies may range from how to graciously refuse an offered drink (that is, if the goal is abstinence, which it may not be) to dealing with tension-provoking situations at home or on the job.

COGNITIVE-ORIENTED THERAPY

In one widely used cognitive therapeutic approach, the individual is first weaned away from any tendency to believe that his or her alcoholism results from a craving for alcohol that the individual may blame on some poorly understood physiological condition. Instead, individuals are encouraged to believe that their weakness is a matter of self-indulgence and that the goal must be to strive for control of that self-indulgence. The longer individuals are able to maintain that control, the greater the sense of selfmastery and confidence. With those feelings strong, the more likely it is that they will triumph over their excessive drinking.

UNANTICIPATED CONSEQUENCES AFTER THERAPY

Once a short-term program is concluded, two possible developments may take place that tend to destabilize the individual.

First, therapists report that the danger is not that there will be a sudden major alcoholic episode, but that through a series of seemingly harmless "minor" decisions, alcoholics will gradually head toward a relapse. Sometimes a spouse will unwittingly elicit such a decision. Take for example, the simple statement, "Helen and Jacob are coming over for dinner tonight." In the interest of being a hospitable host, such a comment may lead the wife to bring home a bottle of Scotch, saying to herself, "I know they like Scotch." With that act, temptation is brought home. Warning about such mini-decisions can help alcoholics see their danger and avoid making such decisions.

A second problem occurs if, in therapy, the goal of absolute abstinence has been set (as is true in Alcoholics Anonymous). Individuals with alcoholism may accidentally, in the course of a social evening, or by deliberate choice take a single drink. Stopping after a single drink is a victory; but if the goal was abstinence, those with alcoholism may not perceive their accomplishment, but assign such significance to that one violation that their confidence is destroyed and they lose their past determination to avoid heavy drinking. This is another important area in which advance warning about such possibilities can be helpful. An alternative is the harm reduction model in which the goal is limiting use rather than complete abstinence.

AVERSIVE SUBSTANCES IN TREATMENT

In the course of the treatment program, the therapist may use the help of an aversive deterrent to drinking, such as Antabuse. This is a chemical that disrupts the metabolic processing of alcohol for two days after it is taken. If the individual is in a total abstinence program and he or she drinks alcohol during the two-day period, the consequences are very unpleasant, including flushing, increased heartbeat, and severe nausea, an event likely to deter the desire to take another drink during the two crucial days following a dose of Antabuse. The rationale behind the use of Antabuse is that is stops impulsive, unplanned drinking. If the alcoholic decides to resume drinking, he or she has to plan two days ahead to do so. In that time, therapists believe, there is a good chance that the determination not to drink will have become reestablished. The problem with such aversive therapy is that unless underlying problems motivating the drinking are solved, the alcoholic will simply decide to give up Antabuse once out of the hospital.

MUTUAL-HELP GROUPS

The most widely known, and for some 20 percent of those who seek its help, the most effective mutual-help program, is Alcoholics Anonymous. Established in 1935 by two sober alcoholics, the program has developed its own philosophy of treatment based on three propositions: 1) Once an alcoholic, always an alcoholic—one never regains the ability to drink normally. 2) No one can stop drinking without help. 3) A spiritual but nonsectarian approach to life is helpful to everyone, and is especially needed by alcoholics.

With no professional staff, AA offers alcoholics the opportunity to meet in groups with other problem drinkers who are in recovery (abstaining from alcohol use). In the course of the meetings, people describe the indignities, pain, and difficulties they faced during their drinking; what brought them to AA; how they have since used AA to live life sober; and the changes that have occurred in them and their lives due to AA. Alcoholics Anonymous uses a mutual support system, which allows an alcoholic who feels the urge to drink or having difficulties with life to call his or her sponsor for help. Ordinarily, in quick order, a member will talk with and help the individual until his or her desire to drink disappears. It is a part of the AA philosophy that in this practice, both individuals are helped: the person providing the support is reinforced in maintaining an alcohol-free life, while the newcomer survives a crisis. Another helpful factor in AA is its widespread availability—AA meetings can be found in most communities in the United Sates and in over 150 other countries.

When the program works, individuals are generous in their praise of it. Unfortunately, a dropout rate of 80 percent limits its usefulness to the 20 percent who persist. Other mutual support groups exist. Many differ from AA by not stressing a spiritual program of recovery (for example, Rational Recovery), or by not emphasizing complete abstinence (for example, harm reduction).

OVERALL VIEW OF ALCOHOL TREATMENT PROGRAMS

Treatment programs for those who use excessive amounts of alcohol get mixed reviews, and how one interprets the research findings depend upon one's expectations of what should happen. Much of this seems to be due to the fact that there is a large degree of variability in both alcohol treatment programs and alcoholics.

The most extensive research on the effects of treatment is that reported by Polich and colleagues in a 1981 report. They reported the negative side of the picture as follows: Only 7 percent of a group of 922 men studied had not used alcohol in the four years following treatment; 54 percent of the group continued to have alcohol-related problems during that time. When the statistics (drawn accurately from the study) are presented differently, one can feel more encouraged about the possibility of treating alcoholics. Of the 922 men in the study, more than 90 percent had serious drinking problems to start with; only 54 percent continued to have problems with alcohol. That is a substantial reduction.

Research has explored matching alcoholics with different characteristics to different treatment programs. Although initial studies supported this, a large-scale longitudinal study did not support treatment matching. Regardless of the treatment model used, drinking and negative consequences of drinking dropped considerably, but no treatment modality was fully effective in eliminating alcohol use. Similar to other studies, one year after treatment, 50 percent of participants reported drinking-related difficulties.

CONDITIONS FOR EFFECTIVE TREATMENT

Carson et al. (1988) describe conditions that improve the likelihood of favorable treatment outcomes. They are early recognition of the problem, acceptance by the individual that he or she has a problem and needs help, and the availability of adequate treatment facilities.

Other Types of Psychoactive Addictive Substances

In this section, we consider three major types of psychoactive drugs: the depressants; the stimulants; and the hallucinogens. These drugs may be taken orally, by smoking or snorting, or intravenously. We examine the nature of the various substances, their effects, etiological factors, and possible therapies.

The Depressants

In addition to alcohol, the depressants are categorized as narcotics, sedatives, and tranquilizers. All have similar characteristics: The user grows tolerant of them and requires increased dosages to produce the desired relaxing effects; withdrawal symptoms develop when the substance is unavailable; and overdoses of the substances depress the functioning of various bodily systems—for example, blood pressure and rate of respiration. Extreme overdoses of any of the depressants can cause death by reducing vital activities to the point where they can no longer support life.

Opium

A principal source of substance abuse, it has been around at least since the Sumerian civilization in 7000 B.C.E. Opium is derived from the seeds of the poppy plant. The principal forms of its modern use are morphine or other prescription pain medications and heroin.

MORPHINE

Morphine is a powerful sedative and pain reliever. Prior to knowledge of its addictive powers, it was used widely in patent medicines and as a means of reducing pain. It is still used occasionally, under strict medical supervision, when intractable and unbearable pain is present.

HEROIN

This opium derivative was developed as a means of controlling the use of morphine, but was soon discovered to have stronger addictive power than morphine, and other negative physiological and behavioral effects, as well. Opposition to its use was led by Theodore Roosevelt; and with his help, in 1914, the Harrison Narcotics Act made illegal the unauthorized use of morphine or heroin. Widespread use of heroin by young people as a kind of daring recreational and escapist activity developed in the 1960s, despite its illegality. Its use decreased in the 1970s and 1980s, but it has again risen in popularity.

EFFECTS OF MORPHINE AND HEROIN

Both drugs produce euphoria, reverie, and drowsiness. In addition, heroin causes a rush effect from intravenous injections, in which the individual is suffused with feelings of warmth and ecstasy. For four to six hours, the individual is in a stupor and seems "out of things." Heroin's appeal is explained well by Solomon's opponent-process model. In that model (as reported in the "Characteristic Ways in Which Psychoactive Substances Work" section earlier in this chapter), the first appeal is pleasure; later, when withdrawal symptoms develop, heroin is then sought to escape the extreme discomfort of withdrawal. Withdrawal symptoms result when neither the drug nor the body's natural processes are at work to produce a sense of well-being.

PREVALENCE

In a 2003 national survey, the estimated number of heroin users was 404,000. Many more young people, survey reports reveal, have experimented at least once with the substance. Nonmedical use of prescription opiate pain medication (medications similar to morphine such as oxycodone and hydrocodone) has been on the rise. In particular, a 2001 survey reported that 3.7 percent of 18- to 25-year-olds admitted to misusing narcotic pain medication in the past month.

Sedatives

The principal sedatives are the barbiturates (for example, phenobarbital, secobarbital, and amobarbital). There are two types of barbiturates, a long-acting type for prolonged periods of sedation, and the short-acting type, which has an immediate effect, causing short-term sedation or sleep. As prescribed medically, barbiturates relax muscles and provide a sense of well-being. When used excessively, they cause loss of motor coordination, slurring of speech, and concentration and cognitive difficulties. As the effect of the drug continues, there is a loss of emotional control and periods of verbal hostility and aggressive behavior.

Stimulants

There are two principal stimulants: amphetamines and cocaine. The amphetamines were available initially as nonprescription inhalants for clogged nasal passages. Their use as artificial stimulants was soon discovered by a mixed population looking for the nonmedical use of their stimulant side effects. Since 1970, the substance has been made a highly restricted prescription medication; yet because it is widely available illegally, it has become a much-used drug. More recently stimulants have been used to treat attention-deficit/hyperactivity disorder and narcolepsy.

AMPHETAMINE USERS

Because of its stimulating effect a user seems, at least for a brief time, to be more alert, have more energy, and feel stronger-its use by soldiers in World War II was encouraged by both Germans and Americans. For the same reasons, it now appeals to long-distance truck drivers and night-shift workers. Among the eighteen-to-twenty-five age group, it is frequently taken by college students cramming for exams and by athletes. Because one of its effects is to depress the appetite, it has become a means of controlling weight; using it for that purpose, without medical supervision, is a dangerous practice. Amphetamines also are used simply for the feeling of being high that they produce.

Excessive use of amphetamines will have serious deleterious effects on one's health, including the possibility of death. Amphetamines can be obtained in different prescription formulations (for example, Ritalin and Dexedrine), as well as an illegally made form known as methamphetamine or meth, which currently is a popular drug of abuse. They all cause both physical and psychological changes.

EFFECTS OF AMPHETAMINES

The drug is addictive whether snorted or taken orally or intravenously. Exceeding the small dosages usually prescribed medically causes increased heart rate, a jump in blood pressure (sometimes to levels high enough to cause death), impaired intestinal functioning, and constriction of the blood vessels on the surface of the body and in bodily membranes. Heavy doses cause such psychological states as nervousness, agitation, heart palpitations, dizziness, and sleeplessness. Beyond those changes, the individual under the influence of the substance may become suicidal or hostile and dangerously assaultive. Use of amphetamines consistently for days can lead to negative health effects of severe sleep deprivation and even psychotic symptoms.

COCAINE

Like opium and marijuana (described in the "Opium" and "Marijuana" sections), cocaine is a plant product; it is extracted from the leaves of the cocoa plant, which is grown extensively in some South American countries.

Prevalence

Its use in the United States is disturbingly prevalent and cuts across demographic groups. In the general population, some 34.9 million Americans admit to having used cocaine at least once.

Effects of Cocaine

The drug acts rapidly on the cortex of the brain, sharpening sensory awareness and suffusing the individual in a haze of euphoria. It accentuates sexual desire, feelings of well-being, and tirelessness. Taking an overdose results in psychotic-like hallucinations and paranoid thinking and other such physical changes as nausea, chills, and sleeplessness. Inveterate cocaine users soon isolate themselves from former friends by their irritability and paranoid thinking. Heavy users frequently find themselves in a hospital emergency room with a heart attack resulting from a myocardial infarct.

Varieties of Cocaine Use

Because of the tolerance effect following regular use, cocaine addicts seek to intensify its effect. One way of doing so is to heat the cocaine with the highly inflammatory ether (a highly dangerous practice), which purifies the cocaine as it produces what is known as a free base, sometimes labeled white tornado or snow. The practice is a frequent one among long-time users of the drug. Another way of using cocaine, introduced initially on the streets of New York City around 1985, is crack. Crack is a free-base form of cocaine, readily available in small doses at relatively low cost. That diabolically clever marketing scheme has made it an increasingly used form of drug.

Hallucinogens

In this section, we discuss the most widely used hallucinogens: LSD (lysergic acid diethylamide); MDMA (also known as ecstasy); and marijuana. There are others, including mescaline, psilocybin, and PCP (angel dust). Because their effects are generally within the range of those produced by the principally used hallucinogens, we discuss here only those three.

PSYCHEDELIC DRUGS

LSD and related drugs are frequently labeled psychedelic drugs. They were first studied during the 1950s because they were believed to produce psychotic reactions, and it was thought that their study might shed light on certain psychotic disorders. The importance of LSD and its attractiveness to a small, highly specialized fraction of the drug-using population grew out of a research decision made by Timothy Leary and Richard Alpert at Harvard (1957). They became interested in the possibility that one of the hallucinogens might have a positive effect on antisocial behavior. Their early, very tentative studies on a population of prisoners suggested that an experience with psilocybin reduced the number of post-prison arrests in the same sample population.

Seemingly attracted by what they thought were the mind-expanding effects of the drug, Leary and Alpert began to use it themselves and encouraged a small group of others to do so. The activity soon attracted the interest of law enforcement authorities. The two left Harvard and set up their own organization to study the so-called mind-expanding properties of LSD and its associated hallucinogens. Following the publicity given to Leary and the promise of mind expansion, a number of well-known artists, writers, and composers took to using the hallucinogenic substances, and an LSD movement developed. It soon became apparent to the group that the psychedelic drugs had no power to increase anyone's creativity. Today, the use of LSD is a relatively minor problem in the field of drug abuse. In a 2003 survey, about 0.2 percent of the population reported using the drug in the past year.

EFFECTS OF THE PSYCHEDELIC DRUGS

The effects of LSD can be produced by minute dosages; larger dosages are required for mescaline and psilocybin. The drugs are taken in liquid form or absorbed into sugar cubes or other substances, which are then ingested by the user. Effects last from six to twelve hours.

As with alcohol, the psychological effects that follow use of the psychedelic drugs depend to a considerable extent upon what the user expects to happen; in other words, expect a trip, get a trip. There is a very real danger of a bad trip, which occasionally results. Panic and profuse anxiety occur; for a small group of users, the result can be a psychotic episode. A typical trip, about eight hours long, brings on kaleidoscopic sensory experiences, shifting emotional experiences, and feelings of detachment and depersonalization. There is little or none of the euphoria of other drugs. Without the expectation and readiness for a mind-expanding experience (which research has demonstrated does not occur), to a nonuser, there would seem to be little reason to use psychedelic drugs, with the possible exception of the appeal of belonging to a group whose practices include the use of such substances.

One unusual and unpleasant effect of the psychedelic drugs is the occasional occurrence of flashbacks. Soon after a trip, without further use of the substance, there is a short-term but dramatic recurrence of the original psychedelic experience. Flashbacks may occur repeatedly for one or two months after use of the substance. Fifteen to 30 percent of psychedelic users have flashback experiences. They are not accompanied by physiological changes that might explain their occurrence. For most individuals who experience them, they are an upsetting, perhaps even frightening, event. The influence of expectations on what the user will experience suggests that the psychedelic user is extremely suggestible. If so, and if flashbacks are expected, they may simply be triggered by ordinary changes in consciousness such as we all experience, but psychedelic users give them a more dramatic interpretation.

Ecstasy, or MDMA, also is a synthetic hallucinogen that also has stimulant properties. Its effects include enhanced sensory perception and energy and a warm feelings toward others. Effects also include nausea, chills, blurred vision, and muscle cramps. It has become a popular recreation drug because of the feelings of "love" it elicits. In 2002, the lifetime prevalence of MDMA use was estimated at 4.3 percent. It is particularly popular at nightclubs and raves.

MARIJUANA

This hallucinogen is smoked as a cigarette, usually referred to as a joint, or occasionally eaten. As with other hallucinogens, its effect is influenced by what individuals expect. For most users, it produces a high different from the use of alcohol. The user experiences a pleasant sense of being relaxed and drifting or floating and altered senses. Marijuana stands apart from the other substances discussed here in that there has been a strong movement to legalize its use.

Regular use of marijuana negatively affects the reproductive processes. In males, it reduces the sperm count; in females, it shortens the fertility period and interferes with ovulation. It raises blood pressure slightly and will create damage to the lungs, because marijuana brings into the lungs many of the same carcinogens as cigarettes; and because it can raise the heart rate dramatically, it has a significant impact on those with potential heart trouble.

Treatment for Drug Abuse and Dependence

Drug dependence is frequently treated through inpatient or outpatient therapy, much the way alcohol dependence is. In fact, many treatment facilities treat both alcohol and drug addiction. Additionally, Narcotics Anonymous is a twelve-step fellowship based on Alcoholics Anonymous that focuses on drug addiction. There are two principal therapies that are specific to drug addiction. One is substitution therapy, in which the addict is given a harmless drug capable of relieving withdrawal symptoms. The second mode of treatment is the therapeutic community.

Substitution Therapy

An essential first step in treating addicts is detoxification; that is, completely withdrawing the addict from drug use. The major challenge here is limiting the pain of withdrawal symptoms. The most successful substitution program is the use of methadone for heroin addiction.

METHADONE TREATMENT

Methadone is a synthetic narcotic developed by Dole and Nyswander in 1966 at Rockefeller University. It is related to heroin and is addictive, but does not have heroin's negative psychological effects.

Advantages of Using Methadone

Most heroin users who stay in the methadone program find that while taking methadone, they can do without heroin and yet not experience the withdrawal effects of giving it up. Because reducing the withdrawal effects is the strong second-stage reason for taking a drug, that effect of methadone has significant value.

There are secondary advantages to the methadone program. Its pharmacological effect—that is, its helpful effect in preventing withdrawal symptoms—lasts for more than twenty-four hours, in contrast to a four-hour effect produced by heroin. The advantage of that is to give the former heroin user a longer period of time when he or she has no reason to visit old haunts in pursuit of heroin. During that twenty-four-hour period during which, in the past, the individual sought contacts from whom to obtain heroin, the repeated pairings of environmental cues, followed by the reinforcement of taking heroin, are eliminated. Thus, in conditioning terms, their motivational value for triggering heroin use should be extinguished, or at least reduced significantly.

Another advantage of methadone is that with high doses of methadone, over a period of time, intravenous heroin no longer produces the sought-after high. Thus, should the individual have a relapse, the heroin would not provide a satisfactory experience.

Disadvantages of Methadone

Methadone substitution does have some serious limitations. For one thing, it keeps the individual drug dependent and requires that he or she visit a hospital or clinic daily to be given the methadone, which is usually taken orally and always supervised by a staff member. And it does have some negative physical effects, such as insomnia, constipation, and diminished sexual performance. A new type of substitution therapy uses Buprenorphine, which has a lower addiction potential than methadone and can be administered in the privacy of a doctor's office.

The negative physical effects and probably the absence of a high following methadone cause a high drop-out rate in most methadone programs. Many methadone programs are accompanied by psychotherapy. Contrary to what one might expect, methadone users not in psychotherapy seem to do as well, socially and psychologically, as do those users who received psychotherapy (Rounsaville 1986). There are no substitution programs for drugs other than heroin.

Therapeutic Communities

The best-known approach to drug use treatment that attempts to restructure the individual's personality is the residential therapeutic community fashioned in the model of the original Synanon program, which has since, for irrelevant reasons, been effectively discontinued. The original program was established by Charles Dederich in Santa Monica, California, in 1958. Other well-known therapeutic communities are Daytop Village, Phoenix House, and Odyssey House. Such programs have as their goal the restructuring of the individual's life perspective so that drugs of any sort no longer have a place in his or her life. The use of methadone is usually discouraged.

CHARACTERISTICS OF SUCCESSFUL RESIDENTIAL TREATMENT

Davison and Neale (1990) describe four features of such therapeutic communities that seem to promote success. Therapeutic programs are successful when: 1) They surround individuals with a drug-free environment in which recovering drug addicts are supported psychologically as they seek to establish a drug-free existence. Addicts who are successfully living free of drugs serve as models and describe their past problems and how they solved them. 2) Confrontational encounters occur in which sober drug users are challenged to accept responsibility for their problems and are pressed to take charge of their lives. 3) Each resident is respected as a fully independent and worthwhile human being and is not stigmatized or criticized for past failures. 4) The residential nature of the treatment center separates the individual from former friends and old haunts and, in that way, breaks up the person's old drug-dominated social network.

EFFECTIVENESS OF THERAPEUTIC CENTERS

Residential therapeutic centers pride themselves on the success of their alumni. Nevertheless, it must be recognized that they are relating to a very select segment of the drug-user population. All participants volunteer to join the community, which means that they come in with high motivation. Even so, the drop-out rate is exceptionally high, an occurrence that leaves an even more select group who eventually go on to become alumni. One of the few research reports (Jaffe 1985) on therapeutic communities concludes that for those who spend a year or more in the center, the experiences helps "a large number" of them.

SUMMARY

Drug abuse is a central concern at all levels of American society. The DSM-IV-TR distinguishes between substance dependence, which is diagnosed when the individual manifests three of seven symptoms, all of which clearly indicate that the individual's loss of control of substance use has seriously disrupted life, and substance abuse, a less severe pattern than dependence, which interferes with social or occupational functioning for at least a month.

Four causative elements operate in the development of substance use disorder. The first two are ready availability of the substance and use of the substance by peers. Third, there is a genetically transmitted vulnerability to addiction. When to these conditions are added unhappy life circumstances or a life that is unexciting or boring, a substance disorder frequently develops.

The opponent-process model describes the motivations for the development of a substance disorder. At first the relaxing or euphoric effect (in either case, a pleasant one) of the drug attracts the individual and continues to motivate substance use. In time, growing tolerance of the substance causes the individual to take larger doses. Guilt feelings or external pressures from family or friends cause the individual to discontinue substance use. Withdrawal symptoms cause the individual to return in desperation to drug use. Initially, the individual seeks pleasure; later on, he or she seeks to avoid pain.

There are five generic types of psychoactive substances. They are alcohol, narcotics (derived from opium), sedatives (principally barbiturates), stimulants (principally cocaine and the amphetamines), and the hallucinogens (which include marijuana).

Estimates of alcohol dependence range from 3.81 percent to 10 percent. Alcohol produces both physiological effects, principally affecting the liver and the brain, and psychological effects, mainly a dampening effect on the individual's inhibitions. Long-term use of alcohol causes malnutrition and severe psychiatric disorders, including Korsakoff's syndrome. Alcohol use by pregnant women is a principal cause of birth defects.

Alcoholism appears to be caused by a genetic vulnerability and environmental factors that lead to consistent exposure to heavy drinking and or psychosocial stressors.

Treatment frequently is undertaken in a residential center. There are three stages of such treatment. They are a drying-out period; a confrontational period, during which the individual is helped to recognize the problem; and a prolonged period of psychotherapy, in which the goal is to restructure the individual's personality. Mutual-help groups, such as Alcoholics Anonymous, play a prominent and helpful part in treating alcoholism.

The principal narcotics are opium, morphine, and heroin. Other depressants include the barbiturates. The principal stimulants are amphetamines and cocaine. Users are principally those who, for whatever reason, seek to find new sources of energy. Heavy doses cause major and dangerous physiological changes and psychological tension. Overdoses can cause suicidal or assaultive behavior.

Two well-known hallucinogens are lysergic acid and marijuana. The psychedelic drugs, principally mescaline, psilocybin, PCP (angel dust), and ecstasy (MDMA) are used by a relatively small portion of the drug-using population. These drugs cause varied and unusual sensory experiences and feelings of detachment and depersonalization. Marijuana should be considered separately from the other hallucinogens. Its effects, although clearly harmful, are less extreme than other drug substances.

Drug dependence frequently is treated with similar inpatient, outpatient, or mutual help programs as alcohol dependence is. There are two principal therapies specifically for drug use. They are substitution therapy, principally the use of methadone for heroin use, and treatment communities, which provide a structured living situation and skills development.

SELECTED READINGS

Critchlow, B. (1986). The powers of John Barleycorn: Beliefs about the effects of alcohol on social behavior. American Psychologist, 41, 746–751.

Kuhn, C., Swartzwelder, S., Wilson, W. (2003). Buzzed: The straight facts about the most used and abused drugs from alcohol to ecstasy (2nd ed.). New York: W. W. Norton & Company.

M. E. (1988). Physician heal thyself: 35 years of adventures in sobriety by an AA 'old timer.' Minneapolis, MN: CompCare Publishing.

Royce, J. E. & Scratchley, D. (1996). New York: Alcoholism and other drug problems (2nd ed.). Free Press.

Shaw, B. F., Ritvo, P., Irvine, J., & Lewis, M. D. (2004). Addiction and recovery for dummies. Hoboken, NJ: For Dummies.

Vaillant, G. E. (2005). Alcoholics Anonymous: Cult or cure? Australian and New Zealand Journal of Psychiatry, 39, 431–436.

Test Yourself

- 1) Substance abuse is characterized by
 - a) continued use despite negative consequences
 - b) tolerance
 - c) withdrawal
 - d) using more than intended
- 2) Which of the following is a hallucinogen?
 - a) alcohol
 - b) barbiturates
 - c) marijuana
 - d) morphine
- 3) Which of the following is a narcotic?
 - a) methamphetamine
 - b) cocaine
 - c) ecstasy
 - d) heroin
- 4) What substance results in feelings of euphoria, tirelessness, and heightened sensory perception?
 - a) alcohol
 - b) cocaine
 - c) LSD
 - d) marijuana
- 5) Which of the following is true of alcohol?
 - a) In large doses, it damages the liver and other body systems.
 - b) It impairs higher mental functions such as judgment.
 - c) It is a depressant.
 - d) all of the above
- 6) There is likely a genetic component to alcohol and drug dependence. True or false?
- 7) Aversion therapy is when an individual takes a nonaddictive substance that mimics the effects of the drug being abused so that he or she does not experience withdrawal symptoms. True or false?
- 8) Alcoholics Anonymous is a group of men and women who help each other recover from alcoholism through admission of dependence, mutual support, and attempts at living a spiritual life. True or false?

Test Yourself Answers

- 1) The answer is a, continued use despite negative consequences. Substance abuse is primarily characterized by continued use of a substance even though the person has faced failure to fulfill responsibilities, dangerous situations, legal problems, and social problems as a result of the use. Substance dependence is characterized by tolerance, withdrawal, and using more of a substance than intended.
- 2) The answer is **c**, marijuana. Marijuana is a mild hallucinogen, resulting in altered sensory experiences. Alcohol, barbiturates, and morphine are all depressants.
- 3) The answer is d, heroin. Heroin and the other opiates are called narcotics. Methamphetamine and cocaine are stimulants. Ecstasy is a hallucinogen that also has stimulant properties.
- 4) The answer is b, cocaine. Cocaine is a stimulant that results in feelings of euphoria, tirelessness, and heightened sensory perception. However, it also can result in nausea, chills, paranoia, and heart attack.
- 5) The answer is d, all of the above. In large doses, alcohol can lead to cirrhosis of the liver and other negative health outcomes. It impairs higher mental functioning such as judgment and calculation, making it particularly dangerous when driving. Alcohol is a depressant that results in disinhibition.
- 6) The answer is true. It is most likely that a genetic vulnerability interacts with factors such as consistent exposure to substance use to result in dependence.
- 7) The answer is false. Aversion therapy involves taking a medication that interacts with the drug being abused so that the person gets very ill when the two are mixed. An example is Antabuse. Taking Antabuse and drinking alcohol at the same time makes a person quite sick, decreasing the likelihood of drinking while on the medication. Substitution therapy is when an individual takes a less harmful substance that mimics the effects of the drug being abused so that they do not experience withdrawal symptoms, such as the use of methadone with heroin addiction.
- 8) The answer is true. Alcoholics Anonymous is a group of men and women who help each other recover from alcoholism through admission of dependence, mutual support, and attempts at living a spiritual life. AA is recommended by many psychologists as an adjunct to psychological treatment, although some people do take issue with its spiritual approach and abstinence-only focus.

Sexual and Gender Disorders

he effects of psychosexual disorders differ in one way that distinguishes them from most other psychological disorders. Common responses of the individual with a sexual disorder are feelings of shame and guilt. While individuals with most other disorders feel that they are sick, troubled, or even abnormal in their behavior, they are not so strongly motivated to keep it secret, nor do they feel particularly guilty, shamed, or disgraced by it. Because the individual with a sexual disorder feels shamed by what should be recognized as an illness to be treated as are other psychological disorders, he or she frequently keeps the ailment hidden. It is probable that until recent years, those feelings kept the individual from seeking treatment either because of shame and embarrassment or because the sufferer did not think it was something that was treatable.

Society's understanding of normal sexual behavior and deviations from it has been changing gradually, partially in response to two pioneering and courageous studies: one, the "Kinsey Report" on frequency of various forms of sexual behavior; the other, the Masters and Johnson studies of sexual disorders. Attitudes towards normal sexual behavior have broadened, and different ways of expressing sexual needs are given more understanding. Today, individuals troubled by sexual problems are increasingly seeking treatment for those problems.

The DSM-IV-TR categorizes sexual disorders into three groupings: sexual dysfunctions, in which the individual's enjoyment of sex is diminished and the usual physiological changes brought on by sexual arousal are prevented or reduced; the paraphilias, in which the individual associates sexual release with objects or situations not part of typical sexual arousal behavior; and gender identity disorder, which is characterized by strong identification as not being the gender that one is labeled.

After a brief description of normal sexual activity, the chapter describes the symptomatology of each subtype of the sexual disorders. Possible causes and therapies are described separately for each disorder. The chapter also discusses rape and incest, which are not addressed specifically in the DSM-IV-TR.

BASPECTS OF "NORMAL" SEXUAL ACTIVITY

In its most rudimentary aspects, sexual activity can satisfy two important and related (but not congruent) human needs—the procreation of children and the experiencing of a unique sensory, physical, and emotional pleasure. As practiced by almost all human beings, the primary motivation for sexual activity is the pleasure it provides; only occasionally in the sexual lifetime of the individual is procreation the primary purpose of sexual activity. Both functions are important, one because of the unique pleasure one receives and is able to give a partner. The later function fulfills a much-desired goal of family life and, in

a less personal but more instinctive sense, because it continues the life of the species or particular social groups, principally those of religions and nations.

In that part of the world that is influenced by the Judeo-Christian traditions, sex, as prescribed in their religious writings and moral codes, has the goal of penile/vaginal intercourse (coitus). The partner, of course, is expected to be a member of the opposite sex. That standard for "normal sex" also was presented in the scholarly works of scientists in the field, principally Kraft-Ebbing and Havelock Ellis, but also emphasized by Freud. And although there are endless variations in the ways in which sexual activity is approached, that form of sex is quite prevalent.

We know from research that substantial proportions of the general population engage in sexual activities other than penile/vaginal intercourse, some of which lead to orgasm. A safe conclusion to reach is that "normal" individuals find sexual pleasure in a great variety of ways not conforming to the limited definition prescribed in traditional religious writings and not conforming to the Freudian dictum or the writings of earlier scholars.

CLASSIFICATION OF SEXUAL DISORDERS

The DSM-IV-TR lists three principal categories of sexual disorder: sexual dysfunctions, inability to participate fully and enjoyably in coitus; paraphilias, in which sexual arousal is stimulated by unusual objects, situations or behavior; and gender identity disorders, in which the individual ascribes to a gender identity other than the one to which he or she was assigned. Most textbooks in the field add to those three, and such extreme sexual behavior as rape or incest. The DSM-IV-TR lists twelve sexual dysfunctions, eight paraphilias, and gender identity disorder. These are discussed separately in this chapter.

Sexual Dysfunctions

The sexual dysfunctions are grouped into three broad categories according to the phase of the sexual cycle in which they occur. They are disorders of the desire phase, of the arousal phase, and of the orgasm phase. Sexual pain disorders and sexual disorders due to a medical condition or substance also are listed.

Disorders of the Desire Phase

There are two levels of this disorder: hypoactive desire and aversion to sex.

HYPOACTIVE DESIRE DISORDER

Here, the dysfunction is a disinterest in sexual activity that results in distress or interpersonal difficulties. Because desire for sexual activity is so variable a characteristic, problems sometimes develop between partners who differ in their desire for sex. It would not be accurate to dismiss a mate as having a sexual disorder simply because he or she desired sex three times a week and not seven. Hypoactive sexual desire disorder refers to a complete or almost complete lack of interest in sex resulting, for example, in routine or uninvolved participation in sexual intercourse simply because it is a duty. Here also, a tooquick diagnosis may be out of order, because the fault might lie in the technique of the individual's sexual partner. Another symptom of hypoactive sexual desire disorder is an absence of or limited sexual fantasies.

SEXUAL AVERSION DISORDER

Hypoactive sex desire must be differentiated from aversion to sex, in which sexual approaches or imposed sexual activity cause repulsion and apprehension. Aversion to sex most frequently is the result of earlier traumatic sexual experiences, such as childhood molestation, incest, or rape.

Disorders of the Arousal Stage

Sexual desire normally leads to specific physiological changes preparing the individual for sexual activity. In the male, the penis fills with blood and becomes enlarged and erect. In the female, an increased flow of blood causes the woman's genitals to swell; in addition, the walls of the vagina secrete a lubricating fluid. When those changes do not occur or occur weakly, the disorder, in males, is erectile disorder; and in females, female sexual arousal disorder.

Disorders of the Orgasm Phase

The peak of sexual activity toward which sexual behavior frequently leads is orgasm. At this point, rhythmic contractions of the muscles in the genital region occur, accompanied by heightened sexual excitement. The male orgasm disorders are premature ejaculation, too early for his partner to have achieved her orgasm, and male orgasmic disorder, a delay or absence of orgasm in men. A delay or absence of orgasm in women is diagnosed as female orgasmic disorder.

Sexual Pain Disorders

There are two sexual pain disorders. One is dyspareunia, in which pain occurs during intercourse. It occurs most frequently in women, although it occasionally occurs in men. The second, vaginismus, occurs exclusively in women by definition. The symptoms are involuntary spasmodic muscle contractions at the entrance to the vagina when an attempt is made at penetration. Ordinarily, the result is an inability to proceed with intercourse. If the attempt is made to persist with intercourse, a painful sexual experience results.

Special Factors in Understanding Sexual Dysfunction

The diagnosis of sexual dysfunction is made only when the disability persists. Such dysfunctions can occur occasionally in all sexual relationships. Fatigue, worry, sickness, or alcohol or drugs may interfere in any phase of the sexual relationship. Inexperience in sexual relations may cause anxieties and concern about performing well, with a resulting failure in performance or desire. An embarrassing failure in sex may cause a lingering effect on subsequent sexual attempts.

In diagnosing sexual dysfunction, the DSM-IV-TR distinguishes between lifelong dysfunction and acquired dysfunction; different etiological factors produce the two types of dysfunction. It also distinguishes between dysfunction in all sexual situations and situational dysfunction. Examples of the latter are these: A man may successfully masturbate to ejaculation but not be able to ejaculate in sexual intercourse; or one partner in a marriage may experience orgasm only in an extramarital affair.

Sexual dysfunction is often diagnosed in both members of a partnership; particularly frequent are premature ejaculation by the man and orgasmic dysfunction in the woman. The cause-and-effect connection in that relationship is easy to understand.

Causative Factors in Sexual Dysfunction

Sexual desire and sexual functioning may be influenced by both psychosocial and physical factors.

Psychosocial Influences on Sexual Dysfunction

A variety of psychosocial influences can cause sexual dysfunction. Performance anxiety, overconcern about pleasing one's partner, poor technique on the part of either person, lack of communication between partners about what is pleasing in sex, and relationship conflict all are psychosocial influences on sexual dysfunction. Faulty learning, negative emotional feelings related to sex, faulty interpersonal relationships between partners, and sexually traumatic experiences all can result in sexual dysfunctions.

FAULTY LEARNING

Behavioral theorists, in particular (but most other clinicians join them), focus on the importance of early respondent conditioning, in which sexual events are associated with negative emotional experiences of shame, fearfulness, feelings of inadequacy, or expectations of failure. Those feelings cause the individual to approach sex tentatively, uncertain about performance. Masters and Johnson state that these feelings cause the individual to adopt a passive role in sexual relations. The individual, on guard, instead of relaxing and enjoying the sexual experience, is more concerned about whether performance is adequate. That very concern interferes with the adequacy and enjoyment of the performance.

NEGATIVE EMOTIONS REGARDING SEX

Negative emotions regarding sex may have been picked up from parents, from other misguided elders, or from punishments administered following early childhood sexual play. Concern about sexual performance may also result from lack of knowledge or experience. Here, especially, the individual is likely to assume the spectator role. An early failure because of that behavior may increase the concern and make it difficult later to enjoy sex fully.

RELATIONSHIP PROBLEMS

Absence of love, closeness, respect, or feelings of admiration for the physical being of the other person in a relationship can cause any one of the sexual dysfunctions, at least in that relationship. Dysfunction can develop in a relationship that has previously been satisfying when strong disagreement about other issues becomes heated. Couples may fight over financial matters, ways of raising children, jealousy, or the existence of an extramarital affair on the part of one of the couple. The result can be a sexual dysfunction in one or both partners.

The negative feelings toward the other person in other areas of life soon overshadow the desirability of sex and impair sexual performance. Once such failures occur, their very existence threatens future sexual relationships, and the dysfunctional behavior sets in and becomes a longtime pattern.

TRAUMATIC SEXUAL EXPERIENCES

Traumatic sexual experiences such as sexual abuse, assault, or rape can lead to sexual dysfunctions. These traumatic experiences may lead to sexual activity or arousal being associated with feelings of anxiety, which can inhibit desire, arousal, or orgasm.

Physical Causes of Sexual Dysfunction

Nonpsychological causes of sexual dysfunction fall into two categories: external substance absorbed into the body's chemistry and medical conditions such as hormonal imbalances. The former, for the most part, cause only transitory dysfunction; the latter are likely to last as long as the precipitating medical condition does.

EXTERNAL SUBSTANCES

Heavy drinking before sexual activity impairs sexual performance. Certain hypertensive medications and antidepressants sometimes limit sexual desire and performance. Drugs that suppress levels of testosterone, such as barbiturates and narcotics, decrease sexual desire.

MEDICAL CONDITIONS

In addition to such external elements, certain medical conditions (for example, a heart condition) will reduce sexual drive because of the debility they cause. Abnormal distribution of male and female hormones may cause a vulnerability to sexual dysfunction in affected individuals.

Treatment of Sexual Dysfunctions

Masters and Johnson and, some time later, Helen Kaplan, have been leaders in developing treatment techniques reported to show a high degree of success, at the 80 to 90 percent level in some reports. Also significant about sex therapy is the fact that so many more of those who suffer from the disorder are now seeking treatment. And beyond that, other scientists in the field continue to develop new approaches to therapy.

Following a comprehensive study of sexual dysfunctions, Masters and Johnson developed their program of direct sex therapy. It differs in three principal ways from earlier efforts at treating the problem. First, it avoided the approach taken principally by psychoanalysts and other clinicians with a psychodynamic perspective who would consider first deeper problems ordinarily associated with other psychological disorders. The sexual dysfunction was considered a symptom of the diagnosed disorder and was treated as such by probing into background factors. Masters and Johnson offered a simpler explanation: The individual has, for example, inhibitions of sexual arousal, which should be treated by eliminating the reasons for the inhibitions.

Second, Masters and Johnson treated couples, not individuals, on the premise that sex is a cooperative and interactive process. They felt there existed the possibility that either individual could enable sexual fulfillment or block it.

Third, they believe that couples should be encouraged to practice sex in ways that remove anxiety and apprehension. Graded exercises were recommended to lead the couple from simple touching and caressing, with no expectation of intercourse or orgasm, eventually to the culmination of a mutually satisfying sexual experience. The pace of advancement in the exercises is set by the couple's progress in finding enjoyment in what they are doing. Enjoyment at an early level of sexual activity leads to taking each next step. In treating premature ejaculation, for example, the partner is encouraged to stimulate the affected man's penis but to stop just before the moment of ejaculation. In this way, through desensitization to sexual stimulation, the man will learn to delay ejaculation to accommodate the pace of his partner.

A major postulate of the Masters and Johnson therapeutic approach is that anxiety blocks sexual excitement and performance by interfering with the preliminary physiological changes that normally precede sexual enjoyment. These are, in women, vaginal enlargement and lubrication and, in men, erection. Without those changes, coitus is difficult, if not impossible, and not enjoyable. Clients are encouraged to avoid being spectators of their own sexual activity and to focus on the sensual pleasures of the graded sexual exercises in which they are engaged.

In Masters and Johnson's technique, clients are taught that there are three stages in what therapists call sensate focus: giving pleasure, achieved principally through stroking and caressing the body; tender genital stimulation; and finally, nondemanding intercourse—that is, intercourse that is enjoyed with no other demands from one's partner. Taking each treatment exercise one step at a time desensitizes the individual and gradually lifts the oppressive anxiety, making pleasure in sex possible.

Masters and Johnson originally reported very high rates of success. In recent years, these reports have been challenged; nevertheless, their theories and therapeutic practices have led the way to sensible attitudes toward sexual dysfunction and ready access to treatment for the disorder. Sensate focus is still used today in the treatment of sexual dysfunction.

THE PARAPHILIAS

The word paraphilia comes from the Greek roots, para, meaning beyond or to the side of, and philia, meaning preferred. The DSM-IV-TR describes the paraphilias as sexual disorders in which unusual objects or acts are required for sexual excitement. It sorts the paraphilias into three types of behavior: 1) those in which there exists a preference for nonhuman objects for sexual arousal (for example, shoes); 2) repetitive sexual activity with human beings involving real suffering and humiliation; and 3) repetitive sexual activity with nonconsenting partners. This section describes symptomatology, cause, and treatment of the paraphilias.

Types of Paraphilias

The paraphilias include a group of psychological disorders that range widely in their impact on other people. The spectrum extends from those that affect only the suffering individual, or that individual and his or her partner, to those that threaten the well-being of other individuals. In all, the DSM-IV-TR recognizes eight paraphilias, which are grouped into three broad categories, as described below.

Sexual Arousal and Preferences for Nonhuman Objects

There are two: fetishism and transvestic fetishism.

FETISHISM

A fetish exists when a person is aroused by a nonliving object. Fetishes may be manifest in one of two ways, one more seriously disordered than the other. One form of fetish is associating coitus with some object, most frequently women's panties or other undergarments. Here the individual, usually a male, seeks to intensify sexual urges by preceding coitus by talking about or holding and fondling the object; for example, a pair of silk panties. It is relatively harmless if the action is taken playfully and is acceptable to his partner. If, on the other hand, the man persists even when the sexual partner objects to or resents the use of the object as a substitute for herself, the fetish must be considered a disorder and harmful, at least in its effect on the individual's partner.

A more extreme form of fetishism is one in which an inanimate object completely substitutes for a human partner. The most common articles used in such fetishes are female underwear, boots, and shoes, and such textured objects as rubber, silk, or velvet. Here, ejaculation is achieved when the individual is alone, fondling the cherished article. Fetishism can cause trouble with the law when it leads to shoplifting special articles, which it occasionally does. Such activity—that is, the shoplifting—seems to cause sexual excitement in the individual.

TRANSVESTIC FETISHISM

This paraphilia exists when sexual excitement is achieved by cross-dressing; that is, a man dressing as a woman. There are two different expressions of transvestic fetishism. In one, the individual seeks to intensify sexual excitement during sex with a partner by fully or partially dressing as a woman. In the other form, the man will wear women's clothing while masturbating. Sometimes men will go into public fully dressed as women.

This disorder has been reported only in heterosexual boys and men. Individuals with transvestic fetishism tend to have fewer than average partners. Occasionally, individuals with transvestic fetishism will develop dissatisfaction with their gender role or identity.

CAUSAL FACTORS IN FETISHES

Much has yet to be learned about the causes of fetishism. Etiological factors in fetishism probably operate at two levels. Primarily existing is a set of early life experiences leading to maladjustment, lowered self-esteem, and feelings of inadequacy, especially in sexual roles. Fetishistic behavior is usually brought on by some triggering experience, often a conditioning event in which orgasm has been stimulated, sometimes accidentally, by strong emotional reactions to some inanimate object. More often, the fetish is traceable to the use of some object, such as female underwear, to increase sexual intensity in early masturbatory activities. Because much masturbation is performed with some stimulating object—a picture, a garment, a perfume bottle—and relatively few males seem to develop a fetish from that activ-

ity, the suggestion is present that some underlying psychopathology might exist in the background of individuals who develop such fetishes.

Individuals with transvestic fetishism frequently have an early history of being dressed up like a girl in early boyhood by unwise mothers, and perhaps by emotionally overinvolved female relatives. Such happenings suggest either the absence of a father with whom the boy can identify or, if a father is present, that he must be either very weak or not very interested in his son's upbringing. Childhood crossdressing that meets the approval of a mother or other well-regarded relative brings operant conditioning into the picture; that is, rewarding and thereby reinforcing the wearing of female dress. Given certain patterns of reinforcement, such behavior would be difficult to overcome.

Sexual Arousal and Preferences for Situations Causing Suffering

There are two such disorders: sexual sadism and sexual masochism. They are complementary in nature: What the sadist needs to inflict, the masochist needs to receive. They are best discussed together.

SADISM AND MASOCHISM: SYMPTOMATOLOGY

Although sexual activity fundamentally is a loving and tender activity, there appears to be an element of aggressiveness in much sexual activity among many individuals. Some who are neither sadist nor masochist have sexual fantasies about suffering or humiliation in sex.

The terms sadist and masochist apply correctly only to suffering associated with sexual arousal. The terms are often used much more loosely to describe socially punitive individuals or long-suffering martyrs. The behavior of neither type of individual comes at all close to that of the disorders. The terms, as psychological disorders, refer to the repeated and intentional infliction on another person of suffering (sometimes a nonconsenting person) in association with sexual arousal; or, for masochism, it requires that an individual ask for the infliction of pain or humiliation in order to be aroused sexually. The terms are derived from the reported sexual exploits of the Marquis de Sade (1740-1814) and the writing of Leopold von Sacher-Masoch (c.1831), whose male characters sought out women who would beat them.

Sadists may seek relationships with obliging partners who have masochistic needs; masochists often relate to prostitutes who encourage or accept a masochistic clientele. But stable coupling of sadists and masochists also takes place in heterosexual and homosexual life. In certain areas of this country, where such demand exists, shops provide suitable equipment, and there are publications that run classified ads that openly suggest invitations for sadomasochistic activities.

Among sadists, there exists the possibility that, over time, the individual will need to inflict increasingly more pain and suffering, occasionally the final result of which is torture, rape, and murder. Masochists may also need to increase their suffering, with the possibility that their relationship will lead to their own injury or murder. The course of the disorder is chronic and may continue to exist throughout the sexual lifetime of the individual, either promiscuously or in a stable relationship.

Causative Factors in Sadism

The causes of sadism are similar in pattern to the causes of fetishes. Strong emotions of any sort can trigger involuntary feelings of sexual arousal. When there is early association of such emotional feelings in response to inflicting pain or even torturing an animal, and when the experience is a vivid, even a haunting one, the result may be a relatively stable linking of inflicting pain with sexual arousal.

Sadism may also be caused in a prudish, narrowly restricted personality with negative attitudes toward sex, perhaps developed on a religious basis. Here, the sadism may be seen as a warped, perhaps even bizarre, attempt to punish the partner who is permitting or even enjoying sex. One can speculate that the occasional individual who makes the headlines for murdering a number of prostitutes is manifesting that kind of motivation.

CAUSATIVE FACTORS IN MASOCHISM

Masochism would seem to be triggered by an early life experience of extreme pain (with strong emotion) which, in some, perhaps accidental way, is associated with a satisfying sexual event. The literature, for example, reports in the history of a masochistic individual this experience: A boy having a bone painfully set without an anesthetic becomes aware of a nurse in attendance caressing him and holding him close to her breast in a consoling way. For the boy, the experience produced a sexual reaction immediately following severe pain. The case report suggests that the experience also later provoked a sadistic response.

Sexual Arousal and Preference for Nonconsenting Partners

This category of paraphilia includes exhibitionism, voyeurism, pedophilia, and frotteurism. All are considered crimes in this country, and all are more common in men than women. Often the onset of these disorders is in adolescence.

EXHIBITIONISM

Indecent exposure is the most common sexual offense leading to arrest. It accounts for one-third of all sexual crimes. Oddly and inexplicably, it appears more frequently in Western society and is totally absent in such countries as Japan, Burma, and India. As a crime, exhibitionism is exposure of one's genital organs in a public place. From a psychological point of view, it should be noted that there is a pattern, almost standardized way, in which individuals exhibit themselves. There are three characteristic features of the exhibition: 1) it is always performed for unknown women; 2) it always takes place where sexual intercourse is impossible (for example, in a crowded shopping center); and 3) it seems designed to surprise and shock the woman. There are reports that when a woman shows no reaction, the act lacks the power to produce sexual arousal in the individual.

Favored settings for exhibitionistic activities are outside of churches and schools, in shopping centers, in the dark of a movie theatre, in the middle of the relative seclusion of a park, or any place where the individual can find victims likely to be shocked and where there are no supervising police officers. The exhibitionist usually exhibits an erect penis, but that does not seem to be an essential for the activity. Ejaculation may occur at the moment of exposure or develop later with masturbatory stimulation. Exhibitionists are not assaultive and are considered to be more of a nuisance than a danger.

VOYEURISM

A relatively common activity is that of looking at sexually arousing pictures or situations. Today's marketplace is full of opportunities to do so. Several television channels features erotic films, and socalled adult videotapes are readily available. Bars with exotic dancing are not far from many neighborhoods, and there are magazines featuring naked and erotically posed women and men.

The difference between those activities and voyeurism lies in the function served by the viewing. In typical watching, the viewing is ordinarily a prelude to more typical sexual activities. For the voyeur, the "peeping" experience replaces typical sexual activity. Nevertheless, voyeurism may exist in a person who also engages in typical sexual activity.

PEDOPHILIA

This paraphilia, because of its damaging impact on the nonconsenting partner, a child, is radically different from exhibitionism and voyeurism, and the strongly condemnatory attitude of the public reflects their concern about the hurtful effects on the child.

Pedophilia is characterized by sexual fantasies, urges, or behaviors with prepubescent children (typically under the age of 13). Contrary to a common view, pedophiles do not skulk about, waiting to pounce on an unaccompanied and helpless child, nor is assaultive behavior an important part of the problem. Violence occurs in no more than 3 percent of pedophilic activities; some coercion or force is nevertheless used in many cases. Ordinarily, the individual with pedophilia is someone who has ready access to the child; he may be a close relative, teacher, recreational leader, or clergyperson. The child or parent would have no reason to suspect the possibility of a pedophilia.

The pedophilic activity itself may begin with the individual exposing himself to the child or alternately taking the child on his lap. Occasionally it involves picture-taking of naked or posing children. Several children at a time may be involved. Some plausible explanation may be given to the child, who may be unsuspecting or very frightened. Sexual aspects include fondling the child's private parts or having the child fondle the perpetrator's genitals. Coercive aspects come into play when they are used to pledge the child or children to secrecy.

FROTTEURISM

A pattern of sexual fantasies, urges, and behavior involving rubbing or touching a nonconsenting person is labeled frotteurism. Typically this occurs in crowded public places, which decreases the likelihood of being caught. The individual with frotteurism typically rubs his genitals against the victim or fondles the individual's breasts or genitals.

Causative Aspects of Paraphilia with Nonconsenting Partners

A common psychological characteristic shared by people who develop exhibitionism, voyeurism, pedophilia, and frotteurism is social isolation, low self-esteem, and particularly feelings of sexual inadequacy. Not psychologically at ease in consenting, developmentally appropriate relationships, people with paraphilias resort to abnormal sexual activity.

Psychodynamic Theory of Paraphilias with Nonconsenting Partners

In Freudian theory, during the phases of psychosexual development, fixations rooted at one level of sexual adjustment prevent normal progress to the next stage of development. In the process of fixation, object-cathexes (attachments) are formed in which strong positive or negative feelings are attached to objects that are otherwise neutral. In the case of a positive cathexis, sexual feelings become attached to the object. Fetishes can result from such early positive attachments. The explanation can less elegantly be used to understand the other paraphilias. A problem with the explanation is that one has to go back into the psychodynamic forces leading to fixations and cathexes and then ask, even given these maladaptive developments, why are particular objects or activities selected to be connected with sexual activity? Any attempt to answer that question comes close to the behavioral explanations.

Behavioral Theory of Paraphilias with Nonconsenting Partners

The basic behavioral interpretation is that sexual arousal has been linked with some unusual object or some activity such as watching (for voyeurs) or exposure in exhibitionism through either classical or operant conditioning. Classical conditioning seems to fit the fetishes better. A stimulus (for example, a shoe) is paired with a sexual stimulus, which is associated with the response of sexual arousal. Eventually, merely the shoe will result in sexual arousal.

But for paraphilias that cause the individual to carry out some extreme action to arouse sexual feelings (exhibitionism, for example), the formula may be that of operant conditioning; a response—for example, exhibiting oneself—is reinforced by the pleasure of the resultant sexual activity. When those conditioning events occur in the life of an individual who, for other reasons, is dominated by feelings of inadequacy and low self-esteem, which limit social life and tend to isolate the individual, a paraphilia readily develops.

Treatment of Paraphilias

Some successful treatment results are reported for behavioral therapeutic approaches, but also many failures. The paraphilias do not respond readily to treatment. When it has been successful, treatment has most often involved some form of aversion therapy; that is, pairing the paraphilic object or activity with either an actual aversive consequence, such as electric shock or a nausea-producing agent; or, in covert sensitization, pairing the object with vividly imagined aversive consequences. Case reports of successful psychodynamic treatment of paraphilias occasionally appear in psychoanalytic journals, but they are infrequent and are more anecdotal than research-oriented.

M GENDER IDENTITY DISORDER

Gender identity disorder exists when individuals, male or female, experience confusion, vagueness, or conflict in their feelings about their own gender identity. There is a sharp struggle between the individual's anatomical gender and subjective feelings about choosing a masculine or feminine style of living. These individuals typically engage in cross-gender behavior and dress and report being, or desiring to be, the other gender.

Elements in Gender Identity

In understanding this disorder, it is helpful to distinguish among the terms gender identity, gender role, and sexual orientation.

Gender Identity

Awareness of being male or female, of knowing "I am a girl (or woman, or boy, or man)," is called gender identity by psychologists. Children can distinguish maleness and femaleness by the age of two. Between their second and third birthdays, they will, when asked, readily identify themselves as girl or boy.

Gender Role

Reminiscent of Shakespeare's "All the world's a stage . . ." a role is the public living of a part. Between their third and fourth birthdays, children can identify a variety of gender differences and have learned that boys and girls behave in somewhat different ways. They begin to assume a male or female gender role.

Sexual Orientation

This aspect of gender relates to what will arouse sexual feeling in the individual: the types of people; the parts of the body; and the specific situations to which the individual will respond sexually. This develops independently from gender identity and gender roles.

Variations in Gender Roles

Before focusing on gender identity disorder, a nonclinical manifestation of gender role variations will be discussed.

There are children who will show cross-gendered behavior; for example, boys who exhibit softness in emotion, gentleness in play, or enjoyment of dolls as toys. Most often, with no other efforts at change, psychosocial pressures, especially those with playmates outside the home, will cause that type of behavior to taper off, with no carryover into later life. Even when cross-gendered behavior continues, it is not necessarily a sign of a psychological disorder. Some individuals simply have a combination of traditionally masculine and feminine traits and interests.

Both psychosocial and biological factors affect gender identity.

Psychosocial Influences

Etiological answers are by no means certain; some psychologists call them speculative. Nevertheless, psychologists tend to believe that for most individuals with gender identity problems, the way parents treat the child may play a role. Many individuals with gender identity disorder had parents who either encouraged or did not discourage gender atypical behavior (that is, traditionally feminine behavior in boys and vice versa). There have been theories that over-involved opposite gender relatives may encourage cross-gender behavior, which confuses the child as his or her gender identity develops. However, there is no conclusive support for this theory. Another theory is that a hostile same-gendered parent pushes the child to identify with the opposite-gender parent, resulting in gender identity confusion. Again, there is not strong support for this theory.

Biological Influences on Gender Identity

Biological factors operating during the fetal stage can cause the malformation of genital organs so that, in appearance and function, they are neither fully male nor fully female. The result is an individual who has been scientifically labeled as a pseudohermaphrodite. Typically, pseudohermaphrodites are surgically assigned to be females, because that is medically easier than male assignment. However, sometimes pseudohermaphrodites who have been assigned to be female identify as male, resulting in gender identity disorder.

During the fetal stages, the mother's body surrounds the embryo with a fluid of mixed hormones. Those hormones promote development and differentiation of parts of the embryo's body. It is possible that prenatal exposure to cross-gendered hormones (testosterone for girls and estrogen for boys) could result in gender dissatisfaction, but there is no conclusive evidence.

RAPE AND INCEST

Although both of these forms of sexual activity are ignored in the official diagnostic manual, most textbook authors consider them in their discussions of sexual disorders. Sexual activity imposed on an unwilling partner, either by actual force or threat, is labeled rape. Here we consider the motivations for rape, characteristics of the rapist, legal and social issues, and prevalence.

Motivations, Characteristics, and Issues of Rape

There are several motivations and characteristics of rape, which are discussed in the following sections. Also explored are legal and social issues surrounding rape and its prevalence.

Power and Anger in Rape

Based on research, motivations for rape have been divided into four categories: 1) Power-assertive rape, in which the attack is motivated by a desire for conquest, which is sought by sexual penetration. Forty-four percent of the rapes studied fell into this category. 2) Power-reassurance rape, in which the conquering of the female is sought to provide reassurance to an individual who has weak feelings of his own masculinity. Twenty-one percent of the group exemplified that motivational basis for rape. 3) Angerretaliation rape, the most dangerous form of rape, which often results in the murder of the victim when the rape has been completed, grows out of a generalized hatred of women. That hatred of women, the source of which can only be surmised, and not a desire for sexual release, was the motivation of 30 percent of the rapes studied. 4) Anger-excitation rape, which can be seen as an extreme form of sadistic behavior in which sexual arousal comes from the violence, not the intercourse, which may or may not take place. Five percent of the rapes were of this type.

Gang Rape

A gang rape widely covered by newspaper accounts was an attack by a gang of ten to twenty young males, some of them still in their teens. The woman was attacked while jogging in New York City's Central Park and was sexually assaulted and beaten viciously. Not all of those present participated in the sexual attack; some mauled her with their hands; others attempted intercourse; still others combined sex with a vicious physical attack. Here, the motives that brought the group together must have varied widely, including, perhaps, variations of those motives identified above. Peer pressure might also have been present.

Acquaintance Rape

Research on acquaintance rape describes these rapists as "sexually very active, successful, and aspiring." In the study, the motivations the rapist verbalized were that the rapist was given "the come-on" by a sexual tease or notoriously promiscuous woman, and he was not to be "put on" in that way. Once sexually aroused, he was not to be frustrated. Perhaps previous experience of finding dates who were willing to "have sex" poorly prepared the rapist for refusal. Such men are astonished and enraged by such a refusal, and they resort to force. Added to this explanation could be the frequent association in the media of sex and coercion or violence, a phenomenon that, it would seem, can only weaken any sense of responsibility and control an individual might have been brought up to exercise.

Other Characteristics of Rapists

Police reports of arrested rapists (by no means all rapists) indicate that they are most often under twenty-five years of age. Thirty percent of arrested rapists were in the age bracket eighteen to twenty-one. In this available (because arrested) sample of rapists, 50 percent were married and living with their spouses. The group studied was predominantly of low intelligence, had low occupational skills, and earned low-level salaries. Those statistics say more in answer to the question of who gets arrested for rape than to the question of who are the rapists.

Legal and Social Issues

Legal issues relate to the incidence of arrest for rape and the weight to be given to the rapist's mental condition in determining punishment. There is a relatively low conviction rate, principally because of the difficulty in identifying the rapist. It is accurate to state that more rapists are free in the community than are behind bars. Yet rapists are ordinarily repeat offenders. Perhaps we should be asking, is rape today being treated as seriously as it should be?

A principal destructive effect of rape is the serious damage it causes in the victim's later adjustment. Individuals who have experienced rape are at increased risk for post-traumatic stress disorder, depression, feelings of anxiety, and disruptions in their lives, particularly in relation to sex and intimate relationships.

Beyond those disturbing consequences, there is the humiliation the victim may experience at the rapist's trial. It is fair enough that an accused rapist be considered innocent until proven guilty, but some judicial behavior suggests that the survivor is on trial. To avoid such humiliation and for fear of the consequences, many women do not report attempts at rape. A majority of states have developed laws to reduce the likelihood of victims being humiliated through the legal process.

Prevalence of Rapes

The FBI stated that there were more than 95,136 rapes reported in 2002. Other estimates suggest that there likely were at least ten times as many. When hospitalization is required, the police will ordinarily demand that the crime be reported, although the individual may still refuse to press any specific charges. Much effort has been made to encourage survivors of rape to report the crime and seek support as needed. Perhaps these efforts will have a positive effect.

Incest

Legally and narrowly defined, incest is coitus between parent and child or siblings. Almost universally across time and cultures, incest has been forbidden. There are sound reasons for this taboo. This section briefly examines three reasons, considers causative factors, and comments on the prevalence of incest.

Reasons for the Universal Taboo on Incest

There are three negative effects of incestuous sexual relations: biological; familial; and psychological.

BIOLOGICAL REASONS

Coitus (leading to pregnancy) between blood relatives increases the likelihood that defective recessive genes will be present in both sexual partners and will be matched. The result of that matching will be the likely appearance of defects in the offspring. Research suggests that, in these cases, birth defects are more common than in children conceived by individuals who are not closely related.

FAMILIAL REASONS

Incestuous sexual activity, whether between parent and child or between siblings, introduces highly emotional and divisive strains into family life. Wife and husband can hardly be comfortable with each other when father and daughter are sharing sexual relations. Among siblings, tensions and rivalries divide the family. The taboo against incest is necessary to keep families intact and a positive force in the functioning of society.

PSYCHOLOGICAL

Children who have experienced an incestuous relationship are prone, in later life, to distressing emotional reactions: depression; guilt; anxiety; and lowered self-esteem. Their capacity to develop warm interpersonal relationships may be lost or badly damaged.

Causative Factors in Incest

One might jump to the conclusion that such fathers would have to be amoral and indiscriminate in their sexual behavior. What research has been conducted on the problem suggests a contrary conclusion. Incest often occurs in the context of a loving familial relationship. Sometimes substance abuse is involved, but most perpetrators of incest do not meet criteria for a specific psychological disorder. It is, nevertheless, a reasonable conclusion to draw that some fraction of incestuous activities occur in severely pathological families or are attempted by irresponsible or sexually promiscuous fathers.

Prevalence

Estimates of prevalence vary widely in this infrequently researched area of sexual behavior. One study in which interviews were conducted in a representative sample of the general population reports a prevalence figure of 16 percent. Other details of that study are that 40 percent of the incidents were carried to abusive lengths; much of it was at the level of child molestation, in which uncles were most frequently involved. Although many of the occurrences were single events, more than half were multiple; and in a small number of cases, several relatives attempted incest.

SUMMARY

The DSM-IV-TR divides sexual disorders into three major categories. First is sexual dysfunctions in which inhibitions prevent or reduce the individual's enjoyment of sex and/or the physiological changes normally brought on by sexual arousal. The dysfunction may be manifest at any of the three stages of sexual activity: the desire stage; the arousal stage; or the orgasm stage.

Disorders of the desire stage are hypoactive desire, a disinterest in sex, or the more extreme form of the disorder, aversion to sex. Disorders of the arousal stage manifest themselves in an absence or weakness of the specific physiological changes that prepare the individual for intercourse. In the orgasm stage, there is male or female orgasmic disorder (inhibited orgasm) and premature ejaculation. There are two sexual pain disorders: dyspareunia, which is pain during intercourse, predominantly a female disorder; and vaginismus, exclusively a female disorder, which produces contractions at the entrance to the vagina and prevents penile entry.

There are both psychosocial and physical factors that may cause sexual dysfunction. Among the psychosexual causes are faulty learning, negative attitudes toward sex learned in traumatic sexual experiences, early disturbances in the individual's psychosexual development, or friction or hostility between the two sexual partners. The physical causes of sexual dysfunction include the effect of ingested external substances such as alcohol or marijuana. The principal internal factor is that of medical conditions.

Treatment of sexual dysfunctions is much more frequently sought today than in earlier decades. Illustrative of treatment approaches are those suggested by Masters and Johnson, who prescribe graded sexual exercises and encourage partners to focus on the sexual pleasures (sensate focus) rather than on whether they are "performing" satisfactorily. High levels of success are reported for such treatment approaches.

The second major category of sexual disorders comprises the eight paraphilias, which can be grouped into three broad clusters.

The first cluster includes fetishes and transvestic fetishism, in which there is a sexual preference for nonhuman objects. A fetish is an attachment to such objects as shoes, female clothes or textured material, either as a supplement to coitus or as a substitute for it. Transvestic fetishism is finding sexual excitement by cross-sex dressing.

Fetishes occur in persons with lowered self-esteem and feelings of sexual inadequacy. The fetish is usually triggered by an early conditioning experience in which the fetishistic object stimulated, often accidentally, an orgasm. When followed by planned use of the object, the fetish soon becomes established. Individuals with transvestitic fetishism often have early experiences of being dressed in crossgender clothing.

A second grouping of paraphilias is those disorders in which there is a preference either for causing suffering as an aspect of sex (sadism) or desiring to have pain inflicted (masochism). Both are developed out of early life experiences that relate pain (given or received) to an orgasm, very much in the same way that fetishes are developed.

A third major grouping of the paraphilias is that of sexual preference and arousal with nonconsenting partners. These paraphilias may take the form of pedophilia (sexual attraction to children), exhibitionism (exposing oneself to unsuspecting individuals), voyeurism (secret viewing of sexual scenes), or frotteurism (rubbing against an unwitting person). All of them involve the participation of nonconsenting individuals in some aspect of a sexual activity. The basis for these paraphilic activities is profound feelings of sexual inadequacy and fear of being embarrassed or rebuffed in consenting activities. The paraphilias do not respond readily to treatment.

The third major sexual disorder, gender identity disorder, exists when individuals, male or female, express a strong desire or insistence that they are or wish to be the other sex. Here, early prolonged experiences in being treated as a child of the opposite gender can have drastic later effects on the individual's sense of gender identity. Biological influences on the developing fetus can cause malformation of the sex organs and predispose the individual to an identity problem.

Although rape and incest are not listed as disorders in the DSM-IV-TR, most textbook authorities consider them in their discussion of the sexual disorders. Strong feelings of need for power and anger against women are considered primary motivations for rape of strangers. Inexperience with handling sexual frustration may play a role in acquaintance rape.

The prevalence of rape is distressingly high. Furthermore, the reluctance of many individuals to report rape due to a variety of fears suggests that the actual number is much higher.

Incest is coitus between parent and child or siblings. There are good reasons for the universal taboo against incest—biological, familial, and psychological. Pregnancies resulting from incest, because of the greater likelihood of matching recessive and defective genes, result in a high rate of physical and intellectual defects in the offspring. Incest, especially that between parent and child, profoundly disrupts family harmony. Individuals who have experienced incestuous sexual relations often, later in life, suffer depression, guilt, anxiety, and lowered self-esteem. The result is extreme difficulty in establishing satisfying interpersonal relations. Research indicates that incestuous fathers can be members of a strongly disciplined but unhappy family, or a family that was relatively well functioning prior to the incest. Many incestuous situations also develop in pathological families or are attempted by irresponsible or sexually promiscuous fathers.

SELECTED READINGS

Bornstein, K. (1994). Gender outlaw: On men, women, and the rest of us. Oxford, UK: Routledge/ Taylor and Francis Books.

Fagan, P. J. (2003). Sexual disorders: Perspectives on diagnosis and treatment. Baltimore, MD: John Hopkins University Press.

Wincze, J. P. & Carey, M. P. (2001). Sexual dysfunction: A guide for assessment and treatment (2nd ed.). New York: Guilford Press.

Groth, A. N. & Birnbaum, H. J. (2001). Men who rape: The psychology of the offender. New York: Perseus Publishing.

Test Yourself

1)	What disorder is characterized by little or	no	interest in sex?
	a) female sexual arousal disorder	c)	male erectile disorder
	b) hypoactive sexual desire disorder	d)	sexual aversion disorder
2)	What disorder is associated with pain during intercourse?		
	a) dyspareunia	c)	premature ejaculation
	b) frotteurism	d)	fetishism
3)	Sexual excitement involving inflicting pain or suffering is a core symptom of		
	a) masochism		sadism
	b) pedophilia	d)	vaginismus
4)	Individuals with gender identity disorder are homosexual. True or false?		
5)	What disorder is characterized by sexually arousing fantasies, urges, or behaviors of watching an unsuspecting person who is naked, undressing, or engaging in sexual activity?		
	a) exhibitionism	c)	frotteurism
	b) fetishism	d)	voyeurism
6)	Individuals with fetishism experience so objects. True or false?	exu	al fantasies, urges, or behavior involving nonliving
7)	Sexual dysfunction may be due to		
	a) medical conditions	c)	substance use
	b) negative sexual experiences	d)	all of the above
8)	Sexual dysfunctions not due to medical conditions or substances frequently are treated with sensate focus. True or false?		
9)	Psychotherapy is a very effective treatmer. True or false?	nt f	for paraphilias with a cure rate of almost 100 percent.
0)	Which of the following are likely motivations for rape?		
	a) anger	c)	sexual frustration
	b) power	d)	all of the above

Test Yourself Answers

- 1) The answer is b, hypoactive sexual desire disorder. Lack of desire for sex is the core symptom of hypoactive sexual desire disorder in men and women. Female sexual arousal disorder is characterized by difficulty attaining or maintaining sexual arousal in women. The primary symptom of male erectile disorder is difficulty in attaining and maintaining an erection. Sexual aversion disorder is characterized by avoidance or aversion to sex in either gender.
- 2) The answer is a, dyspareunia. This disorder occurs in men and women, resulting in pain during sexual activity. Frotteurism is a paraphilia distinguished by rubbing on nonconsenting individuals. Premature ejaculation is characterized by ejaculation earlier than desired. Fetishism is characterized by sexual fantasies, urges, or behavior involving nonliving objects.
- 3) The answer is c, sadism. Sadism results in sexual excitement from inflicting pain or suffering. Masochism involves sexual excitement from receiving pain or suffering. Pedophilia is sexual attraction to prepubescent children. Vaginismus is a sexual dysfunction characterized by vaginal muscle spasms that prevent penetration and or make intercourse difficult or painful.
- 4) The answer is false. Gender identity disorder and sexual orientation are not related. An individual with gender identity disorder has the feeling of being trapped in a body of the wrong gender. Individuals with gender identity disorder, like those without it, may identify as heterosexual, bisexual, or homosexual.
- 5) The answer is d, voyeurism. Individuals with voyeurism experience sexually arousing fantasies, urges, or behaviors of watching an unsuspecting person who is naked, undressing, or engaging in sexual activity. In exhibitionism, the person experiences sexual arousal and gratification in exposing his or her genitals to a nonconsenting person. Individuals with fetishism experience sexual fantasies, urges, or behavior involving nonliving objects. Frotteurism is a paraphilia distinguished by rubbing on nonconsenting individuals.
- 6) The answer is true. Fetishism is characterized by sexual fantasies, urges, or behaviors involving nonliving objects such as shoes or rubber.
- 7) The answer is d, all of the above. Medical conditions such as vascular disease, substance use such as SSRI antidepressants, and negative sexual experiences such as rape all can lead to sexual dysfunctions.
- 8) The answer is true. Sensate focus, enjoying the pleasure of physical contact without pressure for performance, is a common treatment for sexual dysfunctions once physical causes have been ruled out.
- 9) The answer is false. Unfortunately, treatments for paraphilias have not been found to be terribly effective. Several techniques such as covert sensitization, orgasmic reconditioning, and relapse prevention all have been developed, but success rates vary between 78.6 percent and 95.6 percent. None is 100 percent effective.
- 10) The answer is d, all of the above. Rape may be due to anger, power, hatred, or simply sexual frustration resulting in the rapist wanting sex when the other individual does not.

Organic Disorders

Il human behavior, normal and abnormal, has its basis in the activities of the nervous system. The most crucial part of the nervous system that engages in organizing and executive functions is the brain. To reflect the two different ways in which the brain affects the development of abnormal behavior, mental disorders are grouped into two broad categories: 1) organic disorders, those mental disorders known to be caused directly and primarily by pathology in the brain itself; and 2) functional disorders, which result from abnormal life experiences imposed on a nondisordered, but perhaps vulnerable brain. Organic disorders account for 25 percent of all first admissions to mental hospitals.

The other mental disorders described in this book are, for the most part, functional disorders; in this chapter, we discuss the principal organic disorders. As has been indicated in other chapters, functional disorders can result from vulnerabilities that grow out of organic defects. But such defects create only predispositions for particular mental disorders and not the illness itself.

In a demonstration of mind/body interdependence, functional disorders, with no physical basis for causing them, can manifest themselves in physical symptoms (for example, the somatoform disorders), and the behavioral symptoms of organic disorders may be affected by psychosocial aspects of the environment. Individuals with the same brain pathology may show different symptoms because of their differing life circumstances.

Functional disorders are generally considered the province of psychologists and psychiatrists; neurologists diagnose and treat the organic disorders. Depending upon the needs of the patient, a team of all three may work together to help the individual.

This chapter considers the following: the various parts of the brain and their functions; characteristic symptoms of organic disorders; the problems of distinguishing between organic and functional disorders; causes of organic disorders; the principal organic disorders; and neurological approaches to treatment.

MITHE HUMAN BRAIN

Human superiority to animals rests principally on the superiority of the human brain. The human brain is the best-protected organ in the body. The bony structure of the skull and three enveloping layers of tissue afford protection from many, but not all, of life's accidents or illnesses.

The brain is described by neurologists as the most complex biological structure in existence. They also say we know more about the brain than we know about any other organ of the body, perhaps because there is so much more to know about so complex an organ; but they say further that there is so much more

that we don't yet know. For that reason, learning all about how the brain functions is one of the most challenging goals of both medicine and psychology.

In the following sections, we consider the following: the neuron, the basic functioning unit of the brain; localization of function; spatial organization of the brain; and the effects of brain damage.

The Neuron

There are billions of these hard-working units of the brain. The neuron consists of 1) a cell body, which provides the life support of the neuron; 2) dendrites, a system of fine branches that receive electrochemical impulses (messages) from other neurons; and 3) terminal endings that transmit messages to other neurons. The gap between one neuron and another is the synapse. Messages are enabled to cross that gap by the neuron's release of neurotransmitter substances into the synapse. The neurotransmitters, as enabling agents, either activate or inhibit the functioning of other neurons.

The importance of the neurotransmitters is exemplified in Parkinson's disease, a debilitating disease affecting older people. The disease is caused by a degeneration of brain cells (neurons), which limits the supply of the neurotransmitter dopamine. In the absence of dopamine, the message telling certain groups of muscles to flex or to expand is not transmitted across the relevant synapses, and movement is impossible or severely limited. The symptoms of Parkinsonism can be alleviated by the administration of a synthetic form of dopamine.

Localization of Function

Bundles of neurons controlling similar functions are located in the different regions of the brain; thus, there is correlation between behavioral symptoms produced by brain damage and location of the damage. Not all brain functions are entirely localized; however, in general, collections of neurons serving similar functions are located in one or another of the lobes of the cerebral cortex (the surface layer of the cerebrum, which is the main part of the brain). The four lobes are named frontal, parietal, occipital, and temporal.

- The frontal lobe is responsible for emotions and movement and higher level functions such as planning and reasoning.
- · The parietal lobe is associated with sensation and some aspects of language.
- The occipital lobe interprets visual input.
- · Functions of the temporal lobe include hearing, memory, and other aspects of language.

The entire cerebrum is separated into two relatively symmetrical hemispheres.

The cell bodies of neurons of the brain are concentrated in what is called the gray matter of the brain. That gray matter makes possible the higher mental functioning of the human being. The axons, wire-like structures called the white matter because of their white myelin sheath, are bundled into tracts that connect areas of the gray matter.

A convenient way of thinking about the structure of the brain is to consider the gray matter as a group of modules, each with a specialized job to do. The white matter, or bundles of axons, serves to connect the various modules. Some modules—for example, those in the frontal lobes—control wide-ranging functions, such as processing of information. Others are limited, for example, to receiving sensations from the various sense receptors.

Spatial Organization and Brain Function

There are three axes or ways of thinking spatially about the brain: front/back, left/right, and up/down. Those axes relate to various human functions.

Front/Back Organization of the Brain

Motor functions are generally located in the front of this axis and sensory functions at the back. Various aspects of both activities will also be located on the up/down axis in the front and back of the brain. Illustrative of this localization of function in the cerebral cortex is a description of two higher functions of the brain provided by the Russian neuropsychologist Alexander Luria. He named one of those functions the information-processing activity, and he located the place where it was controlled in the back portion of the cerebral cortex. Damage to that part of the brain will cause loss of sensation; damage at other levels of the back portion of the brain will cause such symptoms as poor representation of space or even inability to identify common objects (known as agnosia).

Luria named the other function planning-verification, and located that function in the front of the brain. The area controls the actions the individual takes in his environment. One result of damage to this area is perseverative behavior, in which the individual repetitively makes the same response instead of taking the next step in the normal way of responding.

Left/Right Organization of the Brain

This axis separates the cerebrum into two symmetrical hemispheres. In general, the left hemisphere receives sensory input from and controls actions of the right side of the body. The right hemisphere serves the left side of the body in a similar way. Damage to either hemisphere will affect the opposite side of the body.

Up/Down Organization of the Brain

The vertical organization of the brain affects functioning in a hierarchical way. The upper levels of the brain have to do with cognitive and voluntary behavior. That level builds on and moderates functions of lower levels. There is evidence that in general disease of the brain, such as that of the degeneration caused by aging, there is greater vulnerability to dysfunction of the upper levels of the brain. In Alzheimer's disease, for example, the first functions to be affected are the higher cognitive functions, such as memory, adjusting to new situations, or keeping things in sequence. Only later are more basic biological functions disrupted.

MAJOR SYMPTOMS OF ORGANIC DISORDERS

There are three clusters of symptoms that suggest the presence of organic disease: defects in basic mental activities; impairment in higher intellectual functioning; and certain types of affective disorders.

Defects in Basic Mental Activities

Memory loss is a significant indicator of brain dysfunction, although it may also be a symptom of a functional disorder. It is one of the earliest signs of cerebral deterioration associated with dementia. A prime example is the impairment of memory that is a primary symptom of Alzheimer's disease. The memory impairment in functional disorders manifests itself in markedly different ways from that produced by cerebral degeneration (see Chapter 10). An even more severe indication of brain damage, and one on which initial diagnosis can more confidently be based (although psychosis would also have to be considered), is loss of orientation, in which the individual cannot identify or recognize his or her surroundings, has no awareness of the date or even the season, and may not be able to report self-identity.

Impairment in Higher Mental Functioning

Persons with brain disorders have trouble in making decisions. They make them only after much hesitation and uncertainty, or make foolish decisions about everyday activities. They also make gross errors in financial matters. There can be slowness and inaccuracy in calculating. Their fund of general information is reduced, and knowledge of common items, such as who is the president, can be lost.

Affective Disturbance

There may be lability of affect in which the individual shifts suddenly and inappropriately from one emotion to its opposite; for example, from pleasantness to hostility, or from laughing to weeping. Included in this type of symptom is a loss of resilience. When fatigued or emotionally upset or puzzled, the necessity of making a decision or solving even a simple problem is just too much for the individual.

All of the symptoms described above can be suggestive of possible organic involvement; a number of them also are present in functional disorders. A diagnosis of organic damage can be made only after careful neurological and psychological study.

M DIAGNOSING ORGANIC MENTAL DISORDERS

With the possible overlap in symptoms of functional and organic disorders, diagnosis can be a problem. Mistaking one for the other will, of course, block effective treatment. In organic disorders of some types, delayed treatment can result in death.

Correct diagnostic practice requires that even for apparently minor symptoms that cannot be explained, a thorough physical examination be undertaken before a diagnosis is made. A good dictum to follow is to exclude physical causes before exclusively psychological causation is diagnosed. Sometimes doing that is easy; for example, a long-time specific phobia, with no other symptoms, is not likely to have an organic cause. On the other hand, even a brief loss of consciousness is quite another matter. Such an event could be caused by physical exhaustion, high temperature, or the early sign of a brain tumor.

Fortunately, recent advances in medical technology, especially advances in brain imaging techniques such as computer-assisted tomography, or the more recently developed magnetic resonance imaging (MRI) and functional magnetic resonance imaging (fMRI), make diagnosing brain damage an easier process than in the past. Accurate diagnosis in pinpointing specific performance defects also is possible with the help of specially developed psychological tests; for example, the Halsted-Reitan Neuropsychological Battery. The performance profiles of those tests can help locate the region and extent of the brain damage.

ETIOLOGICAL ASPECTS

There are broad categories of agents that cause brain damage. They are a degenerative process in the brain, brain tumors, brain trauma, vascular accidents, nutritional deficiency, and endocrine disorders. A separate category of organic disorders is epilepsy. For each of the disorders, the extent of behavioral disruption and the specific nature of the symptoms depend upon the amount and location of brain damage.

Before discussing the specific causes of organic disorders, we consider broadly the types of effect the causes can produce, factors that affect the vulnerability of certain parts of the brain to damage, and the availability of redundant systems that can take over lost functions.

The Range of Effects of Brain Damage

The agents of brain damage may cause acute symptoms, some lasting only a few months (for example, some strokes), or chronic symptoms, which may handicap and disrupt the individual's functioning for the rest of his or her life, or even cause death (for example, Huntington's chorea). The symptoms of brain damage may be localized and affect only specific functions, such as speech and/or mobility, as in many strokes; or they may, when extensive areas of the brain are affected, as in the degenerative disorders, cause generalized debility and disorganization of functioning. Symptoms may come on suddenly, as, for example, the early signs of brain tumor, or appear gradually with increasing severity, as with Alzheimer's disease.

Most damage to the brain causes negative effects; that is, there is impairment in the functioning of the affected area. In particular instances, the damage may also increase the activity of the adjoining area. For example, the increased irritation caused by the damage may have the "positive" effect of exciting and activating the nearby area. The effect may nevertheless be disruptive. The convulsive seizures of epilepsy (periods of heightened activity) are explained in this way.

Vulnerable Parts of the Brain

Because an adequate supply of blood is essential to the proper functioning of a neuron, positioning of a neuron cluster that limits access to a supply of blood or that makes it exceptionally susceptible to stroke increases the likelihood of brain damage in the area. The area controlling speech is one such area, and speech impairment is a frequent symptom of brain damage.

Even the axial length of the neuron may make it more vulnerable than a neuron of shorter length. An injury, for example, would be more likely to affect a long neuron than a shorter neuron due to its relative size. Parts of the brain involved in memory are particularly vulnerable for such reasons. As a result, memory is frequently affected by concussion of the brain.

Redundancy

Redundancy in the brain is the presence of multiple cerebral pathways performing the same function. Redundancy is common in the human body. The two kidneys are an example; one is all that is needed. Cellular redundancy makes it possible for a partial liver to function adequately.

Three redundancies in the human brain make it possible for damaged functions to be maintained or shifted elsewhere. They are as follows: 1) a surplus of neurons for a particular function. If only some are damaged, the remaining undamaged neurons can maintain the function. 2) Alternative pathways are available for some functions. For example, left-hemisphere damage can be mitigated by a neural passage going between hemispheres. Some functions (for example, basic biological activities) can be carried on from either hemisphere. 3) Finally, the individual can design behavioral strategies to compensate for disabilities caused by brain damage. Such adjustment could be exemplified by the use of lists, notes, signs, and other memory aids in the case of disorders affecting memory.

CAUSATIVE AGENTS IN BRAIN DAMAGE

In the following sections, we identify seven principal agents of brain damage and illustrate the types of symptoms that result from each.

Brain Degeneration

The wear and tear of living is hard on the organs of the body. Biologists report that the wearing out of the body begins virtually at birth. When one is young, the worn-out cells of the body are replaced regularly by new growth. As the individual grows older, in a process commonly called aging, the replacement process slows down, and a generalized degeneration of the body's tissues gradually takes place. The brain is as affected as are other parts of the body. The rate of biological aging varies among individuals and seems to be related to the individual's genetic heritage. Science has not yet learned to understand the full nature of aging.

When this degeneration process produces changes in the brain, certain alterations in intellectual functioning gradually appear. For most people, these changes initially affect daily life only in minor ways; for example, occasional memory lapses, the inability to recall a name, or failing to remember what

the individual set out to do just a moment ago. As the individual grows older, in a normal and to-beexpected way, the disabilities increase. Examples are a slower way of walking, lessened capacity to handle complex information, and decreased efficiency of memory and in the learning of new tasks.

Aside from this normal aging of the mental and motor processes, in 12.4 percent of the population over age seventy-five, a condition called dementia develops, which brings on a progressive loss of a variety of the higher mental processes. The percentage increases with age. There are two common types of dementia: Alzheimer's disease and multi-infarct disease.

Alzheimer's Disease

There are two symptom patterns to expect in Alzheimer's disease. In half of the group, the illness follows the pattern of simple deterioration. In others, a system of paranoid thinking may develop. Alzheimer's disease is a progressive and fatal disease. Typically, the course is eight to fifteen years life expectancy after the diagnosis is made.

SIMPLE DETERIORATION

Here, various mental capacities begin to fail. Memory loss is usually first. Loss of memory is followed by periods of disorientation, poor judgment, indifference to personal hygiene, and ultimately a complete loss of contact with reality. The behavioral expressions of the disease may vary. None of them make caring for the individual any easier. Some typical examples of Alzheimer behavior are repetitive asking of the same question, walking out of the house and getting lost, or forgetting to turn off running bath water or appliances around the house. Frequent nighttime waking associated with Alzheimer's disease also can take a toll on caregivers. There may be genial amiability (but also irritability) and busyness about useless but harmless activities, for example, saving string or ritualizing household activities to a painful extreme.

PARANOID REACTIONS IN ALZHEIMER'S DISEASE

Much more difficult to deal with is the person with Alzheimer's who develops paranoid thinking. Although this is a less frequent reaction pattern than simple dementia, when it occurs it is the symptom about which most caregivers complain and the one that they find the most difficult to manage. The individual is suspicious and busy concocting plots of the nefarious activities engaged in by the very people who are providing care. Strangely, with this symptom pattern, deficiencies in cognitive functioning seem to be less noticeable. The individual becomes more observant about the behavior of others and uses those observations to justify suspicions. Although rare, paranoid thinking can lead to assaultive behavior. Most often, however, the feebleness of the individual precludes much harm being done.

CAUSES OF ALZHEIMER'S DISEASE

There is evidence of a genetic contribution to Alzheimer's disease. The evidence has not yet been collected and summarized in a way to provide an adequate explanation of how genetic factors work to cause Alzheimer's or even whether or not there is a genetic cause of all cases of the disease. Nevertheless, there would seem to be agreement among neurologists that some genetic basis, not now entirely understood, is a cause of some forms of the disease.

PREVALENCE

With an increasing aging population, Alzheimer's disease has become a major health problem with troublesome corollary social problems. About 4.5 percent of the American population over sixty-five have the disease. Because there is no known cure for it and proper management of the illness at later stages is difficult, nursing homes carry much of the burden. In fact, facilities have cropped up that specifically cater to individuals with Alzheimer's disease.

Multi-Infarct Dementia

Symptoms similar to those described for Alzheimer's disease also can result from multi-infarct disease. That disease is not as specifically age-related as is Alzheimer's disease. It is a vascular (blood vessel) disease that may occur earlier in life than is likely with Alzheimer's disease. Brain degeneration in multi-infarct disease results from the cumulative damage of multiple small strokes (called transient ischemic accidents or TIAs), which are caused by a blockage in the supply of blood to a specific area of the brain. The cause of the blockage is usually a blood clot. The impacted area is called an infarct, and it loses its ability to function and soon begins to degenerate. As those small strokes grow more frequent and the neural damage spreads, dementia ultimately results.

The condition is associated with hardening of the arteries. In that condition, calcified fatty substances accumulate on the interior arterial walls, narrowing them and slowing the flow of blood through them. Eventually, a blood clot forms, and the resulting blockage ruptures the blood vessel, allowing blood to hemorrhage into the brain. A single stroke of that type may result in a variety of psychological and physical symptoms. As they occur more frequently, dementia follows. A sudden onset of symptoms occurs in 50 percent of the cases, presumably as a result of a major stroke involving extensive areas of the brain.

Other Degenerative Disorders

There are two other degenerative disorders, Huntington's chorea and Parkinson's disease. Both involve specific but unrelated areas of the brain at subcortical levels.

HUNTINGTON'S CHOREA

This organic disease is transmitted genetically by a dominant and defective gene of either parent. Its presence can first be observed only when the individual is in his or her thirties. The brain area affected is the basal ganglia, which are bundles of neurons deep within the cerebrum. The characteristic symptom, for which the illness is named, is a spasmodic jerking of the limbs. The disease is a serious one, causing bizarre behavior and loss of bodily functions, resulting in death, usually some fourteen years after the onset of the first symptoms.

PARKINSON'S DISEASE

The disorder results from a degeneration of the neurons in the substantia nigra, a part of the basal ganglia. The absence of the neurotransmitter dopamine makes conduction of impulses across the synapses impossible in the affected area. Characteristically developing in later life, in the sixties, it appears occasionally as early as the forties. Symptoms include muscular rigidity, tremors, and a mask-like fixedness of facial expression. In severe cases, in the latter phases of the disease, dementia may be present.

Although the disease cannot be cured, symptoms can be greatly moderated by regular doses of a synthesized substitute for the missing dopamine. The problem with that drug is that the body gradually accommodates to it, therefore requiring that the dosage be increased gradually, with the danger that its effect may be lost altogether.

Brain Tumors

A tumor is an abnormal growth of body tissues. Some tumors are benign, affecting the individual only because of the pressure they exert. Upon removal of the tumor, symptoms usually disappear. Others are malignant, and unless removed in time, will spread, causing the individual's death. Tumors may appear in many parts of the body, including the brain.

Types of Brain Tumors

Brain tumors are of two types: primary tumors, which originate in the brain itself and may be malignant; and secondary tumors, usually cancerous, originating in other parts of the body and carried to the brain through the vascular system. As the brain tumors grow in the cerebrum of the brain, they increase intracranial pressure and cause a variety of serious physical and behavioral symptoms; and unless removed or reduced, eventually cause death. The secondary tumors are just as dangerous as primary tumors; they simply arise from a place outside the brain, metastasize (that is, break up), and travel to the brain through the blood vessels.

Symptomatology

Intracranial tumors show their presence initially in relatively minor symptoms—headache, visual problems, a brief loss of consciousness. As the tumor continues to grow and affects other parts of the brain, symptoms increase and more seriously affect the health and mental functioning of the individual. Higher mental functions deteriorate, abnormal reflexes develop, emotional expression is blunted, memory and concentration are affected, and disorientation to time and place results. When brain tumors cannot be removed because of their location or size, they eventually cause unbearable pain and extreme personality changes. The patient ultimately becomes floridly psychotic, sinks into a coma, and dies.

Many brain tumors can be removed by surgery or reduced by radiation therapy.

Brain Trauma

There are three types of brain trauma: concussion; contusion; and laceration. They most frequently result from falls, automobile or motorcycle accidents, blows to the head, or penetration of the brain by a foreign object such as a bullet. The critical elements in each type of injury are the extent of the injury and its location in the brain. The most frequent victims of brain trauma are young men. With speed and violence on the increase in our society, it is remarkable that brain trauma occurs no more frequently than it does, which is 99 per 100,000 of the population in any one year.

Concussion

In concussion, the brain is momentarily jarred and shifted from its position. The result is usually nothing more than a brief loss of consciousness, lasting only seconds, or perhaps a minute or two. The longer the period of unconsciousness, the more severe and longer-lasting will the symptoms be. When the individual regains consciousness, he or she may not be able to recall events immediately preceding the accident. Symptoms may continue for several weeks. Those symptoms—their nature, length, and severity—reflect pretrauma personality characteristics, hypersensitivity to pain, or preoccupation with bodily symptoms. The range of such symptoms includes headache and dizziness (most frequent symptoms), memory and concentration difficulties, irritability, and insomnia. Doctors usually recommend a period of quiet for the individual and close observation of behavior. The extent of the brain damage may not be immediately observable. Damage to the brain from a number of concussions, such as those experienced in prize fighting, have a cumulative effect, eventually matching the symptoms caused by a more serious brain injury. This has been labeled pugilistic dementia.

Contusion

Contusion is a more serious jarring of the brain, forcing it out of position and pressing it against the skull. Brain tissue on the cerebral cortex (exterior surface of the brain) may be damaged. The result will be more serious symptoms than those that occur from concussion.

A contusion will cause a longer period of unconsciousness, sometimes for days. The individual may experience convulsions and speech impairment when coming out of the coma. Confusion and some dis-

orientation may also be present. Repeated concussions or contusions may result in permanent brain damage. A tragic example of this is seen in shaken baby syndrome.

Lacerations

When a foreign object passes through the skull and enters the brain itself, the injury is a laceration. It is the most serious of brain traumas. The severity of the injury depends upon its location and the extent of the collateral damage the object causes as it passes through the brain. The effect of laceration varies widely, from death to intellectual, sensory or motor impairment. In rare cases, there will be only minor residual impairment.

Cerebral Vascular Accidents

There are two distinguishable cerebral vascular accidents: cerebral occlusion and cerebral hemorrhage.

Cerebral Occlusion

A blood vessel of the brain may clog from an embolus—that is, a ball-like clump of clotted blood or fat may move through a blood vessel until the vessel becomes too narrow for its passage. When the blood from that blocked vessel no longer provides adequate support for an area of the brain, the brain cells in that area degenerate and can no longer function. The same result can be caused by a thrombus, which is a buildup of fatty material on the inner surface of the vessel. As the buildup continues, it gradually reduces blood supplied to that area of the brain. When a cerebral vascular accident produces a sudden and dramatic set of symptoms, such as paralysis or inability to talk, an embolus, producing an instant clogging of the vessel, is likely to be the cause. A thrombus grows slowly at the same spot in the vessel, gradually reducing the supply of blood and progressively causing the development of symptoms. Cerebral vascular accidents cause a variety of symptoms, from death to such handicaps as aphasia, agnosia, apraxia (see the glossary) and a right- or left-sided paralysis, depending on which cerebral area sustained damage.

Cerebral Hemorrhage

Here, a blood vessel ruptures, and blood pours out onto brain tissue, limiting the capacity of the brain to function. It is that kind of accident about which the individual with high blood pressure should be concerned. The rupture is usually caused by an aneurysm, which is a bulging in the blood vessel. Cerebral hemorrhaging is a serious condition that may cause the death of the victim immediately or in a matter of days. In less extensive hemorrhaging, the symptoms can nevertheless be quite disabling. They may include memory loss, impaired judgment, speech impairment, and/or paralysis. As always with brain damage, its expression in symptoms depends upon its location and the extent of the damage.

Nutritional Deficiency

In this type of brain damage, the cause is the lack of certain vitamins necessary for brain function. The principal disorders resulting from vitamin deficiency are Korsakoff's syndrome, pellagra, and beriberi. The latter two are practically nonexistent in Western societies.

Korsakoff's Syndrome

This disease is a direct result of the inadequate diet that accompanies chronic alcoholism. In particular, a deficiency of vitamin Bl (thiamine) causes the disease. It causes foolish thinking and talking and, in time, generalized weakness and gross intellectual impairment. Damage caused by the disease is irreversible.

Pellagra

An organic disease that has all but disappeared in this country, pellagra results from a diet deficient in niacin, a B vitamin. In the early part of this century, it was a principal cause of admission to state psychiatric hospitals in the South where, at that time, the principal diet ingredient, corn meal, provided inadequate amounts of vitamins. Early symptoms are rash and diarrhea. If the diet deficiency is uncorrected, more serious psychological symptoms may develop, ranging from depression and anxiety to psychosis. When detected early enough, massive doses of the needed vitamin can correct the disorder.

Beriberi

The disorder is most prevalent in Far Eastern countries, where vitamin-deficient polished rice is a major part of the diet. The critical missing ingredient is thiamine. Symptoms are lassitude, irritability, and concentration and sleep disorders.

Endocrine Disorders

The endocrine glands secrete hormones that are critical for such important bodily functions as growth, energy level, and sexual activity. Oversecretions or undersecretions of some hormones can produce serious physical and mental disorders. The two glands in which that problem occurs most frequently are the thyroid and adrenal glands.

In the thyroid gland, either oversecretion or undersecretion can cause problems. Hyperthyroidism that is, too much secretion—causes Graves' disease. The increase in thyroxin creates bodily changes that ordinarily accompany anxiety: sweating; apprehensiveness; and hyperactivity. In extreme cases, hallucinations may develop.

Hypothyroidism, a deficiency of thyroxin, may cause myxedema, which, as might be expected, causes symptoms the opposite of those produced by hyperthyroidism. Its principal symptoms are sluggishness and depression. Hypothyroidism is a good example of the need for a medical examination in properly diagnosing disorders—hypothyroidism can be mistakenly labeled as depression.

In both disorders, patterning of symptoms will be influenced by the individual's personality before onset of the disorders; for example, a worrying type of person will show more of it with the hyperthyroidism, while a depressed and gloomy person will become more so in hypothyroidism.

Brain Damage from Infection

A number of infectious diseases can produce brain damage. The most common are encephalitis and meningitis.

Encephalitis

The term is a generic one meaning inflammation of brain tissue. The source of the infection can be any of a number of living and nonliving agents. The principal culprits are mosquitoes and ticks. The disease also can be caused by infections that travel from other organs of the body to the brain, principally from the ears and sinuses.

A particular epidemic of encephalitis, encephalitis lethargica, occurred in this country and in Europe during the period of World War I. The most prominent symptom, that which gave it its name, sleeping sickness, was an extreme lethargy, causing the infected individual to sleep for days, even weeks. The disease was depicted in the movie Awakenings and is not seen often now.

Encephalitis causes a number of physical symptoms, including vomiting, stiffness of neck and back, fever, and tremors. In its acute phase, high fever, delirium, and disorientation will also occur. Most victims recover completely, although some may be left with paralysis of an arm or leg, severe tremors, and sensory and speech disorders. In infants, the disease may cause mental retardation.

Meningitis

Bacterial infection may inflame the three layers, or coats, that envelop and protect the brain. Such inflammation of the meninges causes symptoms similar to those of encephalitis. The principal epidemic form of the disease results from a meningococcal infection, which is worldwide in its occurrence, tending to reappear in an eight- or twelve-year cycle.

TREATMENT OF ORGANIC DISORDERS

As might be expected, the treatment of organic disorders is notably different from the treatment of functional disorders. It is principally a medically treated problem and makes use of skilled and delicate surgery, pharmaceutical drugs such as the antibiotics, and medical procedures for maintaining the individual's general health. A course of psychotherapy is frequently recommended, along with neurological treatment, to help the patient with functional symptoms that develop in reaction to the neurological symptoms.

Characteristics of Neural Tissue and Neural Damage That Affect Treatment

We consider here basic characteristics of neural tissue and neural damage that affect treatment, and then the principal approaches to treatment of the organic disorders.

Neurologists attempting treatment of organic disorders take account of three characteristics of the nervous system: 1) the impossibility of creating new neural tissue; 2) the recoverability of damaged neurons; and 3) the existence of redundant areas. An example of taking account of those characteristics in neurological treatment is consideration of the fact that when neural tissue in an area of the brain has been completely destroyed, only if there are redundant areas matching the function of the destroyed area is there hope of recovering the lost function.

Another example illustrates a different consideration. When arteriosclerosis or pressure on the brain reduces the supply of oxygen or other nutrients, the affected neural tissue is damaged. In such cases, the appropriate intervention, such as surgical removal of the pressure-causing tumor, can resume the supply of nutrients, after which the neurologist's focus will be to strengthen the general health of the individual in the hope that doing so will enable the damaged neural tissue to recover.

Neurological Treatment Approaches

There are three possibilities: First, the most urgent is to remove or contain the condition causing the damage. Examples are surgical removal of a brain tumor; treatment of an infection with antibiotics; or drainage of fluid that is causing intracranial pressure. The possibility of attempting such procedures depends upon the extent of the neural damage and its accessibility. A second approach is to treat the symptoms so that they interfere less with normal living. The treatment of Parkinson's disease by controlled doses of synthesized dopamine, which ameliorates the symptoms, is an example. A third approach is to modify the patient's mode of carrying out everyday activities (for example, helping the patient to adapt to progressive deterioration of Alzheimer's disease). The help of family members here is usually necessary. Strong motivation is a vital ingredient in order for such an approach to succeed. When considering prognosis, three factors will be uppermost: extent of the damage; its location; and such secondary factors as the general health and age of the individual, energy level, personality, and living circumstances.

EPILEPSY

Epilepsy is best considered apart from the other organic mental disorders. In most individuals, it manifests itself during childhood, sometimes before the age of four. Occurring in 2.7 million Americans, no cause for the illness can be identified in more than three-quarters of the affected group.

Epilepsy is known principally by its most prominent symptom, the epileptic seizure, but an assortment of the other organic disorders also cause convulsions or seizures. In most cases, such seizures are distinguishable from the typical epileptic seizure. Seizures from known pathology other than epilepsy are sometimes loosely referred to as acquired epilepsy; they are the result of very different causes, and should more properly be diagnosed for what they are (for example, brain tumor, encephalitis, and so on). Apart from such convulsion-causing organic conditions, there is what might be called true epilepsy, which is diagnosed as idiopathic epilepsy. The cause of that condition has not yet been identified.

Four types of epileptoid seizure have been identified: grand mal (or major sickness); petit mal (or

small sickness); psychomotor epilepsy; and Jacksonian epilepsy.

Grand Mal Epilepsy

The grand mal epileptic attack is preceded by a visual or auditory aura, signaling the impending occurrence of the attack. The aura is generally a distinctive pattern of changing lights or sounds. The patient will then cry out and lose consciousness.

There are four distinguishable phases to the grand mal attack: 1) the aura stage; 2) the tonic phase in which the individual becomes rigid, with arms tightly flexed and legs outstretched. Muscular contractions continue for a minute or so, and breathing is interrupted briefly; 3) the clonic phase in which jerking motions take the place of the tonic, or rigid, phase. A danger during this phase of the seizure is that the strong jerking movements will cause bodily injury; and 4) soon after, the individual falls into a coma. Coming out of this coma, the individual is confused and responds weakly. There is no recollection of events preceding the attack.

Petit Mal Epilepsy

In one sense, petit mal has been well named. Compared to the grand mal attack, it is indeed a small illness. For some seconds, ten to thirty, without warning, the individual is "absent," sitting or falling, staring, unaware of what is going on, and usually immobile. The attack is so fleeting, with so brief a period of unconsciousness and so few external symptoms, that those around the patient may be unaware of the attack. The individual may also give no sign of being aware of it, picking up the uncompleted activity begun before the attack. The critical element of the small attack, like the proverbial dripping of water, is the wearing effect of repetitive seizures. Some patients may have literally a hundred petit mal "absences" in a day. That frequency of seizure ultimately can have profound consequences.

Psychomotor Epilepsy

This combination of motor and psychic disturbance is the most unusual of epileptic seizures. Following the advance warning of an aura, the attack consists of a loss of consciousness, during which there will be repetitive, seemingly automatic activities. Despite the reduced consciousness, the individual is frequently aware enough to resist attempts to control his or her activities. A grand mal attack may follow a psychomotor seizure.

An unusual feature of the psychomotor attack is the assortment of confused, sometimes psychoticlike, mental content that may accompany the episode. These include perceptual changes, in which ordinary objects take on different shapes and sizes; changes in self-awareness, causing the individual to experience depersonalization; and extreme cognitive and affective reactions. Schizophrenic-like experiences, such as hallucinations or delusions and irrational behavior, are occasionally part of a severe psychomotor seizure. Assaultive behavior, although possible, is rare, and most often takes the form of resistance to efforts to control the bizarre behavior of the patient.

Jacksonian Epilepsy

Named for Hughlings Jackson, who first reported it, this type of epilepsy is more limited in behavioral and mental change than either grand mal or psychomotor epilepsy. Its symptoms principally are tingling and twitching of hands or feet, which may then spread to other parts of the body. Its cause has been localized in a small area of the brain, which may be excised to control the disorder.

Treatment of Epilepsy

Epilepsy is typically treated with medication, diet, vagus nerve stimulation, or surgery. Antiepileptic medications include Carbatrol, Depakote, Felbamate, Klonopin, Lamictal, Neurontin, Phenobarbital, Tegretol, and Valium. In vagus nerve stimulation, an electrode is implanted that stimulates the brain every few minutes. It is not entirely clear how this procedure works, but it has been proved to be effective. The ketogenic diet is a carefully restricted diet that is low in carbohydrates and high in fats. It has been found to be successful in some cases of epilepsy. After brain imaging has identified specific areas responsible for seizures, surgery can be used to remove the affected parts of the brain.

SUMMARY

Mental disorders may be grouped into two major categories. There are organic disorders, which are known to be caused directly and primarily by specific pathology in the brain, and functional disorders, which result from abnormal life experiences imposed on a nondisordered, although perhaps vulnerable, brain. Organic disorders account for 25 percent of all first admissions to mental hospitals.

The functioning unit of the brain is the neuron. It consists of: 1) a cell body, providing the neuron's life support; 2) the dendrites, a system of fine branches that receive impulses from other neurons; and 3) terminal endings that transmit messages to other neurons. The gap between one neuron and another is the synapse. Impulses are transmitted across synapses by neurotransmitters.

Various human activities are controlled by highly specific areas of the brain. In localizing function, we may consider its three axes. They are front/back, left/right, and up/down.

In the front part of the brain is located the planning-verification functions; the information-processing unit is located in the back part of the brain. The left side of the brain (the left hemisphere) receives sensory input from the right side of the body and controls motor behavior of the right side of the body, and vice versa. The left hemisphere sorts things out; the right hemisphere synthesizes. The higher levels of the brain have to do with cognitive and voluntary behavior.

There are three major symptom clusters in organic disorders. They are defects in basic mental activities, such as memory; impairment in higher mental functioning; and affective disturbances.

The principal causes of organic disorders are brain degeneration—that is, deadening of brain cells (neurons)—brain tumors, vascular accidents, nutritional deficiency, endocrine disorders, and infection.

The effects of brain damage range from short-term memory loss to death. Resilience of the brain to behavioral impairment depends upon the presence of multiple cerebral pathways (redundancy).

Four organic mental disorders result from brain deterioration. They are: 1) Alzheimer's disease, initially manifesting itself in severe memory loss; 2) multi-infarct disease, resulting from blockage in the blood vessels of the brain, the primary result of which is a stroke, producing partial to extensive paralysis, with later signs of dementia; 3) Huntington's chorea, which is transmitted by a dominant defective gene. Its symptoms are spasmodic jerking of arms and legs, bizarre behavior, and loss of bodily function. It is a terminal illness; and 4) Parkinson's disease, which causes limited mobility, rigidity of facial and body muscles and, in later stages, dementia.

Brain tumors, which may develop within the brain or move from other parts of the body, may be benign or cancerous. A full array of psychiatric symptoms and death results if the tumor cannot be excised.

Brain trauma includes: a concussion, or slight jarring of the brain; contusion, or jarring which produces a displacement of the brain; and laceration, or penetration of the brain. Impairment depends upon location and extent of the damage.

Clogging of a cerebral blood vessel, either from clotted blood or fat moving into a narrow blood vessel or accumulation of fatty material on the interior of the blood vessel, is called cerebral occlusion and causes the paralysis and associated symptoms of a stroke. A ruptured cerebral blood vessel causes the same symptoms. Either can be fatal.

The principal organic mental disorders resulting from nutritional deficiency are: 1) Korsakoff's syndrome, which is caused by a deficiency of vitamin Bl (thiamine), brought about by bad dietary habits of alcoholics; 2) pellagra, which results from diets deficient in niacin, a B vitamin; and 3) beriberi, which results from a deficiency in thiamine.

Overactivity of the thyroid gland can cause such psychological symptoms as anxiety, sweating, and hyperactivity. The condition is known as Graves' disease. Undersecretion of the thyroid gland causes lassitude and depression.

The principal infectious diseases resulting in organically caused psychological disorders are encephalitis and meningitis.

Treatment of organic mental disorders is principally a medical problem, which may be accompanied by a course of psychotherapy to help the individual and his or her family to adjust to new limitations on behavior and personality changes that occur.

Epilepsy is known principally by the epileptic seizure. There are four types of epileptic seizure. They are grand mal (or major sickness); petit mal (or small sickness); psychomotor epilepsy, causing automatic repetitive motor activities; and Jacksonian epilepsy, the symptoms of which are severe tingling and twitching of hands and feet. The causes of idiopathic (or true) epilepsy are unknown.

SELECTED READINGS

Casson, I. R., Seigel, O., Sham, R., Campbell, E. A., Tarlou, M., & DiDomenico, A. (1984). Brain damage in modern boxers. Journal of the American Medical Association, 251, 2663-2667.

Dash, P. & Villemarette-Pittman, N. (2005). Alzheimer's disease. New York: Demos Medical Publishing.

Pinel, J. P. J. & Edwards, M. E. (1997). Colorful introduction to the anatomy of the human brain: A brain and psychology coloring book. Boston, MA: Allyn & Bacon.

Quarrell, O. (1999). Huntington's disease: The facts. New York: Oxford University Press.

Radin, L. & Radin, G. (eds.). (2003). What if it's not Alzheimer's: A caregiver's guide to dementia. Amherst, NY: Prometheus Books.

Weiner, W. J., Shulman, L. M., & Lang, A. E. (2001). Parkinson's disease: A complete guide for patients and families. Baltimore, MD: Johns Hopkins University Press.

Wilner, A. N. (2003). Epilepsy: 199 answers a doctor responds to his patients' questions (2nd ed). New York: Demos Medical Publishing.

Test Yourself

- 1) Which of the following is true of functions in the human brain?
 - a) None of the functions is localized.
 - b) Many of the functions are localized.
 - c) All of the functions are localized.
- 2) Which portion of the brain is associated with sensation?
 - a) left
 - b) right
 - c) back
 - d) front
- 3) About 4.5 percent of individuals over 65 have Alzheimer's disease. True or false?
- 4) Huntington's chorea is cause by one specific gene. True or false?
- 5) Parkinson's disease is associated with a deficit in
 - a) dopamine
 - b) epinephrine
 - c) norepinephrine
 - d) serotonin
- 6) What is the jarring of the brain against the skull called?
 - a) concussion
 - b) contusion
 - c) laceration
 - d) occlusion
- 7) The brain damage of Korsakoff's syndrome is reversible with large doses of vitamins. True or false?
- 8) What type of seizure is characterized by a person sitting immobile, staring, and being unaware of what is going on around him or her?
 - a) grand mal
 - b) Jacksonian
 - c) petit mal
 - d) psychomotor
- 9) Which of the following is typical treatment for organic disorders?
 - a) Contain the condition.
 - b) Provide support to the person and his or her family in dealing with the disorder.
 - c) Treat the symptoms.
 - d) all of the above

Test Yourself Answers

- 1) The answer is b, many of the functions are localized. Many of the functions are localized in particular parts of the brain. For example, higher functions such as planning and calculating occur largely in the front of the brain. However, not all functions are entirely localized.
- 2) The answer is c, back. The area of the brain associated with sensation is the back half. That is, in general, sensations are received and processed in the back of the brain as opposed to the front portion of the brain.
- 3) The answer is true. Alzheimer's disease is relatively common, affecting 4.5 percent of those over 65. As age rises, so does the prevalence.
- 4) The answer is true. Huntington's chorea is caused by an autosomal dominant gene. It is passed on to the children by parents who do not develop symptoms until their 30s.
- 5) The answer is a, dopamine. Parkinson's disease is caused by a deficit in dopamine. It is treated by medications that increase levels of dopamine. Unfortunately, with time, higher doses are necessary and there is a risk of the medication ceasing to be effective.
- 6) The answer is b, contusion. A contusion is when the brain is jarred and pressed into the skull. An example of this is shaken baby syndrome, when a child develops brain damage because of repeated injuries from being shaken by a caregiver. A concussion results in the brain being jarred, but not pressed against the skull. A laceration involves a foreign object, such as a bullet, entering the brain. An occlusion prevents blood from reaching brain tissue.
- 7) The answer is false. Unfortunately, the cognitive deficits created by Korsakoff's syndrome, unlike some other brain disorders, are permanent.
- 8) The answer is c, petit mal. Petit mal seizures are characterized by a person sitting immobile, staring, and being unaware of what is going on around him or her. Grand mal seizures are characterized by a period of rigidity followed by a period of jerking movements. Jacksonian seizures are characterized by tingling and twitching of hands and feet. Psychomotor seizures are characterized by automatic repetitive motor activities.
- 9) The answer is d, all of the above. Treatment for organic neurological disorders typically involves three components: 1) containing the condition; 2) treating the existing symptoms; and 3) providing support to the person and his or her family in dealing with the disorder.

Mental Retardation

nown in earlier years as feeblemindedness and mental deficiency, mental retardation is said to exist when an individual fails to develop the various skills requisite for independently and adequately solving the problems of ordinary living. If such impairment develops after the age of eighteen, it is an altogether different disorder, which is categorized as dementia.

The American Association on Mental Deficiency, a national association that provides information on mental retardation, promotes research in the field, and supports education and proper care for those with mental retardation, defines mental retardation as, "significantly subaverage general intellectual functioning existing concurrently with deficits in adaptive behavior and manifested during the developmental period." There is general agreement among educators and psychologists that of the two aspects of development included in the definition, adaptive behavior is a much more significant criterion than the formal measurement of intelligence. Approximately 1 percent of the population can be classified as having mental retardation.

TYPES OF MENTAL RETARDATION

There are two distinguishable types of mental retardation: 1) cultural/familial retardation, which is caused by some combination or interaction between normal genetic variation and an impoverished and unstimulating environment; and 2) organic retardation, the result of some physical condition that limits the development of the brain.

Cultural/Familial Retardation

The condition usually results in a mild retardation (in the upper range of those classed as mentally retarded). Cultural/familial retardation accounts for the majority of those with a mild degree of retardation. Individuals with this type of retardation have good, normal physical growth, are normal in appearance, and fall within the normal range in physical abilities. Most of them learn to function in a marginally independent fashion if they are provided with suitable support. This type of mental retardation appears more prevalently in families at the lower end of the socioeconomic scale.

Organic Retardation

This form of mental retardation affects about 25 percent of the population with mental retardation. It results from a physiological or anatomical anomaly affecting brain development. Individuals with this form of mental retardation often are different in appearance and behavior from others, characteristics that

result from the underlying organic malfunction. They are typically more seriously disabled, but this evaluation may be the result of the physical and behavioral anomalies that may mask intellectual functioning.

MISCONCEPTIONS ABOUT MENTAL RETARDATION

Despite the general awareness most people have of the existence of mental retardation, they often include in that awareness misconceptions about the characteristics of mental retardation. In a compassionate article in the professional journal Social Work, J. R. Dudley (1987) identifies five common misconceptions that, in large measure, underestimate the capacity of those with mental retardation to understand their problems, and attribute to them undesirable characteristics that do not commonly exist. Common misconceptions are: 1) The mentally retarded have little or no understanding of their limitations. Except for those with severe and profound retardation, most individuals have a common sense awareness of their limited capacities and readily admit that they cannot do many things as well or as fast as others. They frequently describe themselves as slow at catching on. 2) People with mental retardation are all alike. That belief should be given the same status as the distasteful and obviously inaccurate statement, "All Chinese look alike." Individuals with mental retardation vary in their physical appearance and in their personality characteristics as widely as do other individuals. Some are cheerful and active; others are glum and lethargic; some are handsome or beautiful, and others are not. 3) They have little or no feeling about what people call them. This is not true, and names can be hurtful. Because of the use of the term "retarded" as a put down, many individuals with mental retardation prefer the term "developmentally disabled." 4) They have little understanding of how their limitations affect them in everyday life. Quite the contrary! Most people with mild to moderate mental retardation ask for advice and assistance; they slowly and prudently approach new situations or new problems. 5) They are dangerous. Most individuals with mental retardation are not assaultive. They occasionally have temper tantrums, which may be exacerbated by the frustrations caused by their limitations, as do other individuals of their mental age. Faulty judgment may cause them to violate the rights of others, but they can be taught to conform to social norms.

LEVELS OF RETARDATION

The DSM-IV-TR recognizes four levels of mental retardation. For lack of a more adequate measure, the manual distinguishes levels on the basis of IQs. At the margins between different levels, there may be disagreement on classification, depending upon the nature of the observations available to the diagnostician. The four levels are: Mild, with an IQ of 50 to 70, which accounts for 85 percent of cases of mental retardation; Moderate, having an IQ of 35 to 49, accounting for 10 percent of cases; severe, with an IQ of 20 to 34 and accounting for 3-4 percent, and profound, with an IQ below 20, which accounts for 1-2 percent.

Mild Mental Retardation

This level of retardation may not be diagnosed certainly until the child is three or four years old. In many cases, it is first officially diagnosed soon after the child begins school. For purposes of educational planning, this group is diagnosed as "educable," which means that they can benefit from academic schooling. Even before the time of school attendance, with a caring home environment (which, unfortunately, is sometimes lacking for these children), those with mild retardation can develop basic social and communication skills. Their vocabulary will be notably limited and their enunciation may be poor. There is no notable impairment in sensorimotor areas, although learning to walk and talk will be delayed. They make progress very slowly, and in their late teens they can learn academic skills up to the sixth-grade level. As adults, given the motivation, they will usually develop sufficient social and occupational skills to provide some portion of their own support. They will continue, however, to require guidance and social support throughout their lifetime.

Moderate Mental Retardation

From the point of view of expected achievement level, this group is distinguished from the mildly mentally retarded as "trainable" (rather than educable). The term means that they can be trained in simple skills but will respond poorly to schooling in academic subjects and are usually unable to progress beyond the second-grade level. The schooling experience, under the best circumstances, can provide occupational and social skills that enable them, as adults, to work under supervision in sheltered workshops. Here they work at unskilled or semiskilled jobs and are able to earn some money. Placement in the supported work environment not only provides some income, but also provides guidance during the daytime hours.

Severe Mental Retardation

In every criterion of performance, this group falls behind the less severely disabled. Their disability is manifest at an earlier age; there is poor motor coordination and meaningless speech. Later in childhood, they acquire simple speech skills, sometimes only monosyllables, and can be taught rudimentary habits of hygiene. Never developing vocational skills, they can find employment, if at all, only in highly protective environments, where they may be taught simple, useful tasks; for example, putting items into containers.

Profound Mental Retardation

During the preschool years, these children develop little sensorimotor capacity; for example, coordinating what they see with hand movements. As time goes on, they will show further motor development. As adults, they continue to require constant aid and supervision, ultimately maybe learning some useful self-care habits. Individuals with profound mental retardation tend to be almost totally dependent upon hour-to-hour aid and constant supervision throughout their lifetimes. Whether that care can be provided at home is questionable; but only the parents of a handicapped child can make that decision, and they may need professional support and guidance to do so.

SPECIAL SYMPTOMATOLOGY (OTHER THAN INTELLECTUAL **DEFICIT) OF MENTAL RETARDATION**

Such symptoms vary with the severity of the disorder.

Mild to Moderate Retardation

Here, the symptoms are likely to be such personality traits as dependency, passivity, low tolerance for frustration, depression, and self-injurious behavior.

Severe or Profound Retardation

Here, the special symptoms may be speech disorders, vision and hearing problems, cerebral palsy, or other neurological disorders.

COURSE OF MENTAL RETARDATION

In planning for persons with mental retardation, not only should the level of the disability be considered but also the long-term course of the disorder. The course followed by mental retardation varies with the two types of the disorder: cultural/familial retardation and organic retardation.

Course of Cultural/Familial Retardation

Given a stimulating environment along the way, individuals with mild cultural/familial retardation may make gains in their abilities. By adulthood, they may show a notable improvement in adaptive behavior. Their problem is that it takes them longer to reach that point and requires a more supportive environment. Sometimes that spurt in adaptive behavior appears when they are freed from the more restrictive demands of school attendance. That possibility should not cause parents to remove a child hastily from a good school setting, but it may suggest ensuring that the child gets the appropriate support inside and outside of school.

Course of Organic Retardation

When the cause of the disability is a specific biological abnormality, the expected course is bleaker. In these types of retardation, the disorder is likely to be chronic and without remission and with little hope of improvement from treatment. Symptoms may become more severe with some causes.

CAUSATIVE FACTORS IN MENTAL RETARDATION

The pattern of etiological factors and the effects of those causal factors are notably different for the two major types of mental retardation, cultural/familial and organic.

Cultural/Familial Retardation

Both severe environmental impoverishment and possible hereditary influences must be considered here.

Impoverished Environment

Studies of this usually mildly disabled group confirm the belief that a multiply impoverished home is a principal causative factor in cultural/familial retardation. Recent studies suggest ways in which impoverishment impairs intellectual development. There are four especially significant adverse conditions that block intellectual developments in impoverished homes. They are as follows: 1) Inadequate diet that leads to malnutrition can produce low levels of energy and weak motivation. There is, in addition, an absence of medical care that, for example, by leaving sensory deficits in vision and hearing unattended, can seriously handicap an individual's development. 2) Parents who are so beset and distracted by the struggle to make ends meet may have little time available for their children. The resulting emotional impoverishment and the absence of a rich communication and social exchange among family members provide no stimulus for intellectual growth. Verbal ability, so much a part of intellectual functioning, is stunted. 3) Impoverished parents have low expectations for their children and offer them little stimulation for problem-solving activities, curiosity, reading, or even social conversation, which are all significant aspects of fostering cognitive growth. 4) Children growing up in impoverished homes soon develop the lowered self-esteem of their parents, which discourages them from making any effort to advance. Entering school with those handicaps and performing poorly, they soon fall farther and farther behind, causing their teachers to develop low expectations of any progress from them. Furthermore, these children often, because of socioeconomic factors, attend schools that provide less academic resources and support. There is little in society or the classroom that interrupts that slide down to a lifetime diagnosis of mental retardation.

Possible Hereditary Influence

The mental retardation we are discussing here is not randomly distributed among families living in poverty; it seems to be concentrated in certain families. One study reports that 80 percent of the children with IQs below 80 had mothers with IQs below 80. The report further indicates that the lower the mother's IQ, the greater the probability that her children will have low IQs.

It should be noted that such a correlational finding does not necessarily indicate causation. It does not, by itself, establish a hereditary factor. The mother's low intelligence may only worsen the conditions that impoverishment imposes. It is certainly true that a parent of low intelligence may be challenged to offer optimal stimulation for intellectual development in comparison to a parent of average intelligence, regardless of the level of impoverishment in the home. However, research has continued to suggest a degree of heritability of intelligence.

Organically Caused Mental Retardation

The 25 percent of persons with mental retardation whose retardation is organically caused have more severe levels of retardation than those who fall into the category of cultural/familial, and they also show more associated physical anomalies. Their retardation may be caused by genetic abnormalities, metabolic abnormalities, or by such environmental factors as brain trauma, severe malnutrition, infection, or premature birth.

Genetic Factors

There are two types of genetic influence on the development of mental retardation: chromosomal anomalies and defective recessive genes that, when matched from both parents, produce the disorder. In 1991, two studies, one conducted in England and the other in this country, identified gene mutations on chromosomes 19 and 21 as contributory to the development of mental retardation.

CHROMOSOMAL ANOMALIES

In humans, there are twenty-two pairs of differentiating chromosomes (called autosomal chromosomes), and one pair of sex chromosomes. Mental retardation may result from aberrations in either type.

AUTOSOMAL ABERRATIONS

Here, the normal splitting and matching of each parent's chromosomes (meiosis), the mother's in the egg and the father's in the sperm, does not occur normally; for example, the failure of one parent's number 21 chromosome to split. When fertilization takes place, there are then three number-21 chromosomes, giving the fetus one more chromosome than the normal forty-six. The aberrant process is known as trisomy-21. The result is a type of mental retardation known as Down syndrome. The chances of a mother conceiving a child with Down syndrome is age-related. One study reports that the chance of a woman under the age of twenty-nine conceiving a Down syndrome child is one in every 1,500 births; by the age of forty-five, those chances become one in thirty. Down syndrome results from a spontaneous defect in the mother's egg (or occasionally in the father's sperm), not passed on in the standard hereditary pattern.

The medical procedures called amniocentesis and chorionic villus sampling can identify the presence of this anomaly in the growing fetus. That medical possibility confronts the mother with the choice of preventing the birth of a Down syndrome child by having an abortion.

A child with Down syndrome is born with three types of handicap: 1) Shortened life expectancy. Because of vulnerability to cardiac and respiratory illness, these children are at high risk during the first six months of life. Advances in medicine have increased the survival rate during those months, and many children with Down syndrome now live to adulthood. At age one, having survived the early risks, their life expectancy is fifty-five years. 2) Physical appearance. There are well-known physical characteristics that mark the child as having Down syndrome. They include almond-shaped eyes, a flattened nose and broadened face, enlarged tongue with deep grooves, and stubby fingers. Cosmetic surgery reduces the

abnormalities, particularly that of the tongue. Such an operation considerably improves eating habits and speech and makes interaction with other children more normal. Growth remains stunted. 3) Most, but not all, children with Down syndrome have IQs below 50 and are therefore moderately mentally retarded.

SEX CHROMOSOME ANOMALIES

There are several types of sex chromosome anomalies. The twenty-third chromosome, which is responsible for the determination of the embryo's sex, normally has two X chromosomes in the female, and an XY pair in the male. Aberrations in this pattern can occur in both sexes. In fragile X syndrome, a genetically induced malformation of the X chromosome produces the disorder. It is the most prevalent genetic cause of mental retardation. There are anomalous physical characteristics such as elongated face and prominent jaw and forehead. Of more significance is its seeming relationship to childhood autism. Two and a half to six percent of children with pervasive developmental disorders also have fragile X chromosome. Because females have two X chromosomes (XX), the stronger one seems to compensate for the fragile X chromosome, and, as a result, females are more likely to have learning disabilities rather than mental retardation.

RECESSIVE AND DEFECTIVE GENES

A recessive gene is one whose effect on the physical being of the child can only appear when it is matched with another identical recessive gene from the other parent. Defective recessive genes have been identified as responsible for three types of mental retardation: phenylketonuria (PKU); Tay-Sachs disease; and cretinism. In all of these conditions, the recessive genes produce a malfunction in the metabolic processes.

Phenylketonuria (PKU)

In this genetic disorder, the matched recessive genes leave the child with an excess of phenylalanine. The end result is serious damage to the developing central nervous system, in turn causing mental retardation, seizures, hyperactivity, and erratic behavior.

Early diagnosis, which is now possible and likely because tests for the condition are routinely performed soon after birth, will initiate a regimen of feeding begun during the first months of life. The diet keeps from the child all foods high in phenylalanine. Because of the possibility of eliminating necessary nutrients in the diet of the child, such a diet must be supervised by a competent physician.

When PKU goes untreated, the condition produces severe to profound mental retardation, with the IQ typically below 40, as well as organ damage and unusual posture. On the other hand, when the condition has been treated successfully and an appropriate diet maintained, if a treated woman should become pregnant, there is a high likelihood that her children would be born healthy and with normal intelligence. In any case, where the possibility of PKU exists, genetic counseling should be sought prior to pregnancy.

Tay-Sachs Disease

Another genetic disorder transmitted by matched recessive genes and impacting on the body's metabolic processes is Tay-Sachs disease. The disorder damages metabolism as a result of the absence of the enzyme hexosaminidase A in the cerebral tissues. Although not manifest at birth, it is usually detected between the eighth and twenty-fourth month, when the infant shows progressive muscle weakness, expressed in inability to roll over, to raise the head or torso, or to initiate movement. There is a lack of appetite and loss of sight and hearing. Death usually occurs between the second and fourth years. The disease typically is seen only those of Eastern European and Jewish ancestry.

Cretinism

This type of mental retardation results from a deficient secretion of the thyroid gland. The principal cause of it is a lack of iodine in the blood. Other causes may be operative: birth injury that produces bleeding into the thyroid gland; infectious diseases such as diphtheria, measles, and whooping cough; or occasionally a genetic defect causing the thyroid to be underactive. Public health measures taken both in this country and in most other countries affecting the distribution and use of iodized salt have largely eliminated absence of iodine as a cause of cretinism.

Environmental Causes

Environmental causes of mental retardation fall into three categories: those that operate in the prenatal environment; those resulting from injuries at birth; and postnatal causes.

PRENATAL CAUSES

There are two principal prenatal causes of mental retardation: 1) Viral or bacterial infections of the mother during pregnancy that are transmitted to the fetus through the placenta (protective membrane lining the uterus). Such infections create inflammation of the brain and degeneration of brain tissue. Rubella, or German measles, when contracted by pregnant women, although only a mild illness in the mother, with low temperature and a rash, can cause mental retardation when transmitted to the child. The danger to the fetus is greatest during the first three months of pregnancy. During that period, 50 percent of infected mothers transmit the disease to the fetus. The result, depending upon the severity and location of the resulting brain damage, can be mental retardation, sensory defects, and congenital heart disease. 2) Fetal alcoholic syndrome (FAS). This preventable condition results from use of alcohol during pregnancy. (Any consumption of alcohol during pregnancy is unwise.) Alcohol present in the mother's body acts directly on the child, causing brain damage and the possibility of various physical and mental anomalies. One of the effects can be microcephaly (development of a small brain). Microcephaly causes mild to moderate mental retardation. Apart from mental retardation, which is not always present in FAS, other symptoms are likely, including attention and academic problems, hyperactivity, and behavioral problems.

It is now estimated that FAS occurs in 0.2 to 1.5 of every 1,000 live births. The rate of children exhibiting fetal alcohol effects (a less severe syndrome) is even higher. That statistic indicates use of alcohol by pregnant women as one of the most common causes of organically caused mental retardation.

BIRTH INJURIES

A variety of conditions existing during the birth of a child can damage the brain and cause mental retardation. They include prolonged birth, which can deny the fetal brain necessary oxygen and inflict pressure on the head, and physical trauma. Birth injuries account for a relatively small fraction of organically caused mental retardation.

Among extremely low birth weight infants (born at 27 weeks gestation or less), approximately 48 percent show some signs of neurological problems. They range from later difficulty in learning to mental retardation. The lower the birth weight, the greater likelihood of mental retardation.

A tragic cause of brain damage after birth is child abuse. Statistics are lacking, but one authority suggests that child abuse should be considered a major cause of organic brain damage in children, which condition becomes mental retardation in many cases, especially among infants.

■ CARING FOR PEOPLE WITH MENTAL RETARDATION

Because 85 percent of individuals with mental retardation fall only marginally below the IQ requirement for classification within the normal range of intelligence (an IQ of 70 or above), and because an even

larger percentage of them, despite below-normal IQs, are able to adapt in simple environments, the goal of caring for those with mental retardation should be to bring them as close to normal living as their capacity (latent as well as manifest) makes possible. Considerations for doing that can be examined under three principal headings: the role of parents; society and public policy; and prevention and treatment.

The Role of Parents

Issues include the initial response of parents to the birth of a developmentally disabled child, problems of rearing, and dealing with emotional problems.

Initial Response

Disappointment and hurt in the hearts and minds of parents are the frequent, perhaps universal, greetings that meet children born with mental retardation. For the organically and severely retarded, with notable physical signs, that disappointment, undoubtedly accompanied by anguish for the child's illness, may appear early in the life of the child. For the mildly mentally retarded with no physical stigmata, the disappointment may come gradually as the child fails to meet benchmarks of normal development. The disappointment may be expressed in the way in which parents hold the child or talk to him or her.

Those initial responses are natural. What matters for the future of the child is what feelings follow that initial disappointment. Later responses are dependent upon characteristics of the parents themselves—their own feelings of self-esteem and adequacy, the state of their relationship, their socioeconomic status, the place of intellectual development in their value system, and, indeed, their own intellectual level.

Studies of parental reactions report certain responses to be common. 1) Parents may persistently deny that their child could be developmentally disabled. That denial can cause individuals to go from one doctor or psychologist to another, seeking a different opinion. 2) Parents may covertly feel guilt and/or anger. All sorts of past actions will be dredged up; in some cases, used to feed guilt; or in others, to fuel anger at a spouse. 3) Parents may feel that the retardation of their child is punishment for past misdeeds or sins.

The best resource parents can have is the comfort they can give each other; that, with the help of a professional counselor, clergyperson, or physician, can draw the parents back to their child and the love and care the child will need.

Caring for the Child

Professionals familiar with the needs of individuals with mental retardation and their special problems will point out to parents that the needs of their child are the same as the needs of the normal child: physical care and proper nutrition; love; and a relationship that builds the child's self-esteem and provides opportunity for social life as they grow. A need that is pressing for those with a developmental disability is the satisfaction of discovering what they can do for themselves. Achievements, although they may be at a lower level than those of siblings or typically developing children, are nevertheless rewarding; and a significant part of that reward is the pleasure parents find in their child and the special ways that are created to give recognition to such children for their accomplishments.

Parents face a problem in the achievement area; the achievements of children with mental retardation should be measured by a standard that is all their own. Achievement is an advance over previous behavior; simple things such as feeding themselves, learning to walk independently, and first efforts at communication. For those with mild retardation, as they approach school age, there will be learning to recognize the meaning in a picture, the interpretation of symbols, and then simple words. A big accomplishment will be in writing his or her name. The care parents must take is to encourage their child to stretch toward his or her potential, always on guard not to show disappointment at slowness and faltering steps the child will take toward more advanced behavior. There should not be pressure, but soft challenge, admiration, and pleasure, even when the child takes only half a step in the right direction.

When siblings are present, they, too, must be taught the proper standards for judging performance of a handicapped brother or sister. Yet the siblings' own efforts at growth and accomplishment must also be recognized. It is indeed a happy family when the disabled child and his or her typically developing brothers and sisters take pleasure in each other's different accomplishments.

Education

Choosing a school and knowing what to expect is an anguishing problem. Parents need preparation for this decision, as does the child. Schools in different communities and in different parts of the country vary widely in accommodating students with mental retardation. Parents will profit not only from talking to experts in the field but also from speaking with other parents of children with developmental disabilities, especially if their children are similar in adaptability and if parents have the reputation of doing a good job.

All public schools are now required to provide educational opportunities for all students, but many vary in the level and quality of services. As early as the 1920s, schools in some parts of the country set up special classes for students with mental retardation. In New York City, for example, they were called Classes for Those of Retarded Mental Development (CRMD). A twofold problem existed: Such classes did not exist countrywide, and there was no legal requirement that such children attend classes. In 1975, Congress passed Public Law 94-142, which mandated for every citizen under the age of twenty-one free public education matching the student's abilities or handicap.

For handicapped children, including those with mental retardation, teams of educators, including administrators, psychologists and teachers, now develop for each child an individualized educational program (IEP). Once the group has approved the program, it is committed to writing. The school system is then required to provide the necessary resources. Progress reports are submitted periodically to the original committee for whatever additional recommendations they consider necessary.

Unfortunately, as educational resources are strained, the standards of what must be provided are often lowered. The Supreme Court, in the case of a deaf child seeking a sign-language interpreter (the Rowley decision), has supported the school district's right to determine "a basic floor of opportunity" in its educational programs. Going beyond that to achieve higher levels of academic performance is a matter for the school system (and ultimately the community) to decide.

Emotional Problems

The life of a child with mental retardation, even in a home with caring parents, is every bit as much emotionally trying (if not more so) than that which most children experience. It is no surprise, then, that individuals with mental retardation suffer psychological disorders, from anxiety-based disorders to schizophrenia, too. Parents of children with mental retardation can expect "down" periods that can approach depression, feelings of inadequacy, and apprehension about venturing into new environments. More serious disorders—schizophrenia, alcoholism, or severe behavior disorders—occur in the disabled at a level of 10 to 40 percent.

Parents who have come to accept the developmental disability of their child may find the additional burden of emotional problems that develop as the child grows older a heavy burden, indeed. There is help to be found. Increasingly, professionals who specialize in the field of mental retardation are coming to recognize that it is in the mental health area particularly where they can be especially helpful to parents. As a result, mental health centers tailored for the developmentally disabled are now available in most metropolitan areas across the country.

As the individual with mental retardation approaches adolescence, emotional problems may become more acute, for the child and for the parents. Now the need for increased independence and peer contact,

male and female, becomes more important; physical changes bring on sexual urges. It will be easier for the parent to deal with such problems if he or she has learned how to deal with the intellectual problems. The same common sense, prudence, and supervision that parents of typically developing children must use are also useful in responding to the adolescent with mental retardation. With such children, it all requires a lot more time and greater attention.

Challenges of Adults with Mental Retardation

As a result of the changes in social policy and the changes in social attitudes affected by that policy, it is now easier for adults with mental retardation, especially those with only mild or moderate levels of retardation, to solve problems of adult adjustment, the principal ones of which are independent living, employment, and the possibility of marriage.

Independent Living

Beginning in the 1960s, the establishment of small residential centers for groups of adults with mental retardation now provides one of the most helpful resources for the parents of those with developmental disabilities. Here, in locations close to the homes of the residents, it is possible to offer a family atmosphere and some sense of independence with whatever level of supervision is necessary. The centers, at their best, offer three levels of care: supported living arrangements, in which residents work during the day in sheltered settings and return to the center in the evening; centers that provide community living facilities and 24-hour supervision; and for the severely retarded, small-scale nursing-home-type care. Yet, a large number of the most severely retarded must still be provided mainly custodial care in large hospitals, partially due to medical needs.

Employment

Perhaps the greatest progress in helping adults with mental retardation to live an independent existence is in the area of employment. Their right to employment is now protected by both federal and state laws. Many of those with mild mental retardation work in industrial settings at regular wages; others find employment in sheltered settings, where speed and complexity of job is set to match their capabilities.

Marriage and Parenting

In the past, stable romantic relationships between adults with mental retardation were discouraged, marriage was forbidden, and involuntary sterilization was practiced in many states. A more tolerant attitude now exists, with recognition given to the rights of the individuals to set up appropriate romantic or sexual relationships consistent with their ability and desires.

■ SOCIAL ATTITUDES AND PUBLIC POLICY

For much of the first half of the twentieth century, neglect and denial dominated society's attitudes toward those with mental retardation, and there were few laws protecting their rights. Improvement in those attitudes and passage of federal and state laws came as an extension of the civil rights movement of the 1960s and 1970s. The National Association for Retarded Citizens (NARC) was formed to protect the interests of persons with mental retardation. A major advance was the Alabama federal court decision (Wyat v. Stickney) mandating an individualized treatment program for each person hospitalized with mental retardation, skilled staff to administer such treatment, and a humane psychological and physical environment. Although governing only hospitals in Alabama, the decision provided a precedent for other hospitals, and they moved ahead to implement the decision.

The result of those efforts has been the establishment of a policy platform of human rights for individuals with mental retardation that has molded programs of care and reshaped social attitudes. This platform asserts that, as human beings, persons with mental retardation have the right to be protected from abuse of any sort, to receive an education individually customized, and to live in the least restricted environment appropriate to their adaptive capacities. If institutionalization is required, the institution is mandated to provide continuing treatment. Beyond those basic principles, social policy now vigorously encourages independent living, service programs that are individualized, a system of reports to indicate progress, and mainstreaming the individual in school, employment, and social life as fully as is possible or desired by the individual or his or her parents. A more recent policy development is the supreme court's abolition of the death penalty for crimes committed by individuals with mental retardation.

SUMMARY

Mental retardation affects approximately 1 percent of the population. Some individuals with mental retardation live only a few years after birth, and others die early in adulthood. The DSM-IV-TR recognizes four levels of retardation: mild, with IQs ranging from 50 to 70; moderate, with IQs of 35 to 49; severe, with IQs of 20 to 34; and profound, with IQs below 20.

There are two major types of mental retardation, separated on the basis of etiological factors. They are as follows: 1) cultural/familial retardation, in which causation is judged to be a result of environmental deprivation during early upbringing, and the possibility of hereditary influences; and 2) organically related mental retardation. The cultural/familial type of retardation accounts for the majority of those with mild retardation. Organic factors are operative in 25 percent of the population with mental retardation.

Organically caused mental retardation may result from genetic abnormalities, metabolic abnormalities, or environmental influences, such as birth injuries or brain injuries. The principal types of organic retardation are Down syndrome, phenylketonuria (PKU), Tay-Sachs disease, and cretinism. Fetal alcohol syndrome, related to alcohol consumption during pregnancy, causes the development of a small brain (microcephaly). Children of such pregnancies are usually at least mildly developmentally disabled.

In recent years, as a result of both federal and state court decisions, attitudes toward persons with mental retardation have changed; and with that change have come major improvements in the type of care mandated for those with developmental disabilities. An important outcome is the establishment of a policy platform of the human rights of people with mental retardation. That platform now shapes policies in schools, hospitals, employment, and social life.

SELECTED READINGS

Ainsworth, P. & Baker, P. C. (2004). Understanding mental retardation. Jackson, MS: University Press of Mississippi.

Cegelka, P. T. & Prekin, H. J. (1982). Mental retardation: From categories to people. Columbus, OH: C. E. Merrile.

Drew, C. J. & Hardman, M. L. (2003). Mental retardation: A lifespan approach to people with intellectual disabilities (8th ed.). Upper Saddle River, NJ: Prentice Hall.

Kupfer, F. (1998). Before and after Zachariah: A family story about a different kind of courage. Chicago: Academy Chicago Publishers.

Simon, R. (2003). Riding the bus with my sister: A true life journey. New York: Plume.

Test Yourself

- 1) The prevalence of mental retardation is
 - a) 0.2 percent
 - b) 1 percent
 - c) 5 percent
 - d) 9 percent
- 2) Organic mental retardation is more common than cultural/familial. True or false?
- 3) According to the DSM-IV-TR, severe mental retardation is defined as having an IQ of:
 - a) 50 to 70
 - b) 35 to 49
 - c) 20 to 34
 - d) 0 to 19
- 4) Mild mental retardation accounts for 50 percent of all cases of the disorder. True or false?
- 5) Which of the following is/are a cause(s) of cultural familial mental retardation?
 - a) environmental deprivation
- c) phenylketonuria (PKU)

b) Down syndrome

- d) all of the above
- 6) According to federal law, students with mental retardation need to be educated in separate schools from children without mental retardation. True or false?
- 7) It is not possible for individuals with mental retardation to have other psychological disorders. True or false?
- 8) Many individuals with mild mental retardation live and work in the community with intermittent or limited support. True or false?

Test Yourself Answers

- 1) The answer is **b**, 1 percent. Approximately 1 percent of Americans meet diagnostic criteria for mental retardation. There is some variability across countries, but the world-wide average is similar.
- 2) The answer is **false**. Organic mental retardation (retardation due to biological causes) only accounts for 25 percent of all cases of mental retardation. The rest are cultural/familial.
- 3) The answer is c, 20 to 34. In the DSM-IV-TR, levels of mental retardation are defined by IO test scores. Some object to this method of classification as being arbitrary and deficits-focused, but as it currently stands, the DSM defines severe mental retardation as an IQ of 20 to 34, with significant impairment in daily living activities occurring prior to the age of 18.
- 4) The answer is false. Mild mental retardation accounts for 85 percent of all cases of mental retardation. 10 percent of cases are moderate, 3-4 percent are severe, and 1-2 percent are profound.
- 5) The answer is a, environment deprivation. Environmental deprivation and inherited lower cognitive ability are causes of cultural/familial mental retardation. Down syndrome, phenylketonuria, and other disorders are examples of causes of organic mental retardation.
- 6) The answer is false. Federal law requires that public school systems provide an education appropriate to abilities for all citizens under 21. There are no specifications about separate schools. In fact, the law indicates that all individuals deserve to be educated in the least restrictive environment suitable. For children with mild mental retardation, this might mean mainstreaming; that is, providing supports for the students to be successful in a general education environment. However, subsequent to a push for mainstreaming, many now advocate making educational decisions on an individual basis considering the child's abilities and preferences and the parents' wishes.
- 7) The answer is **false.** Depending on the study methods, research has found prevalence rates of psychological disorders of 10–40 percent in individuals with mental retardation.
- 8) The answer is **true.** A number of individuals with mild mental retardation live independently and work in jobs that fit their cognitive level. Some individuals with mild mental retardation require limited support such as community living arrangements or specially tailored work places. However, many individuals with mild mental retardation are capable of a significant degree of independence.

Abnormal Behavior of Children and Adolescents

ensitivity to the differences between childhood psychological disorders and adult psychological disorders is a fairly recent development. Early theories tended to view children as small adults and did not recognize the cognitive and emotional differences between the two age groups. The developmental processes of childhood and adolescence had not been studied closely, and it was therefore difficult to achieve an accurate understanding of what constituted normal and abnormal behavior for children.

Since that time, theorists have acknowledged those processes, and substantial progress has been made in the study of childhood disorders. This increased understanding has led to improved treatment for children and to a more meaningful classification system for maladaptive behaviors. This is reflected in the difference between the DSM I, published in 1952, and the DSM-IV-TR, published in 2000, which is much more comprehensive in its description of conditions affecting children and adolescents. The need for this increased attention to abnormal childhood disorders is indicated by their prevalence, which most experts place at 13.3 percent of all children in the United States.

■ SPECIFIC DIFFICULTIES IN STUDYING CHILDHOOD DISORDERS

Three possible difficulties in studying childhood disorders are considered here: the influence of adults; developmental considerations; and defining "abnormal."

The Influence of Adults

It is impossible to understand a child's behavior without understanding the role of the important adult figures in the child's life. Children rarely seek help for their psychological problems on their own, so it is up to adults to act on behalf of the child. Parents, other relatives, and school personnel are the obvious key people. Parents can be reluctant to seek help for their child because they may feel that any problems reflect upon their ability as parents. They often view the difficulty as a phase through which the child is going, with the expectation that the child will soon outgrow this stage. This is particularly true of the less impairing disorders such as fears, simple phobias, and social anxiety. Sometimes, however, too much parental intervention can be a problem. By focusing undue or excessive attention on a difficulty, parents can exacerbate a problem that might be only transitory.

The start of school is frequently the time when a child's psychological problems are first recognized. One reason for this may be that behavior that is acceptable at home cannot be tolerated in a school set-

ting. Attention-deficit hyperactivity disorder (to be discussed in the "ATTENTION-DEFICIT AND DIS-RUPTIVE BEHAVIOR DISORDERS" section) is an example of this type of problem. Furthermore, teachers and other educational personnel are exposed to a broad range of children and can use this exposure, in addition to their training and experience, to assess abnormal behavior.

Developmental Considerations

The behavior of children must be evaluated within the developmental context in which the behavior occurs. Normal development involves the interaction of three areas of individual functioning: the cognitive-intellectual; interpersonal and emotional; and physical-motor areas. Development proceeds in these areas, with one improvement building upon an earlier improvement. Difficulties or disruptions at one stage can lead to more serious problems at a later time. It is therefore important to recognize and treat any developmental abnormalities as early as possible. A complicating factor in this process is that children often develop at varying rates, and it is often difficult to differentiate between what is just slow development and what is abnormal behavior.

What is "Abnormal"?

In most cases, the differences between normal and abnormal behavior are not as clearly defined in children as they are in adults. All children, at times, display maladaptive behavior, such as bedwetting or temper tantrums. Such behavior may be a result of specific stress and be a normal response to that stress for a child at a certain developmental stage. Most theorists in this area state that any behavior should be viewed as a problem if it occurs repeatedly and interferes seriously with the child's, or another person's, functioning. Experts in childhood psychological disorders carefully compare the intensity, frequency, and duration of problematic behavior to other children of that age or developmental level when deciding what is pathological and what is difficult but not atypical childhood behavior.

Classifying Children's Disorders

Until relatively recently, diagnosis and classification of the psychological disorders of children have been a woefully neglected and confused area of abnormal psychology. For example, the first Diagnostic and Statistical Manual, issued in 1952, listed only two categories of children's disorders: childhood schizophrenia and a catch-all type of category that was labeled "adjustment reaction of childhood." Neither of these are diagnostic categories in the current DSM.

The DSM-IV-TR now lists ten categories of children's disorders: mental retardation (discussed in Chapter 18); learning disorders; motor skills disorders; communication disorders; pervasive developmental disorders; attention-deficit and disruptive behavior disorders; feeding and eating disorders of infancy or early childhood; tic disorders; eliminatory disorders; and other disorders of infancy, childhood, or adolescence. The major disorders within these categories are discussed in this chapter.

ATTENTION-DEFICIT AND DISRUPTIVE BEHAVIOR DISORDERS

Under this heading, the DSM-IV-TR lists three subtypes of disruptive behavior: attentiondeficit/hyperactivity disorder (usually abbreviated as ADHD); conduct disorder (CD); and oppositional defiant disorder (ODD). All have in common the child's infringement on the rights of and disturbing others.

Attention-Deficit/Hyperactivity Disorder

Behavior of the ADHD child is troublesome to parents and teachers and can cause distress for the child experiencing it. Because of its disruptive effect in the classroom, it is a frequently used (perhaps overused) diagnosis.

Symptomatology

The behavior of children diagnosed as having attention-deficit/hyperactivity disorder is characterized by impulsiveness, inattention, and/or physical hyperactivity that is inappropriate for the child's age. ADHD is divided into three subtypes: predominately inattentive; predominately hyperactive/impulsive; and combined. The predominately inattentive type is diagnosed more frequently in females and adults. These highly distractible children have difficulty remaining still and will race from one activity to another. Nothing seems to hold their attention for very long. They frequently act with little thought of the consequences of their actions and are disruptive when engaged in social activities. In the classroom, they often do not attend to directions, are frequently out of their seats, and will call out at inappropriate times. In school, these children frequently perform below their cognitive abilities and often exhibit specific learning disabilities. Because of their poor scholastic achievement and social difficulties, children with ADHD often display low self-esteem. In addition, their relationships with their parents frequently are strained by their inability to follow rules and their high level of motor activity.

One study (Anderson et al., 1987) reports the prevalence of this disorder at about three to five percent of all preadolescents. As with many childhood disorders, the number of boys diagnosed as ADHD greatly exceeds the number of girls receiving this diagnosis.

Prognosis

There has been controversy regarding the course of ADHD as children mature. In girls, a decrease in observable hyperactive behavior is frequently seen, but restlessness, inattention, and impulsivity may continue. Additionally, many individuals with ADHD still experience symptoms in adulthood. Although outward behavior changes, there are subtler signs and the internal experience of inattention, hyperactivity, and impulsiveness.

ADHD has been correlated with other disruptive behaviors that may continue through life. Many researchers believe that when evaluating long-term prognosis, it is important to differentiate between subjects who exhibit pure ADHD symptoms and those who also display aggressive symptoms. A study by Satterfield (1982) initially demonstrated that hyperactive boys were twenty times more likely to be in trouble with the law than was a sample of "normal" boys. He then divided the hyperactive group into two subgroups, one with aggressive symptoms and one without, and determined that the nonaggressive group had no more legal problems than did the normal population.

Additionally, research suggests that children with ADHD are at increased risk for substance abuse. However, with appropriate treatment of ADHD, that risk decreases significantly. Hence, it appears that children with ADHD are not homogenous. Presence of more symptoms than necessary to make a diagnosis and lack of appropriate treatment appear to be associated with less adaptive outcomes. Conversely, with appropriate treatment and support as needed throughout life, adults with ADHD typically are successful.

Causes of Attention-Deficit/Hyperactivity Disorder

No one definitive cause of ADHD has been discovered. There is evidence (Greenhill, 1990), however, for a biological basis for ADHD. The study determined that participants with ADHD utilized 12 percent less glucose, a source of fuel for the brain, than did non-ADHD participants. The brain area most deprived of glucose was an area associated with attention and motor control, which are the central problems of ADHD children. Subsequent research also implicates lowered activity levels in the parts of the brain responsible for behavioral inhibition. This seems to fit with findings of the effectiveness of stimulant medication, which increases activity in these areas.

Another possible factor is a genetic, or hereditary, basis. ADHD is more common in family members of individuals with the disorder. From this research, a possible genetic basis for the disorder is hypothesized.

Treatment

There are two main treatment approaches for ADHD. These are pharmacological and psychosocial.

THE USE OF MEDICATION

The use of drugs to treat the symptoms of ADHD is probably the most common form of treatment. The drugs most frequently used are central nervous stimulants such as Ritalin and Dexedrine. Studies (for example, Ottenbacher & Cooper, 1983) indicate that these drugs achieve their results without impairing the child's cognitive abilities. School performance is often improved. Not all children with ADHD respond to stimulant medication; about 35 percent of this population receive no benefits. Some researchers believe that those children who also exhibit symptoms of conduct disorder in addition to ADHD are also those who are least likely to benefit from medication. Some children who do not benefit from stimulant medication improve with the use of a newer, nonstimulant ADHD medication, Strattera. This medication also is helpful for children who experience significant negative side effects from stimulant medication.

There are many critics of the use of drug therapy. Gadow (1986) questions the long-term benefits of medication, especially when underlying psychosocial causes of the disorder are neglected. In most instances, when the medication is discontinued, the symptoms reappear. A troublesome result of medication is the physical side effects they produce, such as insomnia, slowed growth, and impaired appetite. These side effects occasionally result in parents opting for "medication vacations," where the child is not medicated during times when school is not in session. Furthermore, the long-range physical effects of these medications upon children have not been studied fully.

PSYCHOSOCIAL THERAPIES

The use of behavior modification techniques has proven slightly helpful in the treatment of ADHD. These include token economy systems, which involve providing a clear explanation of expected behavior to the child, and then a tangible reward system for satisfactory performance. Behavior modification systems have achieved some positive results (Barkley et al., 2002). A criticism of this technique is that it can have a negative impact on the child's belief that he or she can control his or her own behavior (Horn, 1983). Furthermore, there is evidence that children with ADHD respond less positively to consequences (the basis of behavior modification) in comparison to their nonaffected peers.

Frequently, behavioral therapy focuses not on ADHD, but on the surrounding challenges, such as self-esteem, social relations, and academic difficulties. In these cases, therapy provides skills training and support, which cannot be attained from medication alone. For example, social skills training has been shown to improve appropriate assertive behavior in children with ADHD (Antshel & Remer, 2003). Parent training has been used to teach parents how to effectively support their children and has resulted in improved behavior in children with ADHD (Anastopoulos & Farley, 2003). Many researchers report that the use of drug therapy, in conjunction with behavioral techniques, is most effective in treating ADHD and its associated difficulties (Gittelman-Klein et al., 1980).

Conduct Disorder

This diagnosis is considered a more extreme type of disruptive disorder than ADHD and includes antisocial and delinquent behavior.

Symptomatology

The DSM-IV-TR defines conduct disorder as "a persistent pattern of conduct in which basic rights of others are violated or major societal norms are violated." The characteristics include problems at home and in school and the destruction or theft of the property of others. These children often are involved in

physical fights and are at increased risk for developing early substance abuse and precocious sexual activity. It is not unusual for a child with conduct disorder to suffer from emotional problems, particularly depression.

Estimates of prevalence rates vary, but are 6 percent to 16 percent for boys and 2 percent to 9 percent for girls. For some individuals with conduct disorder, the onset is in childhood and tends to be gradual. For others, the onset is in adolescence and tends to be more acute.

Prognosis

Unfortunately, conduct disorder often persists into late adolescence and adulthood. One study (Kazdin 1987) reports that children with conduct disorder in many cases continue the pattern of criminal activities later on as adults. As adults, they have difficulty maintaining employment and frequently experience marital problems. Another study reports that a child diagnosed as conduct-disordered is significantly more likely to become an alcoholic or to develop antisocial personality disorder as he or she grows older than are children with other emotional problems (Rutter & Garmezy, 1983).

Many theorists believe that the diagnosis of conduct disorder more accurately predicts impaired adult functioning than does any other factor or diagnosis, except for childhood psychosis or developmental disabilities.

Causes of Conduct Disorders

The family environment is viewed as an important factor in the development of conduct disorders. These families are often disrupted by marital problems, emotional instability, and inconsistent displays of affection and support. Discipline is often inappropriate and is characterized by particularly harsh or extremely lenient methods. Patterson (1986) addressed the matter of disciplining techniques in a study of children with conduct disorder. His results indicated that the parents of these children were inconsistent in punishing misbehavior and failed to teach skills necessary for social and academic success.

Another social factor in conduct disorder is peers. Children with conduct disorder tend to have peers who engage in delinquent behavior. It is difficult to tease out whether one causes the other, but it is clear that an antisocial peer group can serve to maintain conduct-disordered behavior.

There is some support for the role of genetic factors in the development of conduct disorders. Mednick (1986), in a comprehensive study of more than 14,000 adopted children, concluded that adopted children are more likely to have engaged in criminal behavior if their biological parents were criminals, even if they had never lived with their biological parents.

Treatment

Because family influences are important in the development of this disorder, many treatment methods focus on treating the family unit. These include teaching effective parenting techniques and family therapy to reduce discord in the home. Given the problems and stresses in many of these families, this approach has had limited success.

Educating the child with conduct disorder in the use of cognitive-behavioral skills is another treatment approach. These skills include the identification of problems, the use of self-statements to modify behavior, and the development of more appropriate behavior. The method appears to be more effective with preadolescent children. Generally speaking, earlier intervention is correlated with greater success.

It often becomes necessary to remove the child with conduct disorder from the home and place him or her in a residential treatment setting. This is most common with adolescents. Many of these settings utilize behavior management techniques and control the child's complete environment. The child must comply with rules and demonstrate appropriate behavior in order to achieve specific privileges and rewards. It is also important, through the use of various methods such as role playing, to teach new ways of behaving and important social and academic skills. Unfortunately, the effects of such treatment facilities tend to fade after discharge.

Currently, the most effective (and cost effective) treatment for conduct disorder is a multimodal approach. There are a number of such programs that provide intensive, multimodal services, including in-home family therapy, individual therapy, collaboration with school staff and legal authorities, and interventions in the community. By intervening in all of the areas that contribute to or support conduct disordered behavior, changes are made. However, earlier intervention is still more effective than waiting for problems to escalate.

Oppositional Defiant Disorder

The diagnosis of ODD is used for children who show negative, argumentative, or hostile behavior. Such children lose their tempers frequently, object to directions, and ignore rules. The behavior is most frequently expressed in family settings, but may also be carried over to school or other settings involving authority figures. Occasionally, the child will be relatively subdued at home and act out his or her disruptive behavior only elsewhere, usually in the classroom.

Unfortunately, without successful treatment, children with oppositional defiant disorder frequently go on to develop conduct disorder. Treatment of oppositional defiant disorder typically focuses on increasing warm, positive interactions with parents and guiding parents in developing consistent, effective discipline strategies.

EMOTIONAL DISORDERS

Emotional difficulties exhibited by children differ in several ways from disruptive disorders. Children with emotional disorders rarely cause difficulties for others. The incidence of emotional disorders is about equal for boys and girls in childhood and becomes more common in girls during adolescence, as opposed to disruptive behavior disorders, which are more common in boys.

Children are subject to a variety of disturbing emotional disorders, some of them similar to adult psychiatric illnesses; for example, depression, anxiety disorders, and even preoccupation with bodily symptoms, as in hypochondriasis (see Chapter 10). However, children typically do not have the insight into the disorders expected in adults. For example, children typically do not acknowledge the irrationality of their phobias. Furthermore, children's expressions of mood states may vary; for example, children may express depressed affect through irritable behavior rather than verbal reports of feelings of sadness. It also is important to note that children continue to act like children, even when experiencing emotional disorders. That is to say, children with depression often will still play—this is simply typical child behavior, not a sign that everything is going fine for the child.

In the following sections, we consider emotional disorders to which children may be subject: separation anxiety; fears and phobias; and reactive attachment disorder.

Separation Anxiety Disorder

Some degree of emotional pain at being separated from parents is shown by many children, especially in close-knit families in which the child has developed an emotionally dependent relationship with his or her parents. However, when excessive anxiety, to the point of panic, that is not age appropriate is shown by the child, he or she is said to be suffering from a separation anxiety disorder. Extreme manifestations of the illness are shadowing the parent around the house, refusing to stay alone in a room at home, extreme difficulty in falling asleep without a parent being in the same room, and the appearance of physical symptoms when threat of separation from parents exists. Physical symptoms may range from stomach disorders to heart palpitations and dizziness. The DSM-IV-TR comments that the disorder is "apparently not uncommon," occurring among 4 percent children and young adolescents. They also report it as much more common in girls than in boys.

Antianxiety medications can be used to treat children; however, there are less invasive strategies that tend to have better long-term results with less risk of side effects. Such behavioral therapies as modeling and systematic desensitization are considered helpful psychotherapeutic approaches (see Chapter 8).

Fears and Phobias

Fearfulness about many things is a common problem in childhood. There are three age periods during which specific kinds of fear are most characteristic: 1) Preschool children often develop fears of insects and animals; for example, spiders and dogs. 2) During preadolescence, their fears shift from the concrete and visible to the hidden and imaginative; for example, in the dark, frightening shadows may be imagined as ghosts or hidden, perhaps murderous villains. During this period, there also may be fears of possible disasters in elevators or airplanes or severe weather. 3) Soon after puberty, when social life becomes important, their fears come closer to resembling those of insecure adults; they worry about not being accepted by "the group" and fear new social situations. They may also suffer lowered self-esteem and develop concern about their self-identity.

Unless those emotional reactions seriously disrupt a child's functioning, they can be dealt with by parental understanding and reassurance. Rational explanations and protected direct experiences with the encouragement of parents and the support of childhood friends can reduce the intensity of the child's fears.

When the fears are disabling, professional help may be needed. Anderson and colleagues (1987), in a comprehensive discussion of children's disorders, report that 2 to 3 percent of children develop real phobias. The most effective therapy is modeling in imitation of other children of the same age, who may or may not be friends. With adolescents, the therapist may attempt systematic desensitization (see Chapter 8).

Reactive Attachment Disorder

Reactive attachment disorder is one of the few diagnoses in the DSM with a specified etiology. The disorder is characterized by a failure to form appropriate attachments due to grossly pathogenic care. The failure to form appropriate attachment is evidenced in disrupted social relationships that follow one of two patterns: diffuse bonds, indicated by indiscriminate affection that does not result in a true attachment; or avoidance of bonds, which may result in hypervigilant, ambivalent, disorganized, or inhibited social relationships. Pathological care can result from physical or emotional neglect or frequent changes in caregivers. In order to meet diagnostic criteria, the onset of symptoms must be prior to the age of five.

The disorder is relatively rare. Without intervention, difficulties persist throughout life. With early support and appropriate care, much improvement can be seen. However, treatment after early childhood becomes very difficult and has low success rates.

SPECIFIC SYMPTOM DISORDERS

Here are grouped a number of behavior disorders that have in common three characteristics: 1) the disorder is expressed in a single symptom and does not usually involve a pervasive maladaptive pattern of behavior; 2) that symptom is a troublesome physical expression in the eliminatory function in speech, motor behavior, or eating; and 3) most often, the symptom is troublesome to the individual because it tends to embarrass him or her and bring on social tensions that interfere with the young person's normal development.

In the following sections, we discuss briefly the eliminatory problems of enuresis and encopresis and selective mutism.

Eliminatory Problems

There are two: enuresis, which is urinating in clothes or bed; and encopresis, which is having bowel movements in culturally inappropriate ways.

Enuresis

Involuntary voiding of urine may occur in the daytime or at night. Occasional involuntary daytime voiding, often referred to in the family as "an accident," is common soon after the child has been toilet trained, most often when the child is absorbed in a pleasant activity that the he or she chooses not to leave or during a time of emotional or otherwise exciting play. Enuresis is not diagnosed until symptoms have been present for three months and the child is at least five.

Frequently in enuresis, the problem is nighttime bedwetting (nocturnal enuresis). Enuresis is more prevalent among boys (7 percent), double that of girls at early ages (five or six years of age). It remains higher, at a diminishing rate, through young adulthood.

Causes of Enuresis

Beyond physical causes or urological problems, a couple of psychological factors have been associated with enuresis. None is given special prominence. Among possible causes of enuresis are: 1) regression on the birth of another child; 2) frequent emotional upheavals in the child's home life; 3) faulty learning experiences.

TREATMENT APPROACHES TO ENURESIS

Two notably successful treatment programs are available to the parents of the child with enuresis. The first and simpler method, commonly referred to as the bell-and-pad technique, was developed by Mowrer in 1938. It requires a special bed pad that, when moistened by the child's urine, sets off a loud signal, waking the child and sending him or her off to the toilet. Smaller alarms that are placed in a pocket attached to the child's underpants also are available.

The second method uses a form of aversive therapy and requires only a very short training period, usually less than a week. Azrin and colleagues (1974), who developed the program, prefer that an outside trainer rather than the parents implement the program. Before any training, the dry bed program is explained to the child and parents. In phase one, the child drinks a preferred beverage, lies down in his or her bed, and counts to fifty; then, in an unhurried fashion, the child walks to the toilet and tries to urinate. After several such trials, in phase two, the child is given more to drink and told that he or she will be awakened hourly to urinate. Accidents result in the child being required to change the sheets and to begin training all over again. In the Azrin report on outcome, the group reports that all trained children were continent for at least six months after four nights of training. In both behaviorally oriented therapies, a success rate of 90 percent has been regularly reported.

Medication is sometimes used to treat enuresis. There are several different types of medications that may be used with each having a different method of action. They do have the effect of preventing urination during the night while in use. However, enuresis typically returns upon stopping the medication.

Encopresis

A habit disorder that is much less common than enuresis, encopresis is said to exist if a child older than four years passes feces in inappropriate places, including his or her clothing, at least once a month for 3 or more months. The problem occurs in 1 percent of five-year-olds, more frequently in boys than in

When involuntary rather than deliberate (a determination that is not always easy to make), the cause may be constipation or a tendency to retain fecal matter. When it is deliberate, there is the possibility of oppositional tendencies or even more severe pathology. Whether involuntary or deliberate, a physical examination is in order to identify any organic problem that may be present.

Inconsistent or overly rigid toilet training or painful constipation may contribute to development of this problem. Although there is a paucity of research on encopresis, Levine and Bakow (1975) do report a better than 50 percent success rate when they combined medical and behavioral therapy. Frequently, treatment focuses on alleviating constipation and helping the parent to implement a behavior plan to reward the child for bowel movements in the toilet. The DSM-IV-TR reports laconically that the disorder "rarely becomes chronic."

Selective Mutism

As a child grows beyond infancy, speech becomes a principal tool in the child's developing social life. When speech is seriously impaired, there will be upsetting limitations in the child's social life; and when that impairment persists to school age, it can impair classroom performance. In the case of selective mutism, the child is able to speak, but does not do so in specific social situations. This must occur for at least one month, causing significant impairment, and not be due to language difficulties. The disorder is rare. It is typically treated through behavioral interventions that shape and reward talking in the situations where it had not been occurring.

■ PERVASIVE DEVELOPMENTAL DISORDERS

Developmental disorders are some of the most serious of psychiatric disorders affecting children. They have a pervasive effect on every aspect of the child's behavior and do not go away with time or treatment. The two principal classes of developmental disorders are mental retardation (discussed in Chapter 18) and pervasive developmental disorders. Pervasive developmental disorders include such conditions as autistic disorder and Asperger's Disorder.

Autism

Among the saddest and most devastating of the childhood disorders is autism. Fortunately, it is a relatively rare disorder; two to five children in ten thousand develop autism. Onset is very early in the life of the child and is indicated by a marked delay in motor development and a failure to show responsiveness to physical affection.

Because of its extreme impact on a child's behavior and the disheartening plight of the parents of a child with autism, researchers in the field of childhood behavior have devoted considerable research effort to understanding its etiology. Despite that effort, there is much yet to be learned about causative factors. Treatment is most uncertain, although certain therapies, largely behavioral, have been found somewhat effective in reducing the more extreme symptoms of autism. The DSM-IV-TR reports that one child in six of those affected will make an adequate social adjustment and will be able to do some kind of regular work by adulthood; another one in six makes only a fair adjustment; but two-thirds remain severely handicapped and are unable to lead independent lives.

Leo Kanner (1971), who specialized in the treatment of autism, offers this plaintive portrait of a child with autism as he appeared in the doctor's office: "He wandered aimlessly about for a few moments, then sat down, uttering unintelligible sounds, and abruptly lay down, smiling. Questions and requests, if reacted to at all, were repeated in echolalic fashion. Objects absorbed him, and he showed good attention in handling them. He seemed to regard people as unwelcome intruders. When a hand was held out before him so that he could not possibly ignore it, he played with it as if it were a detached object. He promptly noticed the wooden form boards and worked at them spontaneously, interestedly and skillfully."

The remainder of this section considers the symptomatology of autism, the present status of our understanding of its etiology, and therapies used for the treatment of autism.

Among children with autism, 75 percent are mentally retarded, many severely so, with IQs below 50. The DSM-IV-TR lists six diagnostic criteria, the first of which is onset before three years. A description of the other criteria follows:

- 1. **Disturbance in relating to others:** Children with autism demonstrate significant problems with non-verbal behavior, do not develop age-appropriate peer relationships, do not spontaneously seek to share experiences with others, and seem to lack the interest or ability for bidirectional social and emotional relationships. One father describes his child's behavior in this sentence: "When Robert turned to you, he looked through you as if you were transparent" (Kaufman, 1976, p. 11). A particularly disconcerting aspect of their behavior is their unwillingness (perhaps inability) to maintain eye contact. Some of the least handicapped children later on develop a sham and deceptive sociability; for example, they may run along with a group of other children, but they nevertheless remain aloof from them.
- 2. **Delayed language development.** About 50 percent of children with autism remain mute or use only three or four necessary phrases, which may later disappear. The remaining 50 percent of the autistic group are limited to echolalic expression, repeating words someone has said to them in parrot-like fashion. There is difficulty in sustaining conversations and lack of pretend or imitative play. Children with autism often confuse pronouns; for example, using "you" for "I." Parents must learn that repeating the parental question, "Do you want your dinner?" means "Yes, I do." Children who have autism may use parts of an object or event for the whole, referring to dinner, for example, as milk. When they do use words or react to them, they will be very literal in their usage. Their language may be allegorical, such as the use of a prohibiting command learned from parents; for example, "Don't crayon the walls," as a universal expression for "No" or "Don't do that." Speech may be high-pitched and monotonous, with inappropriately emphasized words. Idiosyncratic or odd responses to the environment are common.
- 3. Restricted movements, behavior, and interests. Included are tiptoeing around the room, sudden starts and stops, flapping of their arms, body rocking or whirling, head rolling, and playing with their fingers pulled up close to their eyes. Objects may be endlessly twirled or fingered in detail. Children with autism may play with pieces of a game but actually play no game. They may develop peculiar attachments to inanimate objects; for example, carrying around a toy mechanized truck as a normal child might carry around a cuddly teddy bear, or exhaustively fingering a light switch. With surprising perceptual acuity and spatial memory, children with autism will order and reorder their world to maintain things as they were, frequently going into temper tantrums when changes caused by others are first noticed. The need for sameness may carry over to the food they choose to eat, the toys with which they play, and the arrangement of their room or bed. Often there is an intense focus on parts of objects rather than the whole.

Asperger's Disorder

Asperger's disorder is occasionally referred to as a milder version of autism. It is associated with interpersonal difficulties and restricted patterns of interests seen in autism, but there is no language delay. Furthermore, most individuals with autism have significant cognitive deficits; conversely, those with Asperger's disorder tend to have average or even above average cognitive abilities.

Causative Factors in Pervasive Developmental Disorders

Little is known about the etiology of autism. There is evidence of a biogenic cause, in particular genetic factors in pervasive developmental disorders.

Biological Differences

Research indicates a wide variety of neurological factors loosely associated with autism. For example, there has been some evidence of abnormal levels of serotonin, seizures, higher rates of abnormal

brain waves, and signs of general neurological difficulties. Also, unusually large brain size (5-10 percent) in toddlers-not always evident at birth and only sometimes in adolescence-has been suggested as a possible correlate of autism (see for example, Fombonne et al., 1999; Volker et al., 2004). General signs of neurological difficulties also are seen in Asperger's disorder.

Genetic Factors

Research consistently suggests a genetic component to pervasive developmental disorders. Family studies imply a genetic component to both autism and Asperger's disorder. Recent genetic-linkage analysis research has implicated a segment of chromosome 3 in autism.

Although much good research has been directed at understanding autism, much about the disease is not yet known. In a general way, what we do know about it can be summarized in the two statements that we quote here. One set of authorities in the field (Goldstein et al., 1986) put it this way: "The autistic child quite likely enters the world biologically different in some ways [from other children], but the biological consequences probably vary with the way the child's environment, especially his mother, responds to that difference." It is a statement with which most clinicians are likely to agree. DeMyer, Hingtgen, and Jackson (1981), in concluding their studies, express the thought less definitely and with a somewhat different emphasis: Children with autism are "beings with an inborn defect or defects in brain functioning, regardless of what other causal factors may subsequently become involved."

Treatment of Pervasive Developmental Disabilities

Beginning with the work of Bruno Bettelheim at the Orthogenic School at the University of Chicago, clinicians working with children who have autism have developed a variety of treatment approaches, a number of which report at least partially successful results. Despite their efforts, the prognosis for the child with autism still is considered bleak. Typical of that opinion is the estimate of Cardon et al. (1988) that less than one-fourth of the children with autism who receive treatment attain even marginal adjustment later in life. Rosenhan and Seligman (1989), while agreeing that treatment is slowly improving, nevertheless predict that most young adolescents and young adults with autism still will need access to intensive support services.

Response to treatment is correlated directly with measured IQ and with the presence of intelligible language before the age of five. Those factors are, of course, related, and both indicate a less severe form of autism. What the relationship between those two factors and response to therapy means is that children with mild to moderate autism may respond to treatment. But even for those treatable children, the course of treatment is prolonged (two to three years) and intense (in some programs, as many as forty hours a week). The cost of such programs is out of the reach of many, perhaps most, families without significant assistance. In line with this finding, individuals with Asperger's disorder who, by definition, do not have significant language impairment and have higher IQs, tend to respond more positively to treatment. Although there is life-long impairment, most individuals with Asperger's disorder are able to function independently and many are quite successful.

Rutter, in an early review (1968) of treatment approaches to autism, reports that insight therapy of a psychodynamic nature has not proven effective. On the other hand, there are many reports of success with a variety of behaviorally oriented treatment efforts that focus intensively on the correction of specific deficits in the child's behavior. Examples of such approaches are teaching specific sounds and identifying them with specific objects; helping a child give up objects to which he or she has become pathologically attached; and helping children make even rudimentary physical contact with others. That type of training makes extensive use of behavioral principles; for example, reinforcing desired responses, even though they move only generally or slightly in the right direction (see the "Shaping" section in Chapter 8).

Some therapists use graded educational approaches adapted to the specific needs of the child in an attempt to remove specific perceptual, cognitive, or motor deficits. Almost all of the successful programs make use of one-on-one, long-term treatment approaches that build warm, loving, and accepting interaction between therapist and patient. Despite the occasional reports of successful treatment, experts on autism advise caution in adopting too optimistic an outlook on outcome of treatment.

SUMMARY

Recognition of the presence of mental disorders among children and adolescents and research on those disorders has lagged behind the efforts at understanding adult mental disorders. Not until the DSM-III-R was an adequate listing of disorders of children and adolescents presented.

Three special difficulties exist in trying to understand the mental disorders of the young: 1) attitudes of adults in the home who so significantly shape their children's personalities and often deny the existence of problems; 2) developmental considerations, which would cause behavior considered normal at one age to be considered abnormal at a later age; and 3) the great difficulty in delineating between the normal and the abnormal in children, who as a whole are prone to occasional behavioral difficulties.

The DSM-IV-TR now lists ten categories of children's disorders; for convenience and clarity, the chapter has discussed them under four principal headings.

- Disruptive behavior disorders: There are three such disruptive behavior disorders. They are attention-deficit hyperactivity disorder (ADHD), which is characterized by inattention and/or impulsiveness and hyperactivity inappropriate for the age of the child; conduct disorder, which includes repeated violation of major rules, norms, and the rights of others; and oppositional defiant disorder, which is manifest in negative, argumentative, or hostile behavior.
- Emotional disorders: Three types of emotional disorders are discussed in this chapter. They are separation anxiety disorder, in which the child shows emotional pain, sometimes extreme, when separated from home and family; anxiety disorders, which also occur in adults but are not characterized by the insight achieved by adults and may be more fanciful; and reactive attachment disorder, which results in attachments that are either diffuse or nonexistent and are due to pathological care.
- Specific symptom disorders: These disorders are usually limited to a specific troublesome symptom that handicaps the child in social and educational life. The principal symptom disorders discussed in this chapter are the eliminatory disorders of enuresis and encopresis and selective mutism. This category of disorders also includes tic disorders, learning disorders, communication disorders, and feeding disorders.
- Pervasive developmental disorders: There are two primary pervasive developmental disorders. They are autism, which is a relatively rare but serious childhood mental disorder in which the child shows marked impairment in communication and interpersonal relating and restricted behavior, interests, or activities, and Aspserger's disorder, in which the individual evidences interpersonal difficulties and restricted behaviors and interests, but not language delays.

SELECTED READINGS

Barkley, R. A. (2000). Taking charge of ADHD: The complete, authoritative guide for parents. New York: Guilford Press.

Gupta, V. B. (2004). Autistic spectrum disorders in children. New York: Marcel Dekker.

Hill, J. & Maughan, B. (eds.). (2000). Conduct disorders in childhood and adolescence. Cambridge, UK: Cambridge University Press.

McHolm, A. E., Cunningham, C. E. & Vanier, M. K. (2005). Helping your child with selective mutism: Steps to overcome a fear of speaking. Oakland, CA: New Harbinger Publications.

Morris, T. L. & March, J. S. (eds.). (2004). Anxiety disorders in children and adolescents (2nd ed.). New York: Guilford Press.

Schaefer, C. E. (1993). Childhood encopresis and enuresis: Causes and therapy. Lanham, MD: Jason Aronson.

Walker, E. C. & Roberts, M. C. (eds.). (2001). Handbook of clinical child psychology (3rd ed.). Hoboken, NJ: Wiley.

Williams, D. (1992). Nobody nowhere: The extraordinary autobiography of an autistic. New York: Times Books.

Test Yourself

1)	What disorder frequently is treated with stimul	ant medication and cognitive-behavioral therapy?
	a) attention-deficit/hyperactivity disorder	c) oppositional defiant disorder
	b) conduct disorder	d) reactive attachment disorder
2)	What disorder is treated with intensive (sometim	nes as much as 40 hours per week) behavioral therapy?
	a) autistic disorder	c) oppositional defiant disorder
	b) encopresis	d) selective mutism
3)	What disorder is the direct result of pathologic	al care?
	a) autistic disorder	c) reactive attachment disorder
	b) conduct disorder	d) separation anxiety disorder
4)	What disorder is likely due to the interaction of a genetic predisposition and social influences such as inconsistent discipline and delinquent peers?	
	a) Asperger's disorder	c) encopresis
	b) conduct disorder	d) separation anxiety disorder
5)	What disorder is characterized by urinating in bed or one's clothes?	
	a) autistic disorder	c) encopresis
	b) Asperger's disorder	d) enuresis
6)	What disorder has symptoms of significant difficulties in interpersonal relationships and restricted interests, behaviors, or activities, but not delayed language?	
	a) autistic disorder	c) oppositional defiant disorder
	b) Asperger's disorder	d) reactive attachment disorder
7)	What disorder is characterized by negativistic and hostile behavior?	
	a) conduct disorder	c) encopresis
	b) oppositional defiant disorder	d) selective mutism
8)	Which of the following disorders is characterize the absence of a caregiver?	ted by apprehension and extreme distress concerning
	a) enuresis	c) separation anxiety disorder
	b) oppositional defiant disorder	d) selective mutism
9)	Approximately 13.3 percent of children have a	psychological disorder. True or false?

Test Yourself Answers

- 1) The answer is a, attention-deficit/hyperactivity disorder often is treated with a combination of stimulant medication, such as Ritalin or Adderall, and cognitive-behavioral therapy focusing on psychoeducation, skill building, and self-esteem.
- 2) The answer is a, autistic disorder. Autism frequently is treated with intensive, one-on-one behavioral therapy that focuses on teaching rudimentary communicative, social, and self-care skills and alleviating behavioral difficulties.
- 3) The answer is c, reactive attachment disorder. Reactive attachment disorder is one of the few disorders in the DSM with a specified cause. It is characterized by disturbed attachments (diffuse or nonexistent) due to pathological care such as physical or emotional neglect or frequent changes of caregivers.
- 4) The answer is b, conduct disorder. While the exact cause of conduct disorder has not been pinpointed, evidence suggests an interaction between genetic and environmental factors. There is evidence of abnormalities of brain activity, which may be passed from generation to generation. Additionally, inconsistent discipline and delinquent peer groups fail to provide appropriate socialization and, in fact, can encourage the violations of major rules and norms seen in conduct disorder.
- 5) The answer is d, enuresis. The primary symptom of enuresis is urinating, intentionally or unintentionally, in one's clothes or the bed after the age of 5. When it occurs during waking hours, it is specified diurnal enuresis; when sleeping, nocturnal enuresis.
- 6) The answer is b, Asperger's disorder. Sometimes referred to as high functioning autism, individuals with Asperger's disorder have the interpersonal difficulties and restricted behavior and interests associated with autism, but not the communication difficulties. Additionally, many individuals with autism exhibit mental retardation, but those with Asperger's disorder typically have average to above average intellectual abilities.
- 7) The answer is **b**, oppositional defiant disorder. The symptoms of oppositional defiant disorder include a pattern of frequently: losing one's temper; arguing with adults; not following requests or rules; purposefully annoying others; blaming others; being easily annoyed; and being angry, resentful, spiteful, or vengeful.
- 8) The answer is c, separation anxiety disorder. This excessive fear of separation from caregivers can be evidenced in the expression of distress in anticipation of the caregiver's absence, obsessive worry about the caregiver's well-being or being separated from caregiver, refusal to be alone or go places without the caregiver (including sleeping without the caregiver near), nightmares about separation, and physical complaints in anticipation of separation from the caregiver.
- 9) The answer is true. At any one time, approximately 13.3 percent of children and adolescents meet diagnostic criteria of a psychological disorder.

Eating and Sleeping Disorders

EATING DISORDERS

Eating disorders involve preoccupation with food and/or weight. However, many psychologists suggest that there are other difficulties underlying these disorders, including issues of control and emotion regulation. The two primary disorders in this category are anorexia nervosa and bulimia nervosa.

Anorexia Nervosa

In anorexia nervosa (often shortened to just "anorexia"), the individual eats too little and borders on a starvation diet.

Symptomatology

Anorexia is characterized by an obsession with body weight, perception of being overweight despite being 15 percent or more below what is healthy, and excessive food restriction, or, in the purging type, when normal amounts of food are eaten, compensatory behavior such as abuse of laxatives or diuretics, self-induced vomiting, or excessive exercise.

Etiology

Onset of the principal symptoms often occurs at the time of a critical life change, such as puberty or going to college. Those experiences are hardly limited to people with anorexia, and for that group, no especially anxiety-producing features of their life "crisis" have been identified. The reaction sometimes is an extreme continuation of early dieting efforts; but again, ordinary dieting is no basis for the extreme reactions of anorexia.

In studies of the interpersonal relations of people with anorexia, it is reported that they are frequently perfectionists in their standards and tend to have conflictual family relations. Family studies and twin studies both suggest a genetic predisposition to anorexia, although the exact mechanism is unknown. Recent genetic linkage analyses suggest the implication of part of chromosome 1 in some cases of anorexia with a restricting pattern (that is, excessive dieting rather than other compensatory behaviors).

The fact that the phenomenon occurs only in the United States and in a few European societies suggests that there may be significant cultural influences that operate on psychological or even physical vulnerabilities that have not yet been identified. Specifically, a cultural emphasis on thinness as beautiful and physical appearance as important appears to be common in cultures with high rates of anorexia. It is not commonly found among the poor and is more common in mainstream American culture than in ethnic or

other minority cultures. Because anorexia is not a newly recognized disorder (it has been diagnosed for almost a century), it cannot be considered a fad.

Prevalence and Course

Prevalence of anorexia is 0.5 percent to 1 percent of adolescent and young adult women. The disorder also occurs in boys and men, but is much less common and the prevalence is unknown. The average age of onset is seventeen. The medical side effects of the self-induced starvation often require hospitalization, and the mortality rate is over 10 percent. Those with anorexia typically refuse therapy and frequently deny any illness. When treatment is accepted, it tends to be slow going, with periodic setbacks.

Treatment

One of the main goals of treatment of anorexia is to safely restore body weight and return the individual to physical health. This must be done carefully, and in the case of severe malnutrition or extreme weight loss (for example, 30 percent or more below healthy weight) requires hospitalization. Long-term anorexia can result in very serious conditions, for example, hypokalemia (abnormally low levels of potassium affecting the ability of cells, including neurons, to function) and heart irregularities. Occasionally, in life-threatening situations, hospitalization and refeeding will be done against the individual's will. This is a large ethical dilemma not only because of the involuntary treatment but also because involuntary treatment tends to be not as effective as voluntary treatment. Unfortunately, simply restoring weight does not fully treat the disorder—without further treatment, the individual almost always loses the weight again.

Psychotherapy typically involves cognitive-behavioral and family therapy. Sometimes, antidepressant medications also are used. Cognitive-behavioral therapy typically focuses on challenging irrational beliefs, as well as exposure and response prevention. That is, preoccupation with weight and perception of being overweight are challenged. The individual also is exposed to eating and slowly gaining weight while being denied the ability to engage in compensatory behaviors such as excessive dieting or exercise or abuse of diuretics or laxatives. Family therapy frequently focuses on changing family interactions to provide age-appropriate support and independence for the affected individual.

Individuals with anorexia often experience denial that they have a disorder. That makes treatment particularly difficult. Furthermore, there is a high relapse rate in the disorder. The rate of relapse with the potentially fatal nature of this disorder make the treatment of anorexia an area of high priority for researchers from multiple disciplines. Many approaches have been tried, but few have been found to be significantly effective.

Bulimia Nervosa

In bulimia nervosa (typically referred to as simply "bulimia"), the principal symptom is episodes of binge eating. These may be planned ahead of time, but usually are engaged in covertly, when the individual is alone. Individuals with bulimia gulp down their food as if emerging from a period of starvation, typically consuming several thousand calories in one sitting. The binge-eating generates self-deprecating thoughts, guilt, and even depression. Binges usually end with the individual in pain from a distended stomach, and are followed by compensatory behavior such as self-induced vomiting, abuse of laxatives, enemas, or diuretics, excessive exercise, or self-starvation. Weight fluctuations are common because the individual alternates between binges and fasting. Many individuals with bulimia are a healthy weight.

Symptomatology and Prevalence

Bulimia is characterized by an excessive preoccupation with weight (for example, conversations and private activities often center around physical appearance and weight) and episodes of binge eating followed by compensatory behavior. In contrast to anorexia, bulimia does not involve a severe distortion of one's appearance or severe weight loss. Bulimia is estimated to occur in 1 percent to 3 percent of adolescent and young adult women. It is ten times more common in women and girls than in men and boys. With men and boys, it seems to be more common among athletes. Onset is typically in adolescence or early adulthood.

Etiology

Similar to anorexia, bulimia appears to occur almost exclusively in industrialized countries such as the United States and predominantely in individuals acculturated into mainstream American culture. This suggests cultural factors such as an unrealistic emphasis on thinness and unhealthy weight control strategies as causal factors in the disorder.

Family studies suggest the possibility of a genetic predisposition to developing bulimia, along with other impulse control and mood disorders. This also is consistent with findings of mood disturbance associated with binging and purging. That is, binging often appears to occur in response to stress and results in a negative affective state such as guilt or depression. This negative affect then seems to precipitate compensatory behavior, perhaps not just to be rid of calories, but to relieve the negative emotions.

Treatment

Treatment of bulimia typically involves cognitive-behavioral therapy. Here, the focus often is on challenging the obsession with weight, providing training in interpersonal and emotion management skills, and employing exposure and response prevention (allowing the individual to eat, but not allowing compensatory behaviors such as purging or restricting subsequent food intake). Sometimes, antidepressant medication also is used, with some benefit. Often, symptoms of bulimia gradually improve in middle adulthood, regardless of treatment status.

SLEEPING DISORDERS

Everyone experiences sleep difficulties at some time or another. But when these difficulties persist and impair functioning, they become sleep disorders. There are two categories of sleep disorders: the dyssomnias, characterized by difficulties initiating or maintaining sleep; and parasomnias, characterized by abnormalities in behavior or psychological states while sleeping.

Dyssomnias

Dyssomnias include insomnia (difficulty initiating or maintaining sleep), hypersomnia (excessive sleeping), narcolepsy (periods of daytime sleepiness), breathing-related sleep disorder (involving disruption of breathing while sleeping), and circadian rhythm sleep disorder (difficulty sleeping at the appropriate time—such as in jet lag). The most common dyssomnias, insomnia and narcolepsy, are discussed here.

Insomnia

Insomnia is characterized by difficulty initiating or sustaining sleep, or, when sleep is achieved, it is not restorative. The symptoms must be present for one month or longer and cause significant distress or impairment. The symptoms cannot be due to another disorder, medical condition, or substance use. Approximately 30 percent to 40 percent of the general population reports sleep difficulties, but the exact prevalence of the disorder is unknown.

COURSE AND ETIOLOGY

Insomnia has a variable course. It may have sudden onset during a period of stress, or the onset may be gradual and not associated with stress. It typically beings in young adulthood or middle age, but it may occur as early as childhood. It may be persistent (chronic), time-limited (acute), or episodic (comes and goes). The cause of insomnia is unclear. There are clear findings of differences in sleep patterns of individuals with insomnia, but the cause of these is unknown.

TREATMENT

Insomnia may be treated with sleeping medication, but medication works only while one is taking it and occasionally has negative side effects, including abuse/addiction potential. Improving sleep hygiene has better long-term effects. Examples of sleep hygiene include being in the bedroom only for sleeping or sex; not consuming mood altering chemicals (caffeine, alcohol, drugs, and so on) prior to sleep; not staying in bed if unable to sleep; going to bed and getting up at the same time every day; and ensuring that the sleeping environment is a comfortable temperature, dark, and quiet.

Narcolepsy

Narcolepsy is characterized by an overpowering need to sleep. This urge can come on at any time and may be triggered by intense emotions. The sleep is restful, and the episodes must occur daily for three months or longer to meet diagnostic criteria. Also seen is either cataplexy (sudden loss of muscle tone that may result in an individual slumping or falling) or rapid eye movement sleep (REM; a dream state) during the transitions between waking and sleep. The intrusion of rapid eye movement sleep can result in hallucinations or paralyses that are limited to the transitions between sleep and wakefulness. Narcolepsy is associated with rapid onset of sleep (frequently within five to ten minutes of lying down during the day) and abnormalities in sleep patterns. Individuals with narcolepsy often appear to be tired during the day. Narcolepsy is rather rare, occurring in equal numbers in both genders at a rate of 0.02 percent to 0.16 percent.

COURSE AND ETIOLOGY

Symptoms of narcolepsy typically begin with daytime sleepiness in adolescence, and full symptoms develop in early adulthood. The disorder frequently is chronic, but there are cases of spontaneous remission. Research implicates multiple genes and the neurotransmitter hypocretin in the etiology of narcolepsy. Additionally, the onset of symptoms often begins after a stressor or sleep disturbance.

TREATMENT

Treatment of narcolepsy typically takes one of two courses: stimulant medication or a program of frequent naps. Stimulant medication decreases the likelihood of sleep episodes. Taking naps during the day operates on the theory that providing sleep in safe, socially acceptable situations decreases the likelihood of an episode occurring at an inopportune time, such as while driving or during an important meeting.

Parasomnias

Parasomnias include nightmare disorder (repeated, disruptive nightmares), sleep terror disorder (characterized by episodes of screaming while still sleeping), and sleepwalking disorder (engaging in physical activity while still asleep). Sleep terror disorder and sleepwalking disorder are discussed here. Nightmare disorder is rarely studied because of its transitory nature and mild levels of impairment.

Sleep Terror Disorder

The primary symptom of sleep terror disorder is repeated instances of the individual giving a panicked scream while sleeping. Individuals frequently sit up in bed, scream, appear terrified, and then return to rest. The episodes usually occur during the first third of sleep, during the non-REM phase, and the individual does not respond to attempts at soothing. Younger children frequently have amnesia for the event, and older adolescents and adults typically remember a vague sense of fear or having seen frightening images, but no specific nightmare or other cause of the episode. Instances of sleep terror that may or may not meet full diagnostic criteria tend to occur in 1 percent to 6 percent of children and about 1 percent of adults. In childhood, the disorder is more common in boys than girls, but by adulthood, the gender ratio evens out.

Course

The course of sleep terror disorder depends on the initial age of onset. Sleep terror disorder that begins in childhood (which is more common) typically spontaneously remits in adolescence. When the onset is in early adulthood, the course is typically chronic.

ETIOLOGY

A clear cause has not been found; however, episodes tend to be more common when the individual is sleep deprived or has a fever. Sleep terror disorder tends to run in families with other parasomnias. Sedation decreases the frequency of sleep terror episodes, but it is not a suitable long-term treatment. Unfortunately, there currently are no other treatments for sleep terror disorder. When an individual has a sleep terror, the most helpful approach is to attempt to soothe the individual back to sleep. Even if that does not have an effect on the person having the terror, it at least helps the startled family member feel better!

Sleepwalking Disorder

Sleepwalking disorder also typically occurs during the first third of the night, during the deepest sleep stages, when the individual is not in REM sleep and voluntary movement is possible. It is characterized by the individual getting out of bed and moving around. The person is nonresponsive and difficult to wake. Individuals with sleepwalking disorder have no recollection of the episodes upon awakening. While episodes of sleepwalking are not uncommon in children, the disorder has a prevalence of about 1 percent to 5 percent in children. The prevalence of the disorder is much lower among adults.

Course

The onset of sleepwalking disorder commonly is in the preschool or early childhood years and typically disappears spontaneously in adolescence. When it occurs in adults, it is likely to be chronic, following an episodic course. It occurs at equal rates across genders.

ETIOLOGY

The cause of the disorder is unknown, but sleep walking is more common during times of stress, fever, sleep deprivation, or other sleep disturbances. There currently is no treatment for sleepwalking disorder. Individuals in a sleep walking episode should simply be led back to bed.

SUMMARY

Anorexia nervosa is characterized by an obsession with weight and the perception of being overweight while actually being 15 percent or more underweight. This weight is maintained by excessive diet, exercise, and/or purging. There are likely genetic and environmental etiological factors. Treatment is difficult and typically combines medical treatment with psychotherapy.

The symptoms of bulimia include an obsession with weight and a cycle of binge eating and compensatory behavior, such as excessive dieting, exercising, and/or purging. There is evidence from family studies that bulimia and mood disorders tend to run in families together. Treatment typically involves psychotherapy focusing on challenging irrational cognitions and breaking the binge-purge cycle.

There are two classes of sleep disorders: dyssomnias, such as insomnia and narcolepsy, which involve problems with initiation or maintenance of restorative sleep; and parasomnias, such as sleep terror disorder and sleepwalking disorder, which involve unusual behavior while sleeping.

Insomnia is characterized by difficulty falling or staying asleep or sleep that is not restful. It is not uncommon and typically is treated with improved sleep hygiene. The symptoms of narcolepsy are repeated intense urges to sleep that result in restful sleep during the daytime and either periods of cataplexy or intrusions of rapid eye movement sleep during falling asleep or awakening. Narcolepsy is most frequently treated with stimulant medication, but occasionally is treated with a program of naps during the day.

The primary symptom of sleep terror disorder is episodes of screaming and physiological arousal during the night. During these episodes, the individual is nonresponsive and difficult to wake. Sleepwalking disorder is identified by episodes of the individual getting out of bed and moving around. The person tends to be nonresponsive, difficult to wake, and has no recollection of the incident upon awakening. There currently is no treatment for sleep terror or sleepwalking disorders, but both commonly spontaneously remit in adolescence.

B SUGGESTED READINGS

Fairburn, C. G. & Brownell, K. D. (eds.) (2002). Eating disorders and obesity: A comprehensive handbook (2nd ed.). New York: Guilford Press.

Hirshkowitz, M., Smith, P. B., & Dement, W. C. (2004). Sleep disorders for dummies. Hoboken, NJ: For Dummies.

Hornbacher, M. (1999). Wasted: A memoir of anorexia and bulimia. New York: Harper Perennial. Utley, M. J. (1995). Narcolepsy: A funny disorder that's no laughing matter. Duncanville, TX: Marguerite Jones Utley.

Test Yourself

1)	1) What psychological disorder is characterized by obsession with weight and either restriction or purging to maintain a weight 15 percent or more below what is healthy?			
	a) anorexia nervosa	c)	bulimia nervosa	
	b) binge eating disorder	d)	dieting disorder	
2) What disorder is characterized by an intense urge to sleep eye movement sleep?			ense urge to sleep and either cataplexy or intrusion of rapid	
	a) insomnia	c)	sleep terror disorder	
	b) narcolepsy	d)	sleepwalking disorder	
3)	3) Screaming and physiological arousal during the night while being nonresponsive is symptoms what disorder?			
	a) insomnia	c)	sleep terror disorder	
	b) narcolepsy	d)	sleepwalking disorder	
4) What is the prevalence of bulimia nervosa in young women?			a in young women?	
	a) 0.2 percent-0.5 percent	c)	8 percent–10 percent	
	b) 1–3 percent	d)	13.3 percent–14.7 percent	
5)	5) How common are difficulties initiating and maintaining restful sleep in the general population?			
	a) 5 percent-10 percent		30 percent—40 percent	
	b) 15 percent-20 percent	d)	55 percent–60 percent	
6)	6) What disorder is typically treated with stimulant medication?			
	a) anorexia nervosa	c)	narcolepsy	
	b) bulimia nervosa	d)	sleep terror disorder	
7)	7) Which disorder frequently requires medical treatment, individual psychotherapy, and family therapy			
	a) insomnia		bulimia nervosa	
	b) sleepwalking disorder	d)	anorexia nervosa	
8)	What is the name of the class of disorders associated with unusual behavior during sleep?			
	a) dissomnias		malsomnia	
	b) hypersomnia	d)	parasomnias	

Test Yourself Answers

- 1) The answer is a, anorexia nervosa. Anorexia nervosa is an eating disorder characterized by obsession with weight and belief that one is overweight despite being 15 percent or more below a healthy weight. Individuals with anorexia typically excessively restrict caloric intake or, after eating a normal amount of food, engage in compensatory behavior such as exercise, purging, or starving themselves. Anorexia has potentially quite serious negative health effects due to starvation, ranging from cessation of menstruation to malnutrition to death. Ten percent of the individuals with the disorder die from physical complications of the disorder.
- 2) The answer is b, narcolepsy. The symptoms of narcolepsy are irresistible periods of restful sleep during the day and either cataplexy (a loss of muscle tone) or intrusion of rapid eye movement sleep (dreaming) during the transition into or out of sleep. Narcolepsy causes significant impairment because of the implications of having spontaneous episodes of sleep or cataplexy during the day and/or the disturbing effects of intrusion of dream sleep.
- 3) The answer is **c**, sleep terror disorder. In sleep terror disorder, individuals give a panicked scream and show signs of physiological arousal, but they do not respond to attempts to sooth them. Those with sleep terrors typically have no memory of the event or have only a vague memory of a sense of fear.
- 4) The answer is b, 1-3 percent. Bulimia nervosa is ten times more common in women than in men, occurring in 1 percent to 3 percent of women. It typically affects adolescents and young adults.
- 5) The answer is c, 30-40 percent. Sleep difficulties are quite common in the general population. Although the exact prevalence of insomnia is unclear, sleep disturbances are known to affect about one-third of all Americans.
- 6) The answer is c, narcolepsy. Stimulant medication (such as Ritalin or Adderall) frequently is used to treat narcolepsy. It works by preventing episodes of daytime sleep. The less commonly used treatment option is a program of regular naps to decrease the likelihood of a spontaneous sleep episode.
- 7) The answer is **d**, anorexia nervosa. Because of the severe health effects of anorexia, medical attention often is needed. Psychotherapy then can be used to treat the preoccupation with weight, distorted perception of body weight or physical appearance, and break the cycle of self-starvation. Family therapy often can be used to support the individual in recovery and prevent relapse by changing family dynamics that tend to maintain the anorexic symptoms.
- 8) The answer is d, parasomnias. From the words meaning "around sleep," parasomnias are unusual behaviors that occur during sleep including nightmare disorder, sleep terror disorder, and sleepwalking disorder.

Legal Issues and Social Policy

hroughout this book, our focus has been the individual: the nature of his or her illness; possible causes of the illness; and treatment approaches. Other people, when they were considered at all, were those who were directly affected by the abnormal behavior, particularly partners, parents, and children. In this chapter, we shift our focus and consider larger societal issues, including legal issues posed by abnormal behavior and social policy questions related to it—what might be considered the conscience issues that the problems of psychological disorders create for all of us.

Those issues fall into three categories: 1) legal issues—those concerning the questions, broadly put, about the rights of patients and how they can be protected, and, at the same time, how can we protect the entitlement of the general public to a safe and secure society in which to live; 2) the issue of prevention—what society is doing now to prevent mental illness, and what more must it do; and 3) what organized efforts on behalf of the mentally ill exist now, and how more Americans can be drawn into those efforts.

EXECUTE LEGAL ISSUES

Abnormal behavior, as we have seen in the preceding chapters, occasionally causes an individual to violate society's norms, sometimes in ways that are criminal. When a person with a psychological disorder commits a crime, especially a serious one, several questions have to be answered:

- Is the mental condition a defense against being punished?
- Is the individual competent to stand trial?
- When the threat of criminal or dangerous behavior is present, how can an involuntary commitment be achieved in ways that are fair to all?
- How can/should treatment be provided to an unwilling person?

Some of those questions have confronted the U.S. Supreme Court and, along the way, various lower federal and state courts. The decisions handed down have not always pointed the way to practical and universally accepted answers to the questions raised. Psychologists and psychiatrists are often drawn into attempts to find answers to these questions; their testimony in court is often required.

The Insanity Plea

Placing an individual on trial for criminal behavior is based on the belief that he or she chose to commit a crime knowingly and was therefore responsible for it and should be punished. Punishment for

criminal behavior has as its rationale the effect of deterring others who might be contemplating a crime; the hoped-for deterrence on the individual's future behavior; and, when punishment involves incarceration, the guarantee that at least for the term of imprisonment, the individual will not commit a similar crime. But the rationale rests also on an ancient ethic that mandates equitable punishment after bad behavior. To the average person, punishment after criminal behavior seems appropriate and, indeed, necessary.

But what happens to that reasoning if the individual was not responsible for the crime in the way in which the typical person is responsible for his or her behavior? What does society do if it can be demonstrated that the individual was "insane" at the time of the crime? What a plethora of problems a plea of insanity makes for a society with a conscience!

Two of the most significant problems are these:

- · How does one support a diagnosis of a psychological disorder as a reason to persuasively exonerate the individual from responsibility for the crime?
- What follows the decision that the individual cannot be held responsible because of his or her psychological state at the time of the crime?

The first question has a long legal history; the second question addresses the issue of involuntary commitment to a psychiatric facility for an unspecified period of time.

Establishing a Diagnosis of "Insanity"

First, it must be established that when law and psychology interact, there is occasionally a clash of goals, values, and language. For example, "insanity" is a legal term, not a psychological term. As a legal term, it indicates an inability to control one's actions or to understand the rightness or wrongness of an action due to a mental illness. Although that definition requires the presence of a psychological disorder, not all psychological disorders meet the legal criteria. That is, most people with psychological disorders are in control of their behavior and able to recognize when behavior might violate laws or the rights of others.

An early court decision (Ohio v. Thompson, 1834) in this country ruled that individuals should not be held responsible for their crimes if it could be established that, as a result of mental illness, they were unable to resist the impulse to commit the crime. An example might be obeying "a command from God," which a person with a psychological disorder might hear and feel compelled to obey. In this ruling, the issue must be resolved by a jury of the individual's peers, presumably with the assistance of the testimony of experts.

The motivation for this court decision is easy to understand: "If the individual had to commit the crime as a result of irresistible psychic forces, how could he or she be held culpable?" The problem, of course, lies in determining when an impulse is irresistible and when is it not. Since the 1834 decision, three other criteria have been offered for the determination of responsibility: the McNaghten rule; the Durham test; and the American Law Institute standard.

THE MCNAGHTEN RULE

Although handed down in an English court in 1843, this decision set the standard for American court decisions. In the McNaghten trial, defense counsel admitted that McNaghten had murdered Drummond, whom he had mistakenly identified as the British prime minister, who was the intended victim. The defense contended that McNaghten believed that the voice of God had directed him to kill the prime minister, and that McNaghten suffered delusions of persecution under which he felt bound to obey the command.

The trial set a precedent for many criminal trials that followed because, for the first time, the testimony of experts had been officially received into the proceedings of the trial. McNaghten was acquitted. In defense of their decision, the judges laid down the McNaghten rule, which has been labeled in legal circles as the right-wrong test. The essential reasoning of this ruling is expressed as follows: It must be proved clearly that at the time of the commission of the criminal act, the defendant was laboring under such a defect of reason, caused by disease of the mind, that he did not know the nature and quality of the act he was committing, or, if he did know, did not know that he was doing wrong. The ruling became known as the right-wrong test because of that language. It was considered a rather narrow basis for the determination of responsibility for criminal behavior.

THE DURHAM TEST

In a federal district court in 1954, the McNaghten rule was broadened significantly and given a totally different perspective. In the words of the judge who enunciated the criteria, "An accused is not criminally responsible if his unlawful act was the product of mental disease or mental defect." The legal basis for successful use of the insanity plea was widened in two regards by this decision. It introduced the concept of mental disease, a condition that could be certified only by a trained specialist, and also explicitly included mental defect, which also could be certified only by an expert.

The attempt to use this criterion—product of mental disease or mental defect—lasted from 1954, the time of its enunciation, until 1972, when it was withdrawn as an experiment that had failed. Two reasons are thought to have been operative in causing the demise of the Durham test: 1) It gave almost exclusive weight to the testimony of professional experts, psychiatrists, and psychologists, in determining responsibility, thereby effectively removing that determination from judge and jury; and 2) with the likelihood of disagreement among those experts, determination of the question of responsibility became a matter of choosing sides—that is, which side (defense or prosecution) most persuasively presents what are essentially, or should be, objective determinations. The professionals themselves are often uncertain of achieving agreement on the diagnosis of "mental disease," especially if such a diagnosis implies an absence of responsibility for one's behavior.

THE AMERICAN LAW INSTITUTE FORMULATION

The rule that now guides judges in federal courts and in a majority of the state courts when instructing a jury on the matter of a criminal's responsibility for criminal behavior sets two criteria for making that judgment: when the individual, by virtue of either mental disease or mental defect, lacks substantial capacity either, 1) to appreciate the criminality (or wrongfulness) of his or her conduct, or 2) to control that conduct, the person may then be deemed not responsible for the criminal act. Careful reading of that language leads one to the conclusion that the presence of mental disease or mental defect in and of itself, without a demonstration of the conditions specified in the ruling, would not lead to an acquittal.

Perhaps to placate that public opinion that considers the law soft on crime, the rule, as it is used in the courts, does not include, in its understanding of a mental disease, an abnormality that is manifest only by frequency of criminal or other antisocial behavior. In other words, a lifetime of crime cannot be used as a demonstration of "insanity."

GUILTY BUT MENTALLY ILL

With the newly created verdict of guilty but mentally ill, some states have found still another way of dealing with the so-called insanity defense. This legal definition seems to have developed in reaction to the national outrage that followed the acquittal of John W. Hinckley, Jr., who, after an attempt to assassinate the president of the United States (Ronald Reagan), was granted a verdict of not guilty by reason of insanity. The assassination attempt was concocted by Hinckley for bizarre reasons, in order to cause an actress (Jodi Foster), whom he had never met but with whom he had become infatuated, to "love and respect" him.

The verdict surprised the judge and Hinckley. The jurors explained that the prosecution had not proved beyond a reasonable doubt that Hinckley had the mental capacity to be responsible for his crime. There was no question about his making the assassination attempt; many thought the burden of establishing his mental illness should have been borne by the defense, rather than the prosecution being forced to prove his sanity.

In any case, the fallout from public reaction was the passage of legislation in several states creating the new verdict, guilty but mentally ill. The virtue of that verdict, in the opinion of many who were concerned about the legitimacy of the Hinckley verdict, is that while an individual, having committed a crime, might escape a prison sentence, he or she would nevertheless be incarcerated in a secure hospital setting.

Once incarcerated, what criteria should be used for granting freedom to the individual? The Supreme Court, in 1983, ruled the permissibility of keeping an insanity-acquitted individual hospitalized indefinitely.

One other result of the Hinckley proceedings was a change in the federal courts that shifted the burden of proof with reference to mental illness from the prosecution to the defense. In those courts, the defense must now prove insanity, rather than the prosecution being required to prove sanity.

DIMINISHED CAPACITY

In addition to all of those considerations, the New York State Department of Mental Hygiene in 1978 proposed an entirely different way of considering the issue of criminal responsibility. One can paraphrase the department's argument as follows: The presence of a mental illness, while it may not entirely remove the individual's awareness of right from wrong, does reduce the capacity of the individual to appreciate the full nature of the crime committed. If that is so, the best approach, the department argued, would be to admit evidence of any abnormal mental condition that would affect the degree of culpability for which an individual is being tried. For example, those crimes requiring intent or full knowledge of the criminal nature of the act; that is, its wrongness, could be reduced to such lesser offenses as reckless or criminal neglect in the case of a mentally ill person.

There is no evidence that this concept has received formal judicial acceptance. Nevertheless, one can speculate that in some of the many cases of plea bargaining about which one now reads, the basis for a reduced charge is the mental condition of the individual at the time of the crime.

Prevalence of the Insanity Defense

No doubt, when in the trial of an individual charged with a particularly heinous crime, the defense lawyer is reported in the newspapers to be planning an insanity defense, many newspaper readers jump to the conclusion that the case is one of many in which proper punishment will be escaped or, at least, reduced appreciably by such a defense. But studies indicate that it is used in only 2 percent of felony cases and is successful in less than 1 percent.

Furthermore, in many cases of guilty but mentally ill findings, individuals remain in such facilities longer than they would have been incarcerated if convicted of the crime. This is likely due to the intractability of the disorders frequently found among individuals who have been found guilty but mentally ill and reluctance on the part of professionals to release such individuals into the community. The reluctance to release individuals from secure psychiatric facilities is likely related to pressure from the public and an acknowledgment (based on research) that mental health professionals are not always able to accurately predict risk of future dangerous behavior.

Competency to Stand Trial

The competency of the individual to stand trial—that is, whether he or she understands the nature of the charges and can participate rationally in his or her own defense—also is a matter of concern to the judiciary. It is a more narrow issue than the question of an individual's criminal responsibility for the

crime. Competency has nothing to do with uncontrollable impulses or right and wrong; a compassionate judiciary system requires only that the individual have a basic understanding of the charges and be reasonably able to cooperate with counsel. Even though psychotic at the time of the crime, an individual may be judged competent to stand trial.

The issue of responsibility is related to the individual's mental condition at the time of the criminal offense; the competency issue is relevant only at the time of the trial, when mental condition can be examined adequately. The judgment about mental condition at the time of the crime can be only retrospective. Individuals may be judged to have been insane when committing the crime, but psychiatrically competent later, when the trial is to take place; or they may have been judged to have been sane when the crime was committed, but not sane at the time of the trial. Trials often are held long after a crime has been committed, sometimes years later. It occasionally happens that the defendant's mental state has changed radically, for better or for worse.

Once judged incompetent, individuals may nevertheless remain incarcerated for a long time, even though they have not been judged guilty and may, indeed, be innocent. The injustice of that situation finally received the attention of the U.S. Supreme Court, and in 1972, it ruled that a person judged to be incompetent at the time of trial could be held in custody on the grounds of incompetency only as long as it would reasonably take to determine whether or not the individual would become competent in the foreseeable future. In the case of a psychotic flare-up, that period might be a short one. For a person judged to be mentally retarded and therefore incompetent, competence would never be achieved. When the probability of the individual ever achieving competence is, in professional opinion, slight, the court ruled that the individual must be committed to a mental institution under legal commitment procedures, or released.

A related issue is that of refusal of treatment necessary for an individual to be restored to competence. Since the development of antipsychotic medication, a difficult problem presents itself to the judge and attorneys. If the individual is allowed to continue on the medication, the medication will reduce or eliminate symptoms and, in that way, might cause the jury to reject an insanity defense. If the individual is denied medication, incompetence, with all of its hazards, may be ruled. But what if the individual refuses medication? According to court precedent (Sell v. United States) an individual can legally be required to take medication to restore competency as long as there is likelihood of medication being effective, the crime is serious, medication is unlikely to impair competence, and the use of the medication is deemed medically appropriate.

The Problem of Civil Commitment

More than half of the commitments to state mental institutions are involuntary. Although a hospital is not a prison, involuntary hospitalization does deny individuals their freedom against their will. Once committed, hospitals or prisons do not provide much of a difference in how individuals will spend their time and live out their lives for years, or even until their deaths.

Such considerations have caused some mental health professionals to demand, for psychiatric patients facing involuntary commitment, the same legal protections granted to an individual on trial for criminal behavior. Those rights are as follows: 1) a decision only after a hearing by jury; 2) the assistance of counsel; 3) freedom from self-incrimination; and 4) proof beyond a reasonable doubt of the necessity of commitment. Because commitment to a hospital, even though protested by the individual, is considered (although not always accurately) a compassionate act and not a condemnation, and because goals other than punishment motivate the decision, adequate protection of those rights has not yet been legally established in all courts.

Providing a Jury Trial

A jury trial is not now provided to a psychiatric patient facing involuntary commitment, and, in the opinion of those in the field, it is not likely to be introduced in the near future. One reason is that peer review of the issues involved in such a commitment is not given much weight by the professionals who might have to live with any decision made. There are practical problems as well: Trials are expensive and time consuming; juries are difficult to select. One answer to the problem, practiced in some hospitals, is to provide the individual with at least the benefit of judgment made by a panel of experts, and not one made by an individual, no matter what the individual's apparent qualifications.

Protecting the Individual Against Self-Incrimination

It may seem inappropriate for mental health advocates to appear to be equating psychiatric illness with criminal behavior. Nevertheless, one can see the point of their talking about self-incrimination. An illustration makes the point: Should a patient be counseled to be passive, indifferent, and silent during the commitment process? Such behavior might indeed be considered pathological in an individual confronting so crucial a judgment. If, on the other hand, he or she does not do so, it is all too likely that the tension of the situation might exacerbate symptoms that, in usual surroundings, would not justify hospitalization.

The Assistance of Counsel

The right to counsel is respected almost universally in commitment procedures in this country. The problem lies in how counselors see their role. The two extremes of such a role might be described as follows:

- The lawyer's usual legal responsibility of acting in order to require the authorities to make out a prima facie case for enforced hospitalization
- · The lawyer's proceeding in such a way as to force the authorities to agree to return the individual (one might say, at all costs) to the community

Most lawyers who agree to take on the responsibility will, to the best of their abilities, try to determine what is best for the client. But, of course, they are trained in law, not in psychiatry or psychology. Some in the field of mental health would choose to define the patient's best interests as what he or she would choose to do if there were complete freedom to do so. This is a difficult call to make. What is right varies with every patient: the need for hospital-administered treatment; its availability; and the quality of the resources available to the patient outside the hospital.

Requirements for Commitment

Society is not irrational or punitive in requiring involuntary commitments, although some individuals involved in making commitment decisions may operate in a hurried or callous way. Involuntary commitment, at least insofar as policy is described, requires that one or more of four conditions be met.

PRESENCE OF MENTAL DISEASE

The individual must be suffering from a mental disease. Usually, no clear definition is provided of which psychological disorders qualify. For example, would a severe phobic reaction qualify, or a somatoform disorder? Even an elementary knowledge of those diseases would cause most individuals to think not. But that does not guarantee that circumstances would never arise to cause just such disorders to be used as grounds for involuntary commitment; for example, extreme pressure from families, perhaps exhausted by efforts to take care of the individual. There is, however, a safeguard available to the patient. All states require that in addition to the presence of a mental disorder, at least one of a set of described characteristics also be present. They are danger to self or to others and grave disability.

DANGEROUSNESS TO OTHERS

Here is what would seem to be a legitimate and socially responsible basis for committing a person with mental illness to a psychiatric hospital without the individual's consent. If other people, either family or strangers, may be killed or harmed (the meaning of "dangerousness") by the person, doesn't the protective system of society, in this case, the mental health system, have the duty of hospitalizing the individual, even if it has the stamp of incarceration?

The issue is not as easy to resolve as it might seem. The problem is that an impressive number of studies indicate that neither psychologists nor psychiatrists are able reliably to predict dangerousness. Most professionals would prefer not to be required to make decisions about the future dangerousness of a patient. Circumstances sometimes force them to express their best judgment.

There is a value judgment to be made here. Whose rights have a greater claim on protection: the individual held involuntarily in a psychiatric hospital on the basis of an evaluation that determines (perhaps inaccurately) the person to be dangerous; or a person in the community whose safety might now be in jeopardy because of the release of a person who is thought to be dangerous?

The U.S. Supreme Court ruled in 1967 that a large number of inmate/patients confined in prison hospitals in New York State be released. Should they be released despite the fact that they were judged in earlier psychiatric examinations to be criminally insane and potentially violent? The court ruled that incarceration violated their constitutional rights.

Steadman and Keveles (1972) followed the released patients and reported four years later that only 2.7 percent of them had been arrested for assaultive behavior and imprisoned again or had been placed in a hospital for the criminally insane. One would judge that, with a history of violence, this population would be prime suspects for future violence, based on the belief that the best predictor of future behavior is past behavior. Yet in four years, according to the study, 97.5 percent of the group were not involved in behavior dangerous to anyone else. Perhaps the best that one can say is that predicting dangerousness is, from a professional point of view, a dangerous occupation. Any such prediction provides a weak basis on which to challenge basic human rights.

DANGEROUSNESS TO SELF

Although any threat of suicide should be taken seriously, predicting which individuals will make those suicide attempts after such a threat is as unreliable as predictions about violence to others. Nevertheless, the involuntary commitment to a hospital of individuals who have threatened suicide seems a less critical violation of the individual's civil rights than other commitments. For one thing, it is usually a short-term commitment; it brings the individual into treatment, even if only for a short time; and later, when distress has subsided, is usually appreciated by the individual. However, caution still should be exerted to protect individuals' civil rights. Furthermore, in the case of individuals with terminal illnesses, the decision becomes more difficult. Does an individual have the right to end his or her own life to avoid inevitable suffering and death? Currently, laws vary by state.

GRAVE DISABILITY

When individuals are clearly so mentally impaired as to be unable to care for themselves—that is, to provide food, clothing, and shelter for themselves—a decision to commit the individual to a psychiatric facility seems the compassionate thing to do. Problems develop when the questions of the standard of care are raised. Freedom to be independent may be so valuable a possession that some individuals may decide, in preference to being hospitalized, to live at such a meager level as to cause social agencies to recommend commitment in a hospital. The decision to hospitalize an individual in such a case is a heartbreaking one, and family or other assistance should first be sought.

LEVEL OF PROOF

One remaining consideration in protecting the rights of the mentally ill remains to be examined, which is the level of proof that criteria actually exist for an involuntary commitment. For example, suppose a patient is alleged in a petition of involuntary commitment to be dangerous to others or to self. How convincing must the evidence be that dangerousness indeed exists—and how absolute the judgments of those who make the decision—to justify denying personal freedom to any individual, whether it be the freedom of an open ward in a hospital or the freedom to live out in the community?

There are three levels of proof: 1) What has been called the 90-to-100-percent level of proof, known in legal circles as "beyond a reasonable doubt." Under the premise that a person is innocent until proven guilty, that level of certainty is required in criminal proceedings. Because individuals charged with a crime are in double jeopardy of losing their freedom and of being stigmatized as a criminal, that high standard is required. 2) At the other extreme when evaluating proof is the requirement that the preponderance of evidence favor a decision; that is, if evidence can be counted, it would presumably mean 51 percent of the evidence. Such a criterion of proof is considered adequate in civil courts dealing with money matters. 3) With respect to the issues involved in involuntary commitment, the Supreme Court, rejecting both the "beyond a reasonable doubt" criterion and the "preponderance of the evidence" standard, set an intermediate standard. It ruled that in involuntary commitment matters, the evidence must be "clear, unequivocal, and convincing." That is, to return to a quantitative statement, a 75 percent level of certainty should exist. It is that standard of proof that all states are now required to use as a standard in involuntary commitment matters. However, forensic evaluations currently are not such a precise science that the certainty of judgments can be quantified so precisely.

Two Unresolved Problems

The long series of court rulings growing out of the mental health community's concern to protect the civil rights of the mentally ill, particularly those rights affected most by involuntary commitment, finally brought an Alabama court to a ruling that effectively established a bill of rights for hospitalized psychiatric patients in that state, and other states are attempting to abide by the parameters of that decision. The case was a class action brought on behalf of a mentally retarded youth, not by a mentally ill person. In his decision, the judge reasoned that it was clearly a violation of due process to deny people their liberty on the grounds that they needed treatment, and then to provide no treatment to them. The judge then went on to require, as a legally binding mandate, that all Alabama state mental institutions provide the following:

1) an individualized treatment program for each patient; 2) skilled staff in sufficient numbers to administer such a program; and, 3) a humane psychological and physical environment. In an extension of his ruling, he detailed the characteristics of a humane psychological and physical environment. For example, the requirements established the patient's right to privacy and dignity, described appropriate bathing and toilet facilities, and included the right to engage in interaction with members of the opposite sex.

The program outlined by the judge remains, to this day, more an ideal to strive toward than a reality; nevertheless, it does provide patients and their advocates a standard against which they can test any psychiatric institution, and, over the years, will bring significant improvement in the level of care provided. The *Wyatt v. Stickney* (1972) decision (that is, the Alabama case) was a hard-won and glorious victory for the mentally ill; nevertheless, two unexpected and troublesome consequences have resulted from the decision: the wholesale release back to unprepared local communities of mentally ill persons; and threatened interference in certain forms of professionally approved treatment.

RELEASE OF PATIENTS

The judge in Wyatt v. Stickney placed heavy emphasis on adequate staffing that, to some extent, set an approved ratio of staff to patients. For most hospitals, that meant skyrocketing costs. Most budgets for

public psychiatric facilities were hardly adequate for the minimal care that had been offered before this decision.

Hospital administrators had little hope that their budgets would be increased enough to meet the newly mandated standards. The only solution they could devise was to reduce the number of patients hospitalized, and the only way to do that was to release many of them into their communities. Under pressure from a citizen's tax protest, California led the states in this action. It closed many of its psychiatric hospitals and sharply reduced its mental health budget.

The decision to return psychiatric patients to their home communities had at least the veneer of sound public health policy. For some time prior to the release, there had been advocacy for closing the monstrously large state hospitals and placing patients in smaller community facilities, free of the bureaucracy and facelessness of the large institutions. The problem was that at the time of wholesale release of patients, few such community facilities had been established. What patients encountered were poorly supervised boarding houses in which the care offered was often worse than in the hospitals from which the patients had been released. Many such patients then chose to live in the streets, occasionally seeking refuge in massive public shelters set up only to give them overnight accommodations. This homeless population soon created impossible social problems for most urban communities and aroused irate reactions from their residents. A solution to this problem seems remote.

INTERFERENCE IN THERAPY PROGRAMS

The problem here is a more subtle one. It arises from a conflict between two well-intentioned groups whose interpretations of a humane environment differ. No one can argue against protecting the mentally ill from forced labor, nor can anyone argue against granting patients accommodations that support their dignity and comfort. The conflict grows out of differing attitudes toward forms of therapy that professional staff consider beneficial in the care of long-term institutionalized patients, but that others—for example, some authorities in the courts—consider a violation of patients' rights.

Contingency Management

Two examples illustrate the conflict. In behavioral therapy, contingency management is considered an effective program for conditioning patients to live harmoniously in a community setting. The token economy is one form of contingency management. In a token economy, various listed desirable activities—for example, making one's bed—are reinforced by issuing a listed number of tokens, which can be spent either for certain privileges—for example, watching television—or for other material rewards that can be purchased in a canteen. The conflict arises when a complaint is made that the principle of a humane environment is violated when privileges or amenities, stated to be the right of the patient, are offered only as a reward for good behavior. Most facilities currently do not allow basic privileges to be withheld unless there is a risk to the safety of the individual. Any use of contingency management must be based solely on earning things above and beyond normal privileges or materials.

Aversive Techniques

A second example relates to the use of aversive techniques in behavioral therapy. In a wellsupervised hospital program, painful aversive techniques, such as non-lethal electric shock, are rarely used, and then only under supervision, in order to discourage seriously dangerous behavior, such as determined head banging. The court system has been alerted to the possibility of misuse of such techniques, and has set narrow limits for their use—too narrow, some therapists believe.

The criticism of aversive techniques has broadened to include physically painless aversive techniques, as well as electric shock; for example, the time out procedure. Here, a patient causing trouble is temporarily removed from a situation that might offer reinforcing satisfactions, such as undue attention,

and placed alone by himself or herself. Here the courts, aware of the punishing use of solitary confinement in the prison system, have focused on time out to make sure that the technique is not misused to isolate a patient for long periods of time in a dismal setting. Currently, facilities are allowed only to use removal or seclusion in cases in which an individual presents an imminent threat to the safety of self or others.

Basically, the conflict with respect to the therapeutic approaches grows, not out of opposition to the proper use of the techniques, but out of the fear that they will be misused by untrained or unsupervised staff. The problem, of course, would probably be reduced significantly or even eliminated if hospitals were funded at levels sufficient to attract and train suitable staff.

COMMUNITY PSYCHOLOGY AND PREVENTION

Community psychology approaches psychological disorders in a way that takes account of the environment as a factor in mental health and encourages the use of community resources to eliminate conditions that may cause psychological disorders.

Clinical Versus Community Psychology

We can compare the different focuses of clinical psychology and community psychology by the ways in which they approach the problem of psychological disorders: individual patient versus environmental factors; attention to weakness (or disorders) versus building strengths; and cure versus prevention. We will, given present limitations in our knowledge of human behavior and the resources we have available for promoting mental health, need both approaches for a long time to come.

The Patient versus the Environment

The word clinical derives from the Greek word for "physician who treats bedridden patients." Its use does highlight the primary (although not now exclusive) approach of the clinical psychologist; that is, a patient and a therapist. In contrast, the community psychologist sees influencing the nature of interactions between the environment and human beings as an important long-range approach to promoting mental health. The clinical psychologist's efforts are to change a client's behavior; the community psychologist seeks to change the social environment affecting people.

Focus on Disorders versus Focus on Health

Clinical psychologists primarily have as their clientele people who are, before they get to the psychologist's office, already disturbed by psychological problems. The community psychologist seeks to create environmental conditions that will promote healthy living; for example, family planning and parental training. The clinical psychologist's role is traditionally seen as alleviating symptoms; the community psychologist's role is seen as fostering strengths.

Prevention versus Cure

The clinical psychologist certainly believes in the efficacy of preventive efforts and supports them, but ordinarily is preoccupied with the needs of individuals seeking immediate help for existing problems. The community psychologist looks further into the future to consider what society, especially neighborhood communities, can do to keep its citizens healthy and to guard against environmental factors that might cause psychological problems in the young.

PREVENTION OF MENTAL ILLNESS

Our focus throughout the preceding chapters has been principally on the work of the clinician. In this section, we consider the concerns of community psychologists, which are primarily preventive.

George Albee (1988), a past president of the American Psychological Association, puts the importance of preventive efforts into perspective for us in the introduction to a book on preventive psychology. Although the statistics are outdated, the issue is current:

The number and distribution of persons with serious emotional problems in our society [are] far beyond what our resources, in terms of both personnel and institutions, [can] deal with on a one-to-one basis. I became convinced of the logic of the public health dictum that holds that no mass disorder is ever eliminated or brought under control by attempting to treat individuals. Every assessment of the distribution of disturbance in the society arrives at an estimate of approximately 15 percent of the population. When we realize that in any given year only about seven million (of the more than twenty-five million who need help) are seen throughout the entire mental health system, we can appreciate the hopelessness of our present efforts. Given those figures, we can judge how important a preventive effort is.

TYPES OF PREVENTION

In 1964, in a book setting out the principles of preventive psychiatry, Gerald Caplan distinguished three levels of prevention. His description is an adaptation of the medical model for preventing physical disease. It is now used widely in the field of mental health, and is outlined in the following three sections.

Tertiary Prevention

As the most immediate preventive effort, tertiary prevention begins with the later phases of the treatment processes we describe in this book. Clinicians are increasingly coming to realize that what happens after treatment is a key component in preventing a relapse. Even a short stay in a psychiatric hospital leaves an individual uncertain and insecure about readjusting to the world outside—the longer the stay, the more difficult the readjustment.

Tertiary prevention is the effort to ease the problem by planning a network of supportive services prior to discharge. Studies demonstrate that the existence of an aftercare program and careful integration of the individual into it produce a significant lowering of the relapse rate, even in those who have gone through a serious mental illness such as schizophrenia. A typical aftercare program is the halfway house, in which individuals stay for a while after hospitalization, free to ease themselves back into the world, with help available along the way.

Even when the illness is not severe or of long duration, impulsive behavior may lead to drastic consequences—a street fight, a crime, a family argument. One may not be able to undo the immediate effects of such behavior, but tertiary prevention focuses on containment of the damage to the individual, the victim (if there is one), and to the immediate family. The goal is to prevent the development of a cycle of reinforcement for psychological problems.

Another example of tertiary prevention efforts are community mental health centers that provide outpatient mental health services. Principally as a result of the community approach, between 1955 and 1983, the National Institute of Mental Health reports that outpatient treatment of psychiatric illnesses has increased from 27.6 percent of all psychiatric care to more than 70 percent of that care. As of 2004, inpatient care, despite being the most expensive treatment option, accounted only for 21 percent of all mental health expenditures. Outpatient care is not only more economical but is also more acceptable and effective. It has no doubt contributed to the larger numbers of the American population who now receive care for their psychological ills.

Especially beneficial features of tertiary care are swiftness of response, the inclusion of persons affected by the situation but who might not reach out for help, availability of services in the neighborhood, and settings that don't have the aspects of an institution.

Secondary Prevention

The principal goal with secondary prevention is to detect psychological problems before they grow into disabilities. A child's sporadic truancy, for example, should suggest a family visit to offer early help. Secondary prevention is based on the maxim that any illness, including psychological illnesses, can best be treated if it is treated at its earliest stage. The principal approach of secondary prevention is outreach. Waiting until the individual is desperate enough or sufficiently discomforted to seek treatment on his or her own usually means that the illness has settled in and has become that much more difficult to

Modern mental health practice has found a number of successful ways of avoiding such a situation. All of them depend on increasing the visibility, convenience, and acceptability of helping services. Trained paraprofessionals, who may be closer in age, style of clothing, and use of language to the troubled individual, may be the best first contacts for attracting persons at risk. If their skill levels are high enough, they often serve at crisis intervention centers, where individuals can be helped on a walkin basis, and then followed up with short-term crisis therapy. The goal of crisis intervention is to deal first with the psychological emergency. Once that is eased, the individual is more likely to be amenable to longer-range treatment efforts, and a stubborn illness is therefore prevented. The readily available hot line, the mobile mental health van in the neighborhood, and on-the-street social workers all signal that help is available, and these strategies are being used increasingly in efforts at secondary prevention.

Primary Prevention

This long-range type of prevention is directed at communities and not at individuals. If the psychological disorders of communities can be treated, so many more possible cases of mental illness can be prevented. Primary prevention efforts typically affect mental health indirectly, although the effect can be quite large. Examples include neighborhood policing to reduce rates of violence and presence of drug dealers. Providing public service announcements for parents about how to prevent mental retardation (for example, abstaining from alcohol during pregnancy and/or not resorting to shaking infants) would be other examples.

Inadequate Treatment Facilities

Despite preventative efforts, not all individuals' mental health needs are currently being met. Notwithstanding the increased numbers now being cared for, so many more people could lead happier and more productive lives if they could be persuaded to make use of community psychiatric facilities. Mental health surveys indicate that more than twenty-five million people in any one year are in need of psychological help, yet less than eight million are receiving it. It is easy to agree with community psychologists that even with the increase in community-based services, it is unrealistic to count on one treatment mode to deal with the myriad problems of mental illness. What is needed are massive efforts to eliminate the conditions in the psychological environment that breed mental illness. Only through such large-scale preventive efforts can inroads be made on what may be the most significant public health problem today.

Goals of Community Change Programs

Three major environmental factors that breed psychological problems have been held up as targets for mental health efforts. They are racism, poverty, and drug abuse. The National Mental Health Association has spelled out four specific programs that have an immediate potential for attacking those targets and, in that way, reducing mental illness: a family focus approach; sex education; an educational thrust; and increasing popular knowledge of mental health resources.

Family Focus Program

A stable and happy family can be a principal source of mental health. Dysfunctional families are a principal source of troubled emotions and psychological disorders. Families can be strengthened by providing increased family planning and prenatal services and by public information campaigns on good parenting practices and healthy family living.

Sex Education

A second proposed emphasis is the prevention of teenage pregnancies. The services needed to achieve that goal are effective sex education in the high schools, contraception and health services to teens, and help during the teen years with responsible decision-making.

The Educational Thrust

School programs that find their way to helping children from unmotivating families to academic achievement sufficient to qualify them for entry-level jobs with a future are a principal need. Those programs also must provide their students with skills for building stable interpersonal relations—a tall order, indeed, but one that society cannot afford to neglect.

Knowledge of Community Resources

The goal of this approach is to provide those in problem situations, such as teenage drug users, battered wives, or families with an alcoholic problem, with information about community resources that are available to them. The presence of resources in the community that troubled people have never learned about is a waste of talent, both the staff's and the troubled person's, and a sure block to preventive efforts. Few argue with this goal. The unsolved problem is to give it a sufficiently high priority so that financial support is provided to implement it. Mental health workers, who live close to the suffering created by a failure to do so, try to maintain a steady focus of public attention on the matter to get adequate action for these problems, and they need help from all of us.

THE MENTAL HEALTH COMMUNITY

Mental health has a constituency in America, but, unfortunately, its members have not yet grown large enough, its voice loud enough, nor its tactics effective enough, to stimulate a primary prevention program adequate to meet the needs. Yet there is reason to be hopeful. Over the past forty years, the power of those efforts to produce change has increased yearly, and the results of those efforts are now becoming apparent. The mental health community exists at three levels: congressional sympathizers and government staff; professional associations; and volunteer groups.

Congressional and State Legislators

One example of this legislative power was the passage in 1946 of the first comprehensive national mental health bill. The bill authorized the establishment of the National Institute of Mental Health. It originally had one primary function: to serve as a center to stimulate mental health research and training. Subsequently, two other services were added to its original purpose: to provide assistance to communities in setting up locally based mental health programs; and to circulate information on mental health to mental health scientists and to the general public. Many more public mental health initiatives have been implemented since then.

Implementing programs stimulated by the federal legislation is the responsibility of state and local governments. Federal funding has enabled them to do this. With that leadership at the national level, legislatures in a number of states have initiated their own programs in mental health with state funding.

Professional Associations

Organizations such as the American Psychological Association, the American Psychiatric Association, Association for Psychological Sciences, National Association of Social Workers, and other associations of the social sciences have increasingly involved themselves in the promotion of social changes vital to the fostering of mental health. They have done this through lobbying federal representatives and issuing amicus briefs.

The Volunteer Movement

In a most crucial sense, the mental health movement has attracted the support, energy, talent, and, to some extent, funding, of a large body of volunteers from all walks of life. The most well known of these volunteer groups are the National Alliance on Mental Illness and the ARC of the United States, supporting individuals with mental retardation. Professional mental health workers are well aware of the importance of this kind of grass-roots support and cooperate extensively with it. Indeed, they occasionally find it is the volunteer groups that take leadership roles in pushing for desirable social legislation and other supportive activities.

SUMMARY

Beginning as early as 1834, British courts and the U.S. federal and state judiciary have handed down decisions protecting the rights of the mentally ill. Courts in this country were particularly active in doing so during the 1970s. Court decisions have protected the rights of the psychologically disordered in three specific areas. They are as follows:

- The insanity plea: In 1834, an Ohio court held that individuals could not be held responsible for their crimes if it could be established that, as a result of mental illness, they were unable to resist the impulse to commit a crime. Because of the impracticality of using that criterion, other criteria have been established over the years, the first of which was the McNaghten rule, which required that the individual at the time of the crime must have been aware of the nature of his or her behavior. In 1954, a federal district court significantly broadened that criterion, stating, in what has come to be called the Durham test, that if the crime was the product of mental disease or mental deficit, the individual could not be held responsible. In 1972, the Durham test was replaced by a Supreme Court decision that stated that an individual could not be held responsible for a criminal act when, because of mental disease or mental defect, he or she lacked the capacity to appreciate the nature of the act or the capacity to control the impulse. It is that decision that largely governs the use of the insanity plea, which has been used in only 2 percent of criminal trials and has been used successfully in less than 1 percent of felony cases. The most recent development, arising out of John W. Hinckley's attempt to assassinate President Reagan, is the use of the verdict "not guilty by reason of insanity." An individual so judged avoids prison but is committed to a mental institution. Once committed, the Supreme Court ruled in 1983 that such a person might be hospitalized indefinitely.
- Competency to stand trial: This issue deals not with the individual's mental state at the time of committing the crimes but rather with whether he or she is competent to cooperate with counsel in the trial. If determined to be incompetent, the individual must be committed to a mental institution.
- **Civil commitment:** Some mental health professionals advocate that before an individual is civilly committed to a mental institution, certain conditions be met. These are entitlement to a jury trial, protection against self-incrimination, and provision of legal counsel. In addition, the individual must manifest one or more of the following two conditions: dangerousness to self or others and grave disability.

In Wyatt v. Stickney, an Alabama court ruled that state mental institutions must provide their patients with an individualized treatment program, an adequate number of skilled staff, and a humane physical and psychological environment.

In the community at large, increased effort is now being directed to the prevention of mental illness and to the provision of neighborhood clinics designed to reach patients at an early point in their illness. The programs involve tertiary, secondary, and primary intervention, including the community mental health movement. Many players are involved in ensuring the community mental health including state and federal representatives, professional organizations, and grassroots volunteer organizations.

SELECTED READINGS

Fersch, E. L. (ed.) (2005). Thinking about the insanity defense: Answers to frequently asked questions with case examples. Lincoln, NE: iUniverse, Inc.

Scileppi, J. A., Teed, E. L., & Torres, R. D. (1999). Community psychology: A common sense approach to mental health. Upper Saddle River, NJ: Prentice Hall.

Steadman, H. J. (1981). The statistical prediction of violent behavior: Measuring the costs of a public protectionist versus a civil libertarian model. Law and Human Behavior, 5, 263–274.

Tardiff, K. & Koenigsberg, H. W. (1985). Assaultive behavior among psychiatric outpatients. American Journal of Psychiatry, 142, 960-963.

Weiner, B. A. (1985). Mental disability and the criminal law in S. J. Brake, J. Parry & B. A. Weiner (eds.). The mentally disabled and the law (3rd ed). Chicago, IL: American Bar Foundation.

Test Yourself

1)	How frequently is the insanity plea successful in felony cases?					
	a) less than 1 percent	c)	10 percent			
	b) 5 percent	d)	20 percent			
2)	Individuals who are found guilty but mentally ill are a) imprisoned					
	b) hospitalized until deemed to be rehabilitated					
	c) released after trial					
	d) retried after they have been rehabilitated to c	comp	petence			
3)	The American Law Institute's definition of insanity includes					
	a) ability to appreciate wrongfulness	c)	mental illness			
	b) control of one's behavior	d)	both a and b			
4)	An individual can be hospitalized and treated against his or her will if deemed					
	a) a danger to others	c)	having grave disability			
	b) a danger to self	d)	all of the above			
5)	Which of the following is true of community psychology?					
	a) its focus is on psychological disorders	c)	its focus is on building strengths			
	b) its primary aim is treatment of disorders	d)	its focus is on the individual			
6)	Which type(s) of prevention intervene(s) at the moting health?	com	munity level with a long-range approach to pro-			
	a) primary prevention	c)	tertiary prevention			
	b) secondary prevention	d)	all of the above			
7)	Which of the following are key players in community mental health?					
	a) professional organizations	c)	volunteer organizations			
	b) state and federal representatives	d)	all of the above			
8)	Which of the following policies is followed by most psychiatric facilities?					
	a) They provide individualized treatment programs.					
	b) They use contingency management programs in which patients must earn basic privileges.					
	c) They utilize aversive techniques to manage patient behavior.					
	d) all of the above					

Test Yourself Answers

- 1) The answer is a, less than 1 percent. The insanity plea is used in only 2 percent of criminal trials and is successful in less than 1 percent of felony cases. Therefore, it is not the get-out-of-jail-free card for criminals that some individuals view it to be.
- 2) The answer is **b**, hospitalized until deemed rehabilitated. In fact, individuals found guilty but mentally ill often are hospitalized longer than they would have been incarcerated if convicted. This is partly due to pressure from the public and mental health professionals' recognition of the difficulties inherent in predicting risk of future dangerous behavior.
- 3) The answer is d, both a and b. The American Law Institute does not include mental illness in its definition of insanity; however, it does include ability to appreciate the wrongfulness of behavior and control of one's actions. This is currently the most frequently used legal definition of insanity in the United States.
- 4) The answer is d, all of the above. The courts will intervene and order hospitalization and treatment if the preponderance of evidence suggests that an individual is a danger to self or others or so gravely disabled as to be unable to provide basic self-care.
- 5) The answer is c, its focus is on building strengths. As opposed to clinical psychology, community psychology concentrates on mental health, aims to prevent disorders, focuses on the community, and emphasizes building strengths. Clinical psychology tends to focus on psychological disorders, aims to treat, intervenes at the individual level, and emphasizes alleviating symptoms.
- 6) The answer is a, primary prevention. Primary prevention intervenes at the community level with a long-range approach to promoting health. In contrast, secondary prevention aims to prevent the worsening of disorders by encouraging early treatment, and tertiary prevention seeks to prevent relapse by providing supportive services after an intervention.
- 7) The answer is **d**, all of the above. Ideally, professional organizations, state and federal representatives, and volunteer organizations work together to share information and resources while making policy decisions that improve public mental health.
- 8) The answer is a, they provide individualized treatment programs. Hospitals in Alabama are required to provide individualized treatment programs according to Wyatt v. Stickney. They also are required to provide skilled staff in sufficient numbers to administer such a program and a humane psychological and physical environment. Hospitals in other states, generally speaking, follow these same guidelines. Concerns regarding humane treatment have resulted in changes in behavioral programs implemented in psychiatric hospitals. Specifically, the use of contingency management programs where patients must earn basic privileges and aversive techniques to manage patient behavior typically are avoided. These strategies, for the most part, are used only in cases of imminent risk of harm to the patient or others.

Glossary

- adjustment disorder: A disorder characterized by disturbance of emotion and/or conduct beyond what would be expected in response to a common stressor.
- **agnosia:** A disorder in which a person fails to recognize common items.
- **agoraphobia:** An irrational and intense fear of public or open spaces. Occurring in the context of panic disorder, the fear of having a panic attack in a place where escape or seeking help would be difficult or impossible.
- alcoholism: A physical and psychological addiction to alcohol that results in impaired functioning. The technical name is alcohol dependence.
- **Alzheimer's disease:** A type of dementia that results in progressive intellectual deterioration and memory impairment; it eventually is fatal.
- amnesia: Loss of memory, either total or partial, that can result from physiological or psychological causes.
- **amniocentesis:** A test performed on pregnant women in which amniotic fluid is tested for chromosomal abnormalities.
- **amphetamines:** A central nervous system stimulant that produces a feeling of well-being and increased energy.
- anal stage: The stage of development, according to Freud, during which the anus is the focus of curiosity and pleasurable activity; corresponds with toilet training.
- **anorexia nervosa:** An eating disorder characterized by an irrational fear of obesity, an extremely limited intake of food and/or compensating for eating normal amounts of food,

- and body weight 15 percent or more below what is healthy.
- antisocial personality disorder: A personality disorder characterized by impulsivity, superficial interpersonal relationships, failure to conform to social norms, disregard for the rights/safety of others, and an inability to accept responsibility.
- **anxiety:** A nonspecific, unpleasant feeling of apprehension and fear coupled with physiological arousal.
- **anxiety disorder:** This DSM-IV-TR classification encompasses panic disorder, social phobia, specific phobia, generalized anxiety disorder, and obsessive-compulsive disorder.
- **aphasia:** A language disorder resulting from brain injury in which the ability to communicate or to understand communication is impaired.
- **assertiveness training:** This cognitive-behavioral technique teaches a person to express his feelings and cognitions in an effective, direct, nonaggressive manner.
- attention-deficit hyperactivity disorder: A behavioral disorder in children in which the child's ability to function is impaired by inattention, and/or impulsivity and hyperactivity.
- **attribution:** This theory, from social psychology, deals with the way people assess and explain their behaviors and events occurring in their environment.
- autistic disorder: This childhood disorder, classified as a pervasive developmental disorder in the DSM-IV-TR, is marked by severe communication difficulties, an inability to develop appropriate social relationships, restricted inter-

- ests and behaviors, and frequently, cognitive impairment.
- autonomic nervous system: The part of the nervous system that regulates the internal environment including the endocrine glands, stomach, heart, and intestines.
- aversion therapy: This type of behavioral treatment attempts to modify behavior by pairing an unpleasant stimulus, such as electric shock, with the behavior that is to be changed.
- avoidant personality disorder: This disorder is characterized by extreme sensitivity to social rejection, poor self-esteem, and social withdrawal.
- barbiturate: A drug that acts to depress many of the functions of the central nervous system. These types of sedatives can be physically and psychologically addictive.
- baseline: This term, used in behavior therapy, represents a person's level of response before any intervention is attempted.
- behavior therapy: This type of therapy focuses on overt behavior and attempts to modify this behavior through the use of classical and operant conditioning principles.
- benzodiazepines: A family of drugs used to decrease symptoms of anxiety. Two of the most common are Librium and Valium.
- biofeedback: A system that allows a person to monitor certain physiological reactions and to achieve limited voluntary control over these reactions.
- bipolar I disorder: This term refers to a condition characterized by mood swings from mania to depression.
- bipolar II disorder: This term refers to a condition characterized by mood swings from hypomania to depression.
- body dysmorphic disorder: An obsessive preoccupation with a falsely perceived physical anomaly.
- borderline personality disorder: This personality disorder is marked by unpredictable and unstable emotions, relationships, sense of self, and behavior as well as fear of abandonment.
- brief psychotic disorder: A psychotic disorder similar to schizophrenia that lasts between one day and thirty days.

- bulimia: This eating disorder is marked by uncontrollable binges, during which enormous amounts of food are eaten, and is followed by compensatory purging behavior or restrictive dieting.
- case study: An encompassing study of a single individual that utilizes observation and biographical information.
- castration anxiety: This term, central to Freud's Oedipus complex, refers to a fear in males of losing their penis as a punishment for their desires.
- catharsis: The release of emotional tension linked to childhood traumatic events through verbal expression.
- cerebral cortex: The surface layer or gray matter of the cerebrum.
- cerebrum: The largest part of the brain, the cerebrum regulates motor activities and is the center of learning and memory. It is divided into two hemispheres.
- chlorpromazine: The generic name for the antipsychotic medication marketed under the name Thorazine.
- **chronic:** This term refers to a long-lasting, often degenerative, condition.
- classical conditioning: A basic learning theory, first described by Pavlov, in which a neutral stimulus is coupled with a response-producing stimulus. After many pairings, the neutral stimulus will elicit the same response by itself.
- clinical psychologist: A type of psychologist who has been trained at the doctoral level, and who specializes in the assessment and treatment of abnormal behavior.
- cocaine: This drug, derived from the coca plant, acts as a stimulant to the central nervous system and produces feelings of euphoria and extreme self-confidence. It can also be used to relieve pain.
- cognition: This term refers to the act of thinking and perceiving, and to the way in which we arrange our thoughts and attitudes about our environment.
- cognitive-behavioral therapy: A treatment modality that focuses on modifying behavior by changing faulty or maladaptive thoughts and beliefs.

- **community psychology:** The branch of psychology that recognizes the importance of environmental conditions on mental health and focuses on preventive intervention in the community rather than on individual treatment.
- **compulsion:** The need to act in a repetitive, often senseless, fashion in order to reduce feelings of anxiety.
- **concussion:** A brain injury, resulting from a blow to the head, that does not cause any permanent damage. Symptoms include mild confusion and short-term memory loss.
- **conduct disorder:** A type of disruptive behavior disorder of childhood that is characterized by a disregard for the rights of others and for the rules of society.
- confabulation: A false and often unlikely story that an individual will use to cover gaps in his memory. The individual believes these stories are accurate accounts.
- **confidentiality:** A guiding principle of many professions that makes it unethical for the professional to divulge information about his client to anyone else without the client's permission.
- **confounding effect:** An effect in an experiment that results from causes other than the independent variable.
- **congenital:** A condition present at birth but not as a result of heredity.
- control group: The group in an experiment who are not subjected to the experimental condition but in all other ways are similar to the experimental groups.
- **controlled drinking:** A behavioral treatment method that attempts to teach alcoholics to drink in a limited, controlled manner.
- **conversion disorder:** This disorder, formerly known as hysteria, results in impaired motor or sensory functioning even though no physical reason for this impairment can be found.
- **coping skills:** A cognitive-behavioral technique that teaches individuals a variety of ways to manage the stresses of everyday life.
- **correlational research:** A study that evaluates the relationship between two or more variables without exploring causal relationships between these variables.
- counter-transference: The feelings a therapist

- experiences toward a patient that are a result of the therapist's past experiences.
- **covert:** This term is used to describe behavior that is not readily observable and may include emotions and cognitions.
- **covert sensitization:** A cognitive-behavioral technique in which distressing imagery is paired with an unwanted behavior to decrease the occurrence of that behavior.
- **cyclothymic disorder:** An affective disorder characterized by mood swings of a less serious nature than those experienced in bipolar disorder. This disorder tends to be chronic.
- **decompensation:** An imbalance or breakdown that occurs when an individual can no longer deal effectively with environmental stresses.
- **defense mechanism:** A psychoanalytic term that describes the unconscious process by which the ego prevents unacceptable anxiety-provoking conflicts from becoming conscious.
- **deinstitutionalization:** An approach that focuses on moving mental patients out of large institutions and maintaining them in the community.
- **delusional disorder:** A psychotic disorder characterized by delusions, but not other psychotic symptoms.
- **delusions:** Inaccurate beliefs that are firmly held, even in the presence of factual and contradictory evidence.
- **dementia:** An impairment of cognitive functioning that results from a deterioration of brain tissue
- **denial:** A psychoanalytic defense mechanism that prevents distressing realities from becoming conscious by asserting that the reality does not exist at all.
- **dependence:** A state of addiction characterized by tolerance, withdrawal, unsuccessful attempts to control use, and/or use despite negative consequences.
- **dependent personality disorder:** This disorder is marked by poor self-esteem and an inability to assume responsibility for one's life. These people cannot tolerate being alone for any extended period of time.
- **dependent variable:** The part of an experiment that is hypothesized to change as a result of the application of the independent variable.

- depersonalization disorder: A disorder characterized by feelings of being outside of and watching oneself.
- depression: This affective state, which is a common psychological difficulty, involves overwhelming sadness, loss of interest in previously enjoyable activities, poor self-esteem, loss of energy, change in sleep and eating habits, social withdrawal, and thoughts of death or sometimes suicide.
- detoxification: A medical process that seeks to remove all alcohol or other drugs from a person's body.
- diagnosis: The assessment and classification of specific disorders.
- diathesis-stress model: A theory that explains abnormal behavior as a result of the combination of physical or psychological predisposition and environmental stress.
- diazepam: The generic name for the anti-anxiety medication marketed as Valium.
- disorientation: A confused cognitive state in which a person is unsure about his own identity and about time and place.
- displacement: A psychological defense mechanism in which feelings about a person or object are shifted to a different, more acceptable person or object.
- disruptive behavior disorders: A group of childhood disorders that includes attention-deficit/ hyperactivity disorder, oppositional-defiant disorder, and conduct disorder.
- dissociative fugue: Psychogenic amnesia, typically brought on by stress, combined with travel from one's home or work and, occasionally, development of a new identity.
- dissociative identity disorder: A disorder characterized by the development of two or more personalities in response to a severe stressor.
- dizygotic twins: Fraternal but not identical twins who are the product of two separate eggs.
- dopamine: A neurotransmitter substance that, when abnormalities are present, has been linked to the development of schizophrenia and Parkinson's disease.
- double depression: Co-occurrence of dysthymia and major depressive disorder.
- Down syndrome: A type of mental retardation

- frequently resulting from an individual being born with an extra twenty-first chromosome.
- Durham ruling: A landmark legal ruling that stated that an individual cannot be held responsible for a crime if that crime was a result of mental disease or deficit.
- dysthymia: An affective condition marked by chronic, moderate depression.
- echolalia: The automatic repeating of the words and sounds of others.
- ego: A term from psychoanalytic theory, Freud saw the ego as the part of a person's personality that is mostly conscious and manages the demands of the id, the superego, and reality.
- Electra conflict: A psychoanalytic term that describes a young girl's theorized sexual desire for her father and his wish to replace her mother.
- electro-convulsive shock treatment: Also known as ECT, this treatment involves applying electric current to the patient's brain in order to produce a convulsion. This treatment is most frequently used with severely depressed patients who are a high risk for suicide.
- empathy: The ability to comprehend the feelings, needs, and desires of someone else.
- empirical: The use of experiments or observation to gather information.
- encephalitis: An acute inflammation of the brain commonly resulting from a viral infection.
- encopresis: A disorder involving loss of sphincter control and inappropriate bowel movements after the age of three.
- endogenous: Resulting from within a person rather than from external events.
- enuresis: A disorder, occurring most commonly in children, in which a person fails to achieve bladder control at a developmentally appropri-
- epilepsy: A disorder marked by impaired consciousness sometimes accompanied by seizures.
- epinephrine: Also called adrenaline, this hormone is released in reaction to stress, resulting in a variety of excitatory physiological changes.
- erogenous zones: Those areas of the body that are sexually responsive.
- etiology: The determination or the causes of disease.

- **exhibitionism:** A sexual disorder in which a person receives gratification by exposing his genitals in public.
- existential therapy: A treatment approach that focuses on an individual's right to freely determine the course of his or her life and to accept responsibility for those choices.
- **exogenous:** Attributable to external causes, this term is frequently used to describe a type of depression.
- **experiment:** The basis for much scientific study, this investigative technique seeks to test a hypothesis by actively manipulating a variable under controlled conditions and observing what occurs.
- **external validity:** A measure of the ability of experimental results to be generalized to other situations and populations.
- **extinction:** A term used in behavior modification in which reinforcement is removed to weaken or eliminate the acquired response.
- **factitious disorder:** A self-limiting physical or psychological condition that is used to receive attention.
- family therapy: A group treatment approach that aims to facilitate communication among family members and to modify dysfunctional behavior.
- fetal alcohol syndrome (FAS): This disorder results from an infant being exposed to alcohol during the mother's pregnancy. Characteristics include impaired cognitive functioning, restricted growth, behavior problems, learning difficulties, attention deficit, and physical abnormalities.
- **fetishism:** A sexual disorder marked by the need to include an inanimate object in sexual activity in order to achieve arousal.
- **fixation:** A psychoanalytic term that describes an individual's inability to progress beyond a certain developmental stage.
- **flat affect:** An inability to experience a normal emotional response. A negative symptom of schizophrenia.
- **free association:** A psychoanalytic technique in which the patient says whatever comes to mind with no restrictions.
- free-floating anxiety: Generalized feelings of

- anxiety that cannot be attributed to a specific source.
- **frotteurism:** Paraphilia characterized by sexual pleasure derived from rubbing against nonconsenting individuals.
- **functional disorder:** Any abnormal disorder for which there is no known organic basis.
- **galvanic skin response:** A measure of the changes in electrical resistance of the skin.
- **gender identity disorder:** A disorder marked by a conflict between an individual's physical characteristics and gender identity.
- **general adaptation syndrome:** A three-stage reaction to stress, postulated by Selye, characterized by a physiological alarm reaction, defensive responses, and exhaustion.
- **generalization:** An operant conditioning term in which a response will occur in the presence of a stimulus similar to the conditioned stimulus.
- **generalized anxiety disorder:** Anxiety experienced in situations in which there is no apparent anxiety-inducing stimulus.
- **genital stage:** The psychosexual stage of development in Freudian theory when an individual develops the capacity for mature sexuality.
- **genotype:** The part of a person's characteristics that can be attributed to genetic factors.
- **gerontology:** The field of scientific study that focuses on the aging process and the interests and needs of older individuals.
- **Gestalt therapy:** A humanistic model of treatment that emphasizes current concerns and the individual's perception of himself and his environment.
- **grand mal:** The most serious type of epileptic seizure, during which an individual suffers extreme convulsions and loss of conscious functioning.
- **group therapy:** A treatment modality utilized by therapists of various orientations, in which two or more individuals are treated at the same time.
- halfway house: A temporary home provided for recently discharged psychiatric patients to ease their transition back to the community.
- hallucination: A false sensory perception that frequently is auditory or visual nature. A positive symptom of schizophrenia or may be induced by the ingestion of hallucinogenic drugs.

- hallucinogen: Substances such as LSD, ecstasy, and marijuana that result in altered sensory experiences.
- **hereditability:** The amount of variation in a population attributable to genes.
- **heroin:** An opiate that is derived from morphine and is addictive.
- hierarchy of needs: A theory developed by Maslow that postulates that an individual's basic needs must be met before higher level needs, such as self-actualization, can be addressed.
- histrionic personality disorder: A disorder marked by excessive displays of emotion, dependency, self-centered behavior, and unstable sexual relationships.
- **humanistic perspective:** The view that emphasizes an individual's free will and responsibility to choose his or her own direction in life.
- **hypertension:** Abnormally high blood pressure. Called essential hypertension when not due to biological reasons; it frequently is related to psychological stress.
- **hypnosis:** A highly relaxed condition resembling a trance, during which an individual is very open to suggestion.
- **hypochondriasis:** A disorder marked by unfounded and excessive concerns about becoming ill.
- **hypomania:** an episode of abnormally elevated mood that does not meet full criteria for a manic episode.
- **hypothesis:** An unproved explanation for behavior that is evaluated in an experiment.
- id: This Freudian concept is identified as the part of the personality structure governed by instinctual impulses and biological drives.
- identification: A psychoanalytic concept by which an individual achieves a higher stage of development by accepting the values and viewpoints of the same-sexed parent.
- incest: Sexual contact between family members.
- independent variable: The part of an experiment that is controlled by the investigator to determine its effect on the experimental subjects.
- **insanity defense:** A legal maneuver by which a defendant admits to committing a crime, but pleads innocence because of mental disease.

- **insight therapy:** A treatment modality that focuses on having the patient better understand the underlying reasons for his or her behavior.
- **insomnia:** A disorder characterized by problems in falling asleep and staying asleep.
- instrumental learning: A process in which a subject is reinforced for performing a designated response so that the frequency of this response will increase.
- intellectualization: A psychoanalytic defense mechanism involving the repression of unacceptable emotions and the replacement of these emotions with a dry, intellectual explanation.
- **intelligence test:** A standardized measure, usually administered by a psychologist, of evaluating an individual's level of intellectual functioning.
- **intermittent reinforcement:** A method of reinforcing responses at periodic rates rather than after every response.
- internal validity: The degree to which the changes that occur in an experiment can be attributed to the independent variable.
- intrapsychic conflict: A Freudian term that describes the attempt by one area of the personality structure to resist thoughts, feelings, or impulses from a different area.
- **introjection:** A Freudian term for the process by which an individual accepts and internalizes the values of another person or group.
- in vivo treatment: A treatment technique that takes place in the actual situation.
- **irrational beliefs:** In rational-emotive theory, thoughts that are self-defeating and lead to unproductive emotions and behaviors.
- kleptomania: An abnormal condition in which an individual steals impulsively, even though there may be no need for that which is stolen.
- **Korsakoff's syndrome:** A psychotic condition resulting from long-term alcoholism that is characterized by severe cognitive impairment.
- lability: An unstable emotional state.
- latency period: The development stage, as defined by Freud, during which sexual impulses are not important to an individual; the focus, instead, is on practicing appropriate social roles.
- **learned helplessness:** The belief, developed in response to previous experiences, that one has no control over what occurs in life and is there-

- fore helpless to make changes. This is a common explanation for depression in cognitive theory.
- learning disorders: Difficulties learning arithmetic, writing, or reading that cannot be attributed to level of cognitive ability, physical impairment, or psychological factors.
- **libido:** A Freudian term for the sexual and instinctual drives harbored in the id.
- **Librium:** The trade name for chlordiazepoxide, an antianxiety medication.
- **lithium carbonate:** A medication, composed of chemical salts, that is used to control the symptoms of bipolar disorder.
- **lobotomy:** An outdated method of treating severe mental disease in which nerve fibers in the brain are surgically severed.
- locus of control: A theory that suggests that people view situations in one of two ways; either they believe they have the ability to control the outcome of a situation or that the outcome is controlled by a source external to the self.
- logotherapy: A form of existential treatment developed by Victor Frankl after his experiences in a concentration camp during World War II, which focuses on an individual's need to create a life that is productive and meaningful.
- **longitudinal study:** A method of investigation and research that focuses on observing and evaluating the same individuals over an extended period of time.
- magical thinking: A belief, common in young children, that thoughts and behaviors can affect situations in ways that cannot be explained by the laws of nature.
- magnetic resonance imaging: A technique that employs the magnetic field around an individual's head to provide information about the functioning of the brain.
- mainstreaming: An educational concept aimed at providing handicapped students maximum exposure to a regular class setting.
- major depressive disorder: An affective disorder in which a person experiences severe depressive episodes but does not experience manic episodes.
- **maladaptive behavior:** Behavior that does not meet the demands of one's environment in an adequate manner.

- malingering: Faking a physical or mental disorder for personal gain.
- mania: A state of unfounded euphoria coupled with heightened cognitive and motor activity marked by pressured speech, poor judgment, and impulsiveness.
- **masochism:** A disorder in which sexual gratification is achieved by being degraded or by having pain inflicted upon you.
- **medical model:** An approach to the diagnosis and treatment of psychological disorders based on the approach medicine takes to physical disease.
- mental retardation: A developmental disability characterized by below-average IQ (typically lower than 70) and deficits in daily living skills.
- **monoamine oxidase (MAO) inhibitor:** A group of antidepressant drugs that are effective with some depressed individuals.
- **narcissistic personality disorder:** A disorder marked by extreme self-involvement and an inflated sense of self-worth.
- **narcotic:** A drug derived from or similar to the opium poppy, including heroin, codeine, and morphine.
- **negative reinforcement:** A behavioral technique in which the cessation of a noxious condition, such as electric shock, will increase the likelihood that a behavior will occur.
- **neo-Freudians:** Theorists who accept many of the basic tenets of psychoanalysis but who have altered Freud's ideas in significant ways.
- **neurology:** The branch of science that studies the central nervous system.
- **neuropsychological assessment:** A battery of tests designed to measure brain damage and its location.
- **neurotransmitters:** A group of substances produced by the body that function within the central nervous system to facilitate the passing of impulses between neurons.
- **object relations:** The internalized important relationships of the past that influence present social functioning.
- **obsessive-compulsive disorder:** A disorder characterized by intrusive, unpleasant thought and irrational, ritualistic behaviors.
- **obsessive-compulsive personality disorder:** Pervasive, chronic disorder characterized with per-

- fectionism, scrupulosity, rigidity, and obsession with order.
- **Oedipus conflict:** A psychoanalytic term that describes a young boy's theorized sexual desire for his mother and his wish to replace his father.
- operant conditioning: A theory positing that learning takes place when new behaviors are reinforced. Also a method of learning in which behavior is controlled by its antecedents and/or consequences.
- oppositional-defiant disorder: A behavior disorder of childhood characterized by argumentative and angry behavior directed mainly toward authority figures.
- **oral stage:** The earliest stage of development, according to Freud, in which the infant's pleasures are focused on the mouth and feeding activity.
- **outpatient:** In the context of psychological treatment, treatment of an individual who resides outside of the treatment center but makes visits to receive continued care.
- **overt behavior:** Behavior that can be readily seen by an observer.
- **pain disorder:** Characterized by pain with no physical cause.
- panic disorder: An anxiety disorder in which a person experiences sudden but temporary overwhelming fear and believes that he or she may go crazy or suffer a heart attack.
- **paranoid personality disorder:** A personality disorder characterized by unfounded suspicion and distrust of others and their motives.
- paranoid schizophrenia: A form of schizophrenia in which delusional ideation and auditory hallucinations are prominent.
- paraphilias: Sexual behavior in which unusual objects or scenarios are necessary to achieve sexual excitement.
- parasympathetic nervous system: The part of the nervous system that controls bodily functions when the body is at rest.
- **Parkinson's disease:** A disease caused by an inability of the brain to produce sufficient dopamine. Symptoms include muscle rigidity, lack of facial expression, and tremors.
- pedophilia: A disorder in which the affected per-

- son achieves sexual excitement through physical contact with children.
- **perseveration:** The act of persisting in a line of thought or activity when it is no longer functional or appropriate.
- **pervasive development disorder:** A serious childhood disorder in which there is impaired functioning across many areas of development; includes autism and Asperger's disorder.
- petit mal epilepsy: A mild type of epileptic disorder in which short periods of loss of consciousness take place.
- phallic stage: The stage of development, according to Freud, during which the genitals are the focus of curiosity and pleasurable activity.
- **pharmacology:** The study of drugs and their effects.
- **phobia:** A fear of a specific object/circumstance for which there is no basis in reality.
- placebo effect: A change or effect that takes place because a person believes and expects it will take place.
- **pleasure principle:** The principle, according to Freud, that instinctual needs that guide the id to strive for immediate gratification of impulses without concern about reality.
- positive reinforcer: In operant conditioning, a consequence that is applied to an individual that increases the likelihood that a behavior will occur.
- post-traumatic stress disorder: A disorder in which a person experiences impairing symptoms (such as flashbacks and heightened physical arousal) resulting from an earlier severely distressing situation.
- **predictive validity:** The extent to which a test can predict future performance.
- **premature ejaculation:** Sexual dysfunction in which the male is unable to control ejaculation, so that it occurs before satisfying sexual relations can take place with his partner.
- **premorbid:** A term that describes a person's level of functioning before psychological problems develop.
- **prognosis:** A diagnostician's prediction on the direction an illness will take in the future.
- projection: A psychoanalytic defense mechanism

- in which a person rejects thoughts or desires he is experiencing and attributes them to someone else.
- projective tests: Measurement instruments composed of purposely ambiguous material that attempts to uncover an individual's unconscious thought processes.
- psychoanalysis: A therapeutic technique, developed by Freud, that focuses on uncovering unconscious material as a way of understanding one's behavior.
- **psychomotor epilepsy:** A form of epilepsy in which the person engages in behavior that is outside of his or her conscious control.
- **psychopathology:** The area of psychology that studies deviant behavior. Also a broad term for the manifestation of psychological disorders.
- **psychopharmacology:** The study of medications and their effects on psychological disorders.
- **psychophysiological disorders:** Physical disorders that result in part from psychological causes.
- **psychosis:** Extreme psychological disturbance in which thought processes are severely impaired and significant symptoms such as hallucinations or delusions are present.
- **psychotherapy:** The systematic treatment of psychological disorders by psychological methods.
- rape: An act of violence in which sexual intercourse takes place through the use of force or coercion.
- rational-emotive therapy (RET): Therapeutic techniques, developed by Albert Ellis, that focus on changing a patient's irrational beliefs.
- reaction formation: A psychoanalytic defense mechanism in which a person replaces an unacceptable impulse with its opposite.
- reality principle: A psychoanalytic term that describes the ego's efforts to mediate between the demands of the id and of the real world.
- **reinforcement:** In operant conditioning, the technique of following a response with a consequence that will increase the likelihood of the response reoccurring.
- **reliability:** The ability of a test to consistently measure a concept.
- repression: A psychoanalytic defense mechanism

- in which unacceptable thoughts or impulses are forced out of conscious awareness.
- **resistance:** A term from psychoanalytic therapy that describes the tendency of patients to avoid working on issues in treatment that make them anxious.
- **retrospective study:** A form of research that focuses on a participant's history when conducting an investigation.
- **Ritalin:** A stimulant drug that has the effect of reducing hyperactive symptoms in children with attention-deficit/hyperactivity disorder.
- **Rorschach test:** A projective test composed of ten bisymmetrical inkblots. The examinee is asked to describe what the inkblots look like.
- **sadism:** Aberrant sexual behavior in which sexual excitement is achieved by inflicting pain upon one's partner.
- **schizoaffective disorder:** A severe psychotic disorder that combines symptoms of schizophrenia with depression, mania, or a mixed state.
- **schizoid personality disorder:** A personality disorder in which a person is socially withdrawn, emotionally aloof, and indifferent to the feelings of others.
- **schizophrenia:** A severe disorder characterized by unusual behavior, distortion of reality, cognitive disorganization, and inappropriate affect.
- **schizophreniform disorder:** A psychotic disorder similar to schizophrenia but lasting thirty days to six months.
- schizotypal personality disorder: A personality disorder characterized by interpersonal and social difficulties, and odd or eccentric behavior.
- **secondary gain:** The increased attention and other benefits that one receives when ill.
- selective serotonin reuptake inhibitors: Medication that prohibits the reabsorption of serotonin at the synapse; used to treat depression and anxiety.
- **self-actualization:** A term, developed by Maslow, that describes a person functioning at his or her full capacity.
- sensate focus: A technique of sexual therapy in which a couple is guided through a series of nonthreatening sexual activities leading to mutually satisfying sexual intercourse.

- **separation anxiety disorder:** A childhood disorder in which a child is extremely fearful of being separated from his family.
- **serotonin:** The neurotransmitter involved in movement, eating, sex, and aggressive behavior. It is implicated in depression, borderline personality disorder, anxiety, and schizophrenia.
- **sexual dysfunction:** Any impairment of a person's ability to desire sexual contact, to become sexually aroused, or to achieve orgasm.
- **shaping:** An operant conditioning technique in which a response that does not occur naturally is taught by rewarding successive approximation of (small moves closer to) the desired behavior.
- **shared psychotic disorder:** A psychotic disorder where the same delusions are held by two individuals with a close relationship.
- **single-blind experiment:** A type of experiment in which the participant is unaware of whether he or she has received a placebo or the experimental condition.
- **social phobia:** Extreme anxiety about being observed in social situations.
- **somatization disorder:** A disorder characterized by a number of physical symptoms with no physical cause.
- **somatoform disorder:** A disorder in which a person experiences physical symptoms that result from psychological rather than physiological causes.
- **statistical significance:** A statistical analysis that determines the probability of an experimental result occurring by chance.
- **stimulants:** A class of drugs that act upon the central nervous system to produce feelings of elation, confidence, and agitation.
- **stress:** A person's internal response to the demands of the environment.
- **stroke:** Impairment to the central nervous system resulting from blockage or total rupture of the blood vessels supplying nutrients to the area.
- sublimation: A psychoanalytic defense mechanism in which psychic energy is directed away from unacceptable outlets and directed toward socially desirable ones.
- superego: The part of the personality structure,

- according to Freudian theory, that has internalized the ethical and moral values learned from parents and other important people.
- **sympathetic nervous system:** That part of the nervous system that controls important bodily functions during times of stress.
- **systematic desensitization:** A behavioral therapy technique that utilizes relaxation training to reduce the anxiety evoked by certain situations.
- tardive dyskinesia: A side effect of long-term use of phenothiazine medication (antipsychotic) that results in neuromuscular impairment.
- **test-retest reliability:** The extent to which a test, given to the same individuals at different times, will produce consistent scores.
- therapeutic community: The structuring of a hospital setting so that all events and activities have a therapeutic value for the patient.
- **tic:** An involuntary muscle twitch, usually in the area of the face.
- **token economy:** A behavioral technique, frequently employed in residential settings, in which targeted behaviors are rewarded with tokens that can be used to purchase reinforcing objects or activities.
- **Tourette's disorder:** An uncommon but severe disorder characterized by tics and involuntary verbalizations.
- **tranquilizers:** Medications that are used to alleviate anxiety and act as antipsychotics.
- **transference:** A tendency on the part of patients, according to Freudian theory, to ascribe to the therapist the qualities of significant people in their lives.
- **transvestic fetish:** Sexual dysfunction in which an individual achieves sexual excitement by dressing as a member of the opposite sex.
- **tricyclic antidepressants:** A group of medications used to treat depression by prolonging the activity of neurotransmitters.
- **Turner's syndrome:** Abnormality in which females are born with one X chromosome instead of two X chromosomes. These girls do not develop sexually at puberty and have specific cognitive deficits.
- **type A personality:** A personality type characterized by aggressiveness, hostility, and an exces-

- sive drive to achieve. Some medical research links this personality type to an increased risk of heart disease.
- **unconditioned response:** A response to a stimulus that occurs naturally and without being taught.
- **unconditioned stimulus:** A stimulus that produces an unlearned, involuntary response.
- **unconscious:** The part of a person's psychological makeup, according to Freud, that stores repressed thoughts, memories, and impulses.
- validity: The ability of a test to accurately measure what it is designed to measure.

- vicarious conditioning: Conditioning that takes place by observing the consequences of the behavior of other people.
- **voyeurism:** A sexual dysfunction in which sexual excitement is achieved by watching people undress or participate in sexual behavior.
- Wechsler intelligence scales: Standardized intelligence tests for preschoolers to adults that provide verbal and performance scale scores and a general IQ score.
- word salad: An incoherent, disorganized speech pattern that is often observed in individuals with psychoses.

Index

A	abnormal modes of, 46	205–210, 214, 216, 218, 221,	fugue, 130, 132
	maladjustment, 11, 12, 53	232, 244, 249, 258, 260, 262,	generalized and continuous, 131
Abnormal, 1, 3–7, 9, 11–13, 16,	1 45	269, 283, 299, 300	localized, 130
21–23, 25, 27, 28, 30–33,	sexual, 45		
35-37, 39-42, 46, 49, 52-54,	see also Post-traumatic stress dis-	abuse of, 7, 98, 179, 180,	onset of, 131
57-59, 61, 63-67, 69, 70-72,	order	202–205, 207, 208	psychogenic, 130, 131
		treatment, 207-210	retrograde, 131
77–80, 84, 85, 90, 103, 112,	Adler, A., 49, 50		selective, 130, 133
113, 119, 136, 151, 159, 167,	Adolescent problems, 15, 34, 46, 50,	relapse prevention treat-	
169, 178, 189, 219, 222, 227,	76, 78, 100, 114, 119, 120,	ment, 208	Amniocentesis, 256
	128–130, 132, 151, 156, 158,	cognitive-oriented therapy,	Amobarbital, see Barbiturates, amo-
236, 242, 243, 248, 265, 266,		208	barbital
274, 276, 288, 289, 291	161, 226, 260, 261, 265–271,		Amphetamines, 191, 204, 211, 212,
behavior, 1, 3–7, 9, 11–13, 16,	275, 276, 279, 281–285, 287	unanticipated consequences	
22, 23, 25, 28, 30, 31, 33,	abnormal behavior, 265, 269	after therapy, 208	216
		alcoholism, 6, 15, 19, 45, 64, 107,	Anal stage or period (Freud), 44,
35–37, 41, 42, 49, 52–54,	amnesia, 284		45
57, 58, 61, 63–67, 69, 78,	anorexia, 281	109, 111, 147, 205–207,	
84, 85, 90, 151, 167, 219,	antisocial personality, 158	214, 216, 221, 232, 244,	Anesthesia, 127
	attention deficit/hyperactivity dis-	249, 258, 260, 262, 269,	Anorexia nervosa, 65, 129,
236, 265, 266, 288, 289		299, 300	280–282, 284, 287
children and adolescents, of,	order (ADHD), 267		Anti-demandants 60 103 105 111 ·
265, 266	body dysmorphic disorder, 130	alcoholic stage, 107	Antidepressants, 69, 103–105, 111,
brain wave patterns, 159, 274	brain size, unusually large, 275	causative factors, 206, 207	156, 172, 174, 175, 177, 180,
		genetic or other biogenic	222, 235, 281, 282
definition, 3, 266	bulimia, 282		SSRI, 235
emotional reactions, 59	celebrities, 100	causes, 206, 207	
enzyme activity, 178	conduct disorder, 268, 269	personality characteristics,	tricyclic, 105, 174, 175
	emotional problems, 260, 270	206, 207	Antisocial personality disorder, see
fears, 113		chronic, 206, 244	Personality disorder, types of,
Freudian concept of abnormal	generalized anxiety disorder		
development, 49	(GAD), 120	dependence range, 205	cluster B, antisocial
human personality, 52	mental retardation, with, 260, 261	fetal alcoholic syndrome	Anxiety, 4, 6, 7, 20, 31, 43, 45–49,
	narcolepsy, 283	(FAS), 258, 262	51–54, 59, 72, 73, 76, 80, 85,
individual, 49	narcotepsy, 203	peer group, 107, 109, 111, 208,	86, 88, 91, 98, 100–105, 108,
inhibition, 53	obsessive-compulsive disorder,		
male and female hormones, dis-	onset of, 119	214, 218	111–113, 118–123, 125, 126,
tribution of, 222	paraphilia, 226	Alcoholic Anonymous, 107,	128, 130, 135, 139, 142, 145,
	pervasive developmental disabili-	109, 111, 208, 209,	155, 159, 161–163, 207, 213,
mental condition, 291		214, 218	221-223, 230, 231, 233, 245,
modes of adjustment, 46, 49	ties, 275		
personality structure, 46	psychology, 34	physiological factors, 207	249, 260, 265, 270, 271, 276,
personanty structure, 40	sexual impulses, 46	pregnancy, consumption dur-	279, 280
psychological condition, 5		ing, 258, 262, 299	castration, 45
psychology, 1, 3, 9, 11–13, 21,	sleepwalking, 284		defense mechanism, and the, 46
25, 27, 31–33, 37, 39–41,	social phobias, 114	psychological factors, 207	
67, 70–72, 77, 79, 112, 136	Adrenal glands, 245	sexual dysfunction, 221, 232	disorder, 49, 112, 113, 119–123,
		crimes, related with, 202	125, 126, 155, 221, 270,
reflexes, 243	Affective, 84, 85, 157, 167, 168,		276, 279
satisfaction, 119	184–186, 190, 199, 201, 204,	effects of, 205, 206	
serotonin, levels of, 274	238, 239, 247, 248, 282	behavioral, 205	causal factors, 120, 121
	behavior, 85	expectations, influence of, 205	core, 123
sexual activity, 227		long-term, 206	therapeutic approaches, 122,
Abraham, M., 52, 56	disorder, 238		123
Acute, 15, 25, 78, 114, 168, 187,	disturbance, 239, 248	physiological, 205	
195, 239, 245, 260, 269, 283	functioning, 184	social, 205	behavioral/learning perspec-
	lifestyle, 157, 168, 199	psychoses, 203	tive, 122
brain damage, symptoms of, 239		delirium tremens, 203	psychodynamic perspective,
conduct disorder, 269	pleasure, 204		122
emotional problems, 260	reaction, 84, 247	Alcoholics Anonymous (AA), see	
encephalitis, 245	schizoaffective disorder, 185,	Alcohol, problems of, alco-	types of, 112, 119, 125, 221,
	190, 201	holism, peer group, Alcoholic	270, 276, 279
mental illness, 15			free-floating anxiety, see
mood disorder, 168	states, 167, 282	Anonymous	
psychotic deterioration, 187	negative, 282	Alexander, F., 142, 145	generalized anxiety
schizophrenia, 187	symptoms, 168, 186	Alexander, L., 238	disorder
	tolerance, 204	Alexander the Great, 15	generalized anxiety disorder
social phobia from acute sense of			(GAD), 112, 119, 125
embarrassment, 114	withdrawal, 204	Alzheimer, A., 4, 20, 22, 24	
Adjustment, 47, 48, 51, 52, 66, 74,	Age, 3, 6, 12, 27, 32, 33, 37, 40, 44,	presence of brain pathology, 22,	obsessive-compulsive disor-
84, 90, 121, 123, 132, 151,	46, 49, 72, 75, 76, 118,	24	der, 112
	128–130, 140, 151, 156, 157,	Alzheimer's disease, 4, 5, 20, 24, 26,	panic disorder, 112
153, 163, 174, 187, 227, 230,		238, 240–242, 246, 248, 251	performance anxiety, 221
240, 261, 266, 273, 275, 298	161, 190, 192, 207, 211, 226,		
childhood, adjustment reaction	228, 230, 241, 242, 246,	causes of, 241	post-traumatic stress disor-
of, 266	251–254, 256, 259, 260,	paranoid reactions in, 241	der, 112
human adjustment affact 52	264–267, 270–276, 279, 281,	Ambivalence, 187	separation anxiety, 270,
human adjustment effort, 52			276, 279
neurotic strategies of, 51	282, 284, 299	American Psychiatric Association,	social phobia, 112
resources for healthy adjustment,	differences, 3	1, 2, 18, 79, 151, 301	
66	group, 6, 33, 37, 40, 211, 265	American Psychological	specific phobia, 112
		Association, 29, 298, 301	drug, antianxiety, 104
sexual, 227	mental, 253		moral, 46
society, to, 121	periods, 271	Amnesia, 47, 127, 130–133, 135,	
social or occupational, 132, 151,	Agnosia, 238, 243	284	neurotic, 46
153, 163, 273	Agoraphobia, 114, 121, 123	anterograde, 131	normal and pathological, 123
	Alcohol, problems of, 4, 6, 7, 15, 19,	asymmetrical, 131	realistic, 46
Adjustment disorder, 11, 12, 45, 46,		dissociative disorder of 127	see also Fear
49, 53, 112, 114, 117, 118,	45, 64, 98, 99, 107, 109, 111,	dissociative disorder of, 127,	
123–125, 224	119, 140, 147, 179, 180, 202,	130–132, 135	Aphasia, 244

Aphonia, 126	compliant, 3	etiology, 282	183, 185, 206, 225, 239, 244,
Apraxia, 244 Arbitrary inference, <i>see</i> Systematic	conforming, 4	treatment, 282	255, 273, 283, 284
logical errors, arbitrary infer-	coping, 6, 117, 120 criminal, 26, 151, 156, 157, 269,	С .	alcoholism, 206, 244
ence	288–290, 292, 293	Case study, 28, 29, 32, 37	bipolar disorder, low grade, 170
Archetypes, 50, 89	defensive, 53, 54	advantage of, 28	cyclothymia, see Cyclothymia dysthymia, see Dysthymia
Asperger's disorder, 274, 275	deviant, 2, 4	disadvantage of, 29	emotional tension, 137
Assertiveness, 62, 99, 100, 108	disorder, 1, 2	Castration anxiety, see Anxiety, cas-	fatigue, 7, 169
training, 99, 100, 108	disorganized, 186, 201	tration	mental illness, 15
Asylums, 18	disruptive, 5, 10, 266, 267, 270,	Catharsis (cathartic method), 24,	see also acute mental illness
Attention-deficit hyperactivity disorder (ADHD), 106, 211, 266,	276	107	mild depression, 183
267, 276, 279	eccentric, 189 emotional, 155, 159, 191	Cerebral, 74, 237, 238, 240, 243,	negative emotion, 142, 147, 150
Attention-deficit and disruptive	erratic, 118, 257	244, 248, 249, 254 clogging of a blood vessel, 240	narcolepsy, 283
behavior disorder, see	exploitative, 5, 7, 158	clogging of a blood vessel, 249 cortex, 237, 238, 243	schizophrenia, 185 sleep-terror disorder, 284
Attention-deficit hyperactivity	frenetic, 4	damage, 74	sleepwalking disorder, 284
disorder	genetics, 36, 38	degeneration, 238	Classical conditioning, 21, 58, 59,
Atrophy, 126, 192	idiosyncratic, 1	deterioration associated with	69, 98, 227
Attribution of causality, 63, 150, 156	immoral, 1, 12, 64, 151	dementia, 238	Client-centered therapy, 53, 91, 94,
Aura, 247 Autism, 100, 257, 273–276, 279	irrational, 125, 247	hemorrhage, 244	96
autistic disorder, 273–275, 279	maladaptive, 3, 4, 6, 7, 9, 10, 21, 54, 70, 84, 89, 91, 97, 99,	hexosaminidase, absence of	Clinical psychology, 297, 304
onset, 273	100, 108, 121, 151, 265,	enzyme, 257 occlusion, 244, 249	Clinical payabologist
treatment, 273	266	palsy, 254	Clinical psychologist, see Psychologist, clinical
symptomatology, 273	manic, 108	pathways, multiple, 240, 248	Clinical social workers, 8, 10, 12
see also Asperger's disorder	narcissistic, 155	ruptured blood vessel, 249	Clinical syndrome, see Syndrome,
Autonomic responses and system, 6,	normal, 1, 3, 4, 12, 57, 66	vascular accidents, 244	clinical
59, 101, 111, 137, 138, 145, 159	obsessive-compulsive, 118, 119	Cerebrum, 193, 237, 238, 242, 243	Cocaine, 204, 211, 212, 216, 218
defensive reaction of, 138	peer, effect of, 100	Childhood problems, 29, 32, 42, 46,	Cognition, 22, 54, 58, 67, 90, 101,
nervous system, 138, 159	pleasure-seeking, 44 problematic, 2	49–51, 54, 57, 85, 89, 93, 114,	102, 117, 136, 137, 146, 152,
voluntary control of, 101, 145	schizophrenic, 189	119, 120, 123, 131, 132, 135, 143, 151, 155, 158, 160, 163,	176, 184, 188, 204, 210, 259, 261, 276, 285, 304
Average range (IQ), see IQ	sexual, abnormal, 46, 166, 186,	187, 198, 220, 222, 225, 246,	261, 276, 285, 304 cognitive perspective, 67
Aversion therapy, 98, 99, 217, 218,	205, 219–221, 224, 227,	254, 257, 265–267, 269–271,	ego, importance of, 90
228	229, 231, 235	273, 276, 283, 284	idiosyncratic, 101
Avoidant personality disorder, see	submissive, 108	abuse, 132, 135	illogical, 176
Personality disorder, types of, cluster C, avoidant	suicidal, 1, 216	adjustment reaction of, 266	individual's behavior, complexi-
Cluster C, avoidant	Behavioral syndrome, <i>see</i> Syndrome, behavioral	Adler, and, 50	ties produced in, 54
В	Behaviorism, 21, 24, 41, 58–61	aggressive character in, 32 authoritarianism and dictatorial	irrational, 285
Barbiturates, 211, 248	behavioral perspective, 58–60	parental behavior, 120	paranoid, 152 positive, 146
amobarbital, 211	Behavior therapy, 21, 24, 97, 98,	autism, see Autism	psychological elements, influence
phenobarbital, 211, 248	111, 156	conduct disorder, 158, 269	of, 22
secobarbital, 211	cognitive-behavioral therapy, 21,	conflicts, 54, 89	psychotic disorder, 184
Baseline without treatment, 34, 35 Bedwetting, <i>see</i> Enuresis	97 critics of, 101, 111	disapproval and rejection, experi-	somatic changes on mental activi
Beers, C., 18, 22	dialectical behavior therapy	ence of, 155 dissociative identity disorder,	ties, influence of, 136
Behavior, 1-7, 9, 10, 12, 13, 16,	(DBT), 156	onset in, 131	stimulus and response, between, 58
20-22, 24-26, 28, 30-33,	Benzodiazepines, 104, 123	early deprivation, 120	stress-related disorder, 117
35–38, 41, 42, 44, 46, 49,	Bernheim, 20, 22	emotional disorders, 270	systematized, 188
52–54, 57, 58, 61, 63–67, 69,	Bethlehem Asylum (Bedlam), 16	experience, 29, 42, 57, 85	Cognitive-behavioral therapy, 21,
70, 75, 78, 83–85, 89–91, 97,	Biofeedback, 99, 101, 108, 111,	fears and phobias, 271	102, 103, 125, 129, 130, 279,
99, 100, 108, 117–121, 125, 145–148, 151, 155–161, 164,	145, 146, 148, 150	phobias, beginning of, 114	281, 282
166, 167, 179, 185, 186, 188,	Biogenic therapy, 108 drug therapy, 108	Freud, and, 49	Cognitive therapy, 108
189, 191, 199, 201, 203, 205,	other biogenic therapies, 108	generalized anxiety disorder, 120 mental disorder, 276	cognitive therapy, 108
206, 211, 213, 216, 219–222,	Bipolar, 4, 72, 106, 168–170,	obsessive-compulsive disorder,	rational-emotive therapy, 102, 108
224, 227, 229, 231, 235, 236,	174–176, 180, 183	119	self-instructional therapy, 108
238–240, 242, 247, 248, 255,	anticonvulsant treatment of, 176	oversolicitude, 120	Collective unconscious, 50
257, 265–270, 276, 288–290,	I disorder, 72, 169, 170, 183	personality formation, 51	Coma therapy, 103
292–294, 297, 298, 301, 304 abnormal, 1, 3–7, 9, 12, 13, 16, 22,	II disorder, 169, 170, 183	psychological disorder, 265, 266	Community psychology, 297, 304
25, 28, 30, 31, 33, 35–37, 41,	lithium treatment of, 175, 183 Bizarre behavior, 5	psychosis, 269	clinical versus, 297, 304
42, 49, 52–54, 57, 58, 61,	Bleuler, E., 28, 184	reactions to parents, 89 dependence, 89	Compensation, 46–48, 116, 117
63–67, 69, 78, 84, 85, 90, 151,	Body dysmorphic disorder (BDD),	hostility, 89	see also Decompensation Compulsion, 118, 119, 122, 123,
167, 219, 236, 265, 266, 288	126, 129, 130, 132, 135	oversubmissiveness, 89	125
adaptive, 6, 121	treatment of, 130	relationship, 93	cleansing, 119, 122
affective, 85	Borderline personality disorder, see	sex chromosome anomalies, 257	normal, 118, 119
aggressive, 3, 5, 20, 32, 54, 205, 211	Personality disorder, types of,	schizophrenia, 266	pathological, 119
antisocial, 3, 12, 151, 156, 157,	cluster B, borderline Bowers A M 193	sleep terror disorder, 284	see also obsessions
159–161, 213, 268, 290	Bowers, A. M., 193 Braid, J., 20, 22	sleepwalking disorder, 284	Concussion of the brain, 240, 243,
anxious, 121	Breuer, J., 20–22	traumatic sexual experience, 220 Chlorpromazine, 195	244, 248, 251 Conflict 2, 6, 43, 44, 46, 49, 54, 57
assertive, 3	Brief psychotic disorder, see	Chorea, 16, 239, 242, 248, 251	Conflict, 2, 6, 43, 44, 46, 49, 54, 57, 77, 89, 92, 94, 96, 101, 115,
bizarre, 5, 10, 186, 188, 242, 248	Psychotic disorder, brief	Chromosomes, 256, 257, 275, 280	121, 127, 129, 138, 140, 173,
catatonic, 185, 188	Bulimia nervosa, 280–282, 284,	Chronic, 7, 15, 25, 78, 116, 118,	222, 228, 280
clinical observation of, 75, 83	285, 287	137, 142, 147, 150, 168–170,	approach-approach, 115

Dopamine, 64, 105, 153, 166, 172, 191–193, 195, 237, 242, 246, Epinephrine, 105, 106, 172, 174 approach-avoidant, 115 repression, 48 avoidant-avoidant, 115 sublimation, 48 Erogenous, 44 Eros, 43, 46, 50, 89 childhood, 54, 89 unconscious, 46 ego and superego, between, 46 emotional, 92, 94 undoing, 48 Delusion, 5, 15, 49, 132, 168, 170, see also Thanatos Double depression, 170, 183 Etiology, 25, 28–30, 64, 126–130, 132, 138, 144, 151–156, 158, 162, 163, 171, 185, 191, 203, Down syndrome, 256, 257, 262, 171, 184–186, 188, 189, 195, 198, 201, 247, 289 id and superego, between, 57 individual and society, between, 2 Dream, analysis of, see Dream interassociated symptoms, 198 category, 185 206, 207, 271, 273, 274, 280, pretation interpersonal, 138 Dream interpretation, 14, 21, 43, 87–89, 93, 96, 153, 155, 283, 287 282-284 personal demands and restriction of reality, between, 44 psychosexual, 54 relationship, 222, 280 unconscious, 54, 89, 101 persecutory, 185, 189 referencial, 185 Euphoria, 202, 204, 211-213, 218 Exercise, 15, 92, 140, 150, 223, 230, 280, 281, 284, 287 latent content, 88 causative factors, 198 benefit, 92, 140 diagnostic criteria, 198 manifest content, 88 excess of, 280, 281 lifestyle, 150 physical, 140 Confounding effect, 27, 37 disorder, 198, 201 REM, 283 grandiose, 5, 185, 189 multiple, 185 Drug addiction, 204, 210-214, 216, see also Internal validity Congenital, 258 218, 232 Conscience, 5, 44, 46, 155, 157, 288, 289 cocaine, 204, 211, 212, 216, 218 marijuana, 204, 212–214, 216, sexual, graded, 223, 230 religious, 185 somatic, 185 treatment, 223 Exhibitionism, 226, 227, 232, 235 218, 232 systematized, 188 superego, resemblance of, 44 Control group, 33–35, 38, 40, 207 absence of, 157 Dementia, 6, 26, 184, 238, 241–243, 248, 252 LSD, 212, 213 Existential perspective, 41, 52-54, opium, 204, 210, 212, 216 85, 86, 91–93, 96, 120–122 psychotherapy, 92 therapy, 54, 91–93 heroin, 204, 210, 211, Dementia praecox, see 214–216, 218 morphine, 210, 211, 216, 218 see also Alcohol, problems of, alcoholism see also Experimental group Contusion, 243, 244, 248, 251 Schizophrenia
Denial (Freud), see Defense mecha-Exogenous, 19 nisms, denial Dependence, 7, 45, 46, 89 Exorcism, 16 Conversion disorder, see Experimental group, 33–35 see also Control group External validity, 27, 37, 40 Somatoform disorders, conver-Dependent personality disorder, see Dunbar, F., 145 Convulsive therapy, 20, 22, 103, 108, 111, 174, 175, 180 electro-, 20, 22, 103, 108, 111, 174, 175, 180 dyspareunia see Sexual deviations or Personality disorder, types of, Extinction, 59–61, 69, 98, 99, 108 Extraversion, 71 cluster C, dependent dysfunction, dyspareunia Dysthymia, see Mood disorder, Dependent variable, 33, 34, 36, 38 see also Independent variable dysthymia Coping skills, 135, 156 Correlational research, 31 Depersonalization disorder, see Dissociative disorder, Factitious disorder, 133 Depersonalization disorder
Depression, 1, 3, 4, 6, 7, 12, 16, 20,
31, 32, 35, 69, 72, 80, 84, 87,
97, 102–105, 108, 111, 118,
125, 141–143, 162, 167–180,
183, 203, 205, 207, 230, 231,
233, 245, 249, 254, 260, 269,
270, 281, 282
major depressive discrete. 170 Family and marriage group therapy, Countertransference, 89 Depersonalization disorder Echolalia, 188 see also Transference Covert, 43, 98, 99, 107, 120, 145, 152, 158, 228, 235, 259, 281 Ego, 42-44, 46, 48, 49, 51, 54, 57, see Multiple persons therapy, 89, 90, 120 family and marriage therapy anxiety, and, 46, 120 Fantasy, 14, 47 defense, see Defense mechanisms identification of, 47 aggressiveness, 120 ego psychologists, 42 see also Sexual deviations or dysangry personality types, 145 see also Sexual deviations or dys function, fantasy Fear, 4, 13, 15, 16, 45, 46, 50, 57–60, 63, 69, 80, 84, 85, 88, 98, 100, 111–114, 119, 120, 122, 123, 125, 129, 135, 155, 157, 159, 161–163, 166, 195, 230, 232, 233, 265, 270, 271, 279, 284, 287, 297 ideal, 44 bulimia, 281 identity, 51 contradictory messages, 107 envy, 152 major depressive disorder, 170 process, 44 guilt feeling, 259 melancholia, 171 severe weakening of, 49 severe, 175, 203, treatment, 97, 102–105, 111, 118, 173–176 repressed items, 43 Electra complex, 44-46, 57 sensitization, 98, 99, 228, 235 see also Ôedipus complex or consensitization, 98, 99, 228, 233 unhappiness, 158 Cretinism, 257, 258, 262 Culture, 3, 4, 6, 12, 13, 21, 27, 32, 40, 49, 65, 66, 68, 122, 152, 155, 184, 194, 231, 280–282 see also Mood disorder Detoxification, 208, 214 Electric shock treatment, 24 Electro-convulsive therapy (ECT), abnormal, 113 Detoxincation, 206, 214
Developmental design, 32, 37
cross-sectional, 32, 37
longitudinal, 32, 37
sequential, 32, 37 anticipation of, 4 see Convulsive therapy, elecelements of, 112 Electroencephalograms (EEG), 73, behavioral element, 113 Cyclothymia, see Mood disorder, cognitive element, 112 cyclothymia Deviant behavior, 2, 4, 5 Diagnosis, 1, 2, 8, 70–74, 78–81, 83, 106, 122, 127, 129, 143, 144, 151, 155–157, 159, 168, 170, emotional element, 112, 113 Electroshock, 103 Ellis, A., 102, 108, 111 Ellis, H., 220 somatic reaction, 112 irrational fears (phobias), 59, 80, 84, 123, 125 Death instinct, see Thanatos Ems, r., 220 Empathy, 86, 91, 92, 155, 166 Empirical, 41, 93, 102, 179 Encephalitis, 245–247, 249 epidemic, 245 Decompensation, 117, 138, 150 171, 185, 189, 197, 198, 203, 220, 221, 238, 239, 241, 255, 257, 266–270, 289, 290 normal, 113 biological, 117 psychological, 117, 138 see also Compensation Oedipus complex, arising from, 45, 46 Defense mechanisms, 42, 46–50, 54, 57, 69, 88, 89, 120, 138 Diathesis-stress model, 137, 144, lethargica, 245 Encopresis, 271–273, 276 process of conditioning, produced by, 58 see also Anxiety 147, 150 anxiety and, 46 breakdown, 48 Disorientation, 184, 241, 243, 245 Displacement, 47, 248 Endocrine glands, 172, 239, 245, see also Panic disorder Disruptive behavior disorders, 5, 10, 266, 267, 270, 276
Dissociation, 47, 155
Dissociative disorder, 47, 126, 127, Endogenous causation, 19 Enuresis, 271, 272, 276, 279 see also Phobia compensation, 46 denial, 47 Feeblemindedness, 252 causes of, 272 Fetal alcohol syndrome (FAS), see displacement, 47 treatment approaches, 272 Epilepsy, 14, 21, 104, 111, 239, 240, 246–249 Alcohol, problems of, alcodissociation, 47 holism, fetal alcoholic syndrome (FAS),
Fetishism, 224, 235
causal factors, 224 130-132 fantasy, 47 functions of, 47, 48 Dissociative amnesia, 127, acquired, 247 identification, 47 130-132 maladaptive, 120 Dissociative fugue, 130, 131 grand mal, 247 sexual fantasies, 235 over-reliance upon, 57 Dissociative identity disorder, 47, idiopathic, 247, 249 personality warping, 49 projection, 47, 48, 57 petit mal, 247 127, 130, 131 see also Transvestic fetishism Depersonalization disorder, 130 Jacksonian, 247, 249, 251 Fixation, 45, 129, 163, 227 psychomotor, 247, 249, 251 seizure, 73, 246, 247, 249 Flat affect, 157, 186, 201 rationalization, 48 Dix, D. L., 18 Dizygotic twins, 36, 190 Dollard, J., 97, 101 reaction formation, 48 Free association, 21, 24, 87, 88, 93,

treatment, 111,

regression, 48

Free-floating anxiety, see Anxiety,	genetics, 64-66, 107, 116, 120,	Hypertension, 7, 142-148, 150	1
disorder, types of, generalized	121, 123, 125, 127, 129,	essential, 142, 147, 148, 150	Jackson, H., 247, 275
anxiety disorder (GAD),	137, 139, 144, 145, 147,	Hyperthyroidism, 245	Jacksonian epilepsy, 247, 249, 251
Freud, Anna, 49, 50	150, 158–160, 163, 166,	Hypnosis, 17, 20–22, 24, 43, 88, 89,	Jung, C. G., 49, 50, 52, 89
Freud, S., 4, 20–22, 27–29, 41–46,	172, 173, 178, 180, 190,	96, 98, 127	Juvenile delinquency, 30
49–54, 57, 86–90, 120, 122,	191, 194, 198, 199, 204,	aid to psychotherapy, 24	
220 influences on current psychody-	206, 215–218, 241, 242,	Freudian psychoanalysis, use in, 88, 96	K
namic theories, 89	252, 256–258, 262, 267, 269, 274, 275, 279, 280,	nature, 21, 22	Kanner, L., 273
neo-Freudians, 41	282, 284	uses in therapy, 21	Kaplan, H., 223 Kierkegaard, S., 52
overview of Freudian concepts,	abnormalities, 256, 262	Hypnotism, see Hypnosis	Kinsey report, 219
49	anomalies, 159	Hypochondriasis, see Somatoform	Klein, 268
concept of abnormal develop-	behavior, 36–38	disorders, hypochondriasis	Korsakoff's psychosis or syndrome,
ment, 49	causes of alcoholism, 206	Hypomania, 168–171, 183	206, 216, 244, 249, 251
concept of normal develop-	component, 163, 166, 178,	Hypothesis, 25, 27, 28, 30, 32–34,	Kraemer, H., 16
ment, 49	190, 217, 275	38, 64, 122, 142, 159, 174,	Kraepelin, E., 19, 20, 22, 170, 184,
later modifications of Freudian views, 50	counseling, 257 factors, 159, 172, 178, 180,	190–192 Hypothyroidism, 172, 245	185
practice, 27	190, 199, 206, 241, 256,	Hysteria, 16, 17, 20–22, 27, 28	L
psychoanalysis, Freudian, 87	269, 274, 275, 279, 284	see also Sexual deviations or dys-	Lability of affect, 239
psychoanalytic theory, 42	influence, 121, 144, 159, 190,	function, hysteria, sexual	Latency period (Freud), 44, 46
psychodynamic perspective, 41	191, 206, 256	nature of	Learned helplessness, 146, 173, 174
psychodynamic therapies, post-	predisposition, 127, 150, 160,		183
Freudian, 89	172, 173, 199, 280, 282		Learning disorders, 266, 276
technique and theory, 21	vulnerabilities, 123, 125, 144,	Id, 43–46, 49, 54, 57, 89, 90	Libido, see Eros
Fromm, E., 53	145, 178, 194, 204, 215,	see also ego	Lithium carbonate, 174, 175
Frotteurism, 226, 227, 232, 235 Frustration, 6, 44–46, 48, 92, 115,	216, 218 heritage, 240	see also superego	Lobotomy, 20, 22, 104
173, 233, 235, 253, 254	inherited, 64	Identification, 33, 45, 47, 128, 151, 185, 208, 219, 269	prefrontal, 104 Longitudinal study, 32, 33, 37, 40,
Functional disorders, 128, 236, 238,	mutation, 256	Imbalance, 63–65, 67, 172, 183,	207, 210
239, 246, 248	recessive, 231, 256, 257	201, 222	Love, feeling of, 46, 47, 52, 53, 89,
symptoms, 246	Genital period or stage (Freud),	biochemical, 63-65	157, 198, 213, 222, 259, 290
treatment of, 246	44–46	biophysiological, 63	absence of, 222
see also Organic disorders	Genotype, 36	chemical, 64, 67	LSD (lysergic acid diethylamide),
Functional psychosis, 198	Gestalt therapy, 91–94, 96	hormonal, 172, 222	see Drug addiction, LSD
G	Goldstein, 197, 275 Grand mal epilepsy, <i>see</i> Epilepsy,	neurochemical, 183 neurotransmitter, 183, 201	М
Galvanic skin response, 101, 111	grand mal	Incest, see Sexual deviations or dys-	Magical thinking, 153
Gender, 6, 27, 60, 72, 114, 154, 219,	Graves disease, 245, 249	function, rape or incest	Magnetic resonance imaging (MRI),
220, 224, 228, 229, 232, 235,	Griesinger, W., 19	Independent variable, 33, 34, 36, 38	26, 74, 80, 83, 239
283, 284	Group therapy, see Multiple persons	see also dependent variable	Magnification and minimization, see
differences, 6	therapy, group therapy	Inferiority complex, 50	Systematic logical errors, mag-
disorder, 219, 220, 224, 228, 229,	Group psychotherapy, 106, 143	Insanity, 18, 151, 156, 288–292,	nification and minimization
232, 235		301, 304 Inconity defense 288, 202, 201	Mahler, M., 50, 51, 90
cross-gender behavior, 228, 229, 232	Н	Insanity defense, 288–292, 301, 304	Mainstreaming, 262, 264 Major depressive disorder, <i>see</i>
cross-gender hormones, 229	Halfway house, 298	Insight therapy, 85, 104, 275	Depression, major depressive
identity, 219, 220, 224, 228,	Hallucination, 5, 15, 49, 132, 170,	Insomnia, 169, 174, 175, 214, 243,	disorder
229, 232, 235	171, 184–186, 189, 194, 195,	268, 282, 283, 285, 287	Maladaptive behavior, see Behavior,
identity, 228, 229	198, 201, 212, 245, 247, 283	cause of, 282, 283	maladaptive
role, 228	Hallucinogens, 204, 210, 212, 213,	treatment, 283	Malingering, 127
General adaptation syndrome, 117,	216, 218	Instincts (Freud), 43, 50	Malnutrition, affects, 206, 216, 255,
137, 138, 150 Generalization, 60, 121, 176	LSD, see Drug addiction, LSD Hashish, see Drug addiction, mari-	Insulin therapy, 20, 22, 24, 103 Intelligence, general, 14, 77, 115,	256, 281, 287 Mania, 16, 106, 167, 168, 170–172,
stimulus, 60	juana	116, 230, 256, 257	175, 180, 183
Generalized anxiety disorder, see	Heidegger, M., 52	Intelligence test, 71, 75, 76, 81, 83,	dancing, 16
Anxiety, disorder, types of,	Heredity, 14, 36, 67, 206	252	hypomania (subacute), 168–171,
generalized anxiety disorder	Heroin, see Drug addiction, opium,	see also Personality test	183
(GAD),	heroin	Internal validity, 27, 37, 40	level of, 168–171, 183
Genes, 7, 10, 36–38, 64–66, 69, 107,	Heterosexuality, see Sexual devia-	see also Confounding effect	symptoms, 167, 168
116, 120, 121, 123, 125, 127, 129, 137, 139, 144, 145, 147,	tions or dysfunction, hetero- sexuality	IQ (Intelligence quotient), 75, 76, 253, 256–258, 264, 275	treatment, 106
150, 158–160, 163, 166, 172,	Hierarchy of needs, 52	four levels of mental retardation,	see also Depression Manic-depressive psychosis, see
173, 178, 180, 183, 190, 191,	Hippocrates, 14, 15, 17, 21, 22	253	Psychosis
194, 198, 199, 201, 204, 206,	Histrionic personality disorder, see	mild, 253	Masochism, 225, 226, 232, 235
215–218, 231, 233, 240–242,	Personality disorder, types of,	moderate, 253	see also Sexual deviations or dys-
248, 251, 252, 256–258, 262,	cluster B, histrionic	profound, 253	function, classification of,
267, 269, 274, 275, 279, 280,	Hitler, A., 52	severe, 253	paraphilias, sexual arousal
282–284	Holistic approach, 9	Irrational, 49, 59, 80, 84, 85, 102,	and preferences for situa-
common in family members,	Homosexuality, see Sexual devia- tions or dysfunction, homosex-	108, 111, 113, 122, 123, 125, 156, 163, 247, 270, 281, 285	tions causing sufferings,
dominant, 64, 65, 172, 180, 206,	uality	behaviors, 125, 156, 247	masochism see also Sadism
231, 233, 242, 248, 251,	Hormones, 139, 172, 222, 229, 245	fears, 59, 80, 84, 113, 123, 125,	Massage, 14
256, 257	Horney, K., 50, 51, 57, 90	163, 270	Masturbation, 224
autosomal, 251	Humanistic perspective, 52, 54, 91,	forces, 49	May, R., 52, 53
defective, 64, 65, 172, 180,	121	idea, belief or thinking, 85, 102,	Medical model, 58, 64, 79, 80, 298
231, 233, 242, 248, 256, 257	Huntington's chorea, see Chorea	108, 111, 122, 281, 285	Melancholia, 171
231	Huxley, 196	self-devaluation, 102	Meninges, 246

Phobia, 4, 21, 37, 59, 62, 69, 80, 86, 97, 98, 101, 102, 108, 111–114, 123, 125, 239, 265, Paracelsus, 17 Paranoid, 152, 153, 155, 185, 186, Meningitis, 245, 246, 249 Mental deficiency, 252 Mental health, 5, 8–10, 12, 18, 19, Narcolepsy, 211, 282, 283, 285, 287 188, 189, 191, 198, 199, 212, treatment, 283 29, 32, 73, 80, 84, 93, 112, Narcosis, 127 218, 241 270 271 128, 160, 168, 197, 202, 260, 291–302, 304 agoraphobia, 114 Narcotic, 204, 207, 210, 211, 214, Alzheimer's disease, reactions in, simple phobias, 113, 123, 265 216, 218, 222 291–302, 304 Mental Health Association, 18, 299 Mental illness, 3–6, 8, 12–21, 64–67, 79, 97, 103, 288, 289, 291, 294, 297–299, 301, 302, National Institute of Mental Health, delusions of persecution and social phobia, 112, 114, 123 112, 298, 300 grandiosity, 189 specific phobias, 112, 113, 125, Negative reinforcement, 60, 61 Neo-Freudians, 41, 42, 93 Neologisms, 186 overtly, 185 239 paranoia, 153, 155, 218 treatment of, 97 schizophrenia, 188, 189, 191, see also Fear 304 see also Panic disorder Pinel, P., 17, 22 Nervous system, 15, 19, 127, 138, 159, 236, 246, 257 198, 199 concept of, 3, 6 problem of, 16 onset, 189 symptoms, 186 thinking, 198, 212, 241 Mental retardation, 2, 11, 245, 252–262, 264, 266, 274, 279, 292, 295, 299, 301 autonomic, 138, 159 Placebo, 35, 40 Pleasure principle (Freud), 43 Positive reinforcement, 60, 61, 98–100 central, 257 characteristics of, 246 Neurologists, 21, 236, 241, 246 treatment, 152 Mescaline, 212, 213, 216 Mesmer, F. A., 20, 22 see Personality disorder, types of, Post-traumatic stress disorder (PTSD), 35, 36, 112, 114, 117, Neurology/neurological, 59, 72, 73, cluster A, paranoid Mesmerism, 20, 24 127, 236, 239, 246, 251, 254, Paraphilias, see Sexual deviations or Microcephaly, 258, 262 258, 274, 275 118, 123, 230 dysfunction, classification of, Neuropsychological assessment/test, 74, 239 Migraine headaches, 145 Miller, N., 97 Preconscious, 42, 43, 57 paraphilias Paresis, 20, 22, 24, 64 see also Unconscious Mind, 3, 18, 42, 54, 59, 64, 76, 111, 119, 136, 137, 141, 147, 184, 185, 187, 213, 236, 290 Parkinson's disease, 191, 237, 242, 246, 248, 251 Predictive validity, 71, 72, 80, 83 Halsted-Reitan Neuropsychological Battery, Premature ejaculation, see Sexual Pavlov, I., 21, 58–60, 67 experiment, 59, 60 deviations or dysfunction, 239 ejaculation, premature Primary process (Freud), 43 Prognosis, 2, 67, 72, 79, 185–187, 194, 198, 246, 267, 269, Neurosis, 20, 22, 50, 51, 89 Neurotic, 46, 49–51 mind-body problem/interdependsignificance of, 59 respondent conditioning, 60 ence, 136, 137, 141, 147, anxiety, 46 236 Pedophilia, see Sexual deviations or dysfunction, classification of, mind-expanding experience, 213 strategies of adjustments, 51 Monoamine oxidase inhibitor helplessness, 51 paraphilias, sexual arousal and Projection, see Defense mecha-(MAOIs), 105, 174, 175 hostility, 51 nisms, projection Projective tests, 76, 77, 81 isolation, 51 preferences for nonconsenting Monozygotic twins, 190 Monod disorder, 86, 103–106, 138, 155, 156, 167–175, 177, 178, 180, 183–185, 198, 201, 202, 207, 270, 282, 283, 285 bipolar, see Bipolar Neurotransmitters, 64, 105, 138, 172, 174, 178, 183, 191, 192, 201, 237, 242, 248, 283 partners, pedophilia Peer group therapy, see Multiple Prostitution, 225 Psychiatric social worker, 8–10, 12, 28, 70, 299, 301 persons therapy, peer group therapy Pellagra, 244, 245, 249 Penis envy, 46, 51, 57 Personality disorder, 2, 5, 151–164, Nondirective therapy, 91 Norepinephrine, 105, 106, 172, 174 Psychiatrist, 8-10, 19, 28, 70, 77 112, 194, 195, 236, 288, 290, causative factors, 171 biochemical, 172 294 Psychiatry, 3, 13, 14, 17–20, 136, 293, 298 166, 169, 198, 269 common characteristics, 163 biogenic, 172 Object relations, 51, 90 Obsession, 118, 119, 122, 123, 125, 130, 135, 280, 282, 284, 287 genetic predisposition, 172 293, 298
Psychoanalysis, 4, 20, 21, 24, 41, 50, 51, 58, 87, 88, 93, 96, 122
Psychoanalyst, 42, 46, 49, 88, 223
Psychogenic, 130, 131
amnesia, 130, 131
Psychologist, 3, 4, 8, 10, 12, 21, 24 diagnosis of, 151, 157 types of, 151–164, 166, 198, 269 neuroendocrinal, 172 congruent, 171 cluster A, 152–154, 161, 166, 198 cyclothymia, 169, 170 normal, 118 depressing, 86, 167–170, 180, 183, 201 pathological, 119 Obsessive compulsive disorder, 4, 77, 80, 112, 118, 119, 163 paranoid, 152, 166, 198 schizoid, 152, 153, 161, dysthymia, 169 incongruent, 171 longitudinal, 171 Obsessive compulsive personality 166 schizotypal, 153, 154, 166 cluster B, 154–161, 166, 269 disorder, see Personality disormanaging, 156 der, types of, cluster C, obsessive-compulsive antisocial, 5, 151, 154. manic, 168 161, 173, 189, 191, 193, 194, 199, 205, 218, 228, 229, 236, Oedipus complex or conflict, 44, 57 156-161, 166, 269 mild to moderate, 169 mood swings (disturbance, shift), 106, 155, 156, 167, 185, 201, 282 See also Electra complex Operant conditioning, 21, 58–62, 67, 69, 85, 97, 98, 101, 103, 121, 145, 146, 225, 227 borderline, 154-156, 166 238, 252, 259, 260, 280, 288, 290, 294, 297, 299 histrionic, 154, 166 narcissistic, 154, 155, 166 clinical, 3, 8, 189, 297 lack of empathy, 166 negative, 138 cluster C, 162, 163, 166 avoidant, 161–163, 166 cognitive, 58, 62, 173 Oral period or stage (Freud), 44, 45 positive, 138 community, 297, 299 Organic conditions, 136, 247 rapid cycling, 171 counseling, 8 dependent, 161, 162, 166 seasonal, 171 Organic disorders, 73, 236, 238, 239, 246, 248 ego psychologists, 42 severe, 170, 171, 174 obsessive-compulsive, 161, physiological, 137 research, 79, 142, 189 163, 166 specifiers, 171 see also Functional disorders stabilizing drugs, 103, 104, 105 suicide, 177 Personality test, 71, 75–78, 81, 143 Organic factors, 184, 262 school, 8 Overcompensation, 47 Personalization, see Systematic logi-Psychomotor, 74, 168, 171, 183, supercharged, 168 treatment of, 174, 183 Overgeneralizations, see Systematic cal errors, personalization vasive development disorder, 257, 266, 273–276 247, 249, 251 logical errors, overgeneralizabiogenic, 174 psychotherapeutic, 174 Morel, H., 19 agitation, 183 tions causative factors, 274, 275 deficit, 74 Overt behavior, 156 epilepsy, 247, 249, 251 Overt manifestation of psychotic treatment of, 275 retardation, 168, 171, 183 Petit mal epilepsy, see Epilepsy, symptoms, 186 Mores, 65 Psychoneuroimmunology (PNI), petit mal Multiple personality, 47 Phallic period or stage (Freud), 44, 45, 57 137, 138, 144 Multiple persons therapy, 106, 107, Psychopathic personality, 156 Psychopathology, 83, 225 Psychopharmacology, 104 Psychophysiological disorder, 137–139, 141, 146 Pain disorder, see Somatoform dis-109, 111 Pharmacology, 103, 104 Phenobarbital, 211, 248 Phenothiazine, 104, 191, 192, 195 family and marriage therapy, 106 orders, pain disorder Panic disorder, 59, 101, 112, 114, group therapy, 106 peer group therapy, 106, 107, 109, 111 121, 123, 125, 180, 204, 213, 270 Phenylalanine, 257 Phenylketonuria (PKU), 257, 262, Psychophysiological illness, 140, Murphy, G., 52 see also Fear Myxedema, 245 145, 146 see also Phobias

Psychosis, 20, 49, 65, 66, 168, 170,	Ritalin, 106, 211, 268, 279, 287	assertiveness, 100	225, 226, 235
171, 184, 185, 191, 193, 198, 201, 238, 245, 269	Rogers, C. R., 52, 53, 57, 86, 91, 93, 122	awareness, 52, 53, 132, 247 care, 140, 254, 279, 304	masochism, 225, 226, 235
amphetamine, 191	Role playing, 75, 100, 197, 269	centeredness, 77, 164	sadism, 225, 235
childhood, 269	Rorschach inkblot test, 77, 83	concept, 51, 53, 67, 122	treatment, 228
florid, 201	Rubella (German measles), 258	confidence, 120, 162	sexual dysfunction, 220–223
functional, 198 manic depressive, 65, 168, 170	S	deception, 47	causative factors, 221, 222
schizophrenic, 193	Sadism, 225, 226, 229, 232, 235	defeating, 162 deprecation, 115	faulty learning, 222 negative emotions
senile, 20, 24	see also Sexual deviations or dys-	destructive, 100	regarding sex, 222
Psychosomatic disorders, 15, 137,	function, classification of,	determined choice, 93	psychosocial influences,
138, 141, 144, 145, 148	paraphilias, sexual arousal	devaluation, 102	221
Psychosurgery, 20, 103, 104, 108, 111	and preferences for situa- tions causing sufferings,	dramatization, 154	relationship problems,
Psychotherapist, 86	sadism	esteem, 33, 46, 47, 52, 72, 94, 155, 161, 162, 169, 173,	222 traumatic sexual experi-
Psychotherapy, 8, 9, 12, 53, 57,	see also Masochism	224, 227, 231–233, 255,	ence, 222
84–86, 89, 91–93, 96,	Sadomasochist, 225	259, 267, 268, 271, 279	disorders of arousal stage,
104–106, 108, 122, 123, 125,	Scaline, 212, 213, 216	fulfillment, 80, 83	221
143, 146, 160, 173, 174, 177, 180, 183, 208, 215, 216, 246,	Schizoaffective disorder, <i>see</i> Affective, schizoaffective dis-	identity, 132, 133, 155, 199, 238, 271	disorders of orgasm phase,
249, 281, 284, 285, 287	order	image, 121, 161, 166, 207	221 hypoactive desire disorder,
client-centered, 91, 93	Schizoid personality disorder, see	incrimination, 292, 293, 301	220
existential, 92, 93, 96	Personality disorder, types of,	indulgence, 208	physical causes, 222
gestalt therapy, 92, 93	cluster A, schizotypal	insight, 47	external substances, 222
group, 143 psychodynamic, 84–86, 89, 96	Schizophrenia, 3, 4, 12, 20, 26, 27,	instructional therapy, 102, 108	medical conditions, 222
Psychotic disorder, 184, 185–199,	28, 36, 37, 64, 74, 80, 103–105, 137, 153, 154,	maintenance regimen, 105 perception, 132	sexual aversion disorder, 220
212	184–199, 201, 260, 266, 298	report, 74, 75, 77, 81, 83	sexual pain disorder, 221
brief, 185	avolition, 187	satisfaction, 100	treatment, 223
general medical condition, due to,	causative factors, 189–194, 201	scrutiny, 130	cocaine, effects of, 212
185 shared, 185	biochemical, 191	statement, 269	cultural influences, 65
substance-induced, 185	biogenic, 190 cultural, 194	talk, 102 Selye, H., 117, 137, 138	delusion, 198 depressive, 168
substance madeca, 103	neuroanatomical, 192	Sensate focus, 223, 232, 235	dyspareunia, 235
R	psychological factors, 193	Separation anxiety disorder, see	education, 300
Rape, see Sexual deviations or dys-	viral infection, 193	Anxiety, disorder, types of,	ejaculation, 221, 223, 224, 226,
function, rape or incest	childhood, 266	separation anxiety	232, 235
Rapport, 72, 74 Rational-emotive therapy (RET), see	course, 187 diagnostic criteria, 198	Serotonin, 104, 105, 172, 174, 175, 178, 207, 274	premature, 221, 223, 232, 235 energy, sexual, 50
Cognitive therapy, rational-	disorganized behavior, 186	Sexual deviations or dysfunction, 2,	fantasy, 44
emotive therapy	disorganized speech, 186	17, 42, 44–46, 48, 50, 54, 57,	Freud, 44, 50, 89, 90, 220
Rationalism, 136	drug therapy, effects of, 195	65, 89, 90, 97, 119, 154, 166,	frustration, sexual, 233, 235
Rationalization, see Defense mecha-	familial pattern, 154	168, 170, 175, 186, 198, 205,	genital stage, 46
nisms, rationalization Reaction formation, <i>see</i> Defense	family therapy, 196 hallucination, 186	212, 214, 219–231, 235, 245, 256, 257, 261, 269, 283, 300	heterosexuality, 225 histrionic, 154, 166
mechanisms, reaction	symptoms, 104, 105, 153, 185,	adjustments, 45	homosexuality, 225, 235
formation	187, 189, 191, 192, 195,	alcohol, effects of, 205	hypersexuality, 170
Reality principle (Freud), 44	198, 201	chromosome anomalies, 257	hypoactive sexual desire disorder,
Regression, <i>see</i> Defense mechanisms, regression	treatment, 64, 103–105, 153, 191, 194–196	classification of, 220–230, 235	hysteria sevual natura of 17
Rehabilitation, 160	types, 187–189, 191	gender identity disorder, 220, 228, 229	hysteria, sexual nature of, 17 id, 44
Reinforcement, 58, 60-62, 67, 69,	catatonic, 187, 201	biological influences on	latency period, 44, 46
98–100, 108, 119, 161, 163,	disorganized, 188	gender identity, 229	libido, 50
214, 225, 298	paranoid, 188, 189, 191	elements in gender identity,	manic, 168
continuous, 61, 69 differential, 99, 100, 108	residual, 188, 189 undifferentiated, 188, 189	228 gender identity, 228	normal sexual activities, 219, 220
negative, 61	Schizotypal personality disorder, see	gender role, 228	obsessions and compulsions, pathological, unacceptable
parental, 163	Personality disorder, types of,	sexual orientation, 228	sexual content, 119
partial, 61, 69	cluster A, schizotypal	psychosocial influences,	phallic stage, 45, 57
past, 119	Secobarbital, 211	229	psychosexual development and
positive, 98–100 removal of, 98	Secondary gain, 126, 127, 129 Secondary process (Freud), 44	paraphilias, 220, 223–228, 235 behavioral theory of, 227	phases, 42, 44, 45, 54, 89 conflict, 54
schedules of, 61	Sedatives, 204, 210, 211, 216	psychodynamic theory of,	rape or incest, 220, 229–231, 235
social, 108	Selective abstraction, see Systematic	227	gang rape, 230
theory of, 67	logical errors, selective	sexual arousal and prefer-	reasons for universal taboo on
Reliability, 26, 70–72, 77, 79, 80, 83	abstraction	ences for nonconsent-	incest, 231
inter-rater, 71, 77, 79, 80, 83 predictive validity, 72	Selective serotonin reuptake inhibitors, 104, 105, 174, 175	ing partners, 226, 235 exhibitionism, 226	sublimation, 48
test-retest, 71, 80, 83	Self, 1, 4, 7, 44–46, 50–54, 57, 67,	frotteurism, 226, 235	transvestism, 224 Shaken Baby syndrome, <i>see</i>
Repressed, 28, 43, 45, 48, 54, 85,	72, 74, 75, 77, 80, 81, 83, 93,	pedophilia, 226	Syndrome, shaken baby
88, 89, 91, 142, 150	94, 100, 102, 105, 108, 115,	voyeurism, 226, 235	Shakespeare, 205, 228
see also Unconscious	120–122, 130–133, 140, 154,	sexual arousal and prefer-	Shaping, 61, 99, 100, 108, 111,
Repression, see Defense mecha- nisms, repression	155, 161, 162, 164, 166, 169, 173, 199, 207, 208, 224, 227,	ences for nonhuman objects, 224, 235	Shared psychotic disorder, 185
Resistance, 13, 16, 88, 89, 93, 96,	231–233, 238, 247, 254, 255,	fetishism, 224, 235	Shock treatment, see Coma therapy;
117, 128, 138, 177, 247	259, 267–269, 271, 279, 292,	transvestic fetishism,	Convulsive therapy
Respondent conditioning, see	293, 301, 304	224, 225, 232	Sleepwalking, 263, 284, 285, 287
Pavlov, I., respondent condi-	absorption, 155	sexual arousal and preferences for	Social phobia, see Phobia, social
tioning	actualization, 4, 52–54, 57, 121	situations causing sufferings,	phobia

Sociopath, 3, 12, 156 Somatization disorder, see Somatoform disorders, somatization disorder Somatoform disorders, 49, 73, 126–133 body dysmorphic disorder, 126, 129, 130, 132, 135 conversion, 27, 126–128, 132, 135 hypochondriasis, 73, 126–129, 132, 135, 270 pain disorder, 126, 129, 132, 135, 220, 221, 232 somatization disorder, 126, 128, 129, 132, 135 Speech, 43, 46, 49, 76, 126, 153, 166, 168, 185, 186, 188, 201, 211, 239, 240, 243–245, 254, 273, 274 area of brain controlling, 240 disabilities, 46 disorganized, 185, 186, 201 disturbance, 76 eccentricities, 153 impairment, 243, 244 incoherence of, 49, 168, 188 limited, 186 loss of, 126 meaningless, 254 oddities, 153 perseverative, 186 rambling, 153 skills, 254 slips of, 43 slurring, 211 vague and hyperbolic, 166 Spirochete, 22, 64 Sprenger, J., 16 SSRI antidepressants, see Antidepressants, SSRI Stimulus generalization, 60

Stress, 4, 6, 7, 10, 29, 31, 34–36, 48, 66, 78, 97, 100, 112, 114–118, 123, 126-132, 135, 137-142, 144-147, 150, 151, 155, 164, 169, 173, 193, 196, 207, 266, 269, 282, 284 coping mechanism, 6, 29 see also Post-traumatic stress disorder (PTSD)
Stressors, 2, 78, 125, 169, 173, 180, 183, 194, 216, 283
Stroke, 74, 239, 240, 242, 248, 249 Stupor, 171, 188, 211 Style of life, 50, 65, 140, 147, 150, 154, 157 Sublimation, 48 see also Sexual deviations or dysfunction, sublimation Suggestion, 14, 20, 22, 101, 132, 135 Sullivan, H. S., 50, 51, 90 Sunreago, 43, 44, 46, 49, 57 Syndrome, 2, 4, 64, 79, 83, 112, 117, 137, 138, 150, 206, 216, 244, 249, 251, 256–258, 262, 264 behavioral, 2 clinical, 2, 112 Down, 256, 257, 262, 264 fetal alcohol, 206, 258, 262 fragile X, 257 general adaptation, 117, 137, 138, 150 Korsakoff's, 206, 216, 244, 249, 251 psychological, 2 shaken baby, 244, 251 Syphilis, 20, 22, 24, 64 Systematic logical errors, 176 arbitrary inference, 176 magnification and minimization, overgeneralizations, 176

Systematic desensitization, 98, 108, 111, 271 Szasz, T. S., 66 Tardive dyskinesia, 105, 195 Temperament, 115, 116 Test-retest reliability, see Reliability, test-retest Thanatos, 43 see also Eros Therapeutic community, 214, 215 Thorndike, E. L., 58, 60 Thyroid gland, 172, 245, 249, 258 disorders, 245 hyperthyroidism, 245 hypothyroidism, 172, 245 Thyroxin, 245 Tic disorder, 266, 276 Token economy, 268, 296 Trance, 22 Tranquilizers, 20, 22, 104, 146, 148, 210 Transference, 88, 89, 93, 96 see also Countertransference Transvestic fetishism, 224, 225, 232 see also Fetishism Transvestism, see Sexual deviations or dysfunction, transvestism Trichotillomania, 101 Tricyclic antidepressants, see Antidepressants, tricyclic Type A personality, 140-142, 145, 147, 150 Unconditioned response, 59 Unconscious, 21, 24, 42–48, 50, 53, 54, 57, 77, 85, 87–91, 101, 126, 141, 147

personalization, 176

selective abstraction, 176

motivations, 42, 54, 57 repressed, 91 see also Preconscious Validity, 27, 28, 37, 40, 70–72, 77, 79, 80, 83 descriptive, 71, 72, 80, 83 divergent, 83 external, 27, 37, 40 face, 83 internal, 27, 37, 40 predictive, 71, 72, 80, 83 Voyeurism, see Sexual deviations or dysfunction, classification of, paraphilias, sexual arousal and preferences for nonconsenting partners, voyeurism Wechsler, I., Wechsler Adult Intelligence Scale (WAIS-III), 75, 81 Wechsler Intelligence Scale for Children, 4th Edition (WISC-IV), 76 Wechsler Preschool and Primary

Scale of Intelligence (WPPSI-

201, 203, 204, 208, 210, 211,

Witches Hammer, The - Malleus

Withdrawal, 153, 187-189, 199,

Maleficarum, 16

214, 216, 218

affective, 204

Wolpe, J., 21, 98

social, 153, 187

III), 76

collective, 50

conflicts, 54

impulses, 46

Tritten by professors, teachers, and experts in various fields, the titles in the Collins College Outlines series provide students with a fast, easy, and simplified approach to the curricula of important introductory courses, and also provide a perfect preparation for AP exams. Each title contains a full index and a "Test Yourself" section with full explanations for each chapter.

BASIC MATHEMATICS

Lawrence A. Trivieri ISBN 0-06-088146-1 (paperback)

INTRODUCTION TO CALCULUS

Joan Van Glabek

ISBN 0-06-088150-X (paperback)

INTRODUCTION TO AMERICAN GOVERNMENT

Larry Elowitz

ISBN 0-06-088151-8 (paperback)

INTRODUCTION TO PSYCHOLOGY

Joseph Johnson and Ann L. Weber ISBN 0-06-088152-6 (paperback)

MODERN EUROPEAN HISTORY

John R. Barber

ISBN 0-06-088153-4 (paperback)

ORGANIC CHEMISTRY

Michael Smith

ISBN 0-06-088154-2 (paperback)

UNITED STATES HISTORY TO 1877

Light Cummins and Arnold M. Rice ISBN 0-06-088159-3 (paperback)

WESTERN CIVILIZATION TO 1500

John Chuchiak and Walter Kirchner ISBN 0-06-088162-3 (paperback)

ABNORMAL PSYCHOLOGY

(coming in 2007)
Sarah Sifers
ISBN 0-06-088145-3 (paperback)

UNITED STATES HISTORY FROM 1865

(coming in 2007)
John Baick and Arnold M. Rice
ISBN 0-06-088158-5 (paperback)

ELEMENTARY ALGEBRA

(coming in 2007)
Joan Van Glabek
ISBN 0-06-088148-8 (paperback)

SPANISH GRAMMAR

(coming in 2007)
Ana Fairchild and Juan Mendez
ISBN 0-06-088157-7 (paperback)

Visit www.AuthorTracker.com for exclusive information on your favorite HarperCollins authors.

Available wherever books are sold, or call 1-800-331-3761 to order.